NATIONAL GEOGRAPHIC March 19..
NATIONAL GEOGRAPHIC August, 1962
NATIONAL GEOGRAPHIC October, 1962
NATIONAL GEOGRAPHIC November, 1962
NATIONAL GEOGRAPHIC December, 1962
NATIONAL GEOGRAPHIC SEPTEMBER, 1966
NATIONAL GEOGRAPHIC NOVEMBER 1975
NATIONAL GEOGRAPHIC OCTOBER 1975
NATIONAL GEOGRAPHIC DECEMBER 1975
NATIONAL GEOGRAPHIC JANUARY 1976
NATIONAL GEOGRAPHIC FEBRUARY 1976
NATIONAL GEOGRAPHIC MARCH 1976
NATIONAL GEOGRAPHIC APRIL 1976
NATIONAL GEOGRAPHIC MAY 1976
NATIONAL GEOGRAPHIC MARCH 1977
NATIONAL GEOGRAPHIC APRIL 1977
NATIONAL GEOGRAPHIC MAY 1977
NATIONAL GEOGRAPHIC JUNE 1977
NATIONAL GEOGRAPHIC JULY 1977
NATIONAL GEOGRAPHIC AUGUST 1977
NATIONAL GEOGRAPHIC SEPTEMBER 1977
NATIONAL GEOGRAPHIC OCTOBER 1977
NATIONAL GEOGRAPHIC NOVEMBER 1977
NATIONAL GEOGRAPHIC DECEMBER 1977
NATIONAL GEOGRAPHIC JANUARY 1978
NATIONAL GEOGRAPHIC FEBRUARY 1978
NATIONAL GEOGRAPHIC MARCH 1978
NATIONAL GEOGRAPHIC MAY 1978
NATIONAL GEOGRAPHIC JUNE 1978
NATIONAL GEOGRAPHIC JULY 1978
NATIONAL GEOGRAPHIC AUGUST 1978
NATIONAL GEOGRAPHIC SEPTEMBER 1978
NATIONAL GEOGRAPHIC OCTOBER 1978
NATIONAL GEOGRAPHIC AUGUST 1979
NATIONAL GEOGRAPHIC SEPTEMBER 1979
NATIONAL GEOGRAPHIC OCTOBER 1979
NATIONAL GEOGRAPHIC NOVEMBER 1979
NATIONAL GEOGRAPHIC DECEMBER 1979
NATIONAL GEOGRAPHIC SEPTEMBER 1982
NATIONAL GEOGRAPHIC OCTOBER 1982
NATIONAL GEOGRAPHIC NOVEMBER 1982
NATIONAL GEOGRAPHIC DECEMBER 1982
NATIONAL GEOGRAPHIC JANUARY 1983
NATIONAL GEOGRAPHIC FEBRUARY 1983
NATIONAL GEOGRAPHIC MARCH 1983
NATIONAL GEOGRAPHIC APRIL 1983

NATIONAL GEOGRAPHIC

125 YEARS

LEGENDARY PHOTOGRAPHS, ADVENTURES, AND DISCOVERIES THAT CHANGED THE WORLD

MARK COLLINS JENKINS

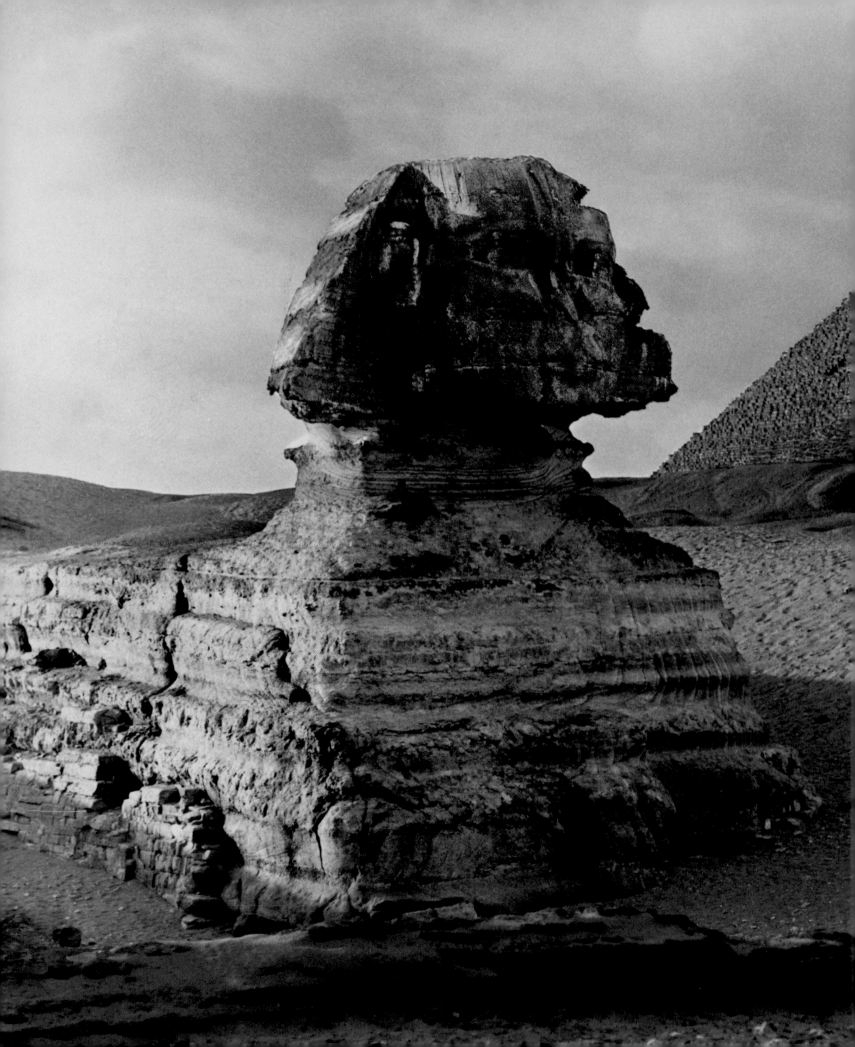

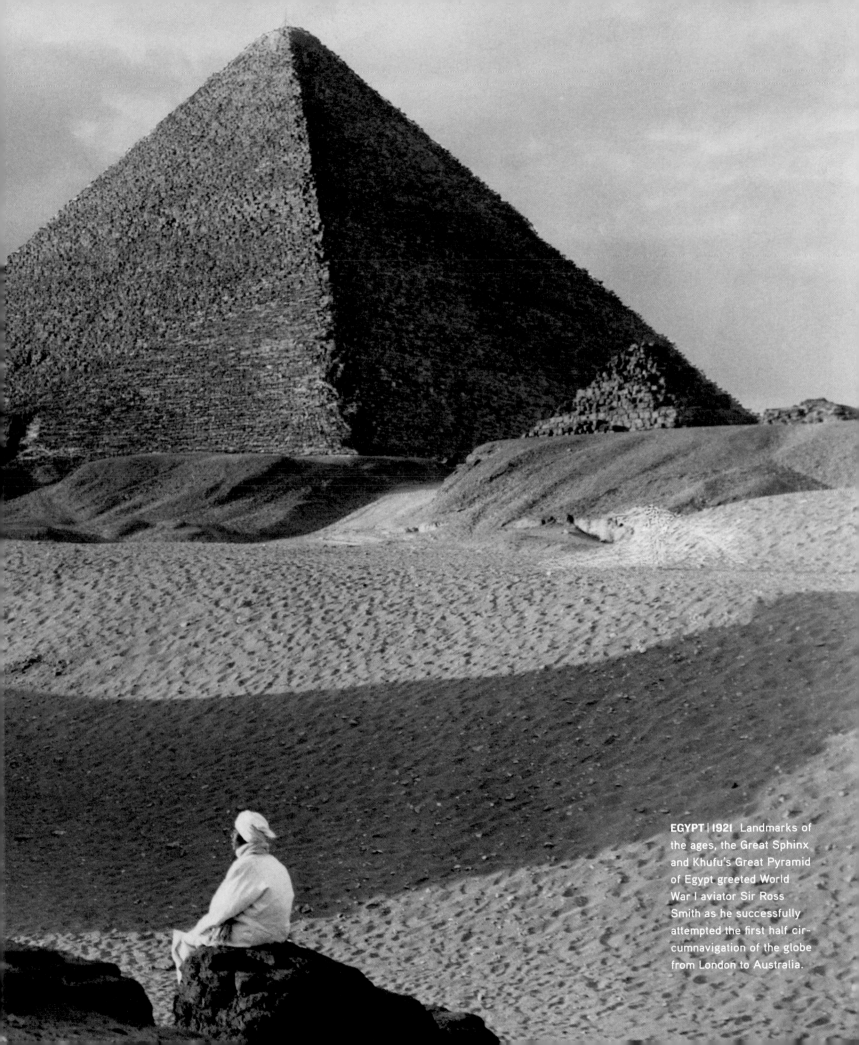

EGYPT | 1921 Landmarks of
the ages, the Great Sphinx
and Khufu's Great Pyramid
of Egypt greeted World
War I aviator Sir Ross
Smith as he successfully
attempted the first half cir-
cumnavigation of the globe
from London to Australia.

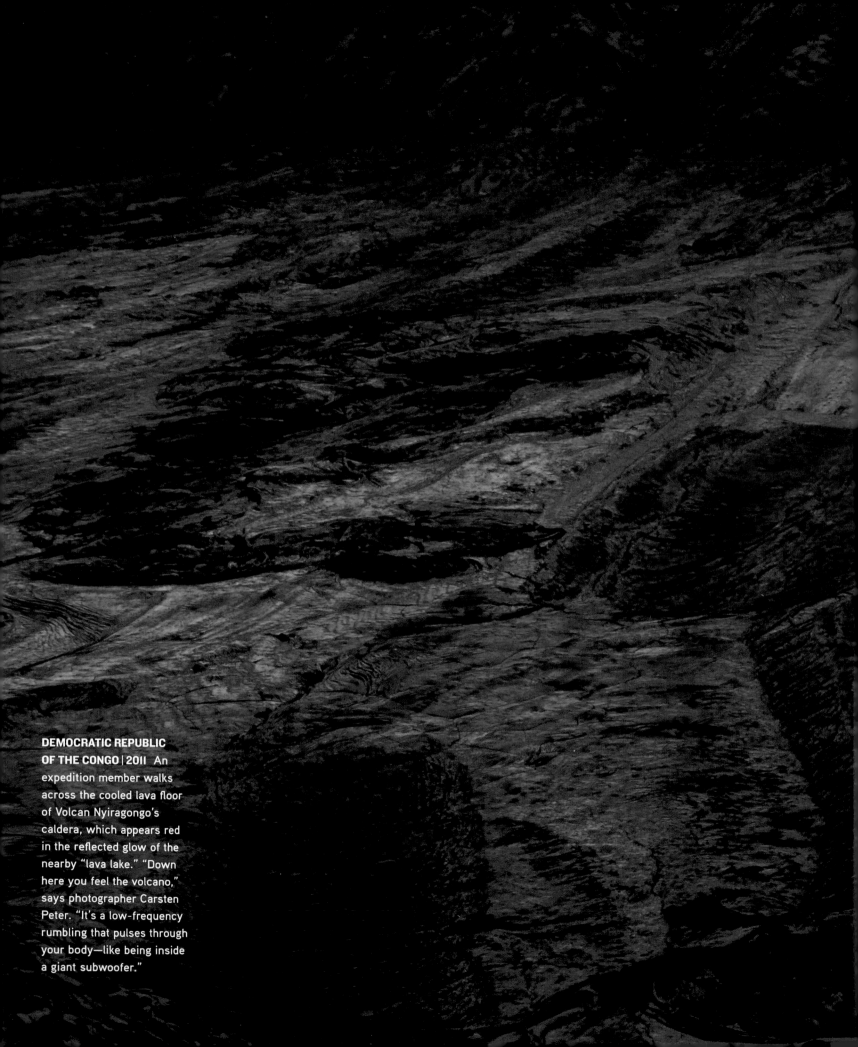

DEMOCRATIC REPUBLIC OF THE CONGO | 2011 An expedition member walks across the cooled lava floor of Volcan Nyiragongo's caldera, which appears red in the reflected glow of the nearby "lava lake." "Down here you feel the volcano," says photographer Carsten Peter. "It's a low-frequency rumbling that pulses through your body—like being inside a giant subwoofer."

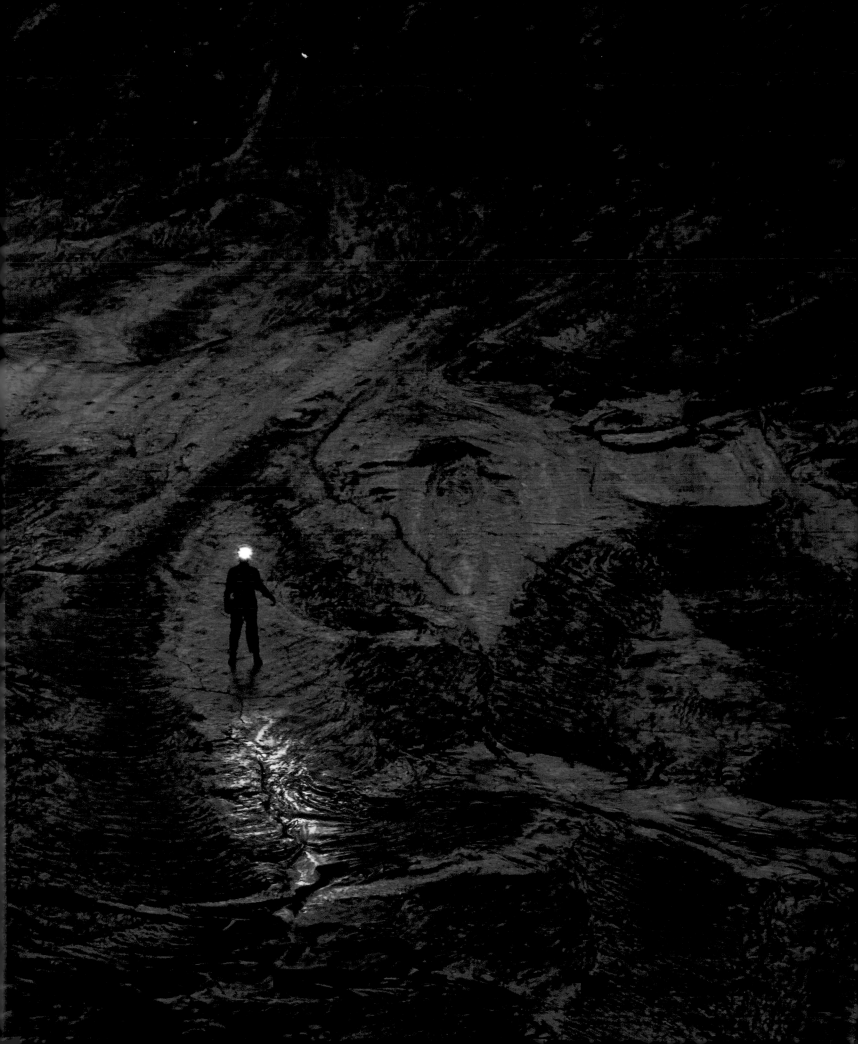

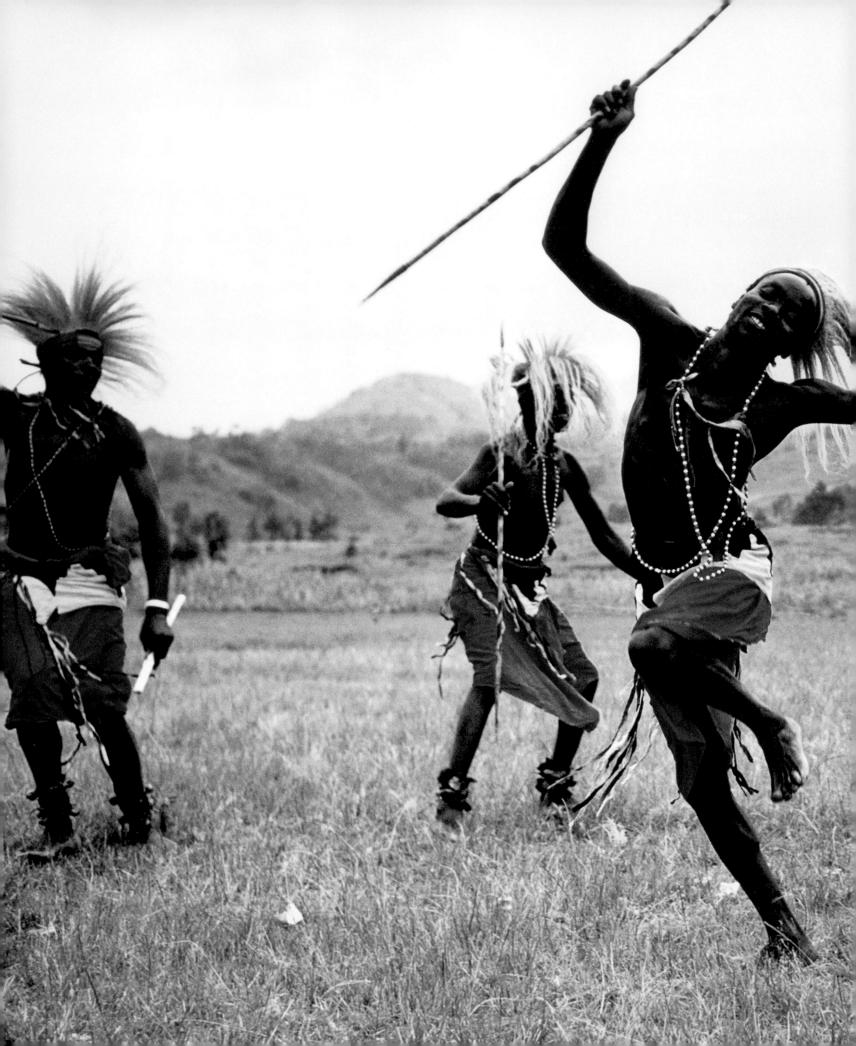

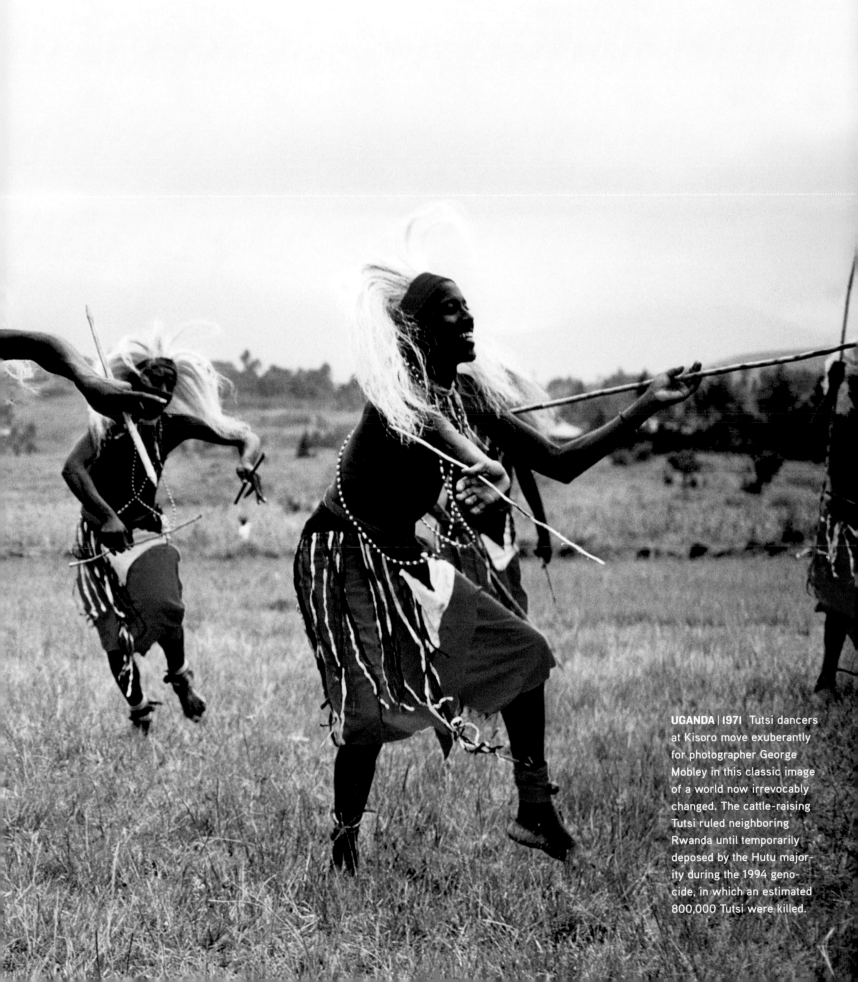

UGANDA | 1971 Tutsi dancers at Kisoro move exuberantly for photographer George Mobley in this classic image of a world now irrevocably changed. The cattle-raising Tutsi ruled neighboring Rwanda until temporarily deposed by the Hutu majority during the 1994 genocide, in which an estimated 800,000 Tutsi were killed.

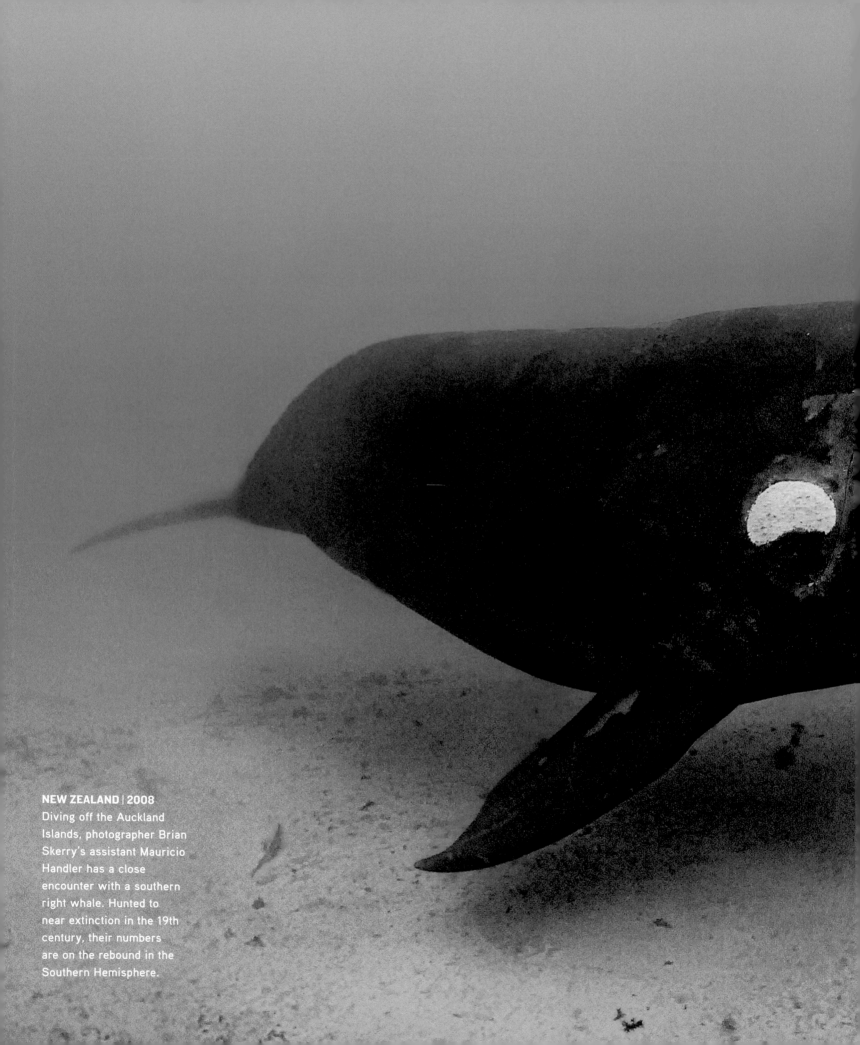

NEW ZEALAND | 2008
Diving off the Auckland Islands, photographer Brian Skerry's assistant Mauricio Handler has a close encounter with a southern right whale. Hunted to near extinction in the 19th century, their numbers are on the rebound in the Southern Hemisphere.

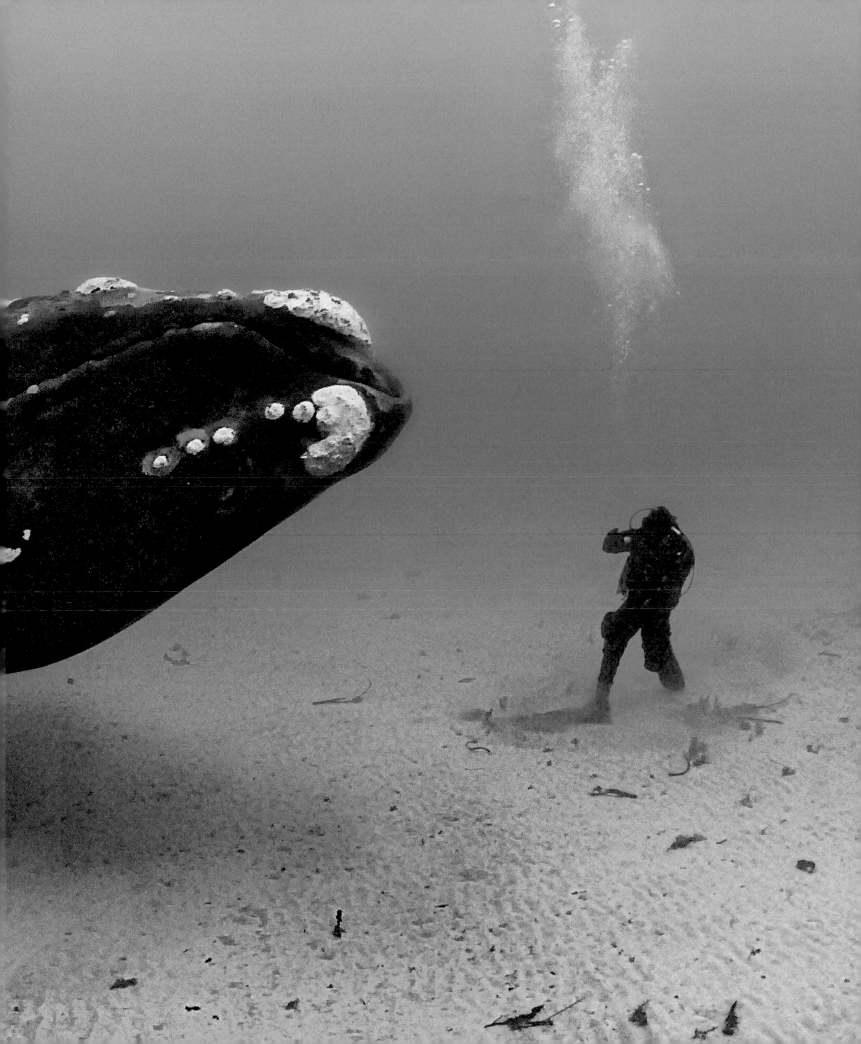

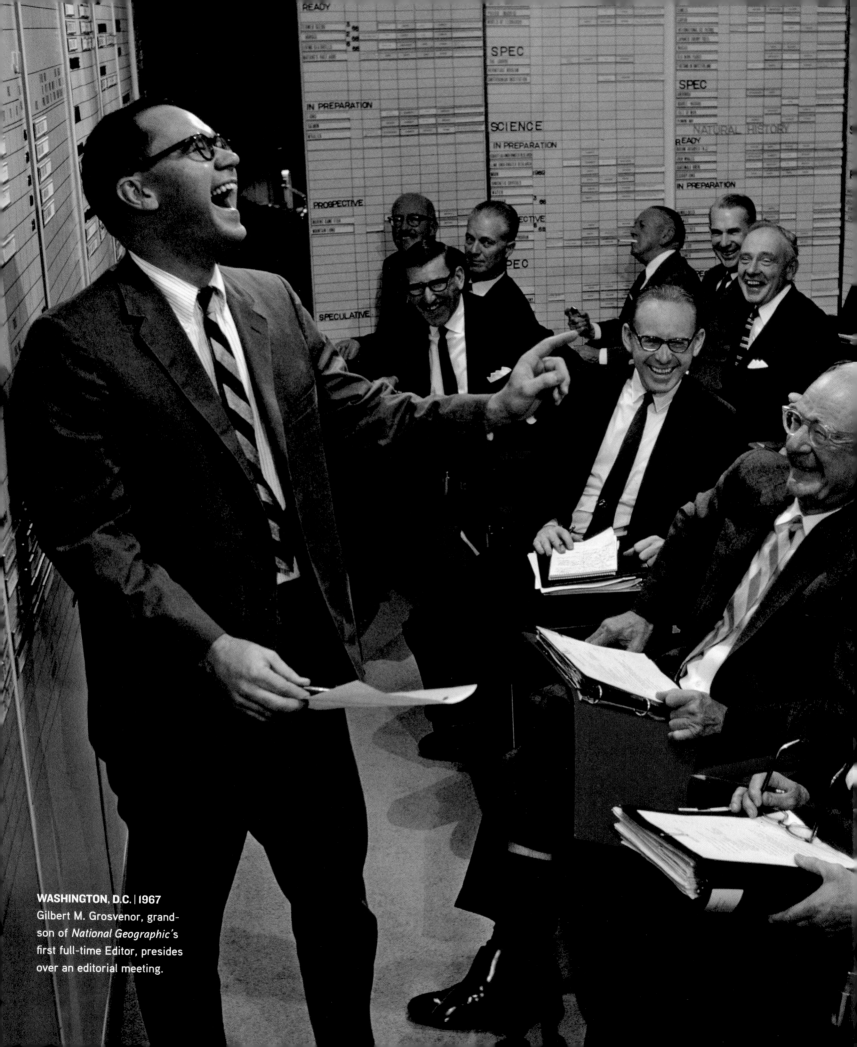

WASHINGTON, D.C. | 1967
Gilbert M. Grosvenor, grandson of *National Geographic*'s first full-time Editor, presides over an editorial meeting.

THE PLACE TO BE
BY GILBERT M. GROSVENOR

⚹ **GIL GROSVENOR**

Gilbert M. Grosvenor is Chairman Emeritus of the National Geographic Society and of its Education Foundation, and continues to serve on the boards of both. He was President of National Geographic from 1980 to 1996, the fifth generation of his family to hold that position. He was Editor of *National Geographic* magazine from 1970 to 1980. In 1975, concerned about the lack of geographic knowledge among students, Grosvenor created a monthly magazine for children, now known as *National Geographic Kids.* In 1985 he launched an effort to improve geography education in America's K-12 classrooms. The Society's Geography Education Outreach division and its local partners have invested more than $110 million toward the cause and there are now geography teaching standards in all 50 states. In 2004 Grosvenor received the Presidential Medal of Freedom.

Having been summoned to the South African Embassy, I was expecting the worst. But even so I had underestimated the ambassador's wrath. Pik Botha was red-faced with anger, fuming over the perceived unfairness of our June 1977 article on his country. As I listened to his harangue, I noticed two magazines on his desk. One was an esteemed American newsweekly; the other the familiar yellow-bordered *National Geographic*. The newsweekly had just castigated South African apartheid in no uncertain terms. Our journal—at least to me, its Editor—had run a balanced and fair piece. When I managed to get a word in edgewise, I asked why he was taking it out on me and not on the other magazine. Botha merely picked up the *Geographic,* slammed it down on his desk, and shouted, "Because people believe what you write!"

All the way back to the Society's Washington headquarters, I replayed that scene in my mind. *People believe what you write.* Of all the reasons that the *Geographic* had become known, loved, and respected around the world, an enraged ambassador had put his finger on the primary one: There was a bond between the Society and its members, and that bond had everything to do with trust.

That had been bred into my bones since I was a boy. I had grown up with the *Geographic* in a special kind of way. My great-great-grandfather was Gardiner Greene Hubbard, who in 1888 had called together a group of government explorers and helped weld them into a society established for "the increase and diffusion of geographic knowledge." Though he was its first President, it was in hindsight an organization bound to founder, if only because it had no endowment and because, as one wag later put it, its forbidding journal was diffusing "geographic knowledge among those who already had it and scaring off the rest."

It was Hubbard's son-in-law—and my great-grandfather—who turned that on its head. Alexander Graham Bell could hardly have refused to step in as President after Hubbard's unexpected death. While his tenure was short—Bell being anxious to return to his tetrahedral kites, flying machines, and hydrofoils—he did realize that, without a dime to its name, the Society needed to make "diffusion" pay for "increase," needed to make *National Geographic* magazine appeal to a broad audience by encompassing, in his words, "the world and all that is in it." His next move was providential.

He tapped as the Society's first, and at the time only, full-time employee a bright young man who happened to be courting his daughter Elsie. Gilbert Hovey

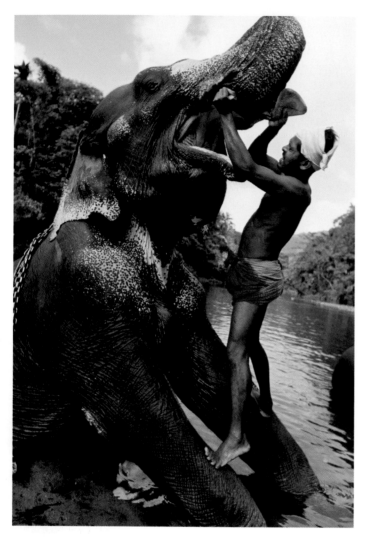

CEYLON | 1966 As a young photojournalist Gil Grosvenor photographed this mahout, an elephant trainer, cleaning his charge's tusks.

Grosvenor, a recent Amherst College graduate, not only accepted the job and married the girl but he also built the National Geographic Society into an extraordinarily successful institution. And he did so by emphasizing two things: One, he made pictures the language of *National Geographic* magazine. Our unsurpassed photographic legacy is primarily due to his pioneering efforts. And two, he stressed *quality*. Articles must be accurate, objective, of enduring value, and of "a kindly nature." That was because my grandfather was a prim, proper, courtly gentleman, though his eyes often twinkled with an impish sense of humor.

As a result, "GHG," as he was known around the office, was able to expand the Society's support of exploration and discovery, sponsoring many famous expeditions. Most important, he had established a lasting bond with the membership, which he increased from around a thousand to two million by the time he retired in 1954—a membership, by the way, with a renewal rate that hovered around 90 percent, which any publisher would envy, then or today. To GHG, a high renewal rate was *the* most important indicator of member satisfaction—a vote of confidence in the Society. The members believed us; they felt they shared in a common enterprise. However, in 1957, when Melville Bell Grosvenor, my father, became President and Editor, the Society was on the verge of stagnation. GHG's chief lieutenant, John Oliver La Gorce, had manned the helm for three years, but MBG, as Dad was inevitably known, had only been biding his time. And when his day finally arrived, the Society exploded with activity. I remember the excitement well, for I had just come aboard, fresh out of college. MBG was hiring talented young journalists like Bill Garrett, Tom Abercrombie, and Bob Breeden, as well as the design whiz Howard Paine. MBG put aside the "kindly nature" bit, and soon the word spread rapidly among photojournalists: *National Geographic* was now THE place to be.

I remember it as a golden era, the era of Jacques Cousteau and Louis Leakey and Jane Goodall. We branched out into book publishing, compiled our first world atlas, ventured into television. Every day brought some new idea. Once MBG summoned us "Young Turks" to his office. "Boys, we're going to put a picture on the cover," he announced. Anticipating our cool response, he tossed a dozen magazines onto the floor. "Find the Normandy article," he challenged. We crawled around on our hands and knees looking for the May '59 issue. Then he tossed out some magazines on which he had pasted photographs. "Find the California article." That was easy; it was

the one with the Golden Gate Bridge pasted on the cover. He had made his point. Henceforth all covers would now feature an illustration.

Above all, MBG kept up that bond with the members. During his decade at the helm their numbers more than doubled and renewal rates held up at 85 to 88 percent. He was so successful, in fact, that when he retired in 1967 the Society had become such a multifaceted institution that the board split up the old position of President and Editor. While prudent Melvin Payne became CEO, editorial veteran Ted Vosburgh took the reins of the magazine. We Young Turks hunkered down, awaiting our turn.

That came in 1970, when the board appointed me Editor and Bill Garrett associate editor, making the *National Geographic*'s leadership the youngest of any major publica tion in America. Setting a tone in our first issue we published the magazine's first major environmental article, December 1970's cover story on pollution. For the next two decades the Society flourished. When I relinquished the Editorship to Bill Garrett to become President, membership stood at 10.45 million, and renewals hovered at around 84 percent. Although Bill was producing excellent magazines, circulation peaked at just under 11 million in 1990.

National Geographic had been immune to publishing trends, but not now. Changes in readership and viewership habits began rocking the publishing industry. The demises of *Look, Life,* and the *Saturday Evening Post* at the peaks of their circulations had not been lost on me. Although it was unpopular at the time, I reduced staff by attrition and retirement incentives and invested money in circulation to stabilize membership at 10 million.

My successors, especially John Fahey, have kept the ship on course. Once again the Society is fortunate in having the right leaders at a critical time. John dramatically expanded local-language editions of *National Geographic* and with Tim Kelly built the National Geographic Channel into a successful international enterprise found in 172 countries. John has pushed into the digital frontier and dramatically increased our mission programs to boot.

So as we celebrate our 125th anniversary, I feel confident about the future. But I still hear the old echo: *People believe what you write.* That special bond of trust with our members and friends is what will sustain this great institution in the years ahead. After all, there's no place quite like it. ■

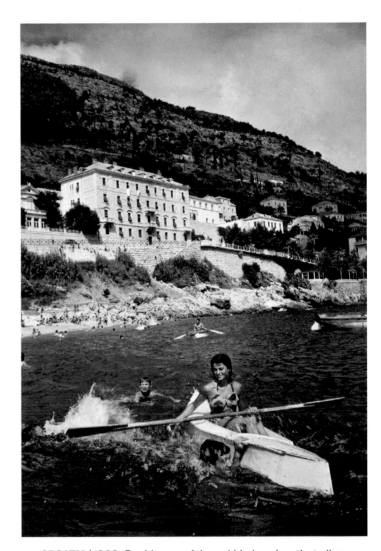

CROATIA | 1962 Beside one of the pebbly beaches that cling to Dalmatia's shores, Romana Milutin paddles her foldboat. Milutin won the Miss Yugoslavia contest after submitting photographs taken by Gil Grosvenor.

1888-

WASHINGTON, D.C. | 1888
Though atmospheric, this painting of the night the National Geographic Society was founded portrays many attendees as older than they were.

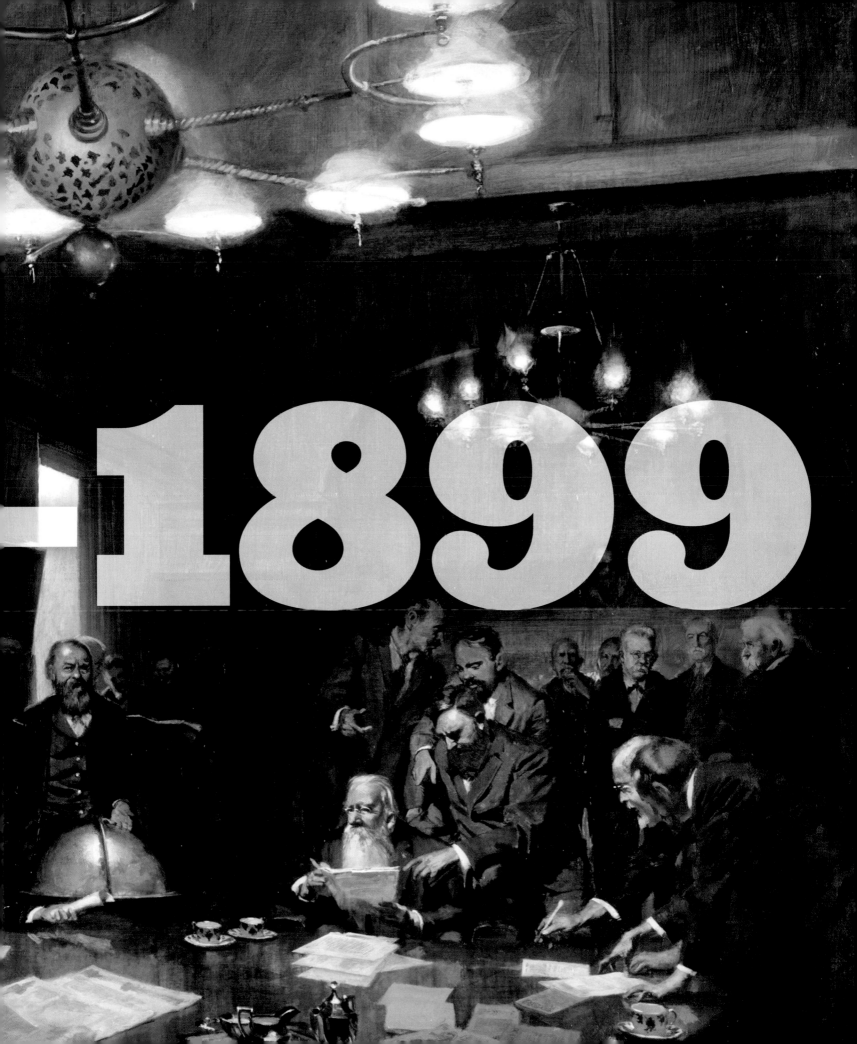

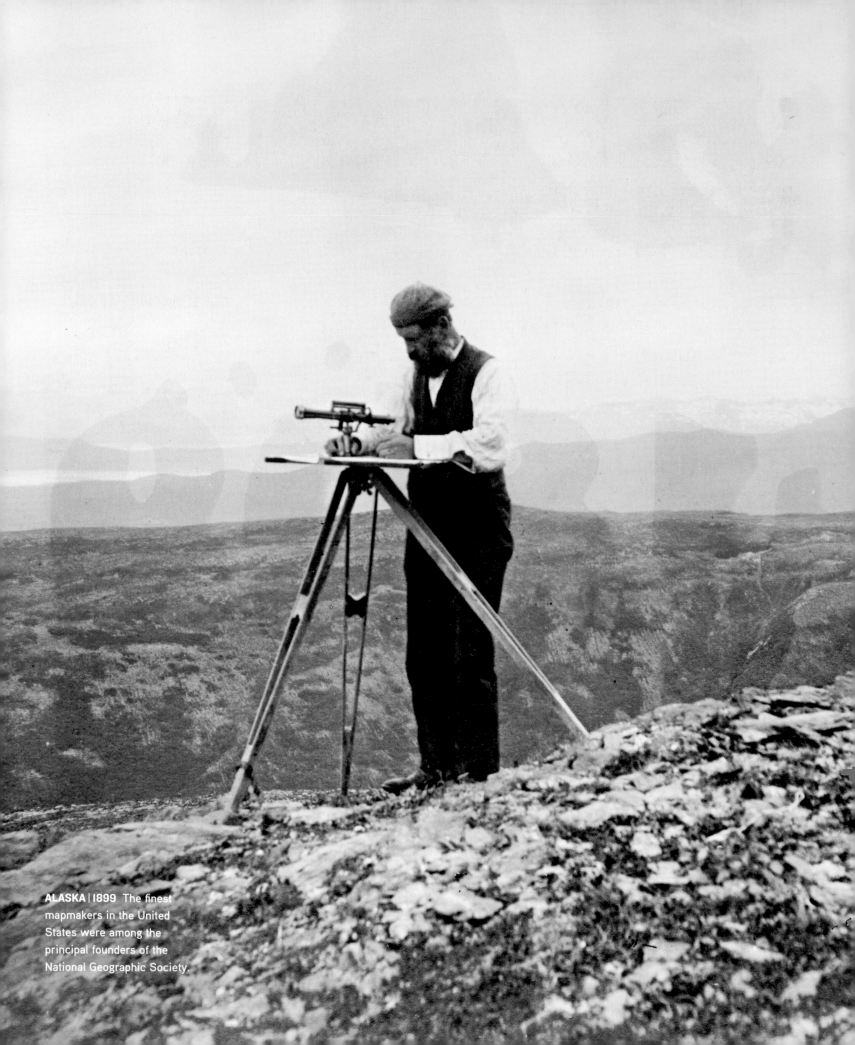

ALASKA | 1899 The finest mapmakers in the United States were among the principal founders of the National Geographic Society.

THE GREAT UNKNOWN

Take two parts desert dust blown in from the West. Mix it with two deep drafts of Gulf Stream water. Chill it with ice taken from north of the Arctic Circle. Stir it with a splash of respect for science, and you have the intoxicating brew sipped by the 33 men who met at the Cosmos Club in Washington, D.C., on the night of January 13, 1888—the night the National Geographic Society was born.

Not literally sipped, of course, though some brandy may have made the rounds, for each man had braved a damp fog to gather by the club's hearth. No doubt they would have looked askance at a drink the color of the muddy Colorado River, and they might have shuddered at the sensation of that ice on their tongues, tainted as it was by hints of unspeakable horrors.

In actuality the men had assembled in response to an invitation from six of their fellows. Two were noted Western mapmakers. Two were seagoing scientists. One was a celebrated—and, in some quarters, vilified—Arctic explorer. And the sixth was an ordinary businessman, possessing (in his words) "only the same general interest in the subject of geography that should be felt by every educated man."

The men had convened to discuss establishing a "Society of Geography" that would promote science and exploration in a nation whose lawmakers often deemed those undertakings too costly. Most of the attendees worked for one government scientific bureau or another, and none of them felt any such reluctance about the expense of inquiry. After all, they were meeting in the Lafayette Square mansion once owned by Charles Wilkes, leader of the 1838–1842 U.S. Exploring Expedition, a government-financed, five-year global odyssey that not only had filled the Smithsonian Institution with specimens but also had been the first expedition to glimpse an Antarctic continent lying beyond the southern ice pack.

Moving among them this night, his right sleeve empty, was Maj. John Wesley Powell, the explorer and battle-maimed Civil War veteran whose own 1869 journey into the "Great Unknown"—the 1,000-mile voyage down the sheer-walled Colorado River—also epitomized their aspirations. Powell was now the champion of the government scientific surveys roving the West, taking the measure of a vast territory stretching from the mouth of the Rio Grande to the frozen shores of Alaska. ■

KEY MOMENTS

1888 The National Geographic Society is founded in January by 33 men. By month's end it numbers 165 and elects Gardiner Greene Hubbard their President. In October the new organization publishes the first issue of *National Geographic* magazine.

1890 The Society mounts its first expedition to the unexplored St. Elias Mountains of Alaska, mapping hundreds of square miles, naming glaciers, and discovering Mount Logan, Canada's highest peak.

1893 At the Chicago World's Fair, the Society hosts the first international meeting of geographers ever held in America.

1896 Once a monograph issued only sporadically, *National Geographic* magazine is transformed into an "illustrated monthly" featuring inexpensive photoengravings. John Hyde, a statistician with the U.S. Agriculture Department, becomes its Editor.

1897 After a decade in office, President Gardiner Greene Hubbard dies in December.

1898 Alexander Graham Bell is elected the Society's second President, succeeding his late father-in-law.

1899 Gilbert H. Grosvenor, 23, arrives in Washington to become the Society's first full-time employee.

FAR-FLUNG EXPLORERS

The post–Civil War years favored American explorers—and cost them dearly.

⚙ TOOLS OF THE TRADE

Rather than topping a tripod with a camera, the Society's founders often used one to support a surveyor's theodolite, or transit—a rotating telescope able to measure horizontal and vertical angles. A plane table helped surveyors sketch topographic features.

ABOVE: An antique theodolite

Cigar-chomping Capt. Clarence Dutton, attached to Major Powell's survey of the Colorado Plateau in the 1870s, might have thought the Grand Canyon was "the sublimest thing on earth," but his geologic ruminations often turned, he once wrote Powell, on the question of just "how high and steep and rough a hill a mule can roll down without getting killed."

About 500 feet, was Croppy's answer. After coaxing Croppy and his yoke mate Dynamite up and down the highest peaks in the Sierra Nevada, U.S. Geological Survey topographer Gilbert Thompson could only watch in disgust as his cantankerous beast hurled itself off a cliff in Oregon. "There goes all that is mortal of Croppy," Thompson mourned, "who climbed to the top of Mt. Shasta, but died in a lonely canyon, by his own hand in a fit of temporary insanity."

Exploration was not without its costs, though few explorers paid the ultimate price that some of their mules did. "Danger is our life," one of Major Powell's men bluntly put it, though the hazards weren't always natural ones. Traveling through Apache country in 1874, Henry Henshaw (one of those naturalists who collected everything that grew, crawled, swam, scurried, or flew) went so far as to shave his own scalp—hoping thereby, he wrote a friend, to "lessen its market value."

A TICKET TO THE CITY OF SCIENCE

The West—with its buttes, canyons, gulches, cliffs, and scarps—may have been a geologist's paradise, but in sun-blasted regions the temperature could hit 114 degrees in the shade, and rocks burned the fingers. Somehow geologist Grove Karl Gilbert worked throughout each scorching afternoon. Even crossing Death Valley one July day, he managed to jot a one-word note of hope in his journal: "Breeze."

Topographers, triangulating from peak to peak, got the best views in the West. They deserved to, though rarely could they enjoy them without first squinting through theodolites, reading angles for mapmakers, for they had heaved the cumbersome tripods

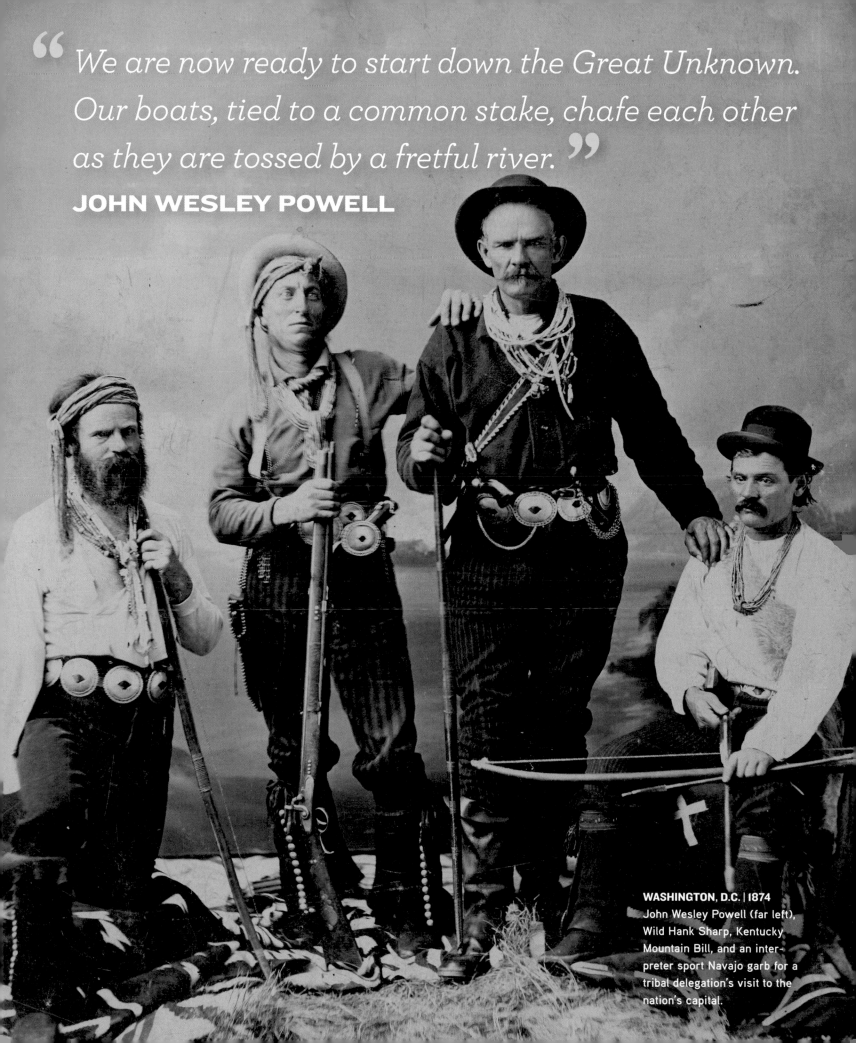

"*We are now ready to start down the Great Unknown. Our boats, tied to a common stake, chafe each other as they are tossed by a fretful river.*"

JOHN WESLEY POWELL

WASHINGTON, D.C. | 1874
John Wesley Powell (far left), Wild Hank Sharp, Kentucky Mountain Bill, and an interpreter sport Navajo garb for a tribal delegation's visit to the nation's capital.

HORROR AT CAPE SABINE

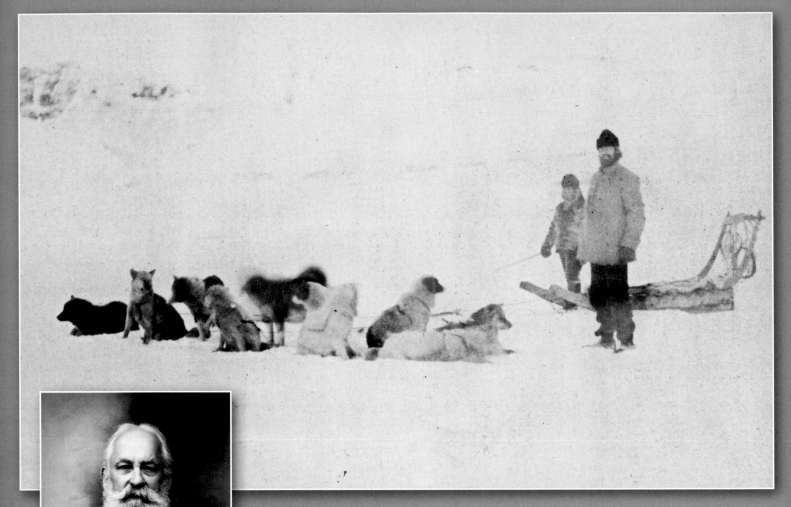

CANADA | 1881 Army lieutenant Adolphus W. Greely sticks close to his sled-dog team on an ice floe in Discovery Harbor, Canada.

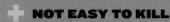

NOT EASY TO KILL

A. W. Greely (above, later in life) was a born survivor. His beard covered the spot where a bullet smashed his left cheek during the Civil War battle of Antietam, and he usually turned that side of his face away from the camera.

Scarcely had the emaciated survivors of the U.S. Army's Lady Franklin Bay Expedition, stranded for two years in far northern Canada, been welcomed home as heroes than did unsettling rumors begin to surface. There was a reason, it was whispered, why their dead comrades had been returned in hermetically sealed caskets.

Those victims of starvation had been found by rescuers buried beneath a scattering of gravel on Ellesmere Island's barren Cape Sabine. Bones on at least six of them, official reports attested, had been "picked clean" of flesh. The conclusion was unavoidable: Some of their desperate comrades, half-crazed with hunger, must have been feeding on the carcasses.

A formal investigation never ensued, and the survivors pleaded ignorance to a man. Indeed, not only was the lieutenant who led the expedition exonerated, he was soon promoted. In 1935, at the age of 91, Gen. Adolphus W. Greely received the congressional Medal of Honor for "splendid public service." ∎

over knife-edged ridges and up vertical faces. Steel spikes anchored the tripods on windblown summits—and were used to kill rattlesnakes at lower elevations.

At sea, scientists aboard U.S. Fish Commission vessels picked through oozy hauls of strange creatures, collecting the first fruits of American marine biology. Grizzled sergeants in the Army's Signal Corps, which was linking distant outposts via telegraph lines, studied barometers and scanned the skies, becoming the world's first official weather forecasters. Naval officers assigned to the U.S. Coast Survey anchored the research steamer *Blake* not once but 164 times in the rolling, impetuous Gulf Stream, sometimes in water more than two and a half miles deep, lowering ingenious current meters into the sea.

In short, it was a golden era for government science. Yet each autumn came that frosty morning when the explorers would creep shivering out of their buffalo robes, strike their tents, pack their gear, crate their collections, and make for the nearest railhead. Back in Washington, D.C., scrubbed and presentable, they spent their winter days cataloging fossils, writing reports, inking in peaks and shoals and soundings on maps, and waiting for next season's appropriations from Congress so they could return to their mules and their fieldwork.

Winter nights, however, might find them at the theater, or relaxing before the fireplace of the Cosmos Club, founded in 1878 in John Wesley Powell's parlor by and for

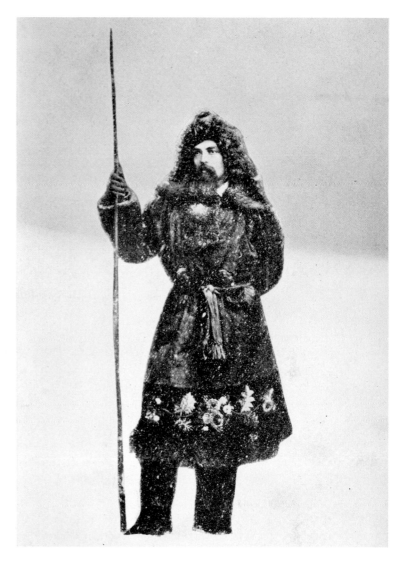

RUSSIA | LATE 19TH CENTURY Later an Associated Press journalist, Society founder George Kennan was the first American to sledge across Siberia.

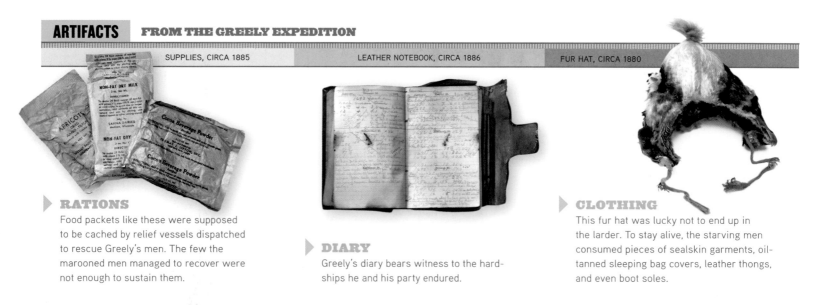

ARTIFACTS **FROM THE GREELY EXPEDITION**

SUPPLIES, CIRCA 1885 LEATHER NOTEBOOK, CIRCA 1886 FUR HAT, CIRCA 1880

▶ **RATIONS**
Food packets like these were supposed to be cached by relief vessels dispatched to rescue Greely's men. The few the marooned men managed to recover were not enough to sustain them.

▶ **DIARY**
Greely's diary bears witness to the hardships he and his party endured.

▶ **CLOTHING**
This fur hat was lucky not to end up in the larder. To stay alive, the starving men consumed pieces of sealskin garments, oil-tanned sleeping bag covers, leather thongs, and even boot soles.

scientific men who enjoyed a cigar and a dram of whiskey with their conversation. A decade later, the Cosmos Club was installed in its own home on Lafayette Square, across from the White House, and Major Powell had become head of the new U.S. Geological Survey—charged with mapping and classifying public lands—as well as of the Smithsonian's Bureau of American Ethnology, headquarters of the nation's archaeologists and anthropologists. The dual appointment made Powell one of the most powerful figures in Washington.

Facing down congressional critics came with that territory. "Pay these scientific men to hunt bugs," ran the tenor of many a grumble. "Pay them to get up fancy colored maps." Major Powell brushed aside such cavils with commonsense civility, defending the government's coordinated programs in exploration with this paean to pure science: "Scholarship breeds scholarship, wisdom breeds wisdom, discovery breeds discovery."

Beneath his unruffled exterior, however, Powell was keeping a weather eye on public opinion—especially when things went wrong.

INTO THE FROZEN NORTH

In July 1879 the U.S.S. *Jeannette* steamed out of the Golden Gate and turned north toward the Arctic Circle, seeking a warm-water current that might carry it to the North Pole. Shortly after passing the Bering Strait, however, the ship hit the Arctic ice pack and soon was locked in the floes. The stars wheeled overhead for two six-month-long winter nights before, in June 1881, the ice crushed the *Jeannette* and the crew took to the lifeboats.

EARLY FOUNDERS GATHERING

WASHINGTON, D.C. | 1894 Four of the men at this U.S. Geological Survey luncheon honoring John Wesley Powell would become a Society President or Editor of its magazine.

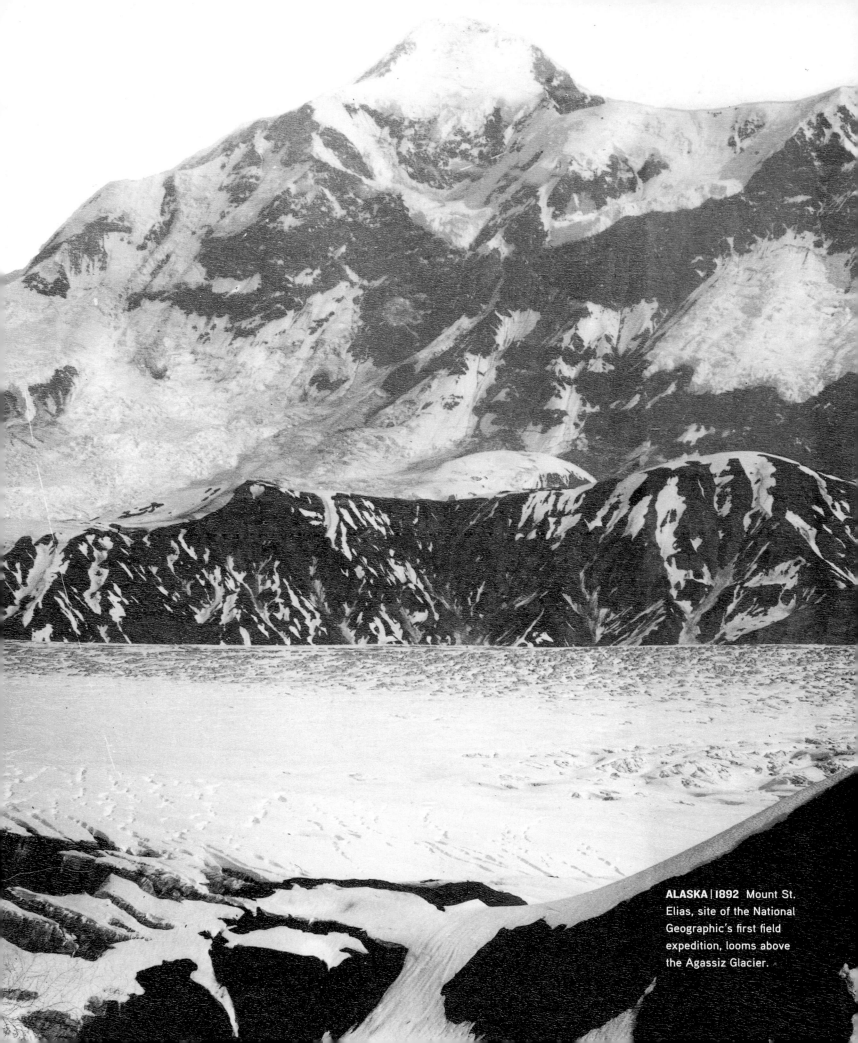

ALASKA | 1892 Mount St. Elias, site of the National Geographic's first field expedition, looms above the Agassiz Glacier.

✳ AN INVITATION TO EXPLORE

Recipients of the invitation above in early January 1888 would have instantly recognized the six undersigned names: All were leaders in the federal government's scientific bureaus or in the intellectual life of the capital. They also would have recognized that those names were reaching beyond bureaucratic rivalries to support a cause common to all: the "increase and diffusion of geographical knowledge."

ABOVE: This invitation to meet and discuss the feasibility of establishing a new geographical society went out in January 1888.

WASHINGTON, D.C. | CIRCA 1910 The nucleus of National Geographic's present headquarters complex is Hubbard Memorial Hall, built in 1902–04 to honor the Society's founding President.

Twenty men perished crossing the Laptev Sea or on the barren coasts of Siberia. Only the 12 in the lifeboat commanded by Chief Engineer George Melville returned to the United States, where one later shot himself and another wound up in a mental asylum.

By 1884 Melville was aboard another vessel, the U.S.S. *Thetis*, pounding through icy seas west of Greenland. Cmdr. Winfield Scott Schley was hoping to rescue survivors of the 25-man-strong Lady Franklin Bay Expedition, which three years earlier had established a scientific base on Canada's Ellesmere Island, only 500 miles from the Pole, but was stranded when several resupply missions failed to reach it. Schley and Melville finally found Lt. Adolphus W. Greely, the expedition's leader, and five other men huddled in a tent on Cape Sabine and nearly dead of starvation.

"Arctic exploration has involved an immense waste of money and life," mourned the *Chicago Tribune* once the inevitable rumors of cannibalism had spread (see sidebar page 24). The *New York Times* agreed: "Not even when it is played under favorable conditions is the game worth the candle."

STRENGTH IN A GEOGRAPHIC UNION

Faced with fickle public opinion and congressional retrenchment, six men began discussing a better way to support scientists and explorers. In January 1888 Henry Gannett of the U.S. Geological Survey came up with the idea of forming a "Society of Geography." It would be modeled on similar organizations that had recently coalesced in the capital to advance everything from anthropology to entomology. Geography, after all, was the common element underpinning the majority of America's exploratory efforts.

His listeners represented a cross section of important government scientists. Greely had bounced back from the deprivations of the Lady Franklin Bay Expedition to become a general in charge of the Signal Corps. Almon Thompson, Major Powell's brother-in-law, had surveyed the last unmapped river, the Escalante, in the lower forty-eight. John Russell Bartlett, commander of the Navy's Hydrographic Office, and Henry Mitchell of the U.S. Coast and Geodetic Survey agreed to put their bureaucratic rivalries aside for a greater good.

The man paying the closest attention, though, was not a government scientist but rather a Boston-bred patent attorney. Gardiner Greene Hubbard was more entrepreneur than explorer, having established the Bell Telephone Company on behalf of his son-in-law, inventor Alexander Graham Bell. Now 65, he had become a patron of science, and he had honed the backroom-negotiating skills needed to bring the right men together to promote a worthy cause. Hubbard's was almost certainly the hand behind the invitation that soon made the rounds of the city's scientific elite, summoning them to the Cosmos Club to discuss organizing "a society for the increase and diffusion of geographical knowledge."

It all led to that fateful evening of January 13, 1888, where the intrepid mule and mesa connoisseur Captain Dutton was elected chairman. Henry Henshaw turned up, as did Gilbert Thompson, George Melville, Grove Karl Gilbert, and Winfield Scott Schley. Major Powell stopped by, given that nearly half of the 33 men who had braved the fog to say aye to the idea were his employees.

Several weeks later, their numbers now swelled to 165, the men gathered to hear their newly elected President deliver his introductory address. "In union there is strength," Gardiner Greene Hubbard told the assembled bug hunters and map colorists, the archaeologists and anthropologists and Army surgeons who collected birds on the side, the dozens of sunburned young topographers from the Geological Survey—all of whom believed in the great ensemble of American science and felt that the game of exploration was indeed worth the candle, to say nothing of $5 in annual dues. "[T]hrough the medium of a *national* organization," Hubbard emphasized, might these visionaries best accomplish their purpose.

And that was why they had come together to form the National Geographic Society. ■

MASSACHUSETTS | 1885 Founding Family: Alexander Graham Bell (center) stands beside his father (left) and his father-in-law, Gardiner Greene Hubbard—the Society's first President.

MISCELLANEOUS MEMBERS

▸ **MARIA MITCHELL,** sister of Society founder Henry Mitchell, was a renowned 19th-century astronomer.

▸ **MISS MARY VON ERDEN THOMAS,** a "computer" at the U.S. Coast and Geodetic Survey, was author of the novel *Winning the Battle, or One Girl in Ten Thousand.* Her brother had been friends with Edgar Allan Poe.

The evening of January 13, 1888, has been enshrined as the night of the Society's founding. Yet it marked only the beginning. Several weeks later, when the new organization held its first meeting, the 33 men who had initially convened had swelled to 165 "original members"—a cross section of Washington's intellectual and scientific elite. Most of them worked for one government bureau or another, notably the U.S. Geological Survey. Others were associated with the Smithsonian Institution. A few soldiers marched among them. One was Washington Matthews, an Army surgeon whose works on the Navajo would be quoted approvingly by Charles Darwin. The National Zoo's W. T. Hornaday helped save the American bison from extinction. At least one early member, Simon Newcomb, was a leading astronomer. George Kennan and Eliza Scidmore (who joined in 1890) were known for travel and adventure books, while Charles Nordhoff was a writer whose grandson and namesake would co-author *Mutiny on the Bounty*.

Yet—odd though it may sound to a modern ear—not one original member was a professional photographer. ■

POWELL *Famed for his Grand Canyon explorations, John Wesley Powell was a pioneering student of Indians. He headed both the U.S. Geological Survey and the Bureau of American Ethnology.*

KENNAN *Journalist George Kennan stands bundled before the sled that took him across Siberia.*

ABBE *Mark Twain said meteorologist Cleveland Abbe—father of the U.S. National Weather Service—had a "mighty reputation for accurate prophecy."*

RUSSELL *A geologist with the U.S. Geological Survey, Israel Russell would lead the National Geographic's first field expedition. Destination: Alaska's St. Elias Mountains.*

PEALE *A geologist and fossil hunter with the U.S. Geological Survey, A. C. Peale was the great-grandson of the famous American painter Charles Willson Peale.*

GANNETT *Henry Gannett (far right) of the U.S. Geological Survey was the nation's leading mapmaker. Not surprisingly, he hatched the idea of a National Geographic Society.*

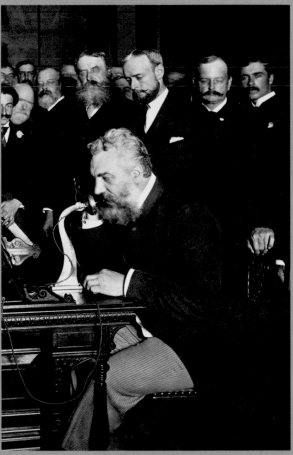

SCHLEY *Later a Spanish-American War hero, naval officer Winfield Scott Schley rescued the six survivors (seated at right) of Lt. A. W. Greely's ill-fated Lady Franklin Bay Expedition.*

MELVILLE *Heroic survivor of an Arctic tragedy that claimed 20 lives, the Navy's George W. Melville, an engineer, would be promoted to admiral and become a gunnery expert.*

THOMPSON *Having honed his map-making skills during the Civil War, topographer Gilbert Thompson joined the U.S. Geological Survey and sketched Western landscapes.*

RILEY *Entomologist Charles Valentine Riley was made a Chevalier of the Legion of Honor in 1884 for saving the French wine industry from a pest ravaging its vineyards.*

MERRIAM *Seen here at anchor in Oregon's Crater Lake, naturalist C. Hart Merriam would later become chief of the Biological Survey, forerunner of the U.S. Fish and Wildlife Service.*

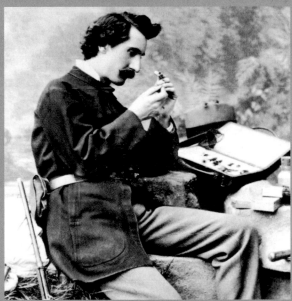

BELL *Alexander Graham Bell was no geographer. So curious about so many things was the Society's second President, however, that he left a lasting imprint on the Geographic.*

SCIDMORE *Travel writer Eliza Scidmore, a member of the board and an associate editor of* National Geographic, *was the most influential early woman member.*

HUBBARD *A patent lawyer turned patron of science, Gardiner Greene Hubbard was elected the Society's first President.*

A MAGAZINE IS BORN

Seeking new worlds to conquer, the fledgling National Geographic Society takes flight—then promptly plummets to Earth.

⊛ COVER STORY

Behind the dour cover of *National Geographic's* volume one, number one lay even more forbidding contents, including "The Classification of Geographic Forms by Genesis," or origin. ("Great Storm off the Atlantic Coast" carried a hint of more readable things to come.)

ABOVE: The inaugural issue of NGM

The freshly minted National Geographic Society led a charmed existence at first, holding glittering receptions and rapidly emerging as the largest scientific association in the capital. The Geographic (as it was soon dubbed) was still a clubby enough affair, however, that practically its entire membership could charter a train for its "annual excursion," clattering out to Virginia's Shenandoah Valley or Dismal Swamp. Though the announced purpose of these homegrown expeditions might be geologic or historic, everyone involved mostly wanted to have a picnic.

In the capital, the Geographic's popular lectures were soon packing the city's auditoriums. Yet the few members living outside Washington remained unenlightened on the views of, say, Russian anarchist Prince Kropotkin or the offbeat Mayanist Alice Le Plongeon, who believed ancient civilizations had been influenced by the lost continent of Atlantis, because only the weightier papers were printed in the Society's official journal. The sober-suited *National Geographic* magazine, first published in October 1888, amounted to little more than a sporadically issued brochure. Yet its founders hoped it might "stimulate geographic investigation" as well as prove "an acceptable medium for the publication of results."

OF GLACIERS AND GLORY

Within two years, the young Society was sponsoring an expedition to the mysterious, snowbound Mount St. Elias region of Alaska, a maze of mountains and glaciers no mapmaker had penetrated. Because the organization was practically penniless, Major Powell's U.S. Geological Survey authorized geologist Israel Russell to assemble a team of topographers. In the summer of 1890, the expedition sailed into Alaska's Disenchantment Bay.

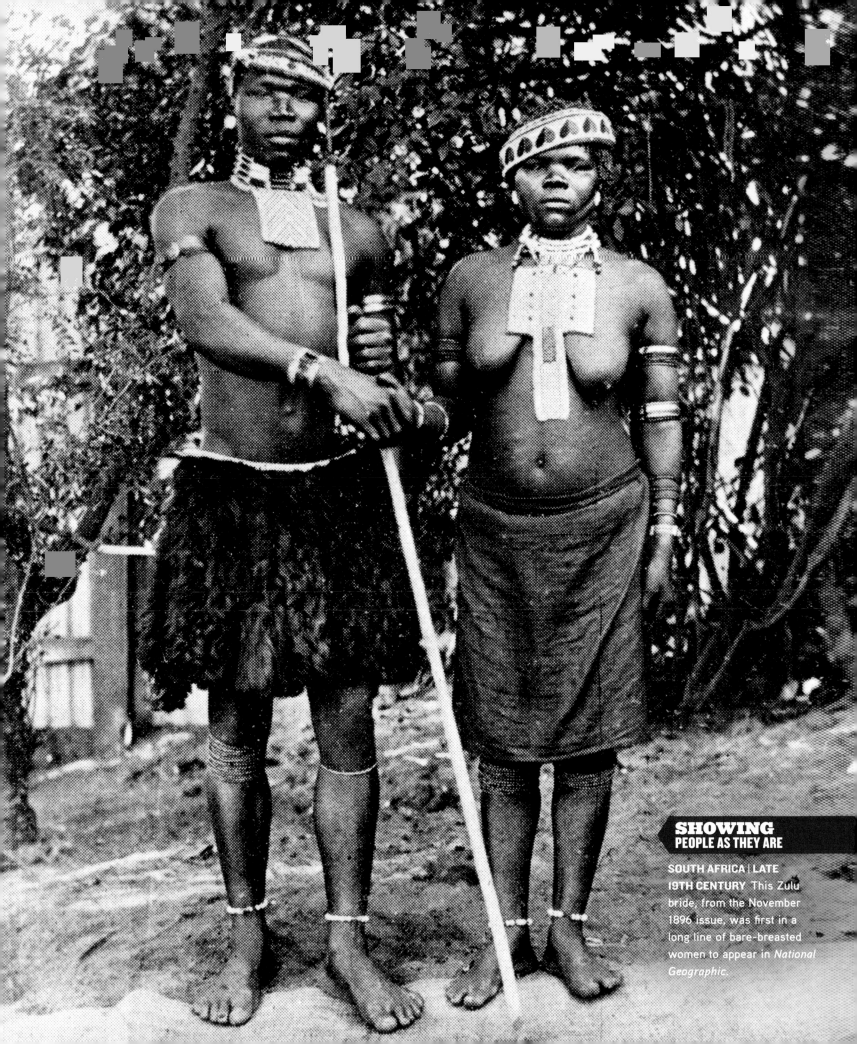

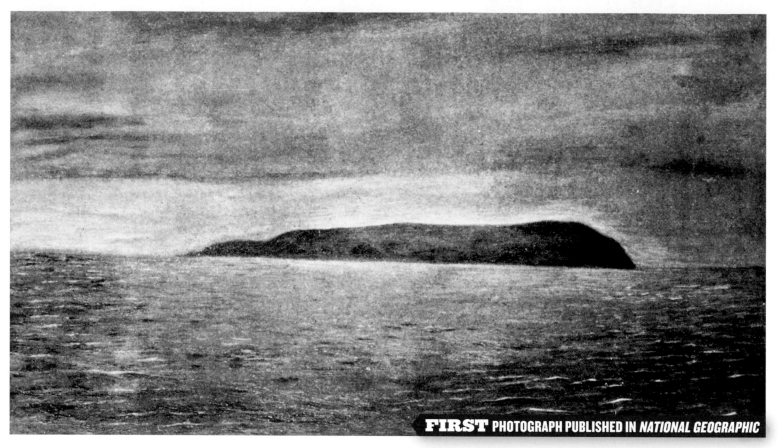

FIRST PHOTOGRAPH PUBLISHED IN *NATIONAL GEOGRAPHIC*

CHUKCHI SEA | 1889 The first outdoor photograph published in *National Geographic* did not appear until July 1890. It showed Russia's Herald Island and was shot from the heaving deck of a ship.

A few weeks later, the men arrived at the foot of Mount St. Elias. No attempt to reach its summit had yet succeeded. Nor did this one. Russell and company were defeated by torrential rain and a terrifying series of avalanches and rock slides. But they did take the measures of many previously uncharted mountains.

According to Eliza Scidmore, most of Alaska's 660,000 square miles were "as good as unexplored." Best known for her pungent travel books on Japan, Java, and China, Scidmore joined the Society in 1890 and soon became a volunteer "associate editor" of *National Geographic,* reborn in January 1896 as an "illustrated monthly." The principal editor, John Hyde, was a statistician with the U.S. Agriculture Department and worked on the magazine only on nights and weekends.

By that point the National Geographic Society, like many ventures into uncharted terrain, was heading for trouble. In December 1897, after nearly a decade as its President, Gardiner Greene Hubbard unexpectedly died.

The man the board elected to succeed him did not want the job. Though Alexander Graham Bell was a celebrated inventor, Hubbard's son-in-law hated business. Bell had to be prodded into accepting the post—and then merely buried himself deeper in his manned-flight experiments. Rudderless, the National Geographic began to founder. Membership ebbed. Debts mounted. Coffers emptied. And John Hyde began pleading for help.

Then one day Bell decided it was high time he did something about it. ■

TERRÆ INCOGNITÆ

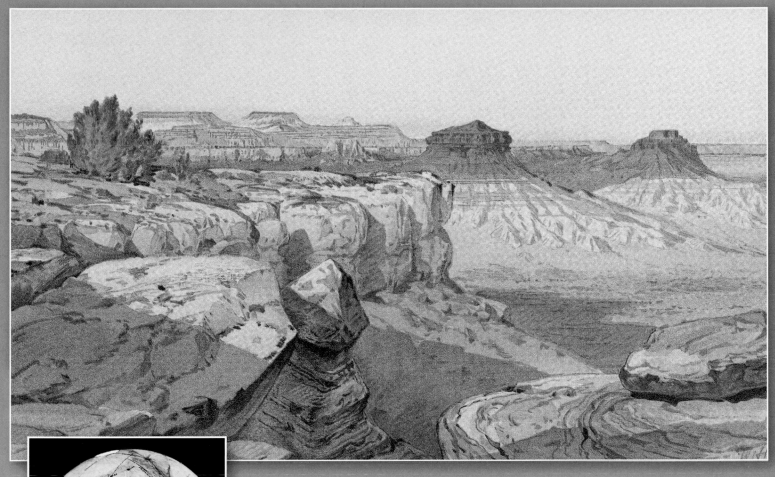

▲ **UTAH | 1870S** Titled "Sunset on the Kanab Desert," this plate was reproduced in Society founder Clarence Dutton's *Tertiary History of the Grand Canyon District*.

◄ **MARS | 1909** Astronomer Percival Lowell's map of the red planet shows its distinctive network of "canals."

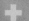 **FLIGHTS OF FANCY**

The canals of Mars (above) weren't the only figment of the spacefaring imagination. An early National Geographic member was Edward Everett Hale, author of the 1869 science fiction story "The Brick Moon," in which a 200-foot-diameter brick sphere was launched into Earth orbit—one of the earliest descriptions in literature of an artificial satellite or space station.

In May 1894 National Geographic members attending a lecture on the "Great Forest of Gaboon" met 63-year-old Paul du Chaillu, perhaps the first Western explorer to see a gorilla in the wild. In a single generation, Africa had ceased to be the unknown Dark Continent. The entire course of the Congo River had been traced, the sources of the Nile had been discovered at last, and the fabled Mountains of the Moon were now officially identified as the Ruwenzori Range.

The great ages of discovery were ending. Though the Arctic and Antarctic might still be marked as unexplored, on most of the globe only isolated pockets—among them Arabia's Empty Quarter, the New Guinea highlands, interior Alaska, and great stretches of the Amazon—remained unmapped.

Scarcely plumbed, by contrast, was the deep ocean. Nor had human eyes yet beheld either Pole, though astronomers were gazing intently through telescopes at other planets. Might those lines marking the face of Mars, for example, be canals that bespoke an alien civilization? Ah, but that was a different world. ■

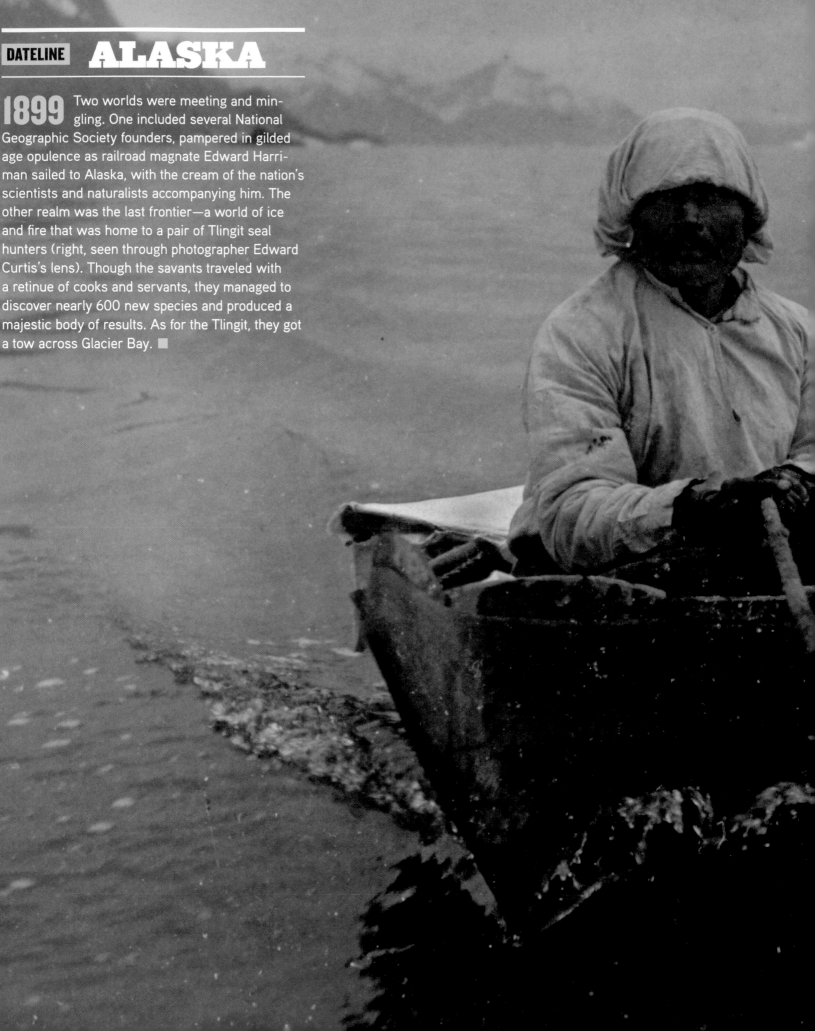

1899 Two worlds were meeting and mingling. One included several National Geographic Society founders, pampered in gilded age opulence as railroad magnate Edward Harriman sailed to Alaska, with the cream of the nation's scientists and naturalists accompanying him. The other realm was the last frontier—a world of ice and fire that was home to a pair of Tlingit seal hunters (right, seen through photographer Edward Curtis's lens). Though the savants traveled with a retinue of cooks and servants, they managed to discover nearly 600 new species and produced a majestic body of results. As for the Tlingit, they got a tow across Glacier Bay. ■

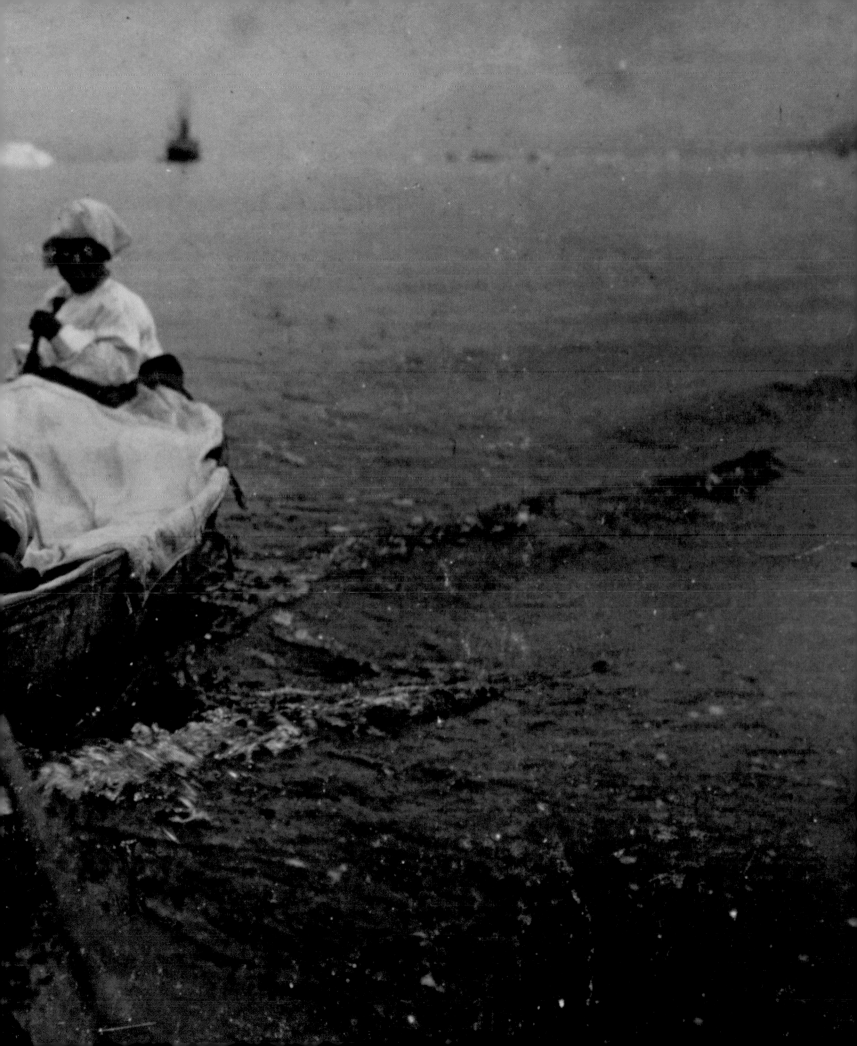

In 1922 Society mapmakers discarded the familiar Mercator projection, which plotted the round Earth as a rectangle and made Greenland seem as large as Africa. Instead they embraced the seldom used van der Grinten projection, which depicted the globe by projecting it within a circle, thus lessening the distortion. National Geographic maps have always striven to be accurate *and* distinctive. You could always recognize one at a glance, for they featured that abundance of place-names, all lettered in specially designed typefaces. They were often displayed in schools and offices, because timeliness was top of mind when the editors issued maps with *National Geographic*. And they were as eye-opening as they were beautiful: Maps of the ocean floors revealed a planet of hidden dynamism, while a 1988 plat of Mount Everest was ranked among the "most dramatic cartographic accomplishments of this century." The tradition continues today, when the round Earth is increasingly downloaded onto small screens—the globe in your pocket. ■

▾ **1922** *For 66 years—1922–1988—the world according to National Geographic was projected within van der Grinten's circle rather than Mercator's rectangle.*

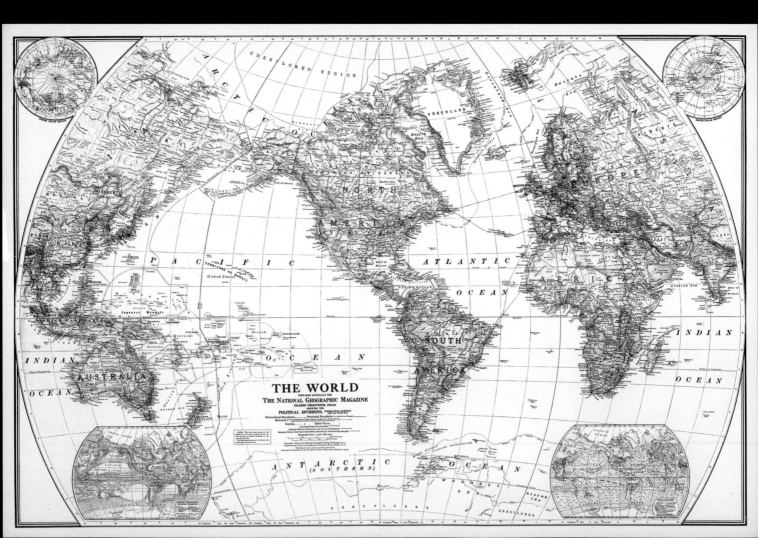

THE WORLD
PREPARED ESPECIALLY FOR
THE NATIONAL GEOGRAPHIC MAGAZINE
GILBERT GROSVENOR, EDITOR
SHOWING THE
POLITICAL DIVISIONS,

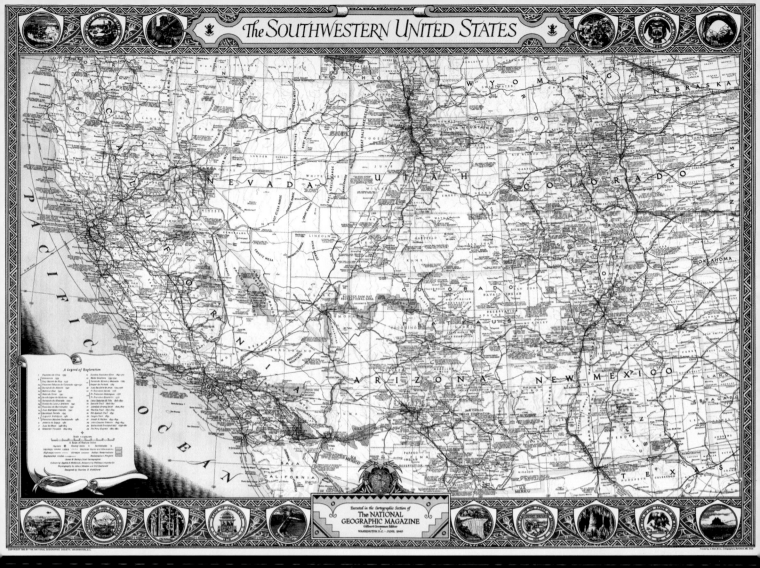

Executed in the Cartographic Section of
The NATIONAL
GEOGRAPHIC MAGAZINE
Gilbert Grosvenor, Editor
WASHINGTON D.C. · JUNE, 1940

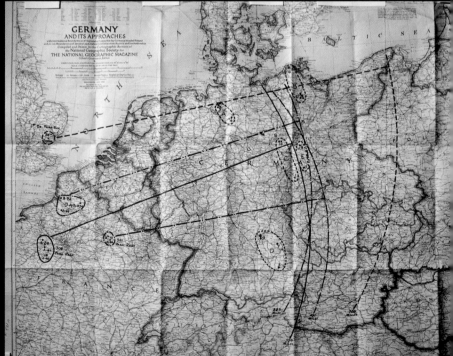

▲ **1940** Map supplements were designed to be both accurate and eye-catching.

▼ **1942** Stacked to high heaven: An employee inserts quarterly map supplements into magazines.

▸ **1944** "Germany and Its Approaches" was unfolded by soldiers in the field and used for strategic planning at Allied Supreme Headquarters.

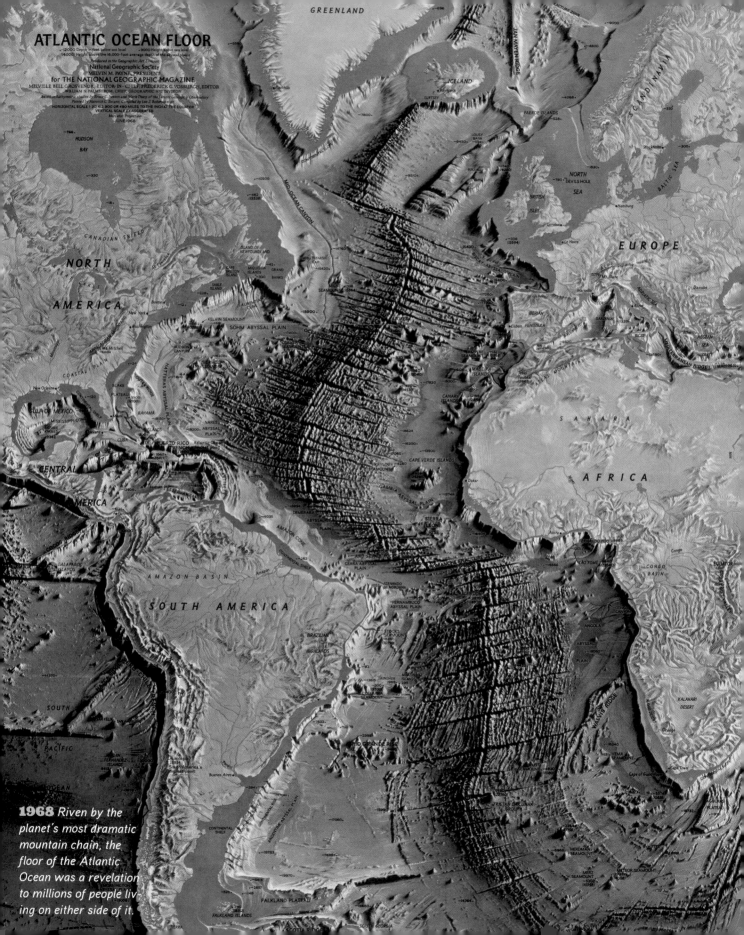

ATLANTIC OCEAN FLOOR

1968 *Riven by the planet's most dramatic mountain chain, the floor of the Atlantic Ocean was a revelation to millions of people living on either side of it.*

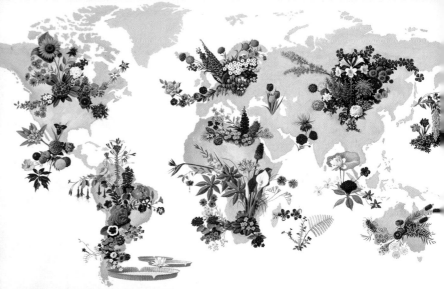

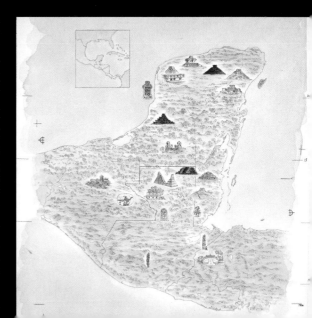

◀◀1968 *A cartographer airbrushes the rim of a lunar crater as she prepares the first map ever to show both faces of the moon on a single sheet.*

▲1968 *Purple prose for peonies: "Emblazoned with beauty," the May issue announced, "this floral map shows the origins of 117 of man's favorite flowers."*

◀1963 *Five years in the making, the first National Geographic Atlas of the World received high praise from reviewers and members both.*

▼1975 *Blending cartography with art and including every place-name mentioned in the text, "page maps" accompany most major articles in the magazine.*

NATIONAL GEOGRAPHIC ATLAS OF THE WORLD

FIRST *NATIONAL GEOGRAPHIC ATLAS OF THE WORLD*

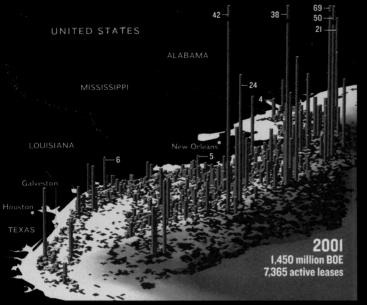

UNITED STATES

ALABAMA

MISSISSIPPI

LOUISIANA

New Orleans

Galveston

Houston

TEXAS

42 38 69
 50
 21

24

4

6 5

2001
1,450 million BOE
7,365 active leases

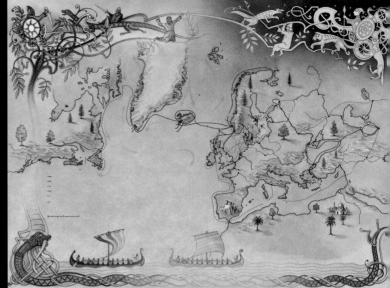

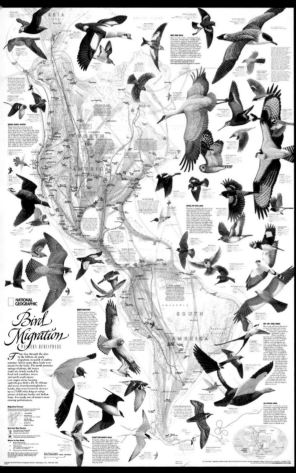

NATIONAL GEOGRAPHIC

Bird Migration
WESTERN HEMISPHERE

▲ **2000** *Geographic maps have been known to mix style with substance in whimsical ways. Here, a chart of Viking voyages.*

◄ **1983** *Like this guide to the Protestant Reformation, maps also illuminate the geography behind history.*

▼ **1992** *The breakup of the Soviet Union meant that 90 percent of Ukraine's place-names had to be changed.*

▲ **2004** *Even graphs became Geographic maps when offshore oil drilling boomed in the Gulf of Mexico.*

▲ **2004** *This double-sided map of bird migrations, with one face devoted to the Western Hemisphere and the other to the Eastern, is a perennial favorite.*

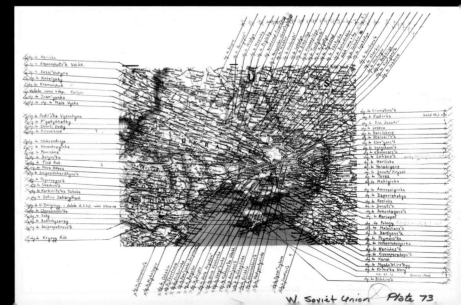

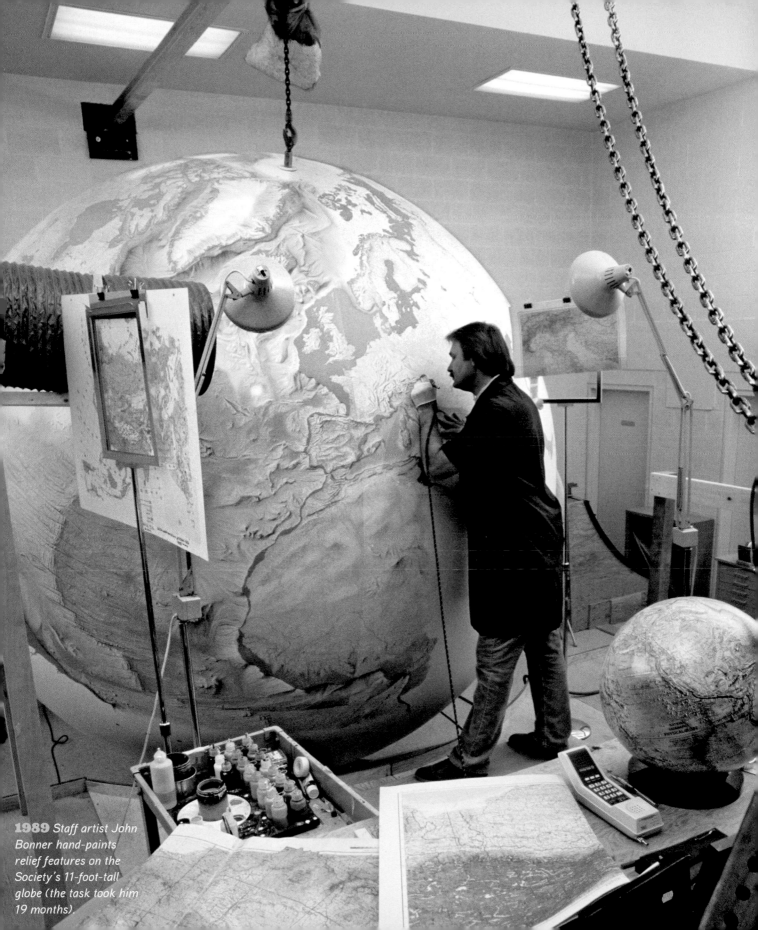

1989 *Staff artist John Bonner hand-paints relief features on the Society's 11-foot-tall globe (the task took him 19 months).*

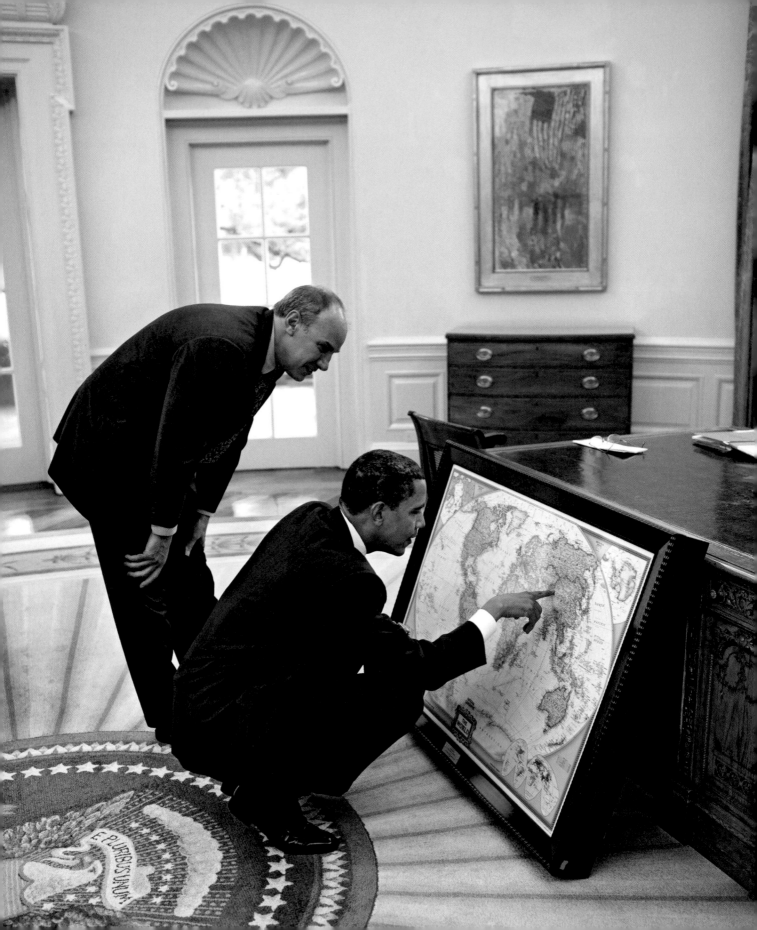

Mars

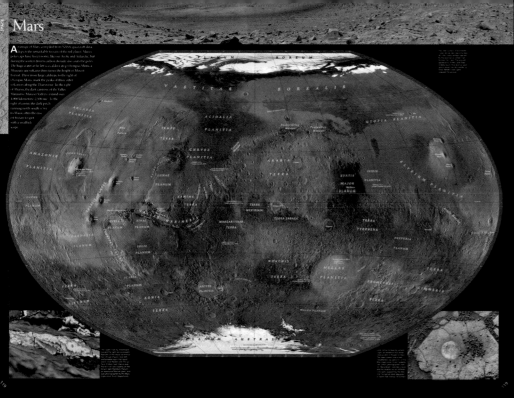

◀◀ **2009** *President Barack Obama points out Afghanistan on his new National Geographic map case. Each Commander in Chief has received one since Franklin D. Roosevelt got his in 1940.*

◀ **2009** *The Geographic's detailed maps of Mars have enthralled armchair astronauts since 1973.*

▼ **2010** *Maps excel at portraying complexly layered phenomena such as ecosystems.*

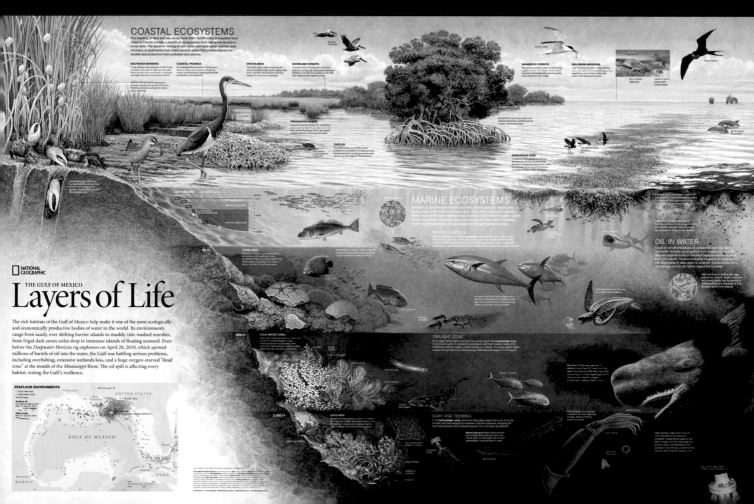

COASTAL ECOSYSTEMS

The meeting of land and sea along more than 16,000 miles of coastline from Texas to Florida creates a wealth of ecosystems, from mangrove forests to coral reefs. This dynamic mixing of salt water and fresh water and the daily infusion of sediments from rivers nourish areas that provide habitat for wildlife and protection from pollution and storms.

MARINE ECOSYSTEMS

NATIONAL GEOGRAPHIC
THE GULF OF MEXICO
Layers of Life

The rich habitats of the Gulf of Mexico help make it one of the most ecologically and economically productive bodies of water in the world. Its environments range from sandy, ever shifting barrier islands to muddy, tide-washed marshes, from frigid dark zones miles deep to immense islands of floating seaweed. Even before the *Deepwater Horizon* rig explosion on April 20, 2010, which spewed millions of barrels of oil into the water, the Gulf was battling serious problems, including overfishing, extensive wetlands loss, and a huge oxygen-starved "dead zone" at the mouth of the Mississippi River. The oil spill is affecting every habitat, testing the Gulf's resilience.

SEAFLOOR ENVIRONMENTS

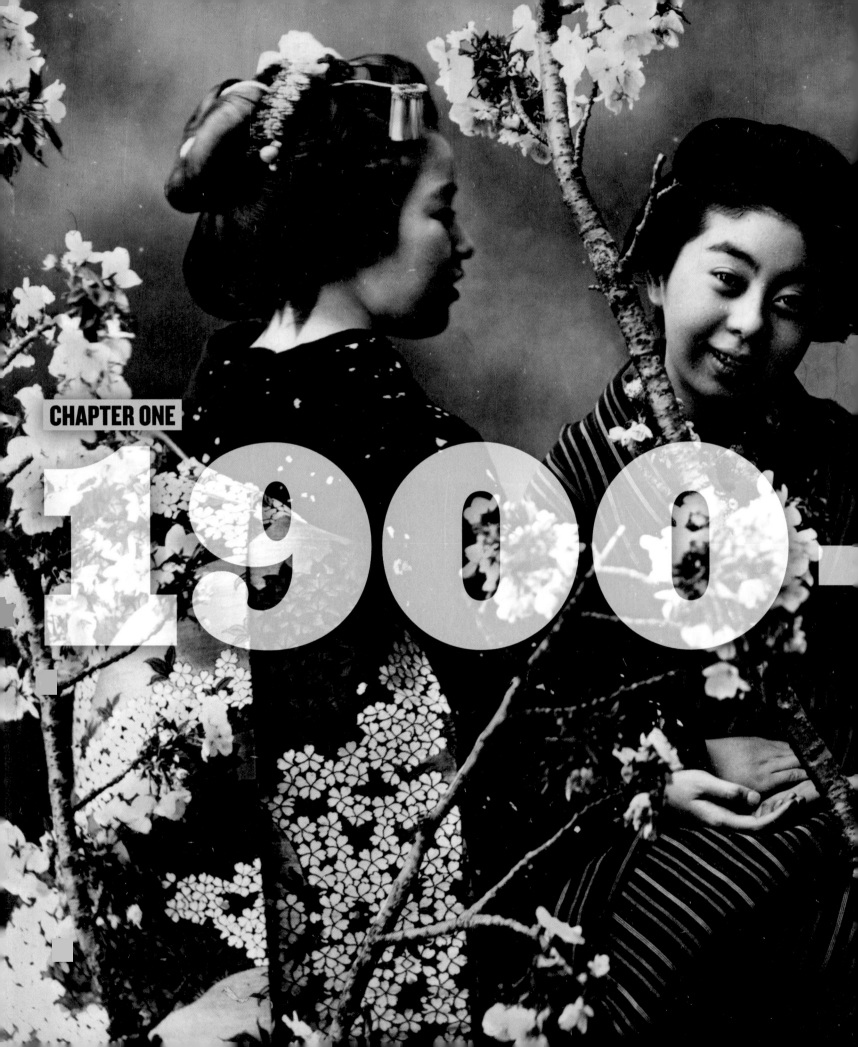

1900-

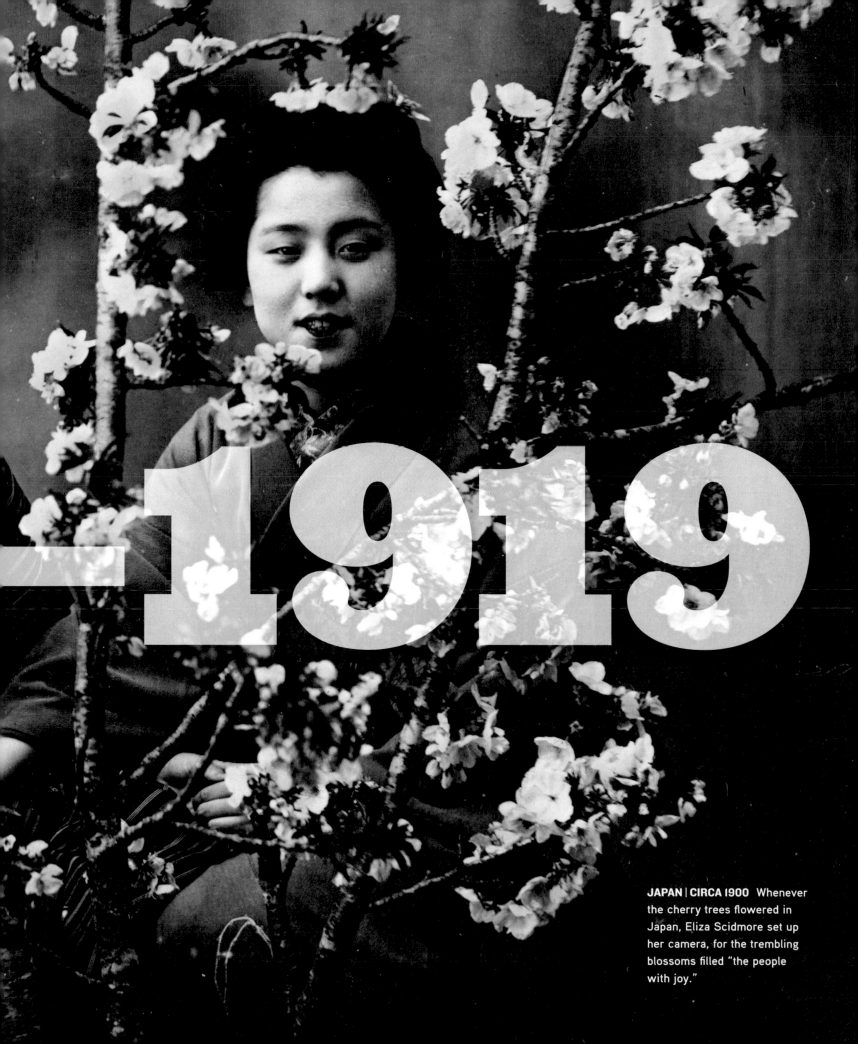

1919

JAPAN | CIRCA 1900 Whenever the cherry trees flowered in Japan, Eliza Scidmore set up her camera, for the trembling blossoms filled "the people with joy."

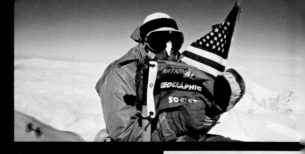

◀ 1903 *The Society-supported Ziegler Polar Expedition gets under way for Franz Josef Land; trapped by ice, it will fail to attain the North Pole.*

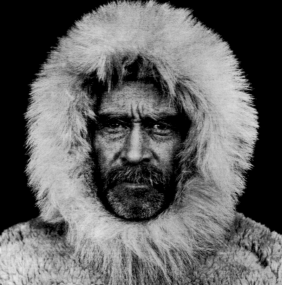

▶ 1907 *The Society prepares a map of the North Pole region for the Ziegler Polar Expedition's report; meanwhile, it sponsors Robert E. Peary's final dash for the Pole.*

▶ 1912 *Eliza Scidmore provides hand-tinted photographs of Japan for* Geographic, *which had begun publishing similar "color" pictures two years earlier.*

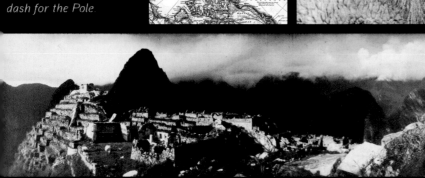

▶ 1915 *The Society commissions artist Louis Agassiz Fuertes to paint a series on North American birds, to be published in installments in the pages of* National Geographic.

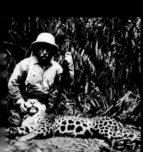

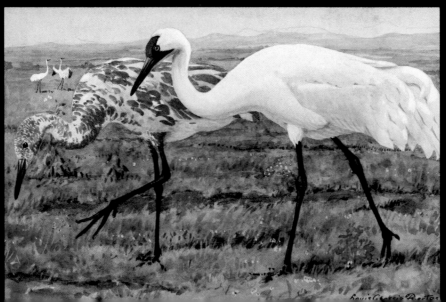

▼ 1900 *A number of prominent conservationists—including Gifford Pinchot, for whom the wilderness below is named—serve on the Society's Board of Managers.*

▼ **1916** *"Land of the Best" is a major article in the April issue. Its publication helped spur the establishment, later that year, of the National Park Service.*

◀ **1911** *The hand-colored photographs chosen to illustrate "The Non-Christian Peoples of the Philippine Islands" appeared in the November issue, a big renewal month.*

▼ **1900** *Pictures of North Africa, though it lay west of the Muslim heartland, nevertheless epitomized the "change-less East" for early Society members.*

▲ **1906** *With the July publication of this and other dramatic shots of wild animals, National Geographic embraces wildlife photography.*

▼ **1916** *Exotic pictures of Tibet, at the time a closed kingdom, appeared in the Geographic whenever Gilbert Grosvenor could lay his hands on them.*

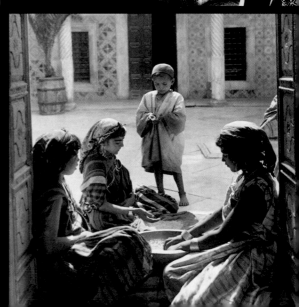

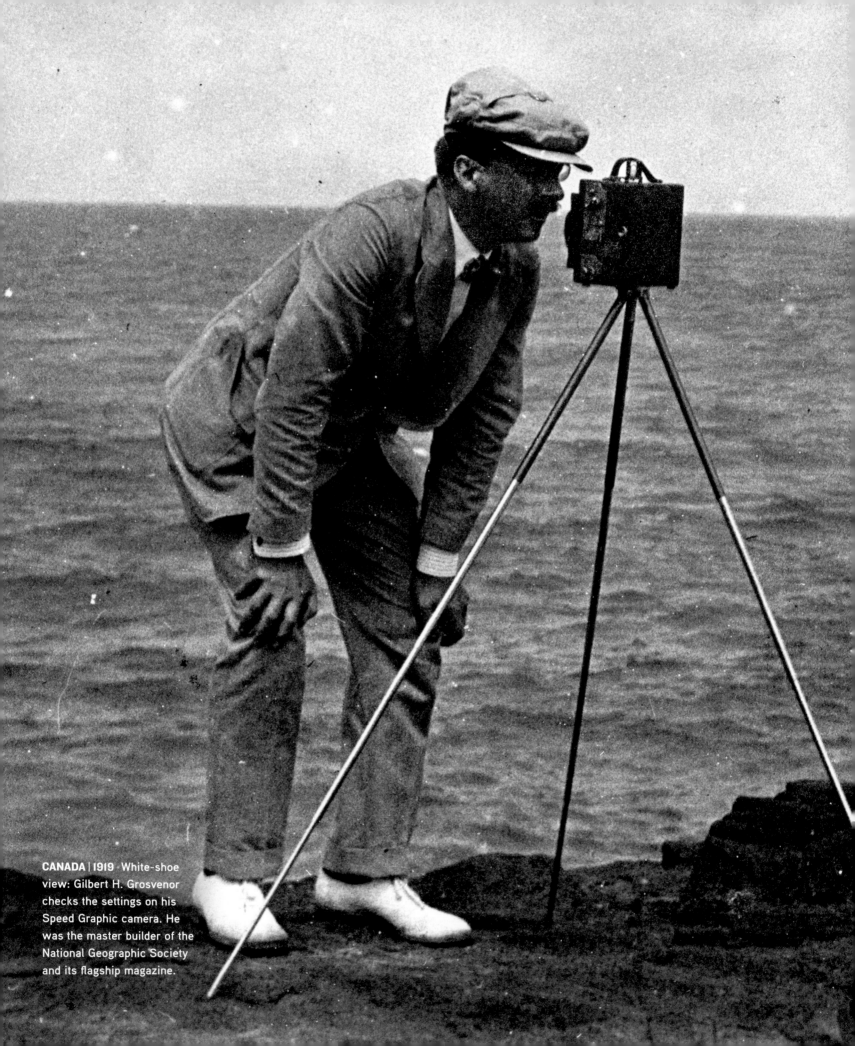

CANADA | 1919 · White-shoe view: Gilbert H. Grosvenor checks the settings on his Speed Graphic camera. He was the master builder of the National Geographic Society and its flagship magazine.

SCENES FROM EVERY LAND

Alexander Graham Bell—gray hair, flowing beard, and a corpulent frame garbed in Scottish tweeds—did not look like an explorer. But an explorer he was, lightning being the emblem of his new frontier: Bell had harnessed electricity to invent the telephone in 1876, revolutionizing our means of communication.

Twenty-three years later this magnetic, much traveled man—born in Edinburgh, he had lived in London, emigrated to Canada, taught the deaf in Boston, and become a U.S. citizen living in Washington, D.C.—was busy devising machines for human-powered flight. Bell was also President of the just launched National Geographic Society, which was rapidly sinking. So he had decided finally to provide *National Geographic* magazine's overworked volunteer editor, John Hyde, with some help. Bell would hire an assistant editor, paying his salary out of his own pocket, to mount a much needed membership drive.

Washington overflowed with worthy candidates for the job. But Bell—perhaps prompted by a daughter—reached out instead to the son of a history professor at Amherst College in Massachusetts. Young Gilbert Hovey Grosvenor was 23 years old in 1899, the year he accepted the inventor's offer to leave his own teaching position in

New Jersey, board a train for the nation's capital, and become the Society's first full-time employee.

"Mony a mickle makes a muckle," Bell liked to say, voicing an old Scottish proverb. A multitude of little things are required to make one big thing. Indeed, it was the "close observation of little things," Bell continually emphasized, that was "*the secret of success* in business, in art, in science, and in every pursuit in life."

Bell, a man with a highly tuned ear, had a range of ideas about how to make the *National Geographic* magazine more resonant for more people. In Grosvenor, conversely, he discovered someone with a sharp eye for color and a genius for pictorial journalism. Bell's ideas would serve as the blueprint, but it was Grosvenor who, year by year and brick by brick, would make a big thing out of a multitude of little ones, laying the foundation of the National Geographic Society that we know today.

KEY MOMENTS

1900 Gilbert H. Grosvenor marries Elsie May Bell.

1903 Grosvenor is appointed the Society's Director and Editor.

1904 Hubbard Memorial Hall, kernel of the Society's Washington headquarters complex, is completed.

1905 Readership surges as a result of membership drives and pictures in the magazine.

1906 Grosvenor prints 74 photos made by pioneering wildlife photographer George Shiras 3d.

1909 The Society supports Robert E. Peary's claim to have reached the North Pole.

1910 Hand-colored pictures are printed in the November issue. Henry Gannett is elected Society President.

1912 The NGS-Yale Peruvian Expeditions to Machu Picchu herald the Society's entry into archaeology.

1913 The new headquarters extension is built.

1914 The first Autochrome is published in the July issue, marking the advent of real color photography in *National Geographic*. O. H. Tittmann is elected Society President.

1916 The Society donates acres of sequoia trees for inclusion in the National Park System, forging a lasting partnership with the Park Service. Society membership passes half a million.

1919 Oceanographer John Elliott Pillsbury becomes Society President.

PICTURES—AND PLENTY OF THEM

Challenged to rebuild the Society, a young Gilbert H. Grosvenor casts about for ways to make *National Geographic* a more appealing publication.

✳ PRIVILEGES OF MEMBERSHIP

For many years you couldn't simply sign up— you had to be nominated for membership. Your name, alongside others, was then approved by a vote of the Board of Managers; only then would you receive an official certificate (above), embossed with the Society's seal. Many people, proud to be included, had the document framed.

With his trim mustache and high, starched collar, Gilbert Grosvenor appeared to be a paragon of New England propriety. But if he was to the manner born, the manor inside which he had drawn his first breath belonged to another world altogether. The twin-gabled, eminently Victorian house overlooked the Bosporus—the fabled Turkish strait connecting the Black Sea to the Sea of Marmara—from the walled compound of American-endowed Robert College, crowning a hill outside Istanbul. That's where his father was teaching history when Gilbert was born in 1875.

With its teeming bazaars and polyglot populace, Constantinople, as the city was then called, was a colorful place for a child with New England roots. An Armenian woman was Grosvenor's first nurse. Albanians, Bulgarians, and Greeks were among his early classmates. Kurdish porters carried goods to the house, itself within easy walking distance of the Sultan's palace and its Imperial Harem. Though by the time Gilbert graduated magna cum laude from Amherst College in 1897 the family had returned to its native Massachusetts, the memory of his exotic upbringing left a lasting impression on the young man's imagination.

A MAN, A MAGAZINE, A MISSION

Grosvenor had barely arrived in town before turning up for work at the Society's "office"—half a rented room in a crowded building across the street from the U.S. Treasury. It was April Fools' Day of 1899, and Grosvenor must have thought the joke was on him: As he took in his new surroundings, his gaze came to rest on a small coal grate, a nearby fire escape—tempting, no doubt—and piles of unsold *Geographics,* returned by local newsstands.

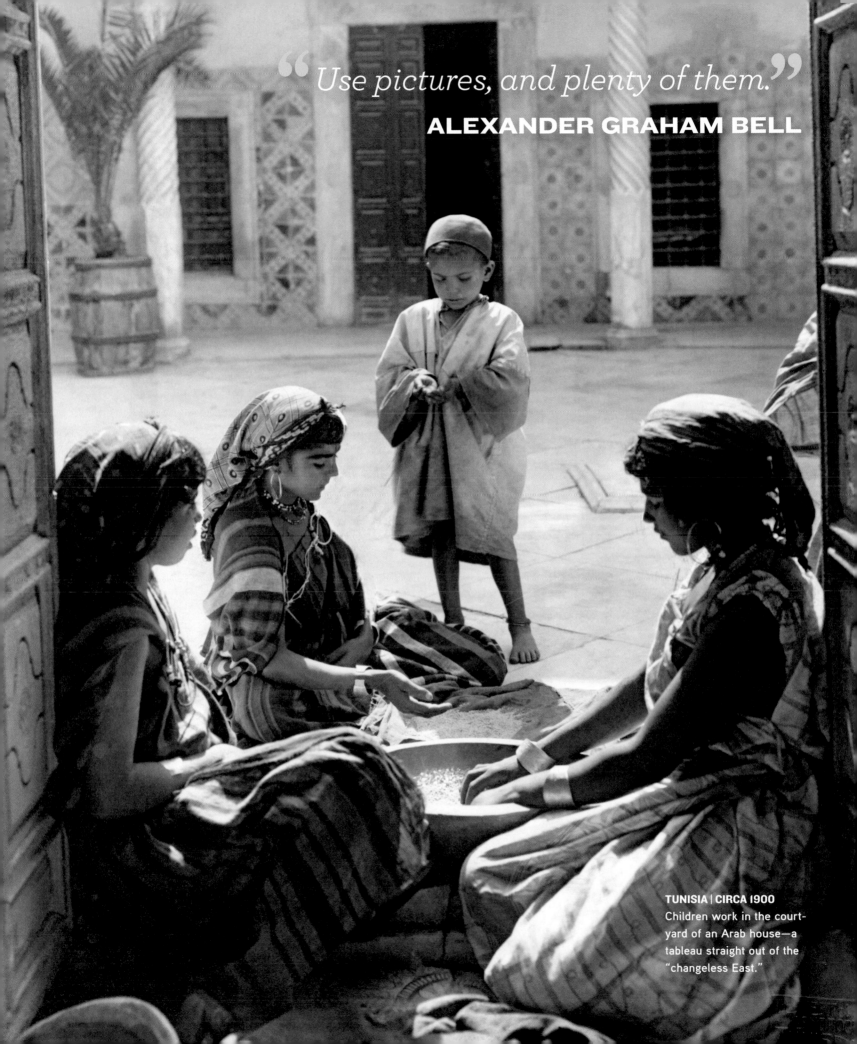

"*Use pictures, and plenty of them.*"
ALEXANDER GRAHAM BELL

TUNISIA | CIRCA 1900
Children work in the court-
yard of an Arab house—a
tableau straight out of the
"changeless East."

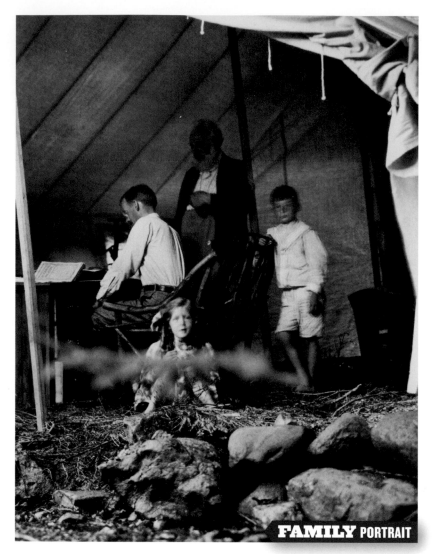

FAMILY PORTRAIT

CANADA | 1909 No rest for a weary Editor: Grosvenor gets some unsolicited help from his children and his father-in-law, Alexander Graham Bell, at the latter's summer estate in Nova Scotia.

Bell, he soon learned, was convinced that a membership composed chiefly of government scientists—among them many who discouraged the "excessive use of picture and anecdote" in their lectures—was too narrow a base on which to build a truly national organization. With only 1,000 names enrolled, he needed to attract a broader spectrum of dues-paying members, and the only instrument he had on hand was *National Geographic*. Grosvenor's task was to help John Hyde make it as smart and appealing as the nation's leading magazines. Use "pictures," Bell urged his new protégé, "and plenty of them." For " 'The world and all that is in it' is our theme, and if we can't find anything to interest ordinary people in that subject we better shut up shop and become a strict, technical, scientific journal for high-class geographers and geological experts."

Eventually the discouraged Hyde resigned outright, leaving Grosvenor huddled by the coal grate on early winter mornings, or working on the fire escape on stifling summer evenings as, month by month, he sought the elusive secret of success. For every sobersided article he published on the work of the government's scientific bureaus, he tried to print a countervailing cultural piece on, say, the Boxer Rebellion in China or the revolt of the Ashantis in Ghana. And wherever he cast about for material, he seized every picture he could lay his hands on. In January 1905 he published 11 rare photographs, shot clandestinely by Russian explorers disguised as Tibetan monks, of the forbidden city of Lhasa. In April came 138 photographs of Philippine tribesmen, pored over by Americans curious about the people in their newest colony, ceded to them as spoils of the Spanish-American War. As a result, membership soared in 1905 from 3,256 to 11,479. Grosvenor had reached the turning point—the end of the beginning.

CURIOUS CORNERS OF THE WORLD

Once Bell's faith in Grosvenor's editorial flair had been vindicated, the inventor resigned the presidency he never wanted, leaving "Bert" as the Society's Director and Editor. And Bell left him working comfortably in ample new headquarters: Thanks to the generosity of the Bell and Hubbard families, Hubbard Memorial Hall stood proudly on 16th Street, six blocks north of the White House. In another way, Bell never

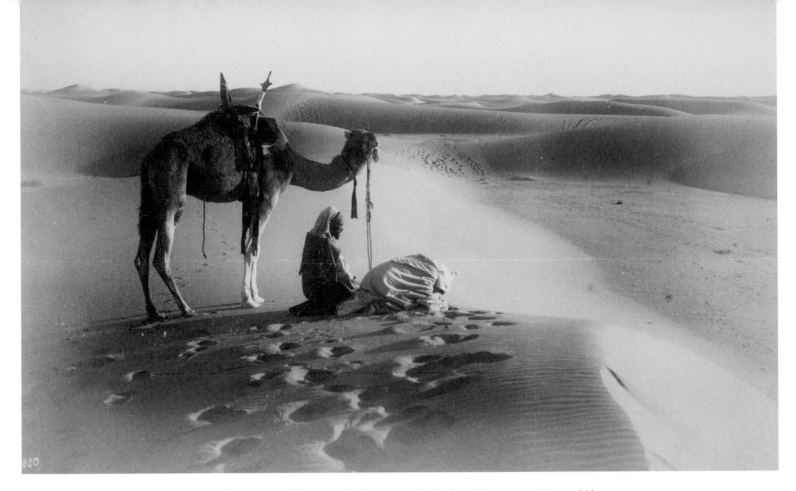

SAHARA | CIRCA 1900 Two camel riders pause in the desert to pray east, toward Mecca.

left Grosvenor at all. In 1900 Bert had married Alec's daughter Elsie, and now he was one of the family.

Through the doors of Hubbard Hall soon wandered the first of that long line of diplomats, soldiers, scientists, and gadabout travelers who would be the magazine's primary contributors for the next several decades. Meanwhile a cavalcade of tattooed and turbaned tribesmen, of figures booted and caped, of warriors garbed in loincloths and carrying spears, of women festooned with neck rings or capped with tremendous bonnets or dressed in traditional costumes or notoriously barebreasted marched out of the magazine's pages and into American parlors. With practically every issue depicting temples or palaces or pagodas, and with every cover bearing titles such as "In the Savage South Seas" or "Queer Methods of Travel in Curious Corners of the World," the humming addressograph machine in Hubbard Hall spat out more and more mailing labels. Membership in the National Geographic Society surpassed 30,000 in 1907. By 1910 it was nearing 75,000. Grosvenor had found the secret of success. ■

✳ CANADIAN ACCORDION

An eight-foot-long foldout of the Canadian Rockies spills from the center of the *Geographic's* June 1911 issue (below). It illustrated Charles D. Walcott's article, "A Geologist's Paradise," describing the author's discovery of the famous Cambrian period fossils known as the Burgess Shale.

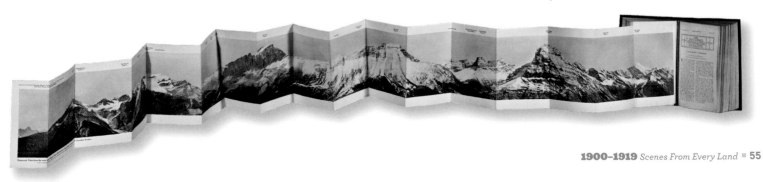

A FLUTTER LIKE NO OTHER

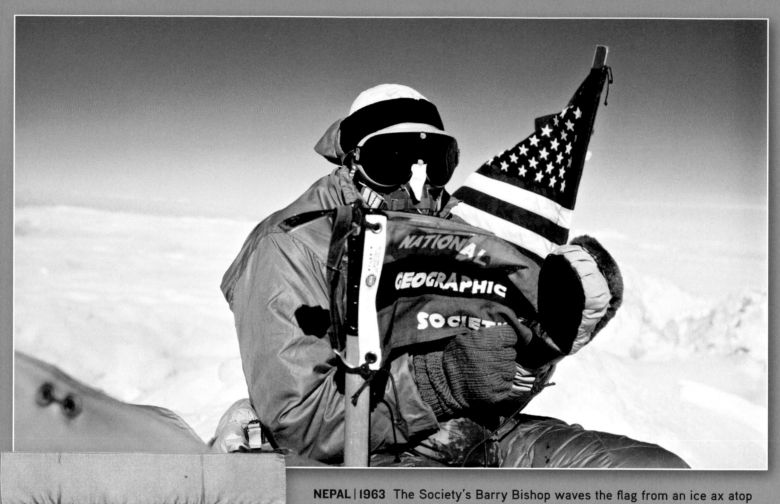

NEPAL | 1963 The Society's Barry Bishop waves the flag from an ice ax atop Mount Everest. The picture cost him dearly.

ABOVE: A faded early prototype of the eventual National Geographic Society flag

It's a pretty simple flag, but to Gilbert Grosvenor simplicity was supreme. Back in 1903 he wanted something easily recognized from a distance, as the Society's standard would soon be flying over its new headquarters in Washington, D.C. Yet he did not want something as complicated as the Society's seal—the Western Hemisphere, with lines of latitude and longitude inscribed thereon—emblazoned on it. "A flag

THE NGS FLAG

The flag has snapped to many a trade wind. ▶

EAST INDIA

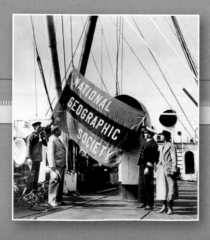

MALAYSIA | 1937
The flag unfurls aboard a prewar Noah's ark—the ship carrying the Society-supported Mann Expedition to the East Indies to collect exotic animals for the National Zoo.

Hoisting the flag up the world's southernmost Pole ▶

SOUTH POLE

ANTARCTICA | 1957
National Geographic's Thomas J. Abercrombie flies the flag at the South Pole while reporting on the International Geophysical Year of 1957–58. He became the first person to carry it there.

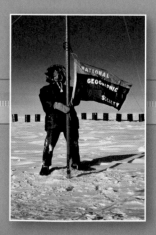

that is not readable fails in the purpose for which flags exist," he grumbled.

So his wife, Elsie Bell Grosvenor—the clever daughter of Alexander Graham Bell—took up the challenge of designing a flag. After some quick work with needle, thread, and strips of cloth, Elsie had produced a pennant with three horizontal stripes: a green one on the bottom representing the oceans, a brown one in the middle standing for the land, and a blue one on top symbolizing the air. Exploring earth, sea, and sky: It couldn't get much simpler than that.

Grosvenor proudly conferred his new banner on 1903's Ziegler Polar Expedition—which promptly failed to reach the North Pole. But the flag's fortunes would fare much better over the ensuing years. It would be carried to every continent and nearly every country on the globe. Desert suns have faded it, jungle downpours have drenched it, trade winds have snapped it tautly in the salt air. It has been planted in the lowest spot on land—the shores of the Dead Sea—and waved from its highest pinnacle, the peak of Mount Everest. It has been taken to the deepest spot in the oceans, the Marianas Trench, and as far skyward as the moon. The man who took it on the first flight over the South Pole, Cmdr. Richard E. Byrd, even claimed that "other than the flag of my country, I know of no greater privilege than to carry the emblem of the National Geographic Society."

And the North Pole? It may or may not have arrived there with Peary in 1909. So on May 20, 1953, a U.S. Air Force plane circled above the featureless location of 90° north while its passenger, an elderly Gilbert H. Grosvenor, dropped the three-striped banner onto the legendary spot—just to be sure. ■

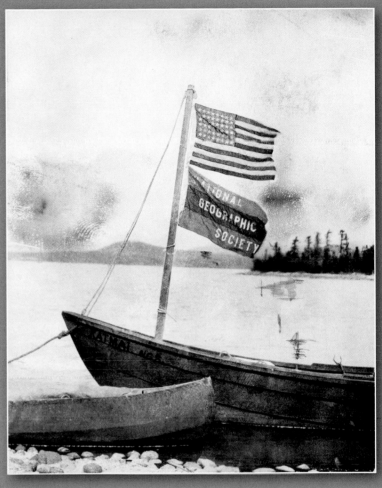

ALASKA | 1918 The National Geographic flag accompanied the Society's Mount Katmai Expeditions to the Valley of Ten Thousand Smokes.

Sylvia Earle took the flag on her famous deep-sea stroll. ▶

PACIFIC OCEAN FLOOR

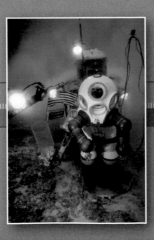

PACIFIC OCEAN | 1979

The Geographic standard descends 1,200 feet with Sylvia Earle. Wearing a "Jim" suit designed for burly oil-rig divers, she was the first human to walk the ocean floor at that depth.

A banner fit for the *Titanic* ▶

NORTH ATLANTIC OCEAN

ATLANTIC OCEAN | 1985

The Society's Emory Kristof (left) and Robert Ballard display a familiar banner aboard the research vessel *Knorr*.

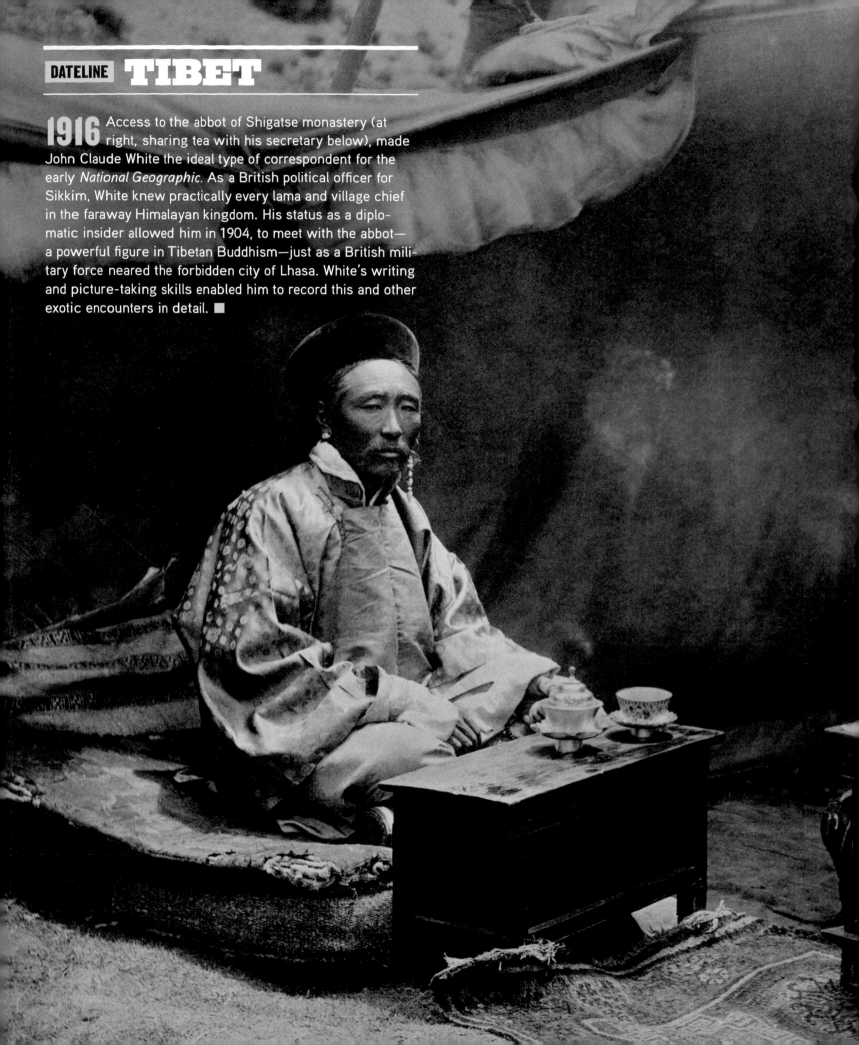

DATELINE TIBET

1916 Access to the abbot of Shigatse monastery (at right, sharing tea with his secretary below), made John Claude White the ideal type of correspondent for the early *National Geographic*. As a British political officer for Sikkim, White knew practically every lama and village chief in the faraway Himalayan kingdom. His status as a diplomatic insider allowed him in 1904, to meet with the abbot—a powerful figure in Tibetan Buddhism—just as a British military force neared the forbidden city of Lhasa. White's writing and picture-taking skills enabled him to record this and other exotic encounters in detail. ■

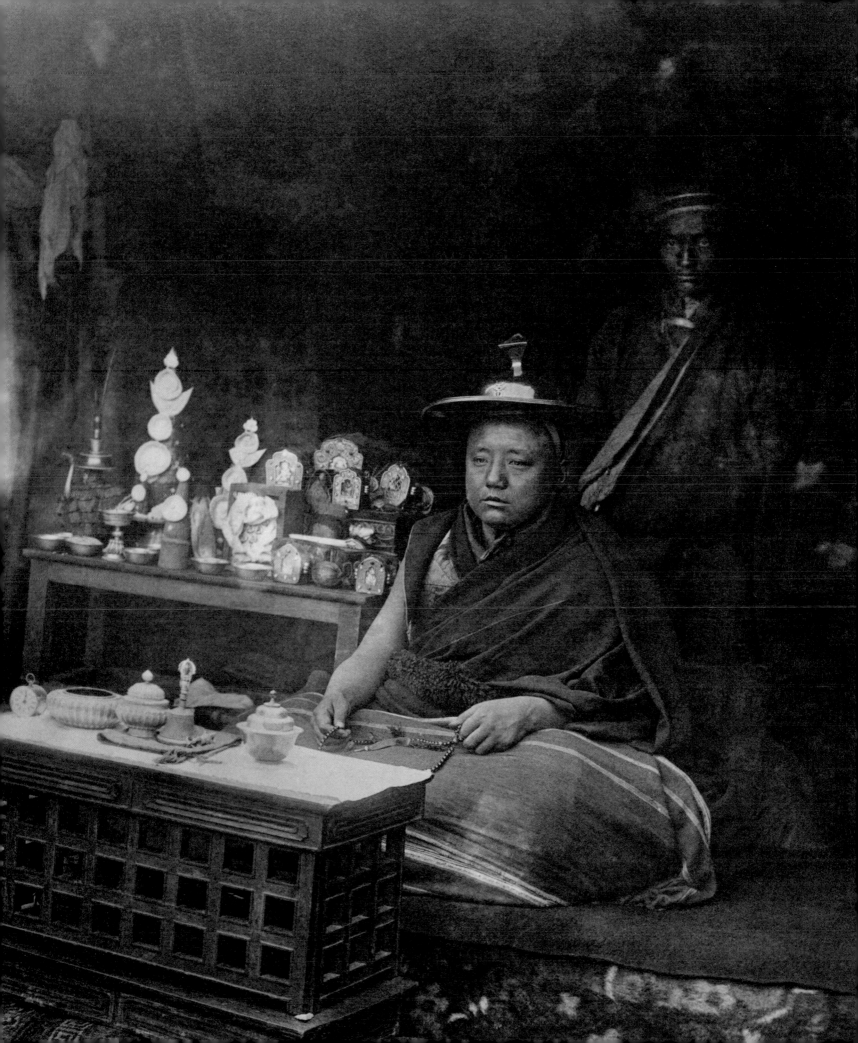

DAMNED FROZEN LANDS

Reinvigorated, *National Geographic* was a financial success, allowing the Society to begin funding expeditions. For explorers, no other place had the magnetic pull of the North Pole.

⚙ "PORTABLE" CAMERAS

With its mahogany lens bed and leather bellows, the folding roll-film camera (the model above belonged to Robert E. Peary) became a favorite of explorers in the early 20th century. The glass plates used until then were not just fragile but heavy. With the new roll film—invented in 1888, the year of the Society's birth—cameras inched that much closer to being portable.

By 1903 the international race for the North Pole had heated up to the point where even a New York baking-powder manufacturer, William Ziegler, was organizing an expedition. Ziegler had plenty of money; the National Geographic Society had practically none. But it did have a nice-sounding name, and it was happy to lend that.

In July 1903 the Ziegler Polar Expedition departed for the Franz Josef Land archipelago—barren, windswept Russian islands perched on the edge of the Arctic ice pack just over 500 miles from the Pole. But there Ziegler's ship was crushed by heavier-than-expected ice, and when it sank it took the expedition's supplies to the bottom. Marooned, the castaways somehow weathered two winters of Arctic gales, making scientific observations and watching the aurora borealis play overhead, before being rescued in 1905.

The Society's next attempt fared no better. Journalist Walter Wellman hoped to reach the Pole by dirigible. He even built the world's largest airship-launching station, off the Arctic island of Spitsbergen. But just three hours after the dirigible got under way one September day in 1907, it settled back down, having traveled only 15 miles.

THE POLE AT LAST?

Meanwhile, Gilbert Grosvenor had hitched the National Geographic wagon to a rising polar star. In early 1907, having stabilized the Society's finances at last, he persuaded its board to contribute $1,000 to an upcoming assault on the North Pole being led by Cmdr. Robert E. Peary.

Peary had long been associated with the Society. In April 1891, after listening to him lecture about an expedition to Greenland, Gardiner Greene Hubbard had practically

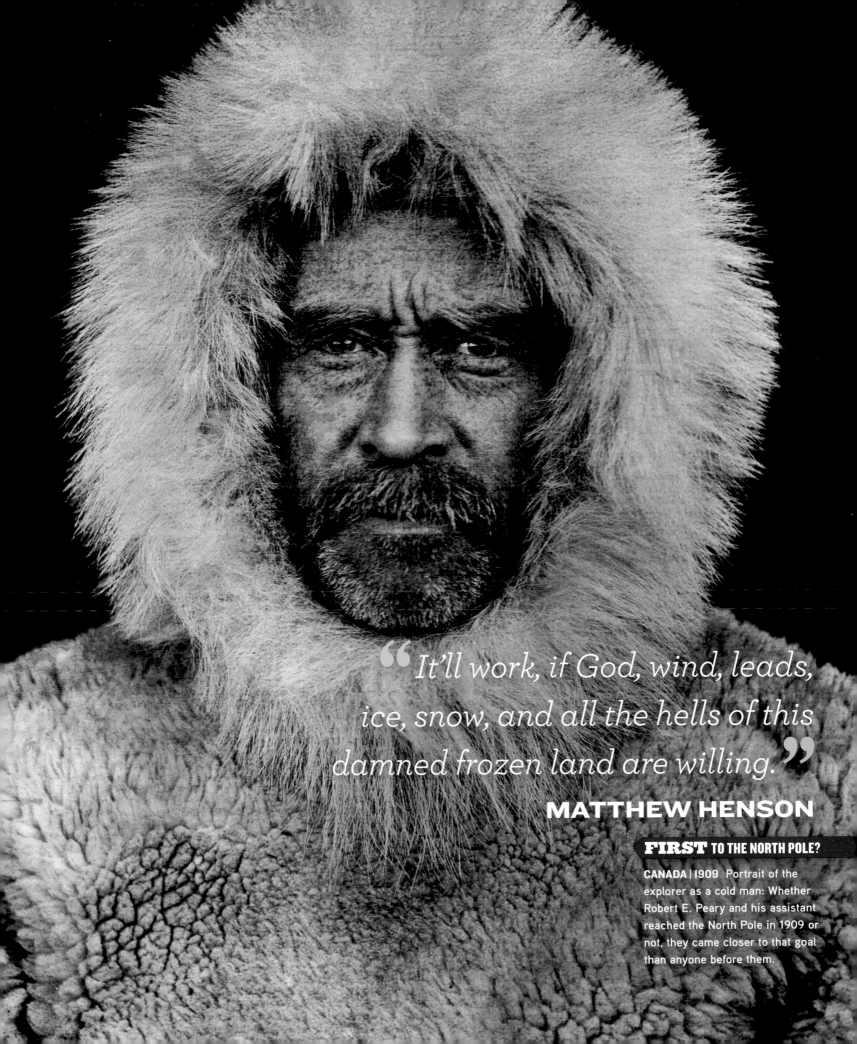

It'll work, if God, wind, leads, ice, snow, and all the hells of this damned frozen land are willing.

MATTHEW HENSON

FIRST TO THE NORTH POLE?

CANADA | 1909 Portrait of the explorer as a cold man: Whether Robert E. Peary and his assistant reached the North Pole in 1909 or not, they came closer to that goal than anyone before them.

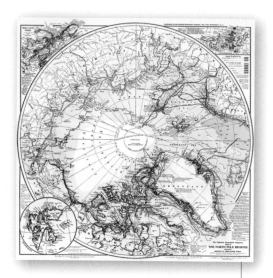

✳ "THE NORTH POLE REGIONS"

Issued with the July 1907 *Geographic*, this chart (above) "would be historical as well as geographical," said its compiler, Gilbert Grosvenor: It traced the routes of every polar expedition undertaken to date. Also tracked was the drift of the Arctic Ocean that carried bits of shipwrecks from Siberia to Greenland. It was an age when blank spots remained on the map; the one north of Alaska is marked simply "Unexplored Territory."

draped an American flag around the explorer's broad shoulders, imploring him to plant it "as far north on this planet as you possibly can!" Fifteen years later, despite having lost most of his toes to frostbite, Peary still cut a fine figure when Theodore Roosevelt awarded him the Society's first Hubbard Medal for having done just that: attaining a new "Farthest North" record—87° 06'—only 175 miles short of the Pole.

Peary's final dash for the Pole got under way on March 1, 1909. Seven expedition members, 17 Inuit, 19 sledges, and 133 dogs set out from Canada's Cape Columbia to cross the frozen Arctic Ocean. Breaking trail through a wilderness of ice peaks, advance sledge parties laid supply caches. By early April, with the sun peeking over the horizon, the final assault team—Peary, Matthew Henson, four Inuit, and the 40 hardiest dogs—was climbing pressure ridges and galloping across the last 130 miles of ice. No one but Peary was trained in navigational observations, and by noon on April 5 he claimed he took a sighting and calculated he was only a few miles from his goal. A quick nap, a final push, and it was "[t]he Pole at last!!!" as he scrawled on a sheet of paper. "The prize of three centuries . . . Mine at last."

Or was it? "I will find a way or make one," Peary once declared. Many people eventually concluded he had made one *up*. Rival Frederick Cook's claim that he had reached the Pole a year earlier was discredited for lack of substantiating records. Peary

RUSSIA | 1903 Rowing out to the S.S. *Amerika*, members of the Ziegler Polar Expedition prepare to set out for the Franz Josef Land archipelago.

NORTHERN EXPOSURE

GREENLAND | 1897 Matthew Henson, Peary's longtime factotum, stands proudly before a 34-ton meteorite they recovered from the Greenland ice cap.

✚ PEARY'S TATTERED FLAG

Robert E. Peary tore bits from this taffeta flag and cached them at various destinations to mark his achievements in Arctic exploration. The diagonal strip was deposited at what he believed to be the Pole itself. The remnants were donated to the Society in 1955 by his widow, Josephine Peary—who had sewn the flag back in 1896.

Did Cmdr. Robert E. Peary ever truly reach the North Pole? In the September 1988 *National Geographic*, polar explorer Wally Herbert examined Peary's original 1909 expedition diary, noting puzzling gaps and a near absence of longitude readings. Because of such "astonishingly slack navigation" and Peary's failure to account for wind-driven ice drift, Herbert concluded that he might have gone the distance, but that he probably veered off from true north by 30 to 60 miles. Then, in the January 1990 issue, the Navigation Foundation reported that photogrammetric analysis of the shadows cast by figures in photographs purportedly taken at the spot indeed correlated with the angle of the sun at that time of year at that latitude. This meant that Peary had been in the "near vicinity" of the North Pole.

Wherever he ended up, it was still well beyond the tracks left by any previous explorer. Peary was decked with medals. But his African-American associate, Matthew Henson, was not awarded a Society Hubbard Medal until November 28, 2000—45 years after his death. ■

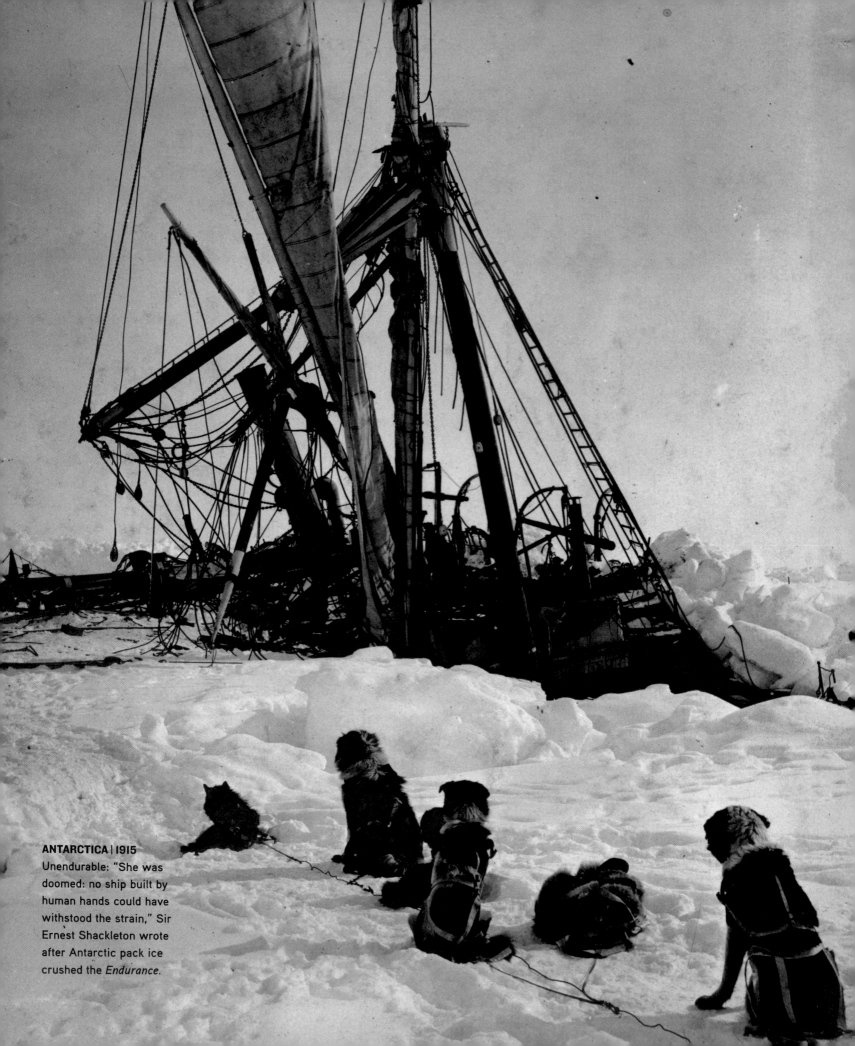

ANTARCTICA | 1915
Unendurable: "She was doomed: no ship built by human hands could have withstood the strain," Sir Ernest Shackleton wrote after Antarctic pack ice crushed the *Endurance*.

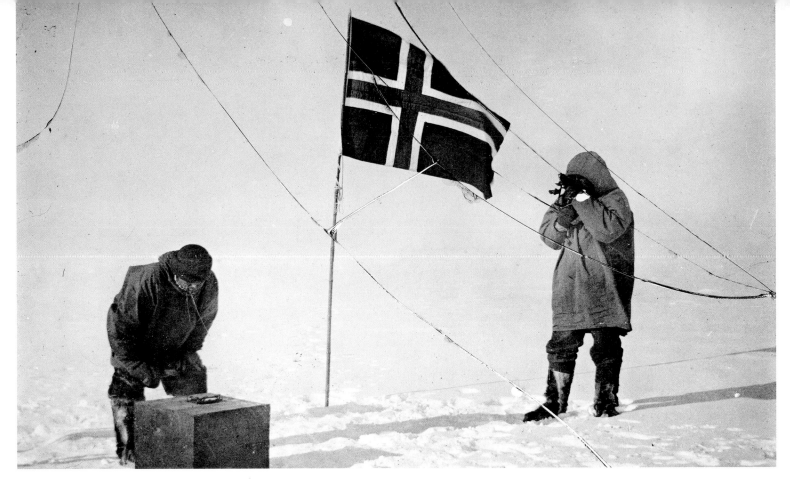

ANTARCTICA | 1911 Roald Amundsen takes observations confirming that he and his party have been the first to reach the South Pole.

submitted data, but it was incomplete—and it remained uncorroborated. Although a National Geographic committee approved his figures, that approbation reflected only a hasty examination of Peary's sextants and notebooks. Still, the committee's conclusions were echoed around the world.

FARTHEST SOUTH

Meanwhile, as the Geographic settled down to watch from afar as the "heroic age" of Antarctic exploration unfolded in the Antipodes, the South Pole came to it.

While Peary and Henson were crossing the frozen Arctic Ocean, British explorer Ernest Shackleton had struggled to within 111 miles of the opposite end of the Earth. A year later, on the evening of March 26, 1910, the freshly knighted Shackleton kicked off his American lecture tour by accepting the Society's Hubbard Medal for his new "Farthest South" mark.

It was only a matter of time before the first explorer to stand at the actual South Pole would be similarly honored. That man, and that moment, arrived on the evening of January 11, 1913: Norwegian explorer Roald Amundsen strode into the National Geographic's annual banquet as its guest of honor, having finally attained 90° south 13 months earlier. More than 700 people stood and applauded as Peary draped a Special Gold Medal around Amundsen's neck. Though the two men reputedly couldn't stand each other, they gamely shook hands. The North Pole and the South Pole had met at last. ■

✳ BANQUETS AND BALLS

It was white tie for everyone except Alexander Graham Bell (far right) when in December 1909 the Society conferred its Special Gold Medal on Robert E. Peary (center). Industrialist Andrew Carnegie is on the phone.

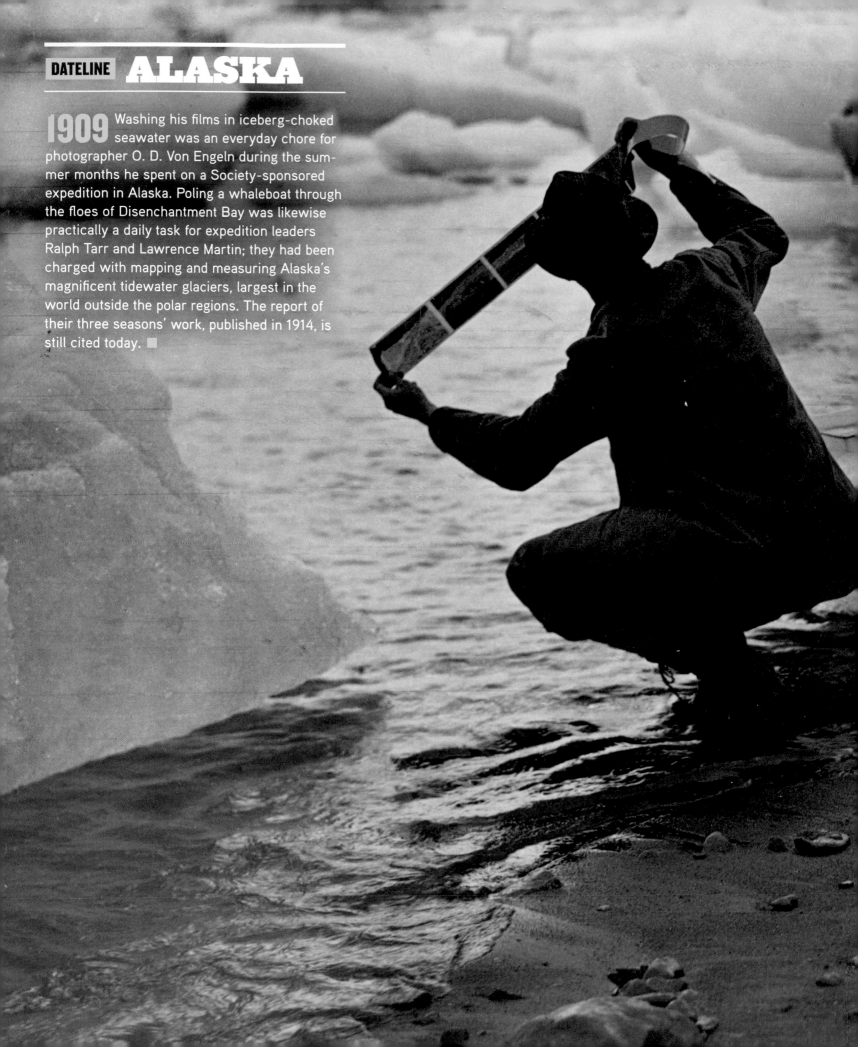

1909 Washing his films in iceberg-choked seawater was an everyday chore for photographer O. D. Von Engeln during the summer months he spent on a Society-sponsored expedition in Alaska. Poling a whaleboat through the floes of Disenchantment Bay was likewise practically a daily task for expedition leaders Ralph Tarr and Lawrence Martin; they had been charged with mapping and measuring Alaska's magnificent tidewater glaciers, largest in the world outside the polar regions. The report of their three seasons' work, published in 1914, is still cited today. ■

CITIES BURIED BY TIME

The decision to sponsor Hiram Bingham's excavation of the spectacular "lost city of the Incas," Machu Picchu, marks the birth of the Society's abiding passion for archaeology.

⚙ FIELD DARKROOM

Former MIT professor Harrison W. Smith found few darkrooms in Tahiti when he lived there around the turn of the 20th century. But he had a flair for improvisation and made one from an old suitcase: A tray of developer fit neatly into the left side, and the whole shebang could be wrapped in a light-tight "dark bag."

In 1906 Ernest Lloyd Harris, the 36-year-old U.S. consul in Smyrna, Turkey, swung up into the saddle and, armed only with a revolver to defend himself against brigands or wild dogs, cantered off to visit the forlorn remnants of places once renowned in classical antiquity. As he reported in a three-part *National Geographic* article, "The Ruined Cities of Asia Minor," Harris found Tralles buried beneath a grove of olive trees. Laodicea, once the emporium of the East, lay desolate, inhabited by "snakes, lizards, turtles, and prowling jackals." Magnesia and Croesus were marked only by broken columns, shattered arches, or empty temples. The ruins of Aphrodisias, where votaries of the goddess of love once gathered by the thousands, may have been "the most imposing ruins in Asia Minor or Syria." But lying three days' journey from the nearest railhead, its famous statues were hidden by tangles of honeysuckle and poppies.

Gilbert Grosvenor had grown up in nearby Constantinople. He too delighted in ruins, and through Harris's dispatches he was introducing the National Geographic Society to a fascinating new—well, old—world to conquer: archaeology.

A SIDESADDLE SALLY

In 1907, with Harris still making occasional pilgrimages to ruined cities, Harriet Chalmers Adams, lugging a trunkful of her photographs, had just returned from an extended journey through Latin America, where among other adventures she had been the first woman known to traverse the jungle between the Amazon River and the shores of French Guiana. While visiting the Peruvian highlands, she had set out from Cusco and, riding her mule sidesaddle, ventured north into the spectacular Andean gorges carved by tributaries of the Amazon. "It was in the Valley of Yucay, 'the sweetest valley in Peru,' that the Incas are supposed to have built their summer

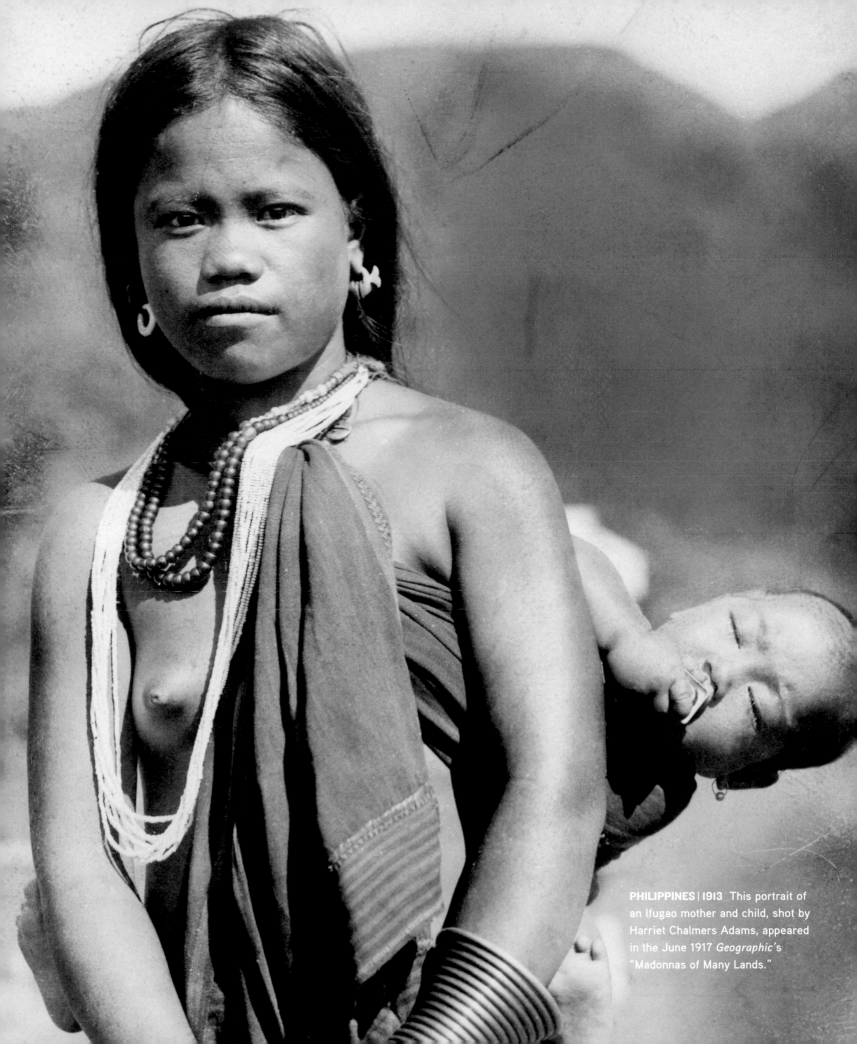

PHILIPPINES | 1913 This portrait of an Ifugao mother and child, shot by Harriet Chalmers Adams, appeared in the June 1917 *Geographic*'s "Madonnas of Many Lands."

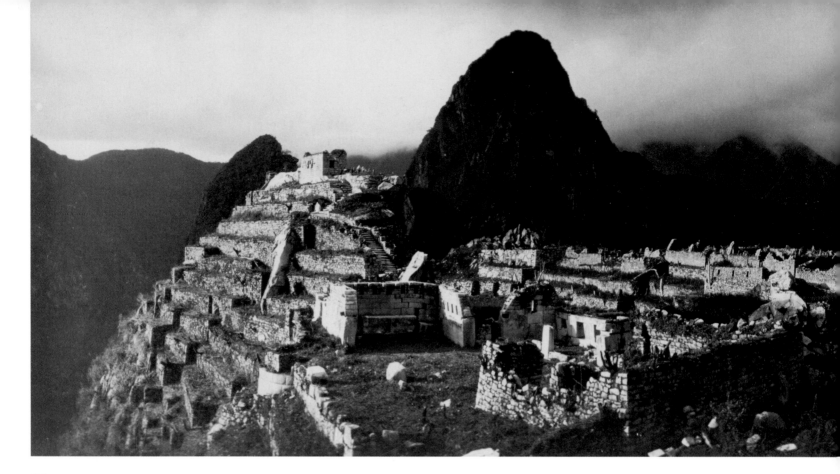

palaces," Adams informed *Geographic* readers in 1908. Although she saw plenty of ancient terraces and tumbledown Inca ruins on the steep slopes of the Yucay, she found no summer palaces.

About the same time that he was publishing Adams's article, one of 21 that would bear her byline, Grosvenor was rejecting similar material submitted by a lecturer in Latin American history at Yale. Unfazed, Hiram Bingham merely regrouped and wrote a successful book instead. Grosvenor began to glimpse the scope of his mistake, however, only when he learned of the young professor's latest discovery. On July 24, 1911, Bingham had been only a few miles downstream from the scene of Adams's wanderings, where the Yucay had become the Urubamba. There he was guided up a sheer slope and shown where its crest was capped by extensive ruins. After one long, lingering look, Bingham was persuaded they just might be the remnants of the fabled "lost city of the Incas." He named them after the "great mountain" on which they were sited: Machu Picchu.

IN A PERUVIAN WONDERLAND

Bingham did not discover Machu Picchu, of course—the locals had known its whereabouts for centuries—but he intended to reveal it to the world. And Grosvenor wanted the National Geographic Society to help him do that.

But it was one thing to publish an article and quite another to squeeze funds out of a board among whom, Grosvenor warned his lanky new friend, there was "considerable feeling that the work is archaeological and not sufficiently geographical." The Editor's

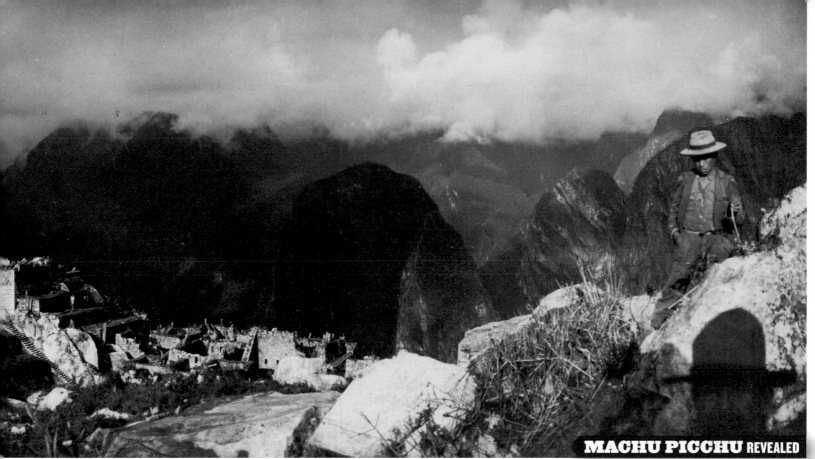

PERU | 1912 Few corners of the world were more spectacular than Machu Picchu—especially just after an army of machete-wielding Indians had cleared away the vegetation for the cameraman.

arguments carried the day, however, and as a result the Society joined Yale University as a co-sponsor of the "Peruvian Expedition of 1912."

For seven months that expedition's 11 men, aided by a troop of Quichua Indians—each of whom was paid in coca leaves—confronted the forbidding site of Machu Picchu. First they had to replace a rickety log bridge that crossed the roaring Urubamba. Then they had to blaze a trail up the precipitous slopes before clearing the lofty ruins of overgrown vegetation. Large trees had to be removed without damaging the underlying masonry in which they had taken root. Poisonous snakes were coiled everywhere. Vampire bats weakened the mules. But bit by bit, temples and plazas and gabled houses emerged. At least 100 granite staircases were found cascading vertiginously down the mountainside.

The initial clearing took nearly five months. Though the expedition would return in 1914 and again in 1915, discovering dozens of burial caves and recovering pottery and some bronze artifacts—but no "Inca gold"—none of the subsequent finds could eclipse the breathtaking impact of the main site. The entire April 1913 *National Geographic,* titled "In the Wonderland of Peru," was given over to the expedition's report. In addition to 250 of Bingham's photographs, it featured a panoramic view of the ruins that could be detached and framed.

Modern archaeologists doubt that Bingham truly excavated the lost city of the Inca—the site more nearly resembled a summer palace—but none of them deem the

THE PERUVIAN EXPEDITION

> ### 1912
> Season One of the Peruvian Expedition was spent removing vegetation and excavating the ruined structures, staircases, and cliffside tombs.

> ### 1914
> Season Two was largely devoted to making better maps of the nearby mountains and valleys.

> ### 1915
> Season Three, the final one, saw teams of naturalists, mapmakers, and archaeologists exploring the elaborate system of highways they had discovered running up the towering peaks and down the dizzying gorges.

ABOVE: An Inca bronze knife pendant found at Machu Picchu

ANYWHERE, U.S.A. | ANYTIME Grandfather, grandson, and cat travel to faraway lands together in artist James Gurney's depiction of Everyman's attic.

✚ LEAFY PROFUSION

The traditional cover only continued to grow before it was eventually pruned back. In May 1928, a decade before the January 1940 issue (above) appeared, a subtle design change resulted in a more luxuriant growth of oak leaves and acorns.

The yellow rectangle framing the cover of every *National Geographic* magazine traces its ancestry back to the Society's early flowering—or rather leafing, for it is rooted in the classic oak-and-laurel cover that first appeared in February 1910. Sprouting from the bottom and running up the sides, the interior border of oak leaves and acorns came to represent the Society's origins and sturdy growth. The garland of laurel at the top recalled the classical crown of victory. Inset at the cardinal points, Earth's four hemispheres—Eastern, Western, Southern, and Northern—suggested that the magazine's contents indeed embraced "the world and all that is in it."

Over the years, the color of the exterior border gradually shifted from buff to a pale straw, and from that to a strongly saturated yellow. The foliage was pruned back and then uprooted altogether, leaving only the yellow rectangle—the bold design that is the Society's logo today. ∎

place any less the awesome for that. As Grosvenor once put it, "What an extraordinary people the builders of Machu Picchu must have been to have constructed, without steel implements, and using only stone hammers and wedges, the wonderful city of refuge on the mountain top."

BATTERED IN BRAZIL

Meanwhile, in Washington, D.C., National Geographic lectures crowded the calendar. People lucky enough to get tickets had to listen extra hard to the speaker who stood on a stage of Convention Hall the night of Tuesday, May 26, 1914.

Three months earlier, Theodore Roosevelt and five companions had clambered into dugout canoes near the headwaters of a stream the Brazilians called the River of Doubt; once it disappeared into the great Amazon forest, no one knew where it emptied. Two months later—having descended endless rapids, and having subsisted largely on nuts, berries, monkeys, and the occasional grilled piranha—the emaciated, fever-ridden survivors debouched into the Aripuanã River, a known tributary of the Amazon.

Inside the lecture hall that night, with 5,000 attendees packing the seats and spilling out onto the sidewalk, the atmosphere must have seemed as stifling as it had been in the rain forest. Gilbert Grosvenor had arranged for Roosevelt to deliver his first address to the Society on returning from Brazil, and members hung on the former President's every whispered word: Roosevelt, his health broken by the experience, soldiered on hoarsely for over an hour. "Not a person," Grosvenor recalled, "left the hall." ■

"In the wilderness, people think of danger from Indians, alligators, and jaguars. They are not the things you mind. It is the mosquitoes, the poisonous ants, the maribondo wasps that are perfectly awful. It is the *borrachudos* and plum flies—like the black flies of the north woods, only worse . . . The day after I threw away my spare clothing ants ate up my underwear. These were white ants. Driver ants try to eat the man instead of his clothes."

TEDDY ROOSEVELT
GREAT ADVENTURES WITH
NATIONAL GEOGRAPHIC, 1963

ABOVE: T. R. shows off the first jaguar taken on the River of Doubt expedition.

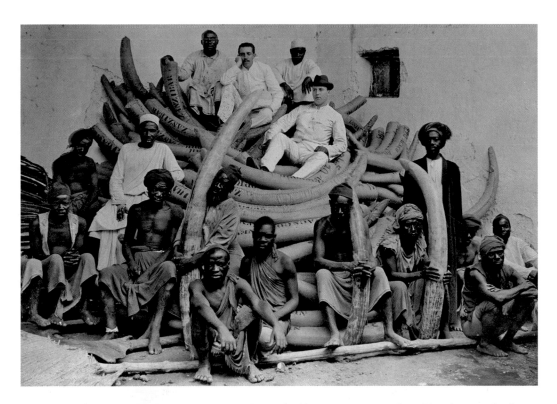

ZANZIBAR | CIRCA 1900 Piles of elephant tusks await shipment from a port famed for cloves and spices.

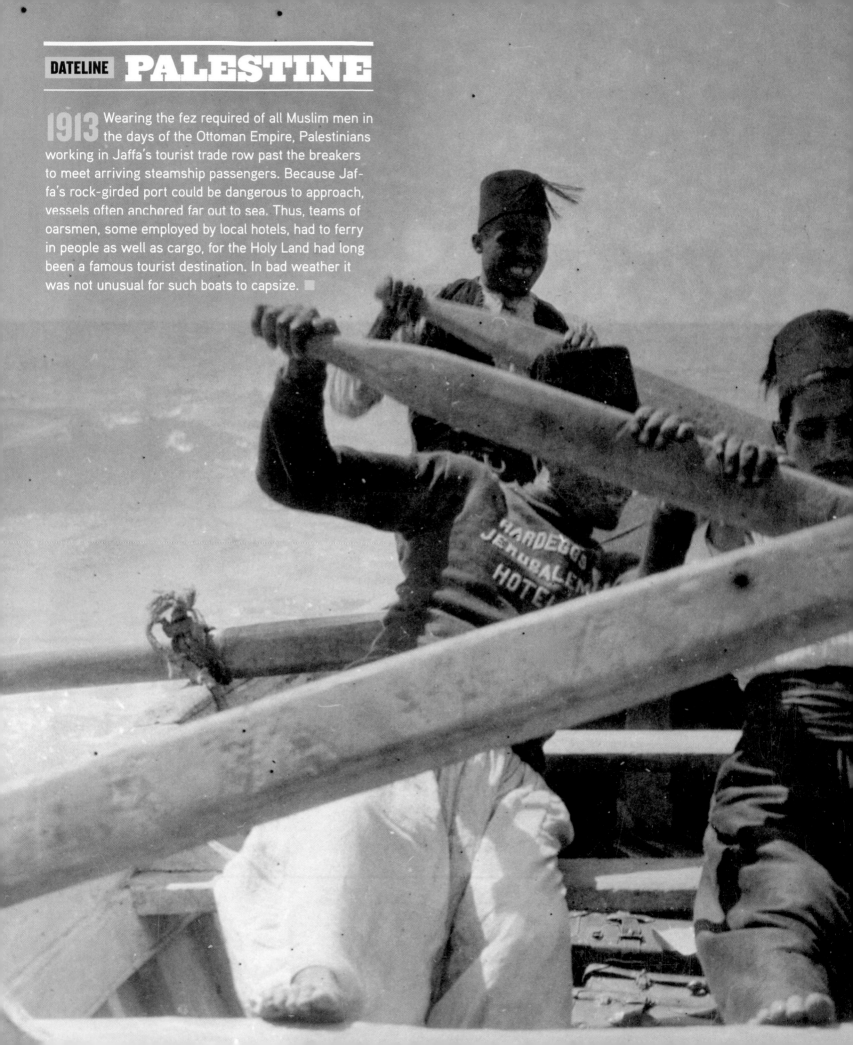

1913 Wearing the fez required of all Muslim men in the days of the Ottoman Empire, Palestinians working in Jaffa's tourist trade row past the breakers to meet arriving steamship passengers. Because Jaffa's rock-girded port could be dangerous to approach, vessels often anchored far out to sea. Thus, teams of oarsmen, some employed by local hotels, had to ferry in people as well as cargo, for the Holy Land had long been a famous tourist destination. In bad weather it was not unusual for such boats to capsize. ∎

WONDERFULLY BEAUTIFUL

One glance at hand-tinted photographs and Gilbert Grosvenor decided it was not a black-and-white world after all. Color was on its way to becoming the signature of *National Geographic*.

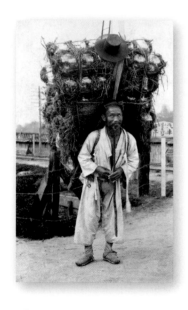

✳ PAINTED PICTURES

The results could be garish, but hand-tinting black-and-white prints was common practice at the turn of the 20th century. An entire street in Yokohama, Japan, specialized in the trade.

ABOVE: A Korean drayman carries a bundle of bottles.

Having just concluded a voyage around the world, Society member William Wisner Chapin wrote to Gilbert Grosvenor in early 1910 asking whether or not the Editor might want to see Chapin's hundreds of photographs, many of them hand-colored by a Japanese artist. Grosvenor's curt reply: "We cannot use colored prints."

Perhaps his 60 years had toughened Chapin's skin, for he simply submitted them anyway. One look at the exquisitely tinted scenes from picturesque China and Korea was enough to chasten Grosvenor. He wrote Chapin a second note: "Your colored prints are wonderfully beautiful"; they "ought to be published." Not one to leave undone those things that ought to be done, Grosvenor himself published them, in the November 1910 *Geographic*—although it cost the Society four times the normal printing fee.

ENTER THE AUTOCHROME

Because of that added cost, Grosvenor initially resolved to flood his pages with color only in November, the big renewal month: A magazine featuring colored pictures, he reasoned, might win out in a pocketbook contest with rivals. So readers who in December 1911 enjoyed "The Sacred City of the Sands: An Account of the Extraordinary Tortures Welcomed by Devotees" at Kairouan, an Islamic holy site in Tunisia, had probably renewed their memberships after gazing at hand-colored "Glimpses of Japan" the previous month. In November 1912 appeared tinted "Glimpses of the Russian Empire," and in 1913 it was the turn of "The Non-Christian Peoples of the Philippine Islands" to be depicted in vibrant, almost lurid, tones. In July 1914, however, an Autochrome, or "self-coloring" (as opposed to hand-tinted), photograph was published in *National Geographic*. The 5x7 Autochrome glass plate

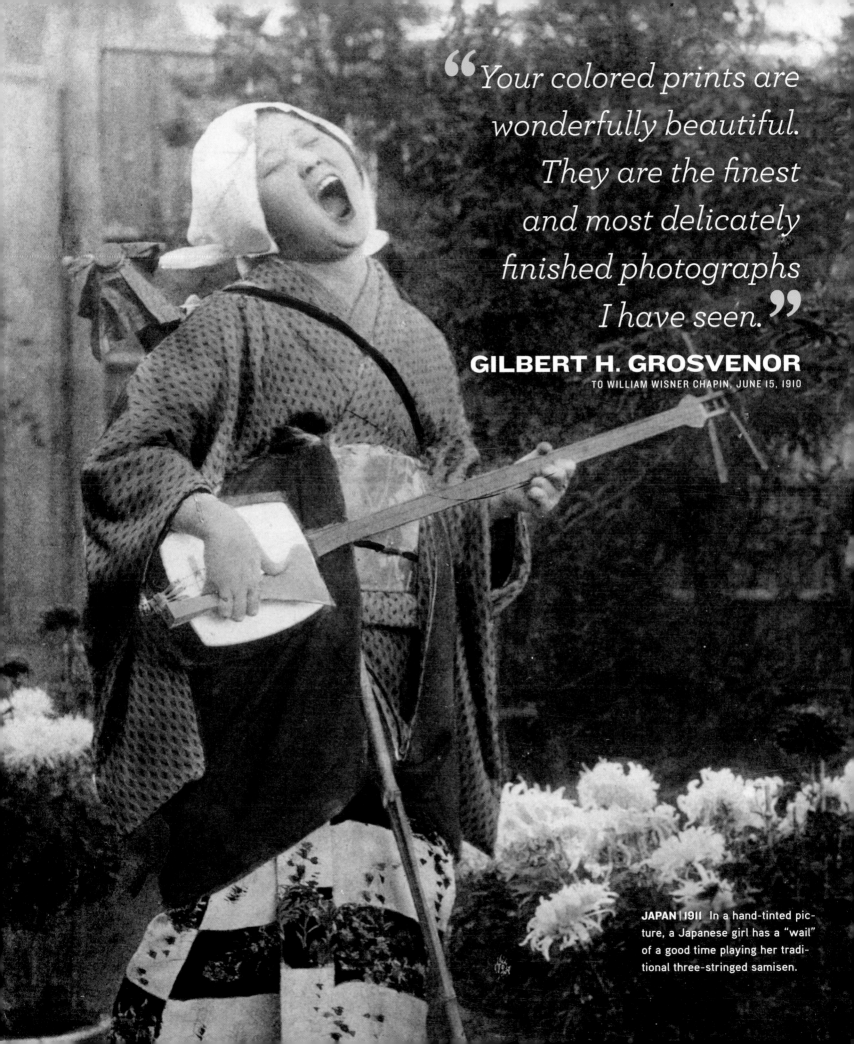

"Your colored prints are wonderfully beautiful. They are the finest and most delicately finished photographs I have seen."

GILBERT H. GROSVENOR
TO WILLIAM WISNER CHAPIN, JUNE 15, 1910

JAPAN | 1911 In a hand-tinted picture, a Japanese girl has a "wail" of a good time playing her traditional three-stringed samisen.

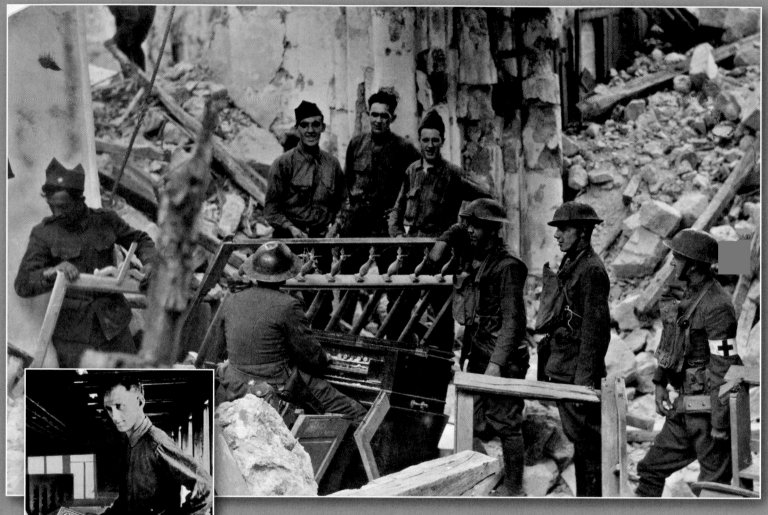

NORTHERN FRANCE | 1918 Doughboys fill a shattered church with Christmas carols.

✚ **GEOGRAPHIC INDOCTRINATION**

A confident-looking military instructor at Camp Kearny, California, grasps his primary text for teaching English to foreign-born recruits: a trusty copy of *National Geographic*.

When the bugles blared in 1917 and the doughboys marched off to war, the National Geographic, in addition to supplying them magazines and maps, did its best to ease the soldiers' burdens. It lent its headquarters library to the Red Cross, whose volunteers used the space to roll more than 75,000 bandages, storing them in glass-fronted bookcases. It also subsidized two wards in the American Hospital in Neuilly-sur-Seine outside Paris. Among the "medical" provisions purchased was a Victrola, allowing wounded soldiers to recover to the strains of George M. Cohan's "Over There" and the latest hit back home, "After You've Gone." The Society also forwarded boxes of afghans, pillows, "happiness" quilts, and convalescent robes lovingly hand-stitched by its members—only to find, when it was finally over over there, that not one package had made its way to France. ■

provided real color photography at last, and Grosvenor, enchanted by its luminous hues, was soon bringing the world in "natural colors" to his readers.

"MENTION THE GEOGRAPHIC"

Color was just one of the reasons why the National Geographic Society tipped the scales at more than half a million members by 1916. Though it hardly resembled the small association they had founded scarcely a quarter of a century earlier, those still on the board who had been around in January 1888 gladly added their signatures to a resolution commending Gilbert Grosvenor for his achievement.

The Society's original cadre of government explorers had long been overlain with members from all walks of life. "Mention the Geographic—It Identifies You" now appeared as a tagline in the magazine's advertising pages, and thousands of dreamers, doctors, dilettantes, and simply curious men and women found that Society membership conferred a cosmopolitan aura indeed. One lady proclaimed that she "would rather be without shoes than this magazine."

Membership was also reaching into every corner of the globe—every corner not being wrecked by the First World War. The conflict invaded the magazine, too: Grosvenor supplemented articles such as "Village Life in the Holy Land," by John Whiting, with war reporting such as Herbert Corey's "On the Monastir Road." He rallied his members to the Allied cause by printing "Do Your Bit for America" and "Plain Tales from the Trenches," and issued detailed maps of the Balkans, the Near East, and the Western front. ■

✱ THE AUTOCHROME

The culmination of a long quest for true color photography, the Autochrome was originally a standard 5x7 glass plate. One side— the filter mosaic layer— was coated with a fine mixture of starch grains dyed red, green, and blue (RGB). Once the plate was inserted into the camera, the image-bearing light was admitted through the lens and filtered through this RGB mosaic before it struck the emulsion. The result: a positive image that retained all the colors present in the scene being photographed.

ABOVE: An Autochrome plate, which, given the rigors of the field, was all-too-easily broken.

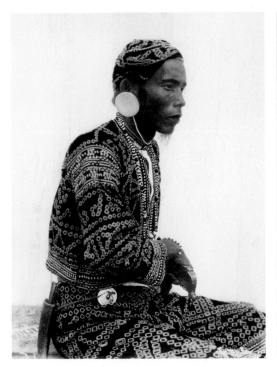 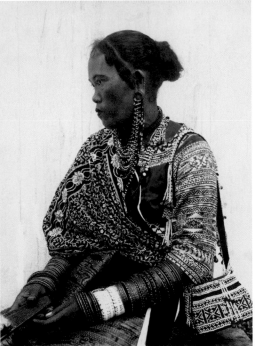

PHILIPPINES | CIRCA 1910 A Bagobo chief wears ceremonial garb, and his wife a matching skirt, announcing that he is a killer of men.

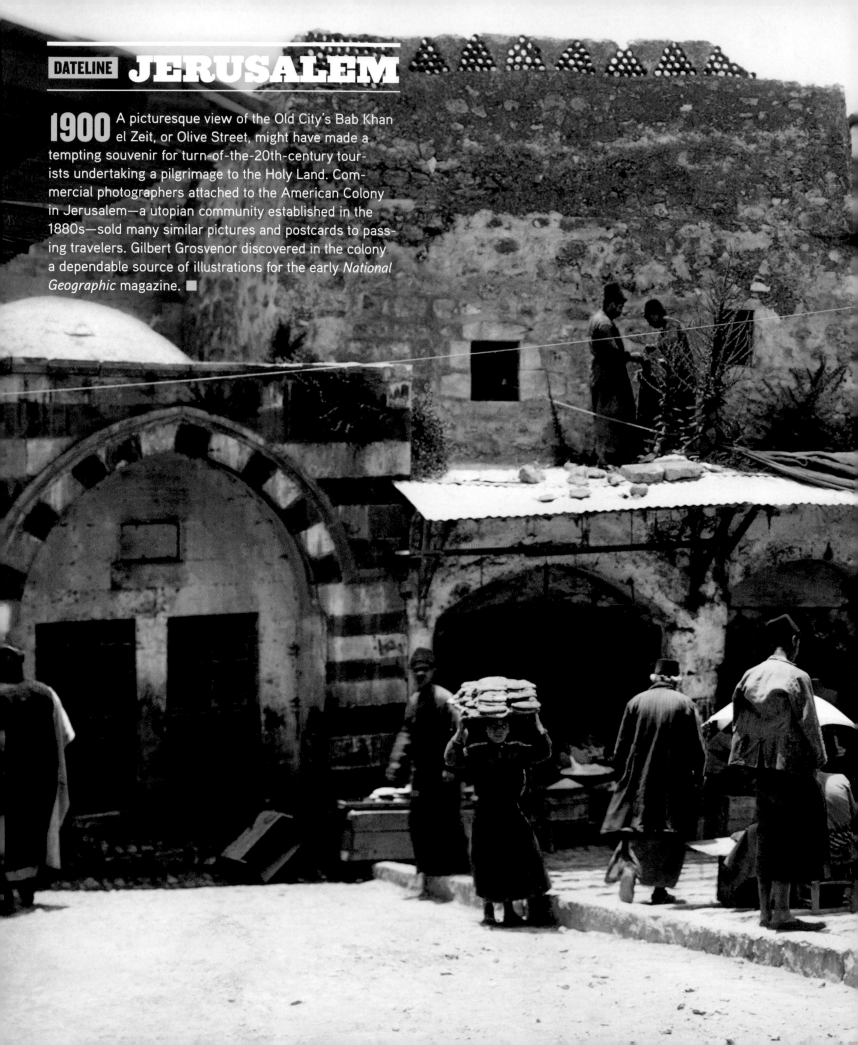

1900 A picturesque view of the Old City's Bab Khan el Zeit, or Olive Street, might have made a tempting souvenir for turn-of-the-20th-century tourists undertaking a pilgrimage to the Holy Land. Commercial photographers attached to the American Colony in Jerusalem—a utopian community established in the 1880s—sold many similar pictures and postcards to passing travelers. Gilbert Grosvenor discovered in the colony a dependable source of illustrations for the early *National Geographic* magazine. ■

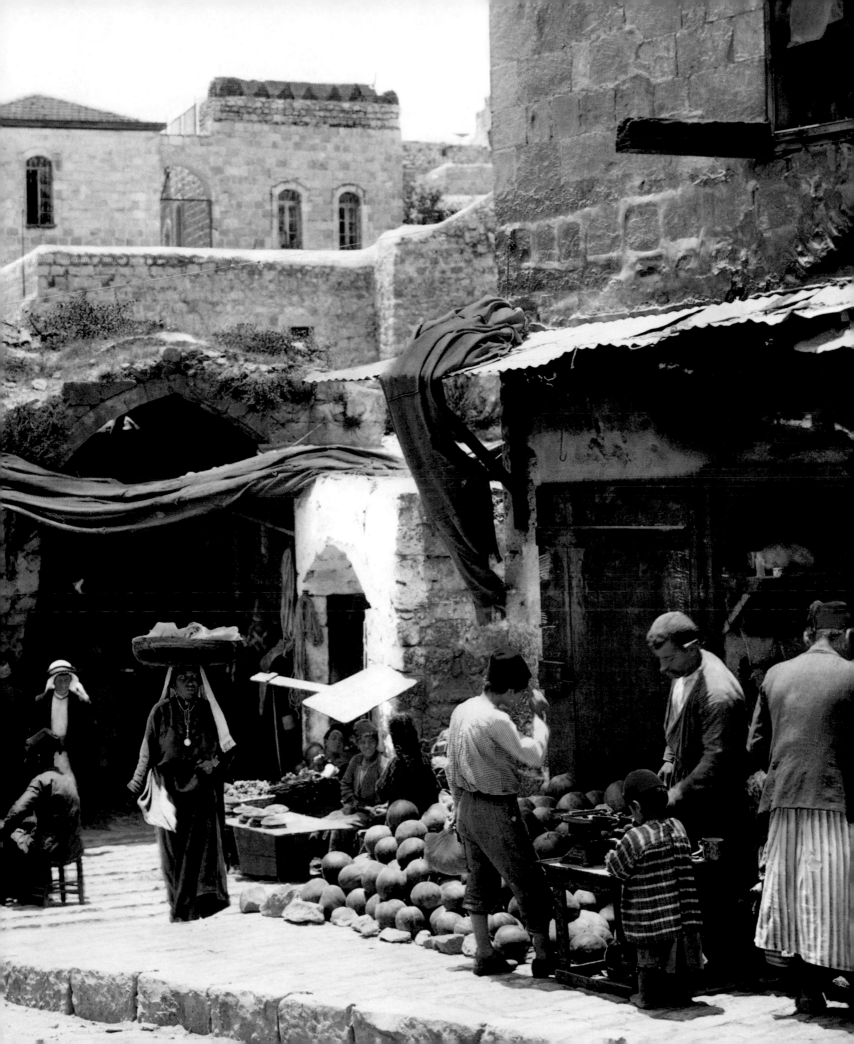

WANDERING OFF INTO NATURE

Despite a board member's grumbles ("Wandering off into nature is not geography"), wildlife photography—and conservation—soon pervaded the pages of the magazine.

✳ OUR GUIDES ARE FOR THE BIRDS

First published in 1918, *The Book of Birds* would hatch some noble progeny: a century's worth of Geographic bird guides, including today's esteemed *Field Guide to the Birds of North America.*

andering off into nature" should have been expected: Many Society founders had been prominent conservationists as early as the 1870s. As head of the U.S. Geological Survey, for example, Maj. John Wesley Powell had tried to impose proper watershed management on the arid West, but special interests derailed his plans. C. Hart Merriam and Henry Henshaw had spent their formative years as naturalists roaming mountain, desert, and prairie, shotgun in one hand and butterfly net in the other. They went on to become the first two chiefs of the U.S. Biological Survey, a forerunner of the U.S. Fish and Wildlife Service. William Healey Dall, one of the first scientists to study the flora and fauna of Alaska, had a mountain sheep named after him. And Gifford Pinchot, founder of the U.S. Forest Service, served on the Society's board and advised President Theodore Roosevelt on natural resource issues. It was Pinchot who described William John ("WJ") McGee, the Geographic's President in 1903, as being the "brains of the conservation movement." But whatever might be their standing on the national stage, these were all busy men, able to give only a few hours each week to the needs of a tiny scientific society.

STRANGE SIGHTS FROM FAR AWAY

It fell to that city-bred editor from Constantinople to graft an enduring interest in wildlife conservation onto the *National Geographic* stock. Such a development was a natural outgrowth of Bell's notion that the magazine should include the "world and all that is in it." But it also mirrored Grosvenor's discovery that stories about animals were bankable attention-grabbers. He had found that readers could not resist titles such as "Strange Sights in Faraway Papua," "An Impression of the Guiana Wilderness," or "Hunting Bears on Horseback." Soon he was trolling the ocean for "Some Giant

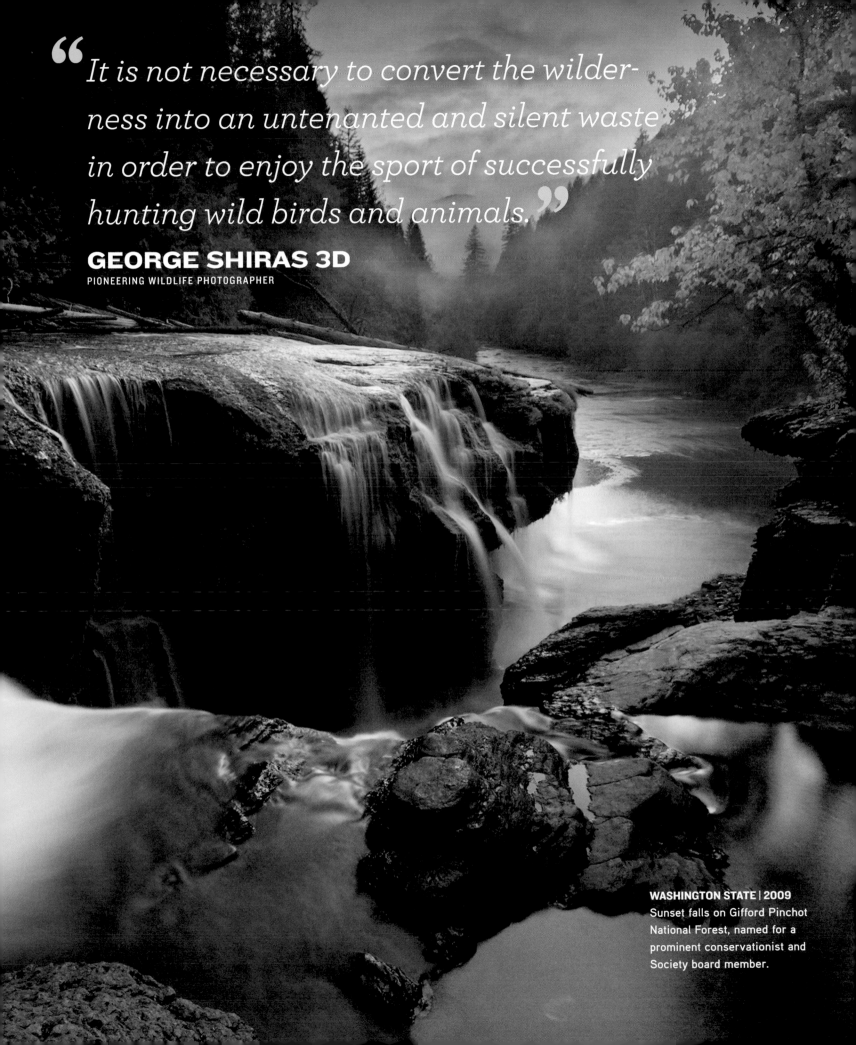

"It is not necessary to convert the wilderness into an untenanted and silent waste in order to enjoy the sport of successfully hunting wild birds and animals."

GEORGE SHIRAS 3D
PIONEERING WILDLIFE PHOTOGRAPHER

WASHINGTON STATE | 2009
Sunset falls on Gifford Pinchot National Forest, named for a prominent conservationist and Society board member.

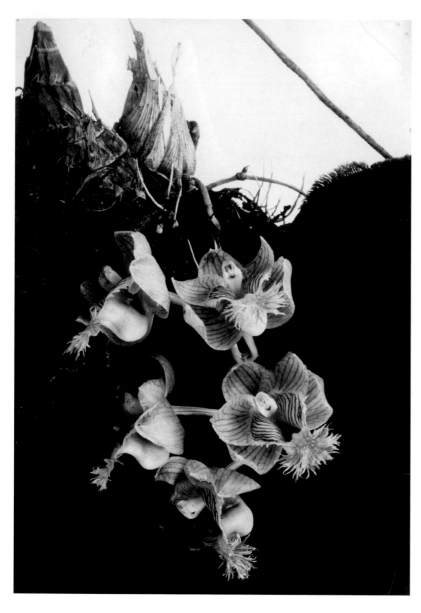

PANAMA | CIRCA 1910 This *Catasetum* orchid was found growing near the Panama Canal.

Fishes of the Seas," including that most inexhaustible of themes, "Man-Eater Sharks." Grosvenor even threw in oddments such as "Notes on the Distances Flies Can Travel." Imaginative readers might conjure up insects shrilling by the billion as they read about faraway jungles; but their editor also brought them face-to-face with "Monsters of Our Back Yards"—David Fairchild's close-up photographs of garden-variety bugs, rising from the page like dinosaurs of the everyday.

"TO STAND AND MEET THE CHARGE"

For natural-history adventures, Grosvenor followed the tracks of the big-game hunters. And there was no place like Africa for big game. The *Geographic* followed every stage of Theodore Roosevelt's epic 1909–1910 safari across Kenya and Uganda. The former President was on a collecting trip for the Smithsonian, slaying for science. "We brought back . . . some 14,000 specimens of mammals, birds, reptiles, fishes, et cetera," he rather ebulliently recounted in a lecture to Society members.

Carl Akeley of the American Museum of Natural History hunted elephants for his life-size dioramas. But stalking the most dangerous game on Earth at close quarters was a perpetually unnerving experience. "A hasty glance around convinced us there was but one thing to do, to stand and meet the charge from the elevation where we were," he wrote in the August 1912 *Geographic*. "If we tried to escape to one side or to the forest we could not see them over the high grass before they were upon us."

Puttee-clad British explorers were always reliable tale spinners. "One would not in the least be surprised to see pterodactyls flying screaming overhead . . . or iguanodons floundering through the morasses and browsing on the tree-tops," said the irrepressible Alfred Wollaston about the forests of the Ruwenzori—the Mountains of the Moon—in the May 1909 issue. To his ears the nocturnal cries of chimpanzees were "a most melancholy sound, like the wailing of children in distress."

Such authors relied on their vivid storytelling skills. The accompanying pictures, however, generally featured dead animals, the trophies of the hunt. Dramatic photography of wild creatures still on their feet was another matter altogether—as Grosvenor had already discovered.

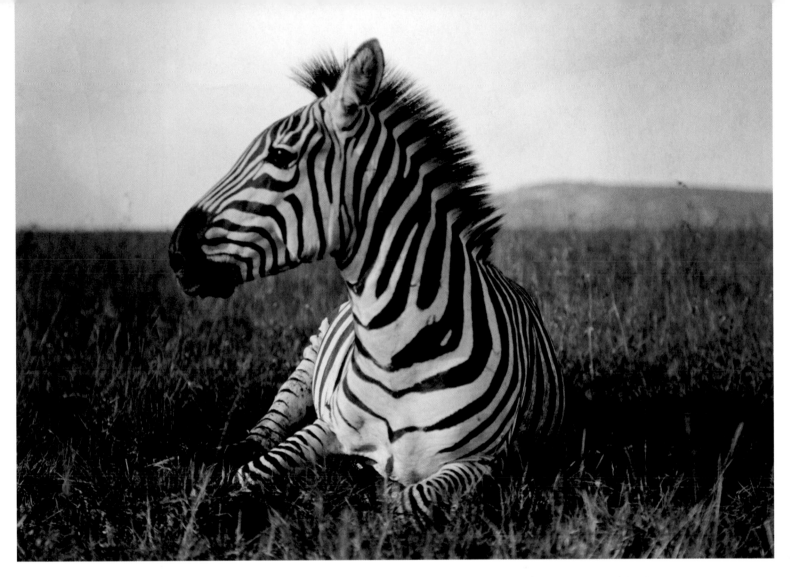

KENYA | CIRCA 1910 Carl Akeley captured this startlingly detailed close-up of a Burchell's zebra at rest on the Athi Plains.

"HUNTING WITH A CAMERA"

At first glance the man who brought true wildlife photography to the *National Geographic* did not resemble a pith-helmeted big-game hunter. George Shiras 3d (he preferred the Arabic numeral to the Roman) was instead a quiet, courteous lawyer and former congressman whose single term in the House of Representatives had been largely devoted to promoting conservation. That stance won him the friendship of President Theodore Roosevelt.

Growing up the son of a wealthy Supreme Court justice, Shiras had spent his summers at a family cabin on Michigan's Upper Peninsula, hunting and fishing in the nearby woods and lakes. In the late 1880s, however, he exchanged his deer rifle for a bulky 5x7 view camera. "Hunting with a camera," as Shiras called it, became his new passion.

Wildlife photography hardly existed. But Shiras was the inventive type. He rigged early camera traps, stretching wires across game trails that, when tripped, fired off trays of flash powder. He mounted cameras on the bow of his canoe, gliding quietly along the lakeshores, closing in on unsuspecting creatures—then firing his flashgun and releasing the shutter. The breathtaking results were soon winning prizes at international expositions.

▶ **JOURNEY INTO EDEN** To Theodore Roosevelt in 1909, the train from Mombasa to Nairobi was a trip through the "Garden of Eden." Game herds abounded on every side. Giraffes cantered away at the locomotive's approach, yet hartebeests paid it no mind. "Then we would come around a curve and the engineer would have to pull his whistle frantically to get the zebras off the track," he wrote in the *Geographic*. "The last of the herd would kick and buck and gallop off 50 yards and turn around and again look at the train."

INDIA | 1995 A female tiger captures her own image in Bandhavgarh National Park.

THEN it was largely a matter of mechanical ingenuity: How best to rig trip wires so keen-eyed animals would not see them? What, perhaps, to bait them with? (A piece of cheese often lured the raccoon at left.) How to safeguard the wires' connections to bulky cameras camouflaged in blinds or mounted on posts? How to synchronize the camera shutters with a flash system that depended on explosive magnesium flash powder? And how to arrange the setup so that images might have visual impact? By meeting such challenges, George Shiras and other early practitioners established a body of technique that not only resulted in better photographs but also gave biologists a useful new tool.

NOW, thanks to sophisticated electronics, digital technology, infrared sensors, and weatherproof housings, camera traps are preferred tools for sampling wildlife populations, especially those of notoriously elusive species such as snow leopards or Bengal tigers (above). Photographers still have to outsmart the animals. In Africa, Frans Lanting masked his human scent by wrapping his cameras in cloths soaked in elephant dung and water. ▪

✚ INFERNAL MACHINES

Stretching to reach a baited string, a raccoon takes its own picture. Frank Chapman and Louis Agassiz Fuertes, wilderness buddies of camera-trapping pioneer George Shiras 3d, grew wary of approaching their campsite at dusk: "Infernal machines [were] secreted anywhere and everywhere."

But Shiras believed that magazine publication would be a better way to put his pictures before the public eye. In early 1906 he got that chance.

"THIS COUNTRY STANDS IN NEED OF A GREAT NATURALIST"

One memorable spring day, Shiras walked through the doors of Hubbard Hall carrying a box full of his wildlife prints. He was hoping that Grosvenor might publish some of them. In his inner sanctum, the Editor spread the pictures out on his desk and studied each one. Then, looking up at his visitor, he announced that he'd like to publish them all.

Grosvenor printed 74 of Shiras's pictures as "Hunting Wild Game with Flashlight and Camera" in the July 1906 *National Geographic*. And that was what sparked board member Alfred Brooks, a geologist for whom the Brooks Range in Alaska is named, to utter that famous grumble about wandering off into nature.

Yet most people were mesmerized by these images of wild animals emerging from the inky night, brilliantly illuminated against a background of black. Years later Grosvenor would characterize his coup as "one of the pioneering achievements of the *National Geographic* . . . I can't exaggerate the enthusiasm with which [those pictures] were received by our members."

One notable member was especially moved. At Sagamore Hill, the Long Island summer home of Theodore Roosevelt, the President picked up his copy of the July 1906

> "You see the magazine, of course?"
> "Absolutely . . ."
> "I enjoyed very much, too, the wild animal photographs of George Shiras three."
> "They were damned fine."
> "I beg your pardon?"
> "They were excellent. That fellow Shiras—"
> "You call him that fellow?"
> "We're old friends," said Harris.
> "I see. You know George Shiras three. He must be very interesting."
> "He is. He's about the most interesting man I know."
>
> **ERNEST HEMINGWAY,**
> "HOMAGE TO SWITZERLAND"

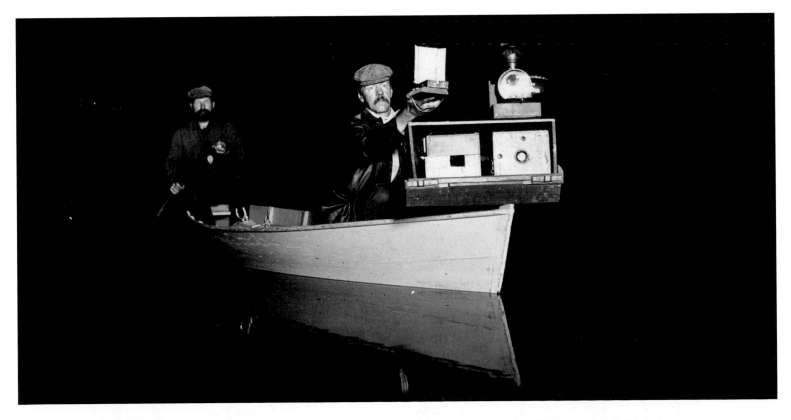

MICHIGAN | 1893 George Shiras demonstrates his revolving camera tray, mounted jacklight, and handheld flashgun.

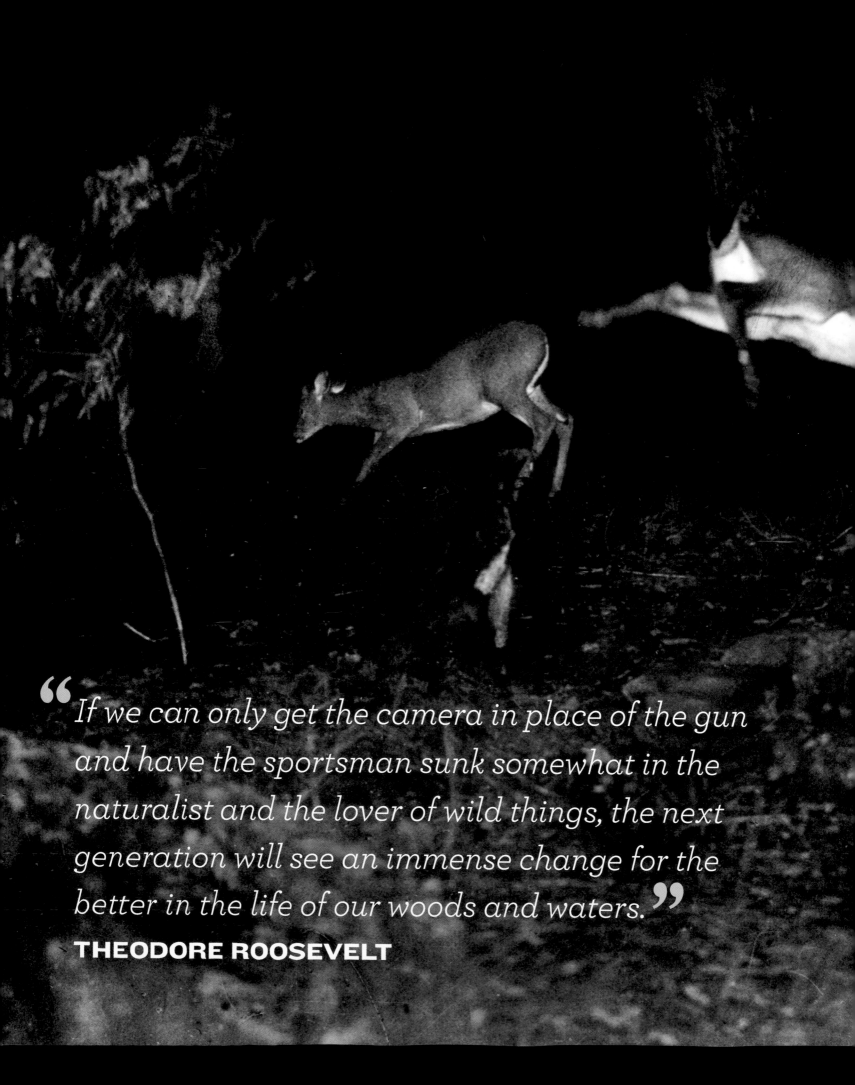

> *If we can only get the camera in place of the gun and have the sportsman sunk somewhat in the naturalist and the lover of wild things, the next generation will see an immense change for the better in the life of our woods and waters.*

THEODORE ROOSEVELT

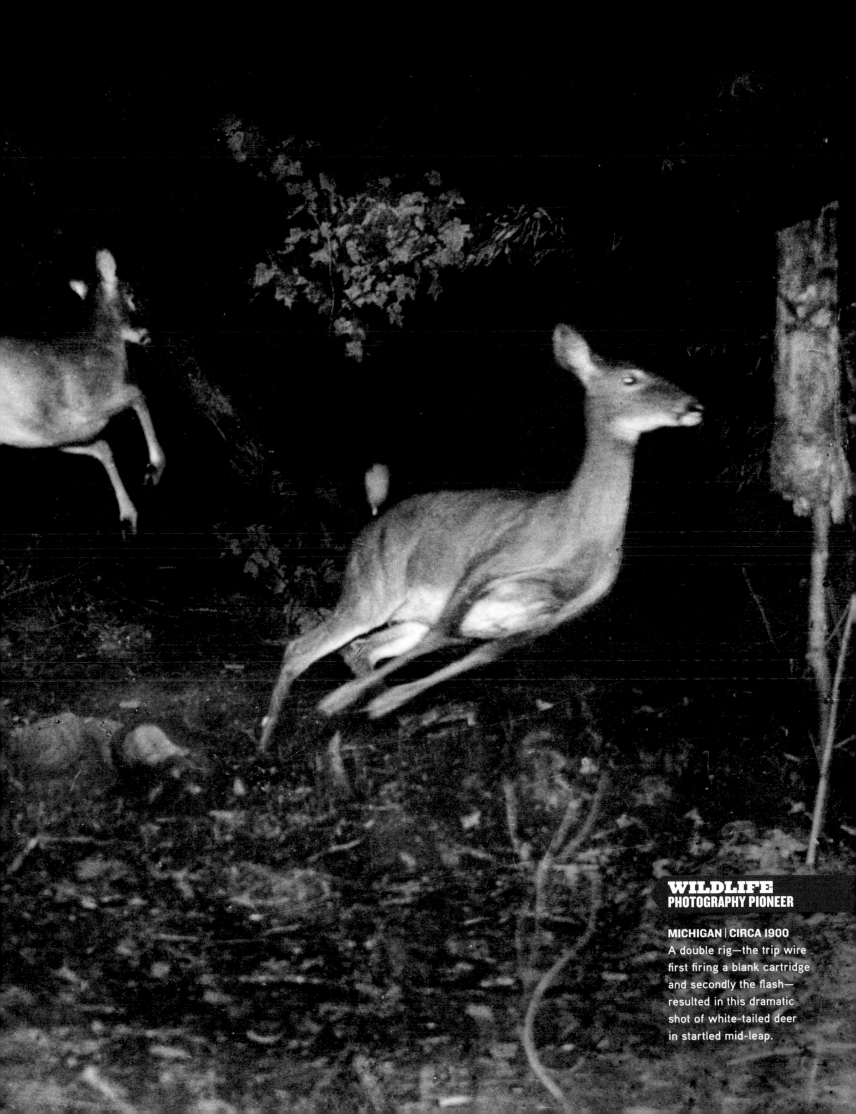

NEW VIEWS OF BIRDS

Once upon a time, the ornithologist's primary tool for identifying birds was his gun. But late in the 19th century, Florence Merriam, sister of Society founder C. Hart Merriam, began advocating a new instrument: opera glasses, known today as binoculars.

issue and leafed through it. Shortly afterward he seized his pen and dashed off a note to Shiras. "I have been looking through your photographs in *National Geographic Magazine,*" he wrote. "Now, my dear sir, no other work you can do is as important as for you to write a big book . . . I feel strongly that this country stands much more in need of the work of a great outdoor faunal naturalist than of the work of any number of closet specialists and microscopic tissue cutters."

Wildlife photography had entered the pages of the *Geographic*. Given its popular and presidential fervor, it was there to stay.

FEATHER SPLENDOR

George Shiras would remain a key *National Geographic* contributor for decades, becoming a member of the Society's board and the driving force behind one of conservation history's most crucial pieces of legislation: the 1913 Migratory Bird Law (officially the Weeks-McLean Act). He was also a member of a close-knit community of field naturalists that had a major impact on Gilbert Grosvenor.

One of them was Frank Chapman, curator of ornithology at the American Museum of Natural History. Grosvenor had bought an old farm on the outskirts of Washington. Walking across its overgrown fields one day, it struck him how few birds he could identify. So he purchased one of Chapman's pioneering field guides and was soon rattling off the names of more than 50 species. He was hooked, and before long appointed Chapman an associate editor of the magazine.

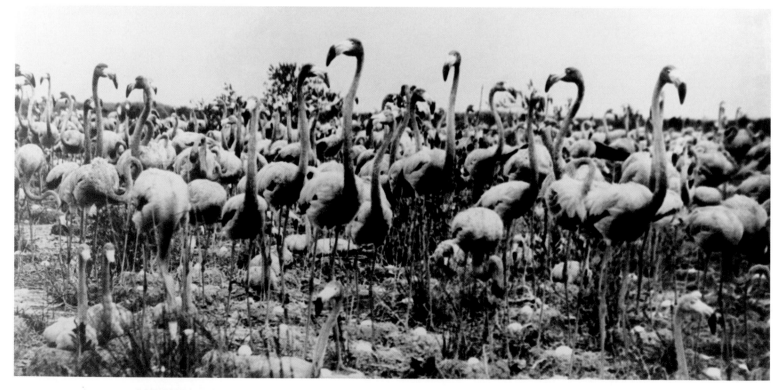

BAHAMAS | 1901 Pink flamingos guard their nests on Andros Island in this Frank Chapman photograph.

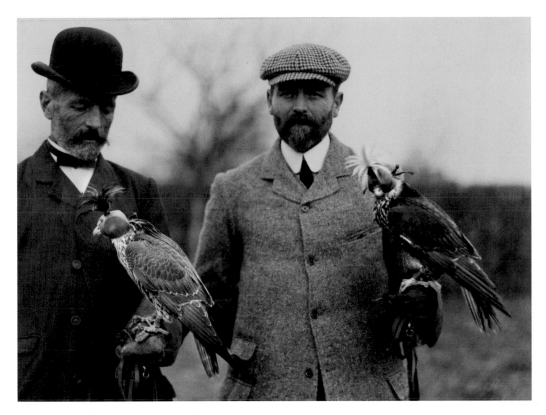

HOLLAND | EARLY 1900S Two Dutch falconers show off their prized predators for the benefit of photographer Louis Agassiz Fuertes.

Grosvenor then cultivated Society founder Henry Henshaw. Now chief of the Biological Survey, Henshaw had written an Agriculture Department bulletin, "Fifty Common Birds of Town and Orchard," that Grosvenor enthusiastically reprinted in the magazine's June 1913 issue. An acquaintance with birds, Chapman wrote in an accompanying piece, "may bring you more unalloyed happiness than the wealth of the Indies."

It certainly brought an increase in Society members—and sowed the germ of an idea in Grosvenor's mind. To help it grow, he turned to the man who had painted the bulletin's illustrations, Louis Agassiz Fuertes.

Over the next 15 years the dashing Fuertes illustrated three more articles about birds for Grosvenor, who was soon asking for a series on mammals, then one on dogs. Before long the *Geographic* was publishing illustrated field guides, using a variety of painters, on every subject from wildflowers and reptiles to fish and stars. But Fuertes remained its Audubon. "I feel that criticizing your bird portraiture is almost as improper as criticizing the works of the Almighty," Grosvenor wrote to him. "However, here goes about the owls." Fuertes countered with a proposal for an article on falconry. Uncharacteristically, the Editor hesitated, "though I am always ready to be convinced."

It was a good thing he was. In 1930, a pair of 14-year-old twin boys came across Fuertes's 1920 *Geographic* article on falconry, and it changed their lives. Frank and John Craighead would become famous for their Society-supported work with grizzly bears at Yellowstone National Park. ■

✳ A JUNKET FOR SCIENCE

In 1920 associate editor John Oliver La Gorce and illustrator Louis Agassiz Fuertes ventured to desolate Andros Island in the Bahamas. Frank Chapman had encountered a threatened population of pink flamingos there in 1901, and 19 years later the two men hoped to make color pictures of the birds for Miami's Flamingo Hotel. Instead of promotion, they achieved preservation: "You will be glad to hear that an Order in Council passed giving complete protection to the flamingo," the governor of the Bahamas wrote Gilbert Grosvenor. "This glory of our marshes owes your expedition a debt of gratitude."

ABOVE: A Fuertes illustration of falcon talons

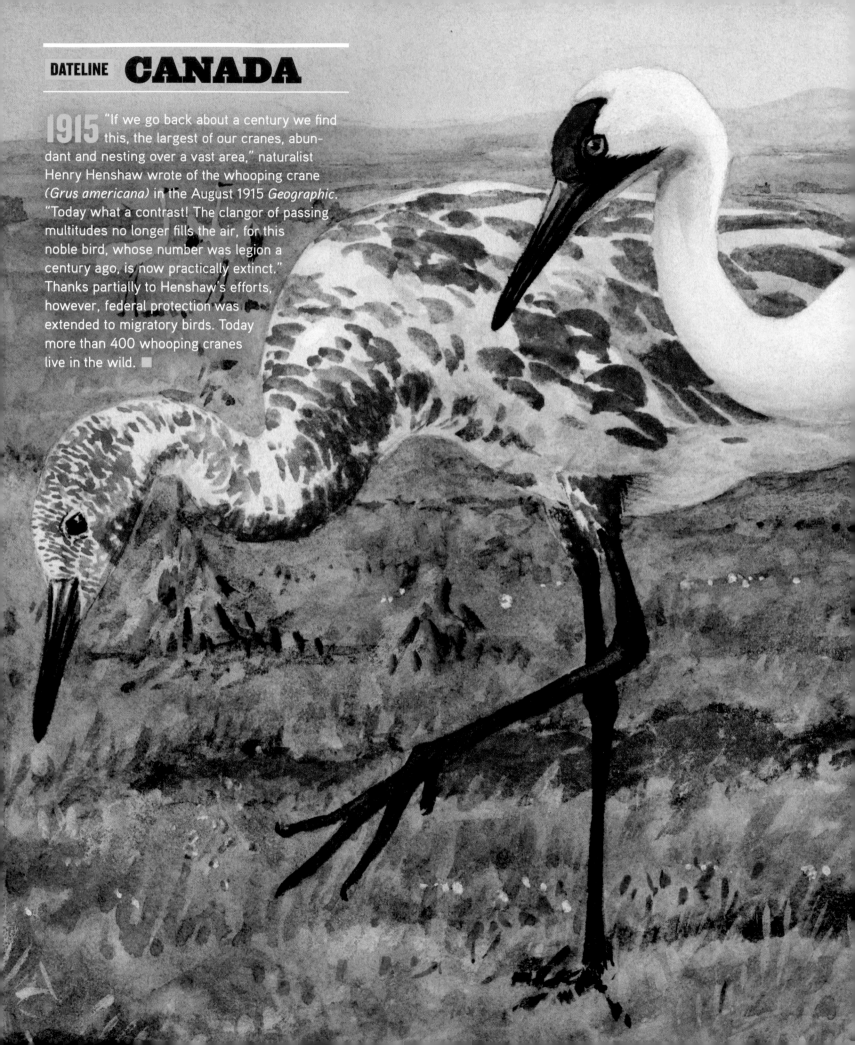

1915 "If we go back about a century we find this, the largest of our cranes, abundant and nesting over a vast area," naturalist Henry Henshaw wrote of the whooping crane (*Grus americana*) in the August 1915 *Geographic*. "Today what a contrast! The clangor of passing multitudes no longer fills the air, for this noble bird, whose number was legion a century ago, is now practically extinct." Thanks partially to Henshaw's efforts, however, federal protection was extended to migratory birds. Today more than 400 whooping cranes live in the wild. ■

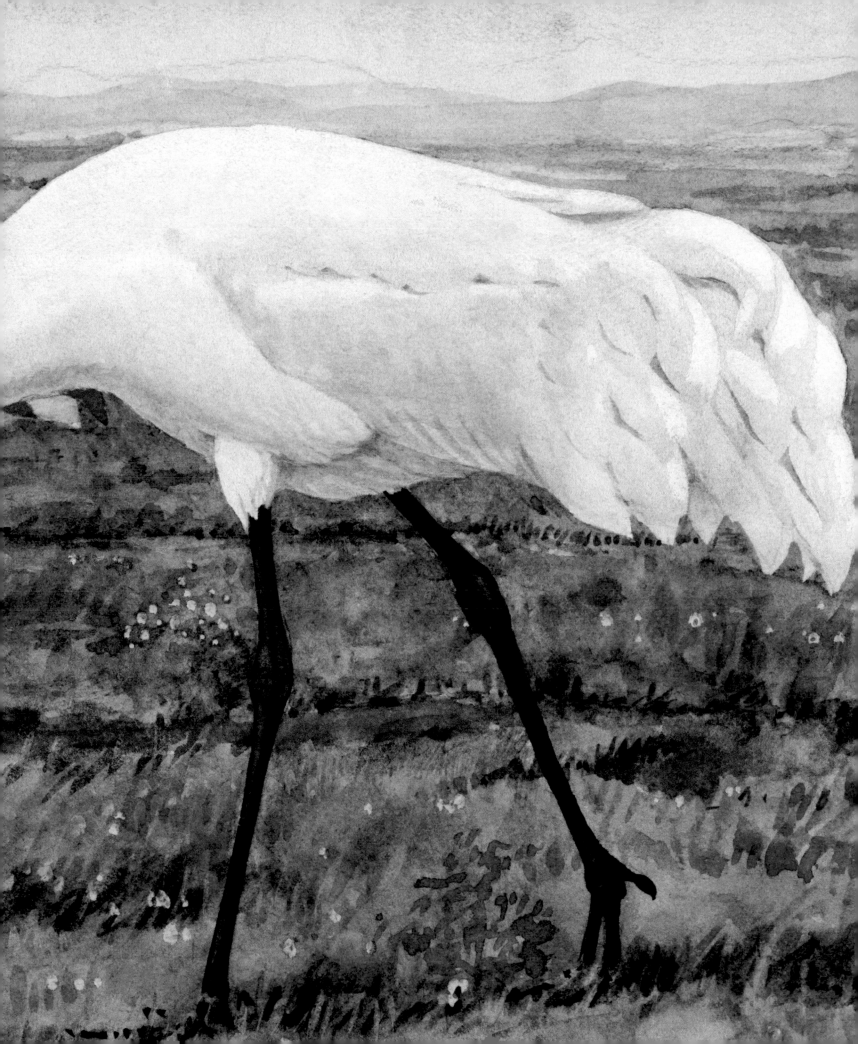

SCENIC WONDERLANDS

Wilderness booster Stephen Mather helps the final piece of the Geographic puzzle fall into place: the long association between the Society and the world's national parks.

✱ ROUGHING IT

Trail cook Ty Sing kept the members of the Mather Mountain Party well fed; one man wolfed "a grapefruit, a cantaloupe, a few trout, two tenderloin steaks, potatoes, hot biscuits, and coffee" for breakfast. A typical dinner included "soup, salad, fried chicken, venison and gravy, potatoes, hot rolls, apple pie, cheese, and English plum pudding with brandy sauce."

Though Gilbert Grosvenor had traipsed all over the Near East, he didn't venture far west of the Mississippi until 1915. That summer found him astride a mule on a two-week pack trip into California's Sierra Nevada mountains. Not just any pack trip, though, for the cadre of influential writers, reporters, and businessmen that made up the contingent slept comfortably on air mattresses and ate sumptuous meals served on white linen tablecloths. This was the "Mather Mountain Party," arranged by retired millionaire Stephen Mather who, hoping to persuade Congress to establish a government agency to administer the neglected national parks, had turned to the nation's leading "opinion-makers" to stimulate interest in "scenic wonderlands" such as Yosemite and the nearby groves of giant sequoias. All this grandeur, Mather emphasized with a sweep of his arms, would be at stake if Congress failed to act.

Grosvenor came out of the mountains a confirmed believer. He lobbied for passage of the bill that created the National Park Service in 1916, with Mather its first director. Grosvenor also harnessed the National Geographic Society to the cause: He persuaded its initially doubtful Board of Managers to buy certain tracts of colossal trees—ones still in private hands, even though they stood in the heart of Sequoia National Park—and then donate them to the public.

THE VALLEY THAT NAMED ITSELF

At the same time the National Park Service was officially established by President Woodrow Wilson's signature, a stalwart if self-effacing botanist named Robert Griggs was leading a National Geographic expedition out of Alaska's scorched Katmai Peninsula. In 1912 a volcano there had erupted with such force that its tremendous blasts were felt all over the Northwest. For the second year in a row, Griggs had been

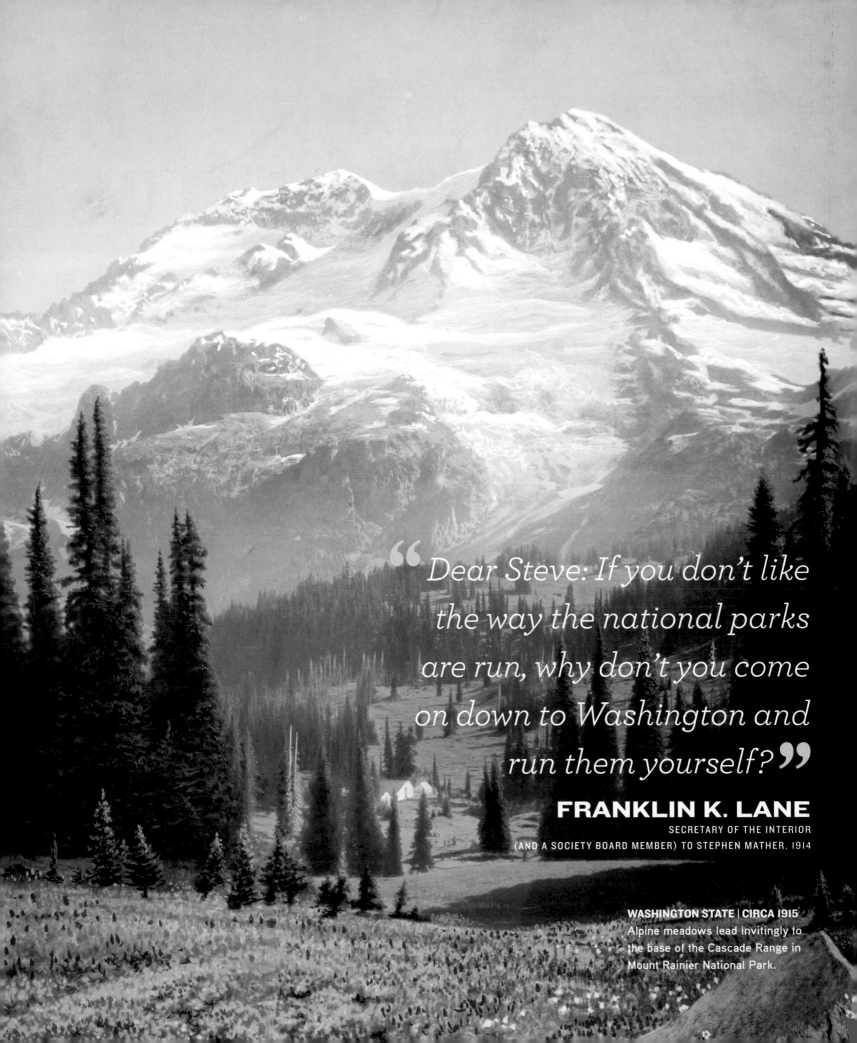

"*Dear Steve: If you don't like the way the national parks are run, why don't you come on down to Washington and run them yourself?*"

FRANKLIN K. LANE
SECRETARY OF THE INTERIOR
(AND A SOCIETY BOARD MEMBER) TO STEPHEN MATHER, 1914

WASHINGTON STATE | CIRCA 1915
Alpine meadows lead invitingly to the base of the Cascade Range in Mount Rainier National Park.

fording ash-choked rivers, struggling through knee-deep mud, and skirting beds of quicksand to reconnoiter a ravaged landscape. He had slogged through pumice, slept in pumice, even averted his eyes from windblown specks of pumice. But in August 1916 he could not tear his gaze from the sight of the river valley that, having been buried in hot cinders, was still seething with steam vents. "Ten thousand smokes!" marveled Griggs. "The valley named itself."

No camera could really capture it. "Tear up your damn pictures," one of Griggs's companions told a photographer. "They'll never help anybody imagine what this is like." But on the strength of a single roll of film, the Society sponsored three more expeditions to the Valley of Ten Thousand Smokes. Thanks in part to the spectacular panoramas that soon appeared in *National Geographic*—to say nothing of the photos of awestruck scientists stepping gingerly among volcanic vents, which they reported as "hissing" or "roaring"—in September 1918 President Wilson signed another document, this one creating what eventually became Katmai National Park.

In less than two decades, 43-year-old Grosvenor had succeeded in transforming a struggling geographic society into the world's largest and most influential scientific and educational association. ■

CALIFORNIA | 1915 Gilbert H. Grosvenor awakens after a night spent beneath a giant sequoia tree during the Mather Mountain Party.

MONTANA | CIRCA 1915 An idyllic log getaway perches beside Lake McDermott in Glacier National Park, courtesy of "Land of the Best."

➕ PROMOTING THE PARKS

"In hundreds of articles dealing with the natural and historic treasures of our parks," the magazine announced in its July 1966 issue (above), "the Geographic has always emphasized their use and enjoyment."

There is a "National Geographic Grove" in Sequoia National Park and a "National Geographic Tree" in Redwood National Park—tributes to a remarkable partnership forged nearly a century ago. As Congress debated establishing a national park service in 1916, the single most important publication influencing them was the April 1916 *National Geographic*. Celebrating the "Land of the Best," the issue extolled America's scenic wonders at length—100 pages of paeans and pictures. Enhanced by 32 plates of "natural color" photographs and a two-foot-long pictorial supplement of a giant sequoia tree, it was placed in the hands of every senator and representative just in time for the scheduled vote to authorize such a supervisory body. In this way, as conservationist Horace Albright, a former National Park Service director himself, put it, "Gilbert 'Tenderfoot' Grosvenor had come through for Stephen Mather and the ideas he had expressed around the Sierra campfires." ■

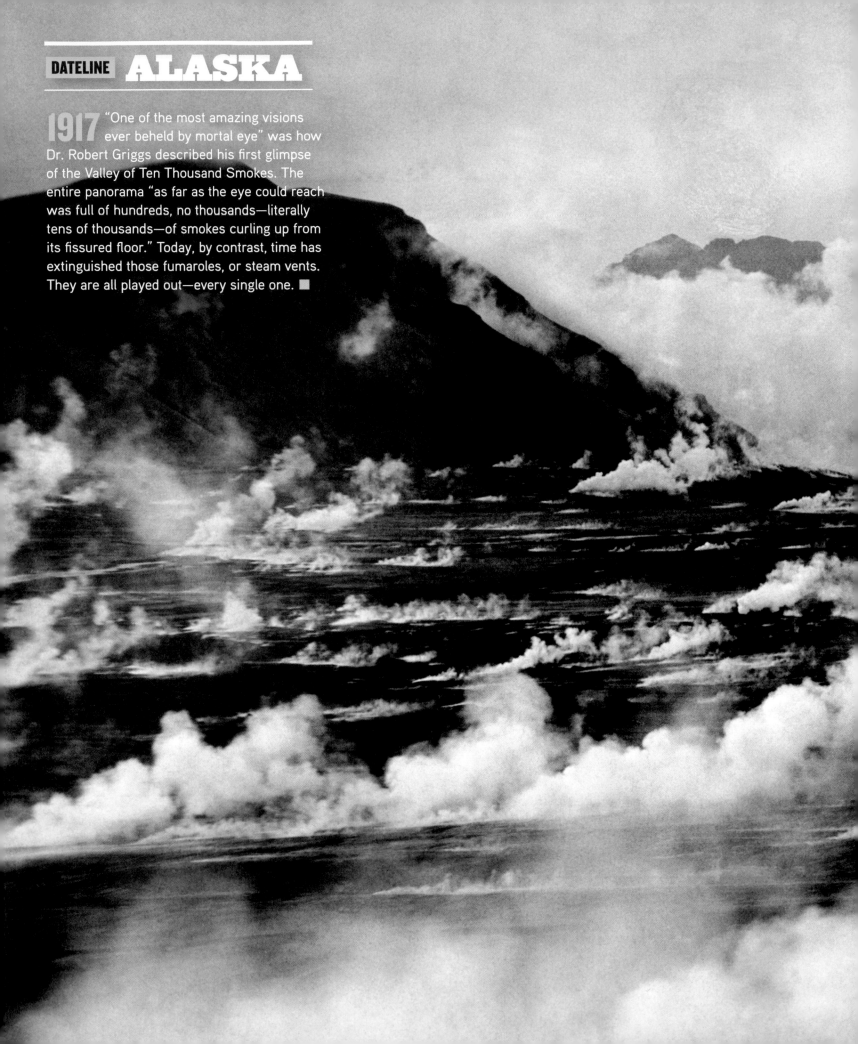

1917 "One of the most amazing visions ever beheld by mortal eye" was how Dr. Robert Griggs described his first glimpse of the Valley of Ten Thousand Smokes. The entire panorama "as far as the eye could reach was full of hundreds, no thousands—literally tens of thousands—of smokes curling up from its fissured floor." Today, by contrast, time has extinguished those fumaroles, or steam vents. They are all played out—every single one. ■

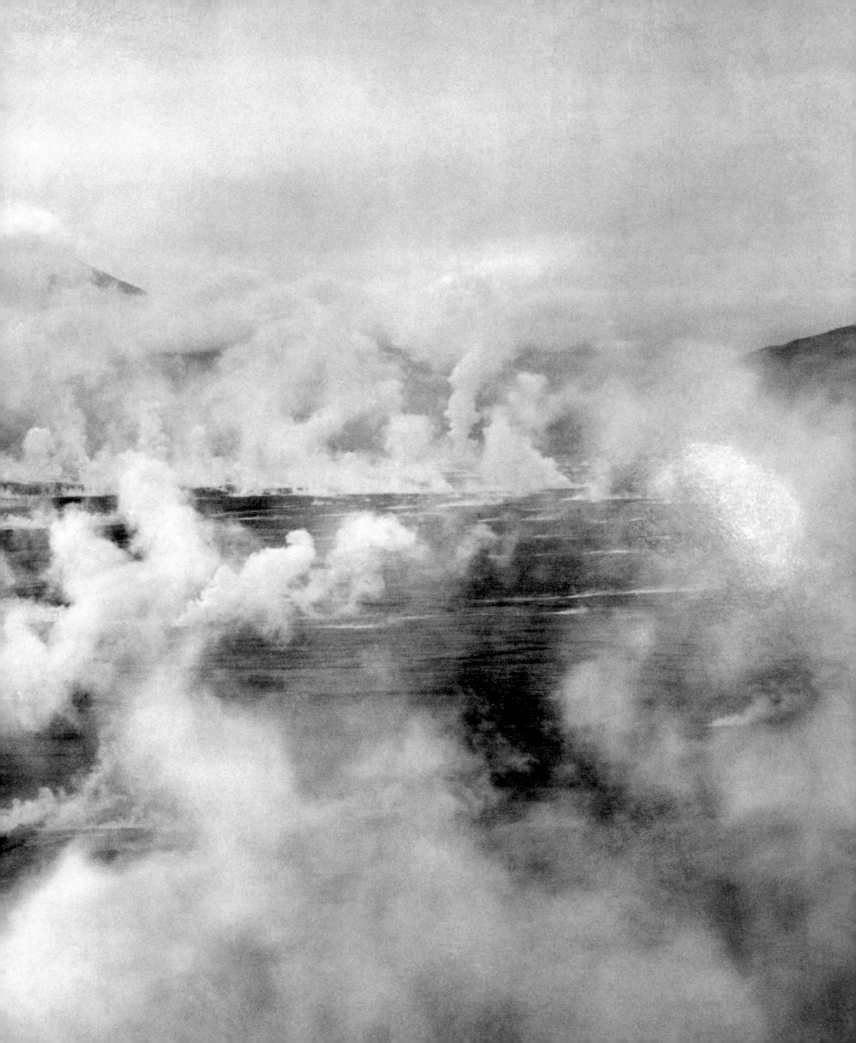

VIOLENT EARTH

Perhaps no history repeats itself quite like that of natural disasters. In the November 1896 *National Geographic,* Eliza Scidmore reported on the devastating tsunami that had recently ravaged the coast of Japan—one nearly equaled in size by the March 2011 tsunami, likewise featured in the magazine. The Society's publications and television programs have always drawn attention to our violent Earth. Indeed, the Geographic's founders included geologists whose studies of volcanoes and earthquakes were classics a century before a January 1981 *Geographic* story on the eruption of Mount St. Helens became one of the most popular articles in the journal's history. Lt. John P. Finley, an "original member" from 1888, has been called the "first severe storms forecaster" for his pioneering work on tornadoes. Today photographer Carsten Peter rappels into the maws of active volcanoes while the Society sponsors improved "tornado-cams" and "lightning-cams"—everywhere closing in on the hair-raising image without losing sight of the gut-wrenching story. ■

▼ **2011** *The deadly March 11 tsunami breaches a seawall in Miyako, Japan. The water surged as high as 125 feet and killed 401 townspeople.*

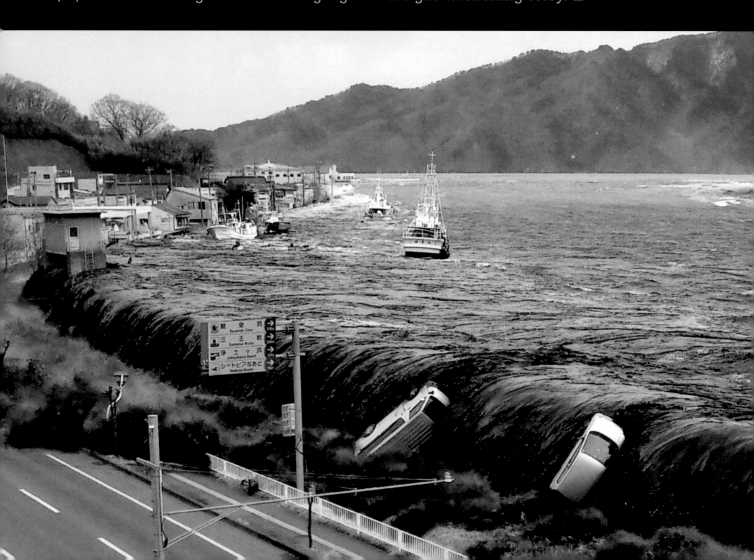

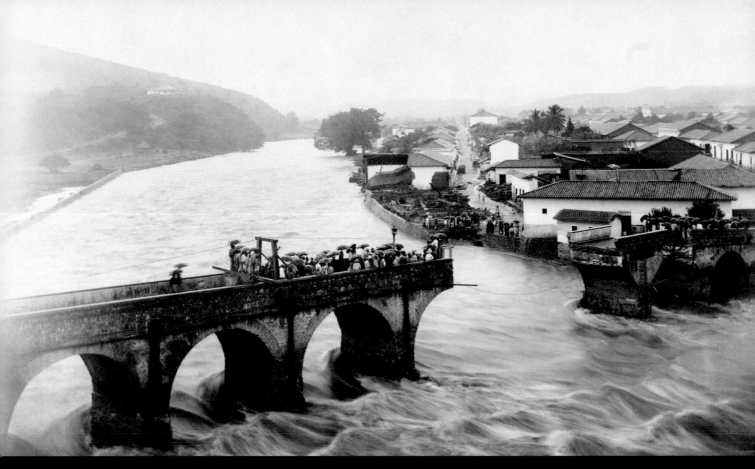

▲ **1916** *A flood neatly severed the center span of this bridge in Tegucigalpa, Honduras.*

▸ **2005** *Katrina survivors use improvised paddles to navigate hurricane-flooded New Orleans.*

▾ **1984** *An Indian tailor rescues his sewing machine from a monsoon flood.*

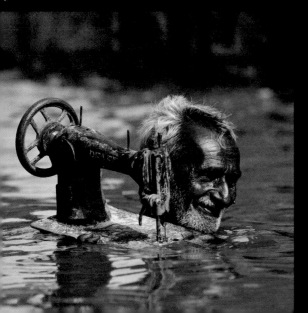

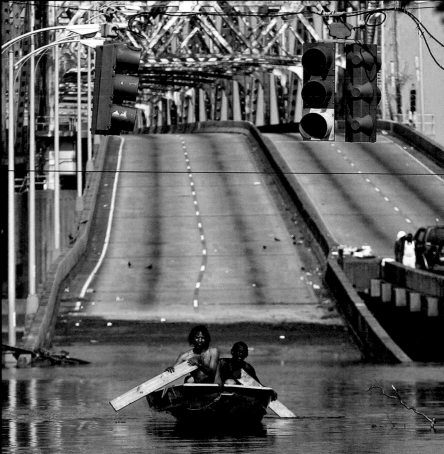

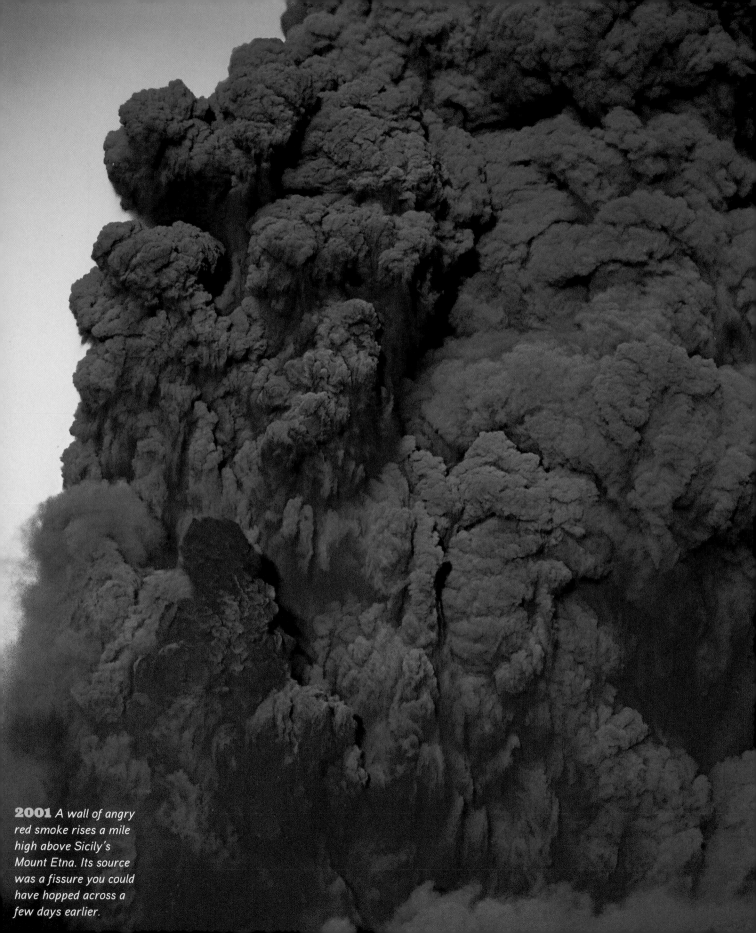

2001 *A wall of angry red smoke rises a mile high above Sicily's Mount Etna. Its source was a fissure you could have hopped across a few days earlier.*

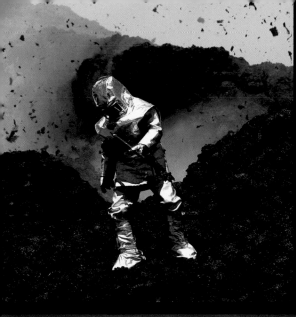

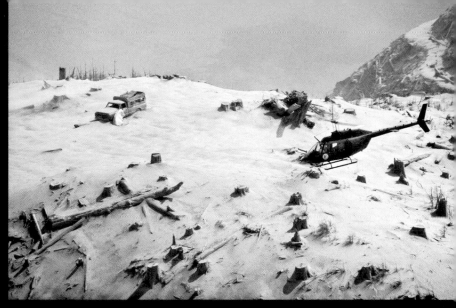

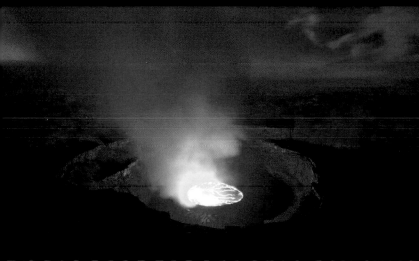

◄◄ 2001 *Flying magma and lethal fumes assail a volcanologist wearing a thermal suit and helmet to collect lava samples.*

▲ 1980 *A National Guard helicopter flies over an ash-blasted landscape, seeking survivors of the eruption of Mount St. Helens.*

◄ 2010 *Caldera cauldron: The lava lake filling the Democratic Republic of the Congo's Nyiragongo is the largest one in the world.*

▼ 1992 *The petrified likeness of a Pompeian citizen lies where the body fell in A.D. 79. As the body decayed, it left behind an eerie mold, soon filled by volcanic ash.*

◄◄, ▼ 1902 *Nearly 30,000 people were killed in St.-Pierre, Martinique, by the colossal eruption of nearby Mount Pelée.*

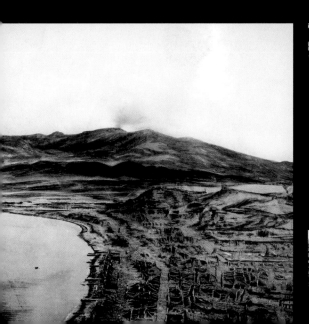

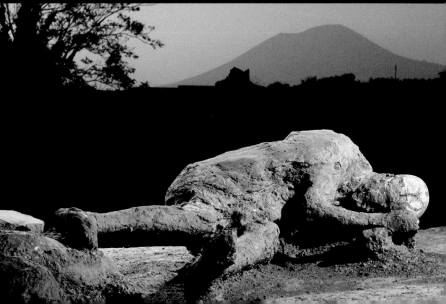

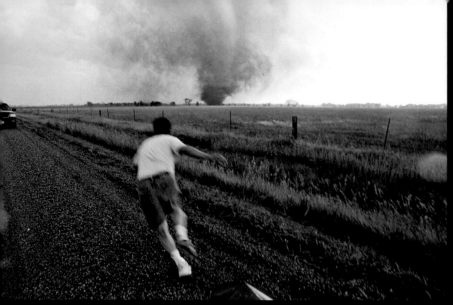

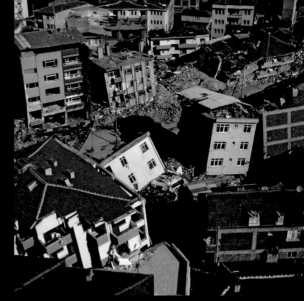

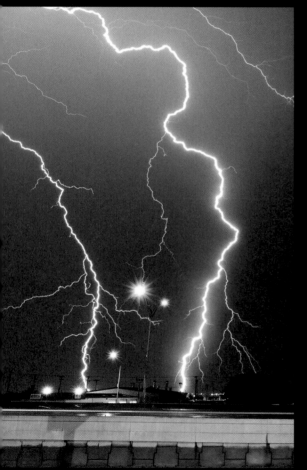

1999 *Quashed by a quake, Adapazari, Turkey, pinned most of the damage on shoddy builders.*

1974 *Plants struggle for life in arid Western Australia, where droughts can persist for years on end.*

2010 *A Catholic church brought to its knees after the great earthquake flattened most of Port-au-Prince, Haiti*

2010 *Lightning bolts rake the Kansas plain as an enormous thunderstorm lashes the tallgrass prairie.*

2003 *Storm chaser Tim Samaras plants a probe in the path of a tornado sweeping across a South Dakota field—then hightails it back to his vehicle.*

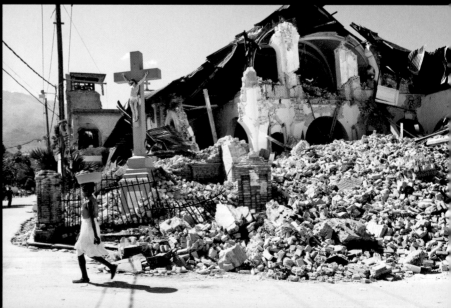

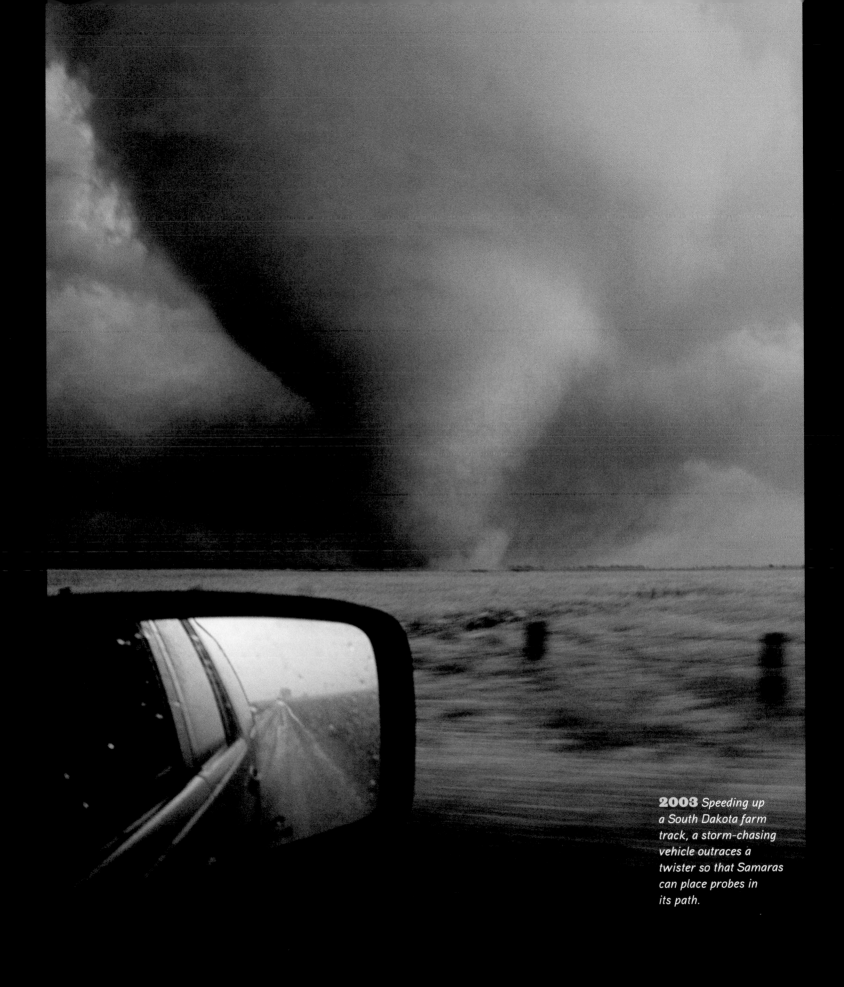

2003 *Speeding up a South Dakota farm track, a storm-chasing vehicle outraces a twister so that Samaras can place probes in its path.*

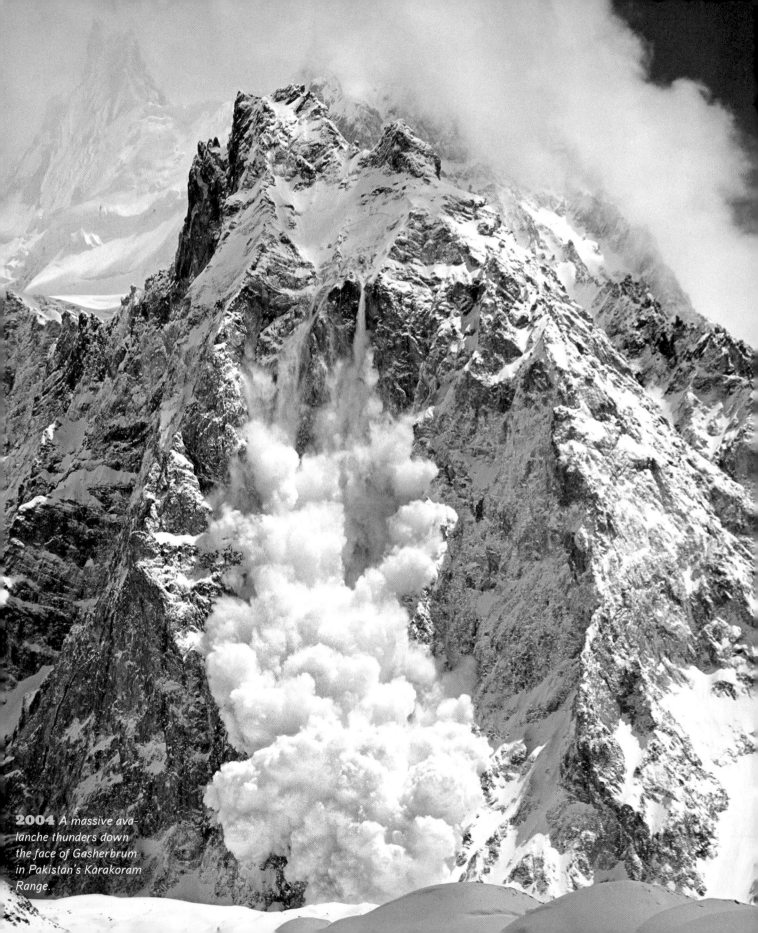

2004 A massive avalanche thunders down the face of Gasherbrum in Pakistan's Karakoram Range.

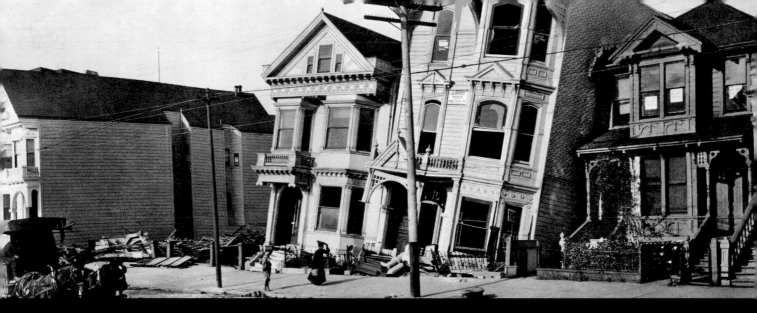

1906 *Lean on me. A pair of houses that escaped being leveled by San Francisco's 1906 earthquake were instead knocked out of plumb.*

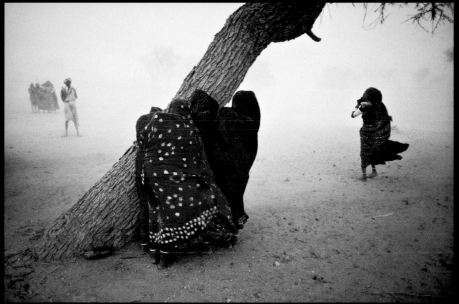

◂ **1983** *Village girls shield themselves from flying dust as a storm scours the plains of Rajasthan at the approach of the monsoon.*

▾ **2011** *Punishing Hurricane Irene wheels across the Atlantic Ocean toward the Bahamas and eastern Cuba.*

▾ **2008** *A California wildfire consumes building, camper, and truck in one scorching gulp.*

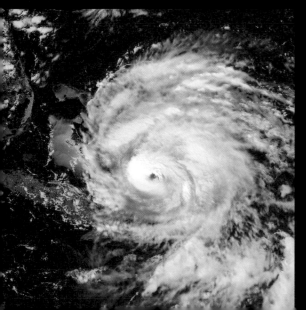

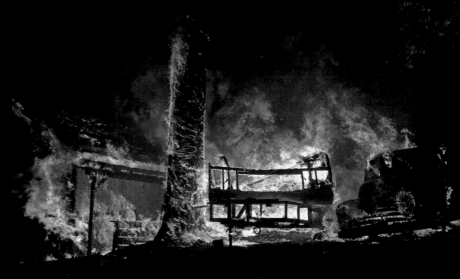

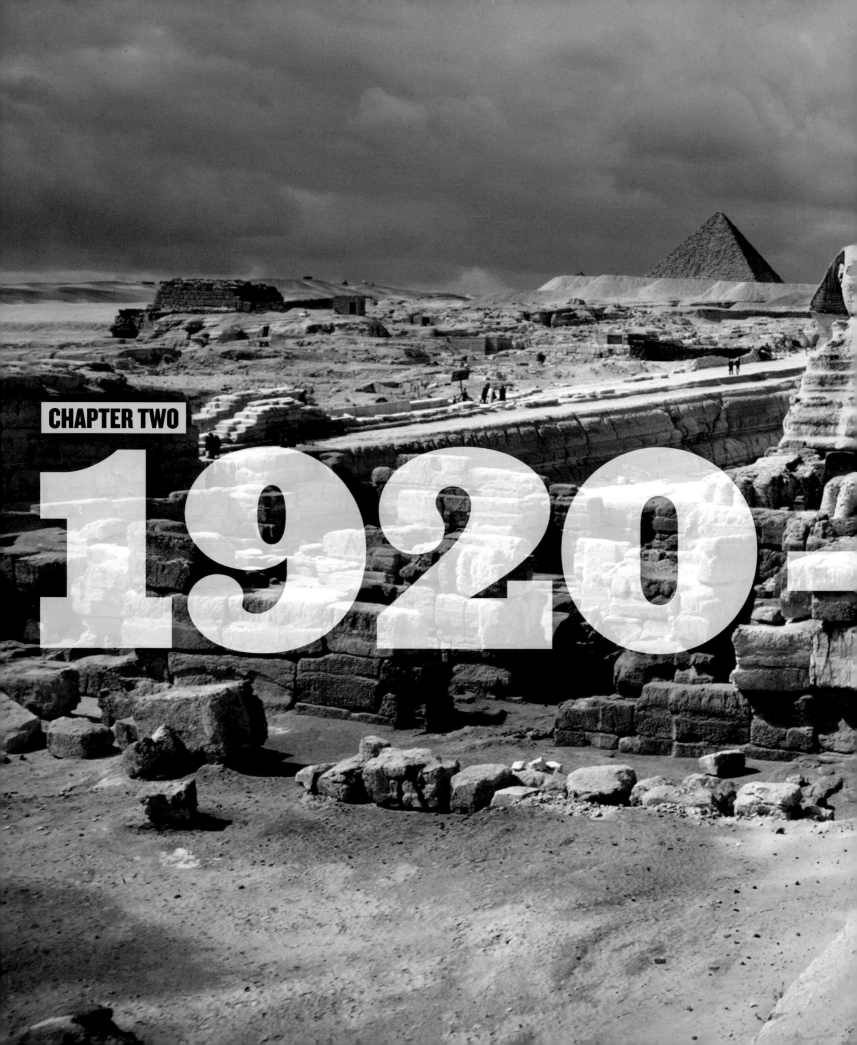

1920-

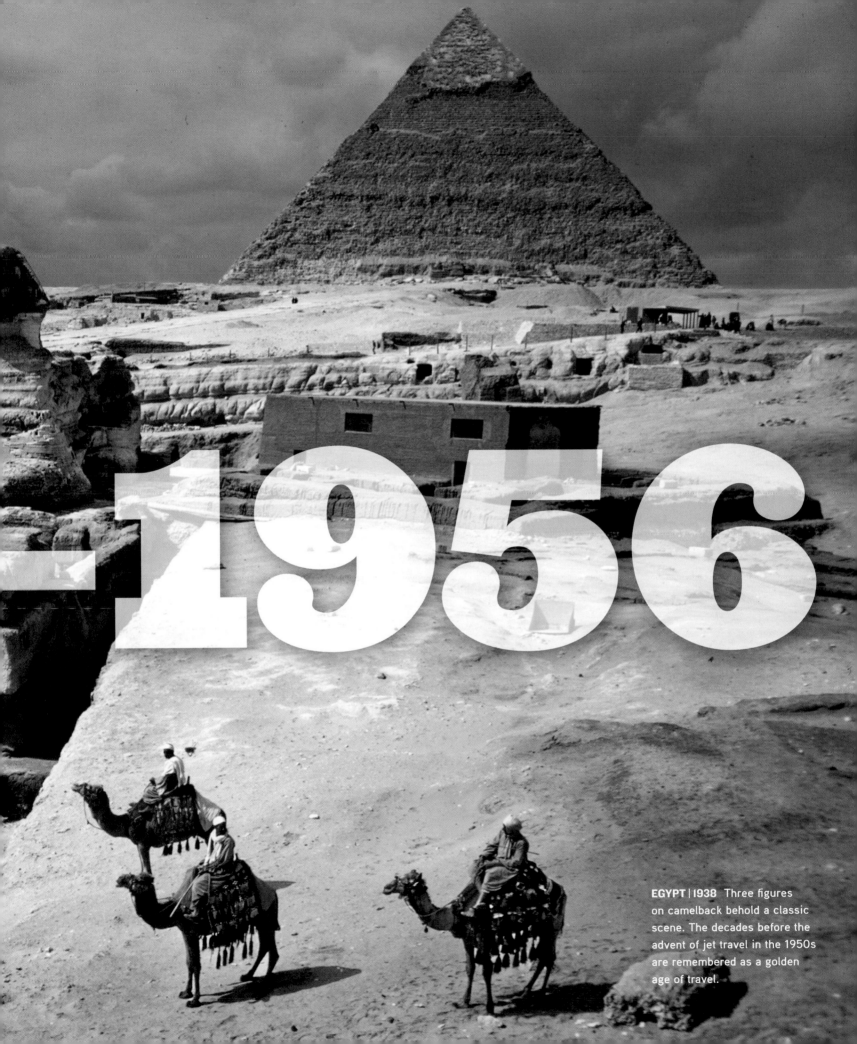

1956

EGYPT | 1938 Three figures on camelback behold a classic scene. The decades before the advent of jet travel in the 1950s are remembered as a golden age of travel.

1931 *The Geographic's Maynard Owen Williams, passing through Afghanistan with the Citroën-Haardt Trans-Asiatic Expedition, photographs these men and boys in Herat.*

1944 *W. Robert Moore, one of* National Geographic's *correspondents, reported from battlefields all over the Pacific Theater, including the Marshall Islands (below).*

1936 *It is a golden age for "triple threat" staff men, like Luis Marden, able to write articles, shoot pictures, and make a 16-mm lecture film, all while living in faraway countries.*

1938 *The first of seven Society-supported archaeological expeditions to southern Mexico begins uncovering the remains of the vanished Olmec civilization of Central America.*

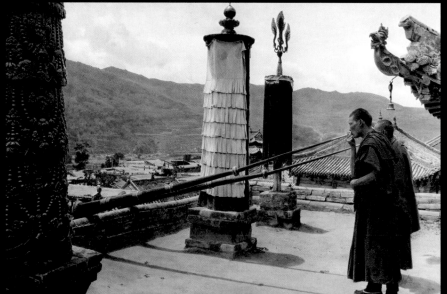

1926 *Throughout the twenties, botanist Joseph Rock roamed the mountains of southwestern China, collecting rare plants and photographing little-known tribal ceremonies.*

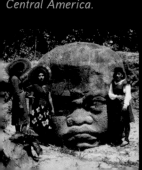

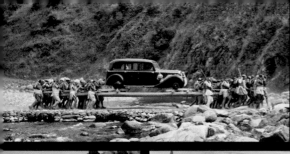

1938 *The advent of 35-mm Kodachrome film leads to color-saturated pages in the Geographic, as well as to a derisive dismissal: the "red shirt school of photography."*

◄ 1948 *A Society-supported expedition to Nepal, the first permitted to enter parts of that kingdom in over a century, collects the spiny babbler (center), a bird long thought extinct.*

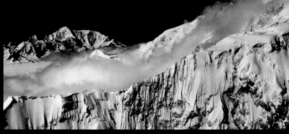

▶ 1935 *The NGS–U.S. Army Air Corps stratosphere balloon Explorer II rises nearly 14 miles into the sky, setting a manned altitude record that would stand for 21 years.*

▶ 1928 *Adm. Richard E. Byrd (right) leads the first of two Society-supported expeditions to Antarctica, the highlight of which is the first flight over the South Pole.*

▼ 1948 *During the Berlin airlift, American pilots, led by Lt. Gail Halvorsen, ferry in emergency supplies while raining down chocolate candies for the city's children.*

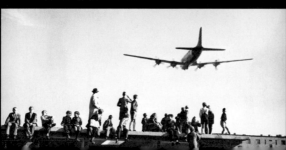

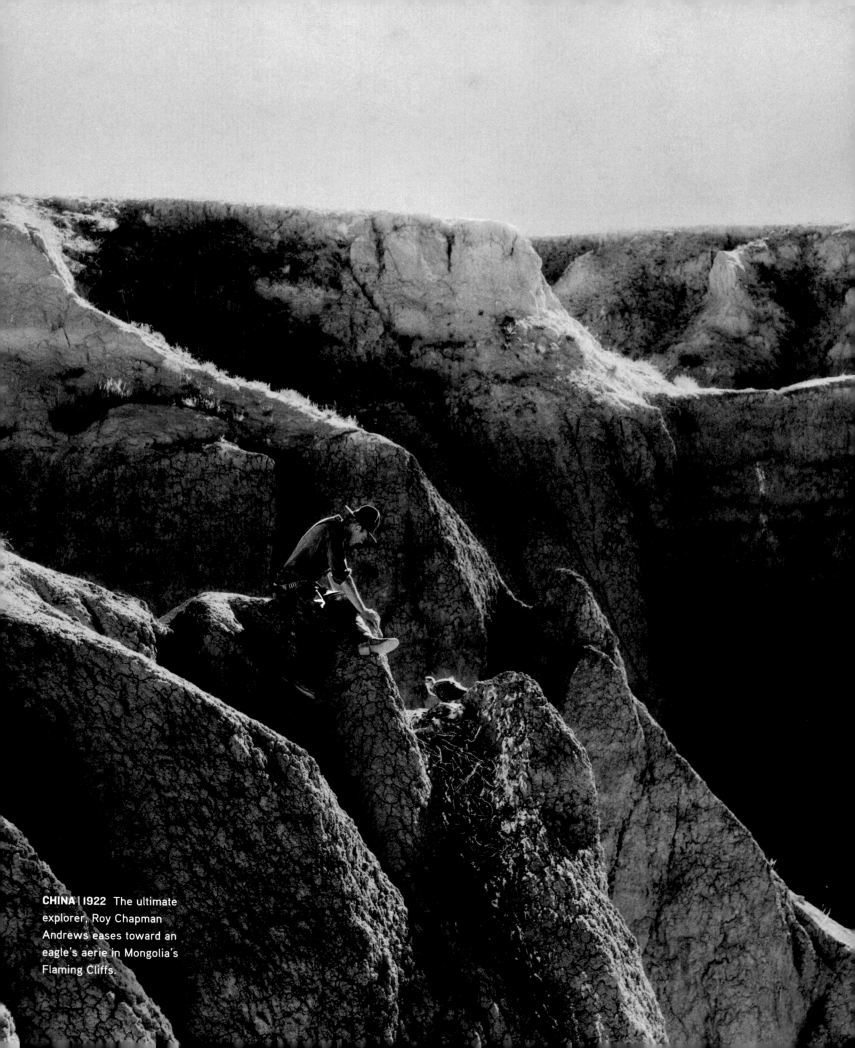

CHINA | 1922 The ultimate explorer, Roy Chapman Andrews eases toward an eagle's aerie in Mongolia's Flaming Cliffs.

FAR-OFF, RUGGED PLACES

If Cary Grant had worked for *National Geographic,* he could not have been more attractive and appealing than was Howell Walker. The magazine's urbane and polished correspondent had charmed his way around the globe several times before encountering the small-town California newspaperman who openly envied a life spent reporting on "far-off, rugged places, in the National Geographic manner."

Between the 1920s and the mid-1950s, when Gilbert H. Grosvenor finally stepped down as Editor, that "National Geographic manner" was one part dignity—a dignity embodied in the marble of the Society's Washington headquarters—one part the romance of travel, and two parts exotic adventure. Howell Walker may have spent eight months in the Australian outback, but there were few places more rugged and far-away than the Gobi desert, and few explorers better captured the popular fancy than did Roy Chapman Andrews, who led six expeditions there. (Richard E. Byrd ran a close second, leading five ventures to Antarctica, the most far-off and rugged place of all.) Other explorers probed equally alien realms: William Beebe descended deep into the midnight sea, for example, while his counterpart, Albert Stevens, rode a balloon to the front door of space. They all climbed the Society's stone steps and entered its bronze doors.

Above all, however, that manner was most apparent in *National Geographic* itself. The Society *was* its magazine, and it had become not only an "American institution" but was being sent all over the globe, to places so remote it sometimes arrived via camel caravan or outrigger canoe. The monthly copy that eventually reached the Mir of Hunza in Pakistan's Karakoram Range would travel by freighter, train, airplane, jeep, and finally by runner. There was nothing quite like the *Geographic*. People cherished it for any number of reasons: aesthetic, educational, practical—thousands of Hollywood costumes were supposedly copied from its pages—as well as for a few peculiar ones: "Oh, I meant to ask you," novelist Flannery O'Connor remarked to a friend in 1956. "Do you read the *National Geographic* or do you smell it? I smell it. A cousin gave me a subscription when I was a child as she noted I always made for it at her house, but it wasn't a literary or even a geographical interest. It has a distinctly unforgettable transcendent apotheotic and very grave odor. Like no mere magazine." ■

THE FIRESIDE TRAVELER

At a time when most people could travel only by armchair, the *Geographic* brought home the world in color—often through contributors colorful in their own right.

✳ "ROMANCE OF DISCOVERY"

In 1927 American artist N. C. Wyeth unveiled his "Romance of Discovery" paintings gracing the marble staircase at Society headquarters. These giant panels depict emblematic scenes of exploration by land, by sea, and by air.

ABOVE: Byrd's *Josephine Ford* strives to reach the North Pole.

It must not have taken long for writer Ishbel Ross to find an apt conclusion to "Geography, Inc.," her 1938 *Scribner's* magazine piece profiling the National Geographic Society celebrating its 50th anniversary. Flipping through the oak-and-laurel-bordered journal, Ross had noticed a few indulgent items missing from its advertisements. "Dr. Grosvenor once said that he would take his readers around the world and that he would take them first class," she typed. "He has done it and, most remarkable of all, he has done it without letting his fireside travelers have a drink, a smoke, or a bicarbonate of soda."

Perhaps that was due to the *Geographic*'s being found in schools and doctors' offices as often as it was in homes. But readers all too willing to overlook such prohibitions still fished the magazine out of a pile of periodicals and settled into that armchair precisely because, as one woman from Northern Ireland wrote in, "chained by circumstances to quiet homes, denied adventure, denied travel, denied the chance to explore the beauties of their world," they found the magazine to be their "magic carpet" to faraway places—places, as the magazine's own promotional literature put it, as "alive with color as they are with history and romance."

THE AUTOCHROME GLOW

The 1920s were the golden decade when Autochromes—more than 1,800 of them— ruled the pages of *National Geographic*. The slow exposure times required by that magical glass plate meant posed pictures, still lifes, or landscapes. But it also lent the resulting images a timeless tranquillity. And that was the quality most sought by Grosvenor's internationally recruited corps of "autochromists," whose crates of glass plates, dispatched from distant ports, might have been their only tangible contact with Society headquarters.

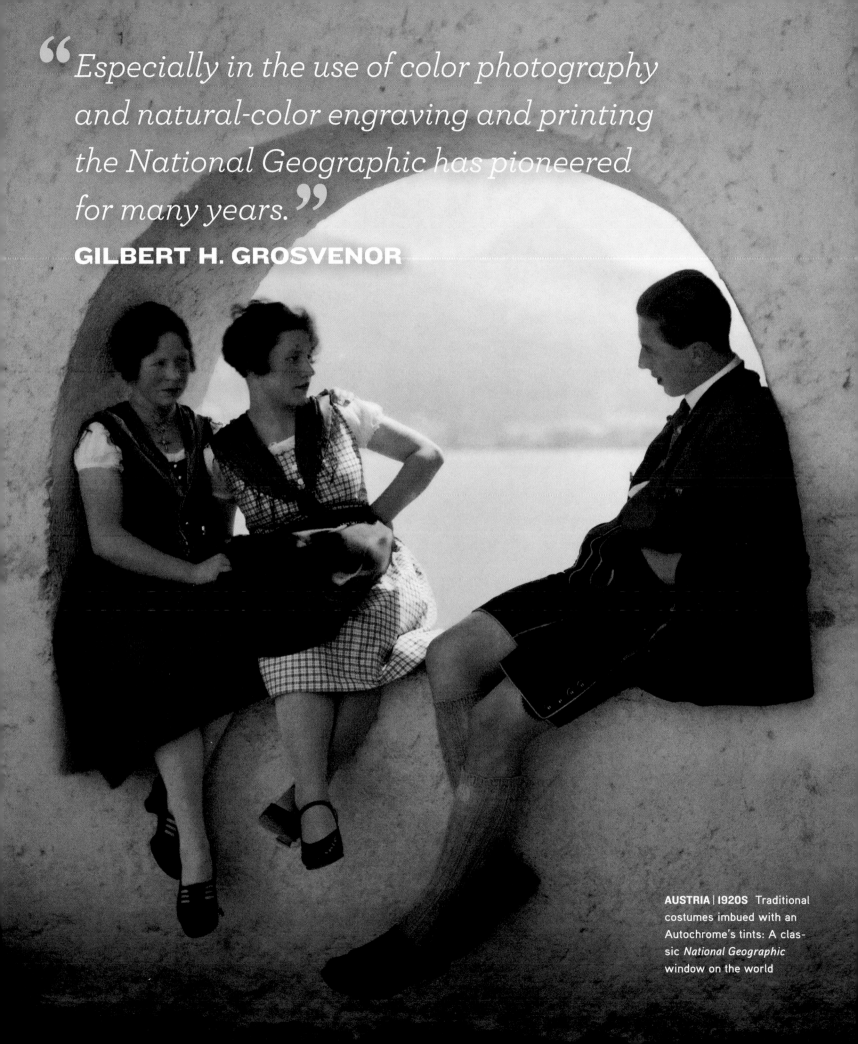

> *Especially in the use of color photography and natural-color engraving and printing the National Geographic has pioneered for many years.*
>
> **GILBERT H. GROSVENOR**

AUSTRIA | 1920S Traditional costumes imbued with an Autochrome's tints: A classic *National Geographic* window on the world

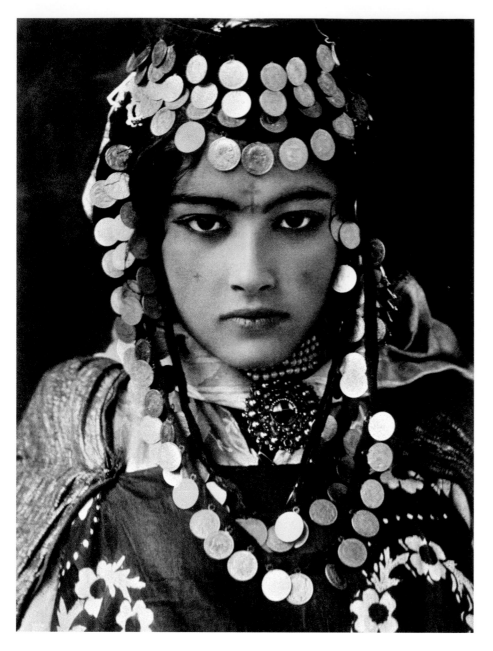

ALGERIA | EARLY 20TH CENTURY A girl of the Ouled Naïl tribe, famous as belly dancers, wears her dowry of gold coins.

One such artist was Jules Gervais-Courtellemont. The French writer, explorer, and photographer had such a passion for the Middle East that he eventually converted to Islam. But the hundreds of Autochromes he transmitted not only depicted a sun-splashed North Africa but also an undulating French countryside, an immemorial Spain, and further exotic scenes from as far afield as India and Indochina. Another contributor was Hans Hildenbrand, whose color plates evoked "rainbow hues from Hungary" or that dreamlike "Grimm's Fairyland" of gingerbread houses, gabled towns, and sturdy peasants that could have been set anywhere between the Black Forest and the Balkans. Wilhelm Tobien also depicted German scenes while Gustav Heurlin, the Swedish court photographer, supplied illustrations of Scandinavia.

Franklin Price Knott had been a painter of miniatures who, when his eyesight began failing, sought a creative outlet in a new color medium. In 1927 he embarked on a 40,000-mile tour of the Orient, making hundreds of Autochromes along the way, including the first color pictures of the court of Kashmir. Well past the age of 70, Knott waded ashore on Bali and reported that he had discovered a paradise of coconut groves, volcanoes, and beautiful women unclad from the waist up. "The quest for photographic adventure along these island paths," he enthused, "past green fields, temples, and walled villages, is an endless delight."

DREAMING OF ADVENTURE

Novelist Joseph Conrad may have been the biggest literary lion Grosvenor ever netted, and it was the author of *Heart of Darkness* who, in the March 1924 *Geographic,* pointed out that the secret of geography's appeal was that "sedentary people . . . like to dream of arduous adventure in the manner of prisoners dreaming behind their bars of all the hardships and hazards of liberty."

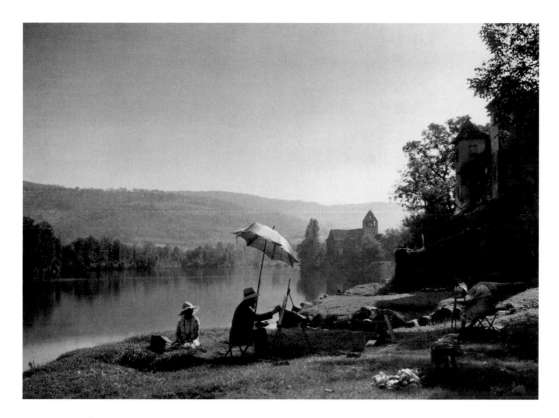

FRANCE | EARLY 20TH CENTURY An elegiac afternoon along the banks of the Dordogne River

At a time when the magazine's color plates were still just islands in a sea of black and white words, those words were often first-person accounts of "arduous adventure" or—especially among those with inherited titles or diplomatic cover—of the perils of adventurous living.

There was nothing everyday, for instance, about "Every-Day Life in Afghanistan," published in the January 1921 *Geographic*. It was purportedly based on the "secret notes" made by a European who had penetrated the closed kingdom in mufti under the assumed name of Haji Mirza Hussein. But his real name was Capt. Oskar von Niedermeyer, "one of Germany's shrewdest secret agents in all the East," in ex-diplomat Frederick Simpich's words, and during World War I he had slipped into Afghanistan to persuade the Emir to renounce neutrality and incite uprisings along the frontiers of British India.

In September 1931's "Sailing Forbidden Coasts," the American expatriate writer Ida Treat introduced *Geographic* readers to the swashbuckling Henri de Monfreid—a gunrunner, hashish smuggler, and romantic adventurer whose exploits in the Red Sea had captivated his native France. In December 1939 Baroness Irina Ungern-Sternberg told readers about her ancestral home, Estonia, without once mentioning that her brother was the infamous and bloody "Mad Baron" of Mongolia—a tyrant who, during the Russian Civil War, had hoped to establish a monarchist *and* Buddhist empire stretching from Europe to China.

Two documentary filmmakers, Merian C. Cooper and Ernest B. Schoedsack, contributed a pair of articles on Siamese and Sudanese peoples before moving on to produce,

✳ FREDERICK SIMPICH

On the first day he reported to work at the Geographic in 1927, Frederick Simpich changed its atmosphere. Merely by kindling a cigar, he broke a long-standing ban on smoking at headquarters. But the former diplomat and ex-Philippines rover soon lightened as well as clouded the air, for his craggy face was always set in a devilish grin. A man who saw things "eye-high and close up," he wrote 89 stories for the magazine. That number may never be matched.

ABOVE: Fred Simpich writes while flying in a Royal Canadian Air Force bomber. He was also known to travel by submarine—and once shared a tank with General Patton.

HOLLYWOOD | 1981 The intrepid archaeologist Indiana Jones (Harrison Ford) gazes upon a golden idol in his cinematic debut, the blockbuster *Raiders of the Lost Ark*.

HERGÉ
THE ADVENTURES OF
TINTIN
AND THE
PICAROS
EGMONT

✚ **RIGHTING WRONGS IN THE JUNGLE**

The 21st and last tale in the Adventures of Tintin series, "Tintin and the Picaros" sees the dauntless young hero, along with Captain Haddock and Professor Calculus, journey to South America to battle a military dictatorship.

What do Tintin and Captain Haddock have in common with Scrooge McDuck? Their creators were often inspired by reading old *National Geographic* magazines. Georges Prosper Remi, better known as Hergé, began his Adventures of Tintin series in 1929, and many episodes—*Tintin in Tibet* and *Tintin and the Temple of the Sun* among them—were drawn from the magazine whose authority he never questioned. Carl Barks gave birth to the miser of Duckdom just after World War II and soon was taking him on journeys as far afield as Howdoyoustan, using tales from the magazine to cook up plots such as "Pirate Gold," "Tra La La," "Land Beneath the Ground," "The Terries and Fermies," and "Ghost of the Grotto." Indiana Jones? Though many people see parallels between the intrepid archaeologist and *Geographic* contributors such as Hiram Bingham and Roy Chapman Andrews, Indy more likely springs straight from the pulps—a character *truly* out of fiction. ◾

write, and direct the 1933 cinema classic *King Kong*. Douglas Burden described actual giant monitor lizards—and incidentally debuted a new name—in an August 1927 article on "Komodo Dragons." A decade later, Lady Vera Broughton published her tale of collecting Komodo dragons in the September 1936 *Geographic*. She was not only a big-game hunter but—rumor had it—someone who had sampled human flesh in Borneo.

DRINKING CELESTIAL KOUMISS

That adventuresome spirit permeated the pages of the magazine. In an era of proudly trumpeted "firsts"—the first "natural color" pictures made in various parts of the world, the first made from the air, the first beneath the sea—even technical achievements were imbued with adventure. In 1924, as one team made the first underground color photographs in New Mexico's Carlsbad Caverns, they glanced nervously at needle-sharp formations hanging above them—for they had seen where one stalactite, weighing an estimated 100,000 tons, had already crashed to the floor.

In 1930, when the first color photographs were made from the air—it helped that the shooting platform was a relatively stable dirigible—they were not exposed on Autochrome plates. The marginally faster, if grainier, Finlay plates were used instead. Grosvenor tried every new color process that cropped up, and before the end of the decade had found what he was seeking—although it was the younger men on the staff who first claimed that the tiny, postage stamp–size transparency called

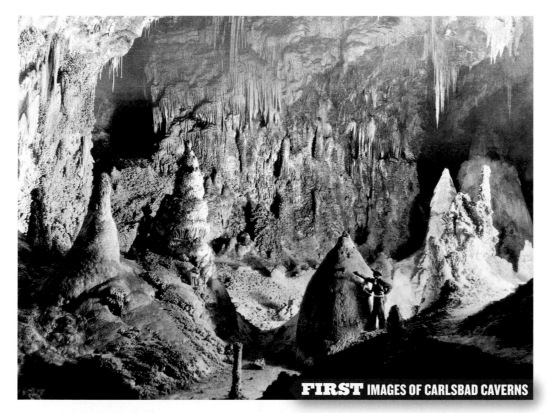

FIRST IMAGES OF CARLSBAD CAVERNS

NEW MEXICO | 1924 A wilderness of dripstone and flowstone, Doh's Kiva, named for an Apache legend, is a central feature of the Big Room at Carlsbad Caverns.

✳ DELICIOUS SATIRE

Becoming a "national institution" exposed *National Geographic* to the merciless satirists at the early *New Yorker*. A typical cartoon might show a cannibal's cauldron bubbling away in some remote glade, with a punch line from the locals tending it—or, to better comic effect, from the blundering explorers who were the pot's contents. And sometimes, as here, a drawing's impact hinged on role reversal for hunted prey.

ABOVE: Deep-sea explorer William Beebe might have left the bathysphere's hatch unlatched. *New Yorker*, 1934.

⚙ A COLORFUL TRICK

Red shirts, red scarves, red sweaters—early color photographers often carried extras with them, for red was supposed to make other hues pop. Hence the disparaging term: "red shirt school of photography."

Kodachrome, released in 1936, offered the fastest and most saturated color that had yet appeared. After they loaded portable 35-mm cameras like the German-made Leica with Kodachrome film and began taking action pictures in color, the magazine abandoned its Autochromes and Finlay plates and wholeheartedly embraced the new format—years before the rest of the publishing industry joined the trend.

Meanwhile, the magazine's literary side continued appealing to the armchair escapist. Roy Chapman Andrews's "Explorations in the Gobi Desert" took up most of the June 1933 issue. But more quixotic getaways were equally the stuff of the *Geographic*. G. E. P. Collins built his own Malay prau and drifted beneath star-flecked tropic nights. Aimé Tschiffely carried readers on a 9,600-mile horseback journey from Buenos Aires to Washington, D.C. The sexagenarian botanist Isobel Wylie Hutchison strapped on her sturdy shoes, straightened her tam-o'-shanter, and strolled across Scotland. Edward Stevenson Murray's summer idyll in the yurts of Central Asia's Celestial Mountains, with its endless rounds of koumiss drinking, ranks among the most delightful of *Geographic* travel narratives.

Revisiting Merlin Minshall's "By Sail Across Europe," published in May 1937, leaves the reader with only the tale of a honeymoon cruise across the canals of northern France to the Danube. The unwritten backstory was far more colorful: After his wife left Minshall midstream, a beautiful German agent appeared; assuming that he was a British spy, she tried to kill him. Perhaps she was right: Minshall worked for Ian Fleming during World War II and reportedly inspired certain character traits of the latter's fictional James Bond. ■

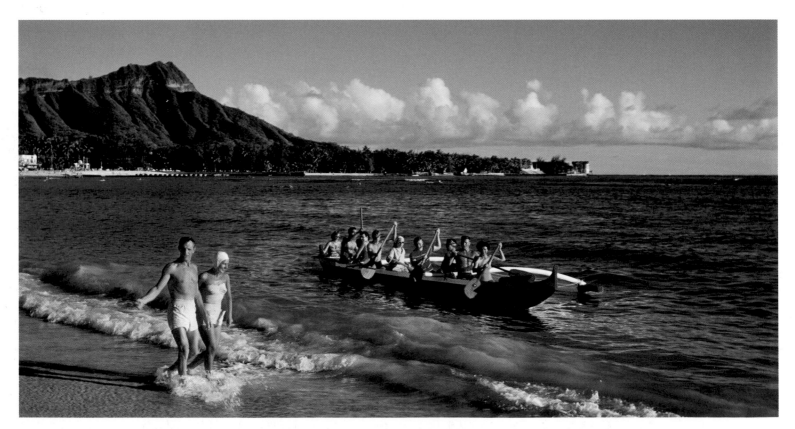

HAWAII | 1953 Banked clouds kept far out to sea in the sun-splashed pages of the 1950s *Geographic*.

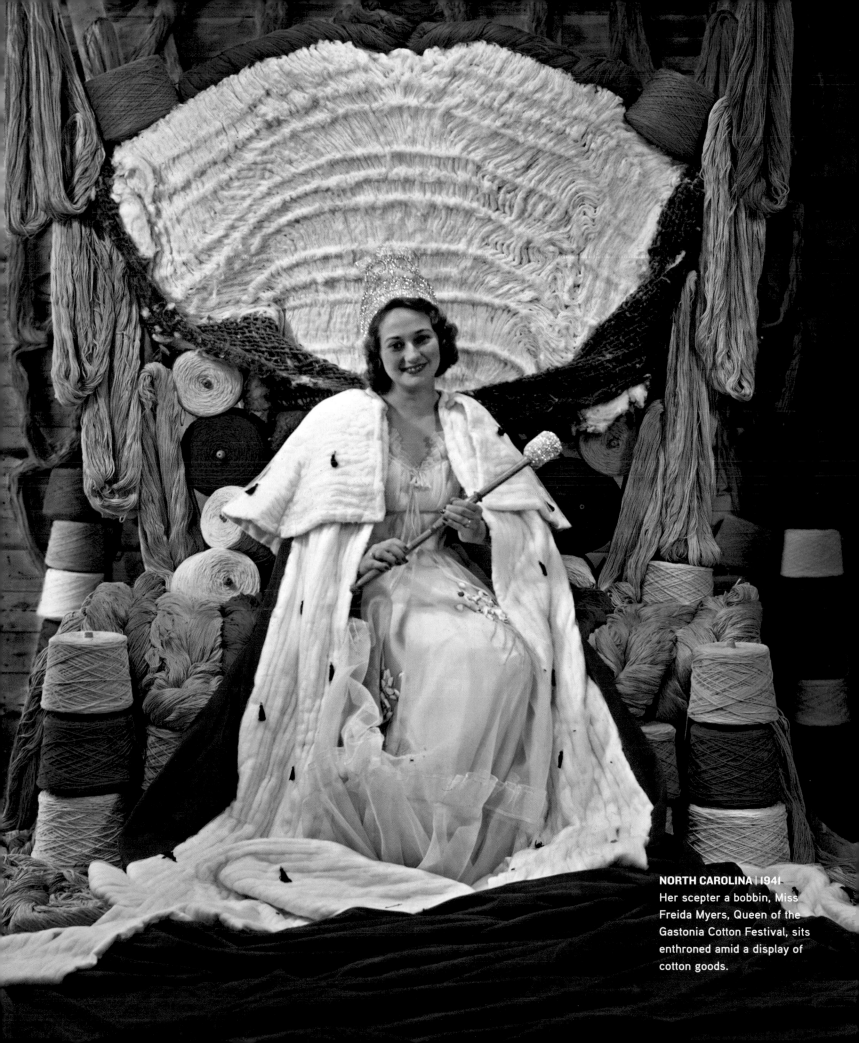

NORTH CAROLINA | 1941
Her scepter a bobbin, Miss
Freida Myers, Queen of the
Gastonia Cotton Festival, sits
enthroned amid a display of
cotton goods.

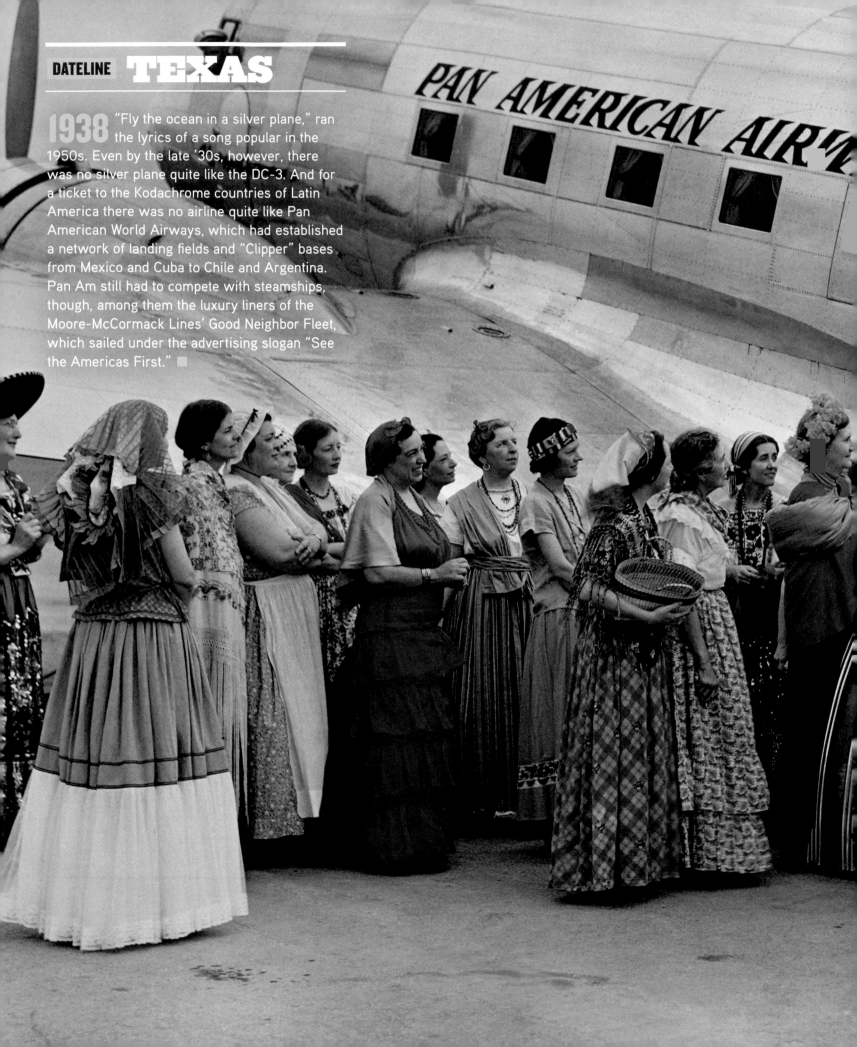

1938 "Fly the ocean in a silver plane," ran the lyrics of a song popular in the 1950s. Even by the late '30s, however, there was no silver plane quite like the DC-3. And for a ticket to the Kodachrome countries of Latin America there was no airline quite like Pan American World Airways, which had established a network of landing fields and "Clipper" bases from Mexico and Cuba to Chile and Argentina. Pan Am still had to compete with steamships, though, among them the luxury liners of the Moore-McCormack Lines' Good Neighbor Fleet, which sailed under the advertising slogan "See the Americas First." ■

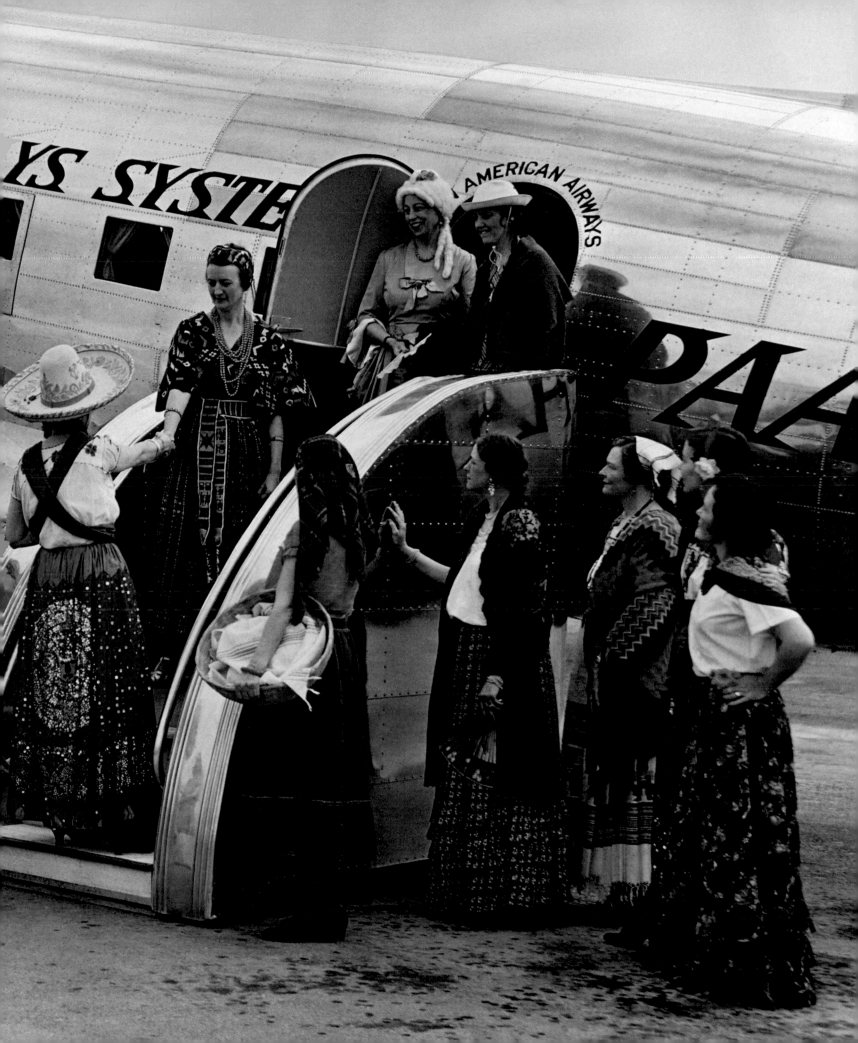

GEOGRAPHIC MEN

To bring back the right stories and illustrations, the Society dispatched its own staff writers and photographers around the globe. Many became legends of the breed.

⚙ CAPTION BOOKS

They shot all day while the light lasted, but when dusk fell the photographer's day was still not done. There was gear to clean and caption books to complete. A photographer was required to keep captions for every roll shot on assignment. Yet to err is human. One perhaps apocryphal story had dozens of rolls, taken between France and Bulgaria, showing up captioned with a single word: "Europe."

I n December 1953, as they shadowed newly crowned Queen Elizabeth II's royal progress around the British Commonwealth, members of the world's press corps spent a night in a large tent in Fiji. The next morning, a *Life* magazine correspondent awoke, pushed back his mosquito netting, glanced around, and declared, "Well, here we are, all 21 of us—19 journalists and two gentlemen from the *Geographic*."

The two gentlemen in question, Luis Marden and Howell Walker, were indeed in journalism but not of it. Despite their pencils and notebooks and cameras, they were primarily card-carrying emissaries of a "non-partisan scientific and educational organization" that just happened to publish a very successful magazine. In truth, they belonged to the *Geographic*'s Foreign Editorial Staff, those men (for they were exclusively male) dexterous enough to write articles, take pictures, and make a 16-mm lecture film in faraway places. Such "triple threats" had to be linguistically adroit and culturally sophisticated, and though they often wandered about the world in first class, they did stray into the back of beyond. The debonair Walker once spent so much time in the remote outback that he sprouted a bushy beard, inviting predictable cracks from clean-shaven colleagues about a "Robinson Crusoe in Arnhem Land."

THE PIONEER

The idea for a Foreign Editorial Staff came from a big, smiling former missionary named Maynard Owen Williams, who had been hired in 1919 as the Society's first full-time correspondent. Williams suggested establishing a corps of staff writer-photographers who would not only gather magazine material abroad but also serve as the Geographic's "foreign service," representing its interests and spreading its good name around the globe.

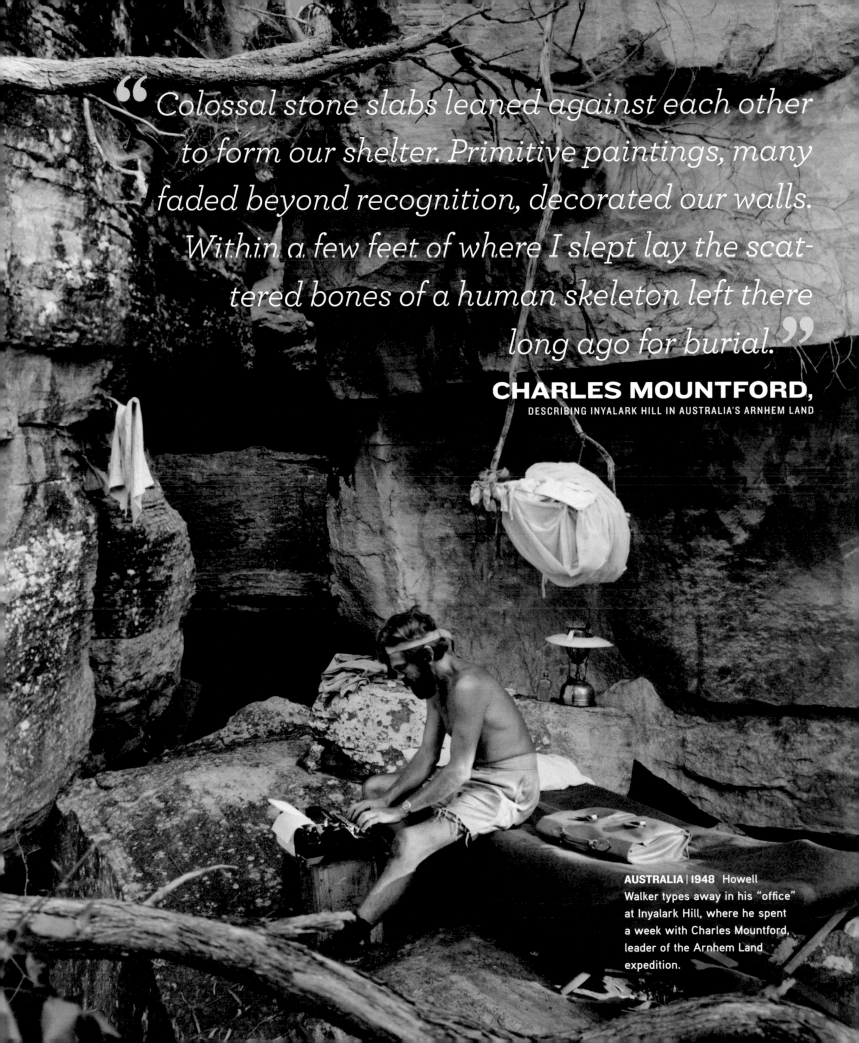

> "Colossal stone slabs leaned against each other to form our shelter. Primitive paintings, many faded beyond recognition, decorated our walls. Within a few feet of where I slept lay the scattered bones of a human skeleton left there long ago for burial."

CHARLES MOUNTFORD,
DESCRIBING INYALARK HILL IN AUSTRALIA'S ARNHEM LAND

AUSTRALIA | 1948 Howell Walker types away in his "office" at Inyalark Hill, where he spent a week with Charles Mountford, leader of the Arnhem Land expedition.

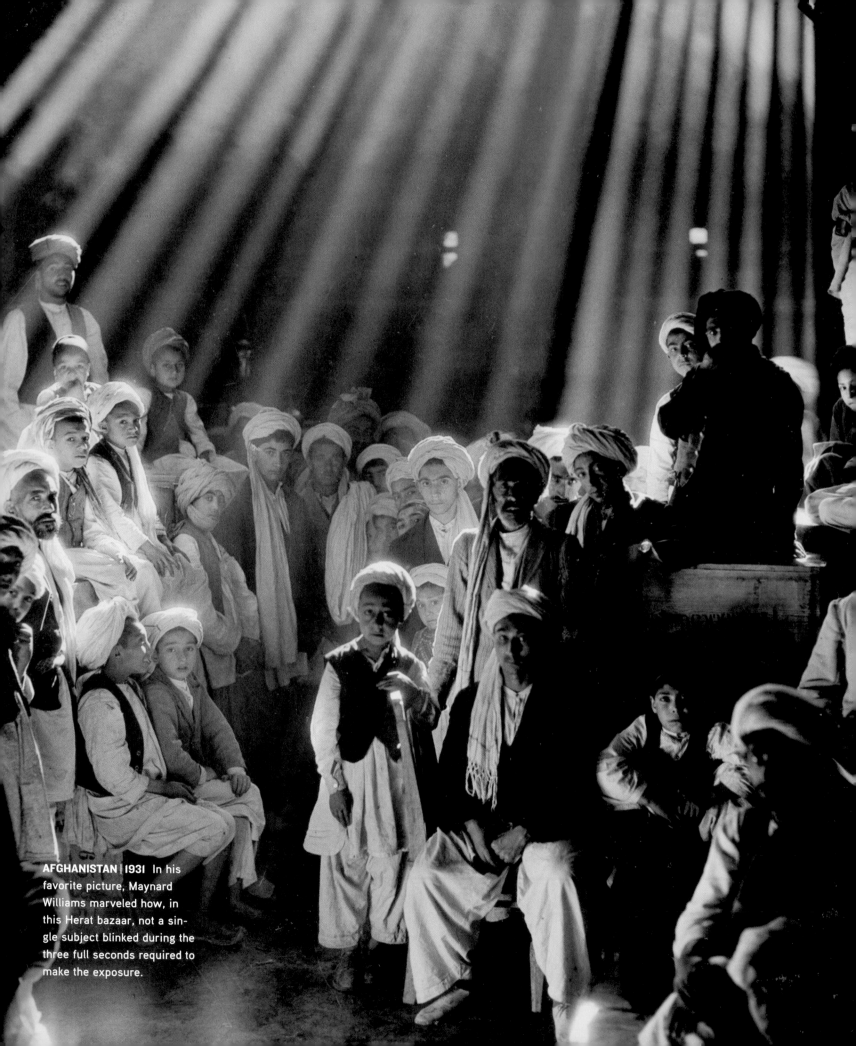

AFGHANISTAN | 1931 In his favorite picture, Maynard Williams marveled how, in this Herat bazaar, not a single subject blinked during the three full seconds required to make the exposure.

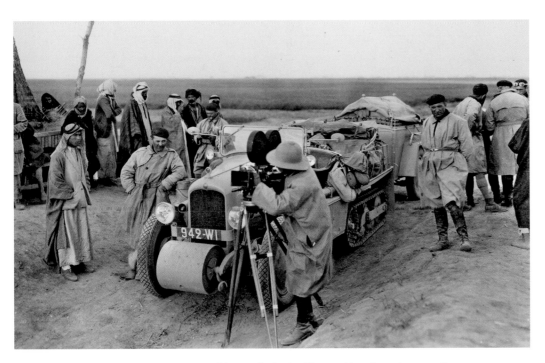

IRAQ | 1931 Sporting the expeditionary look, the Citroën-Haardt explorers roll across the Middle East with characteristically French panache.

Williams was nothing if not earnest. Throughout the 1920s he proved his point, filing stories from Europe to India while living in France, Syria, Turkey, and Greece. By 1931, when the Citroën-Haardt Trans-Asiatic Expedition was gearing up, he was the Society's natural choice to accompany it. Part Gallic éclat and part motor rally, the Citroën-Haardt expedition was led by a Belgian named Georges-Marie Haardt who had undertaken a similar odyssey down the length of Africa. Maynard, the only American in a largely French contingent, clambered aboard one of the custom-designed vehicles built by French automobile maker André Citroën and took his place alongside the archaeologists, naturalists, motion-picture cameramen, and mechanics. Departing Beirut in April 1931, they rolled east across the deserts of Syria and Iran before threading the mountains of Afghanistan. In China, however, they ran into a rebellion, forcing them to undertake a wild, bone-jarring, 2,000-mile run, dodging warlords and sandstorms and rarely stopping to sleep—the numerous walled towns often being crenellated by severed heads—until at long last, they rolled down the broad boulevards of Peking (today's Beijing). On February 12, 1932, the vehicles halted before the French legation. The dusty men had crossed Asia in 314 days.

In Peking Williams met a new colleague, W. Robert Moore, who had been the sole cameraman to shoot Autochromes at the 1930 coronation of Emperor Haile Selassie of Ethiopia, where, he would jokingly relate, he was the only person who could give the Lion of Judah a direct order and be instantly obeyed—for he had told him, "Hold still."

"DO INDIA"

Not every "Geographic man" who snapped pictures was on the Foreign Editorial

⚙ A GEOGRAPHIC WORKHORSE

They called it "belly-button photography": Shooting with a twin-lens reflex camera like the Rolleiflex compelled the photographer to look straight down into the viewfinder. The medium-format workhorse, used mostly for black-and-white photography, was only one camera in the *National Geographic* kit before about 1960. The others were large-format, tripod-mounted Linhofs or Graflexes and the small 35-mm Leicas that photographers loaded almost exclusively with Kodachrome film.

ABOVE: A Rolleiflex twin-lens reflex medium-format camera

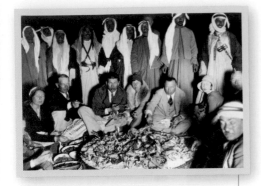

✳ DESERT NIGHT

A *mansaf*—a traditional Jordanian feast—was served to the *Geographic's* associate editor John Oliver La Gorce (left) and his friend, world heavyweight boxing champion Gene Tunney (center left), one desert night in 1931. To feed his dinner guests, Sheikh Majid Pasha el Adwan, who had known Lawrence of Arabia, had ten men bring in the six-foot-wide main dish. It brimmed with rice, gravy, the meat of five sheep, and—according to the squeamish Mrs. La Gorce (center)— their eyeballs as well.

Staff. Some used a pencil only to fill out expense accounts and caption cards, for they were exclusively cameramen. Jacob Gayer made Autochromes in the Arctic, Latin America, and the Caribbean. Clifton Adams unfolded tripods all over the United States, as well as in the British Isles, Mexico, and Haiti. And Edwin "Bud" Wisherd, who arrived in 1919 still wearing knickers and whose first job in the penthouse Photo Lab was to dry prints on cookie sheets in the sun, was soon carrying a 5x7 Ica Jewel and leading a mule burdened with 50 pounds of glass plates into the canyons and pueblos of the Southwest. By 1929 Wisherd had 90 of his pictures of Louisiana published in a single issue.

Joseph Baylor Roberts had taken some of history's first photographs in the Oval Office, driving President Calvin Coolidge from the room with the acrid smoke from his flash powder. Richard H. Stewart would be the Society's most dependable expedition photographer, often doubling as camp cook in backwoods Alaska or tropical Mexico. His younger brother, B. Anthony Stewart, eventually became the most prolific *National Geographic* photographer of his generation, having many more pictures published than accounted for by the mere 100 stories that carried his byline.

In 1946, given the terse command to "Do India," Volkmar Wentzel spent the better part of two years at the task. The native of Dresden, Germany, had joined the *Geographic* in 1937, and though assignments for the magazine would take him all over the world, his Indian odyssey—coming on the eve of that country's independence from the British—remained his lifelong favorite. Driving about in a surplus U.S.

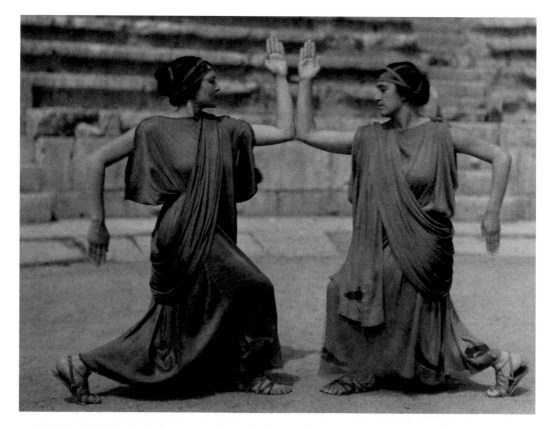

GREECE | 1930 A classical pose at the Delphi Festival as captured by Maynard Williams's camera

▲ **PARIS | 1936** "The eye ignores what it doesn't want to see," Williams wrote of this picture. "Here the camera reveals more than a man sees himself."

‹ **CHINA | 1932** Maynard Owen Williams seeks warmth in Sinkiang Province (today's Xinjiang Province) during the Citroën-Haardt Trans-Asiatic Expedition.

✛ **VITAL STATS**

97 bylined *National Geographic* articles as writer, photographer, or both

2,250 self-illustrated pages

34 years to the day on the Society's staff

"Ours is a job of courting friendship, not adventure," Maynard Owen Williams liked to say. And he performed that job with the happy zeal of the missionary he once had been. As the first person on the staff to visit a swath of countries stretching from the Mediterranean to the Far East, Williams practically opened the world for *National Geographic*. Son of a classics professor at Michigan's Kalamazoo College, Williams began his own career as a schoolteacher in Syria. There, while penning dispatches for the *Christian Herald*, he met a young English archaeologist named T. E. Lawrence—the future Lawrence of Arabia.

Hired in 1919, Williams wrote and photographed nearly 100 stories before his 1953 retirement. "Making raw material into the *Geographic* is one of the biggest jobs in America," he declared, believing it facilitated global understanding. While he courted friendship, he still remembered the Citroën-Haardt Trans-Asiatic Expedition as being "the greatest adventure of my life." ∎

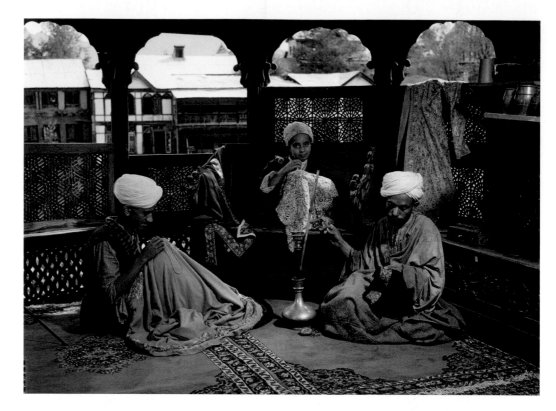

INDIA | 1947 Working on a balcony overlooking the Vale of Kashmir, turbaned silk weavers in Srinagar share a water pipe.

Army ambulance that he had converted into a rolling darkroom/bedroom—"National Geographic Society Photo-Survey Vehicle" emblazoned in English, Hindi, and Urdu on its side—Wentzel wandered from Kashmir to Coromandel. Gates opened for him everywhere. He photographed the fading splendor of princely palaces, the sculptures and frescoes of the Ellora and Ajanta temples, and finally the end of the British Raj as Governor-General Mountbatten ceremonially handed over power to his Indian successor, Chakravarti Rajagopalachari.

"INTREPIDEST" EXPLORERS

Wentzel was one of the young men who began their *Geographic* careers by coming up through the Photo Lab, where many of the globe-trotting lensmen got their start, mixing chemicals in earthenware crocks.

Howell Walker followed a different path. The Princeton man didn't just stroll in after graduation and nab the job, though. He was told to go away and gain some experience. So he spent the next three years traveling around the world and sending pictures back to the *Geographic*. The editors apparently liked the results, for Walker came aboard in 1936. Eventually he was made the magazine's "Australia man," and during the 1948 Arnhem Land expedition—the one that unleashed the bushy beard—he went walkabout not once but twice. "I feel genuinely sorry and not a little sheepish about the reported-missing incidents," Walker wrote the home office, explaining

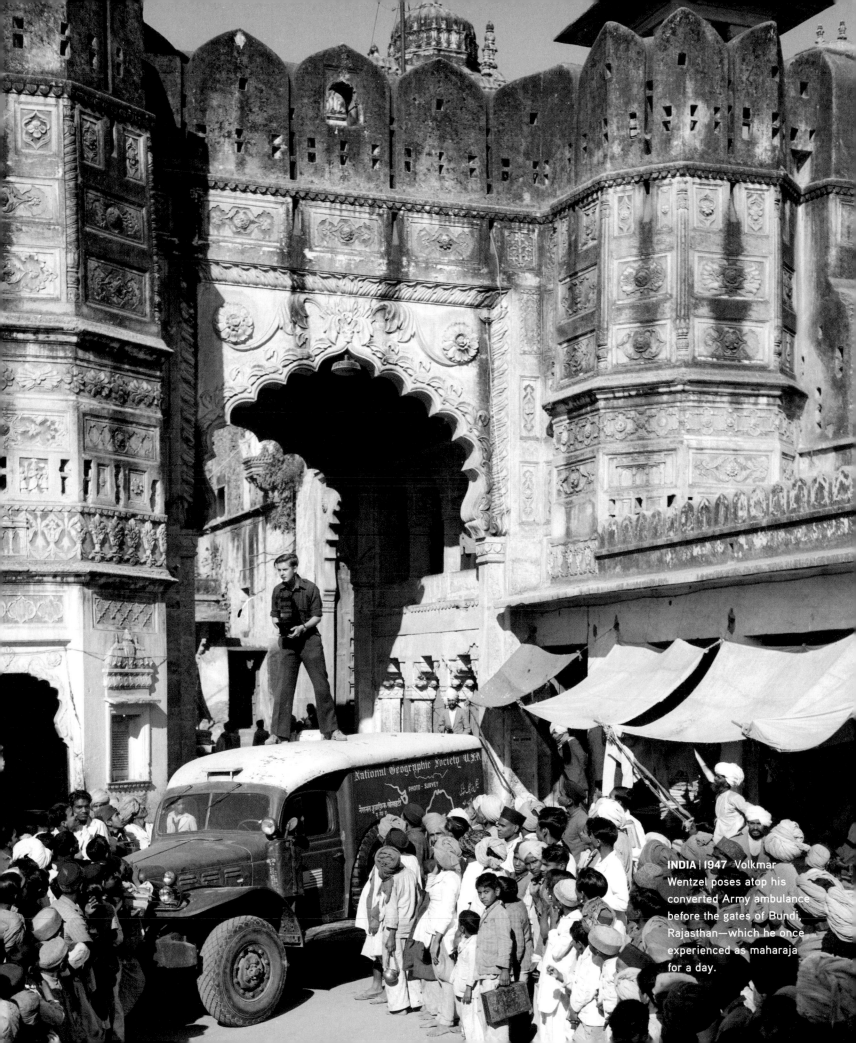

INDIA | 1947 Volkmar Wentzel poses atop his converted Army ambulance before the gates of Bundi, Rajasthan—which he once experienced as maharaja for a day.

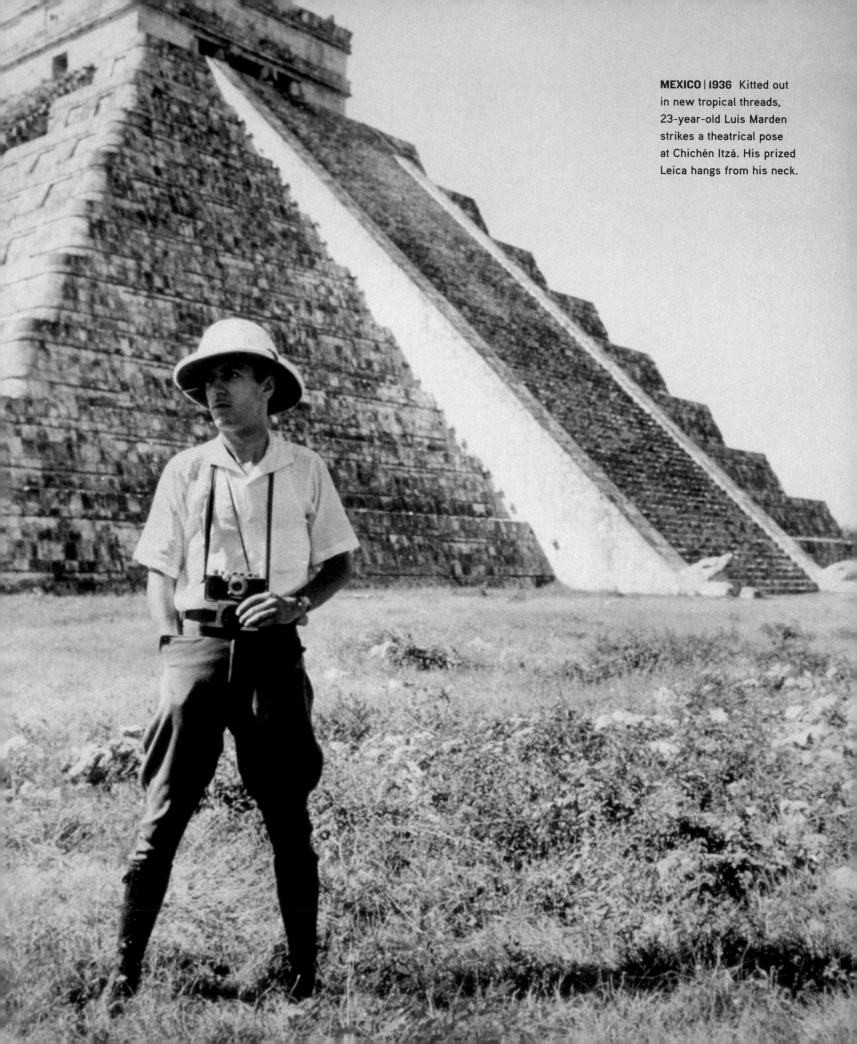

MEXICO | 1936 Kitted out in new tropical threads, 23-year-old Luis Marden strikes a theatrical pose at Chichén Itzá. His prized Leica hangs from his neck.

how for weeks he had been marooned on a stranded freighter before holing up in a remote cove to wait out storms. Nevertheless, because he had gone missing two times compared with Luis Marden's single disappearance, he was dubbed the Society's "intrepidest" explorer.

Marden would have made his characteristic bow, though his describing Walker in Chaucerian terms as the Society's "parfit gentil Knight" displayed only one aspect of his many-sided mind. A Society stalwart for half a century, Marden in turn would come to be called the "epitome" of the *National Geographic* man. His interests ranged from aeronautics—he was a pilot—to undersea exploration, for he was also a pioneering scuba diver. He routinely returned from assignments with some newly discovered orchids or a previously unknown sea flea. And his circle of acquaintances included Jacques Cousteau, science-fiction writer Arthur C. Clarke, and architect Frank Lloyd Wright, who designed a house that Marden promptly filled with books and the finest *grand cru* Burgundies.

Hired in 1934 at the age of 23—he had already written one of the first guides to 35-mm color photography—Marden, too, started out in the Photo Lab, where he quickly pushed the use of Kodachrome. Because Spanish was one of his six languages, he was soon dispatched to Latin America, where one day he ordered a pair of trousers made in Buenos Aires—insisting, however, they include one modern convenience. He was later told he had thereby introduced the zipper to Argentina. ■

⚙ HOT BLOOD, COOL HAT

"'The Aura.' Prevents Sunstroke. Made in London for Abercrombie and Fitch." Luis Marden's pith helmet—sometimes called a sun helmet or a topee—reflects the once prevalent belief that exposure to the tropical sun might inflict all manner of maladies on people of European descent. The alleged impairments ranged from sunstroke to liver complaints to nervous disorders—and ultimately, perhaps, to unbridled sensuality.

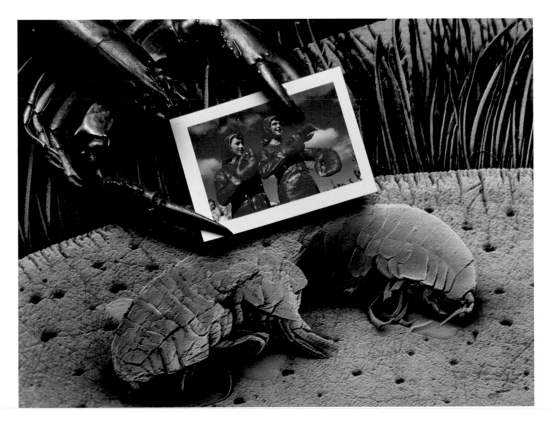

MAINE | 1952 *Dolobrotus mardeni*, a sea flea that Marden discovered in lobsters, appears via a scanning electron microscope—with an antic picture from a 1952 Maine lobsterfest.

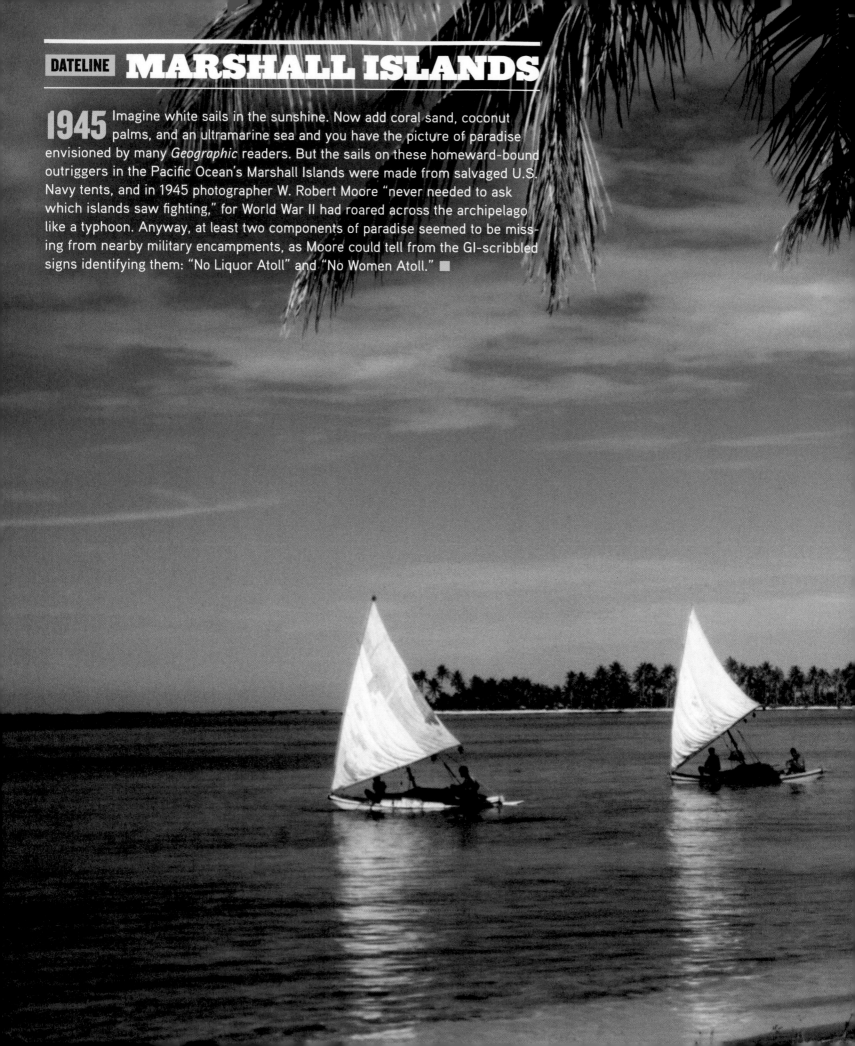

1945 Imagine white sails in the sunshine. Now add coral sand, coconut palms, and an ultramarine sea and you have the picture of paradise envisioned by many *Geographic* readers. But the sails on these homeward-bound outriggers in the Pacific Ocean's Marshall Islands were made from salvaged U.S. Navy tents, and in 1945 photographer W. Robert Moore "never needed to ask which islands saw fighting," for World War II had roared across the archipelago like a typhoon. Anyway, at least two components of paradise seemed to be missing from nearby military encampments, as Moore could tell from the GI-scribbled signs identifying them: "No Liquor Atoll" and "No Women Atoll." ■

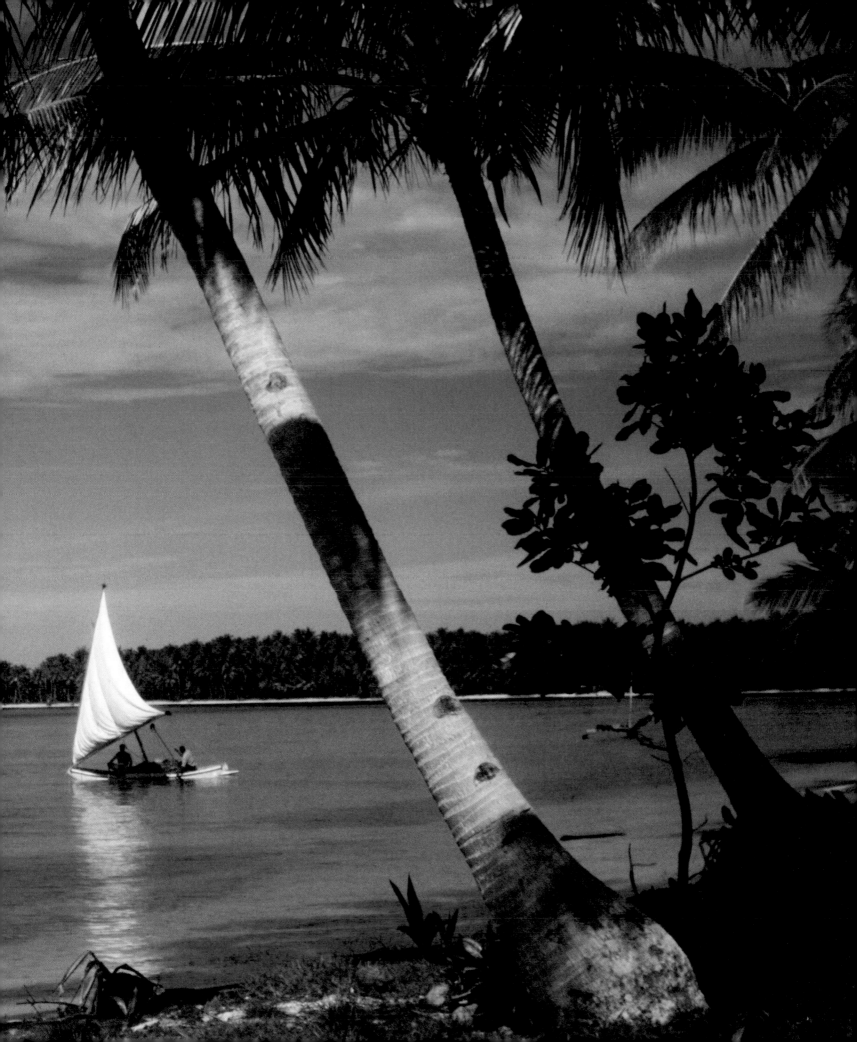

OUR MEN IN CHINA

Few places on Earth were more exotic to the average American than the turbulent China of the early 20th century. Fewer places still claimed as much real estate in the pages of the *Geographic*.

✱ HAIR TO SPARE

A century ago "The Hairnet Industry in North China," according to H. W. Robinson, supplied the gossamer webs holding millions of Western coiffures securely in place. Because it had the most heads—many of which sported queues that reached to the feet—China had hair to spare.

ABOVE: A barber braids a Manchu queue.

As every American child knew, the fastest way to get to China was to dig straight down. If you dug far enough, you wouldn't have to worry about the long ocean voyage. You would emerge in a land where everything was topsy-turvy, a land, as you might have read in the *Geographic,* where the printed page ran from right to left rather than left to right; where the groom and not the bride was celebrated at weddings; where a woman's beauty was in her feet, not in her face; and where women wore pants and men long gowns, their hair braided in flowing pigtails.

It must have been an irresistibly fascinating place, judging from the number of articles *National Geographic* published on it—more than 100 of them in the first half of the 20th century alone. But that superlative output wasn't solely because Americans liked to gaze at pictures of pagodas and camelback bridges and the fabulous serpentine Great Wall. It was also because China was where the action was—a land convulsed by civil wars and rampaging bandit armies, a beautiful, alluring, dangerous, and romantic country for people fond of vicarious adventure.

A PISTOL-PACKIN' BOTANIST

No one strode the eastern stage for *National Geographic* readers with quite the flourish of Joseph Rock. Plant hunters were known to be a rugged breed, and the Viennese-born Rock ventured into the mountains of Yunnan and Sichuan Provinces and across the dizzying gorges of the upper Mekong, Salween, and Yangtze Rivers. He not only collected the rich but little-known flora he found there; he also wrote spellbindingly about the many tribes dwelling in those unmapped regions. And because he was an excellent photographer, warming his developer over yak-dung campfires, Joseph Rock was the right man for the *Geographic* in the right part of the world at that time.

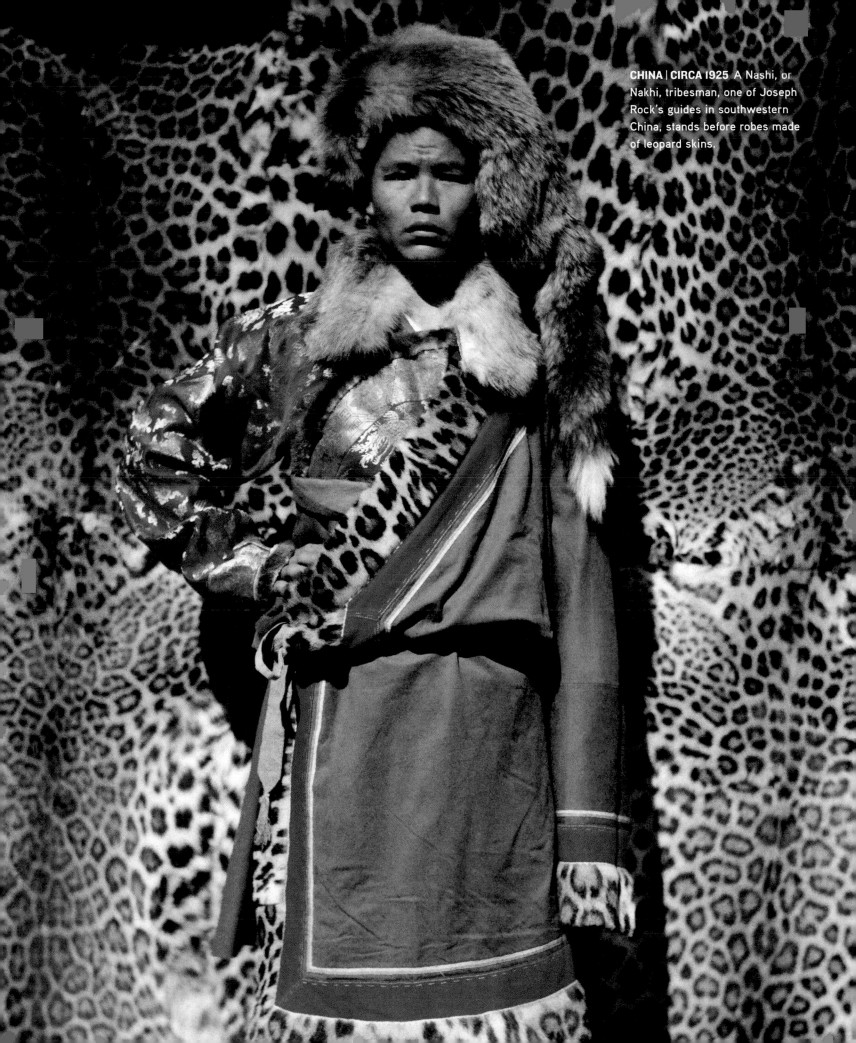

CHINA | CIRCA 1925 A Nashi, or Nakhi, tribesman, one of Joseph Rock's guides in southwestern China, stands before robes made of leopard skins.

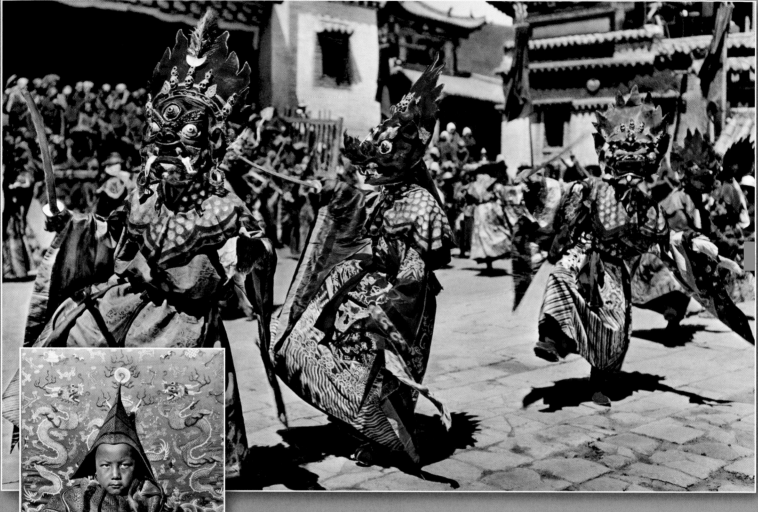

▲ CHINA | 1926 Demons parade across Chone's courtyard. From the mouth of Balden Lhamo (left), source of all diseases, dangles the corpse of her son.
◄ CHINA | 1926 The Living Buddha of Guya, only six years old, ruled a monastery not far from Chone.

✚ LIVING BUDDHAS

During his Chinese travels, Joseph Rock encountered at least three children ruling over Buddhist lamaseries. These "Living Buddhas"—the one at Guya (above) being six years old, the one at Labrang ten, and the spiritual head of Chone only four— were believed to be reincarnations of former lamas.

The only travelers to have reached it are those in James Hilton's 1933 novel *Lost Horizon*. But that hasn't dissuaded numerous attempts to locate a real-world valley that corresponds to Hilton's fictional Himalayan utopia. Tantalizingly, the author might have been inspired by reading Joseph Rock's articles in *National Geographic*; indeed, Shangri-La may be based on Rock's portrait of the little kingdom of Muli in far western China.

The ethnically Tibetan tribes of the area did dwell in a secluded, almost medieval world of their own, far from Peking (today's Beijing). And Muli was ruled by a lama who might have stepped out of Kipling's *Man Who Would Be King*, if not *Lost Horizon*. But whether or not it was Muli—or better yet, Chone, a lamasery to the north in Gansu Province—Rock knew how to ingratiate himself with local princes and lamas. He would arrive garbed in a coat and tie and riding in

a sedan chair. He would be generous with gifts, including a choice Colt .45 or two, complete with ammunition.

In return, he gained access to rites and ceremonies seldom witnessed (much less photographed) by Westerners. The reigning prince at Chone, where Rock made his headquarters for two years, arranged for the writer to meet the ten-year-old Great Living Buddha of Labrang, who ranked third in the Tibetan spiritual hierarchy behind the Dalai Lama and Panchen Lama. The prince also ordered the Chone monks to pose for Rock's camera at festival times.

As a result, readers who opened their November 1928 *Geographic* gazed upon a bizarre panoply of demon dancers and yak-butter idols. How could they know that this unearthly world would soon lie in ruins, plundered by a renegade army in one of China's interminable civil wars? ■

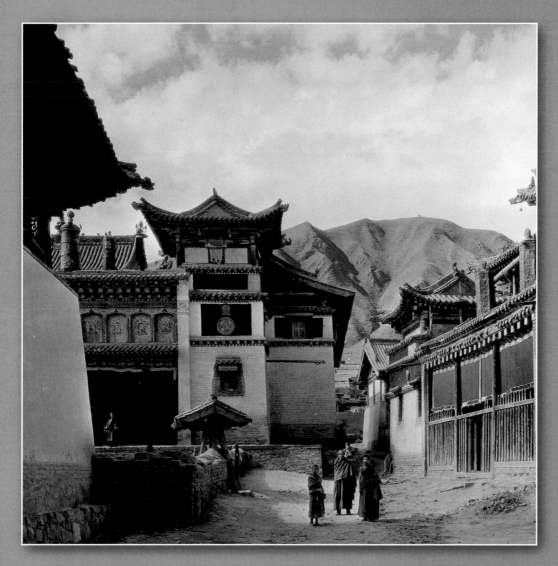

CHINA | 1926 Chone Lamasery comprised 10 chanting halls and 172 other buildings—some of them 600 years old.

ROCK'S TRAVELS IN CHINA

▶ **GANSU:**
Rock spent two years at the Chone Lamasery while striving to reach Tibet's A'nyêmaqen Shan (Amne Machin Range).

▶ **SICHUAN:**
Rock visited the tiny kingdom of Muli and declared Gongga Shan (Minya Konka) to be higher than Everest.

▶ **YUNNAN:**
Rock's headquarters, when he wasn't on the rove, were near Lijiang.

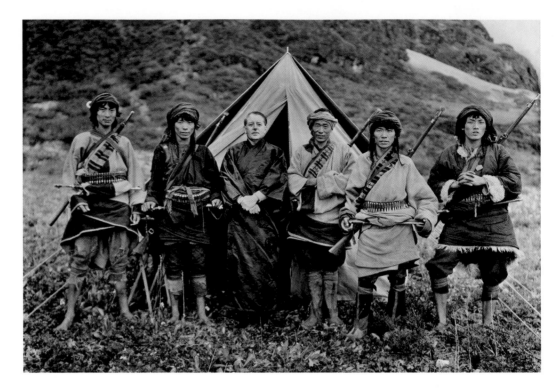

CHINA | 1920S Our man in China: Joseph Rock and his bandit escort pose for his camera in the Konkaling Mountains of Sichuan Province.

Danger seemed to stalk him. As civil war and rebellion roiled China, unpaid troops lapsed into bandit hordes, menacing his caravans. In Gansu Province, Muslims and Tibetans committed such atrocities on each other that the pistol-packing botanist had to weave a careful line between them. In Sichuan's Konkaling Mountains he deliberately entered a brigands' stronghold, making friends with the chief himself.

Rock could be aloof, touchy, and temperamental, once complaining that his was the "most comfortless, disreputable, miserable existence" imaginable. Even in the remotest backcountry, he habitually insulated himself against all things Chinese—scrubbing germs off in an Abercrombie and Fitch folding bathtub, eating Viennese-style meals rather than local fare, listening to German operas on a portable phonograph—yet he could never leave the land for long. His ten articles for the *Geographic*

NG DISCOVERS **FROM THE COLLECTION OF JOSEPH ROCK**

A Tibetan horse harness ▼ A Tibetan yak-hide boot ▶

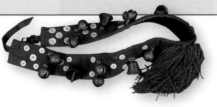

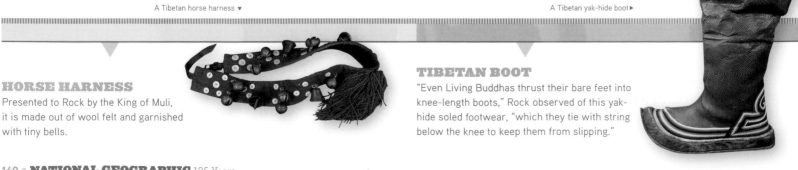

HORSE HARNESS
Presented to Rock by the King of Muli, it is made out of wool felt and garnished with tiny bells.

TIBETAN BOOT
"Even Living Buddhas thrust their bare feet into knee-length boots," Rock observed of this yak-hide soled footwear, "which they tie with string below the knee to keep them from slipping."

WHEN IN KASHGAR...

Rock's temperamental opposite was Owen Lattimore, a young scholar and adventurer who, when he decided to travel among the Chinese, plunged in wholeheartedly—"going native." Though born in Washington, D.C., Lattimore grew up in China, where his father was a teacher. By 1926, fascinated by the sight of camels plodding down the Silk Road, he decided to join one of the caravans. He did so as a Chinese caravaneer, wearing the same clothes, speaking the same tongue, eating the same food, and sleeping among the same bedbugs. It was a story richly told in "The Desert Road to Turkestan," appearing in the June 1929 *Geographic;* a story capped by a description of the idyllic honeymoon he and his bride shared among the nomadic tribes and snow-clad mountains of China's far west.

Lattimore next surfaced in China's northeastern province "not only to see and hear about, but to live among, the events of Manchuria"—then a flashpoint among China, Russia, and Japan. He spent a year living with the remaining indigenous tribes there, relating his encounters with Mongol frontiersmen, cigarette-smoking Manchu infants, and "Fishskin" Tatar shamans for *Geographic* readers. Even during World War II, after President Franklin D. Roosevelt had appointed him a special adviser to Gen. Chiang Kai-shek, Lattimore remained a contributor. In 1949, however, Lattimore, Rock, and almost all Westerners were ousted from China by Mao Zedong's victorious Communist army. Decades passed before *National Geographic* could return. ■

CHINA | 1931 Nominally Chinese, Manchuria was fought over by Russia, Japan, and China until after World War II.

A porcelain vase collected by Rock ▶

One well-traveled envelope ▶

PORCELAIN VASE

Perhaps dating from the Ming dynasty reign of the Chenghua emperor (1465–1488), this vase came from the Kopati monastery.

ENVELOPE

Rock was a prolific correspondent, sending sheaves of closely spaced, handwritten letters to Society headquarters. In them he detailed his ongoing ordeal in the no-man's-land that was 1920s China.

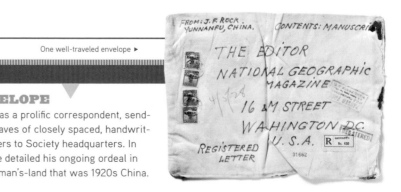

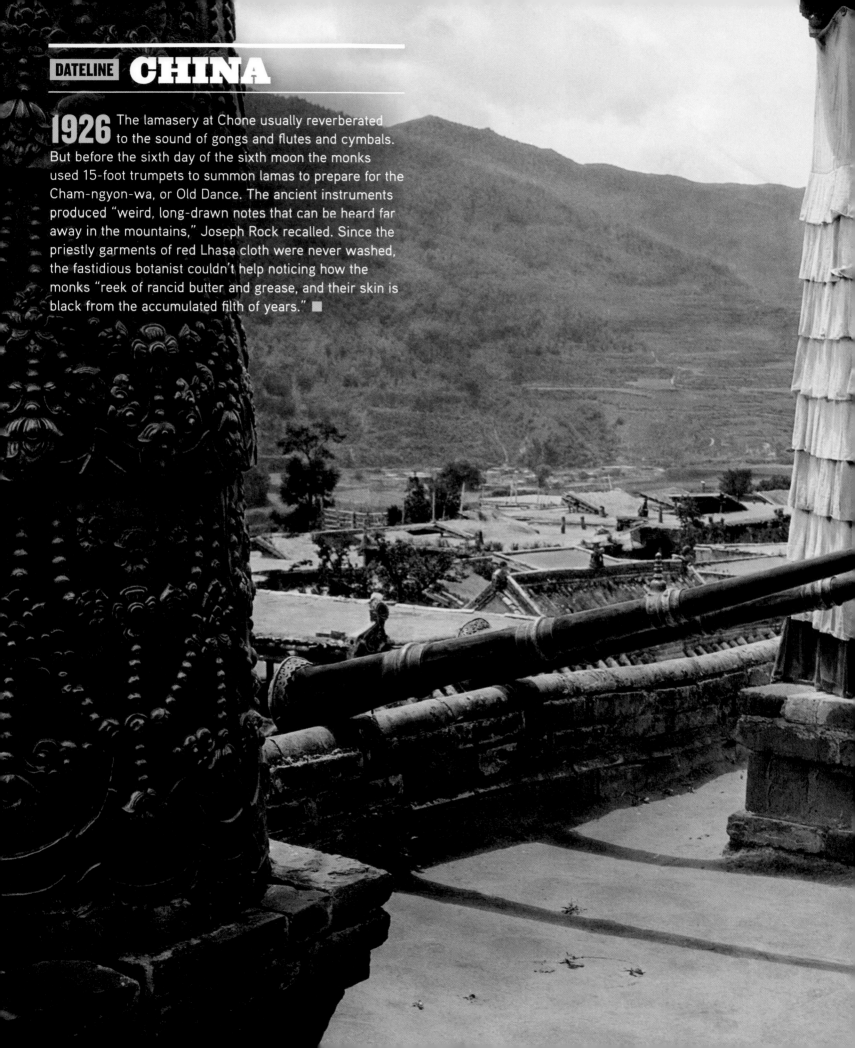

1926 The lamasery at Chone usually reverberated to the sound of gongs and flutes and cymbals. But before the sixth day of the sixth moon the monks used 15-foot trumpets to summon lamas to prepare for the Cham-ngyon-wa, or Old Dance. The ancient instruments produced "weird, long-drawn notes that can be heard far away in the mountains," Joseph Rock recalled. Since the priestly garments of red Lhasa cloth were never washed, the fastidious botanist couldn't help noticing how the monks "reek of rancid butter and grease, and their skin is black from the accumulated filth of years." ■

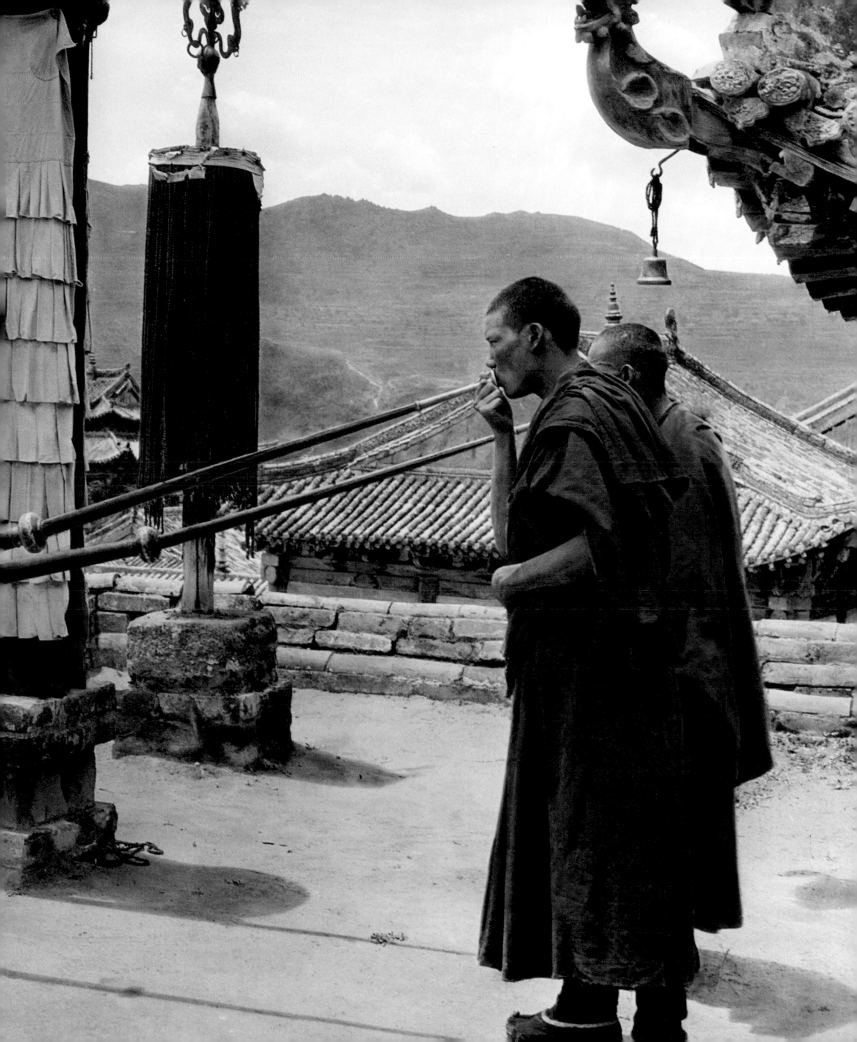

LOST WORLDS

In the twilight of old-school exploration, Society expeditions unlock some of the last geographic puzzles hidden behind remote mountain ranges.

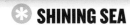

FIRST UNDERSEA COLOR PHOTOGRAPHY

✳ SHINING SEA

In 1926, using a brass-bound waterproof camera and dragging a raft rigged with a pound of explosive flash powder—the equivalent of 2,400 flashbulbs—marine biologist William Longley and *Geographic* photographer Charles Martin stalked the shallows around the Dry Tortugas, having a blast—once quite literally so, when Longley got severely burned. But they also got their pictures.

A huge table-land, remote, forbidding, belted by stupendous precipices of craggy sandstone." Thus did G. H. H. Tate describe Venezuela's Mount Roraima, where Sir Arthur Conan Doyle had placed living dinosaurs in his popular adventure novel, *The Lost World.* Tate, who wrote an account of his journey to Roraima for the November 1930 *Geographic,* was only one of numerous explorers—including Ruth Robertson, whose story of leading the first expedition to Angel Falls appeared in the November 1949 issue—who ventured into this mysterious, jungle-clad corner of the globe.

Among them was Ernest Holt, an ex-protégé of the doomed Col. Percy Fawcett, who in 1925 had disappeared in Brazil's Xingu River region while searching for fabled lost cities. From 1928 to 1930, Holt led several National Geographic expeditions into the forests of southern Venezuela. Whether poling a small boat up creeks so choked with fallen trees that guides had to clear a path with axes, or following surveyors charting the alternately swampy or mountainous 900-mile border with Brazil, Holt found the dense tropical forests to be terra incognita. He collected hundreds of plants and more than 3,000 birds. "Strange birds they were, too, many of them," wrote Holt, "others surpassingly beautiful."

STRANGE BIRDS INDEED

Fewer lost worlds were more imposing than New Guinea. By the mid-1920s, however, the airplane was breaching its forested ramparts. Elmer W. Brandes, seeking disease-resistant varieties of sugarcane, landed his big bird on a Papuan lake. Along its shores, as described in the September 1929 *Geographic,* he encountered Stone Age tribes dwelling "in unmapped nooks of sorcery and cannibalism." A decade later a wealthy young adventurer, Richard Archbold, mounted an expedition to Dutch New Guinea that also included a seaplane. As he related events in the March 1941 issue, Archbold was flying along the north slope of the Snow Mountains when he discovered a "Hidden Valley," as he called it, 40 miles long and so densely populated that it looked like the farm fields of Central Europe.

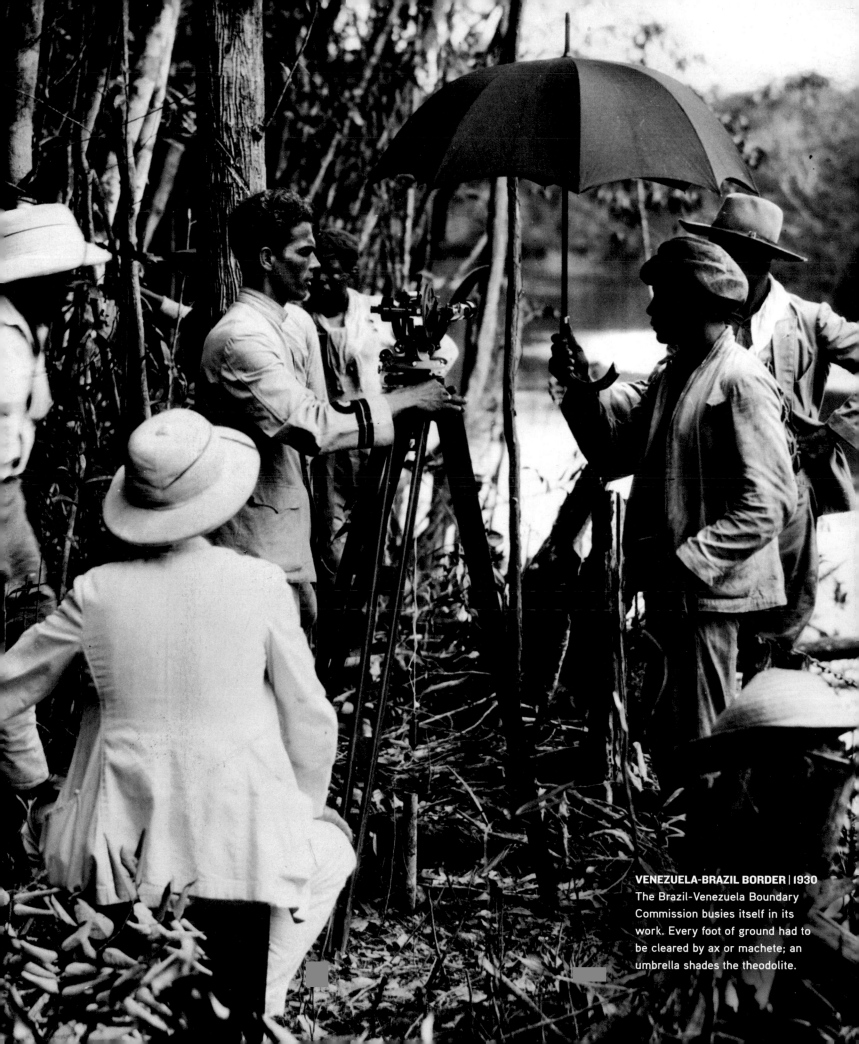

VENEZUELA-BRAZIL BORDER | 1930
The Brazil-Venezuela Boundary Commission busies itself in its work. Every foot of ground had to be cleared by ax or machete; an umbrella shades the theodolite.

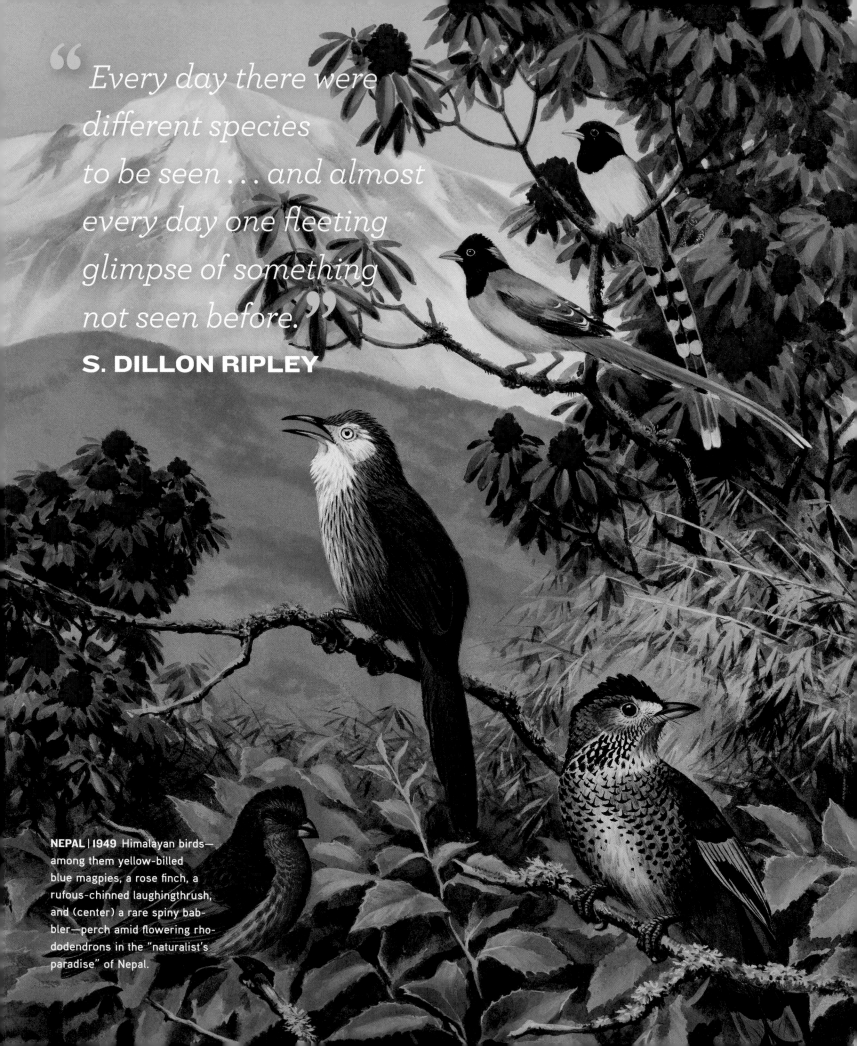

> *Every day there were different species to be seen ... and almost every day one fleeting glimpse of something not seen before.*

S. DILLON RIPLEY

NEPAL | 1949 Himalayan birds—among them yellow-billed blue magpies, a rose finch, a rufous-chinned laughingthrush, and (center) a rare spiny babbler—perch amid flowering rhododendrons in the "naturalist's paradise" of Nepal.

Nepal had been a closed kingdom for so many years that in 1948 a National Geographic–sponsored team of naturalists became the first Western scientific expedition permitted to visit in over a century. It went in hoping to find the Himalayan quail (*Ophrysia superciliosa*), which had not been seen since 1885; it came out instead with the spiny babbler (*Turdoides nipalensis*), a bird assumed to have gone extinct. The party also emerged with specimens that its leader (future Smithsonian Institution Secretary S. Dillon Ripley) called "Alice-in-Wonderland" creatures: a flower mouse, a red-headed laughingthrush, and a "somersault-turning ratel," or honey badger.

Indeed, venturing anywhere in Nepal struck the expedition members as tantamount to visiting the 16th century: Monks carried trumpets made from human thighbones, and long would Ripley remember "the tinkling bells of the temples, and the wild bray of the curling horns."

HIDDEN MYSTERIES

As the first full professor of ornithology in the United States, Arthur Allen of Cornell had pioneered both bird photography and the recording of their songs. Though he spent much time in his lab, at heart he remained a field scientist who hoped to solve a long-standing ornithological puzzle: the whereabouts of the bristle-thighed curlew's nesting grounds. Ever since 1769, when Captain Cook's naturalists had first collected *Numenius tahitiensis* in its namesake Tahiti, science had been seeking its eggs. Scattered clues suggested they might lie some 6,000 miles away—in Alaska. If so, by 1948 the curlew remained the only North American bird whose nest and eggs had never been discovered.

In that year, however, Allen, with the Society's blessing, finally tracked the creature to a spot on the Seward Peninsula near the lower Yukon River. It was actually Allen's

✱ CURLEW'S NEST

When Arthur Allen's cable, "Have found the curlew's nest," arrived at Society headquarters in June 1948, there was widespread rejoicing at the ornithologist's success in tracking down the breeding grounds of the bristle-thighed curlew. Not ten years later, however, Luis Marden discovered the remains of the famous ship *Bounty* at Pitcairn Island. He sent the same message, word for word, confident that his colleagues would understand the coded reference. Upon his returning home, however, they only complained about getting "some garbled cable about a bird."

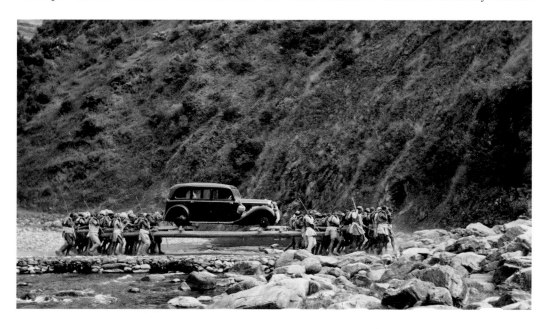

NEPAL | 1948 Stripped of its wheels and bumpers, this old Mercedes was carried on poles from Kathmandu across roadless Nepal to India.

ABOVE: The *Bounty*'s anchor, found in Pitcairn Island's Bounty Bay

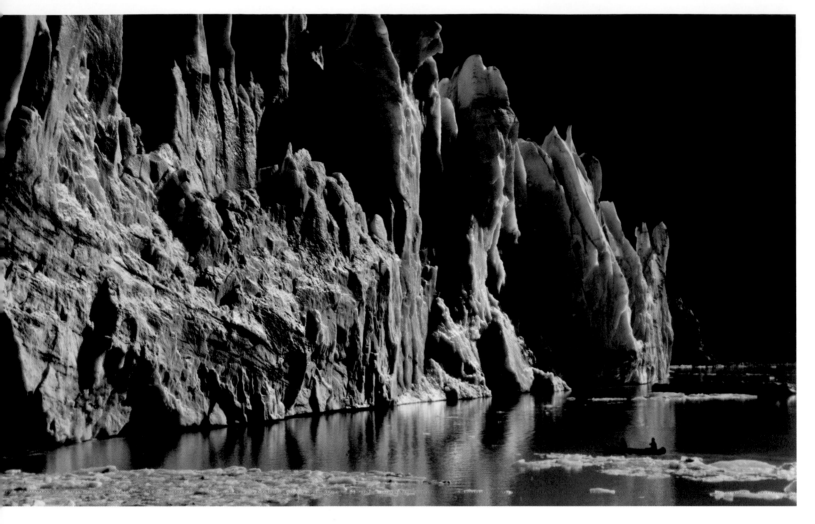

ALASKA | 1934 Given the danger of ice crashing down the 160-foot face of the Crillon Glacier, this canoe "is considerably closer to it than safety would dictate."

ALASKA | 1940 Brad and Barbara Washburn were a mapmaking and mountaineering team for more than six decades. In 1947 she became the first woman to summit Denali.

teenage son, David, who first spied "a bit of tundra" suddenly sprouting "an eye and bill"—a camouflaged curlew on its nest. The four eggs in that bit of lichen made front-page news.

Most of the headline-grabbing expeditions of the era, however, were big affairs, ranging from Roy Chapman Andrews's quasi-military camps in the Gobi to the Society-supported Arnhem Land expedition. The latter was the largest ever mounted in Australia: Led by anthropologist Charles Mountford, a team of ethnologists, botanists, ornithologists, ichthyologists, and filmmakers fanned out across an enormous area of stony escarpments and scrubby bush, collecting masses of material.

Some of the farthest-flung Geographic expeditions, though, stared skyward, observing eclipses. In 1937 a team of astronomers sailed to Canton Island in the Pacific Ocean to study the longest-lasting solar eclipse since A.D. 699—when not battling hordes of introduced rats. Fifteen years later, in 1952, George Van Biesbroeck erected a photo-telescope in the desert near Khartoum, Sudan. He needed to make only two exposures: one of the total eclipse of the sun that occurred overhead on February 25, and another of the night sky from the same spot six months later. When the images were compared,

the professor detected a slight shift in the starlight passing near the sun's corona during the eclipse. This was the Einstein shift, and Van Biesbroeck had just helped confirm the theory of relativity.

FILLING THE LAST EMPTY QUARTER

In 1934 a young Harvard graduate named Bradford Washburn, who had just made the first ascent of Alaska's Mount Crillon, organized a Society-sponsored expedition to map the last blank spot in North America. Most maps labeled the 5,000 square miles stretching east and north of the St. Elias Mountains into Canada's Yukon territory as "rugged country" because it was almost completely unknown.

By February 1935 Washburn and his party of five fellow mountaineers were bucking the gales in a Fairchild monoplane outfitted with skis. Leaning out of the fuselage (a door had been removed to permit aerial photography), they flew over "the last stronghold of the great ice age," in Washburn's words, aiming a bulky, 50-pound camera at "peaks and glaciers whose immense size and number have never been dreamt of by the early explorers of the Yukon." After six weeks of aerial mapping they began the ground surveys, using sled dogs to pull their equipment over the ice. Two months and six blizzards later they completed the first crossing of the St. Elias Mountains from Yukon to Alaska.

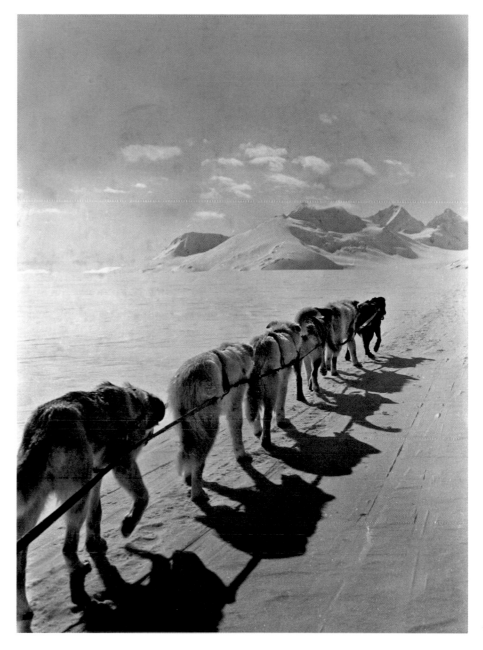

YUKON | 1935 Doggedly persistent, a Yukon expedition sledge team trots across the Lowell Glacier. They progressed a swift 18 miles a day across the ice.

All told, the Washburn party discovered and mapped four new glaciers and 45 previously uncharted peaks. They named two of the highest after King George V and Queen Mary, the reigning sovereigns of Canada. Shortly afterward, Washburn received a telegram from a British diplomat that made a fitting coda to his exertions: THE KING COMMANDS ME TO EXPRESS TO YOU THE SINCERE APPRECIATION OF THE COMPLIMENT WHICH THE NATIONAL GEOGRAPHIC SOCIETY-YUKON EXPEDITION HAVE PAID TO HIS MAJESTY AND TO THE QUEEN ... ■

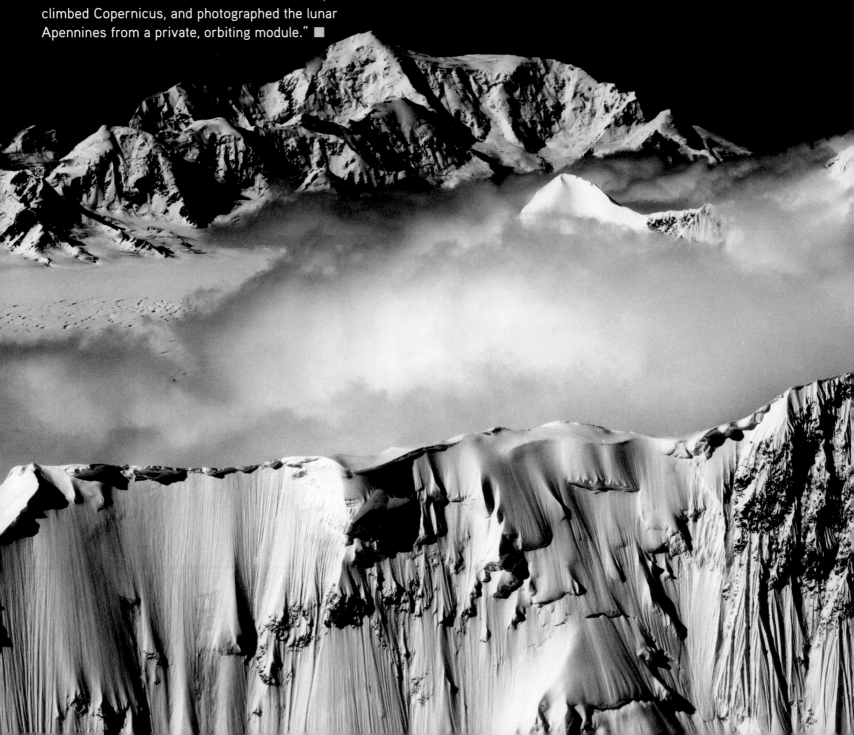

1935 "Something hidden. Go and find it. Go and look behind the Ranges," Rudyard Kipling urged all explorers everywhere. Behind Alaska's St. Elias Mountains—storm-swept, snowbound, heaving its ramparts above the Pacific Ocean— something was indeed hidden: a 5,000-square-mile blank on the map of Canada. Thanks to Brad Washburn, that blank reared itself into a map, contour by rock-ribbed contour. "I fully expect to hear someday," photographer Ansel Adams once forecast, "that Bradford Washburn has visited the moon, climbed Copernicus, and photographed the lunar Apennines from a private, orbiting module." ■

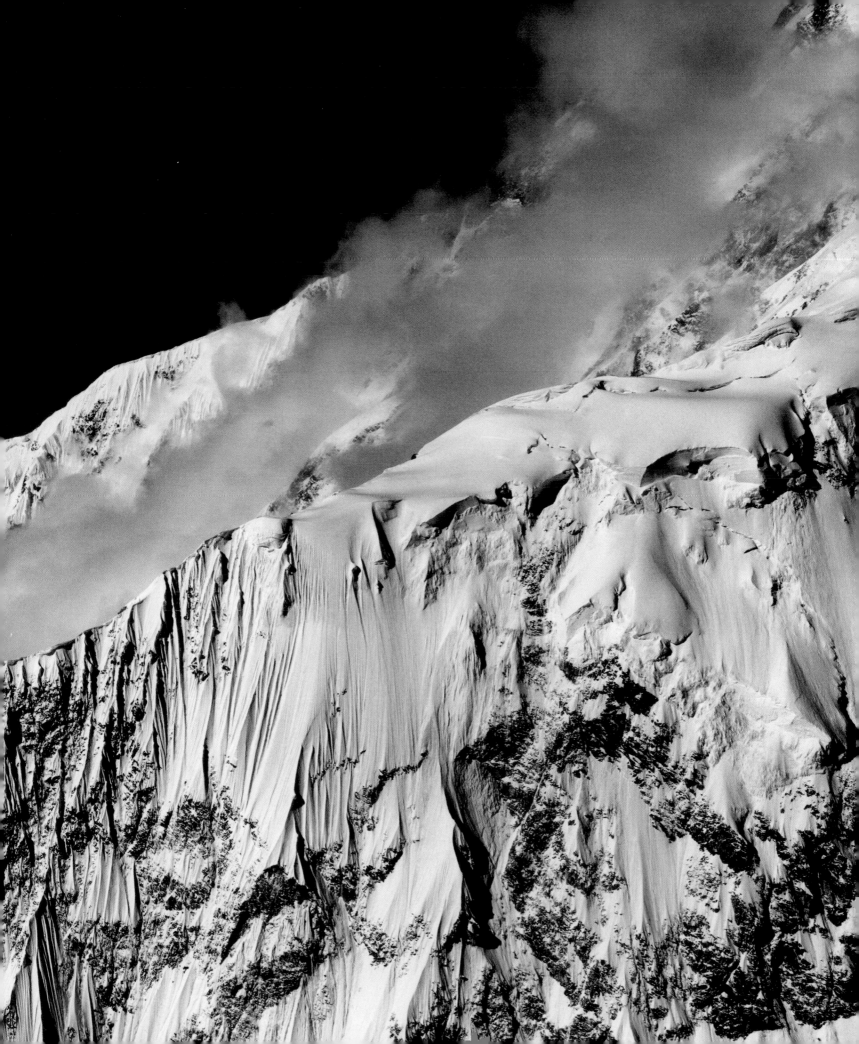

UNCOVERING THE PAST

The Society champions New World archaeology with a series of now classic expeditions.

✳ FIRST FRUITS

A buried altar found at La Venta depicts carved infants on its four sides—including a full relief figure of a priest, arms extended, holding out a baby. It was "a rather grim portent," Stirling wrote, "suggesting infant sacrifice."

ABOVE: Olmec figurines of babies

R umors of a giant stone head protruding from the floor of the Mexican jungle intrigued Matthew Stirling, chief of the Smithsonian's Bureau of American Ethnology, more than the spectacular but well-known Maya sites scattered throughout Central America. So in 1938 he mounted the first of eight National Geographic–sponsored expeditions to the wilds of Tabasco and Veracruz. There he excavated not 1 but 11 colossal stone heads. Emerging from the ground alongside them came evidence of an entire civilization—the Olmec—that had lain buried for 15 centuries.

As *Geographic* readers stared at pictures of those stony faces, they were treated to details of expeditionary life: camps infested by scorpions and prowled by jaguars; undergrowth abounding in chiggers, fer-de-lance, and coral snakes; trees echoing to the dawn roar of howler monkeys and bright with flashing flocks of parakeets. Nor did Stirling, one of archaeology's most appealing figures, stint on descriptions of their camp diet, which rarely varied from tortillas (though their fillings ranged from toucan and iguana to armadillo and ocelot) and the occasional handful of toasted flying ants.

Stirling simply shrugged it all off, for as he trenched and spaded his way into the jungle-covered mounds, he was also bringing to light something far more significant: artifacts from the "mother culture" of the Americas.

THE GOLDEN SHOVEL

It was near such hamlets as Tres Zapotes, La Venta, and San Lorenzo Tenochtitlan that Stirling earned his nickname: the Golden Shovel. He dug up jade axes, jade earplugs, and exquisitely carved jade figurines. He disinterred a basalt-pillared tomb, a jaguar-faced sarcophagus bearing traces of its long-disintegrated occupant, and Stela C—a stone calendar recording a date several hundred years earlier than any Maya Long Count calendar known at that time. Stirling's probes would reshape the story

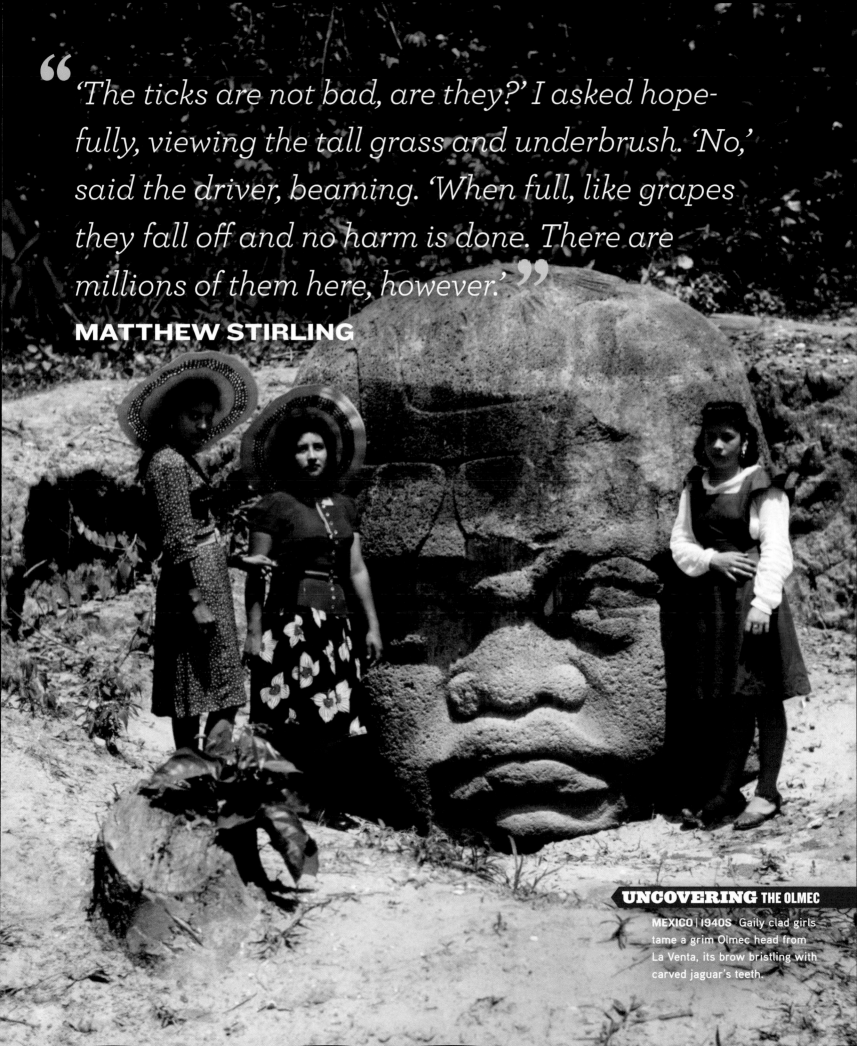

"'The ticks are not bad, are they?' I asked hopefully, viewing the tall grass and underbrush. 'No,' said the driver, beaming. 'When full, like grapes they fall off and no harm is done. There are millions of them here, however.'"

MATTHEW STIRLING

MEXICO | 1940S Gaily clad girls tame a grim Olmec head from La Venta, its brow bristling with carved jaguar's teeth.

of Mesoamerican archaeology, for they proved that the Olmec had flourished from roughly 1500 B.C. to A.D. 500, centuries before the Classic Maya did.

Stirling even chased down rumors of a nearby "lost city," paddling a dugout canoe far up a tangled river—only to find nothing but some pottery sherds and a hand-forged iron spike of European origin. And though he may never have discovered the legendary lost mines of the conquistadores on the surf-beaten coast of northern Panama, he did disclose the existence of many ancient tombs, some of them 30 feet deep.

LIVES LIKE WINDBLOWN SAND

North of the Rio Grande, one of Stirling's friends had already spent a decade unearthing the most impressive pre-Columbian site in the United States. Pueblo Bonito, or "beautiful village," was only one of the many spectacular ruins, half-buried in sand, scattered along the floor of Chaco Canyon in northwestern New Mexico. First probed by an Army expedition in 1849, the ancient village had seen only haphazard efforts at archaeological excavation before the Society, in 1920, initiated the series of expeditions led by the Smithsonian's Dr. Neil Judd.

Season after season, Navajo and Zuni workers removed tons of sand, debris, and gravel, carting it away in horse-drawn wagons. Bit by bit, magnificent circular kivas (ceremonial rooms) revealed themselves, as did the remnants of hundreds of apartments. "Pueblo Bonito with its 1,200 or more inhabitants, was unquestionably the outstanding communal settlement of the Pueblo area," Judd concluded; "its influence at that time was vastly greater than that of any Pueblo village of modern times, reaching as it did, to the Pacific Coast and even the valley of central Mexico." In 1923 Judd took a break from his spade-and-shovel work to lead a National Geographic expedition into an area of southeastern Utah that had never been "traversed by White Men." But in the maze of twisting canyons between the San Juan and Colorado Rivers, men and mules nearly foundered in quicksand. At other times

PANAMA | 1948 Marion Stirling examines a grisly discovery: a necklace made of 800 human teeth, "mostly incisors," found buried with a male skeleton.

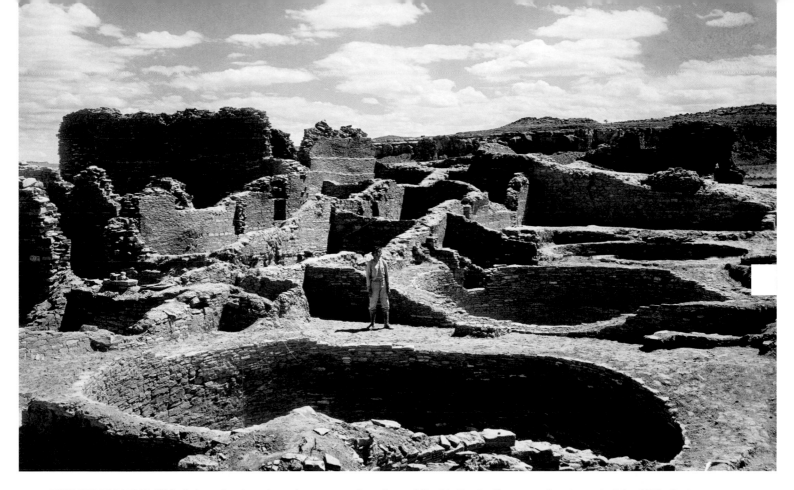

NEW MEXICO | 1922 With their walls shored up, the excavated portions of Pueblo Bonito lie exposed at the end of the 1922 digging season.

they had to skirt rivers that had overflowed their banks from unseasonable rains. Prehistoric peoples had left some impressive cliff paintings, but they had not built for the ages; no ruined dwellings were found. In such desolate country, Judd mused, "a single human life is as a grain of windblown sand—it comes, rests awhile, drifts on."

Hoping to understand when Pueblo Bonito's builders had abandoned Chaco Canyon, Judd turned to an astronomer: Andrew Ellicott Douglass suspected that variations in the width of tree rings betrayed not only wet and dry years but also might reflect the waxing and waning of sunspots. He therefore began creating a tree-ring calendar, matching up progressively older tree ring sequences from Southwestern pine trees. Judd and Douglass hoped to use these records to date Pueblo Bonito's surviving ceiling beams.

Douglass's chronology was a "floating" one; he needed a missing link to anchor it. So for six seasons the National Geographic Beam Expeditions fanned out over the pine-clad mesas, seeking both the oldest trees still standing and more ancient timbers found in 17th-century Spanish churches, Indian pueblos, and abandoned cliff dwellings. The missing link proved elusive until a charred timber was recovered from a trash pile, and it took them all the way back to A.D. 700. As a result, Douglass was able to establish that Pueblo Bonito had been inhabited from A.D. 919 to 1130. And as he refined his technique, Douglass managed to date more than 40 other pre-Columbian ruins throughout the Southwest. Soon dendrochronology was adopted everywhere, and today tree-ring chronologies have been established around the world, dating back many thousands of years. ■

▶ **PICTURES FROM AN EXPEDITION**

At one time the Society compiled its expedition photographs in big leather albums. Here Neil Judd, director of the Society-supported excavations at Pueblo Bonito, confers with Santiago Naranjo, governor of nearby Santa Clara Pueblo. Judd's success at clearing the ruins depended upon close collaboration with the local Native Americans.

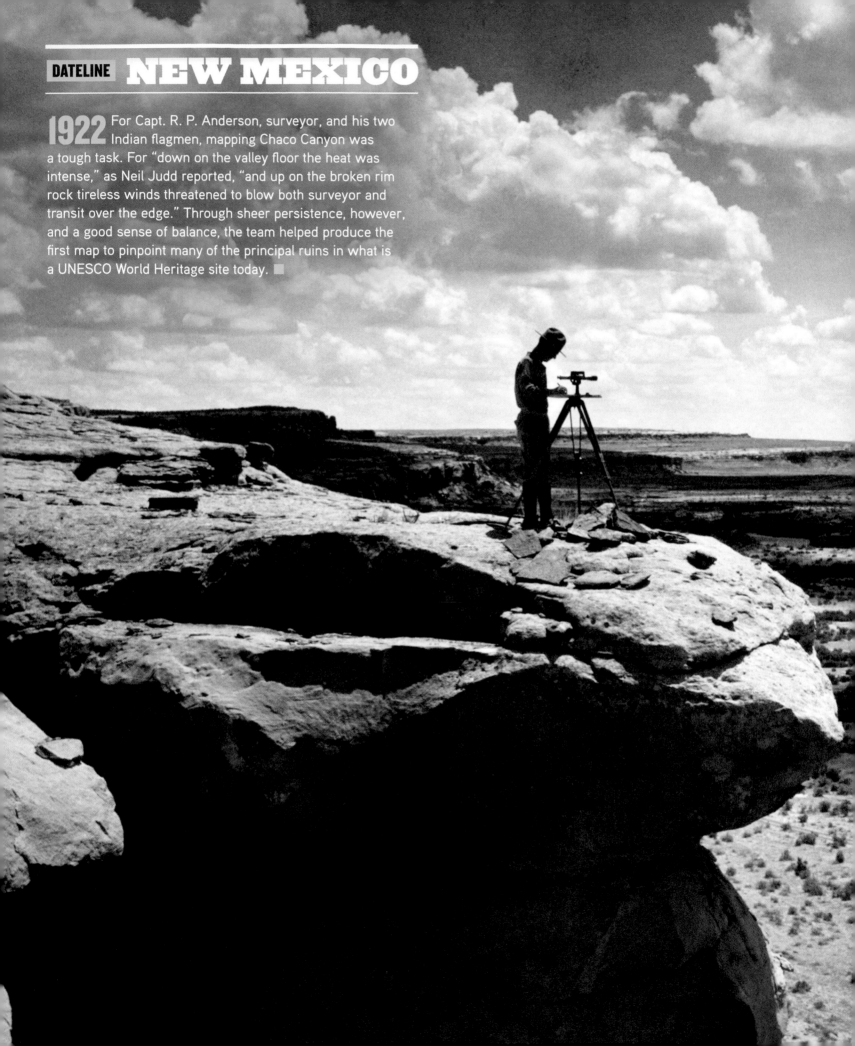

1922 For Capt. R. P. Anderson, surveyor, and his two Indian flagmen, mapping Chaco Canyon was a tough task. For "down on the valley floor the heat was intense," as Neil Judd reported, "and up on the broken rim rock tireless winds threatened to blow both surveyor and transit over the edge." Through sheer persistence, however, and a good sense of balance, the team helped produce the first map to pinpoint many of the principal ruins in what is a UNESCO World Heritage site today. ■

NEWS OF THE WORLD

A fascination with aviation and a patriotic response to World War II showed that the *Geographic* did not live solely in a world of its own making.

✴ TOMB OF TUT

When, on November 4, 1922, the tomb of Tutankhamun, in Egypt's Valley of the Kings, was first opened, it made sensational headlines worldwide. But when the *Geographic*'s Maynard Owen Williams was allowed a peek, three months had passed. His reaction, after all the buildup? "Disappointment."

The National Geographic Society's love affair with aviation had begun long before October 15, 1928, when its employees crowded onto its headquarters roof for a glimpse of the cigar-shaped *Graf Zeppelin* hovering over the nation's capital. Beginning back in those turn-of-the-century days when Alexander Graham Bell had flown his tetrahedral kites, the magazine had reported on every stage in the progress of aeronautics: The first flights across the United States or the Pacific; the first from London to Australia or down the Andes or over the Amazon, Europe, Egypt, the Holy Land, and China; the first charting of airmail routes and sky paths for commerce—all had been hailed in the *Geographic*. The Society had conferred its medals on Charles Lindbergh for being the first man to fly the Atlantic, on Amelia Earhart for being the first woman to follow suit, on Richard E. Byrd for tackling the Poles, on Lincoln Ellsworth for his 22-day aerial crossing of Antarctica, and on Hugo Eckener, who had helmed the *Graf Zeppelin* on history's first global circumnavigation by airship.

But that romance with flight was strongest, as it was for most people with a passion for wings, in the years before World War II brought home just how deadly aircraft could be.

BULLETS FOR STORIES

When the United States went to war in December 1941, the National Geographic's "paramount objective," as Grosvenor declared, was to aid its "successful prosecution." Immediately thereafter, he opened its collection of maps and photographs—with their depictions of cities, harbors, railroads, and even caravan trails—to government officials, uniformed or otherwise. The magazine's staff was reduced to a skeleton crew as

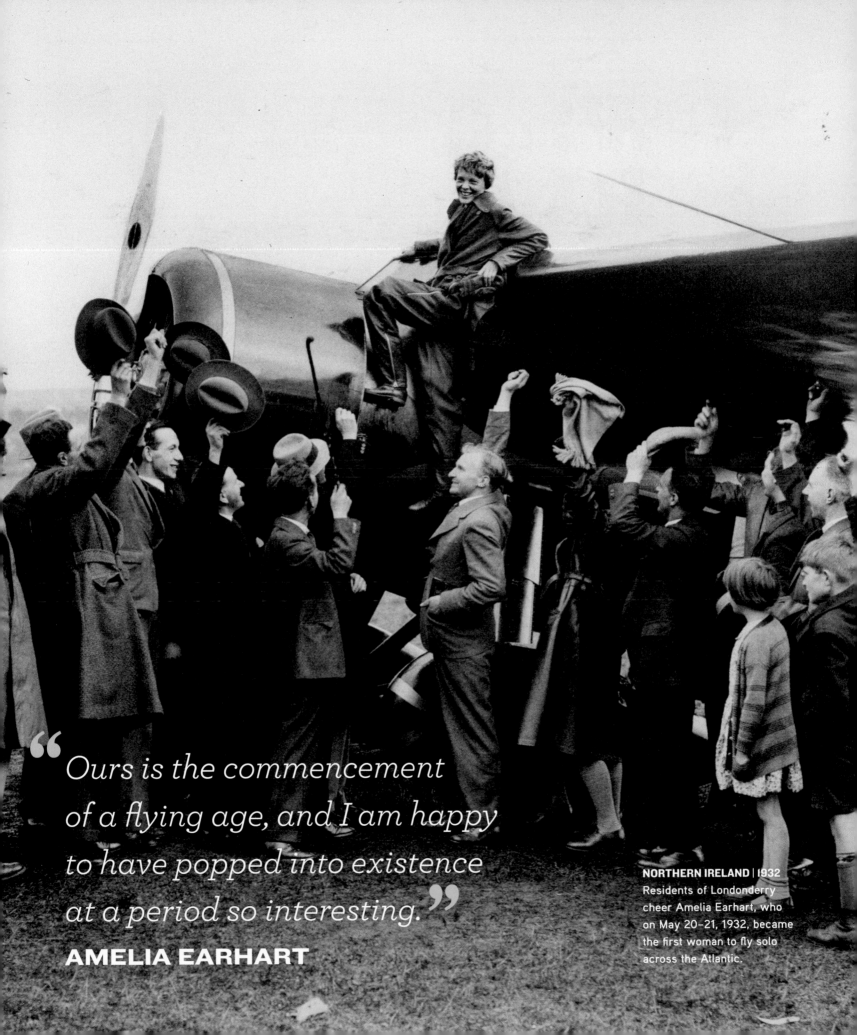

> *"Ours is the commencement of a flying age, and I am happy to have popped into existence at a period so interesting."*

AMELIA EARHART

NORTHERN IRELAND | 1932
Residents of Londonderry cheer Amelia Earhart, who on May 20–21, 1932, became the first woman to fly solo across the Atlantic.

✳ MAPS FOR VICTORY

When Churchill and Roosevelt sketched out the division of postwar Germany, they did so on *National Geographic's* July 1944 map, "Germany and Its Approaches." When Army truck drivers bringing supplies up to the front hit a fork in a French road, they scrutinized enlarged copies of that same map, which had been posted at key junctions. And when Adm. Chester Nimitz landed safely on Guadalcanal in September 1942, it was thanks only to an old *Geographic* chart of the Pacific Ocean that his plane had not been lost in rainsqualls.

ABOVE: September 1941's "Map of the Atlantic Ocean"

PACIFIC OCEAN | 1941 U.S. Navy mosquito boats—so named for their ability to sting with torpedoes at close range—look almost dashing in this rendering by maritime artist Arthur Beaumont.

men flocked to the colors. Volkmar Wentzel and Howell Walker were soon serving in the Pacific Theater, while Frederick Vosburgh, a future *National Geographic* Editor in Chief, landed on Omaha Beach nearly a month after D-Day. He soon found himself a mile from the front, mortar shells raining down on hedgerows and pastures nearby.

Other *Geographic* men were accredited war correspondents. Joe Roberts was attached to the Navy, where his picture of a church service aboard the shattered carrier U.S.S. *Franklin* earned him an Edward Steichen Award for one of the "Best Hundred Pictures of the War." W. Robert Moore visited bullet-shredded Pacific isles such as Tarawa and Saipan. Flying into Peleliu, he thought the plane was dropping into a volcano—"the eruption of heavy demolitions, banging mortars, tat-tatting machine guns, and the fire from flame throwers and phosphorus bombs." The battle was still raging at "Bloody Nose Ridge," only 500 yards from the airstrip.

One casualty was easily replaced. The entire shipment of November 1942 issues bound for Britain ended up at the bottom of the Atlantic, sent there by a U-boat's torpedo. Grosvenor simply went back to the presses—and the next batch got through safely.

WAR THE *GEOGRAPHIC* WAY

While its maps were pinned to the walls of homes and offices, and its booklet illustrating nearly 2,500 insignia and decorations of the U.S. armed forces included shoulder patches for an imaginary 14th Army—part of an elaborate ruse by the government to mislead the Axis?—the Society trained *National Geographic's* sights on the war effort.

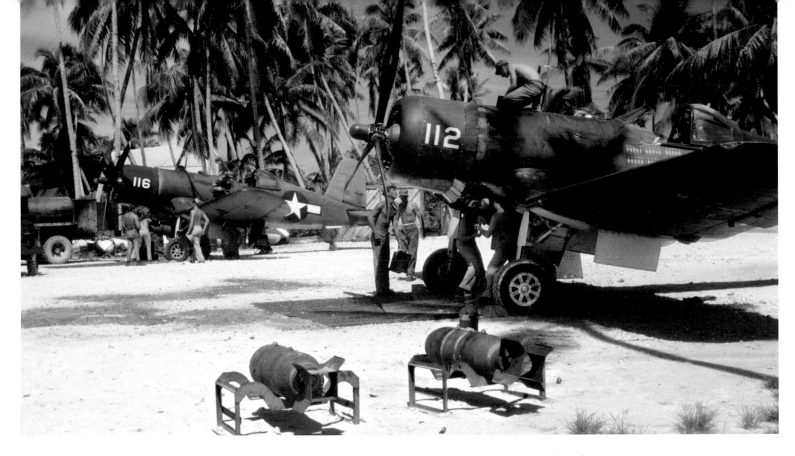

GILBERT ISLANDS | 1944 Ground crews ready Corsair fighter-bombers for strikes against Japanese outposts.

"The cars and tracks were very near now under the absolute black cross hairs," Lt. Benjamin McCartney wrote in the March 1945 issue, recalling the moment when, hunched in his B-26's Plexiglas nose, he depressed the "pickle" and released bombs over Florence—his favorite city during a prewar student idyll. The ordnance hit home in another coup for a squadron distinguished for its ability to hit marshalling yards without damaging the architecture of surrounding cities. The day after his manuscript and photographs reached Society headquarters, however, the bombardier died from shrapnel wounds sustained on a raid outside Milan.

A young Marine photographer, David Douglas Duncan, was awed by the Fijian guerrillas he accompanied as they fought their way to safety from behind Japanese lines. "Cloaked with ferns from head to waist . . . the Fijians became part of the jungle in the half-light and the rain," he wrote in "Fiji Patrol on Bougainville" for the January 1945 issue. "Cool and casual, they placed each shot with terrific speed, but utmost care."

Meanwhile, construction crews hacking out the Stilwell Road, a supply route running from India to China across the hills of Burma, eventually pushed into the territory of the Naga people. One of its chiefs approached engineer Nelson Tayman and asked to see the nesting place of the "roaring giant birds." Tayman showed them a nearby airfield. "The loinclothed visitors stood with folded arms in complete silence for fully half an hour as they watched the big planes land and take off," he wrote in the June 1945 *Geographic*. "Only visible sign of excitement was the increased tempo of their jaw movements as they chewed betel nut. Then, their curiosity satisfied, they fell again into single file and returned to the jungle." ▪

✳ **APRÈS LA GUERRE**

"Champagne cocktails are the principal drink offered from depleted Montmartre stocks," the *Geographic* author Frederick Simpich, Jr., noted in the March 1945 article "Paris Freed." An army of war correspondents and USO entertainers had invaded the bistros and boulevards. "Ernest Hemingway is here, looking like a puckish philosopher with his graying beard, and Marlene Dietrich had been entertaining the troops and looking like a million, even in slacks!"

DATELINE **BERLIN**

1948 He would waggle his wings on approach, Lt. Gail Halvorsen told a National Geographic lecture audience in February 1949, and the children would leap for joy. The U.S. Air Force pilot, after flying his first run of food and fuel to West Berlin following the June 1948 Russian blockade, had promised the urchins who pleaded for chocolate that he would bring some on his next trip. Steering his plane toward Tempelhof Airport a day or two later, he spotted those anxious upturned faces in the rubble below, and it was bombs away! Chocolate bombs, that is: Candy bars cascaded down. His fellow pilots followed suit. Within seven months, more than 250,000 tiny parachutes—each containing its precious payload of chocolate—had been dropped. ■

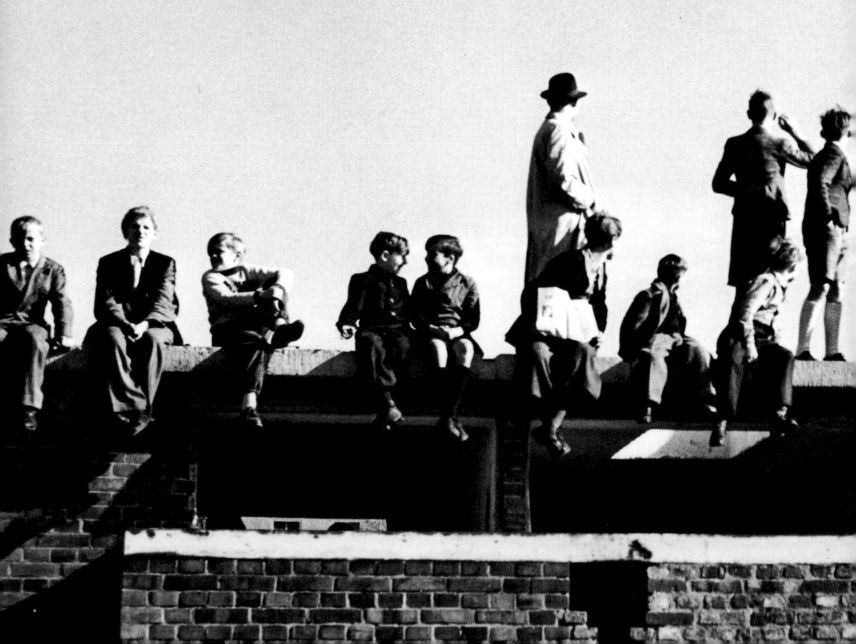

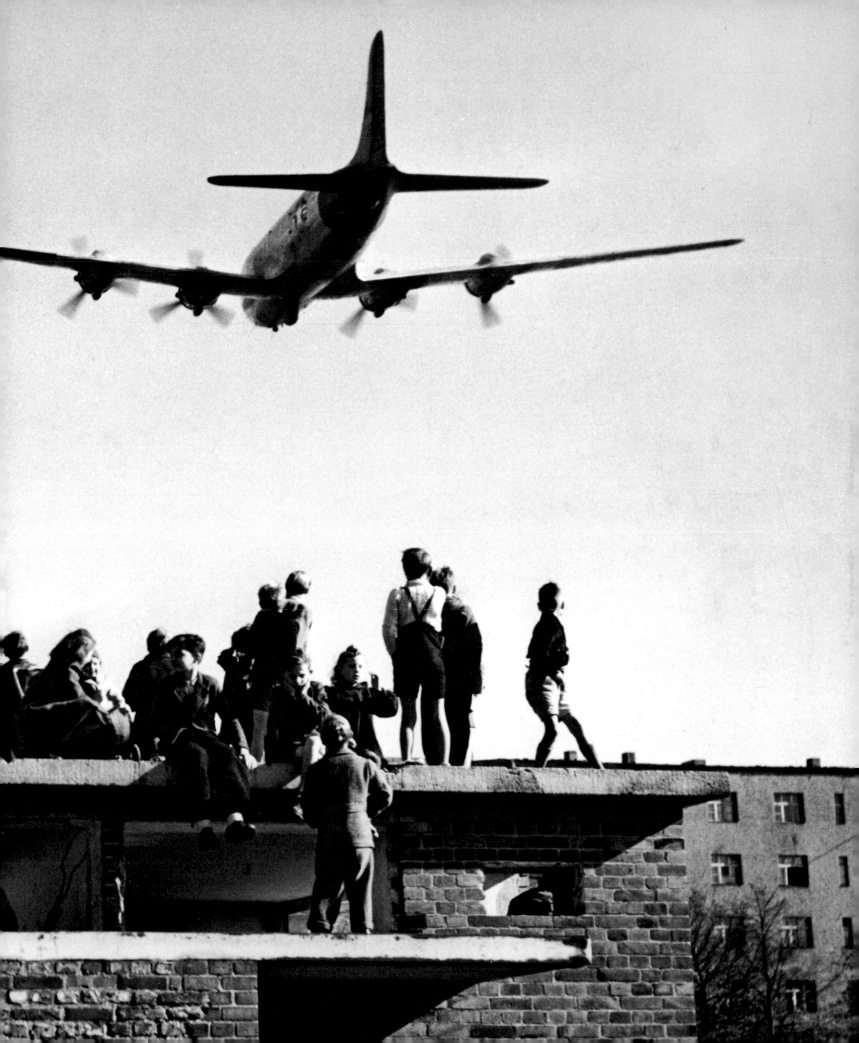

TO THE ENDS OF THE EARTH

Sending expeditions to the bottom of the world, the depths of the sea, and the heights of the stratosphere, the Society harnessed technology to expand the frontiers of exploration.

FIRST SOUTH POLAR FLYOVER

✳ A HUNGER TO EXPLORE

When Richard E. Byrd and three companions made the first flight to the South Pole on November 28, 1929, they jettisoned their food supplies to clear 15,000-foot-high mountains. Since the 1,400-mile round trip took 16 hours, the returning explorers were surely as hungry as they were triumphant.

ABOVE: The *Floyd Bennett*, the plane that conquered the South Pole

Though he affected an easy charm, Richard Evelyn Byrd was an intensely competitive man. So after an ankle injury disqualified the Naval Academy graduate from sea duty, he turned skyward instead—and flew.

Naval aviation took him to the Arctic, where on May 9, 1926, he claimed to have been the first to fly to the North Pole. Wittingly or not, Byrd may in fact have fallen short of that goal. But if he did allow his ambition to eclipse his judgment, he redeemed himself at the other end of the globe.

Using technology to open a continent locked in ice, Byrd became one of the great figures in Antarctic exploration. His airplanes mapped hundreds of thousands of square miles of peak and glacier. His ski-mounted trucks replaced dog sleds as the chief means of transporting supplies and equipment. "Little America," perched on the edge of the Ross Ice Shelf, became the first in a series of self-sufficient research stations. Electrically lit, kerosene-heated barracks, machine shops, and even a gymnasium were buried beneath the snow, out of which peeped 70-foot-high radio towers—the sole means of communication with the outside world.

The dark Antarctic winter howled, but Byrd never lost a man. Except almost himself, for he once spent five months—alone—in an advanced weather hut 123 miles from Little America. There the intrepid explorer was nearly done in by carbon monoxide fumes emitted from the hut's stove.

MEN ON A WIRE

A lifetime of adventures in remote jungles had not prepared naturalist William Beebe for the glories he glimpsed when he donned a diving helmet and slipped beneath the waves. The hours he spent stalking about the reefs persuaded him that oceangoing

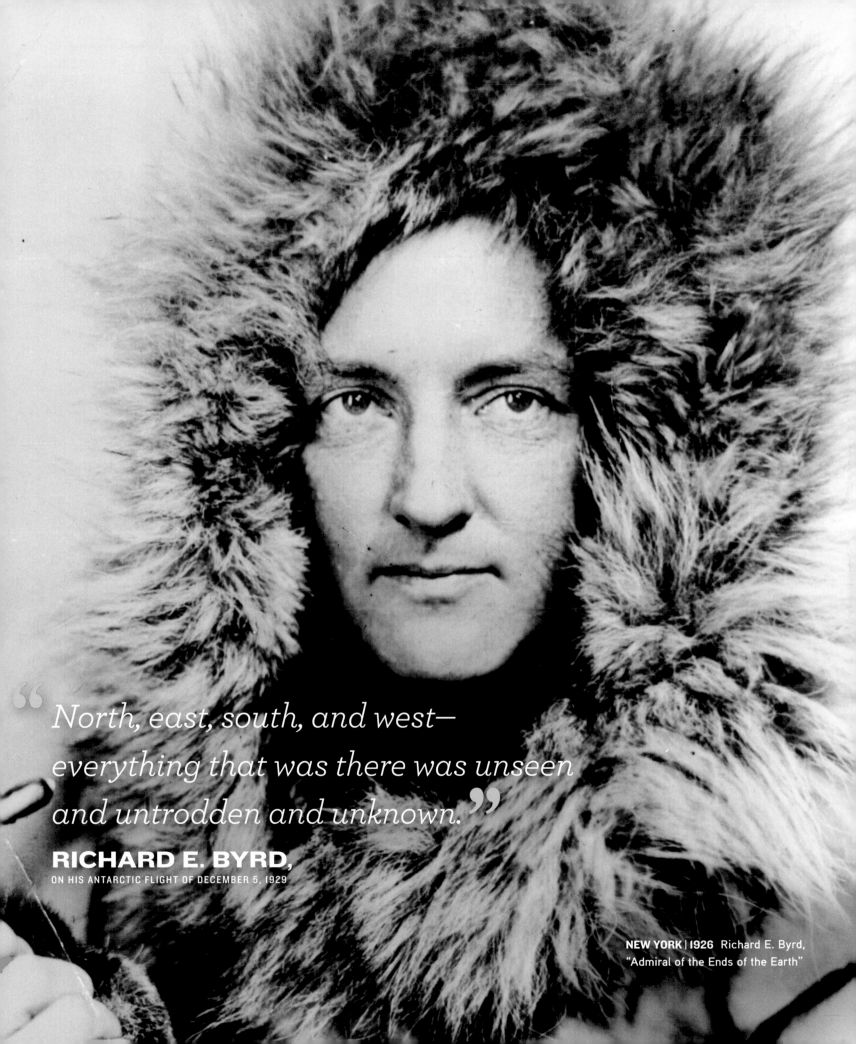

"North, east, south, and west—everything that was there was unseen and untrodden and unknown."

RICHARD E. BYRD,
ON HIS ANTARCTIC FLIGHT OF DECEMBER 5, 1929

NEW YORK | 1926 Richard E. Byrd,
"Admiral of the Ends of the Earth"

ABOVE: A great gulper eel—they grow nearly five feet long—gobbles up a giant lanternfish.

research vessels, dependent on blind nets, trawls, and dredges, were not obtaining a representative sampling of marine life. Only a deep-sea observation chamber, he concluded, would allow scientists to see for themselves what lurked in the abyss.

Beebe got one in the bathysphere. The two-ton hollow steel cylinder, featuring a cramped interior and two portholes of transparent fused quartz, had been designed by engineer Otis Barton but resembled something out of a Jules Verne novel. It swung from the end of a long steel cable less than an inch in diameter, itself suspended from a derrick mounted on a barge. Beebe and Barton were brave enough—or bonkers enough—to climb into this contraption and sink beneath the waves off Bermuda.

Beginning in 1930, the pair made more than 30 deep-sea dives, firing the imaginations of millions of people who listened, via an NBC radio hookup, as Beebe marveled at the phantasmagoric creatures, pulsating with luminosity, which dwelled in that blue-black world. "I knew that I should never again look upon the stars," he wrote in the *Geographic,* "without remembering their active, living counterparts swimming about in that terrific pressure."

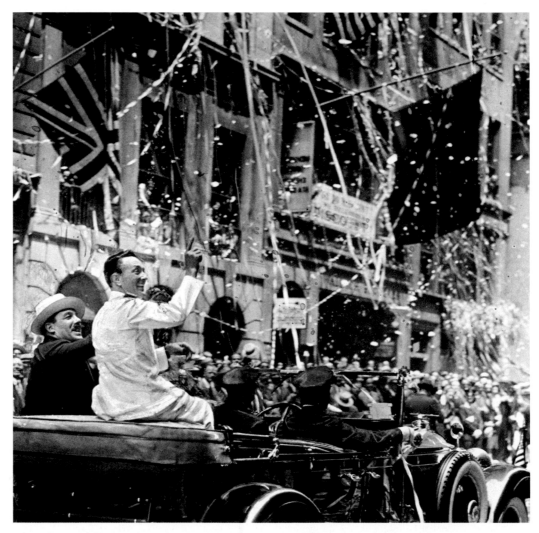

NEW YORK CITY | 1930 Ticker tape rains down on Admiral Byrd—parading up Broadway on June 19, 1930—in celebration of the first flight over the South Pole.

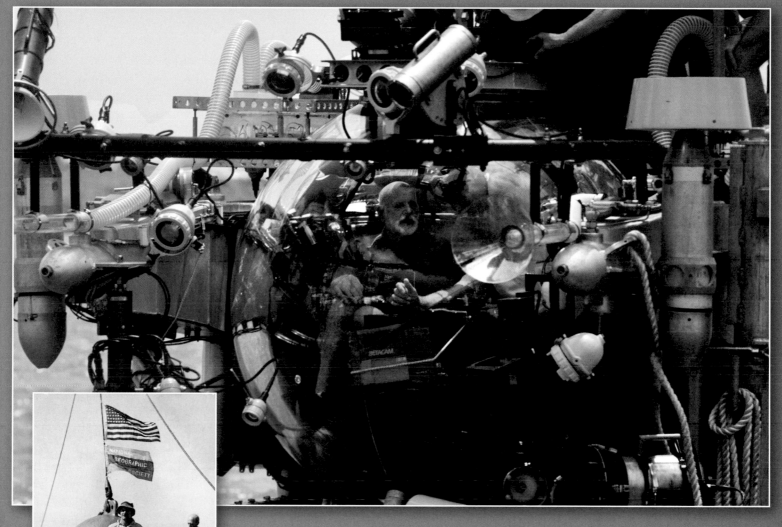

Otis Barton, designer of the bathysphere, investigates the Johnson *SeaLink* in 1984, the 50th anniversary of Half Mile Down.

✛ THE BATHYSPHERE

In their crude bathysphere, Beebe and Barton resembled the scientist in H. G. Wells's 1895 story, "In the Abyss," who rode a remarkably similar craft to the seabed. Resurfacing, the scientist had exclaimed, "You thought I should find nothing but ooze. You laughed at my explorations, and I've discovered a new world!"

The Columbuses of the Lower Depths," as William Beebe and Otis Barton were called after surfacing from their 1934 record dive, dreamed that a fleet of bathyspheres might one day explore the oceans. When Barton, the 85-year-old inventor of the craft, was feted on the 50th anniversary of Half Mile Down (Beebe had died in 1962), he was shown a submersible very unlike his original design. Instead of sitting in a hollow steel ball with two tiny portholes, he was surrounded by a transparent acrylic sphere with a panoramic view. Rather than dangling from a winch, he could steer a fully maneuverable craft powered by jet thrusters. In place of a fixed spotlight, he could control a battery of still and video cameras. Topping it all off, manipulable robotic arms invited him to claw, grasp, or scoop up seafloor samples. Indeed, had 3-D imaging systems and advanced life-support capabilities been available in 1984, Barton would have glimpsed the high-tech research submersibles of today. ■

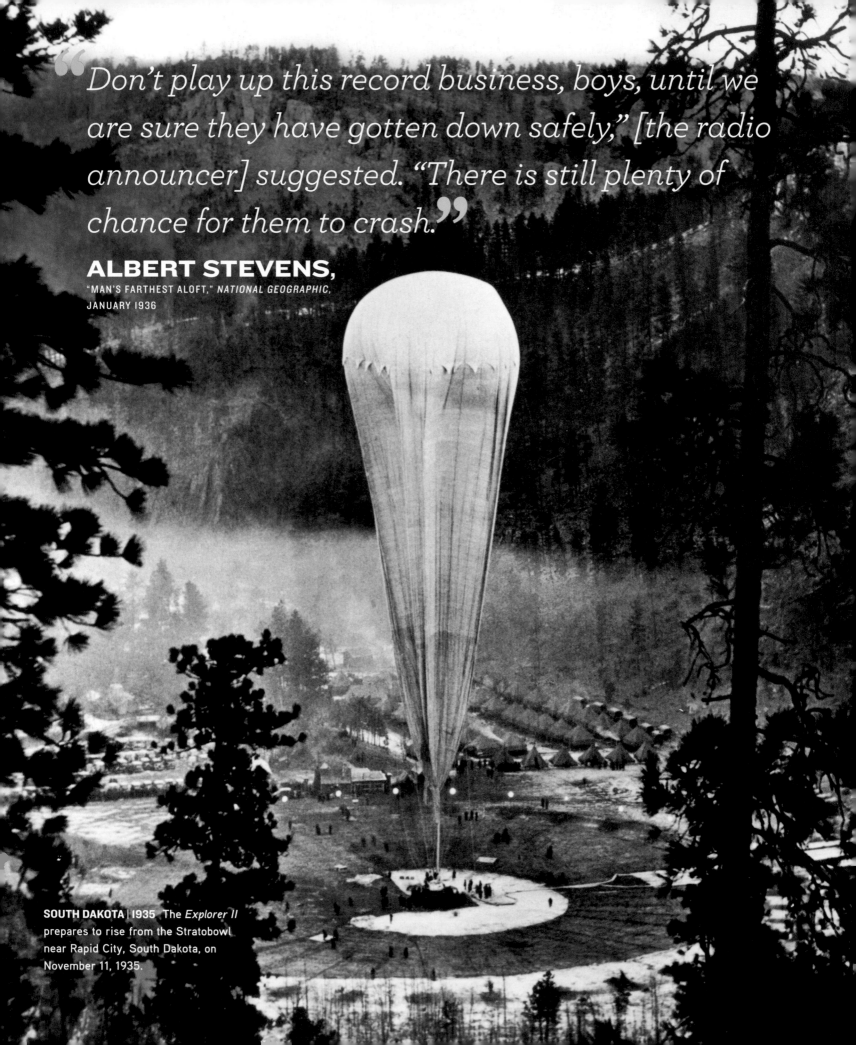

Don't play up this record business, boys, until we are sure they have gotten down safely," [the radio announcer] suggested. "There is still plenty of chance for them to crash."

ALBERT STEVENS,
"MAN'S FARTHEST ALOFT," *NATIONAL GEOGRAPHIC,*
JANUARY 1936

SOUTH DAKOTA | 1935 The *Explorer II* prepares to rise from the Stratobowl near Rapid City, South Dakota, on November 11, 1935.

When the bathysphere was lowered into the sea for one final dive on August 15, 1934, the Society's name was painted on the hull side and its flag flew from the support cable. As the winches turned, the little craft descended ever deeper into the abyss. The winches finally stopped just before the cable ran out. At the end of their tether, Beebe and Barton swung more than half a mile beneath the surface—3,028 feet, to be precise—dangling amid vast shoals of luminous creatures.

After it was hauled, swaying and streaming seawater, back on deck, the bathysphere opened and the astounded aquanauts tumbled out. No one would go deeper for another 15 years, making Beebe and Barton the first men to explore that alien a realm and return to tell the tale.

A NEW SKY PATH

Scarcely 15 months later, the Society could proudly point to a complementary achievement. On November 11, 1935, the National Geographic–Army Air Corps stratosphere balloon *Explorer II* carried two "aeronauts" 72,395 feet—nearly 14 miles—into the stratosphere. It was the highest men would go for another 21 years.

The project was the brainchild of Capt. Albert Stevens, an Army Air Corps aerial photographer who never could get high enough. Several balloonists had already been edging into the stratosphere—the atmospheric layer 7 to 30 miles above the ground—when Stevens persuaded the Geographic to help him top them. He soon harnessed a consortium of corporations, construction firms, and government agencies, as well as the Society to help him reach higher into the sky.

Launching from a "Stratobowl" built in the Black Hills of South Dakota, *Explorer II,* a gondola ringed with portholes and hatches and bristling with instruments, hung from a balloon as tall as a 26-story building. It carried Stevens and a fellow aeronaut, Capt. Orvil Anderson, to a transition zone where the stratosphere was banded from pale blue to deep black. They shot the first photos to portray the curvature of the Earth, and returned to the planet's surface with an abundance of scientific data, having charted a new path through the sky—toward space. ■

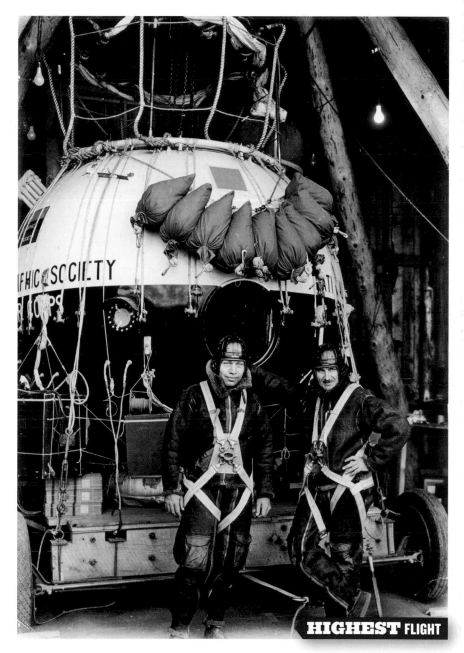

HIGHEST FLIGHT

SOUTH DAKOTA | 1935 Sporting crash helmets supplied by a local football squad, captains Orvil Anderson (left) and Albert Stevens stand before *Explorer II*'s gondola.

SKY SURVEY

1956 The farthest-flung National Geographic venture of all had nothing to do with Earth: Its focus was extraterrestrial, possibly even extragalactic. The NGS–Palomar Observatory Sky Survey (1949–1956), a photomapping of the night sky as seen from the Northern Hemisphere, expanded the region of known space 25 times. Captured on its plates were more than 89 million stars, comets, asteroids, mysterious objects eventually called quasars, galaxies, and immense archipelagoes of galactic clusters lacing the universe. It remains the mother of all sky surveys to this day—or night. ∎

UNIVERSE | 1950S A plate from the sky survey shows a section of Sagittarius, glowing bright with hydrogen clouds.

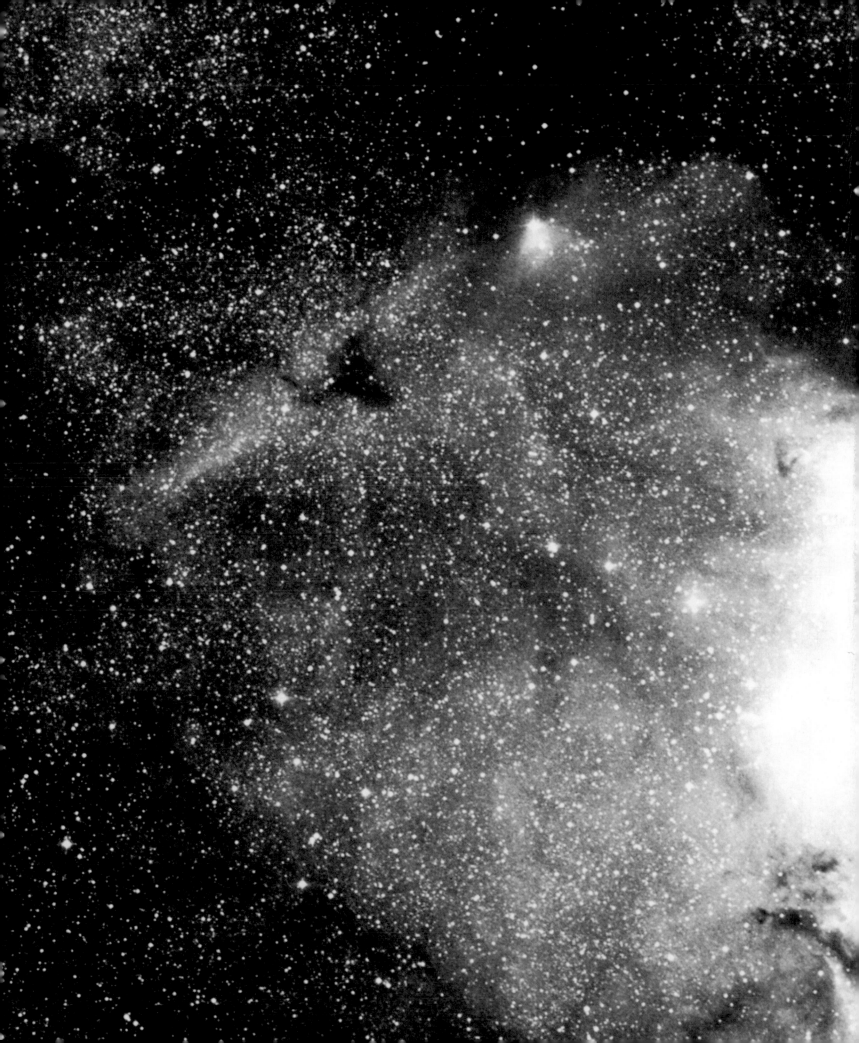

Humanized geography," it was once called at the National Geographic. Depictions of faraway places were never complete without the human figure to give them scale. And the more those figures looked the part, dressed the part, the better the picture played in the pages of the magazine. Whenever a Geographic photographer arrived in some European town, for example, trunks carefully packed with crocheted costumes were dragged out for the sons and daughters to pose in traditional garb.

That was the kind of travel photography that appealed to many people in the years before World War II. But after that conflict had ceased, and the age of mass tourism descended, pictures tinged with deliberate exoticism seemed quaintly old-fashioned. They were soon derided by a new generation of photojournalists as being "postcard views." These camera-wielding men and women sought instead to depict a world that was altogether grittier, less glowing, indeed less faraway. Many of them cultivated an ironic detachment, and though well traveled themselves, were always ready to send up a hoary old stereotype or two. ∎

▼**1927** *Three members of the Crow Nation survey the Montana battlefield where their ancestors may have served as scouts for General Custer 51 years earlier.*

▲ **1923** The muscular steel legs of the Eiffel Tower dwarf the old twin-towered Palais du Trocadéro, built in 1878 and pulled down in 1937.

▶ **1915** A young Swiss goatherd feeds one of his charges in a notably hand-colored photograph.

▼ **1930** A flapper unleashes her inner thespian before a New Orleans theater.

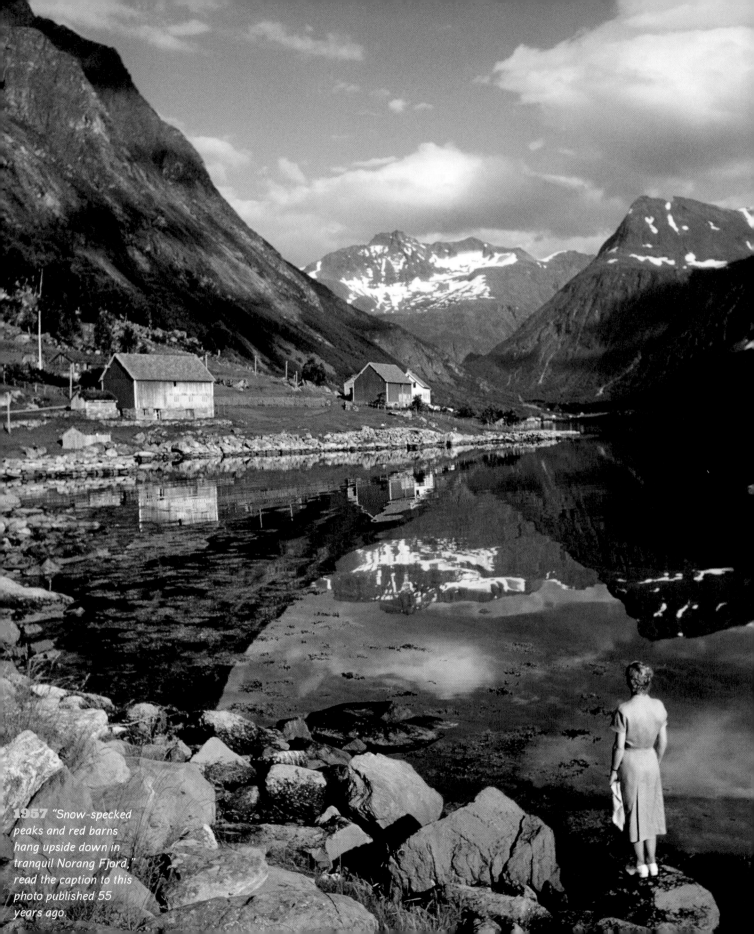

1957 *"Snow-specked peaks and red barns hang upside down in tranquil Norang Fjord," read the caption to this photo published 55 years ago.*

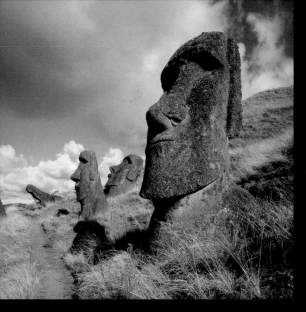

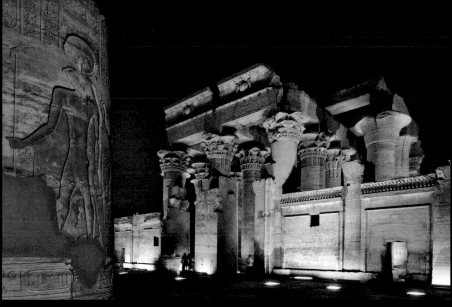

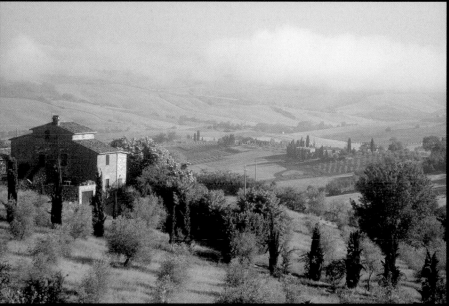

◂◂**1978** Aringa ora, *or living faces, maintain their eternally precarious vigil on the side of an Easter Island volcano.*

◂ **1998** *A stone farmhouse and hillside olive grove overlook a limeless Tuscan landscape.*

◂◂**1953** *London's trademark double-decker buses jockey to navigate Piccadilly Circus beneath the ornate building fronts of ritzy Regent Street.*

▴ **2009** *Columns topped with carved lotus flowers tower above visitors to the unusual double temple of Kom Ombo in Egypt. It honored both Sobek (the crocodile god) and Horus (the falcon god).*

▾ **1986** *The Kremlin (right) shimmers through the gauzy lace curtain of a Moscow hotel room. Would we give the scene a second glance without the pears?*

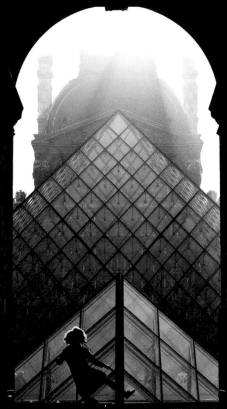

▲ **2006** *A Croatian woman welcomes visitors to her home in Lamna Draga with a bottle of home-brewed schnapps.*

◄ **2005** *A woman in the know enjoys a quiet lunch at Brooklyn's loudly decorated Sherwood Café.*

▼ **1997** *French tourists embody the burdens of travel as Tahitians tote them ashore.*

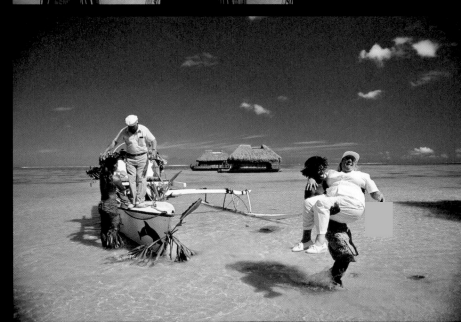

▲ **1989** *Photographer Jim Stanfield nailed France's celebration of its bicentennial with this complex shot of a girl kicking up her heels before the glass pyramids of the Louvre.*

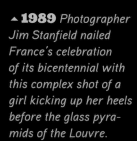

▲ **2006** *Two toreros are a study in anticipation as they prepare to face the next bull in the ancient Roman arena of Arles, France.*

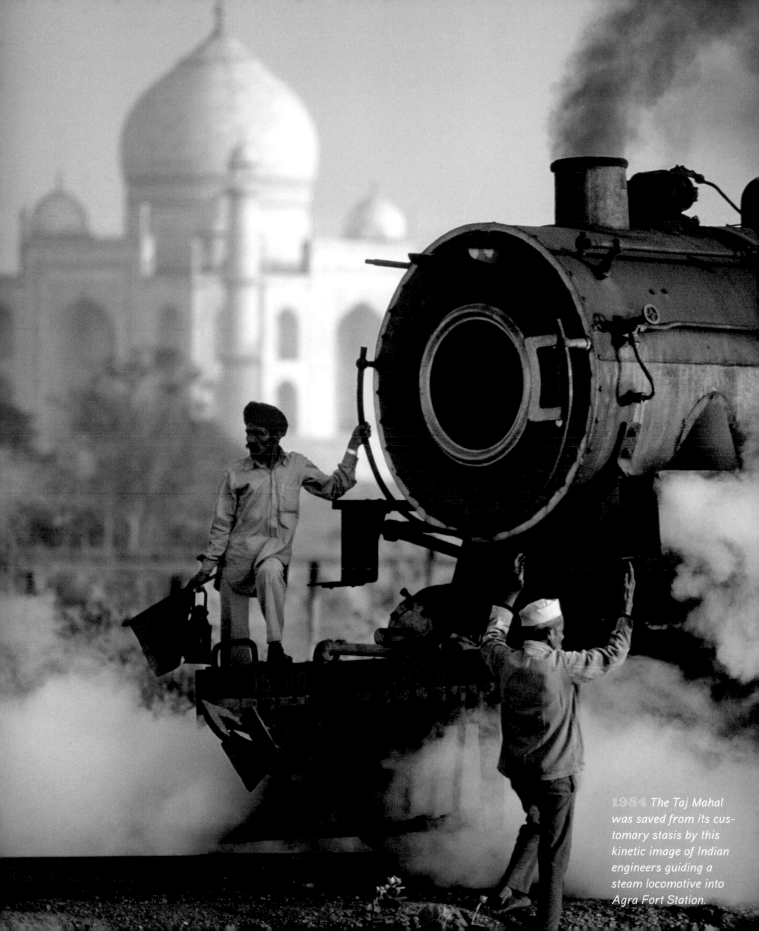

1984 *The Taj Mahal was saved from its customary stasis by this kinetic image of Indian engineers guiding a steam locomotive into Agra Fort Station.*

1993 *Hands entreating sky and earth, a Sufi mystic whirls to the rhythm of divine incantations at Istanbul's dervish school of Mevlana.*

2001 *A fishing boat sits secured four ways from Sunday in the Scottish Highlands harbor of Plockton.*

2008 *Salt-encrusted boulders litter the shore of Israel's Dead Sea at sunset.*

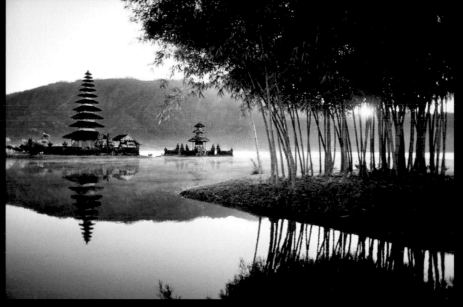

2009 *In a shot that went viral after posting on nationalgeographic.com, a squirrel inspects a remote-triggered camera in Canada's Banff National Park.*

2003 *The sea and two Hindu shrines create a scene of serenity on the montane coast of Indonesia's Bali.*

2011 *Quick: Is it a Matisse cutout or a quintet of camel-thorn trees backed by a dawn-tinged sand dune in Namibia's Namib-Naukluft Park?*

VIRAL SENSATION

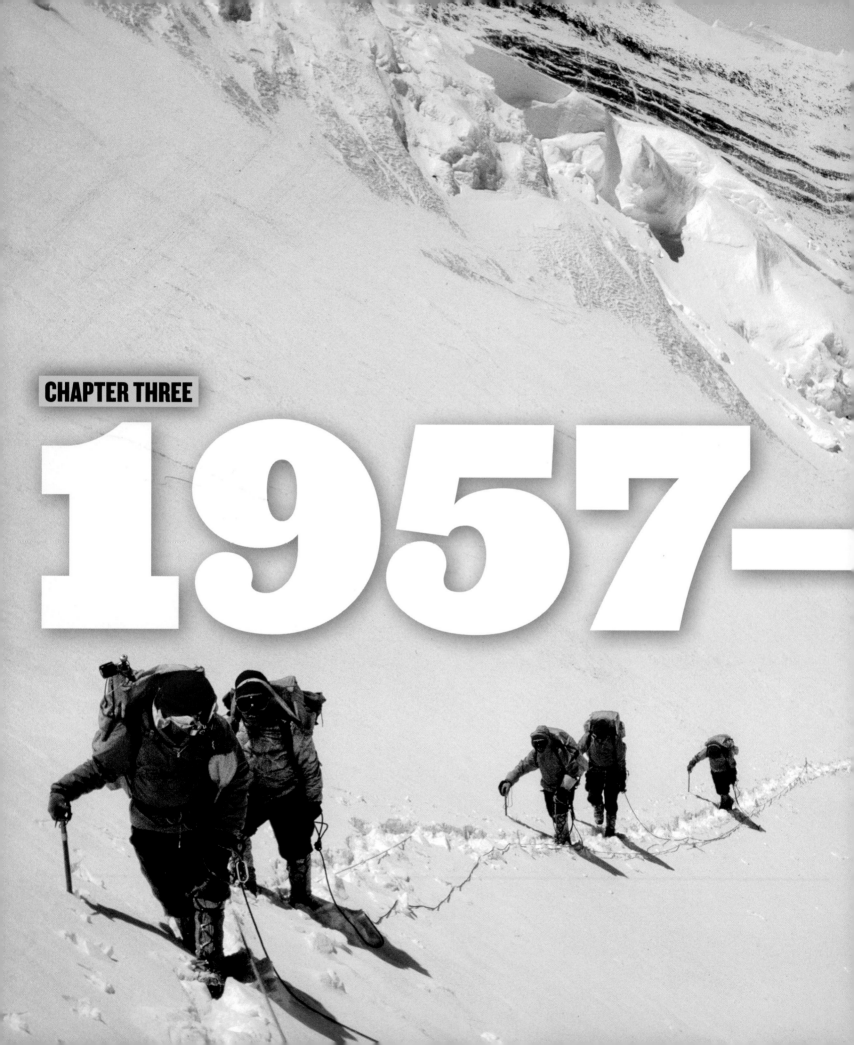

1957–

1969

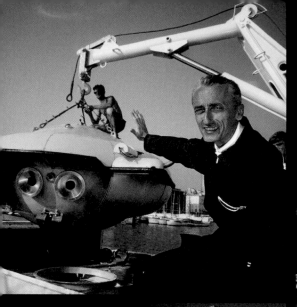

▾**1959** *Louis Leakey (below, with fossil) walks into Society headquarters, inaugurating over a half century of close ties with the National Geographic and the "First Family of Paleoanthropology."*

▴**1960** *Society support for Jacques-Yves Cousteau—1952–1967—results in improved underwater photography and the first fully maneuverable research submersible (above).*

▸**1963** *The Society commemorates its 75th anniversary by dispatching the American Mount Everest Expedition to the top of the world.*

▸**1961** *By agreeing to sponsor the chimpanzee studies of an inexperienced Jane Goodall, the Society helps effect a revolution in our understanding of ourselves as a species.*

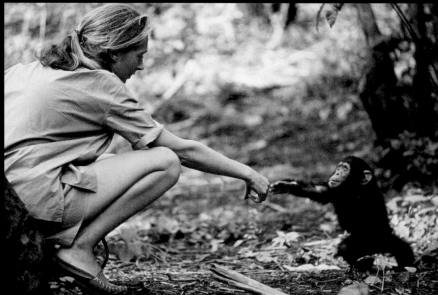

▾**1956** *Vanguard of a new photojournalism at the Geographic, Tom Abercrombie will become an expert in the Middle East.*

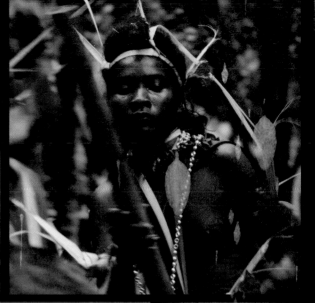

◄ 1964 National Geographic *staff photographer Dean Conger, one of a dynamic new cadre of photojournalists at the magazine, begins long-term coverage of the secretive Soviet Union.*

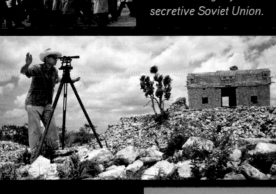

◄ 1960 *The Society begins a special relationship with NASA, providing color photography expertise to document Projects Mercury, Gemini, and Apollo for posterity.*

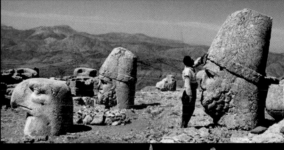

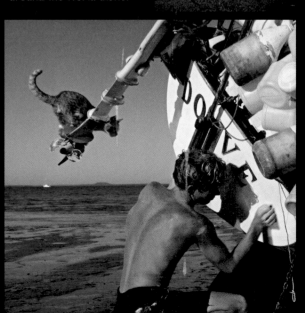

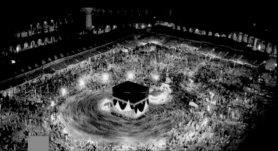

▼ 1966 *Sixteen-year-old Robin Lee Graham departs Los Angeles in* Dove, *and millions of* National Geographic *readers will follow his five-year adventure sailing around the world alone.*

▲ 1965 National Geographic *staff photographer Thomas J. Abercrombie, a Muslim convert, is permitted by Saudi Arabian authorities to photograph the annual pilgrimage to Mecca.*

▲ 1969 The Music of Greece, *an LP featuring traditional Greek music, inaugurates the Sounds of the World series, one of many product lines that flourished at this time.*

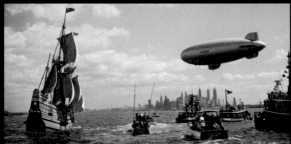

FLORIDA | 1963 With a blaze of neon, a Cocoa Beach motel announces the arrival of the space age.

FLY ME TO THE MOON

For three decades he had moved in the shadow of his father. But Melville Bell Grosvenor, a Naval Academy graduate who had worked at the National Geographic since 1924, only patiently twirled an absentminded finger through his silvering hair when younger staff men entrusted him with their ideas. He was anticipating the day that finally arrived in January 1957, when the 55-year-old Grosvenor was elected President and Editor. "Times change, gentlemen," was the tenor of his call to action, "and we are remiss—we are in trouble—if we do not change with them."

A dynamic new National Geographic Society then burst out of its old shell. Faster, better, brighter: Pent-up energies exploded as book publishing, television, atlases, and globes buttressed a reinvigorated magazine. Higher, deeper, farther: Funding for research and exploration increased tenfold, with Cousteau, Leakey, and Goodall becoming household names.

Generous, gregarious, enthusiastic: Melville's personality proved infectious, attracting a young, vigorous staff that responded to his "Ah, *boy*, that's good!" and his "Ah, yes, that's *great!*" with redoubled efforts. For it was precisely because he "knew how to say yes," as Luis Marden put it, that working for him became "such an abiding pleasure." And since he also possessed "perfect pitch," his contagious zeal caught on among the magazine's readers

as well: During his ten years as skipper, membership in the Society tripled.

It all made for a lively, glamorous era. Like the true son of the deep he was, Melville Grosvenor the sailor put the Geographic's wheel hard over for adventure. "Hitch your wagon to a star" had been one of his grandfather Alexander Graham Bell's favorite maxims; before he retired in 1967, Grosvenor would point the Geographic toward its greatest adventure yet: He allied the Society with the incipient U.S. space program, effectively hitching its wagon to—and ultimately planting its flag on—the moon. And that gave Ted Vosburgh, his successor as *National Geographic*'s Editor, an apt metaphor for describing "MBG's" ten-year tenure: It was "that fabulous decade, when the Geographic took off like a rocket with Melville at the helm." ■

KEY MOMENTS

1957 Melville Bell Grosvenor elected President and Editor; Luis Marden finds remains of H.M.V.S. *Bounty*; the Society launches its Book Service.

1959 Pictures start appearing on the *National Geographic* cover; long-term Society support for the Leakeys begins.

1960 Jacques Cousteau's diving saucer is unveiled; *National Geographic* starts special photographic assistance to NASA's Project Mercury.

1961 Society support for Jane Goodall and George Bass begins; the first National Geographic globe is released.

1963 The Society's 75th anniversary is commemorated by the American Mount Everest Expedition's successful summiting of Earth's highest peak; by the construction of a new ten-story headquarters building; and by the release of a world atlas.

1963-68 Various Society activities play a key role in the establishment of Redwood National Park.

1965 *Americans on Everest* introduces National Geographic Specials on CBS.

1967 Melville Bell Grosvenor retires; Frederick Vosburgh becomes Editor, Melvin Payne President.

1969 Apollo 11 carries the National Geographic Society flag to the moon; 6,500,000 copies of the December magazine include a supplement record, *Sounds of the Space Age*.

COUSTEAU AND CALYPSO

A parade of new heroes had started as early as 1952, when National Geographic supported an unknown French naval captain who had co-invented the first practical scuba system.

✳ SAILFISH SCIENCE

By the time a newborn sailfish is the size of the one shown above, it resembles a miniature adult. That's what Gilbert Voss discovered when he cracked the secret of their life history during a series of Society-supported research voyages in the 1950s. Tinier ones, though, look entirely different.

ABOVE: A sailfish (*Istiophorus platypterus*) from the Gulf of Mexico

Jacques-Yves Cousteau approached the National Geographic awash in ideas: Skippering a converted World War II minesweeper called the *Calypso,* the French Navy captain declared his "greatest confidence that our work, helped by your Society, will be particularly fruitful."

Cousteau was not given to understatement. In 1955 the *Calypso* embarked on a legendary voyage to the Red Sea and Indian Ocean. There, diving on coral reefs so pristine they resembled, in Luis Marden's words, "submarine gardens of Eden," Cousteau made a documentary, *The Silent World,* that won an Academy Award. The pictures Marden shot alongside him—published in the February 1956 *National Geographic*—revolutionized underwater photography. After the Society placed Harold Edgerton, inventor of the high-speed strobe light, aboard *Calypso,* Cousteau's spare figure, intense eyes ablaze, hunched beside that of the bespectacled MIT professor as they refined deep-sea cameras and underwater sonar to retrieve unprecedented pictures from the abyss. And *Geographic* readers simply loved what one editor described as his "lean, vivid, compelling style, the same far-seeing, creative imagination that marks Captain Cousteau's every utterance."

"WHAT A CHARIOT!"

By 1960 Cousteau was a household name—a visionary who symbolized an era as excited about exploring the sea as it was the stars. Just as the astronauts were soaring into "outer space," Cousteau's aquanauts plunged into "inner space." They even had their own flying saucer—or "diving saucer," nicknamed *Denise*. Bristling with view ports, sonar transducers, and deep-water cameras, it appeared out of the underwater gloom, to Cousteau's eye, like "some great bivalve or strange crustacean." Yet the hydrojets that powered the diving saucer made it the world's first fully maneuverable research submersible: fast, stable, and

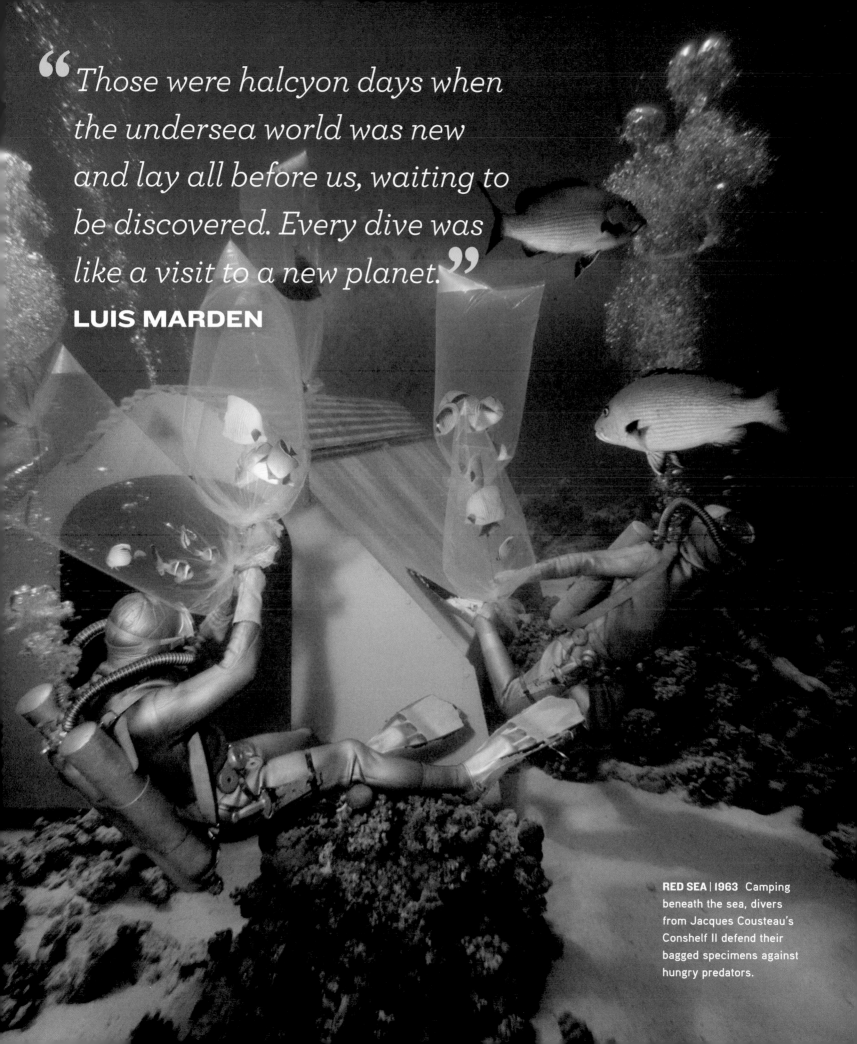

> *Those were halcyon days when the undersea world was new and lay all before us, waiting to be discovered. Every dive was like a visit to a new planet.*
> **LUIS MARDEN**

RED SEA | 1963 Camping beneath the sea, divers from Jacques Cousteau's Conshelf II defend their bagged specimens against hungry predators.

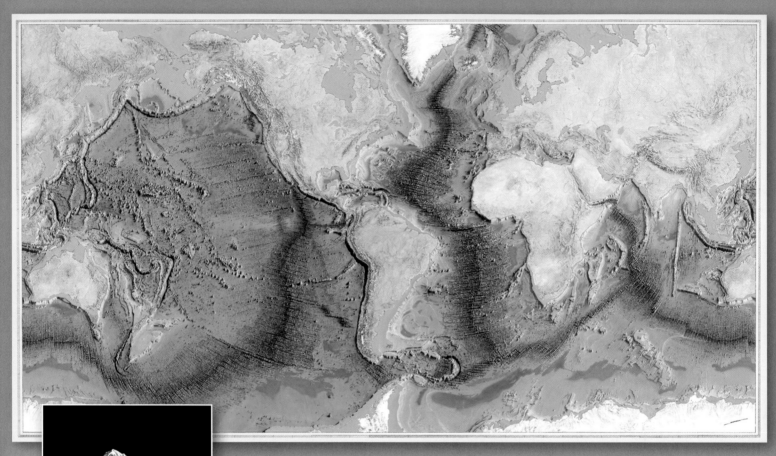

The Geographic's 1981 "Map of the World Ocean Floor"

◄ Left: Mount Everest, as painted by Heinrich Berann

✚ HIGHEST VS. TALLEST

In 1963, Heinrich Berann painted Earth's highest peak, 29,029-foot Mount Everest (above), but it wasn't until October 1969's "Pacific Ocean Floor" map that he depicted the planet's tallest mountain: the island of Hawaii, which rises nearly 33,000 feet from the seabed—but only 13,796 feet of it protrudes above the surface.

Neither one intended to be a mapmaker. Only during World War II did music major Marie Tharp receive cartographic training and start working for geophysicist Bruce Heezen. While plotting his sonar soundings of the ocean floor on bathymetric charts, she noticed the figures dipped when crossing the Mid-Atlantic Ridge—indicating the possible presence of a rift valley.

"Continental drift" constituting geologic heresy at the time, Heezen initially rebuffed Tharp's hypothesis—if you define rebuffing as angrily erasing portions of a colleague's work. She returned fire by pelting him with bottles of India ink. Eventually, though, Heezen was forced to acknowledge that Tharp's patterns were undeniable, and the two scientists joined forces to plot thousands of additional soundings.

Still, their work did not spring to life. That happened only after the Geographic introduced them to Heinrich Berann, an Austrian painter of mountain landscapes. The ocean-floor maps that resulted from the trio's collaboration—issued between 1967 and 1981—depicted great abyssal plains and soaring seamounts; encircling mountain ranges and rift valleys splitting the globe like the seams of a baseball. The charts opened millions of people's eyes to the unseen three-quarters of their planet. ■

responsive. One oceanaut emerged from a test spin exclaiming, "*Nom de Dieu!* What a chariot!" Initially deployed in the Caribbean, Mediterranean, and Red Seas, *Denise* could descend to about 1,000 feet. That should be deep enough, its inventor thought, to explore most of the world's continental shelves—which, Cousteau believed, would soon abound with human habitations and underwater cities.

HOMO AQUATICUS

Jacques Cousteau, prophet of the coming age of *Homo aquaticus*, persuaded the Society to help sponsor the series of experimental submarine habitats called Conshelf I, II, and III. The futuristic dwellings, deployed in the Mediterranean and Red Seas, saw oceanauts living like undersea Jetsons at depths ranging from 33 to 330 feet. Within those underwater palaces they relaxed by reading newspapers delivered daily by divers. A tender at the surface provided electricity and telephone service; because the men below were breathing a mixture of oxygen and helium, however, they spoke over the receiver with Donald Duck voices. After one group managed to stay underwater for 23 days, a Geographic executive exclaimed, "Another brilliant feather (or fin) in Jacques' cap!" Yet years later, the mercurial Cousteau, by then an ardent environmentalist, shrugged it all off as having been a "complete fantasy." ■

✱ REMEMBERING JYC

Jacques-Yves Cousteau left an indelible imprint everywhere he went. A staff artist even embellished the Society's official guest book after a visit by JYC. "Zheek," as those initials were pronounced, had been describing his plans for Conshelf III, the sphere-shaped colony he hoped to plant on the Mediterranean seafloor.

ABOVE: A memorable sketch in one of the Society's guest books. The fish is holding a sign stating, "Unfair— Get lost!"

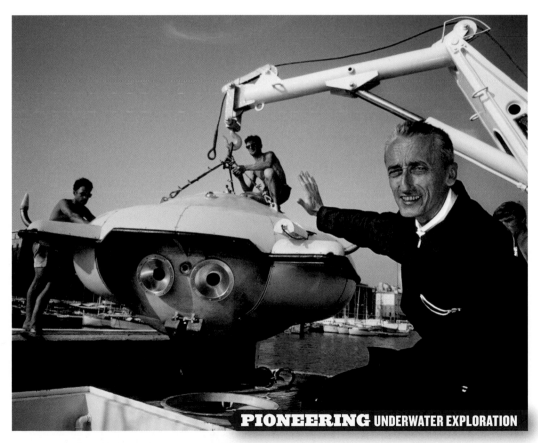

PIONEERING UNDERWATER EXPLORATION

PUERTO RICO | 1960 Jacques-Yves Cousteau unveils *Denise,* his revolutionary, Society-sponsored diving saucer.

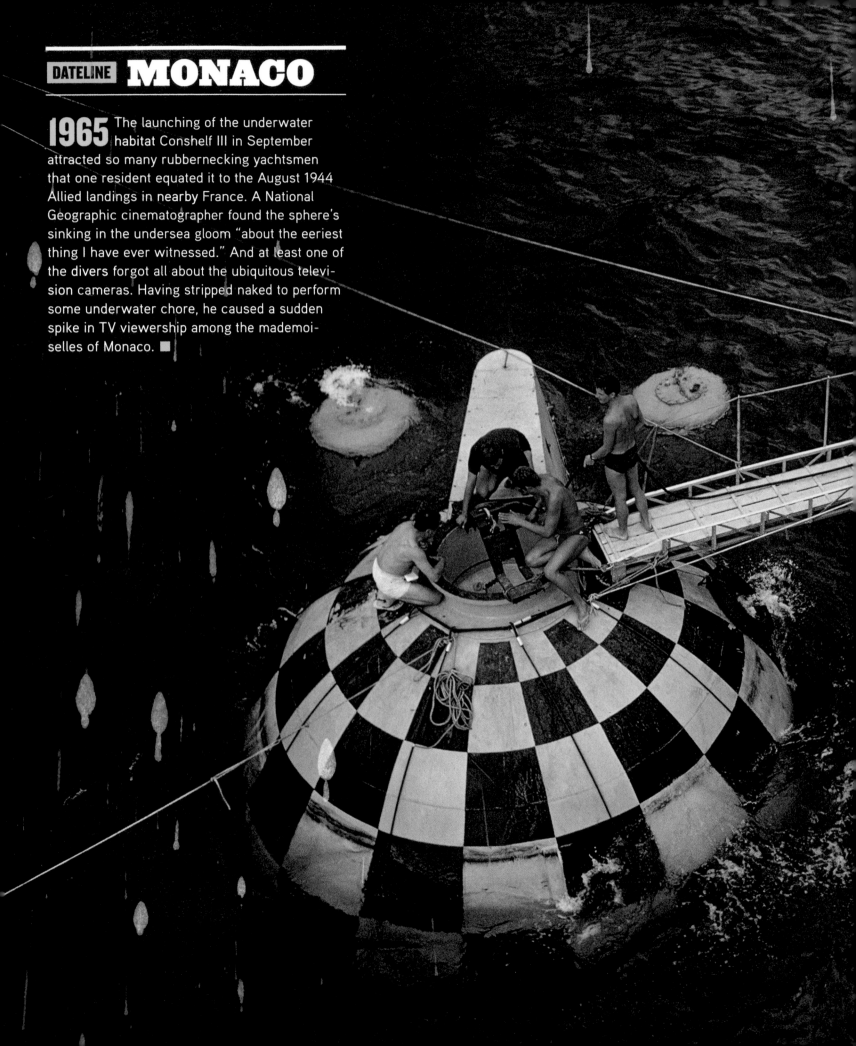

1965 The launching of the underwater habitat Conshelf III in September attracted so many rubbernecking yachtsmen that one resident equated it to the August 1944 Allied landings in nearby France. A National Geographic cinematographer found the sphere's sinking in the undersea gloom "about the eeriest thing I have ever witnessed." And at least one of the divers forgot all about the ubiquitous television cameras. Having stripped naked to perform some underwater chore, he caused a sudden spike in TV viewership among the mademoiselles of Monaco. ∎

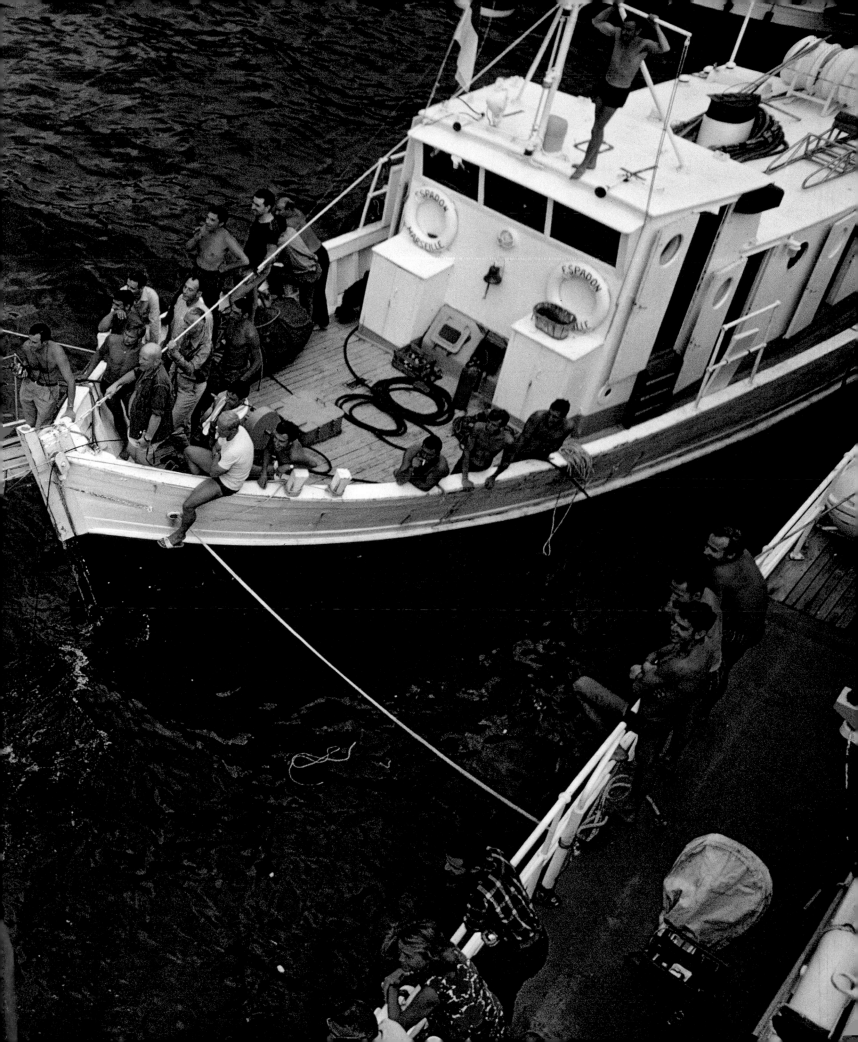

LET THE CAMERAS ROLL

Adventure, National Geographic–style, reached millions more armchair travelers when the Society first ventured onto the nation's television sets.

Americans on Everest
SEE IT ON TV
FRIDAY
SEPT. 10

✳ A BRAND-NEW ERA

One critic hailed *Americans on Everest*, the Society's small-screen debut, as "television's finest hour," perhaps because other shows that season included *Green Acres*, *Hogan's Heroes*, *I Dream of Jeannie*, and *Lost in Space*.

ABOVE: The magazine urged its members to watch *Americans on Everest*.

In January 1957, on faraway Pitcairn Island in the South Pacific, Luis Marden capped six weeks of diving in thundering surf by discovering the remains of the H.M.V.S. *Bounty*. The ship made famous by a mutiny had been sailed to that lonely spot and scuttled in 1790, and no one had thought to look for her since.

Though he was able to salvage little more than copper spikes and sheathing nails, the discovery made front-page news. It was also good for a whopping 60-page article in the magazine. And it turned Marden himself—who sported cuff links made from those sheathing nails—into a swashbuckling figure. So in 1962, when moviegoers watched Marlon Brando stride the decks of a magnificent replica of the fabled square-rigger in MGM's *Mutiny on the Bounty*, those who worked for the Society spotted a familiar face among the crew—Luis Marden's.

Yet a different type of movie would set the Society on an exciting new course. One Sunday night in February 1958, Marden's lecture film on his Pitcairn adventures was broadcast on NBC's *Omnibus*. It scored one of that program's highest ratings that season—and launched the good ship Geographic into the age of television.

SIX TO THE SUMMIT

The *Omnibus* venture was a testing of the waters, a chance to see whether or not the Society's popular travelogue lectures, which routinely packed Washington's cavernous Constitution Hall, could make the leap onto the small screen. Its success confirmed Melville Grosvenor's sense that a "far wider audience" was within reach. He promptly set up a television division, though its first production was not set in the lush South Seas. Instead it starred a soaring rampart of rock and ice.

In the spring of 1963 long lines of porters wound their way through the valleys of Nepal

64 **1969:** Apollo 11's Neil Armstrong and Buzz Aldrin set foot on the moon, carrying with them the hopes of humanity (and a tiny National Geographic Society flag). ▼

65 **1970:** *National Geographic* presents an unsparing look at pollution in a December cover story that inaugurates an era of hard-hitting photojournalism.

66 **1971:** Biruté Galdikas, the third of "Leakey's Angels," begins her long career studying Borneo's endangered orangutans.

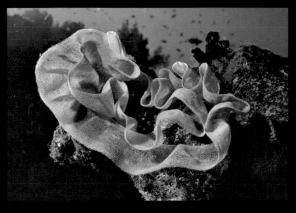

67 **1971:** Working in the Red Sea alongside marine biologist Eugenie Clark, studying swaying garden eels and poisonous flatfish, David Doubilet launches his remarkable career as one of National Geographic's preeminent underwater photographers. ▲

68 **1976:** The haunting songs of humpback whales are studied by Roger Payne, one of the first scientists to identify individual cetaceans by the characteristic markings on their flukes. ▼

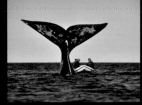

69 **1974–1988:** Working the rain forests of Peru and Colombia, Alwyn Gentry collects thousands of plant specimens, hundreds of them new to science. His efforts provide a model for later rapid-assessment programs in threatened natural habitats.

70 **1975:** Revealing the marvels of the human body, the Society's first Special on PBS—*The Incredible Machine*—breaks viewership records.

71 **1975:** *World* magazine (later renamed *National Geographic Kids*) replaces an aging *National Geographic School Bulletin* as the Society's publication for children. By year's end it reaches a circulation of 1.3 million.

72 **1975:** In the year after his sensational discovery of "Lucy," a 3.2-million-year-old hominid, Donald Johanson uses Society funding to return to Ethiopia and uncover 13 additional individuals, dubbed the First Family of Hominidae. ◀

73 **1975:** Fred and Norah Urquhart's team discovers the long-sought wintering grounds of the eastern population of North America's monarch butterflies in a handful of fir forests high in Mexico's Sierra Nevada mountains. ▲

74 **1977:** Thanks to a *National Geographic* photographic team, scientists discover the first hydrothermal vents deep in the Pacific Ocean's Galápagos Rift—and gaze on a previously unsuspected ecosystem, the first ever found not ultimately dependent on the sun for energy. ▲

➡ Pull to open

75 **1978:** Mary Leakey uncovers the world's oldest hominid footprints, left in volcanic ash some 3.6 million years ago. They had been made by upright-walking australopiths—apelike forebears of humans—proving that bipedalism is a more ancient inheritance than is *Homo sapiens'* large brain.

76 **1979:** Wearing a pressurized hard-shell diving suit, Sylvia Earle strolls on the seafloor off Oahu, some 1,200 feet beneath the surface. Twelve men had already visited the moon, but "Her Deepness" becomes the first human to walk untethered this deep in the sea.

77 **1981:** Writer Rowe Findley's "Eruption of Mount St. Helens: Mountain with a Death Wish," published in the January issue, becomes one of the most popular articles in National Geographic history.

78 **1981:** A special 13th issue, focusing on energy needs, is published by *National Geographic*. A special issue on water follows in 1993. ▼

110 **2005:** Dean Falk's endocast studies of an elfin hominid skull found in Indonesia indicate that *Homo floresiensis*—or the "hobbit"—was indeed a separate species.

111 **2005:** Grantees Tim Samaras and Carsten Peter take the first photographs inside the cone of a tornado. ▼

112 **2005:** A "lost world" is discovered by Stephen Richards and Bruce Beehler in the remote Foja Mountains of New Guinea. It is inhabited by hundreds of different kinds of plants and animals, 40 of them previously unknown.

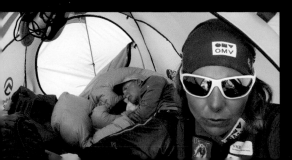

113 **2005:** Marine ecologist Enric Sala inaugurates his Pristine Seas initiative documenting some of the last unspoiled coral reefs in the Pacific and prompting the creation of marine preserves in Costa Rica and Chile. ◄

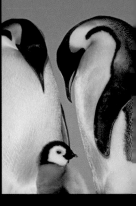

114 **2006:** *March of the Penguins* wins an Academy Award for best documentary feature. ▲

115 **2006:** President George W. Bush creates the Northwestern Hawaiian Islands Marine National Monument. The need for the park had been championed for years by Explorer-in-Residence Sylvia Earle.

116 **2006:** *National Geographic* publicly reveals the only known surviving copy of the Gospel of Judas, a document dating to roughly the third century. Initial interpretations of the controversial text suggest that Jesus may have planned the events leading to his death. ◄

117 **2007:** Photographer and mountaineer James Balog documents the shocking speed at which ice on Earth is vanishing in his cover story "The Big Thaw" and a corresponding book, *Extreme Ice Now.* ▲

118 **2007:** On their "Language Hotspots" map, K. David Harrison and Greg Anderson identify languages in danger of extinction. The Society's Enduring Voices Project is also striving to document such tongues before it is too late.

119 **2009:** In an attempt to stem the drastic decline of the world's big cats, Explorers-in-Residence Dereck and Beverly Joubert spearhead the Big Cats Initiative, a campaign to raise awareness and fund research. ▼

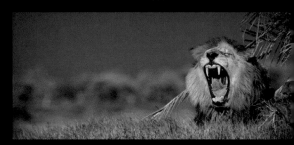

120 **2009:** Using crowd-sourcing and such noninvasive technologies as ground-penetrating radar and online networks, grantee Albert Yu-Min Lin searches for Ghengis Khan's tomb.

121 **2010:** The National Geographic World Atlas app for iPhones is downloaded more than one million times. The first fully interactive and downloadable edition of *National Geographic* magazine likewise premieres.

124 **2011:** Dr. Krithi Karanth receives the Society's 10,000th grant. The funds are being used to examine the conflicts that frequently occur between humans and India's storied wildlife.

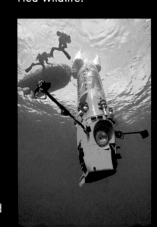

125 **2012:** Six and a half miles below the surface of the sea, Explorer-in-Residence James Cameron completes the first solo trip to the ocean's deepest spot: the Mariana Trench. ◄

122 **2011:** Gerlinde Kaltenbrunner becomes the first woman to summit all 14 of the world's 8,000-meter peaks without using supplemental oxygen. ▼

123 **2011:** *Restrepo,* a film that documents an Army deployment to a remote valley in Afghanistan, is nominated for an Academy Award.

The Adventure Continues

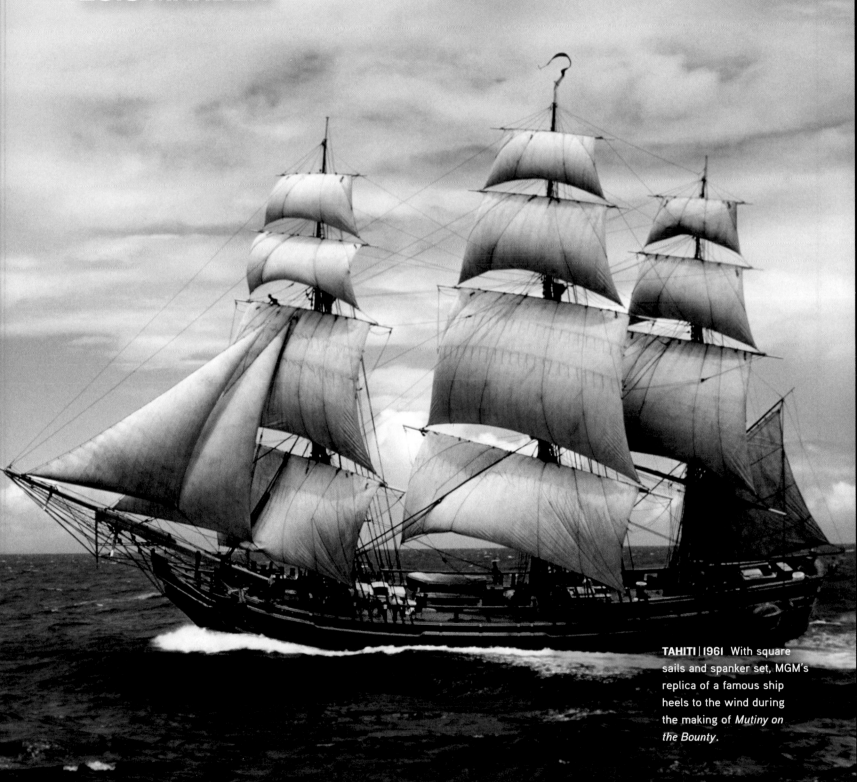

"When we brought the sheets home, the wet sails bellied out into beautiful curves and began to draw."

LUIS MARDEN

TAHITI | 1961 With square sails and spanker set, MGM's replica of a famous ship heels to the wind during the making of *Mutiny on the Bounty*.

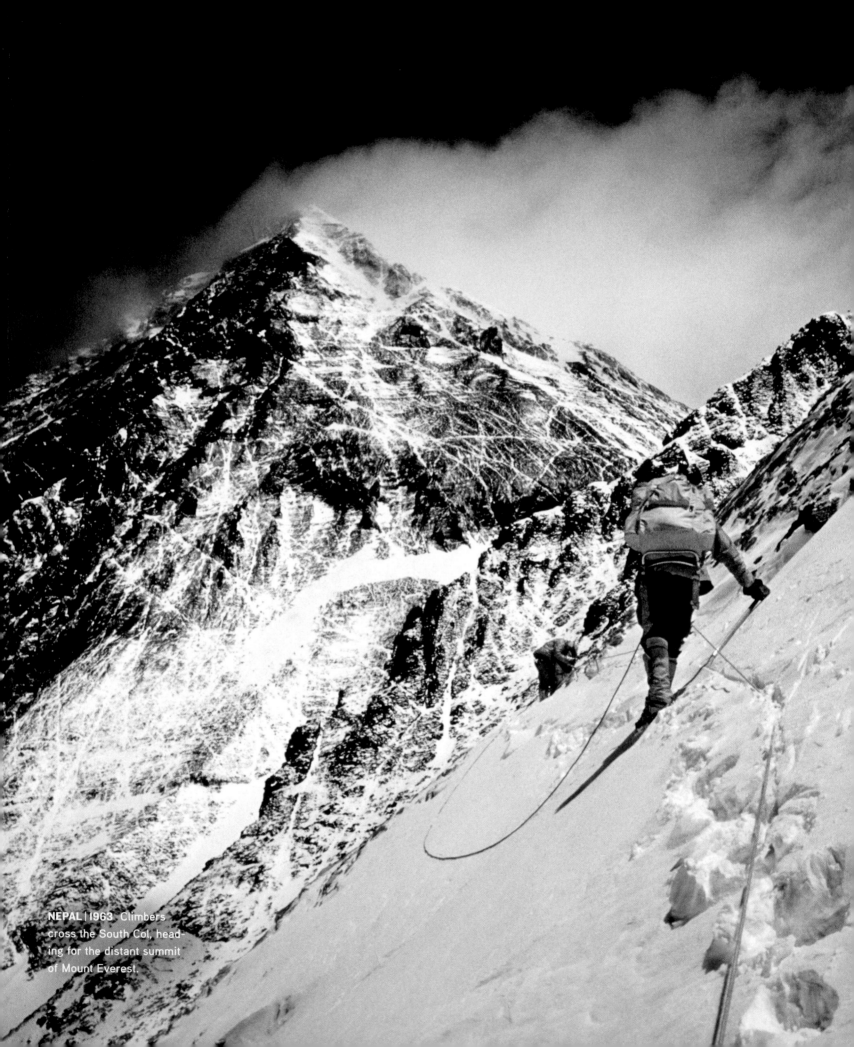

NEPAL | 1963 Climbers cross the South Col, heading for the distant summit of Mount Everest.

to the foot of Chomolungma, "goddess mother of the world." The Society-sponsored American Mount Everest Expedition, with its 19 climbers and 32 Sherpa guides, was a miniature army preparing to lay siege to a mountain. Among its 27 tons of supplies—which also included freeze-dried rations, oxygen canisters, bottles of beer, and cartons of cigarettes—were seven movie cameras and 28,000 feet of film, for expedition leader Norman Dyhrenfurth was not only an expert climber but also a talented cinematographer.

During the month of May the expedition pushed a record six climbers onto the summit, including the Society's own Barry Bishop. All of them survived—barely: Bishop lost his toes to frostbite. Two of the men even succeeded in making the first successful traverse up Everest's western slopes, across the summit, and down again to the safety of lower elevations via the established South Col route.

Meanwhile, those movie cameras never ceased clicking and whirring. Dyhrenfurth returned with gripping footage of men inching their way, by ice ax and crampon, up frozen slopes to a peak soon planted with American and National Geographic flags, both snapping in the wind. When edited down—and narrated by the sonorous baritone of Orson Welles—it was sure to be a television hit.

EXPANDING HORIZONS

Standing in the Rose Garden one July day in 1963 to bestow the Society's Hubbard Medal upon the first Americans to summit Everest, President John F. Kennedy

⚙ BY HIS BOOTSTRAPS

Barry Bishop's leather-and-fur boots could not protect him against the rigors of a night spent exposed on the slopes of Everest. The Society's representative lost all ten toes to frostbite.

ABOVE: A boot that failed

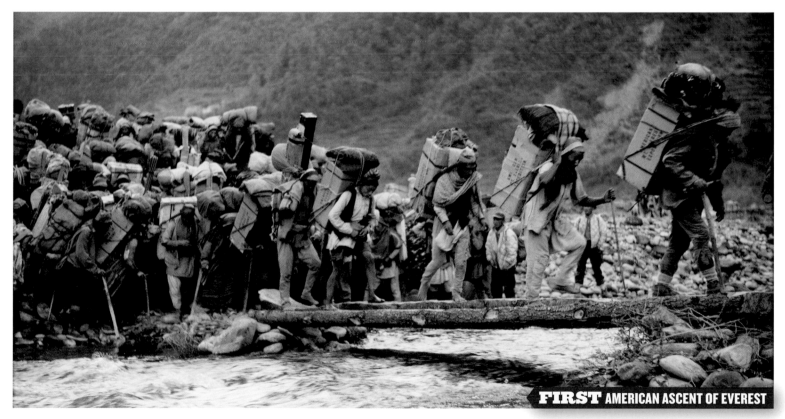

FIRST AMERICAN ASCENT OF EVEREST

NEPAL | 1963 In a "little war against a big mountain," 909 porters carried 27 tons of equipment from Kathmandu to the expedition's base camp.

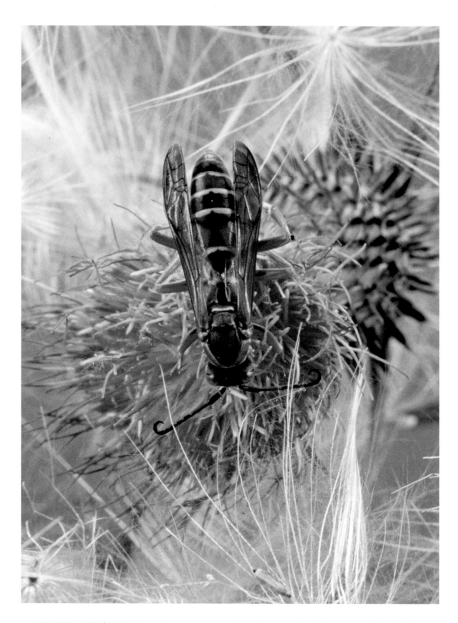

INSECTLAND | 1952 A male paper wasp feeds on a thistle's nectar. *The Hidden World* brought the marvels of insect behavior to a mass television audience.

PROGRAM GUIDE

1967—THE HIDDEN WORLD

"This is the incredible world of insects, teeming beneath leaf and log, in flower and field, in exotic jungle and your own backyard."

1969—POLYNESIAN ADVENTURE

"On April 15, your own passport to the South Pacific will be your TV screen, when the National Geographic Society presents 'Polynesian Adventure.'"

commended them for having journeyed to the "far horizon of experience." Two years and two months later, on September 10, 1965, millions of Americans followed them there, tuning their television sets to CBS and watching the Geographic's prime-time debut, *Americans on Everest*—which scored the highest ratings of any television documentary yet broadcast.

That success also opened new horizons for the Society. Each year a series of four National Geographic Specials followed the path it had blazed into America's living rooms. Millions of people who never saw the magazine encountered Jane Goodall and Jacques Cousteau and Louis Leakey via television. CBS broadcast all the specials in color—and all in prime time. The mix of subjects resembled that found in the *Geographic*. *The Hidden World* brought viewers face-to-face with insects. *Australia, the Timeless Land* took them to the outback. *The Lonely Dorymen* followed Portuguese fishermen across the Atlantic. *Siberia, the Endless Horizon* looked crystal-cold courtesy of a movie camera designed to function at minus 70 degrees Fahrenheit. And in February 1968 some 35 million people watched *Amazon,* the first documentary ever to top every TV ratings chart.

LOVING A CHALLENGE

Melville Grosvenor was meanwhile expanding the Society's horizons in every direction. He cast off the shackles of old printing technology, and by February 1962 high-speed presses were churning out an all-color *National Geographic*—one now featuring photographs on its cover, despite one Englishman's grumble, when the first ones appeared in 1959, that "if God had intended a picture on the cover of the *National Geographic* he would have put one there in the first place!"

Melville also modernized the Society's mapmaking efforts. He soon had the Cartographic Division laboring away on the first *National Geographic Atlas of the World,* published in 1963. And if he was going to compile an atlas, Melville concluded he might as well produce a globe too. Tired of bending over every time he wished to follow the progress of Antarctic expeditions, however, Grosvenor called for one that could be freely rotated in its cradle. It would also be capped by a transparent plastic "geometer"—a device that allowed users to trace satellite orbits, calculate azimuths,

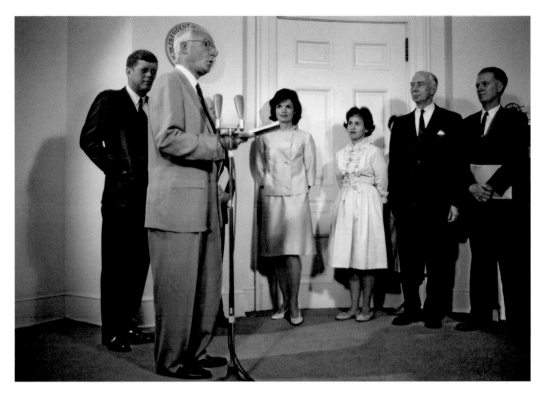

WASHINGTON, D.C. | 1962 Melville Grosvenor presents *The White House: An Historic Guide* to the First Family.

or solve a host of arcane geographic puzzles. The bells and whistles made it a "globe for the space age," as its designers were calling it. The Smithsonian Institution's Astrophysical Observatory adopted it immediately for use in its satellite tracking stations. But when the finished product was presented to President Kennedy, the geometer slipped off and shattered on the floor.

Melville had been trooping down to the White House on a regular basis anyway. If he wasn't asking the President to present a gold medal to the American Mount Everest team, he was having him confer one on Jacques Cousteau. But one day in early 1962 Grosvenor had made the six-block journey because the First Family wanted something from *him*. Mrs. Kennedy, deploring the Executive Mansion's lack of period furnishings, had established the White House Historical Association to help restore it; inspired by a 1961 *Geographic* article on her new home, she decided that selling an official guidebook to the White House might help fund its face-lift. So Melville, who already had one book division spinning out new publications, told an assembly of dignitaries gathered in the East Room that National Geographic would produce a guidebook for her as a public service.

Melville, as one friend put it, "loved a challenge and had a way of making you believe the impossible wasn't really difficult to achieve." Which meant that a team of editors then went to work achieving the impossible: They toiled seven days a week—on top of their regular magazine duties—to produce the 132-page illustrated White House guidebook within six months. Hardly had it been presented to the First Lady in June before similar "public service books" on the Capitol and the Supreme Court were being planned. It was an exciting, if exhausting, time. ▪

✳ FIRST LADY'S TOUR

"It was planned—at first—for the children," Jacqueline Kennedy wrote in the first edition of her guidebook, *The White House: An Historic Guide*. "Its purpose was to stimulate their sense of history and their pride in their country." Soon enough, though, "so many little-known facts were gleaned from forgotten papers," she said, that it became a book for adults as well. Fifty years and 22 editions later, it has sold millions of copies.

ABOVE: First edition of *The White House: An Historic Guide*

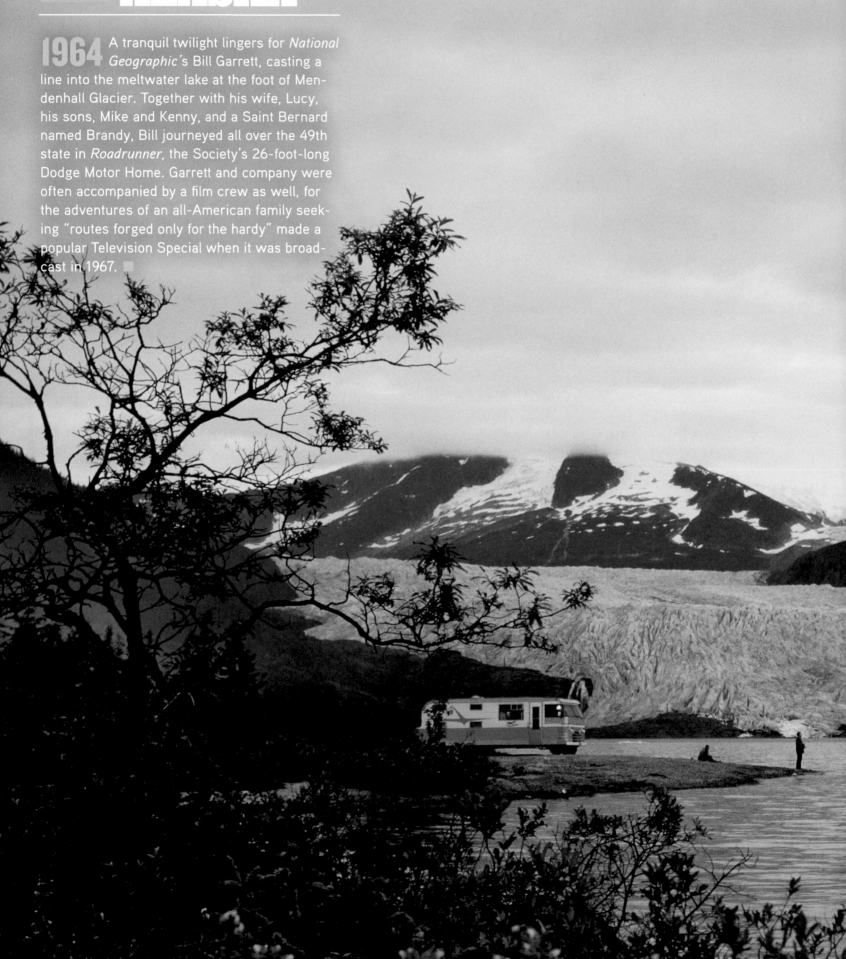

1964 A tranquil twilight lingers for *National Geographic's* Bill Garrett, casting a line into the meltwater lake at the foot of Mendenhall Glacier. Together with his wife, Lucy, his sons, Mike and Kenny, and a Saint Bernard named Brandy, Bill journeyed all over the 49th state in *Roadrunner,* the Society's 26-foot-long Dodge Motor Home. Garrett and company were often accompanied by a film crew as well, for the adventures of an all-American family seeking "routes forged only for the hardy" made a popular Television Special when it was broadcast in 1967. ∎

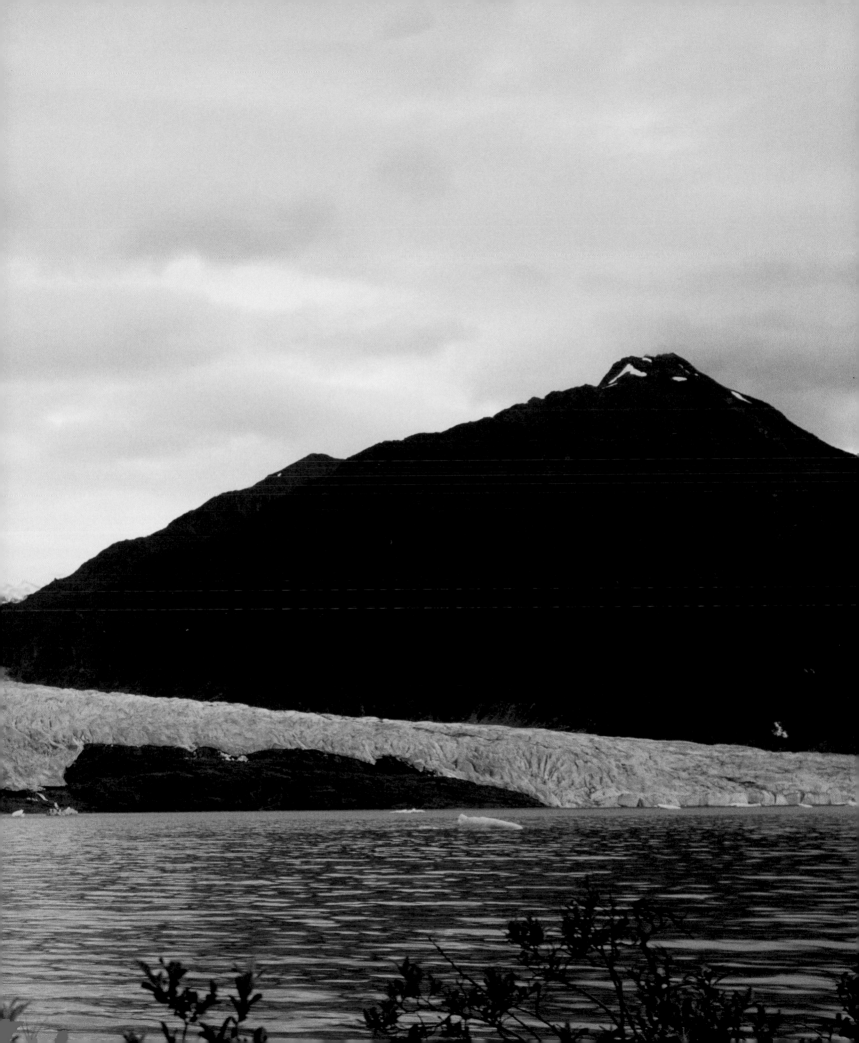

IN THE SHADOW OF MAN

By taking a chance on a tarnished paleontologist and an untested primatologist, the Society revolutionized our understanding of what it means to be human.

⊛ LEAKEY'S MENAGERIE

Visiting the Leakeys was a trip to the zoo. At Olduvai, Dalmatians warned of snakes, leopards, lions, or rhinos. In Nairobi, hyraxes strolled across the dinner table. Pet pythons and vipers cruised the yard. Tame owls, gnus, and duiker antelope were seen hanging around. And Simon, Mary's pet Sykes monkey, might launch itself at her prettier guests.

ABOVE: A Dalmatian has a stretch at Olduvai Gorge.

He was a man with a past. Dogged by unsustainable claims, paleontologist Louis Leakey was putting a checkered career behind him in late 1959. The rumpled, silver-haired director of Kenya's Coryndon Museum, a repository of archaeological and natural history artifacts, had good reason to believe that a professional resurrection was at hand, for he had finally found something he had long been seeking.

For three decades, meager resources permitting, Leakey and his wife, Mary, had been exploring Tanzania's Olduvai Gorge, which snakes across the Serengeti Plain, its exposed cliffs layered with the fossils of extinct animals and an abundance of stone tools. Leakey had been seeking the toolmaker, and Mary had that summer discovered a shattered hominid skull, some 1.75 million years old, that he thought might represent "the world's oldest known human."

Melville Grosvenor believed him. So he steered a generous research stipend Leakey's way. That enabled the couple to concentrate their efforts; as a result, Olduvai soon began yielding its secrets. Over the next few years the *Geographic* took its readers to the colorful camp perched on the rim of the gorge, where Leakey, in his worn Khaki coveralls, described their astonishing finds: fossil skulls, teeth, jawbones, tibias, and toes. Taken together, these constituted the discovery of the newly named *Homo habilis*, or handy man. The Leakeys were proving that Africa, not Asia, was the cradle of humankind.

THE CHIMPANZEES OF GOMBE

Hardly had Leakey secured his first Geographic grant before he was seeking additional funding. Because apes and humans sprang from the same genetic root, he argued, a study of chimpanzees, our closest cousins, might provide a glimpse into

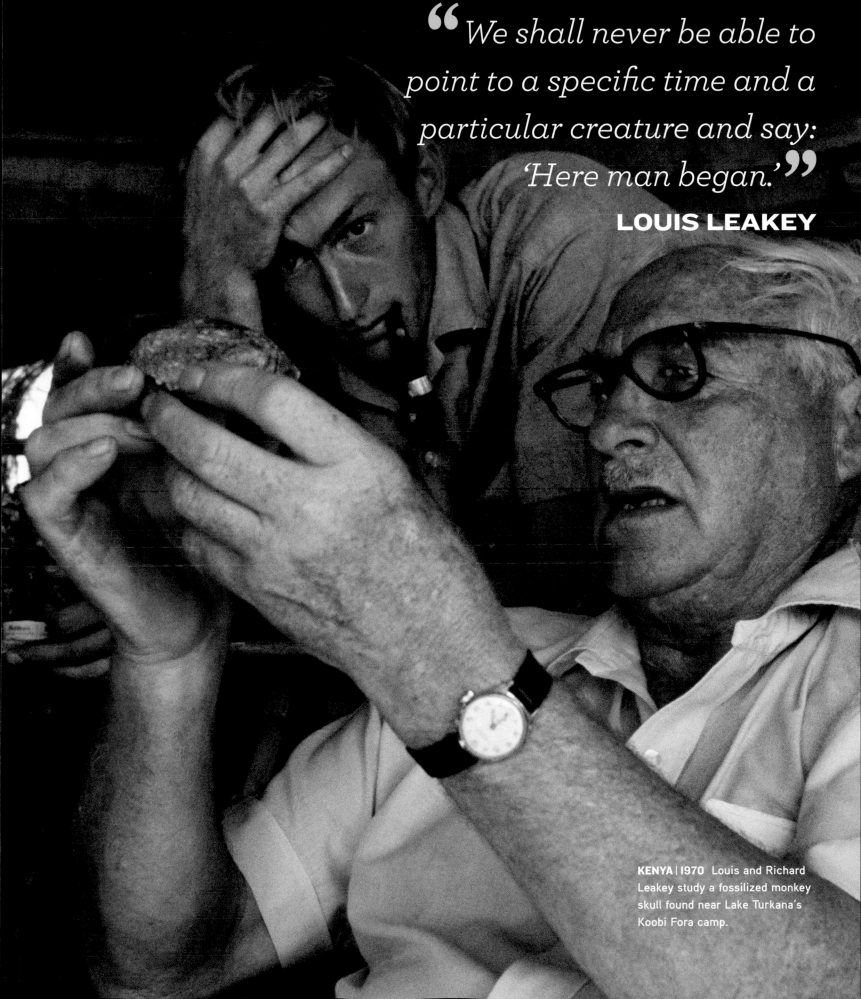

> *We shall never be able to point to a specific time and a particular creature and say: 'Here man began.'*
>
> **LOUIS LEAKEY**

KENYA | 1970 Louis and Richard Leakey study a fossilized monkey skull found near Lake Turkana's Koobi Fora camp.

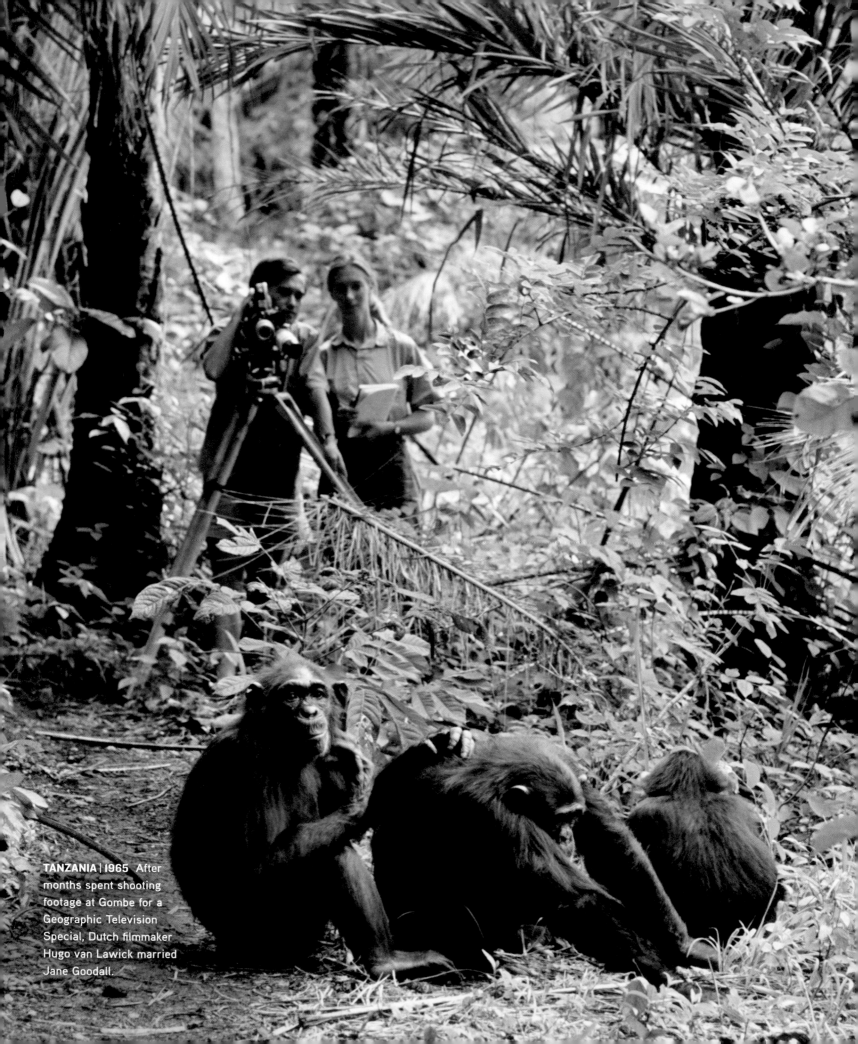

TANZANIA | 1965 After months spent shooting footage at Gombe for a Geographic Television Special, Dutch filmmaker Hugo van Lawick married Jane Goodall.

WASHINGTON, D.C. | 1962 Visiting Society headquarters, Jane Goodall and the National Zoo's Lulu meet Melville Grosvenor (left) and Leonard Carmichael, chairman of the Geographic's Research Committee.

early hominid behavior. Leakey knew that chimpanzees lived in Tanzania's Gombe Stream Reserve on Lake Tanganyika. He had a researcher working there—a former secretary who lacked academic credentials but was already making startling discoveries.

Again Melville Grosvenor believed him, so in 1961 the Society began supporting Jane Goodall. That she leaped into superstardom was no doubt due partially to the Beauty among the Beasts appeal of her story. But her discoveries *were* startling: She had seen chimpanzees—assumed to be vegetarians—stalk, kill, and eat other animals. She had watched them strip the leaves from twigs, insert the sticks into termite mounds, and fish out delectable snacks. This meant chimps were not only using tools but fashioning them as well, a trait previously considered exclusively human. She had even observed them perform ritualized "rain dances."

Patiently she had habituated the apes to her presence in the forest: First she was tolerated, then accepted, and finally allowed to play with their infants. Yet even this idyllic "Chimpland," as Goodall called Gombe, would be darkened, she later discovered, by chimpanzee wars. In fact, so closely did they resemble humans, Jane would assert, that chimps "cannot be thought of as animals—they just cannot." ■

✱ JANE'S CHIMPS

"Unaware of the scientific prejudices of the day," Jane Goodall once wrote about her early years at Gombe, "I gave the chimps names and described their rich personalities in human terms." What *Geographic* reader could ever forget David Greybeard, the first to accept Jane those many years ago? Or those other denizens of 1960s Chimpland, Goliath, Gremlin, and little Flint, who died so young? And of course Flo, the matriarch whose daughter Fifi would give birth to Frodo and Flirt, among others. Though torn at times by heartbreaking deaths, the saga of the generations still unfolds at Gombe today.

BELOW: Goodall's sketches of a chimpanzee leaping a stream

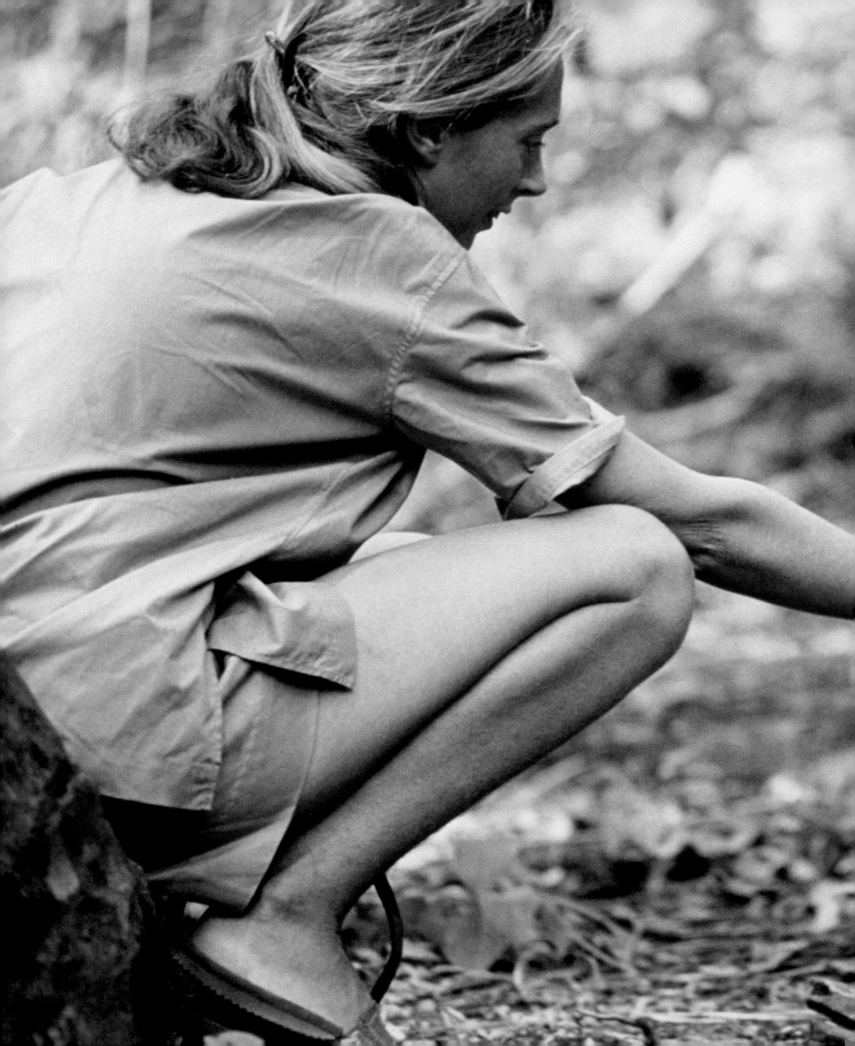

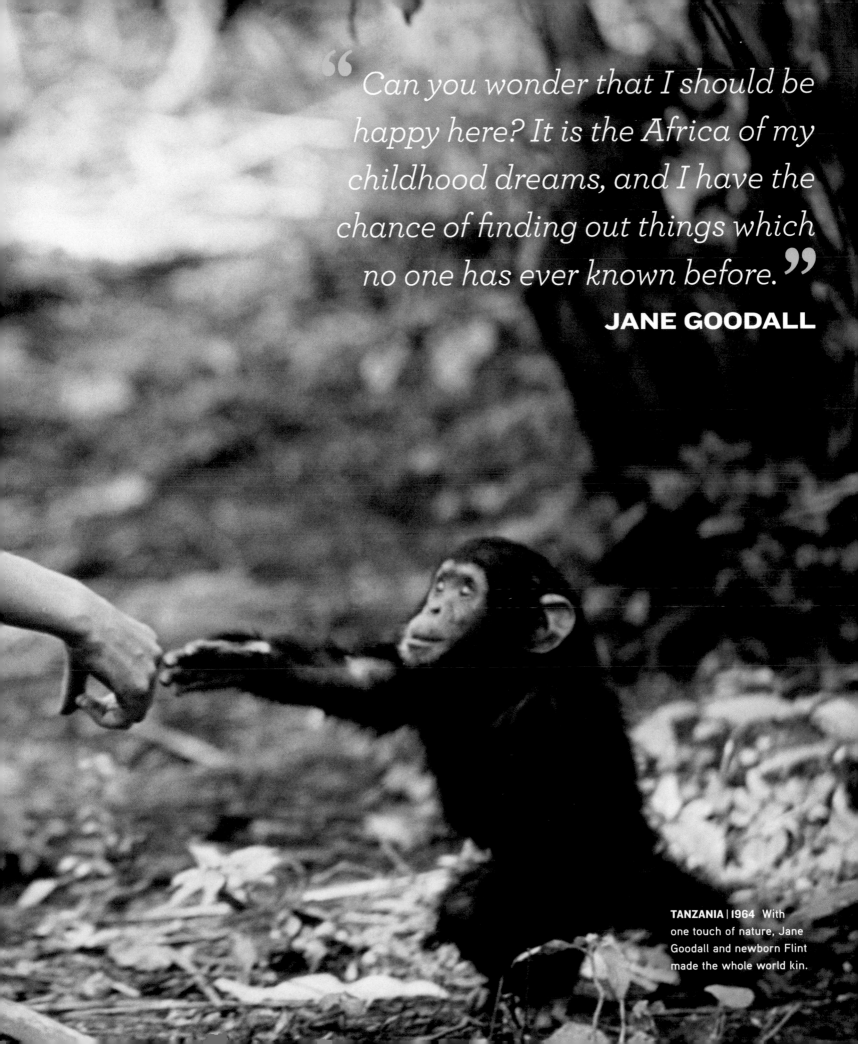

> *Can you wonder that I should be happy here? It is the Africa of my childhood dreams, and I have the chance of finding out things which no one has ever known before.*
>
> **JANE GOODALL**

TANZANIA | 1964 With one touch of nature, Jane Goodall and newborn Flint made the whole world kin.

THE PHOTOGRAPHERS

In the 1960s a fresh crop of *National Geographic* staff photographers, trained in photojournalism, brought a new look to the pages of the magazine.

⚙ THE LEGENDARY NIKON F

Released in 1959, the Nikon F mixed versatility and durability, helping it dominate the field of professional photography. The camera's single-lens reflex design allowed the eye to look through the viewfinder *and* the lens, making both telephoto and wide-angle lenses easier to use.

ABOVE: A Nikon F with Photomic prism, or light meter

Franc Shor may have been the *Geographic*'s old China hand, having parachuted behind Japanese lines there during World War II. But that didn't make life under shell fire on Quemoy Island any easier in 1958 when Shor—by then Melville Grosvenor's senior assistant editor—ventured back to the turbulent China coast with a young photographer willing to head wherever the shelling was heaviest. Bill Garrett, a recent graduate of the Missouri School of Journalism, had been hired as a photo editor. But he had formerly been a Navy cameraman in Korea: Festooned with a pair of Japanese-made Nikons, Garrett exemplified the new breed of photographer that Grosvenor was hoping to attract to the magazine.

Another one happened to be Melville's own son, Gil Grosvenor. Just a few months after Shor escaped Quemoy unharmed, the younger Grosvenor accompanied President Eisenhower on an official swing across Europe and Asia. Though not yet 30, Gil outhustled the veteran press corps and produced coverage that won him a first prize in the National Press Photographers Association's (NPAA) prestigious "Pictures of the Year" competition.

A new era in *National Geographic* photography was coming into view.

THE *GEOGRAPHIC* EYE

That new era's first great practitioner had been a young shooter at the *Milwaukee Journal* with a reputation for daredevil photography. Shortly after Thomas J. Abercrombie took his place on the magazine's staff in 1956, he was turning the place upside down—that is to say, his innovative camera angles were bringing fresh perspectives to traditional *Geographic* fare. Abercrombie bloomed at the *Geographic,* vaulting from being a talented kid from Minnesota who subsisted largely on peanut butter to someone who sipped fine wines with Jacques Cousteau, developed a keen

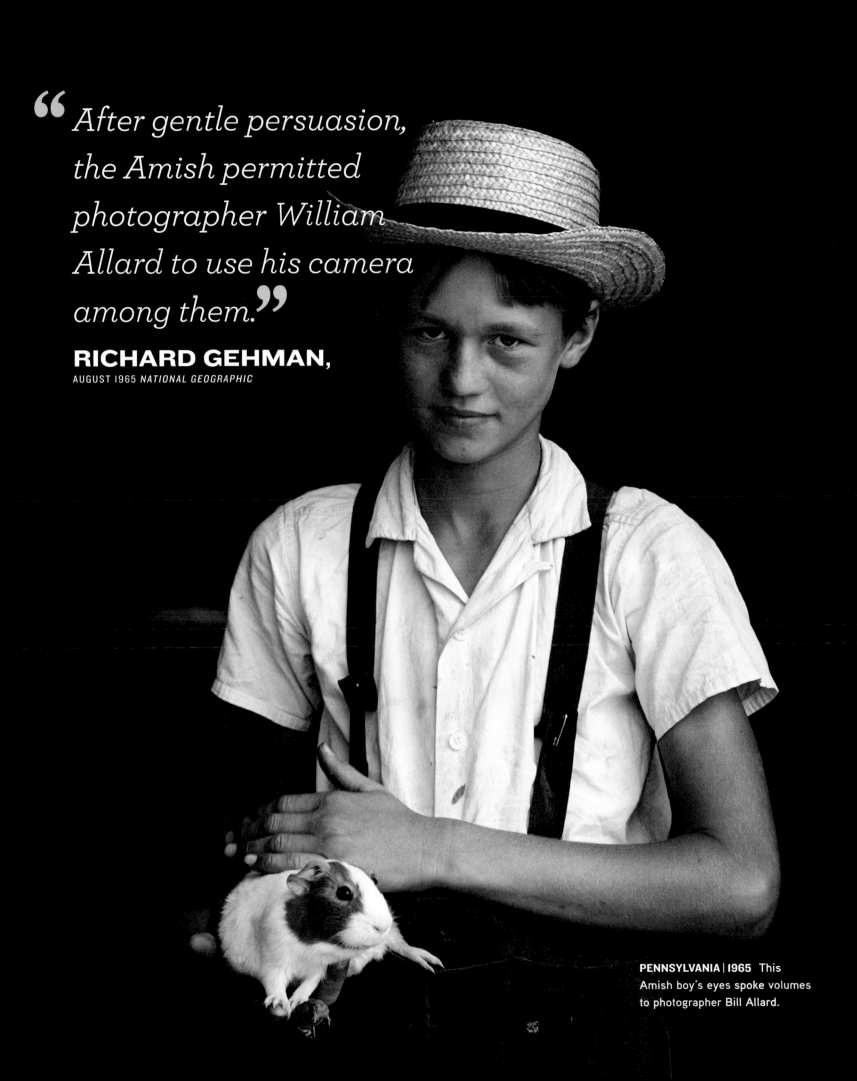

> *"After gentle persuasion, the Amish permitted photographer William Allard to use his camera among them."*

RICHARD GEHMAN,
AUGUST 1965 *NATIONAL GEOGRAPHIC*

PENNSYLVANIA | 1965 This Amish boy's eyes spoke volumes to photographer Bill Allard.

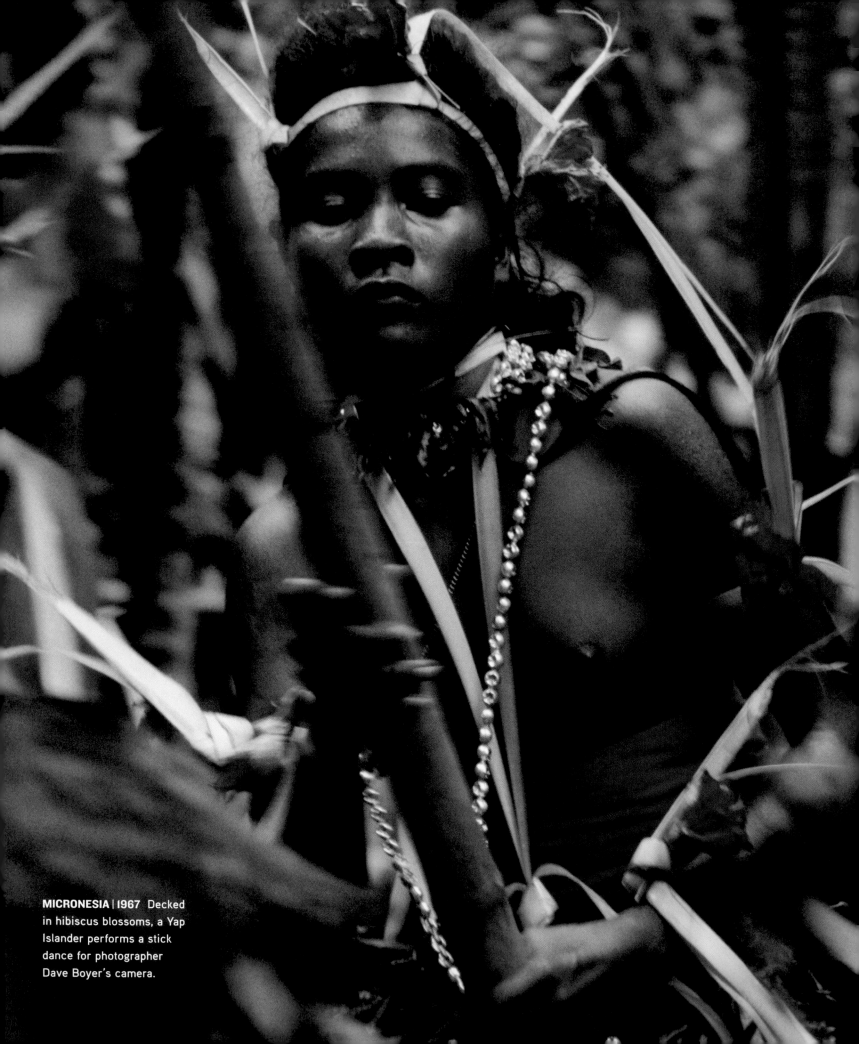

MICRONESIA | 1967 Decked in hibiscus blossoms, a Yap Islander performs a stick dance for photographer Dave Boyer's camera.

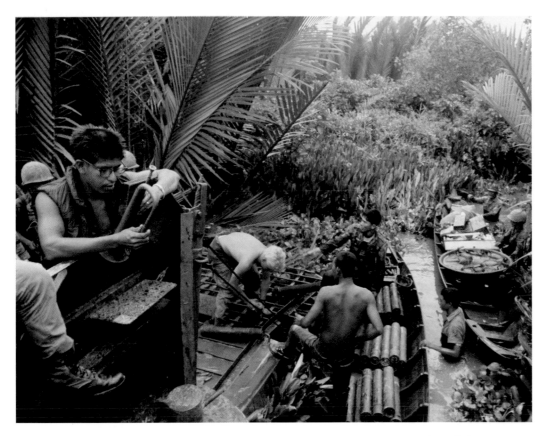

VIETNAM | 1968 U.S. Marines raid a Viet Cong weapons cache in the Mekong Delta.

ear for languages, and became the first journalist ever to stand at the South Pole. As a fully fledged member of the Foreign Editorial Staff, Abercrombie was entrusted with difficult and dangerous assignments in the world's far corners. Enchanted above all by the muezzin call of the Middle East, he taught himself Arabic, and then—converting to Islam—made those deserts and bazaars his principal beat.

By the 1960s a stable of young Nikon-toting photojournalists, many of them trained in demanding newspaper work, some of them former combat photographers in Korea, had been lured onto the magazine's staff. Winfield Parks, Thomas Nebbia, Dean Conger, George F. Mobley, James P. Blair, Bruce Dale, William A. Allard, and James L. Stanfield soon became familiar bylines. They had what was called the "*Geographic* eye," eschewing posed setups, shooting with available light whenever possible, and favoring a documentary sensibility that portrayed real people engaged in real tasks. What's more, they would take on assignments ranging from faraway countries to scientific projects to the burgeoning interstate highway system. Versatility was the name of their game.

THE "GREATEST PHOTOGRAPHIC STAFF"

This "greatest photographic staff in the world," as Melville Grosvenor proudly called it, was harnessed by a tough taskmaster named Robert E. Gilka. As director of photography at *National Geographic* from 1963 to 1985, Gilka won the loyalty of those who

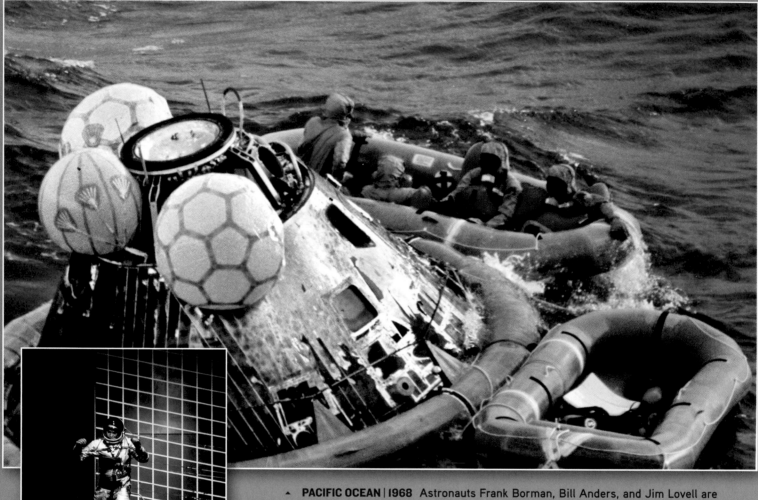

▲ **PACIFIC OCEAN | 1968** Astronauts Frank Borman, Bill Anders, and Jim Lovell are retrieved from the capsule of Apollo 8, which splashed into the Pacific on December 27.

‹ **VIRGINIA | 1965** An astronaut in training walks up a wall wearing a special harness designed to simulate low gravity.

✚ HUMAN FLY

"In this simulator at NASA's Langley Research Center in Virginia, the astronaut hangs in a harness like a puppet and walks flylike on an inclined wall. The angle of the wall is designed so that just one-sixth of his weight rests against it."

Robert Gilruth, "The Making of an Astronaut," January 1965 *National Geographic*

For millennia earthbound stargazers had watched the constellations wheel imperturbably overhead. Then, one October night in 1957, a blinking satellite crossed the sky, and suddenly the possibility that the stars might be a destination, after all, leaped into view. Sputnik ushered in the space age, and every face turned upward, scanning the heavens for "missiles" (as one *National Geographic* writer put it).

The Society got in on the ground floor of this enthralling new adventure. It offered NASA the services of its finest photographers, who in the hurly-burly days of the X-15 experimental aircraft and Project Mercury rubbed elbows with test pilots and astronauts. Peering in "on the fascinating world of tomorrow," they made pictures that sprouted on magazine covers around the world. Other *Geographic* cameramen photographed rocket launches, their excited hurrahs swept up in the rolling thunder.

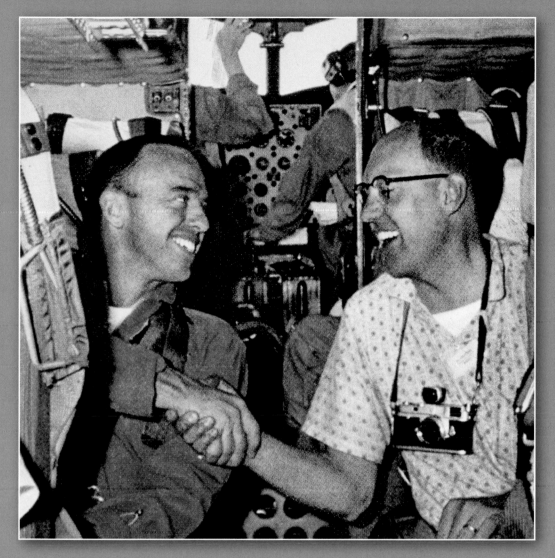

IN THE AIR | 1961 Dean Conger (right) congratulates Alan Shepard for completing the first American flight into space.

ABOVE: Dean Conger's photograph of John Glenn after his historic orbital flight

1960 The Society lends photographers Luis Marden and Dean Conger to NASA so that a color record of the space program can be made.

1961 Dean Conger's picture of Alan Shepard, the first American in space, being plucked out of the ocean is flashed around the globe.

1962 Dean Conger and Otis Imboden take unrivaled photographs of John Glenn after his return from Earth orbit.

1967 *National Geographic* photographer Jack Fletcher invents an automatic camera rig that photographs Saturn V launches—from which cameramen were banned for safety reasons—by the light of the rocket ignition alone.

1968 The Society publishes the first map of the moon to show its two faces on a single sheet, "increasing and diffusing selenographical knowledge."

1969 After the Society presents its Hubbard Medal to the astronauts of Apollo 11, they return a Geographic flag they had carried to the moon.

They entrusted their unprocessed rolls to the Society's lab technicians, who had made a makeshift darkroom out of a nearby Cocoa Beach motel suite: As headquarters of the Still Photo Pool, these converted rooms became a hive of activity, with men from *Life*, the *Saturday Evening Post*, and other publications in addition to the *Geographic* moving from bathtub to sink, developing roll after roll of film for release to the world's press. Not to be outdone, the magazine's writers won numerous awards honoring the high quality of their stories. In 1964, the Space Writers Association gave its Special Citation to the entire staff of *National Geographic* for the single article "Footprints on the Moon."

For many *Geographic* writers and photographers, therefore, the decade between 1959 (when Project Mercury was announced) and 1969 (when Apollo 11's lunar module touched down on the moon) proved to be indelibly memorable. Humanity had at last arrived "at that crossroads in time," as one of them wrote, "those fleeting minutes in the history of the race, when earth's shackles might be cast off." ■

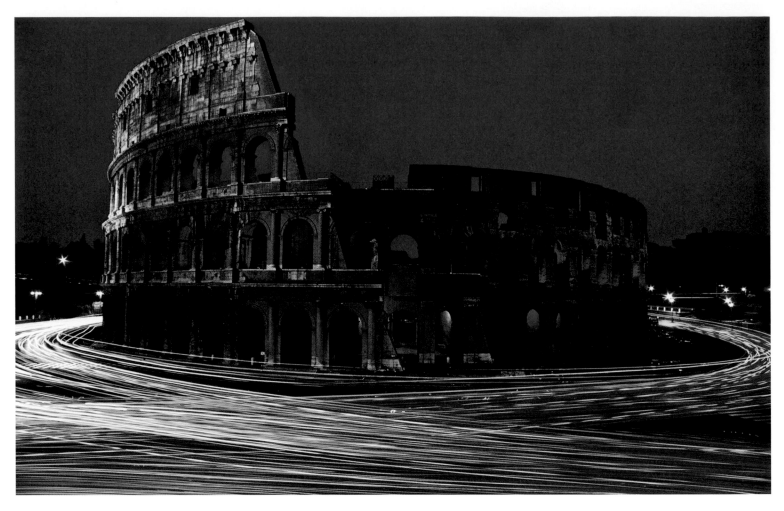

ROME | 1969 Winfield Parks's time-lapse shot of the ancient Colosseum captures the notorious traffic of modern Rome.

▶ **MAY 1966**
Don't bother checking. There never was such an article, nor any photographer named Robert Kincaid. In 1995, the magazine dummied up this fake cover for use in the film version of Robert James Waller's best-selling novel.

worked for him. He was also well respected in photojournalism circles. Before long, his photographers were sweeping the NPPA "Pictures of the Year" competition. In 1966 alone they won a record 29 of its 55 magazine awards, with Parks, Allard, Dale, Blair, and Dave Boyer all taking home prizes.

Although assignments still ranged from science to pomp and pageantry—and though the magazine's tone remained relentlessly upbeat—lensmen like these, bolstered by a talented circle of freelancers, were shooting more and more behind-the-headlines stories. The first published pictures of American servicemen fighting in Vietnam appeared in the November 1962 *National Geographic*. By 1968 Bill Garrett had been named NPPA's "Photographer of the Year" on the strength of his Vietnam coverage. He was one of several staffers (Abercrombie, Conger, and Dale were the others) to receive that accolade before the decade ended. Shooting high, shooting low—hounded from suqs, routinely arrested, their cameras smashed and their film confiscated—the staff photographers still managed to provide nearly half the magazine's pictures. Dean Conger, who delivered unrivaled coverage of the Cold War Soviet Union, not only suffered a frostbitten nose and fingers; he also had to keep pace with his hosts vodka for vodka, making picture-taking "barely possible at times." ■

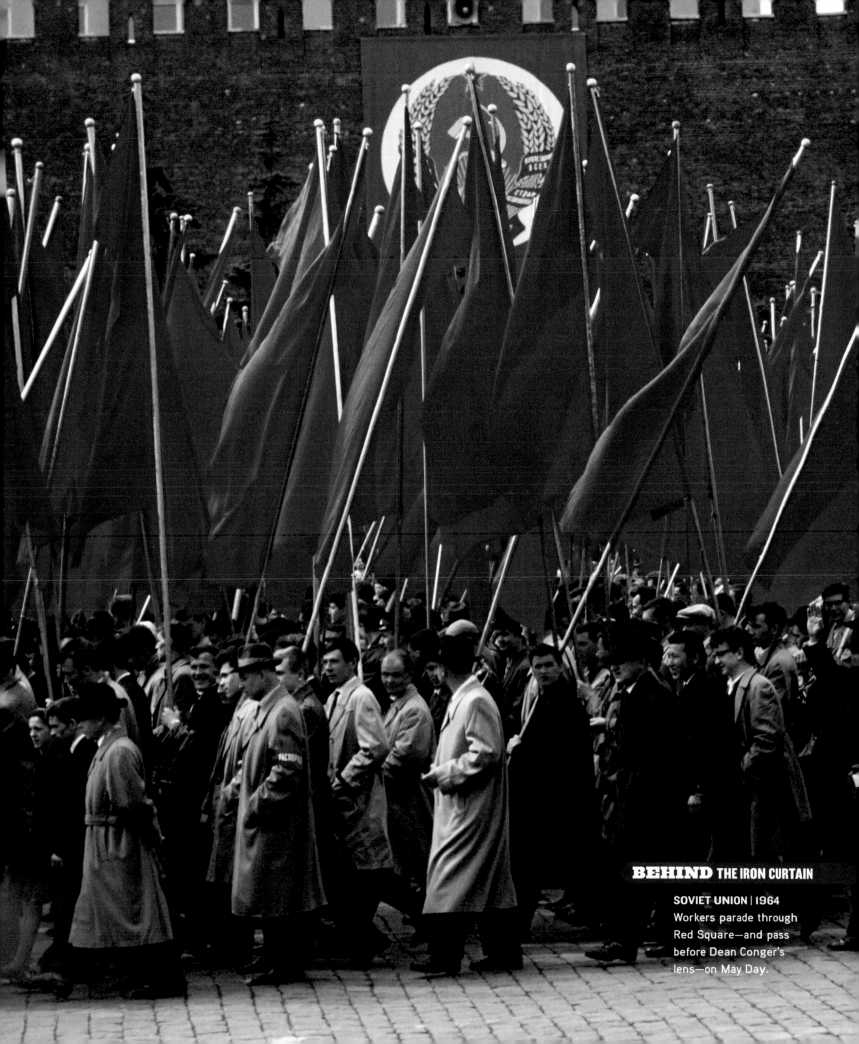

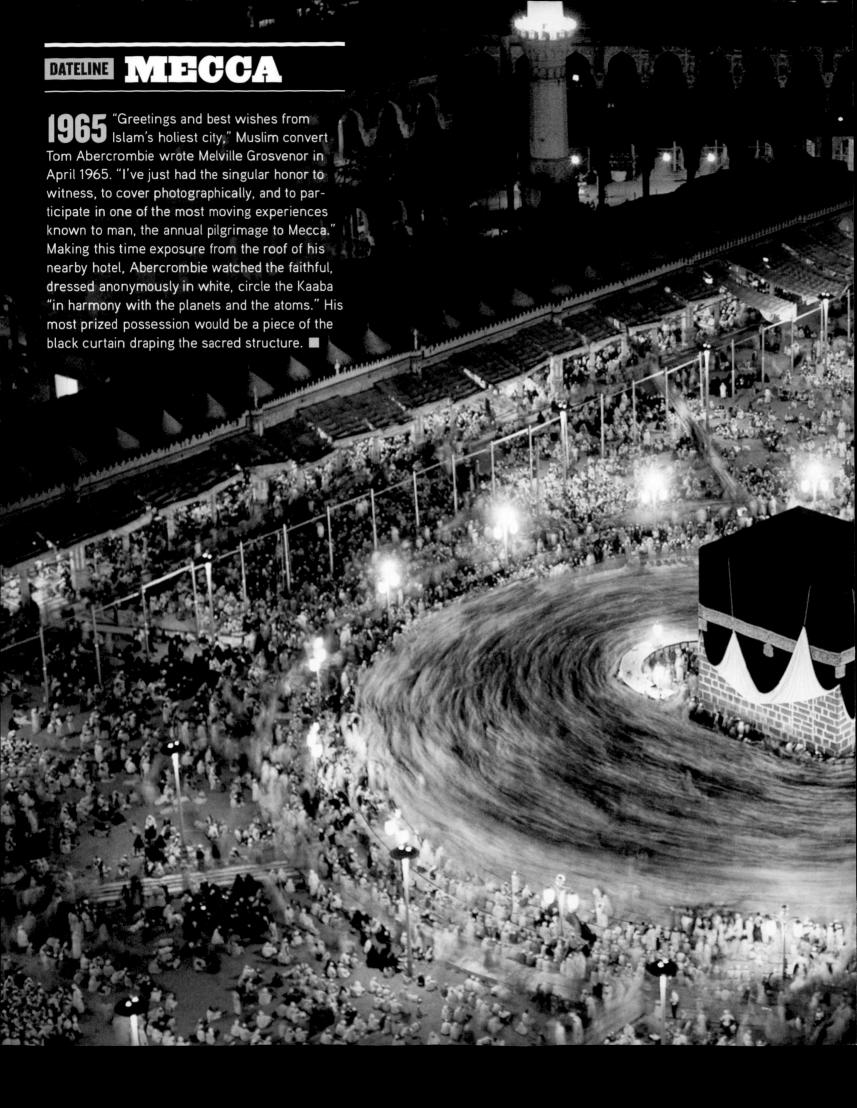

DATELINE MECCA

1965 "Greetings and best wishes from Islam's holiest city," Muslim convert Tom Abercrombie wrote Melville Grosvenor in April 1965. "I've just had the singular honor to witness, to cover photographically, and to participate in one of the most moving experiences known to man, the annual pilgrimage to Mecca." Making this time exposure from the roof of his nearby hotel, Abercrombie watched the faithful, dressed anonymously in white, circle the Kaaba "in harmony with the planets and the atoms." His most prized possession would be a piece of the black curtain draping the sacred structure. ■

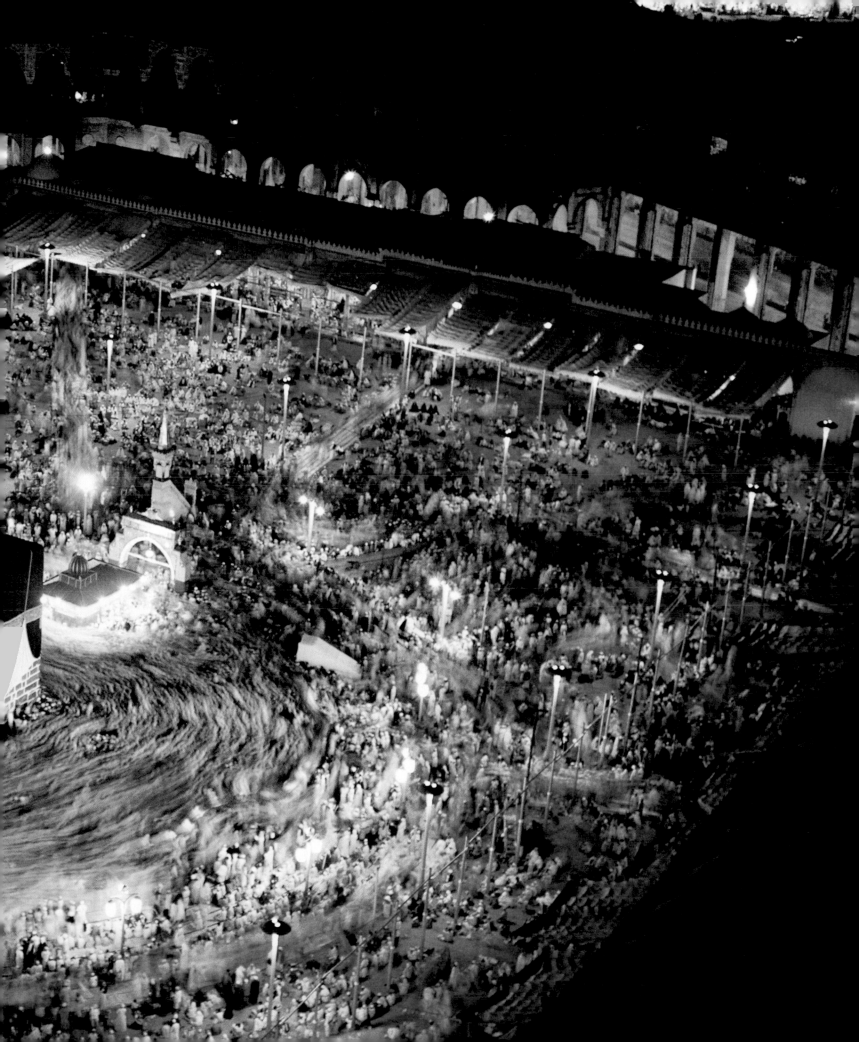

FAR-FLUNG FIELDWORK

From Western canyons to African plains, from the shipwreck-littered seabed to exotic birds of the sky, the Geographic put its weight behind a welter of field projects in the 1950s and '60s.

✳ LOFTIEST LIMBS?

The "Mt. Everest of all living things." That's how staff naturalist Paul Zahl described the world's tallest redwood in the July 1964 *Geographic*. The giant he discovered scraped the sky at 367.8 feet. Society efforts helped win national park status for the groves.

ABOVE: Redwoods eclipse the oak leaves.

I n 1888, the year the National Geographic Society was founded, Colorado's five Wetherill brothers were herding cattle in a far corner of their state when they stumbled upon a long-abandoned Indian village tucked into a cliffside niche. Such ancient ruins pocked the canyons, the brothers found. By 1906, when Congress set the area aside as Mesa Verde National Park, more than 4,000 sites—including some 600 cliff dwellings—had been discovered there.

As late as 1958, however, only the park's best known monuments, Cliff Palace and Balcony House, had received many visitors. Most of Mesa Verde's ruins remained practically unexplored, and many were fast deteriorating. The spectacular cliff dwellings in Wetherill Mesa, for example, had never echoed to the tramp of tourists' feet.

Thus was born the National Geographic Wetherill Mesa Archaeological Project, undertaken jointly with the National Park Service. For the next five years teams of archaeologists worked at 11 major sites, surveying, stabilizing, and excavating in the largest such undertaking the country had seen to date. Not only were new sites opened to accommodate an expected upsurge in tourist traffic, but the project arrived at a better understanding of why the places had been abandoned. Drought, it seemed, had driven Mesa Verde's inhabitants from their canyons more than 600 years earlier.

GHOSTS OF DZIBILCHALTÚN

There was no dearth of Society-supported expeditions during Melville Grosvenor's tenure, and one of them lay far to the south on Mexico's Yucatán Peninsula. There a young cartographer, George Stuart, was mapping 20 square miles of bush-choked, tick-infested mounds with the insect-trilling name of Dzibilchaltún. In 1958 he watched as laborers removed the rubble from one of the largest mounds, revealing

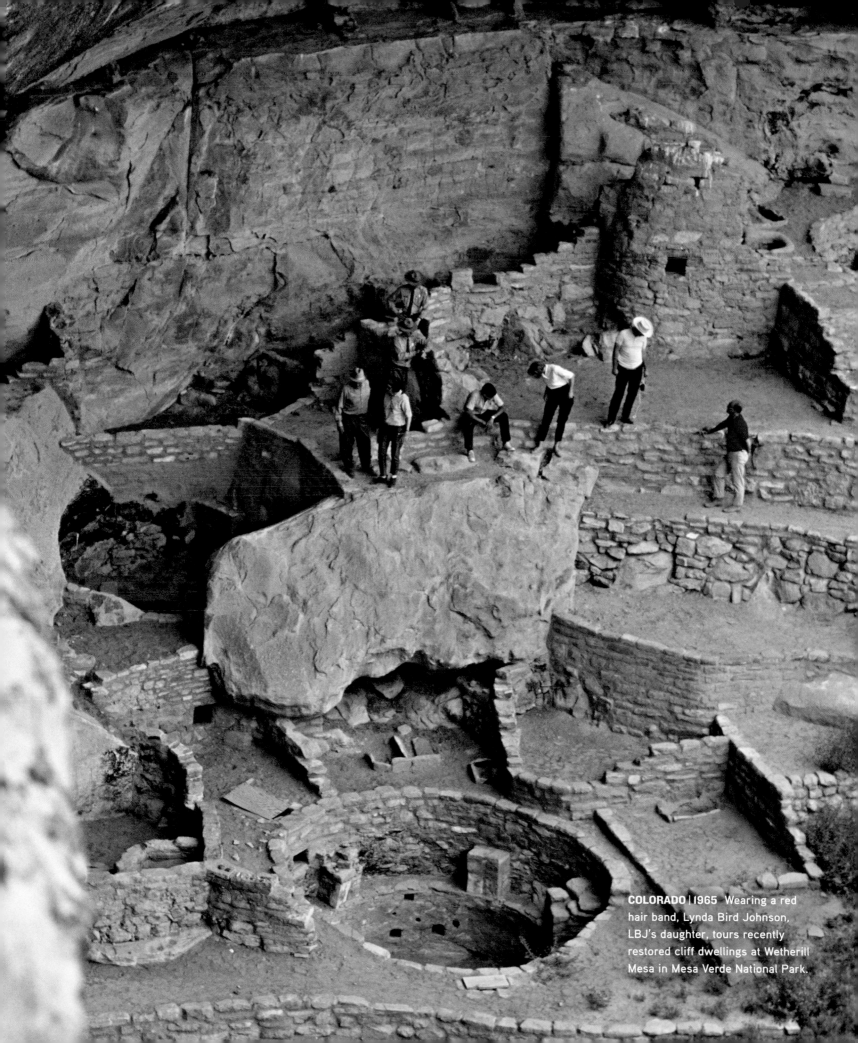

COLORADO | 1965 Wearing a red hair band, Lynda Bird Johnson, LBJ's daughter, tours recently restored cliff dwellings at Wetherill Mesa in Mesa Verde National Park.

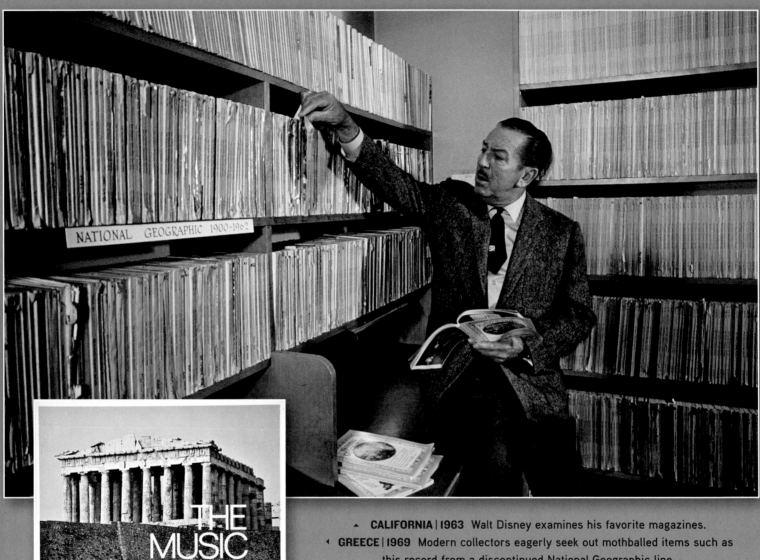

NATIONAL GEOGRAPHIC 1900-1962

THE MUSIC OF GREECE

▲ **CALIFORNIA | 1963** Walt Disney examines his favorite magazines.
‹ **GREECE | 1969** Modern collectors eagerly seek out mothballed items such as this record from a discontinued National Geographic line.

✚ LINER NOTES

Released in 1969, *The Music of Greece*—available on both vinyl and audiocassette—inaugurated a nine-title series, Sounds of the World, that also included Tongan, Scottish, and Hawaiian albums. Sixteen more titles, the quaint-sounding *Steamboat's A-Comin'* and *Westward Ho!* among them, composed American Adventure. Both series were played out by 1979.

William Holden, escaping the pressures of Hollywood stardom, was content merely to catalog his collection. Walt Disney, checking out costumes, found his set to be "an invaluable research tool." During the years when the *Geographic* was the most hoarded of American magazines, however, it spawned a breed of obsessed collectors. One Madison Avenue executive laid out a considerable sum to assemble a complete set, binding it in the finest blue morocco; he then bought a second set and bound it in red. The truly compulsive likewise scooped up every book, atlas, map, globe, promotional brochure, or piece of ephemera that bore the Society's name. Even ordinary people, their attic floors groaning beneath the paper weight, treasured their magazines—though none so much as the man said to have placed this personal in the *Denver Post:* "SHEILA: Please return my National Geographic Collection. You may keep the engagement ring." ■

MEXICO | 1958 George Stuart, the Society's future staff archaeologist, surveys the ruins of Dzibilchaltún and its Temple of the Seven Dolls.

a buried temple inside. Working with the project's director, Dr. E. Wyllys Andrews, Stuart then discovered the remains of seven crude clay figurines hidden beneath the floor of the structure. Inevitably, the find led the site to be dubbed the Temple of the Seven Dolls. Although they clearly possess immense ritual significance, the figures have never yielded their secrets.

Perhaps they should have been left undisturbed. Or perhaps the votive offerings that National Geographic divers brought up from the depths of Dzibilchaltún's sacred pool, or cenote, should have remained untouched. One afternoon Luis Marden and Bates Littlehales, both experienced divers, surfaced at the cenote with dangerous cases of nitrogen narcosis—the dreaded "bends." An emergency recompression chamber was hastily rigged from a discarded oil tank, but the two men's conditions deteriorated rapidly. They had to be flown to a U.S. Navy hospital in Panama City, Florida. Fortunately, each man recovered fully.

SECRETS FROM SHIPWRECKS

Although he never hung up his flippers for good, Marden gradually ceded predominance in underwater photography to his younger colleague Littlehales. Bates shot pictures in seas ranging from the Caribbean to the Mediterranean, including waters surrounding a sandy island just off the Turkish coast called Yassi Ada. There was found the tent city that served as headquarters for George Bass, an archaeologist from the University of

> **"** *At first we had avoided putting our fingers inside the amphorae … because they make fine homes for sharp-toothed moray eels.* **"**
>
> **GEORGE BASS**

TURKEY | 1967 A diver hoists a barnacle-encrusted amphora from a shipwreck off Yassi Ada.

Pennsylvania. In the summer of 1960 Bass had been offered a prized opportunity—the chance to direct a Bronze Age dig—by his departmental superiors. The only hitch was that the site lay beneath 90 feet of ocean water. Undeterred, Bass took one impromptu scuba lesson in a swimming pool before departing for the shipwreck-littered coast of southern Turkey. He would earn his fins and face mask off storm-lashed Cape Gelidonya, working out of an old sponge boat with assistants just learning to dive themselves. By summer's end, Bass had completed the first excavation carried out entirely on the seafloor.

With the Geographic's support, Bass expanded his operations to include the wreck of a Byzantine-era ship that lay off Yassi Ada in much deeper water. All the while he constantly devised new tools and refined old methods, gridding the site, labeling each visible object, even using bicycle spokes to pin rotted wood to the seabed. Soon George Bass was running the largest diving operation in the world, with a perfect safety record. He was also being hailed as the father of underwater archaeology.

BIRDS OF A DIFFERENT FEATHER

When it became all too apparent that Frederick Kent Truslow would never fit the corporate boardroom in which he had wasted half his adult life, both his doctor and his wife urged him to quit before it was too late. She recalled that a schoolboy paper he had written, deploring the slaughter of egrets for their nuptial plumes, had won an Audubon Society prize. So for relaxation she steered him toward wildlife photography. And that's where, at 53, Truslow found his true calling. His patience was so proverbial—and his pictures unique—that he wound up shooting for the *Geographic,* perhaps the only spot where a singular genius like Truslow could thrive. He made enduring portraits of birds from flycatchers to eagles; and though he set out to document behavior over beauty, his pictures were beautiful nonetheless. It wasn't long before Truslow was acclaimed the "Audubon of the camera."

Paul Zahl was another who might never have found the kind of spiritual home he did in the pages of the *Geographic.* In 1949 the Harvard-trained biologist, who worked as a cancer researcher in Manhattan by day, photographed the spectacular scarlet

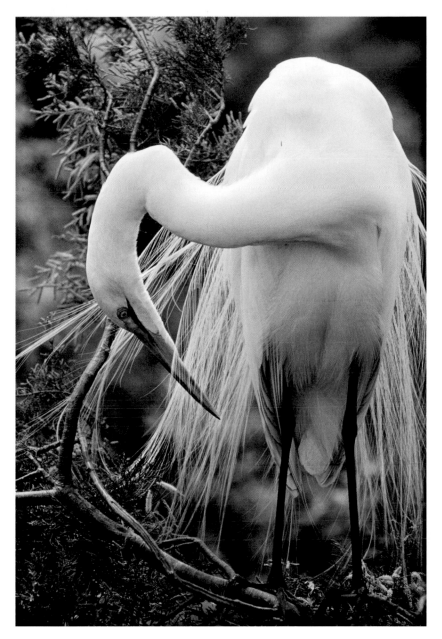

FLORIDA | 1965 Frederick Kent Truslow photographed this common egret (*Ardea alba*) displaying its nuptial plumes.

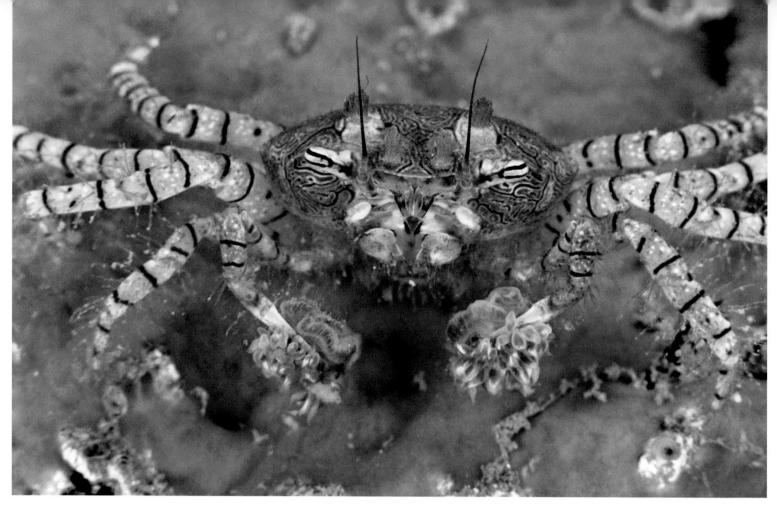

HAWAII | 1959 A boxer crab brandishes poisonous sea anemones in a Paul Zahl photograph.

FREAKS OF NATURE

▶ **FROM "LITTLE HORSES OF THE SEA":** "The sea horse has a colt's head, an insect's shell-like body, and the pouch of a kangaroo, yet actually is a fish. Moreover, the male gives birth to the young."

▶ **FROM "IN QUEST OF THE WORLD'S LARGEST FROG":** "The head was as broad as a saucer, and each eye, with its black almond-shaped pupil set in a speckled yellow iris, equaled the size of a five-cent piece. The forelegs were almost as thick as my wrist."

ibis in Venezuela's swamps for the magazine. He contributed more than 50 additional stories over the next quarter century, focusing on colorful birds or mountain gorillas or monarch butterflies. But Zahl's prime quarry was bizarre creatures such as slime molds, four-eyed fish, and insectivorous plants—those, and the world's largest frog, ant, beetle, and tree. Though he often fished strange beings from the deep, all glistening eyes and long fangs, the loveliest of October 1959's "Unsung Beauties of Hawaii's Coral Reefs" was Eda Zahl, Paul Zahl's wife. Diving mask perched stylishly on her head, she was the first person ever to grace a cover of *National Geographic*.

OUT OF AFRICA

By the late 1960s Jane Goodall was spending about as much time on Tanzania's Serengeti Plain as she was back in Chimpland at Gombe. Her husband, Hugo van Lawick, was immersed in several wildlife-photography assignments there for the *Geographic*. Even in those grasslands, however, Goodall was making new discoveries. She and van Lawick had observed Egyptian vultures picking up stones in their beaks and flinging them against ostrich eggs to crack them open—another case, as *Geographic* readers learned in May 1968, of tool use among animals.

Fresh insights into animal behavior, it seemed, were emerging all across the savanna. A new era in wildlife studies, much of it underwritten by the Society, was

dawning in East Africa. Goodall and van Lawick, for instance, often visited Hans Kruuk in the nearby Ngorongoro Crater. Kruuk was discovering that spotted hyenas lived in a world of mutually warring clans; they were bold predators, he established, not the craven scavengers of hearsay. When van Lawick and Goodall piled into their Land Rover and returned to the Serengeti, they looked up George Schaller, who was conducting the first intensive, long-term study of lions in the wild. Schaller personified the new approach to watching wildlife; he even tried living off scavenged lion kills, as he speculated primitive humans must have done. After darting, immobilizing, and radio collaring 150 of the beasts, Schaller proved how lion predation helped regulate the immense numbers of hoofed animals on the Serengeti. Hoofed animals, especially the wildebeest, or gnu, were meanwhile being studied by Richard D. Estes, who would come to be called the "guru of gnu" after years of Society-supported work among Africa's various antelope.

Many a baboon must have paused when it spotted the stuffed leopard, animated by a windshield-wiper motor, standing on the savanna. Heinz Sielmann of the Max Planck Institute was hoping to film the baboons' aggressive reactions for an upcoming National Geographic Television Special. And when they weren't helping photograph these various activities, Alan and Joan Root were back in Kenya's Tsavo National Park, sweltering in a blind while documenting how a female hornbill, walled up in her own nest, raised her young; or swimming among crocodiles in the otherwise Edenic oasis of nearby Mzima Springs, bopping the reptiles on the snout with a camera lens when they came too near. Ten years after the Society discovered Louis Leakey, the National Geographic was in East Africa to stay. ■

✳ PANEFUL EXPOSURE

An African hornbill and her offspring, walled up for 40 days in their tree-hollow nest, were never more snug than the *National Geographic* cameraman who captured their sequestered behavior. Alan Root photographed the birds through a glass pane, artfully inserted over the hollow, from a blind wrapped tightly around the tree trunk. Flood lamps needed to light the scene made the Tsavo afternoon even more stifling.

ABOVE: A hornbill tends her two chicks in seclusion.

TANZANIA | 1967 Spotted hyenas, one nursing a half-grown cub, laze about in Ngorongoro Crater.

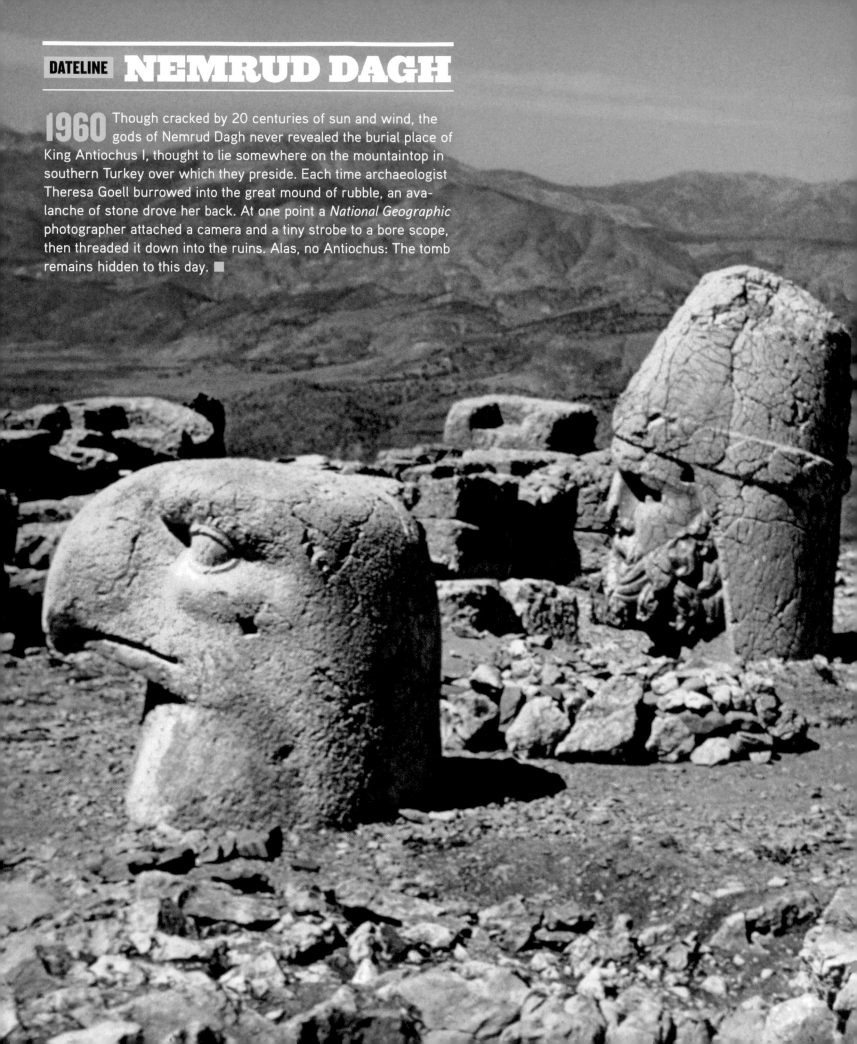

DATELINE NEMRUD DAGH

1960 Though cracked by 20 centuries of sun and wind, the gods of Nemrud Dagh never revealed the burial place of King Antiochus I, thought to lie somewhere on the mountaintop in southern Turkey over which they preside. Each time archaeologist Theresa Goell burrowed into the great mound of rubble, an avalanche of stone drove her back. At one point a *National Geographic* photographer attached a camera and a tiny strobe to a bore scope, then threaded it down into the ruins. Alas, no Antiochus: The tomb remains hidden to this day. ■

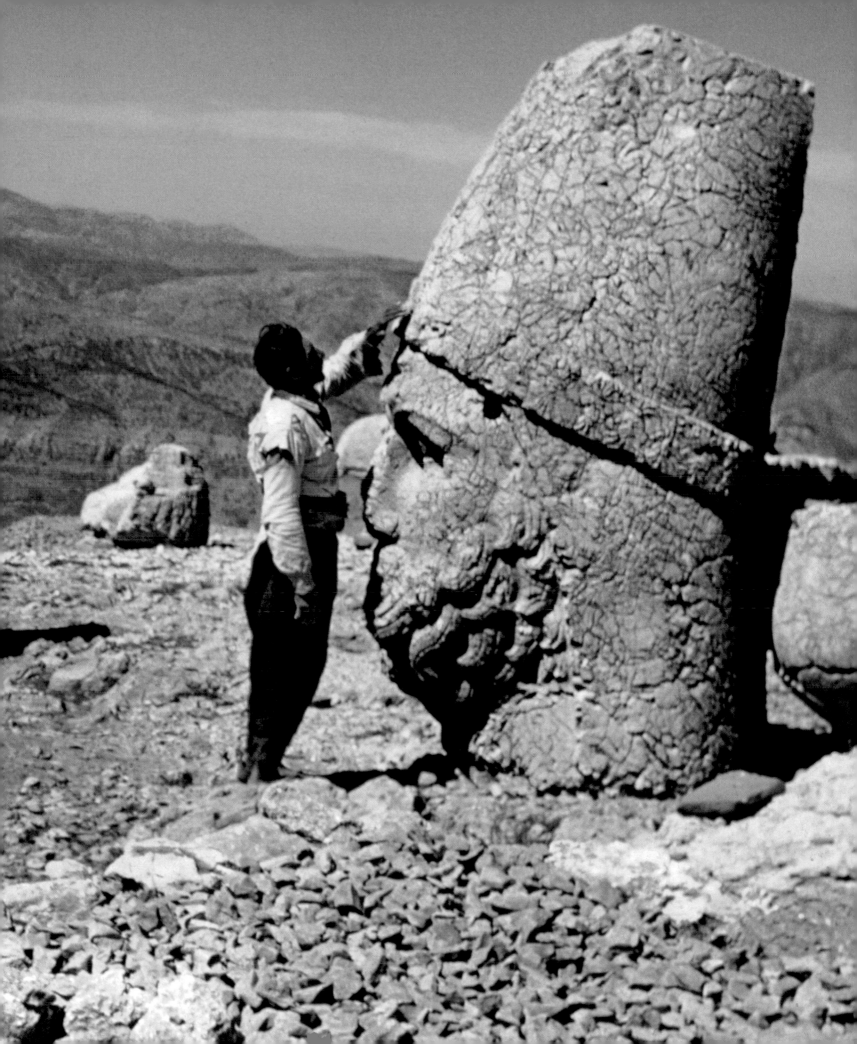

OVER THE CURVE OF THE WORLD

Voyages of exploration and discovery, whatever the ship and wherever the destination

⊛ ONE THAT GOT AWAY

In 1946 the Society declined to support Thor Heyerdahl's plan to sail halfway across the Pacific on a balsa-wood raft. Too bad—the resulting Kon-Tiki Expedition is now considered one of the greatest adventure stories of the 20th century.

ABOVE: The first edition of Norwegian Thor Heyerdahl's best-selling *Kon-Tiki*

"Circle February 11 on your calendar," the magazine urged its readers in 1966, "and stand by to board a blue-water sailing ship. Destination: the Seven Seas. On that Friday evening, switch on your television set and ease into your armchair. High adventure awaits in visits to faraway ports."

Those who did switch on their sets to watch *Voyage of the Brigantine Yankee* sailed vicariously from Gloucester, Massachusetts, to the South Seas and back—all in the span of an hour. They also heard, for the first time, the trumpet fanfare that soon became the universally recognized television signature of the National Geographic Society. That this familiar call to armchair adventure is the echo of a sea voyage typified the era when Melville Grosvenor was the Society's skipper. The magazine had been taking readers a-wandering with rovers Irving and Electa Johnson and their *Yankee*, crewed by young men and women working their way around the world, long before it put them on television. It had shipped with the Australian sailor Alan Villiers in the last of the great windjammers, and with Melville himself in his yawl, the *White Mist*.

Indeed, sea fever would always lap at the magazine's pages, even during the era of Apollo. One of its most popular stories was the three-part saga of Robin Lee Graham, who in 1966 departed Los Angeles as a 16-year-old lad in a 29-foot sloop called *Dove*. Graham returned there 1,739 days later a man—a married man, it's true, though one who had still sailed around the globe alone, his only shipboard company in those five years an ever changing crew of cats.

HIGH ADVENTURE

At the Society, the voyage of discovery would remain a favorite metaphor. Now, however, its destinations were changing. In 1964, with a display of rhetoric impressive

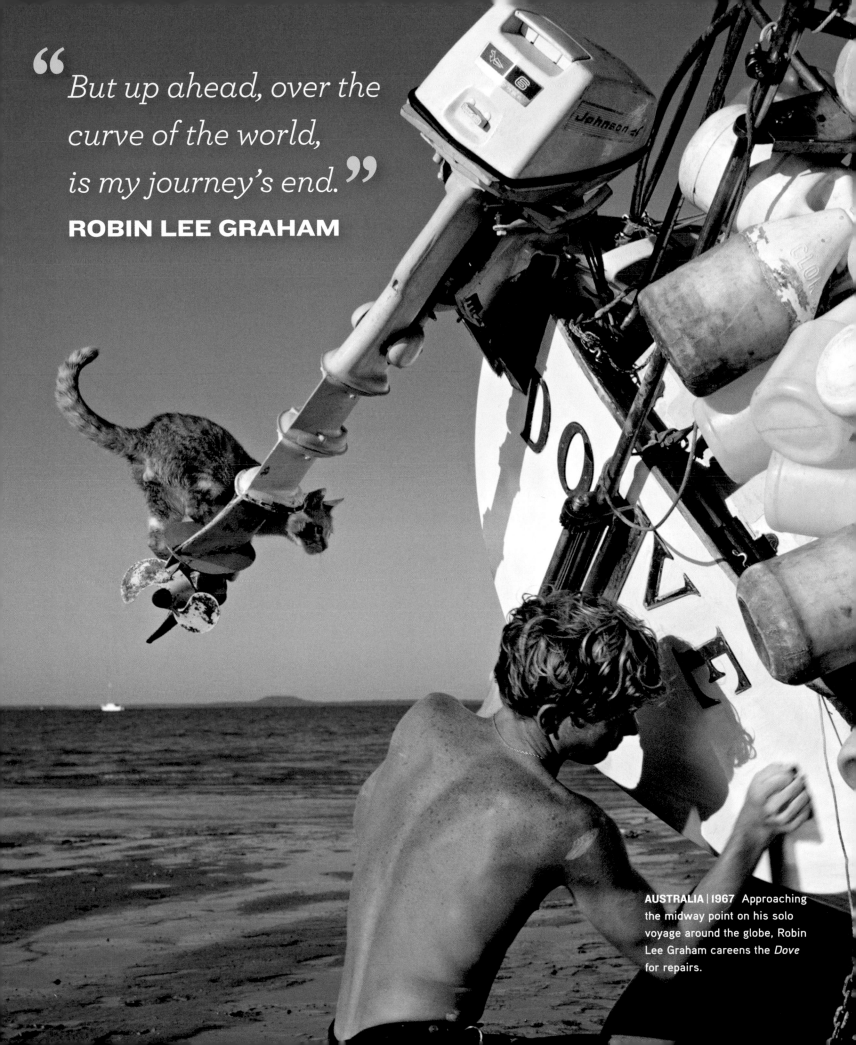

"But up ahead, over the curve of the world, is my journey's end."
ROBIN LEE GRAHAM

AUSTRALIA | 1967 Approaching the midway point on his solo voyage around the globe, Robin Lee Graham careens the *Dove* for repairs.

for one who claimed "my mammy raised me with a Bible in one hand and the *Geographic* in the other," President Lyndon B. Johnson dedicated the Society's new ten-story Washington headquarters building with a ringing call to "participate in the high adventure of advancing man's knowledge of both the universe about us and the capacities within ourselves." For "all the seas have been sailed," he emphasized, "all the continents explored. The highest mountains have been scaled—the darkest jungles penetrated. We have reached into the realms of space—and out toward the domain of the stars."

DISTANT LANDFALLS

On August 16, 1960, when Air Force captain Joe Kittinger leaped out of a stratosphere balloon's gondola from a height of 102,800 feet, more than 99 percent of the Earth's atmosphere lay beneath him. It took 13 minutes and 45 seconds for him to fall 19 miles—and he did open a parachute—to a soft landing in the New Mexico desert. A human being had leaped from the edge of space, and a remotely operated camera, positioned in the balloon's gondola by *National Geographic* photographer Volkmar Wentzel, memorably captured the instant he did so, producing an image that summed up the high adventure of the space age.

But another photo captured its wonder. On Christmas Eve 1968, the Apollo 8 command module was completing its fourth orbit of the moon when, coming around the curve of that forbidding world, the usual mission patter on the voice recorders gave way to something different. "Oh my God, look at that picture over there!" Commander Frank Borman exclaimed. "Here's the Earth coming up. Wow, that is pretty." As astronaut Bill Anders hurriedly loaded his camera with color film, squeezing off two frames, crewman Jim Lovell was gasping, "Oh, that's a beautiful shot!" Then the spacecraft hurtled on, the view was lost, and the cameras were again focused on the moon.

Three days later the command module splashed down in the Pacific. Hardly had the thousands of frames of mission photography been developed by NASA's photo lab in

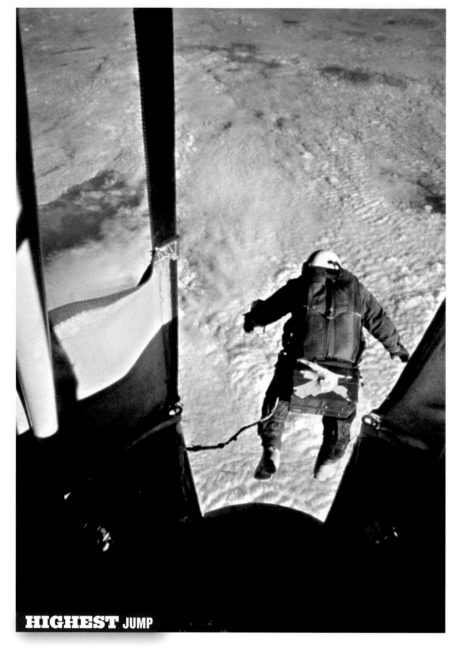

HIGHEST JUMP

NEW MEXICO | 1960 One second into his "long lonely leap," balloonist Joe Kittinger contemplates the 19-mile fall awaiting him.

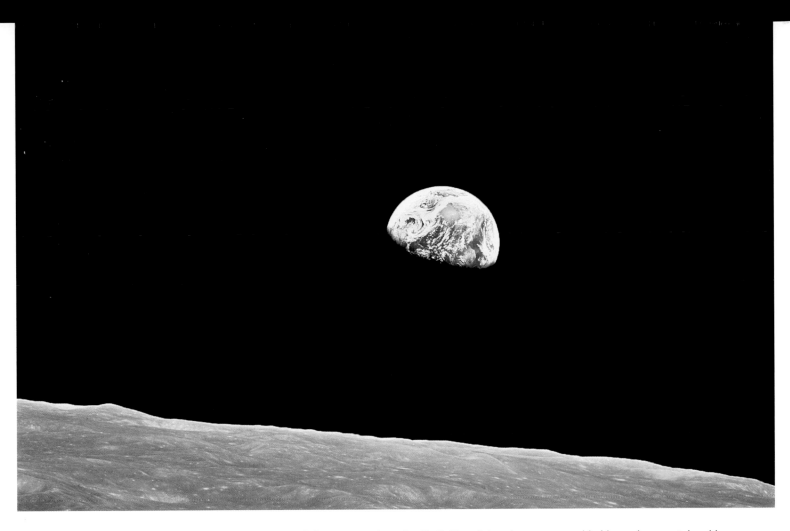

LUNAR ORBIT | 1968 The long voyage home: earthrise, as seen from Apollo 8. The picture became a worldwide environmental emblem.

Houston than press representatives were gathering. Black-and-white pictures of the stark, rugged face of the moon were readied. But a young *National Geographic* photo editor, Jon Schneeberger, had heard whispers of something breathtaking in the mission photography, and he pushed for the release of two color frames as well. One of them, of course, was the picture that changed the world—or the way people viewed the world. That image of the Earth—a blue ball rising from the blackness, swirled with white clouds and bathed in the bright light of the sun—became an icon of the age. No other photograph has so inspired so many people to care about the planet.

As Anders squeezed off those two shots, somewhere in that command module, perhaps tucked away with the small bottles of brandy that remained unopened, was a two-by-three-inch National Geographic flag. John Glenn had carried a similar one, in recognition of the Society's "pioneering contributions to space research," when he became the first American to orbit the Earth. And seven months after the Apollo 8 astronauts returned, when the Saturn rocket boosting the Apollo 11 lunar module thundered skyward, yet another Geographic flag was tucked aboard, somewhere in the safekeeping of Neil Armstrong and Buzz Aldrin.

Eight decades after the Society was founded by men who had mapped the canyons and mountains of the West, its standard was accompanying the greatest exploratory voyage of them all—and soon would be carried onto the cratered surface of another world altogether. ▪

MUSIC OF THE SPHERES

▶ **DECEMBER 1967**

"Mars moves through our skies in its stately dance, distant and enigmatic, a world awaiting exploration. If we but choose, it waits for us."

CARL SAGAN, *astronomer*

▶ **MAY 1969**

"To see the earth as it truly is, small and blue and beautiful in that eternal silence where it floats, is to see ourselves as riders on the earth together, brothers on that bright loveliness in the eternal cold—brothers who know now they are truly brothers."

ARCHIBALD MACLEISH, *poet*

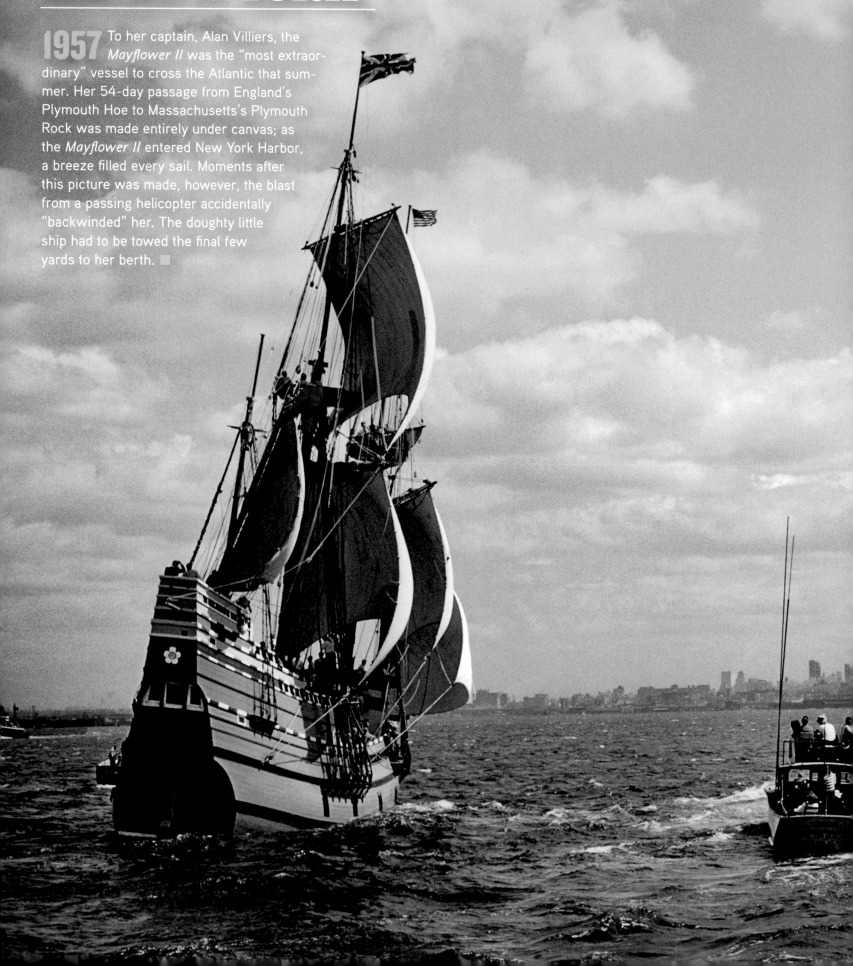

1957 To her captain, Alan Villiers, the *Mayflower II* was the "most extraordinary" vessel to cross the Atlantic that summer. Her 54-day passage from England's Plymouth Hoe to Massachusetts's Plymouth Rock was made entirely under canvas; as the *Mayflower II* entered New York Harbor, a breeze filled every sail. Moments after this picture was made, however, the blast from a passing helicopter accidentally "backwinded" her. The doughty little ship had to be towed the final few yards to her berth. ■

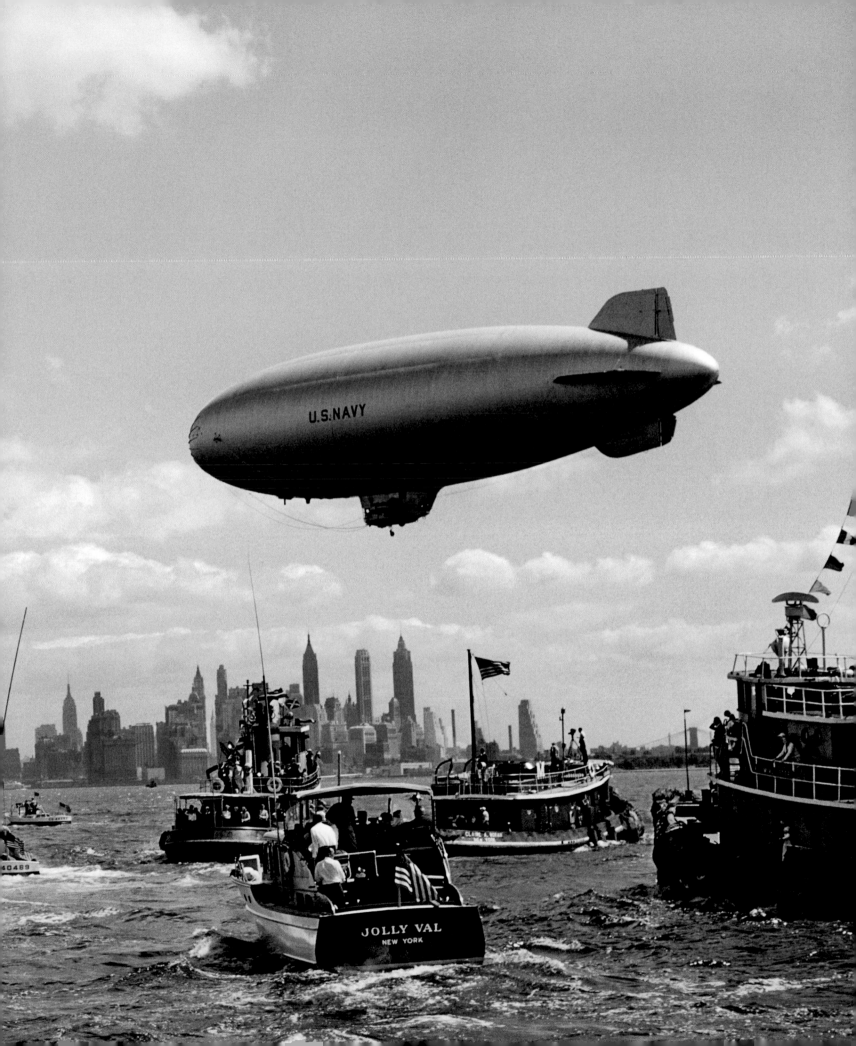

WILD LIVES OF WILDLIFE

▸**1990** *Antelope, doves, and an elephant return to a favorite water hole as day breaks over Botswana's Okavango Delta.*

▾**1986** *A lion cub drapes a paw over its mother's shoulder in a startlingly humanlike gesture on Tanzania's Serengeti Plain. Many a human mother wrote to Society headquarters seeking a copy of this photo after its May 1986 appearance.*

Animals communicate a lot with body language," *National Geographic* wildlife photographer Frans Lanting once observed. For more than a century the magazine has published photos of wild creatures expressing every gesture a body can convey—starting with prostration, for many early pictures depicted slain trophies of the hunt. As the years passed, however, photographers with improved equipment have captured dramatic images of living bodies flowing with motion—stalking, feeding, courting, fleeing. Animals have been detected at languid rest or in tense equipoise, gaze alert, nostrils aflare, ready to explode in charge or retreat. Such images unlock mysteries of behavior even as they document the planet's ever withering tree of life. As the Society has brought animals into sharper focus, a kind of "street photography of the wild" side has likewise emerged: *Geographic* photographers have been reading the body language of animals anew, depicting even vanishing creatures in startlingly novel ways. ■

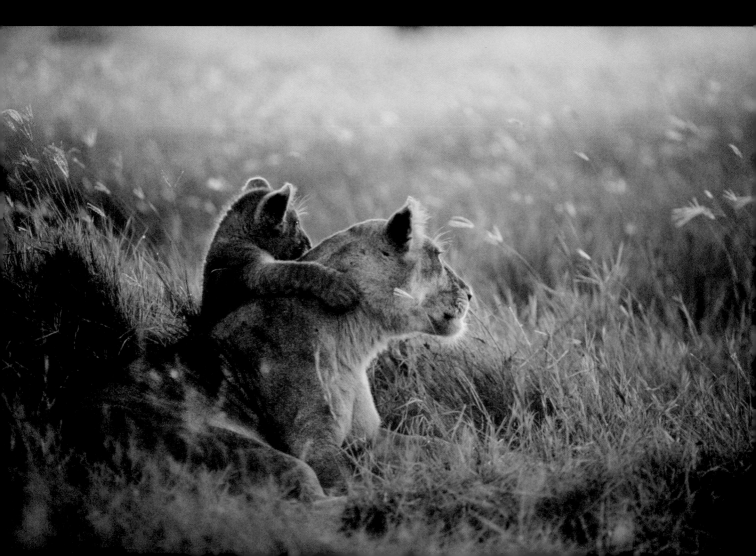

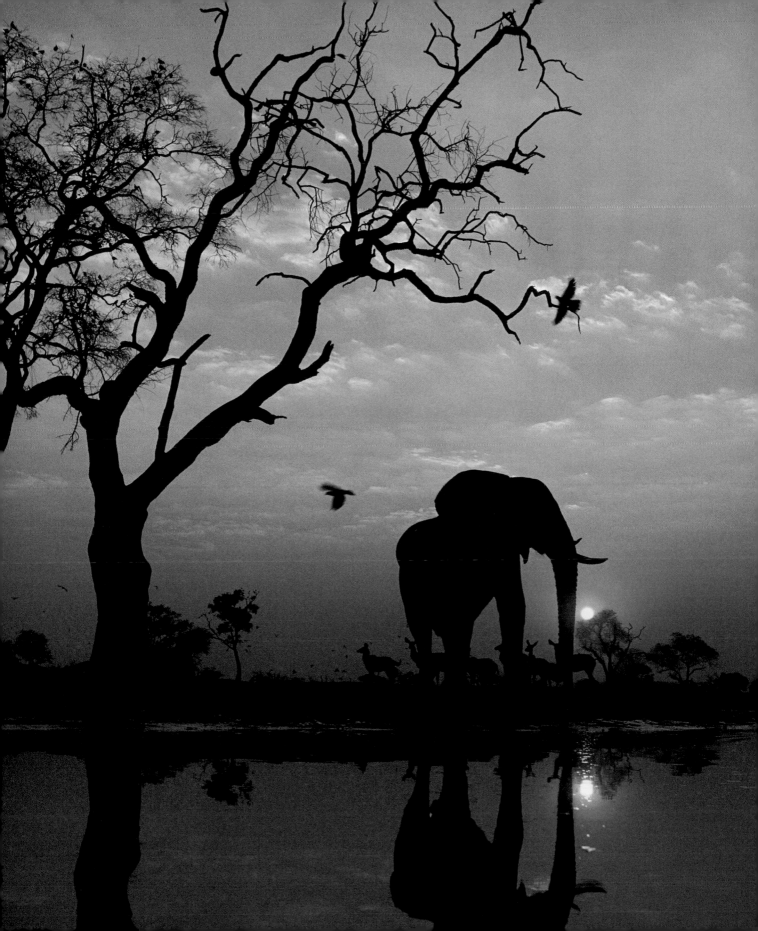

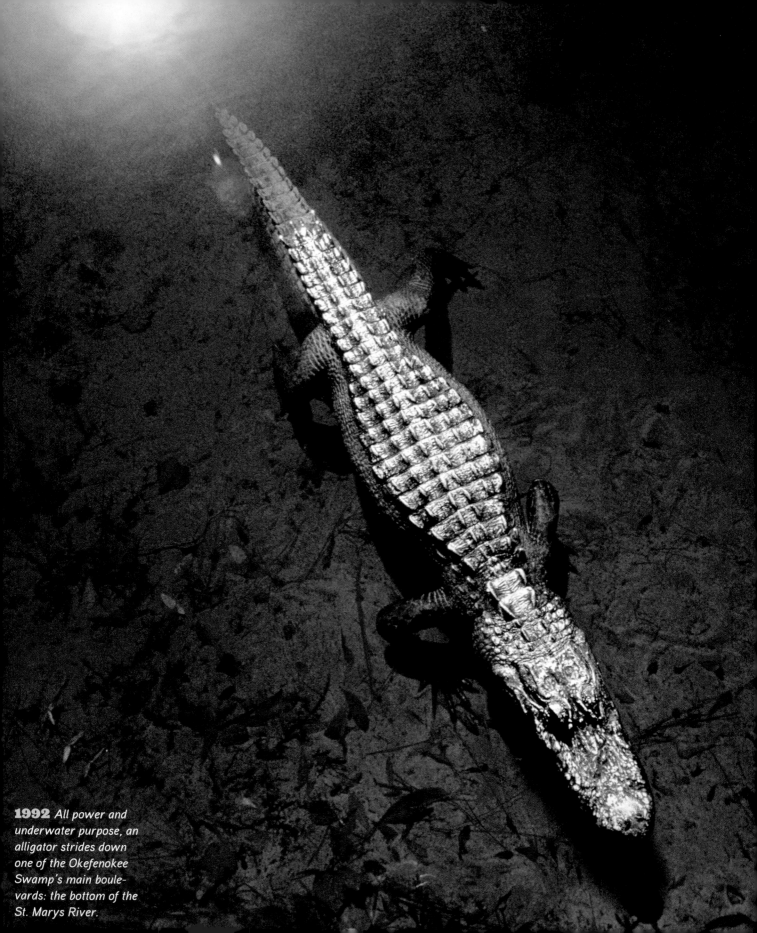

1992 *All power and underwater purpose, an alligator strides down one of the Okefenokee Swamp's main boulevards: the bottom of the St. Marys River.*

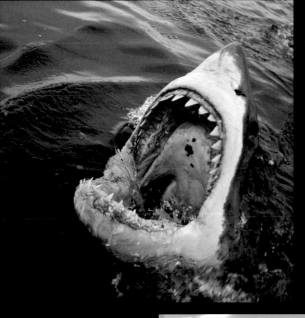

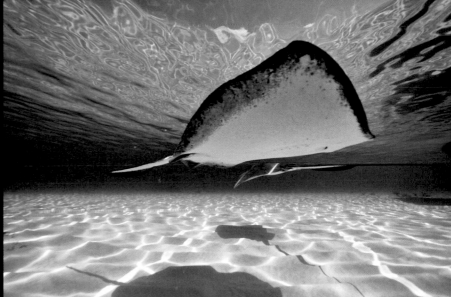

▲ 2009 A great white shark breaks the surface of the sea off Gansbaai, South Africa.

▸ 2008 Jut-jawed denizen of the sea, a longfin spadefish, a familiar figure in the world's oceans, hovers for plankton off Japan's Muko Jima island.

▾ 1981 A northern puffer bloats up to a threatening size by inflating a belly sac with water.

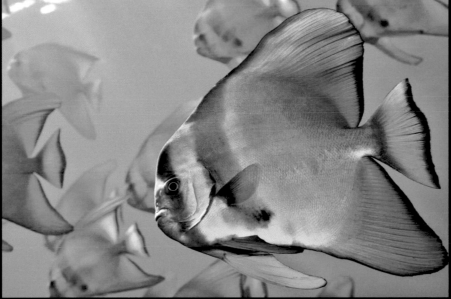

▲ 1999 Fish passing in the night—or day—two southern stingrays, often found in pairs, glide over white-sand shallows near Grand Cayman Island.

▾ 1996 An alligator snapping turtle consumes a fish in Florida. The victim may have been enticed to its destruction by the fleshy "lure," resembling a worm, found in the reptile's mouth.

▲ **2001** *Its hood flared in agitation, a king cobra in Thailand prepares to strike—its final answer, for the snake prefers flight to fight.*

◄ **2008** *Proboscises pointed skyward, two elephant seal bulls square off for battle on South Georgia Island.*

▼ **2007** *The endangered St. Andrew beach mouse is never happier than when safe in its burrow.*

▲ **1910** *A female housefly rests briefly on a pane of glass. The humdrum insect can transmit deadly diseases, including typhoid and cholera.*

⯅ **2007** *Winter moonlight becomes an arctic fox near Churchill, Manitoba. The animal's thick white fur will turn as brown as the surrounding tundra when summer arrives.*

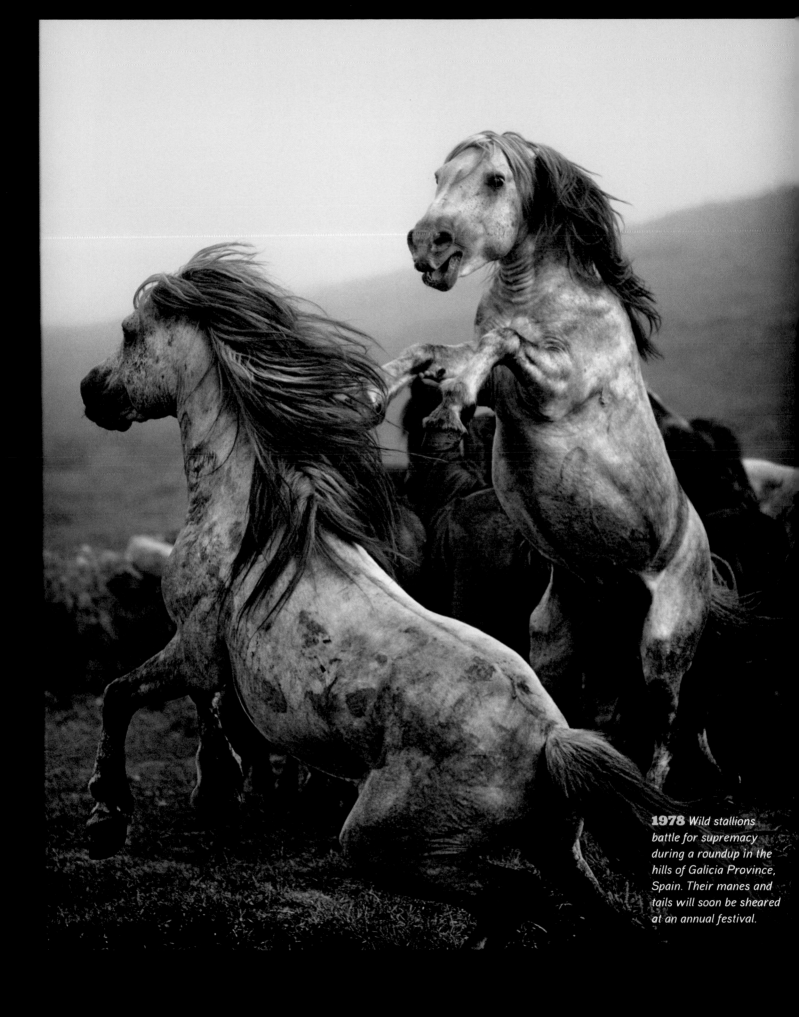

1978 *Wild stallions battle for supremacy during a roundup in the hills of Galicia Province, Spain. Their manes and tails will soon be sheared at an annual festival.*

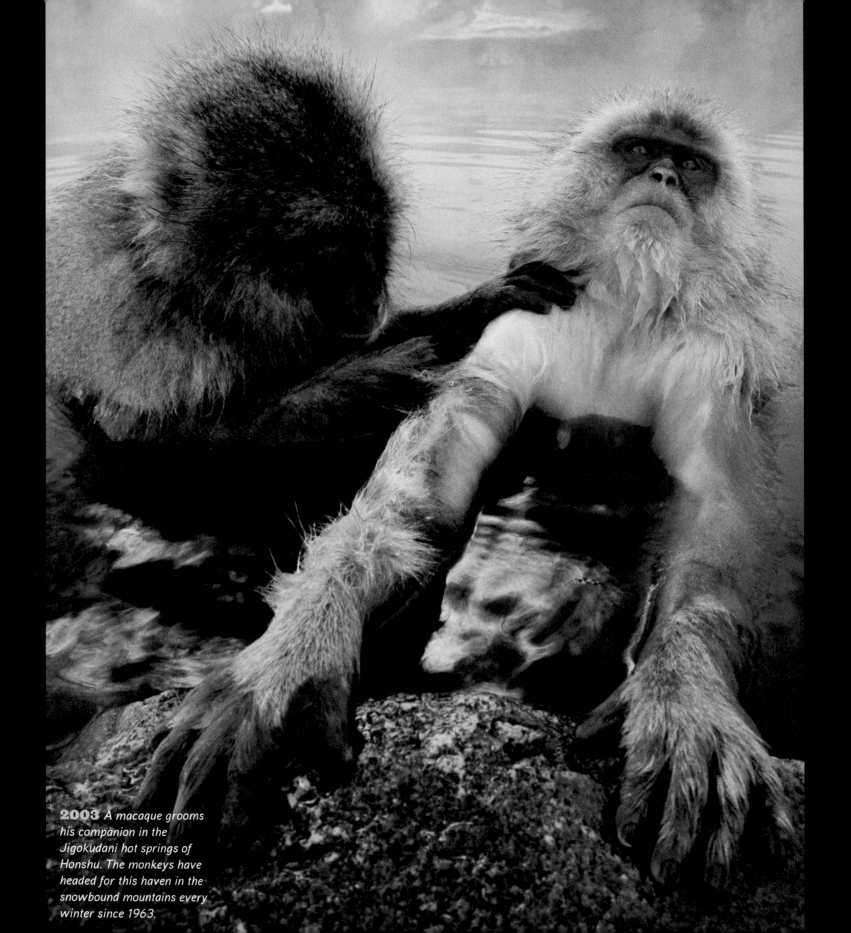

2003 *A macaque grooms his companion in the Jigokudani hot springs of Honshu. The monkeys have headed for this haven in the snowbound mountains every winter since 1963.*

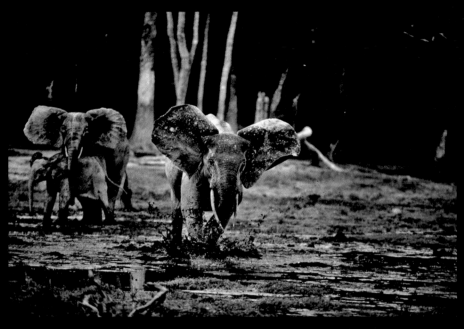

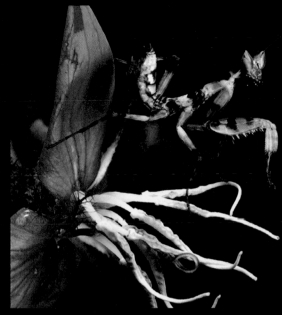

▲ 1993 *Spying an intruder, a forest elephant charges across a salt lick hidden deep in the Central African Republic.*

▶ 1977 *Wandering albatrosses return to islands such as South Georgia to court mates—with whom they may bond for 50 years.*

▼ 2002 *A gelada baboon, usually content to graze grasslands in Ethiopia, bares its fangs.*

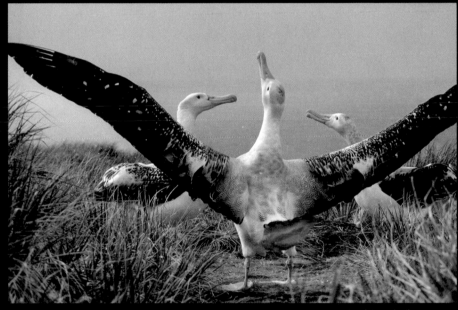

▲ 2006 *Hover, pray, eat: A juvenile flower mantis mimics the stamens of a flower in Burma in a bid to lure prey.*

▼ 1996 *The wind and the lion: Panthera leo stalks a dry riverbed in southern Africa's Kalahari Desert.*

1970-

1996

CALIFORNIA | 1977 Summing up a high-flying era, Bruce Dale's picture of a Lockheed Tristar on autopilot was made by a camera fixed to the tail fin.

◀ **1981** *Deep in the Foja Mountains of New Guinea, Jared Diamond caps years of ornithological expeditions by discovering the long-sought yellow-fronted gardener bowerbird.*

▶ **1966–88** *Supported for nearly two decades by Society grants, Turkish-American archaeologist Kenan Erim excavates Aphrodisias in Turkey, a "miracle in marble."*

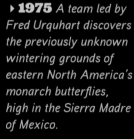

▶ **1975** *A team led by Fred Urquhart discovers the previously unknown wintering grounds of eastern North America's monarch butterflies, high in the Sierra Madre of Mexico.*

▼ **1972** *Diving in the Red Sea, young David Doubilet begins his career as the Geographic's preeminent underwater photographer.*

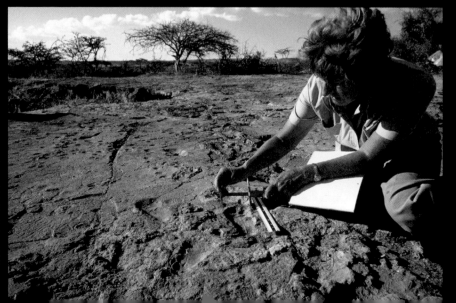

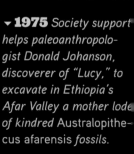

▼ **1975** *Society support helps paleoanthropologist Donald Johanson, discoverer of "Lucy," to excavate in Ethiopia's Afar Valley a mother lode of kindred* Australopithecus afarensis *fossils.*

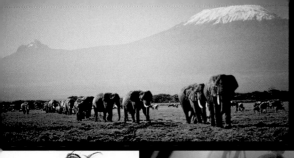

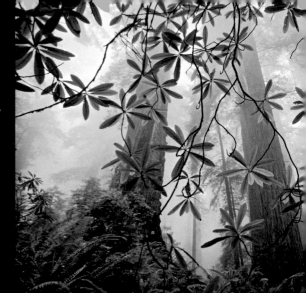

1977 *By deploying camera sleds and other deep-sea imaging systems, staff photographer Emory Kristof and the "Geographic Navy" provide invaluable assistance to marine scientists.*

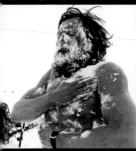

◀ **1985** *Assisted by National Geographic–designed imaging technologies, Bob Ballard finds the resting place of the Titanic, one of the most dramatic shipwreck discoveries of modern times.*

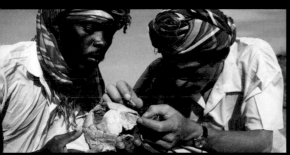

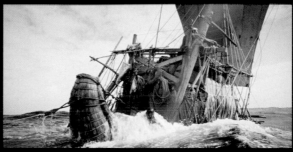

1977 *When Jodi Cobb becomes a Geographic staff photographer, she joins a group that, in its heyday, includes Jim Stanfield, Jim Blair, Bruce Dale, Bill Allard, and David Alan Harvey.*

▲ **1972** *A team led by Richard Leakey (right) discovers a nearly complete skull, dubbed "1470," of Homo rudolfensis— one of a series of remarkable finds made near Kenya's Lake Turkana.*

1984 *Dick Adams discovers an unlooted tomb at the Maya site of Río Azul in Guatemala. It is only one of many spectacular finds being made by Society-supported New World archaeologists.*

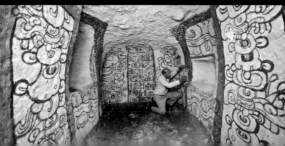

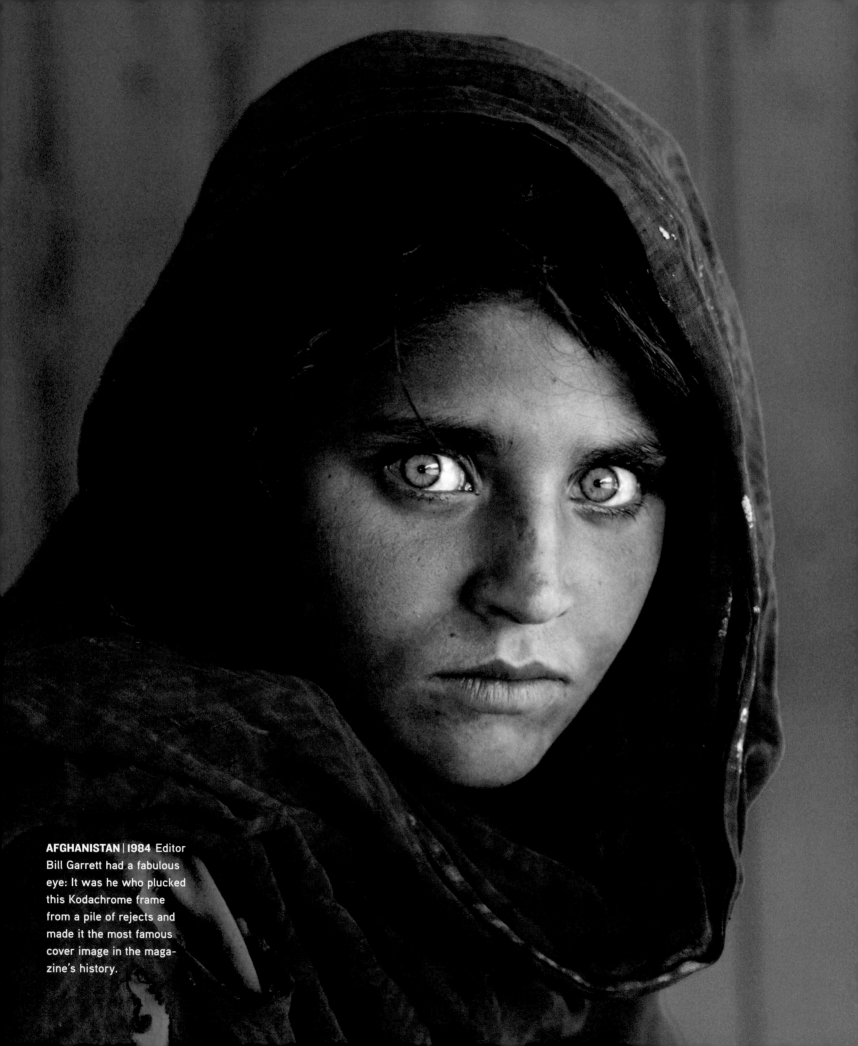

AFGHANISTAN | 1984 Editor
Bill Garrett had a fabulous
eye: It was he who plucked
this Kodachrome frame
from a pile of rejects and
made it the most famous
cover image in the maga-
zine's history.

TOWARD A BETTER STEWARDSHIP

By chronological fate," Gilbert M. Grosvenor told a gathering of scientists on the centennial of the National Geographic Society in January 1988, he—a fifth-generation President—happened to be the steward "of an extraordinary institution at a critical time in its history." Grosvenor's remarks came as he stood in a

new addition to its Washington headquarters complex. The annex had been dedicated in 1984 by another chief executive, Ronald Reagan, who singled out the Geographic for bringing home "the profound truth that we are . . . a human family living together on a tiny blue-and-green planet." Grosvenor might have further observed that the Society was expanding its reach into every corner of that planet. Out from headquarters would go writers, photographers, filmmakers, and explorers, and in would pour a flood of manuscripts, photographs, footage, and scientific reports. Out again surged books, atlases, globes, educational materials, magazines, and television programs. Thanks to the bold and brilliant Bill Garrett, Editor since 1980, some 40 million people read *National Geographic* each month. The Society was also emerging as one of the world's leading documentary filmmakers, producing about 60 hours of programming a year. Soon 20 of the 25 most popular PBS shows would be National Geographic Specials.

Forget about that prodigious outreach, Grosvenor cautioned; the Society needed to redouble its efforts. For one thing, he had discovered that American students were woefully ignorant of geography. So he set about trying to reverse that trend. As teachers from around the country began arriving at headquarters to attend training institutes, Grosvenor set up the National Geographic Society Education Foundation to raise funds and provide grants to support their efforts. The popular televised National Geography Bee (later renamed National Geographic Bee) would soon follow. And by 1994, a set of National Geography Standards would be drafted and adopted for use in the nation's classrooms.

And secondly, Grosvenor believed—from the moment he became Editor in 1970 to the day he would retire as President in 1996—that pressures on global ecosystems were approaching the crisis point. In 1988, therefore, he gave members the signature pledge of his era: "The National Geographic Society began its first century with a determination to better understand the world. We have begun our second with the same determination but with an added imperative: to encourage a better stewardship of the planet." ■

A MIRROR OF ITS TIMES

With the image of the blue planet came a planetary perspective— and global challenges began to dominate the pages of *National Geographic*.

When Gil Grosvenor became the Editor of *National Geographic* in 1970, he announced that the magazine would thenceforth serve as "a mirror of its times, reflecting the changes through which we pass." And the times they were a-changin': Setting the tone of the new era, a visually uncompromising article on pollution was the cover story of the December 1970 issue.

Over the next few years, articles on Castro's Cuba, North Korea, and South African apartheid entered the magazine's once staid editorial mix. In 1980 the talented Bill Garrett became Editor (Grosvenor having risen to Society President), and soon the *Geographic* looked smarter—and was ranging farther afield—than it ever had before. Turmoil in Africa, the Middle East, and Central America was reflected in its pages. But so were reports on garbage, the mystery of sleep, and the sense of smell.

Yet first and last the magazine was suffused by its emerging environmental consciousness. The *Geographic* showcased the vanishing wildlife of Africa and Asia. It highlighted the plight of elephants, pandas, rhinoceroses, and whales. It summarized the challenges of pesticides, nuclear power, and acid rain. In 1981 an extra—a 13th issue, devoted to the topic of energy—was so well received that 50,000 additional copies had to be printed to meet press and government requests. (Another 13th issue, this one on water resources, appeared in 1993.)

Star authors, meanwhile, debuted in the magazine's pages. John McPhee wrote about New Jersey's pine barrens, Peter Benchley dived in the Bahamas, and Robert Redford described Utah's Outlaw Trail. More familiar bylines included the *Geographic*'s own staff writers: Howard La Fay, a fabulous raconteur; Bart McDowell, a graceful stylist; and Peter White, whose research materials on his wide-ranging assignments filled several pallets in the Society's warehouse. Spy novelist Charles McCarry and associate editor Joseph Judge, the eloquent "Irish poet," harnessed these spirited scribblers.

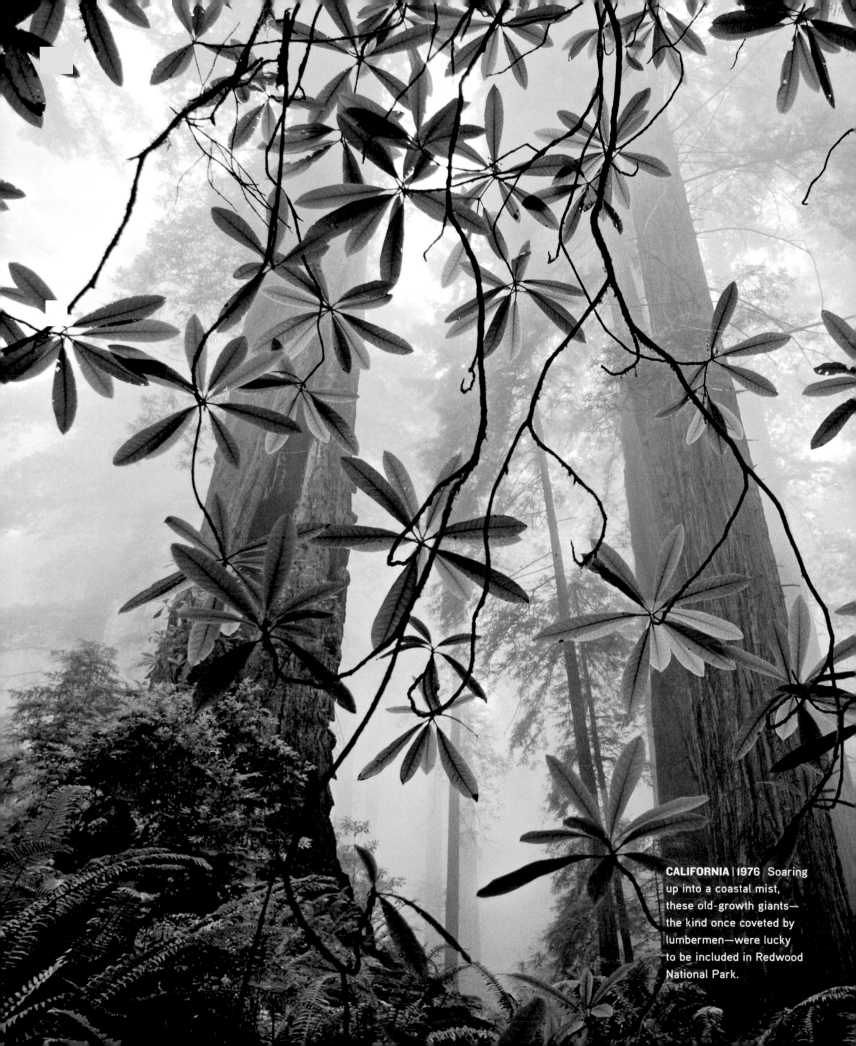

CALIFORNIA | 1976 Soaring
up into a coastal mist,
these old-growth giants—
the kind once coveted by
lumbermen—were lucky
to be included in Redwood
National Park.

GILKA'S GORILLAS

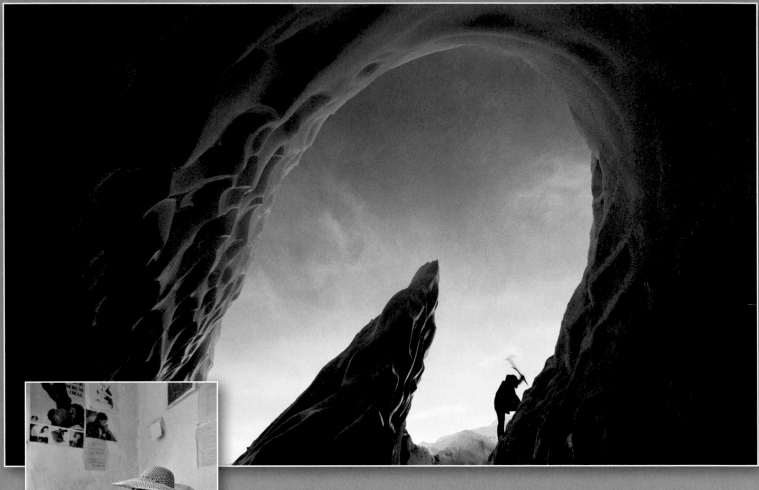

▲ ALASKA | 1976 A shot by George Mobley—an early member of "Gilka's Gorillas"—shows the view from inside an ice cave in the Matanuska Glacier.

◄ HAITI | 1987 A young mother, who has just been told that her baby is seriously ill, turns to gaze at another of "Gilka's Gorillas," staff photographer James P. Blair.

✚ **JAMES P. BLAIR**

This moving portrait of a young Haitian mother just discovering her child has syphilis reflects the kind of documentary photography Jim Blair practiced. Over a *Geographic* career lasting from 1963 to 1994, Blair concentrated on social and environmental issues.

The sign outside his office door was daunting: "Wipe your knees before you enter." Within sat a crew-cut, jut-jawed Minnesotan named Robert E. Gilka, National Geographic's director of photography from 1963 to 1985. Gilka, who never indulged pomposity or prima donnas, was so taciturn that "one grunt" meant "you did pretty well," recalled James L. Stanfield, who shot many a picture for him. Two grunts, it seemed, denoted a blockbuster coverage.

Yet somewhere behind that withering glance lurked a steadfast champion of *Geographic* photographers. Gilka promoted their interests and eased the strain of long assignments on their families. In return, he won their unswerving loyalty. Though Jane Goodall named a chimpanzee after him, his camera-wielding protégés instead called themselves "Gilka's Gorillas" (honoring, perhaps, *Garrison's Gorillas*—a mid-1960s TV drama in which a World War II lieutenant dispatched his elite commandos on seemingly impossible missions). ■

It was a heyday for Geographic photographers as well. Some were taking documentary realism in artistic directions: Sam Abell infused Newfoundland with a contemplative beauty, for example, while Bill Allard endowed his cowboy subjects with a sort of light-struck resilience. Others carved out specialties. Bob Sisson and Bianca Lavies preferred nature photography. Jodi Cobb gained entrée to the secluded world of Saudi women. David Alan Harvey gravitated toward Latin America, while Jim Stanfield tackled sweeping historical epics. And the versatile Bruce Dale ranged from people and places to challenging technical and scientific assignments.

For a 1973 article on Skylab, photo editor Jon Schneeberger peered at 42,000 pictures of Earth. But when Garrett published an innovative hologram on the cover of the December 1988 issue—a special edition dedicated to the environment—the expected image of our lonely orb traveling through infinite space was nowhere in evidence. Instead, above the message "Can Man Save This Fragile Earth?" there appeared an even more arresting visual: Bruce Dale's pulsed-laser photograph of a bullet shattering a crystal globe. ■

▶ **FEBRUARY 1983**
An article on the "Peoples of the Arctic" featured the work of fine photographers such as David Alan Harvey and Sisse Brimberg.

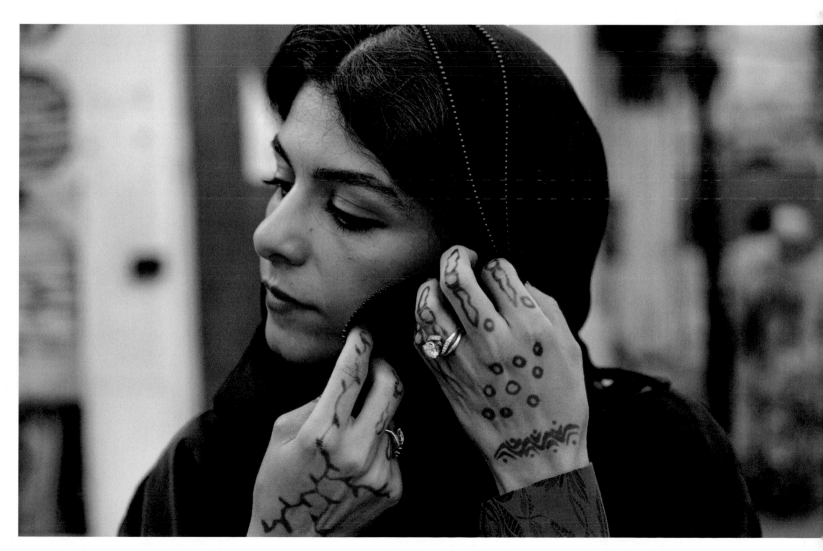

SAUDI ARABIA | 1987 This Oxford doctoral candidate, photographed by Jodi Cobb, practiced the Arab custom of decorating her hands with henna.

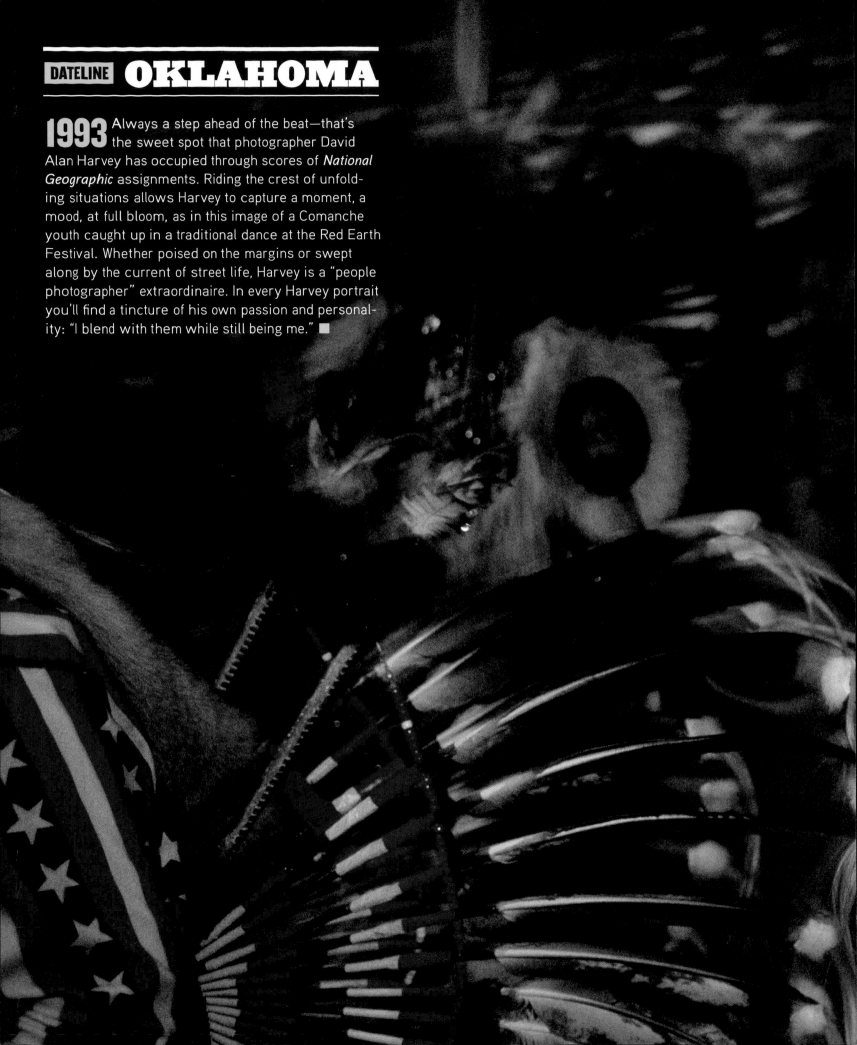

DATELINE OKLAHOMA

1993 Always a step ahead of the beat—that's the sweet spot that photographer David Alan Harvey has occupied through scores of *National Geographic* assignments. Riding the crest of unfolding situations allows Harvey to capture a moment, a mood, at full bloom, as in this image of a Comanche youth caught up in a traditional dance at the Red Earth Festival. Whether poised on the margins or swept along by the current of street life, Harvey is a "people photographer" extraordinaire. In every Harvey portrait you'll find a tincture of his own passion and personality: "I blend with them while still being me." ■

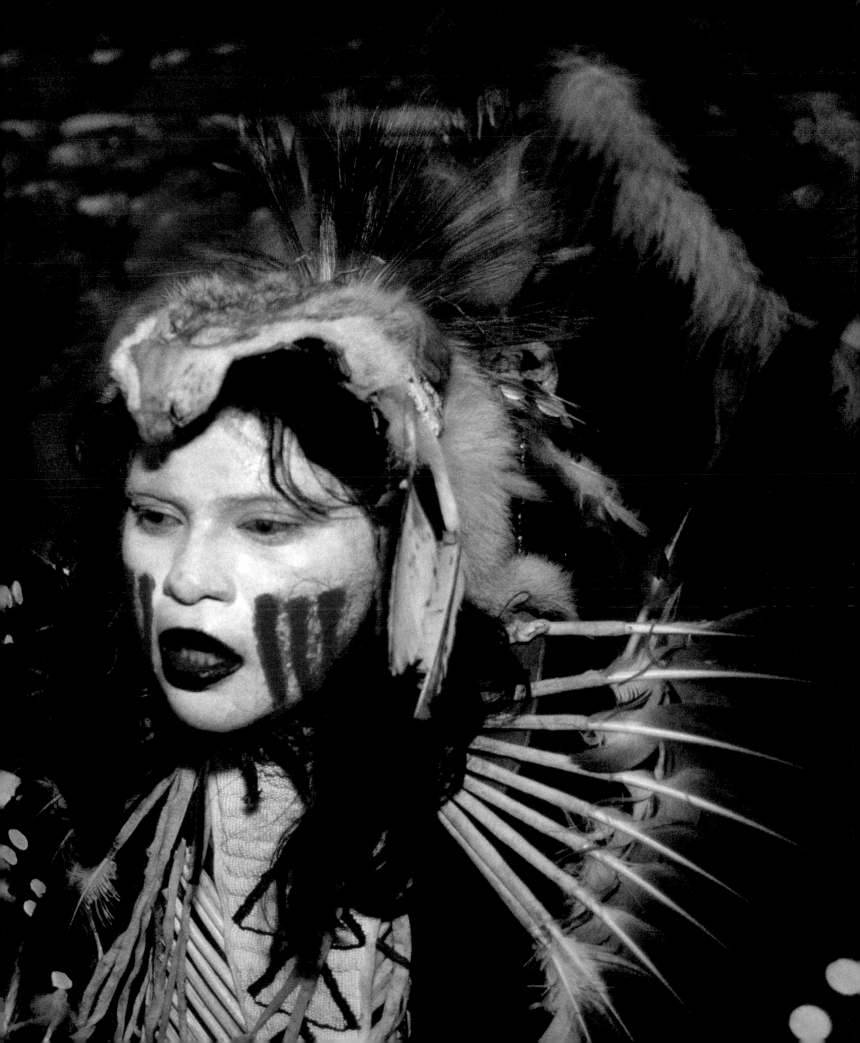

NEW LIGHT ON WILD ANIMALS

An exciting era in wildlife studies is tempered by the knowledge that many species were in dire need of being protected.

ANIMAL'S-EYE VIEW

✳ CRITTERCAM

In 1986 the sight of a remora clinging to a shark got marine biologist Greg Marshall wondering: Why couldn't a lightweight video camera, similarly mounted, capture a remora's-eye view of the world? Thus was born the National Geographic Crittercam, which has provided new glimpses into the behavior of sharks, marine mammals, and even lions.

ABOVE: An emperor penguin, outfitted with a Crittercam, becomes an unwitting cameraman—er, camerabird—for a Geographic documentary.

George Schaller had worked with gorillas in the Belgian Congo (now the Democratic Republic of the Congo), lions in Tanzania, and tigers in India, but in December 1970 he found himself high in the mountains of Pakistan's soaring Hindu Kush, conducting a wildlife survey for the Prince of Chitral, who was thinking of turning his lofty ancestral estate into a game sanctuary. For several weeks the world's preeminent field biologist watched the markhor, a spiral-horned wild goat, climb into evergreen oaks to feed on their tender leaves. Then, slogging through the snow one day, Schaller came across tracks made by no markhor. Instead he recognized the pug of its predator, the notoriously elusive snow leopard. Fewer than five Western scientists had ever seen one in the flesh.

Eventually, after weeks of stalking and watching, Schaller snapped the first photographs ever published of the "ghost cat of the Himalaya." When those grainy images appeared in the November 1971 *National Geographic*, virtually nothing substantial was known about snow leopards. Within a decade, however, Society funding would allow biologist Rodney Jackson to undertake the first thorough study, in Nepal, of the creature that had struck Schaller as a "wisp of cloud" gliding among the crags. By then, of course, the Geographic was helping naturalists everywhere make new discoveries about the inner lives of wild animals.

THE BROTHERS CRAIGHEAD

In 1935 a pair of 19-year-old twins walked into Society headquarters, initiating a half-century relationship that would result in 13 *National Geographic* articles, two Television Specials, and more than 30 research grants. Frank and John Craighead had been inspired by reading Louis Agassiz Fuertes's 1920 *Geographic* article on falconry, which soon led to one of their own: "Adventures with Birds of Prey," published in the

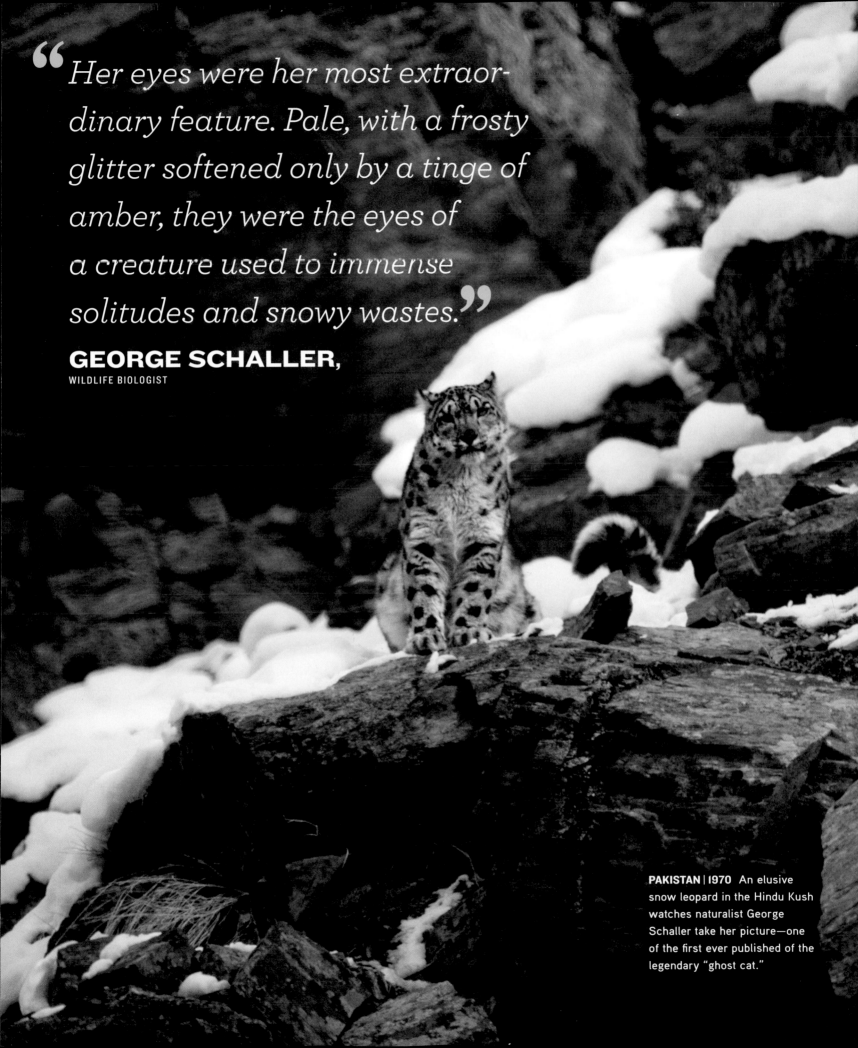

> "*Her eyes were her most extraordinary feature. Pale, with a frosty glitter softened only by a tinge of amber, they were the eyes of a creature used to immense solitudes and snowy wastes.*"
>
> **GEORGE SCHALLER,**
> WILDLIFE BIOLOGIST

PAKISTAN | 1970 An elusive snow leopard in the Hindu Kush watches naturalist George Schaller take her picture—one of the first ever published of the legendary "ghost cat."

July 1937 issue, was first in a series that took readers alongside the twins to India, where they hunted with falcon-loving maharajas; to remote Pacific atolls, where they taught survival skills to World War II aviators; and finally to Yellowstone National Park, where the Craigheads, having become respected wildlife biologists, embarked in 1959 on their signature project: a 12-year, Society-supported study of grizzly bears.

As the brothers refined techniques for trapping, immobilizing, and (quickly) tagging the sharp-clawed bruins, they learned how to outfit them with radio-tracking collars. Eventually they graduated to satellite-based biotelemetry transmitters, which relayed information on the animals' heartbeat and respiration, though the twins had to crawl into the animals' winter dens to fit the devices onto the hibernating bears. Soon they were using satellite data to map habitats as well, engendering an ecosystem-wide concept of wildlife management. As a result, a complete picture of grizzlies began to emerge—"the first penetration of human light," as one authority put it, "through the ancient opacity of bearhood."

By the mid-1980s, the Craigheads had saved grizzly bears from extinction in the lower forty-eight. They had also inspired an entire generation of younger wildlife biologists. Maurice Hornocker, to cite one instance, had served his apprenticeship working for the twins. In subsequent years Society grants helped Hornocker study wolverines, bobcats, and mountain lions. In 1992, again with Geographic support, he teamed up with fellow big-cat specialist Howard Quigley—who had once helped George Schaller place radiotelemetry devices on Brazilian jaguars and Chinese pandas—to establish the Siberian Tiger Project: This promising effort aims to check the plummeting populations of the world's largest, and most threatened, big cat.

TREASURES OF THE SIERRA MADRE

Biologist Fred Urquhart had marveled at eastern monarch butterflies since he was a boy in Ontario. Though they danced and skimmed over summer meadows from Canada to Florida, no one knew where they went in the winter. That they streamed south was certain. But then they

WYOMING | 2011 A grizzly bear rests in a Yellowstone National Park meadow.

NEW GUINEA'S LOST WORLD

AUSTRALIA | 2010 A mating bower, constructed by a male great bowerbird
(Chlamydera nuchalis)

+ VITAL STATS

WHAT: Male golden-fronted bowerbird *(Amblyornis flavifrons)*

WHERE: Foja Mountains, New Guinea

WHEN: 2008

THEN, meaning 1953, was when E. Thomas Gilliard published in the April *Geographic* the first photographs of New Guinea's birds of paradise displaying their extraordinary plumage in the wild. Yet he was more interested in discovering the whereabouts of the mysterious golden-fronted bowerbird, one of a feathered tribe that constructed magnificent trysting grounds. It fell to the multitalented Jared Diamond, in 1981, to find that elusive bird in the remote Foja Mountains of western New Guinea. Diamond believed he had stumbled onto a lost world—a pristine ecosystem that had rarely felt a human footfall.

NOW, meaning the 21st century, had hardly dawned when a rapid assessment survey returned to the Foja Mountains and proved Diamond right. Led by Bruce Beehler in 2005, the team tabulated hundreds of species in just two weeks, 40 of them new to science. Meanwhile, Tim Laman has been photographing all 39 species of New Guinea's birds of paradise, showcasing their astonishing mating displays. ■

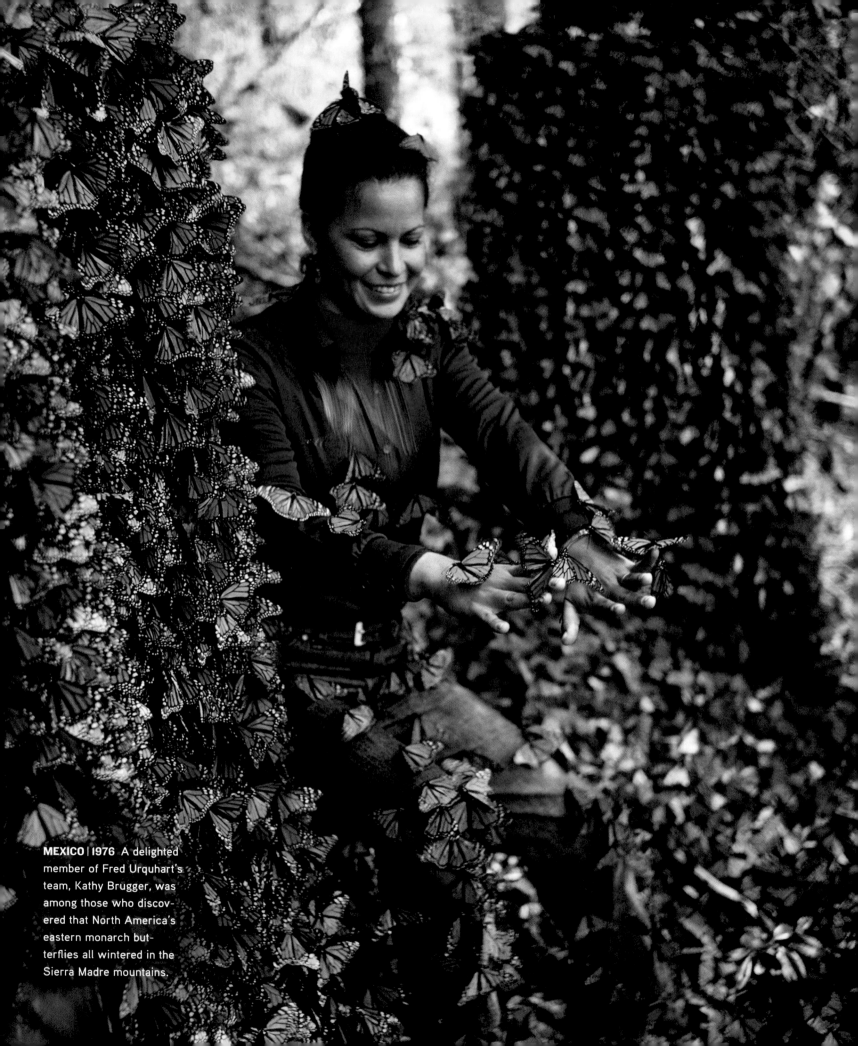

MEXICO | 1976 A delighted member of Fred Urquhart's team, Kathy Brugger, was among those who discovered that North America's eastern monarch butterflies all wintered in the Sierra Madre mountains.

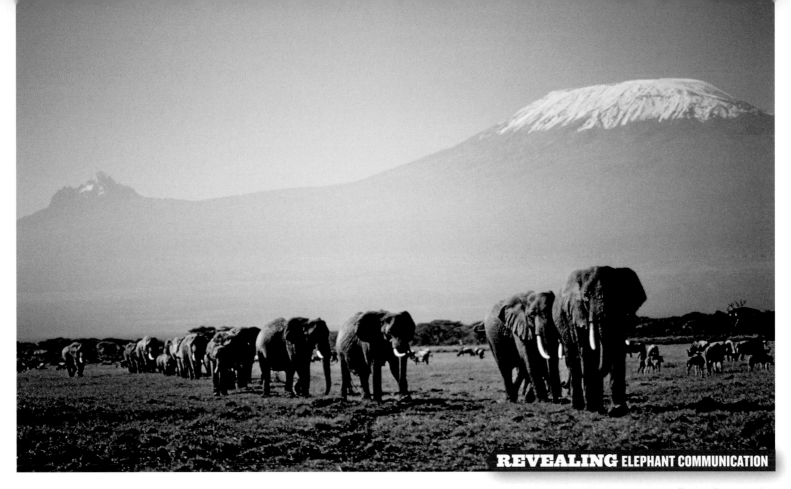

REVEALING ELEPHANT COMMUNICATION

KENYA | 1980S Elephants in Amboseli National Park communicate with distant herds via infrasonic means, Katy Payne and Joyce Poole discovered.

disappeared. So in 1937 Urquhart and his wife, Norah, started tracking the butterflies. Financing the operation on a shoestring, they were close to quitting for lack of funds when National Geographic stepped in.

Five years of Society support allowed the Urquharts to straighten up and fly right. As a result, in early 1975, members of their volunteer team, climbing ever higher in Mexico's Sierra Madre, reached the fir forests of remote Michoacán state, where they found the monarchs in mind-boggling numbers, covering thousands of trees so thickly that branches were breaking beneath their weight; found them carpeting the ground to a depth of six or eight inches. An entire mountainside was one quivering mass of butterflies.

The sensational discovery was announced to the world in the August 1976 *Geographic*. Though a dozen similar sites were later found, all nestled within those same mountains, the battle to protect them has been long and uphill.

The magazine could no longer ignore the world's wildlife wars. As researcher Iain Douglas-Hamilton, son of a Scottish nobleman, raced against time to compile life histories of Kenya's elephant families, poachers were ravaging the pachyderms for their ivory tusks. Driving around Tsavo National Park in a battered Land Rover with her husband, Iain's wife, Oria, found it to be "littered with mounds of 'eleskeles,' white bones draped with a dark skin like a blanket covering the dead," as she described the grisly scene in the November 1980 *Geographic*. Oria felt as if they were "watching the extermination of the elephant," she wrote, "and no one seemed to care."

▶ **DECEMBER 1981 COVER**

During a six-month sojourn in China, George Schaller became the first Westerner permitted to study and photograph endangered pandas in the wild.

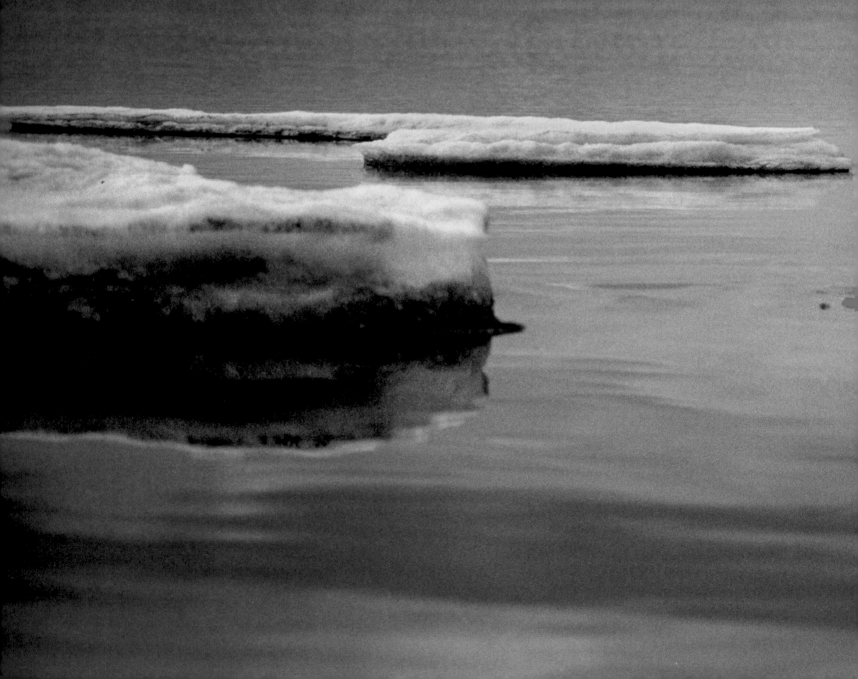

1986 "Good photographs of wolves could define elusiveness," Jim Brandenburg once admitted. Of all the animals the celebrated wildlife photographer had studied, wolves had always been his favorites—yet in 20 years he had made only seven good pictures of them. Then Brandenburg and biologist L. David Mech discovered, on Canada's remote Ellesmere Island, a pack of arctic wolves with almost no previous exposure to humans. To the pair's astonishment, the pack accepted their presence, and for one glorious summer the two men practically joined the animals in their den. It was the highlight of their careers: the chance to observe, and photograph, the daily lives of wolves up close. ■

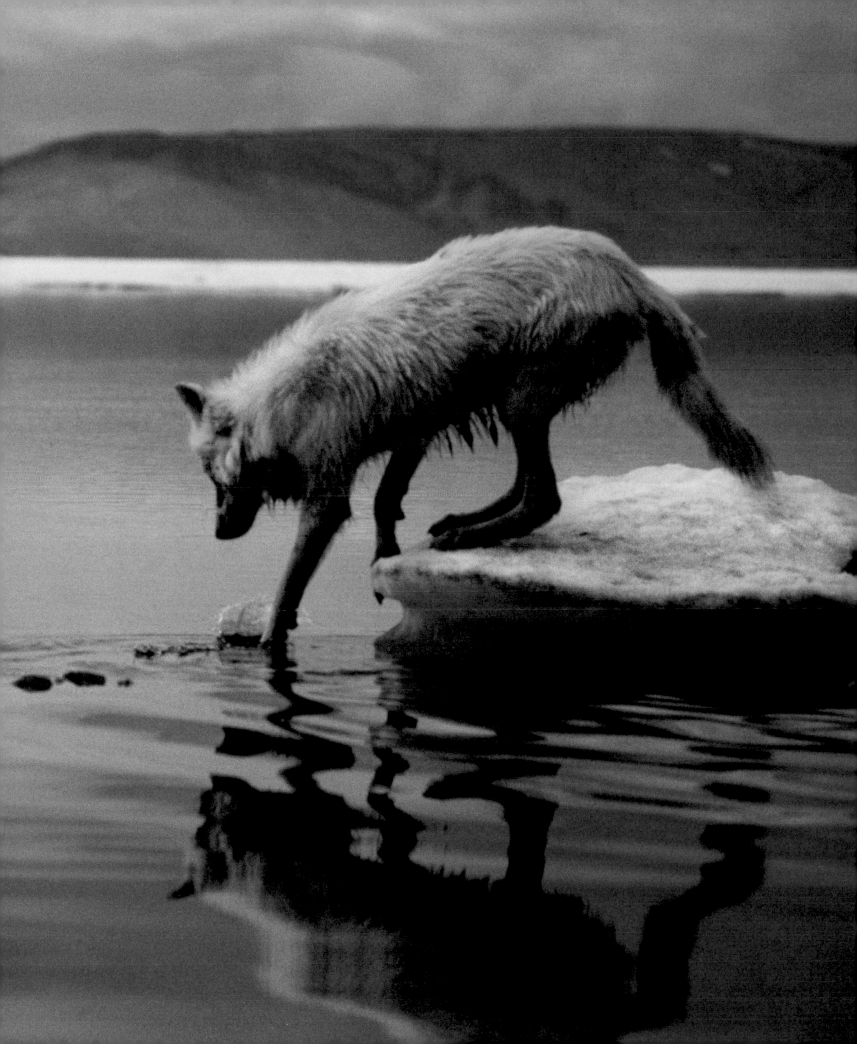

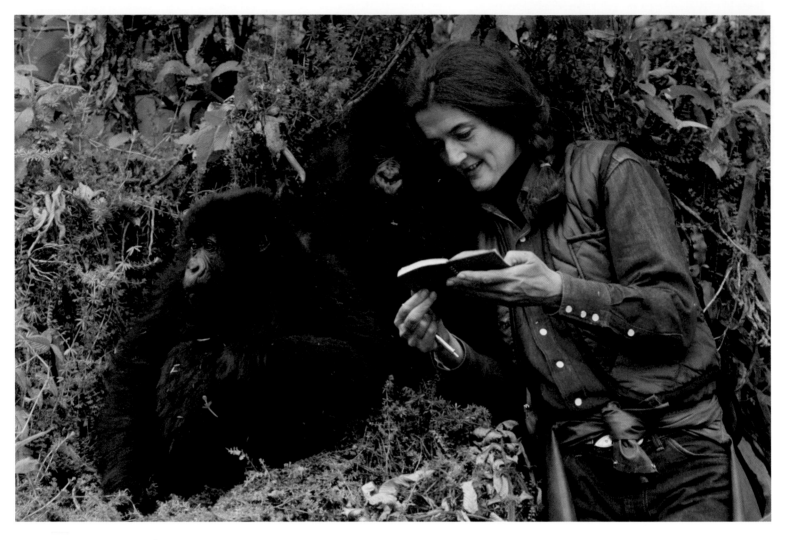

RWANDA | 1969 Dian Fossey with Coco and Pucker—two orphaned gorillas—near Karisoke in the Virunga Mountains.

Meanwhile, other researchers were untangling the mystery of elephants' seemingly telepathic communication: Herds separated by many miles moved as one, converging on water holes simultaneously. The answer involved nothing like telepathy, Joyce Poole and Katharine Payne discovered. Rather, the animals were emitting a deep rumbling, pitched so low the human ear could not detect it, which carried for great distances. Working primarily in Kenya's Amboseli National Park and Namibia's Etosha and Skeleton Coast National Parks, Poole and Payne furthered this research by testing elephant responses via wireless microphones and playback experiments.

GORILLAS IN OUR MIDST

Though she could be difficult with people, "no one loved gorillas more," as her epitaph proclaimed. The tall, dark-haired Dian Fossey had been handpicked by Louis Leakey to be the Jane Goodall to the endangered mountain gorillas. In 1967 Fossey established the Karisoke Research Center, a cluster of cabins 10,000 feet high in Rwanda's cool, misty, lushly forested Virunga Mountains. There she would work, sponsored

largely by the National Geographic Society, for two tempestuous decades.

Fossey began quietly enough, identifying local gorilla groups and habituating them to her presence: grunting in imitation of their calls, grooming and scratching herself as they did, gobbling—or pretending to—their stalks of wild celery. Nairobi-based photographer Bob Campbell, eager to produce close-up pictures, pushed Fossey to approach the shy but intimidating creatures.

Then came the momentous day when she lay prone and quivering among the gorillas. The male she had named Peanuts came near, reached out—and touched her hand.

Though Dian Fossey would go on to make first-rate observations of gorilla behavior and group dynamics, these unshakable images—Fossey lounging in their midst—persuaded the general public the apes were not such fearsome beasts after all.

As Fossey studied gorillas in the cool highlands, a third primatologist, also recruited by Leakey, arrived in the sweltering, vine-choked tropical forests of Indonesian Borneo. In 1971 anthropologist Biruté Galdikas and her photographer husband, Rod Brindamour, settled into a thatched hut in the Tanjung Puting Reserve and began the first long-term study of orangutans. So little was known about these apes— they tended to lead solitary lives—that they had never been seen coming down from the trees. Galdikas, however, observed them foraging on the ground and occasionally even in grasslands. Soon the chestnut-haired surrogate mother—draped in orphaned orangutans, and already a fierce advocate for her charges—was appearing on the cover of the magazine, as well as in the 1976 TV Special *Search for the Great Apes*.

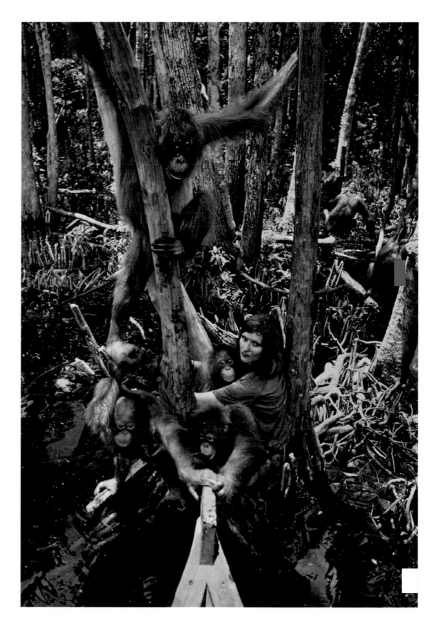

BORNEO | 1979 Biruté Galdikas not only studied wild orangutans in Indonesia's Tanjung Puting Reserve but she also rehabilitated former captives and orphans.

The following year, when poachers killed Dian Fossey's favorite gorilla, Digit, they transformed the scientist into an avenging angel. Fossey became "a law unto herself," in Jane Goodall's words. She waged a one-woman war on the poachers, tearing up their snares, wrecking their forest camps, even kidnapping them. And making too many enemies: Fossey was murdered inside her Karisoke cabin on December 27, 1985. The crime has never been solved.

"Had it not been for Dian Fossey," Gil Grosvenor wrote appreciatively of her struggles in the May 1986 issue, "there is no doubt in my mind that the mountain gorilla would by now have joined the list of extinct species." ■

INTO THE RUBBLE OF EONS

Using tools from dental picks to machetes, Society-supported paleontologists and archaeologists continue rewriting the story of the past.

✳ NOT ANOTHER MILE

In 1968 a balky camel forced Richard Leakey, riding east of Kenya's Lake Turkana, to halt for the night short of his destination. The following dawn he awoke and sauntered up a dry streambed. There he saw, sitting in the sand, a fossil hominid skull, dated at 2.8 million years old—the first of many great finds to come.

ABOVE: Richard Leakey hoped camels would be better suited for the tortured terrain east of Lake Turkana. But they didn't work out.

Several years before Louis Leakey's death in 1972, his son Richard, who had often claimed he was no bone hunter, finally succumbed to the family's ruling passion. As one of the leaders of the 1967 Omo River Expedition to Ethiopia, the younger Leakey, despite several close calls with crocodiles, returned with a 100,000-year-old human skull.

He had also overflown nearby Lake Turkana and noticed that the stark, eroded badlands stretching away from its eastern shores appeared to be promising fossil country. After a quick visit produced two-million-year-old stone tools, young Leakey insisted on mounting a major expedition to this Kenyan desert. Though his father was dubious and Richard himself was a high-school dropout, National Geographic reluctantly cut him a check in 1968. It was handed over with the admonition not to come knocking again should the Society's trust be misplaced.

LEAKEY'S LUCK

Richard Leakey's instincts were soon validated. Hardly had he established a headquarters on a windy lakeside promontory called Koobi Fora when his assistants began delving into the "rubble of eons," as he put it in the May 1970 *Geographic*. In the first five years alone, they recovered fragments of some 90 hominids.

One day in August 1972, Bernard Ngeneo, one of Leakey's fossil hunters, was scouring a gully when he spotted some promising fragments poking from the wall. After Meave, Richard's wife and herself an expert on fossil monkeys, had painstakingly pieced the fragments together, Skull 1470 (its registration number) proved to be the oldest complete cranium—dating back nearly two million years—of what is today called *Homo rudolfensis*.

"Leakey's luck" continued to hold on the lake's western shores. In July 1984 Kamoya Kimeu, exploring within sight of the camp tents, spied another bit of hominid skull

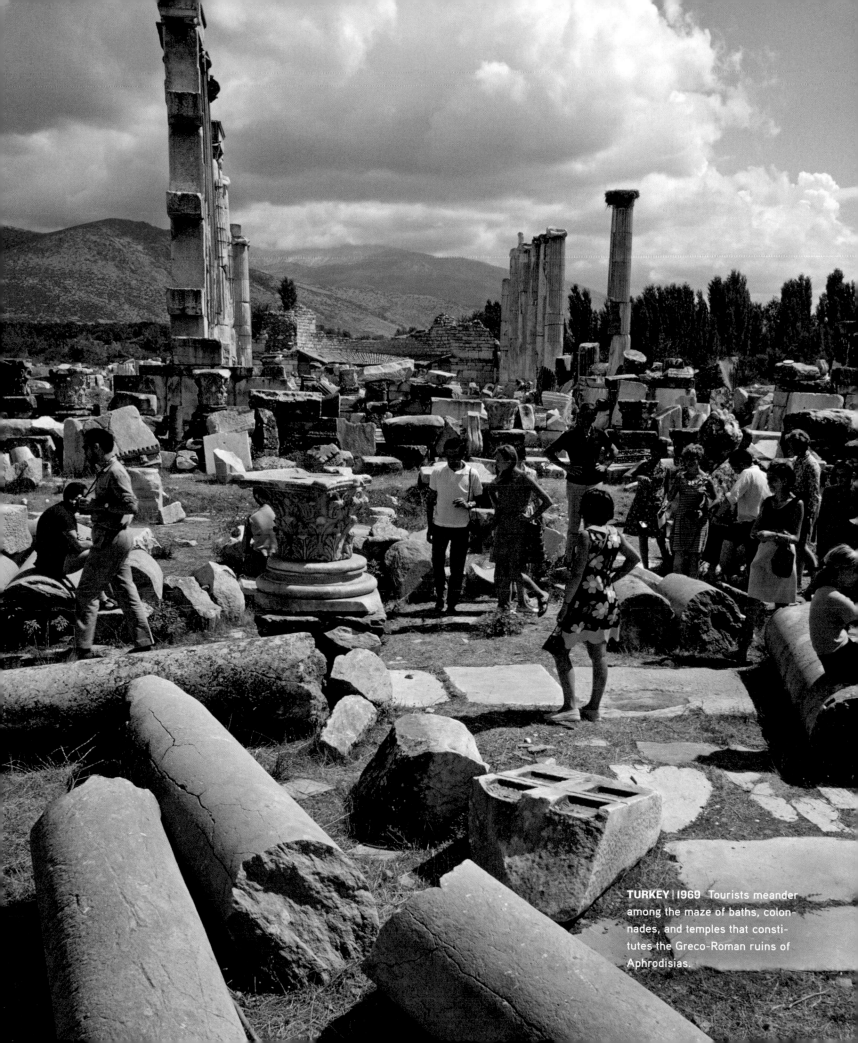

TURKEY | 1969 Tourists meander among the maze of baths, colonnades, and temples that constitutes the Greco-Roman ruins of Aphrodisias.

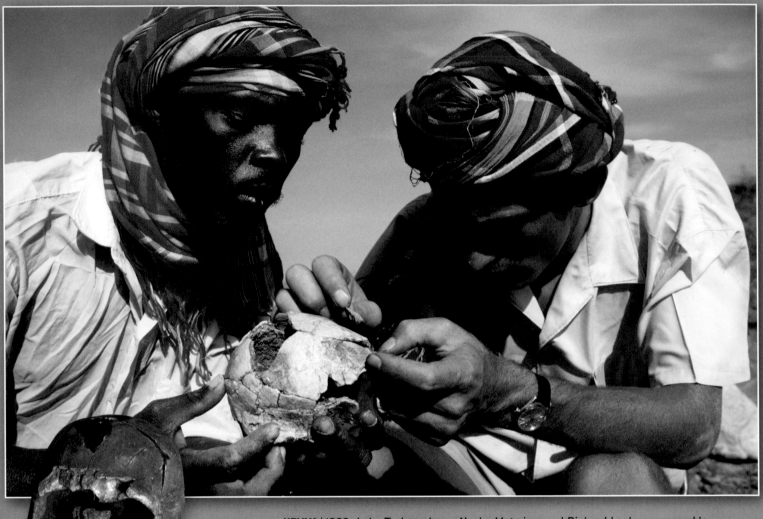

KENYA | 1969 Lake Turkana boys: Nzube Mutwiwa and Richard Leakey reassemble a fossil skull at Koobi Fora.

+ VITAL STATS

WHO: Turkana Boy

WHAT: 1.5-million-year-old *Homo erectus* skeleton (skull shown above)

WHERE: Nariokotome near Lake Turkana, Kenya

WHEN: 1984
AGE: Perhaps 8 to 12 when he died

In 1960, when Kamoya Kimeu was 20, he and some of his fellow Kamba tribesmen were recruited by Mary Leakey to help shift dirt at Olduvai Gorge. Sharp-eyed young men, they quickly learned to distinguish a shard of extinct rhinoceros from a bit of shattered hominid cranium. When Richard and Meave Leakey began hunting for traces of early man near Kenya's Lake Turkana, they asked Kimeu, Bernard Ngeneo, and Nzube Mutwiwa to accompany them. Relying on acute vision and bound by a strong esprit de corps, the Hominid Gang—as Kimeu's growing field staff came to be called—was soon finding most of the fossils that have made Koobi Fora a famous name in paleoanthropology. In 1977 Kimeu became the National Museums of Kenya's curator for prehistoric sites, and when eight years later President Ronald Reagan draped the Society's La Gorce Medal around his neck, it was to honor the Kamba's "accomplishment in geographic exploration" and his contributions to the quest for humanity's African roots. ■

in a gravel outcrop. After the mound had been excavated, the team realized it had secured the first nearly complete skeleton of *Homo erectus,* which had once given form to a lad, dubbed Turkana Boy, who died some 1.5 million years ago.

"Absolutely magnificent!" had been Mary Leakey's first reaction, back in 1969, to her son's astonishing finds. But she was not easily outdone. When hominid teeth, jaws, and skull fragments were found at Laetoli, a Tanzanian site only 30 miles from Olduvai Gorge, she shifted her attentions there. By 1978 she was investigating a layer of hardened volcanic tuff—deposited as moist ash by a prehistoric eruption—that erosion had partially exposed to inspection. Imprinted in the rock were the tracks of long-vanished ostriches, hyenas, antelope, a saber-toothed cat—and hominids.

Gingerly removing the overburden of grass and soil, Mary Leakey revealed a set of recognizable footprints; indeed, they looked as if they had been made yesterday. They were, in fact, 3.6 million years old—making them the oldest evidence of hominid activity found up until then. The most likely culprits were small-brained australopiths, an early human lineage, suggesting that our ancestors walked upright long before they fashioned tools or evolved large brains.

LOVE IN THE RUINS

When Kenan Erim first laid eyes on Turkey's Aphrodisias, the ruins were tumbled, choked in poppies and honeysuckle, and overgrown with laurel and olive trees. From 1966 to 1988, however, the Turkish-American archaeologist drew on Society backing to painstakingly clear and clean the site. Bit by bit, an astonishingly complete ancient city

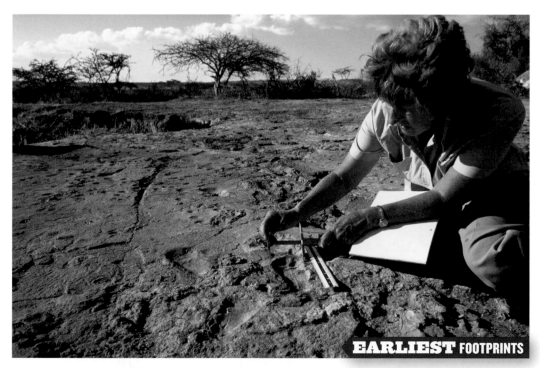

EARLIEST FOOTPRINTS

TANZANIA | 1978 Mary Leakey measures the length of a footprint uncovered at Laetoli. A passing pedestrian left it 3.6 million years ago.

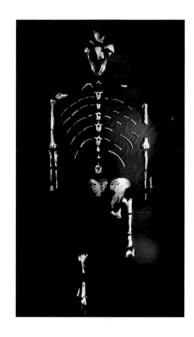

✳ LUCY'S KIN

After Donald Johanson's sensational 1974 discovery of Lucy, a 3.2-million-year-old *Australopithecus afarensis* skeleton, the Society helped the paleoanthropologist return to the eroded badlands of Ethiopia's Awash River Valley. In 1975, on a crumbling cliffside called Hominid Site 333, Johanson found the fossilized remnants of 13 additional *A. afarensis* individuals—soon dubbed the First Family of Hominidae.

ABOVE: Lucy, or Denkenesh (Amharic for "You are wonderful!")

It was the most dramatic shipwreck discovery of its era, announced to the world during a press conference at Society headquarters in September 1985. A French-American team, led by Dr. Robert Ballard, had found the resting place of the *Titanic*, more than two miles beneath the surface of the North Atlantic. And it had done so without wetting the first toe. *Argo*, a remotely operated deepwater vehicle, had done the work, using an electronic camera system partially designed by *National Geographic* photographer Emory Kristof.

After his 1994 retirement, Kristof carried the equivalent of a movie studio's lights 12,000 feet down to the famous site. There he shot such spectacular footage of the great liner that movie director James Cameron later adopted many of Kristof's techniques to film the blockbuster *Titanic*.

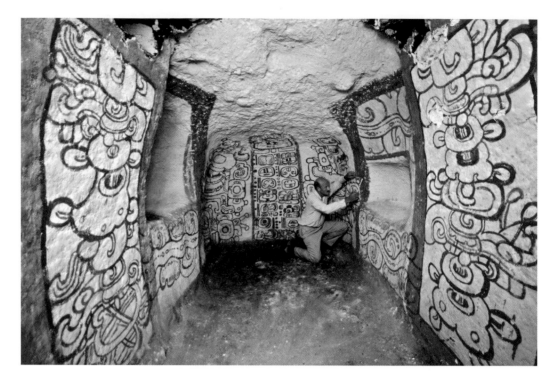

GUATEMALA | 1984 Archaeologist Dick Adams examines the complex wall murals found in Tomb One at Río Azul.

emerged. Covering some 250 acres, it boasted an odeon, or theater; an agora, or public square; Baths of Hadrian and a Temple of Aphrodite; a stadium that once echoed to the roar of spectators; and marble statues as finely wrought as any in the Roman Empire. Aphrodisias had once been home to 50,000 people. That was before a series of earthquakes sent the residents packing.

Río Azul, in northern Guatemala, may have been ten times the size of its Turkish counterpart. But the surrounding jungle had engulfed it so completely that it wasn't discovered until 1962. By 1984 Society support was helping Dick Adams map the site, though he seemed to be racing robbers to every find. Shifting the heavy slab off Tomb 19 one day, however, Adams discovered that it was still untouched. So was Tomb 23, examined the following year. Both were rich repositories of ancient Maya funerary art.

Finding unlooted tombs became a paramount objective for Society-sponsored archaeologists. None had quite the good fortune of Christopher Donnan, however.

NG DISCOVERS **LOST TREASURES FROM BURIED CITIES**

Silver coin faced with Apollo, god of music and arts ▶ Bronze snake-head bangles found next to victim of Vesuvius ▶

GREECE, CIRCA 353 B.C. ITALY, A.D. 79

APHRODISIAS

Apollo, the god of music and the arts, adorns a silver coin issued between 377 and 353 B.C. by the local satrap Mausolus, after whom the mausoleum at nearby Halicarnassus was named.

HERCULANEUM

With eyes made from jasper, these golden snake bracelets were found with the body of a 45-year-old woman killed by ash fall at Herculaneum in A.D. 79.

He had spent years uncovering the buried story of the early Moche culture, which flourished in Peru from A.D. 100 to 800. While securing the great mound at Sipán from looters, Donnan discovered an untouched pre-Columbian tomb. It was the eternal resting place of a Moche warrior-priest, who had made his journey to the afterlife accompanied by a trove of fabulous jewelry—the richest such find ever made in the Americas.

UNDER THE VOLCANO

The ancient Italian cities of Pompeii and Herculaneum had been entombed suddenly, catastrophically, beneath tons of ash when nearby Vesuvius erupted in A.D. 79. As an Italian construction crew discovered when it unearthed nearly 150 skeletons at Herculaneum in the early 1980s, many residents had fled toward the city's seafront.

Here was a poignant opportunity for physical anthropologist Sara Bisel. Funded by the Society, she spent the next four years overseeing the excavations and examining the numerous victims, many of whom were found contorted with terror, preserved that way by the blanket of ash. Some skeletons were curled protectively, if futilely, around the bones of their children.

The pictures of these heartrending scenes appeared not just in the magazine but also on one of the first episodes of a new TV series. In April 1985, the weekly National Geographic EXPLORER debuted on Nickelodeon. One of its first episodes was *Herculaneum: Voices from the Past.* ■

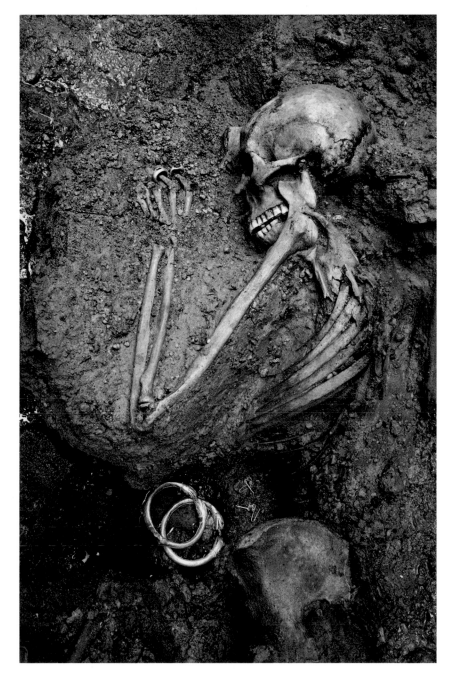

ITALY | 1984 This lady of Herculaneum died wearing her rings and bracelets when she was buried by ash after Vesuvius erupted in A.D. 79.

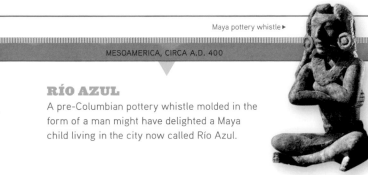

Maya pottery whistle ▶

MESOAMERICA, CIRCA A.D. 400

RÍO AZUL

A pre-Columbian pottery whistle molded in the form of a man might have delighted a Maya child living in the city now called Río Azul.

This ear pendant is a resplendent example of Moche gold work and inlay. ▶

PERU, CIRCA A.D. 100

SIPÁN

A gold ear ornament, inlaid with turquoise, depicts a domestic duck. It was part of the pre-Columbian hoard found at Sipán in 1987.

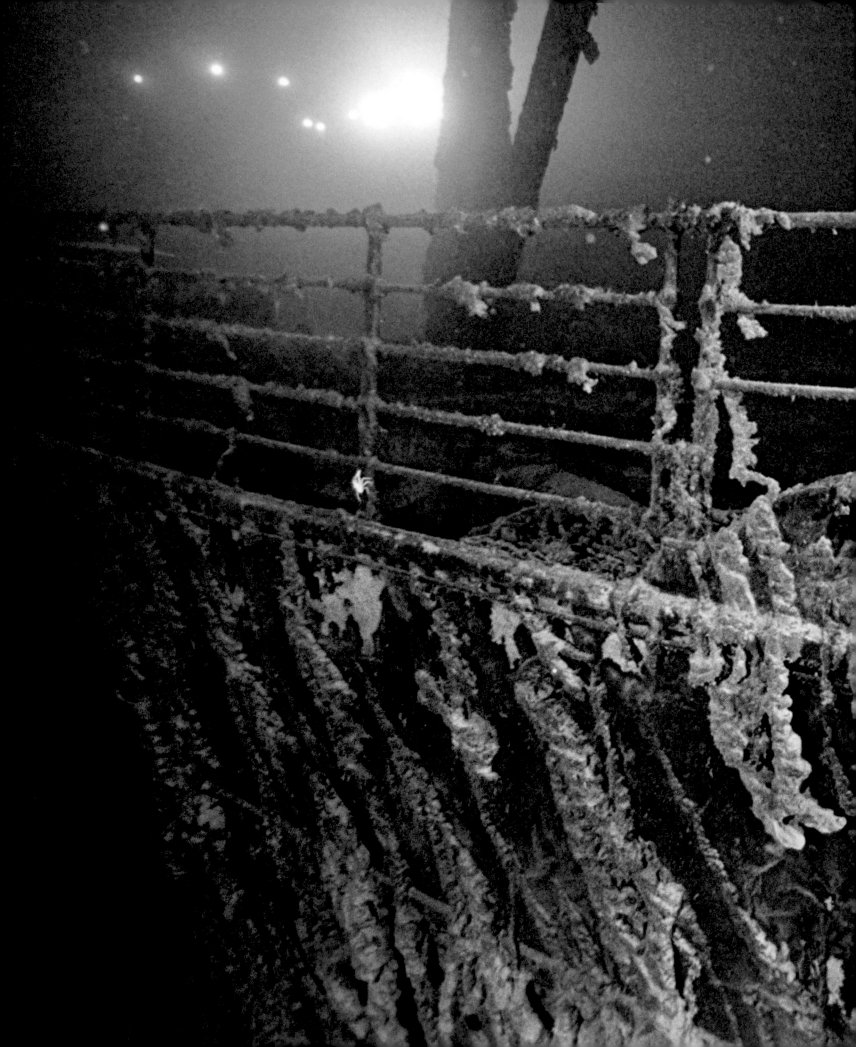

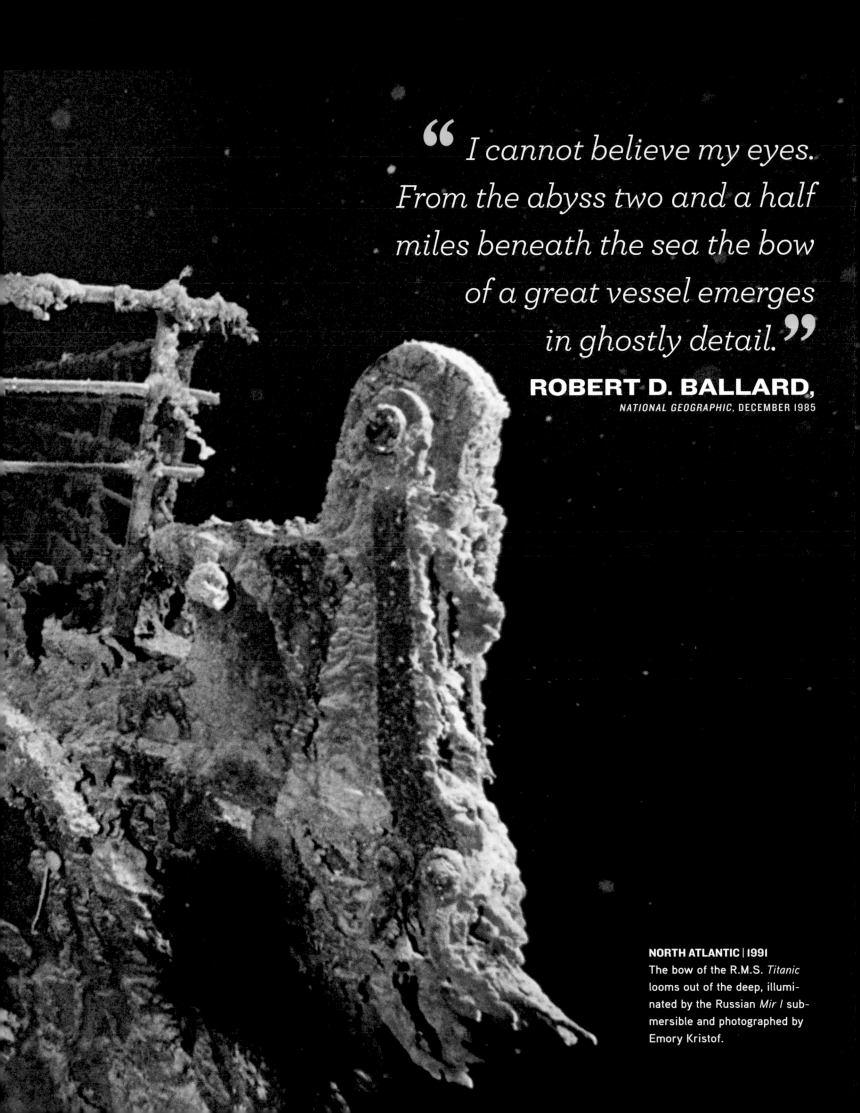

" *I cannot believe my eyes. From the abyss two and a half miles beneath the sea the bow of a great vessel emerges in ghostly detail.* "

ROBERT D. BALLARD,
NATIONAL GEOGRAPHIC, DECEMBER 1985

NORTH ATLANTIC | 1991
The bow of the R.M.S. *Titanic* looms out of the deep, illuminated by the Russian *Mir I* submersible and photographed by Emory Kristof.

THAT SPECIAL BREED

Those willing to devote their lives to documenting vanishing cultures or reporting from "exceptional places" appear with greater frequency in the *Geographic*.

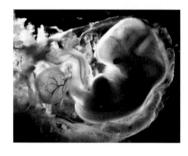

✳ FANTASTIC VOYAGE

Miniaturized endoscopes probed deep tissue layers and threaded even the tiniest blood vessel, ensuring that *The Incredible Machine*—the 1975 debut of the National Geographic Specials on PBS—was the first of many to smash viewership records.

ABOVE: A six-week-old human embryo floats in blissful contentment inside the "incredible machine."

Eager to escape the Manhattan photography scene, in 1967 Malcolm Kirk joined several friends and embarked on a possibly dangerous trek across the mountainous interior of Papua New Guinea. As he related in the March 1969 *Geographic*, the young men soon found themselves "slipping in and out, from present to past, between yesterdays and tomorrows, seeking in remote mountain villages and valleys the old ways before they faltered and were gone." Kirk himself became so enthralled by certain Papuan customs—elaborate ceremonial body art, for one—that he made six more visits to the island over the next 13 years, documenting with Nikon and Kodachrome the many permutations of self-decoration in New Guinea.

Kirk was one of those men and women both willing and able to steep themselves in other cultures, thus gaining access to patterns of life seldom witnessed, much less photographed, by outsiders. Not surprisingly, *National Geographic* was often their first choice when it came to publishing their work.

OTHER PEOPLE'S LIVES

Eric Valli and Diane Summers, a photographer-writer team based in Kathmandu, were explaining their vocation to Geographic members in December 1993: "It's our duty to record these ways of life before they disappear," they said. Their total immersion in vanishing cultures had recently resulted in spectacular articles on cliff-hanging Nepalese honey hunters, salt-carrying Himalayan caravaneers, and torch-bearing, cave-crawling Malay harvesters of edible if inaccessible swifts' nests.

It was a calling that Roland and Sabrina Michaud understood well. The French couple had immersed themselves in the nomadic caravan culture of Central Asia for decades, and several of their portfolios had appeared in the magazine. Carol Beckwith

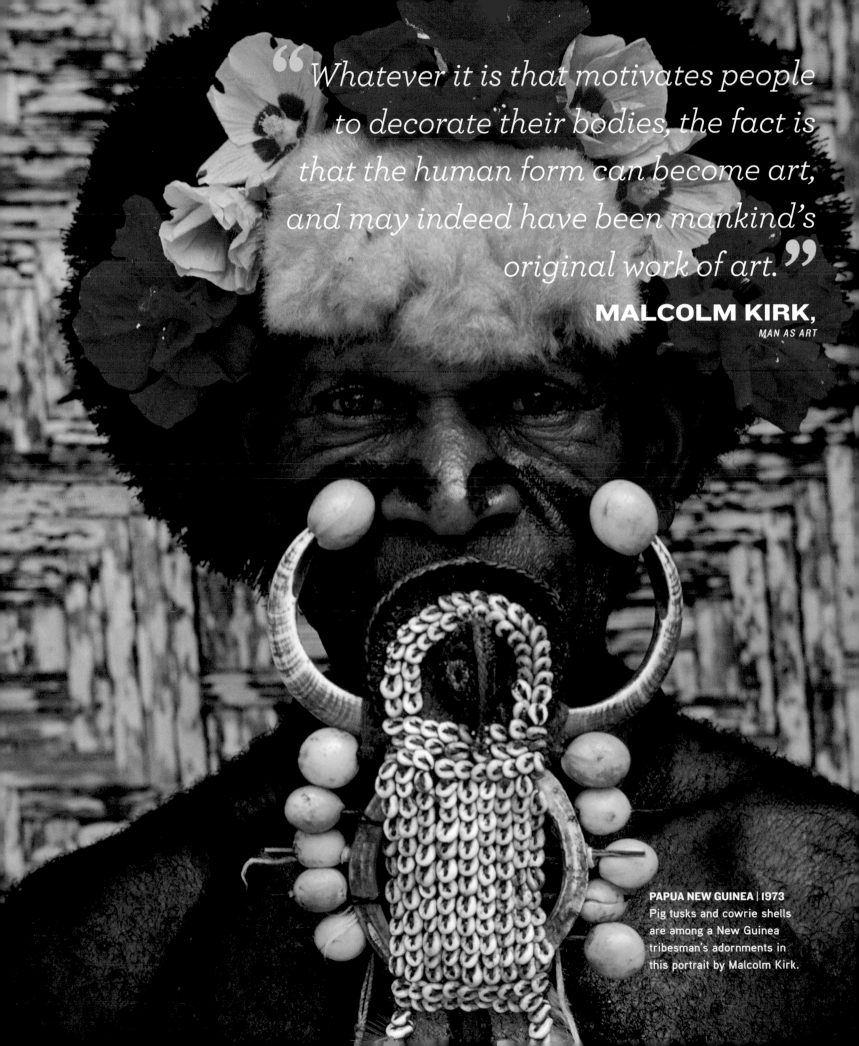

"*Whatever it is that motivates people to decorate their bodies, the fact is that the human form can become art, and may indeed have been mankind's original work of art.*"

MALCOLM KIRK, *MAN AS ART*

PAPUA NEW GUINEA | 1973
Pig tusks and cowrie shells are among a New Guinea tribesman's adornments in this portrait by Malcolm Kirk.

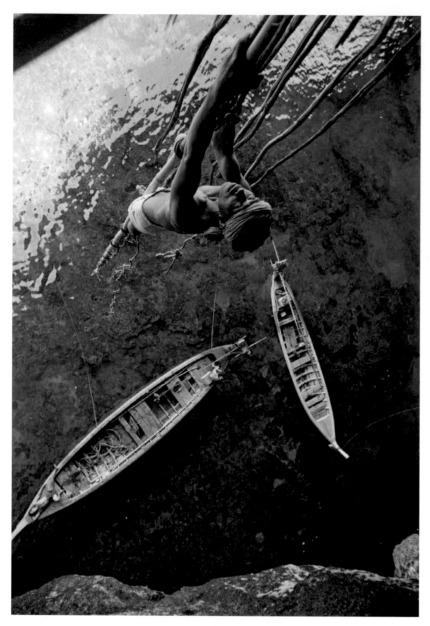

THAILAND | 1989 A Malay fisherman shins his way up bamboo scaffolding to the cliff-face entrance of a sea cave, where he will harvest swifts' nests for bird's-nest soup.

and Angela Fisher, meanwhile, were busily documenting fast-changing patterns in African personal adornment, while a shambling Prussian giant named Jesco von Puttkamer had won access to newly contacted "Stone Age" tribes of the Brazilian rain forest such as the Kreen-Akarore, the Urueu-Wau-Wau, and the Cinta Larga, whose ancestors had solemnly watched Theodore Roosevelt paddle down the River of Doubt back in 1914.

EXCEPTIONAL CONTRIBUTORS

The *Geographic* always had a special regard for what Gil Grosvenor called that "special breed" of self-reliant, often freelance writer-photographers capable of solid reporting from "exceptional places." Fred Ward, who gained access to Castro's Cuba, and former *Life* combat cameraman Howard Sochurek, a pioneer in medical imaging, exemplified the type and were dependable contributors.

So was Bob Caputo, who had not originally planned to be a photojournalist. But he fell in love with Africa during postcollegiate travels there, even receiving some photographic pointers from Hugo van Lawick in Gombe. By 1981 Caputo had seen more of Sudan than any other Western journalist, having driven 10,000 miles over its practically road-less interior. His March 1982 *Geographic* article on that country launched a series of journeys up the rivers and through the bush of Central and Eastern Africa: Caputo shared meals of roasted goat stomach with Swahili-speaking locals while documenting the stories behind the continent's headline-grabbing wars, epidemics, and famines.

Loren McIntyre's exceptional place was South America, which he had first seen as a young merchant seaman. In succeeding years the World War II naval veteran became fluent in Spanish and Portuguese, ran seven miles a day to stay in shape for Andean treks and Amazonian traverses, and got to know the continent better than rival American journalists, contributing more than a dozen stories to the *Geographic* along the way. McIntyre even thought he identified the ultimate source of the world's mightiest river, the Amazon, tracing it to a small pool nestled high on a Peruvian mountainside—a source confirmed by some more recent surveys but not by others.

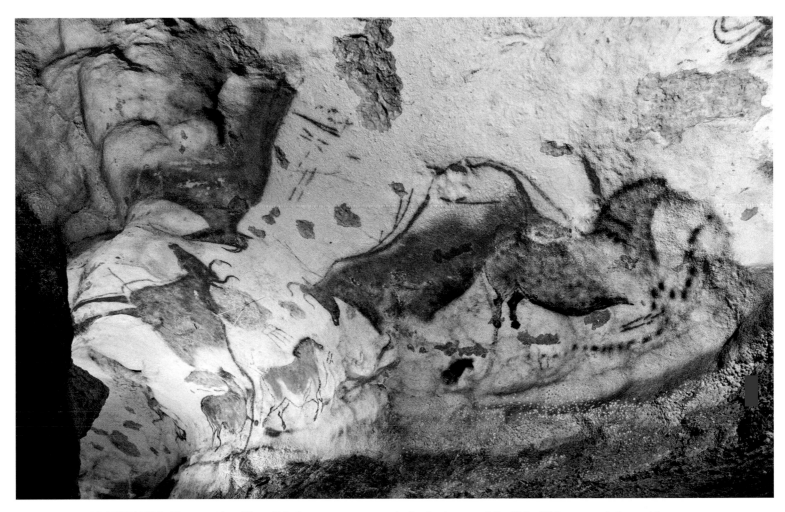

FRANCE | 1988 Photographer Sisse Brimberg won rare permission to document the Paleolithic cave paintings at Lascaux. The subterranean galleries are usually off-limits due to the masterpieces' fragile condition.

THOSE EYES

There's a Rudyard Kipling feel to many of the assignments freelance photographer Steve McCurry shot for the magazine in the first 15 years of his *Geographic* work: railroad journeys across India, monsoons sweeping over Bombay or Burma, visits to hill tribes near the Khyber Pass, and sorties, disguised in Pashtun garb, across the troubled Afghan frontier. Though McCurry also photographed war-ravaged Beirut and Baghdad—and even Hollywood's Sunset Boulevard—he made his most famous picture in Pakistan.

In 1984, as he threaded his way through the warren of Afghan refugee camps, McCurry entered a tent being used as a makeshift school. There he encountered a young girl wearing a haunted expression. Her village had been bombed. Her relatives had been killed. And the girl herself had been trekking through the mountains for weeks.

When "Along Afghanistan's War-torn Frontier" was published in June 1985, it was filled with images of anguish and suffering. But the girl's portrait stared out from the cover. To McCurry, her expression "summed up the horror" in Afghanistan. To the rest of the world, however, her mesmerizing gaze soon made her into an icon of the *Geographic*. ■

▶ **CHINA, 1991**
The *Geographic*'s Lou Mazzatenta—called Ma Lao, or Old Horse Face, by Chinese friends—was the first Western journalist allowed to photograph the hundreds of terra-cotta soldiers found in the tomb of Han emperor Jing Di, who died in 141 B.C. The quartet above was beheaded by the passage of time.

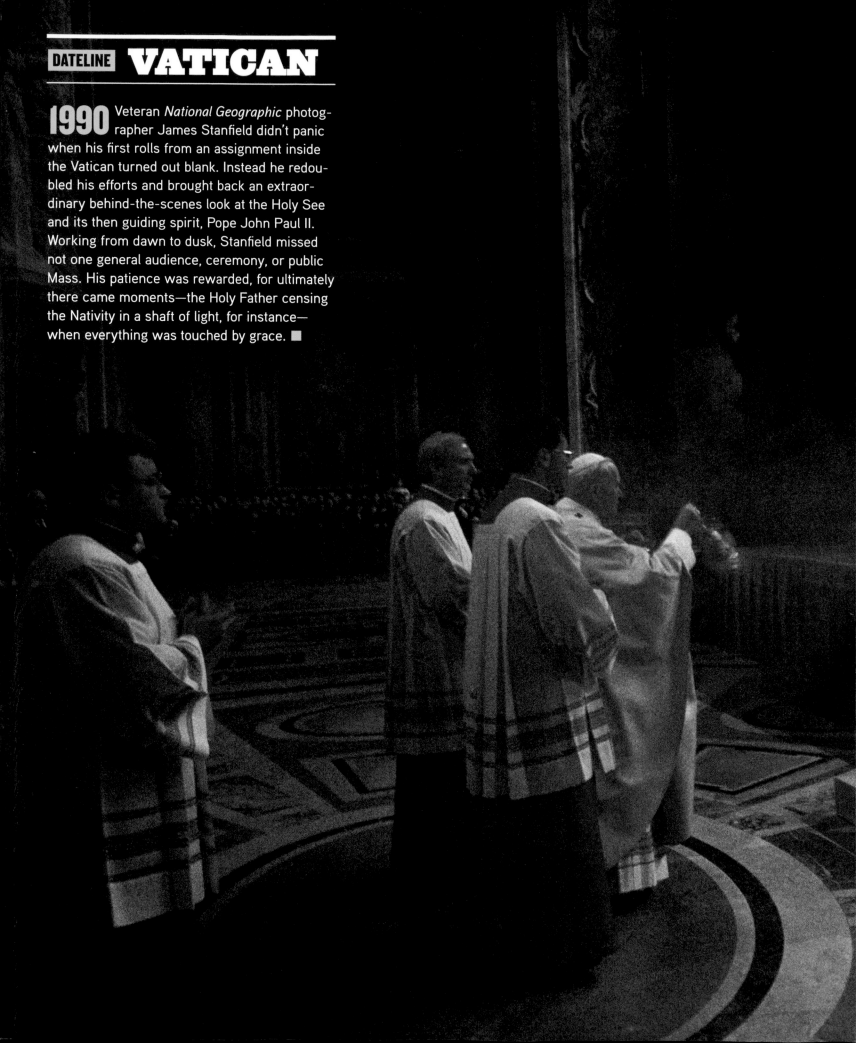

DATELINE VATICAN

1990 Veteran *National Geographic* photographer James Stanfield didn't panic when his first rolls from an assignment inside the Vatican turned out blank. Instead he redoubled his efforts and brought back an extraordinary behind-the-scenes look at the Holy See and its then guiding spirit, Pope John Paul II. Working from dawn to dusk, Stanfield missed not one general audience, ceremony, or public Mass. His patience was rewarded, for ultimately there came moments—the Holy Father censing the Nativity in a shaft of light, for instance— when everything was touched by grace. ■

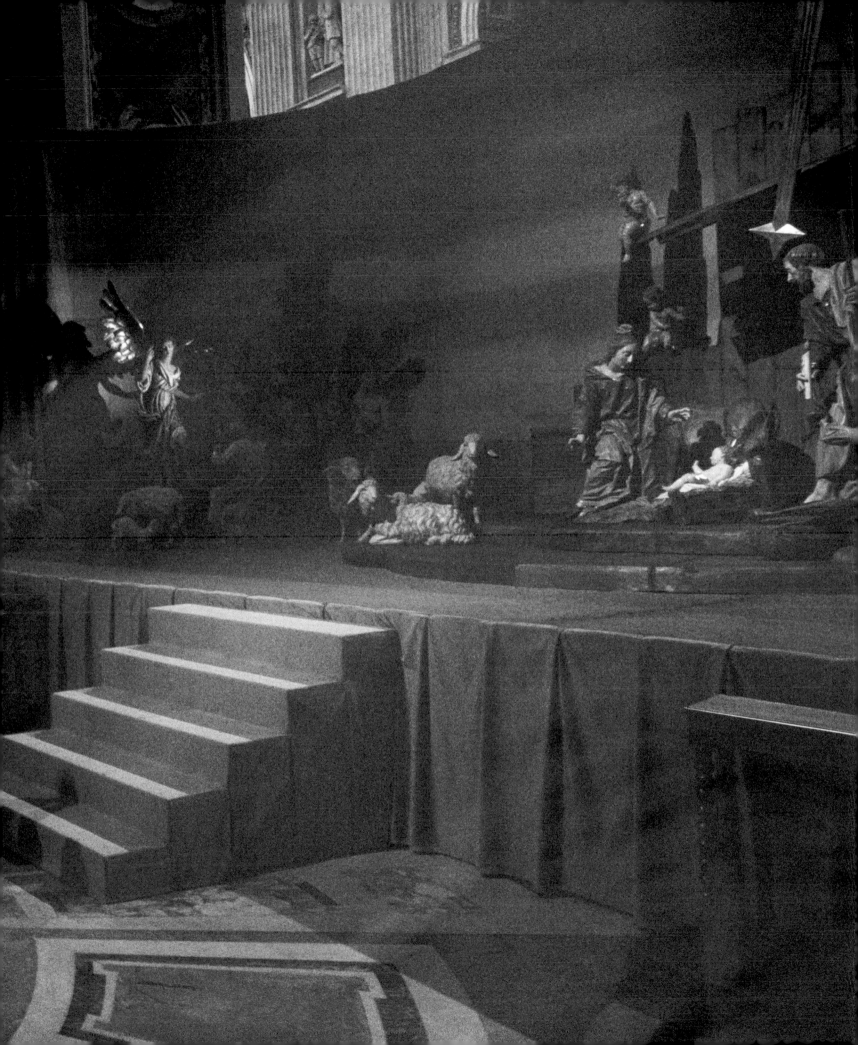

NEW WORLDS IN THE SEA

Society-sponsored underwater photographers reveal new wonders in the undersea world.

⚙ OCEANEYE

In 1968 National Geographic photographer Bates Littlehales designed the OceanEye underwater camera housing, a Plexiglas dome—large enough to encompass camera and lenses—that permitted wide-angle photography while correcting for optical distortions.

ABOVE: An OceanEye underwater camera housing

"There is only one great area of exploration left to man on Earth," wrote staff photographer Emory Kristof in a December 1988 memo, "and that is underwater." In that realm, he said, "the *Geographic* has always been a major player through the strength of the images it has brought before the public."

Kristof had evolved from all-purpose cameraman into the Society's chief designer of deep-sea imaging systems—"a fisherman with a lens," as he once described himself. But his comments applied equally to the sunlit upper reaches of the sea, for underwater exploration everywhere was being wedded to underwater photography.

Throughout the 1970s and '80s, for example, David Doubilet's depictions of reef and fish married science to art in breathtaking fashion. Whether he was working Red Sea coral gardens with marine biologist Eugenie Clark or swimming over sandy Pacific bottoms littered with the encrusted debris of World War II, Doubilet always surfaced with images that pulled readers out of their chairs and into the sea. Meanwhile, Bill Curtsinger and Chuck Nicklin were among the first to photograph whales in their native element. The *Geographic* had sent the pair to Península Valdés, Argentina, where Dr. Roger Payne was pioneering the identification of individual southern right whales by the unique marks on fluke or fin.

Payne had cut his baleen as a marine-mammal researcher in the 1960s by dropping hydrophones into the ocean and recording the haunting "songs" of humpback whales. To his musically trained ears, these submarine arias resembled "alien oratorios, cantatas, and recitatives." By the early '80s, when Payne had returned to these investigations, Flip Nicklin (Chuck's son) had mastered the technique of diving to 130 feet without scuba gear. This skill enabled him to draw near a singing humpback with no telltale cloud of bubbles to betray his approach. After photographing the creatures—his body resonating to their reverberant tones—Nicklin found that all the singers were males.

Emory Kristof himself was instrumental in one of the more astounding undersea

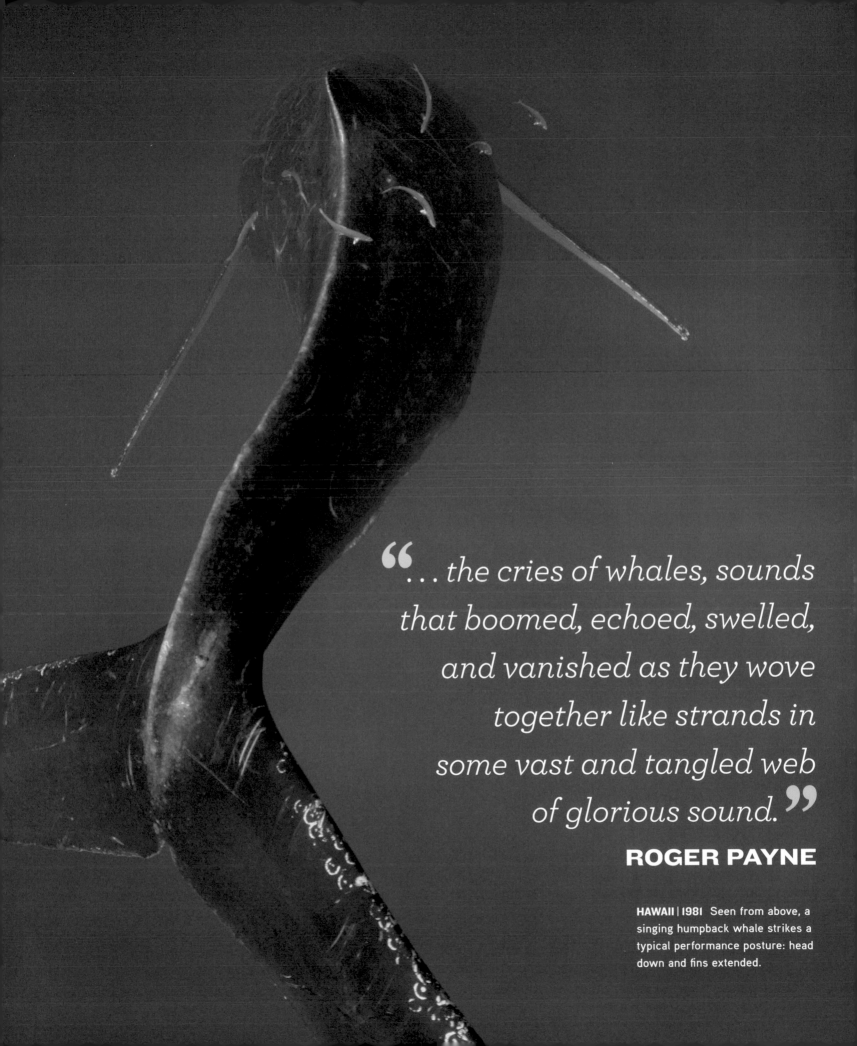

"… the cries of whales, sounds that boomed, echoed, swelled, and vanished as they wove together like strands in some vast and tangled web of glorious sound."

ROGER PAYNE

HAWAII | 1981 Seen from above, a singing humpback whale strikes a typical performance posture: head down and fins extended.

SYLVIA EARLE

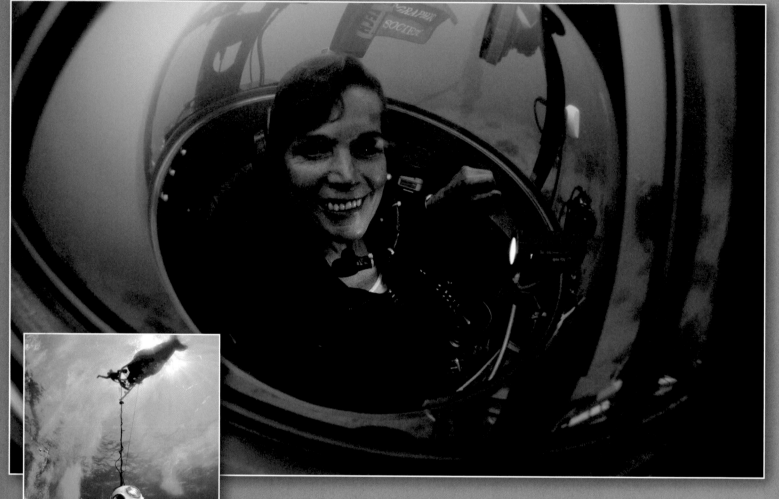

THE SEA | 2000 All smiles in her submersible, Sylvia Earle prepares to drop into the deep.

THEN Sylvia Earle was an expert in marine algae, the leader of the first all-women team to live in the underwater habitat called Tektite II, and the only person to strap on a Jim suit—a pressurized, hard-shell diving outfit—and stroll tetherless among bamboo corals 1,200 feet below the ocean's surface. Twelve astronauts had walked on the alien world of the moon. "Her Deepness," as the Earle of the sea was dubbed, was the only human to have walked that far down in the alien world of the ocean bottom.

NOW the former chief scientist for NOAA is a National Geographic explorer-in-residence who for five years led the Sustainable Seas Expeditions. That venture explored the 12 U.S. national marine sanctuaries, practically unknown realms when compared with their land-based counterparts, the national parks. Earle remains a tireless advocate of the oceans and their eco-systems: One day, she hopes, humans will come "to know the sea as birds know the sky." ■

✚ VITAL STATS

WHO: Sylvia Earle
WHEN: September 1979
WHERE: Hawaii

WHAT: A "Jim" suit, a reticulated body shell—or "personal submersible," replicating surface pressure and atmosphere—that resembles a hard-body space suit.

WW 1,200 feet
HEIGHT: Barely five feet
WEIGHT: Negligible

discoveries. In February 1977, he and two colleagues—the "Geographic Navy"—were aboard the research vessel *Knorr,* accompanying Robert Ballard on a scientific voyage to the Galápagos Rift, a gash on the Pacific Ocean floor near the enchanted islands of that name. Thanks in part to the *Geographic's* photographic expertise and equipment, the marine geologists found hydrothermal vents—hot-water springs—roaring deep in the cold, pitch-black abyss.

They also became the first scientists to see life down there—clams, mussels, crabs, anemones, fish, octopuses, giant tube worms, and otherworldly, dandelion-like creatures—in a place where life was not supposed to exist. They had stumbled across a submarine garden of Eden: In a thriving huddle around the warm-water geysers was the first known food chain not ultimately dependent on the life-giving energy of the sun. Dwelling at depths too dark for chlorophyll, these particular creatures subsisted on hydrogen sulfide emitted by the vents.

It was one of the biological discoveries of the century. Yet not a single biologist was aboard the *Knorr*. When the expedition returned to port in triumph, samples of the strange new life-forms were packed in Tupperware containers, soup tureens, and roasting pots, embalmed in duty-free Russian vodka purchased in Panama. ■

SEPTEMBER 1975
David Doubilet's pictures not only illuminated Eugenie Clark's "The Strangest Sea." They also spilled over into a photo essay, "Rainbow World Beneath the Red Sea."

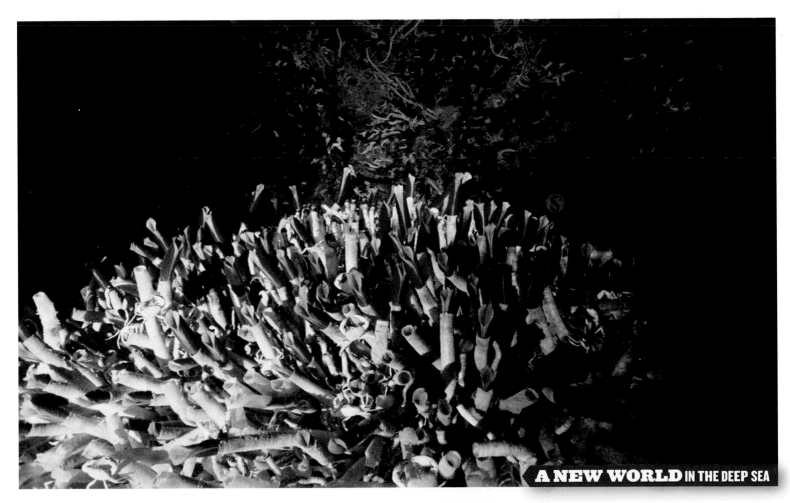

A NEW WORLD IN THE DEEP SEA

PACIFIC OCEAN | 1994 Tube worms huddle about a hydrothermal vent on the Galápagos Rift.

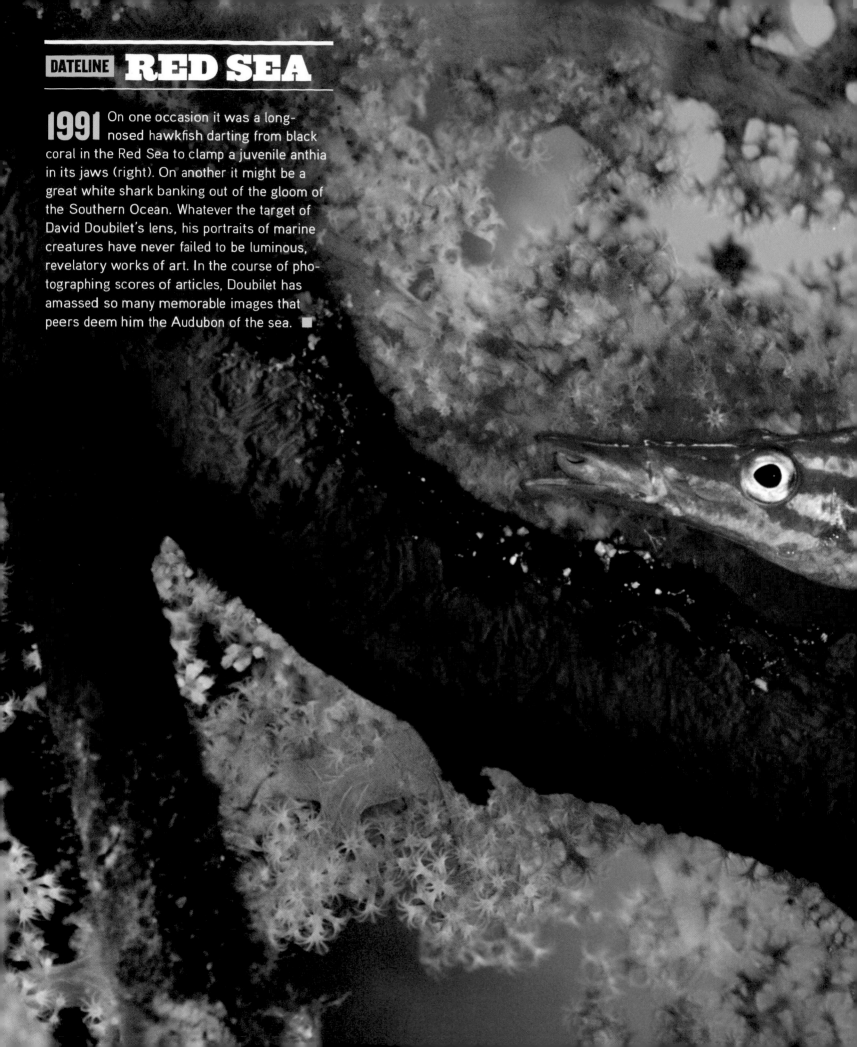

1991 On one occasion it was a long-nosed hawkfish darting from black coral in the Red Sea to clamp a juvenile anthia in its jaws (right). On another it might be a great white shark banking out of the gloom of the Southern Ocean. Whatever the target of David Doubilet's lens, his portraits of marine creatures have never failed to be luminous, revelatory works of art. In the course of photographing scores of articles, Doubilet has amassed so many memorable images that peers deem him the Audubon of the sea. ■

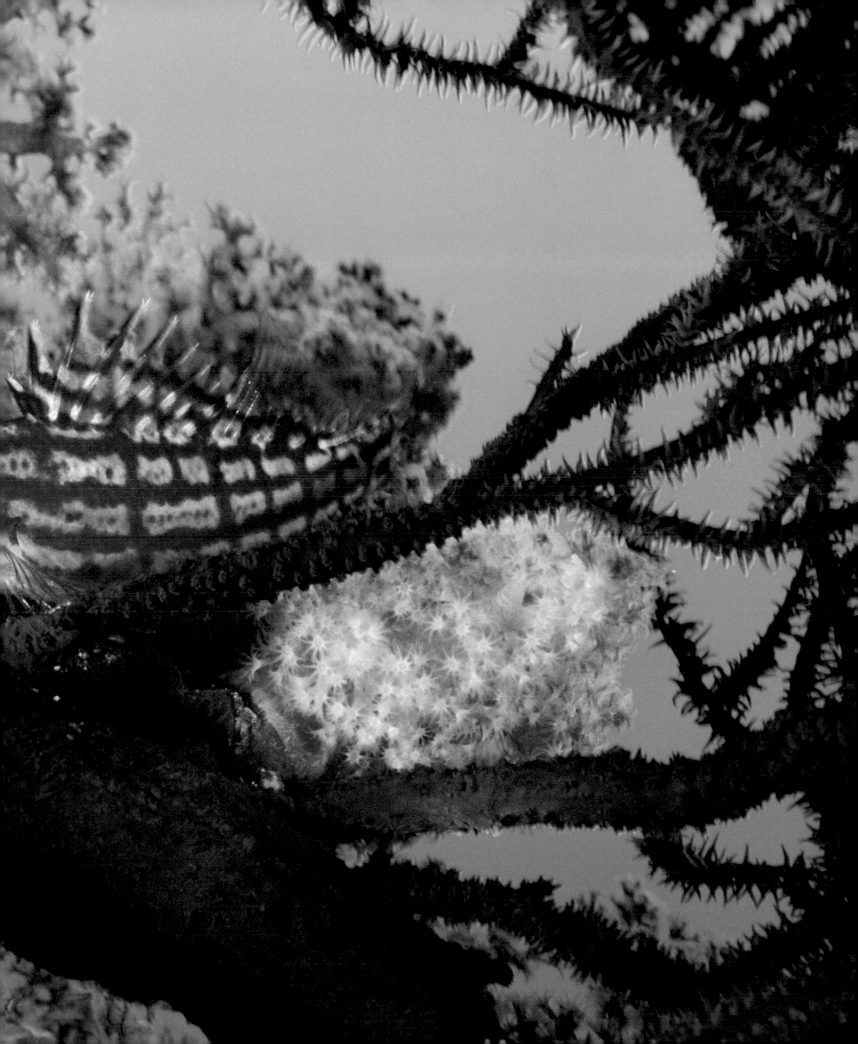

STAR PATHS

Quixotic voyages of adventure and discovery reach journey's end in the pages of the *Geographic*.

✳ A LIFETIME OF TOURS

National Geographic Traveler **took its place on the Society's growing shelf of publications in March 1984. Today it is the most widely read magazine in its field, and an elegant champion of sustainable journeying to places not always found on the beaten track.**

A compass can go wrong, the stars never," the wizened mariner told David Lewis, a gadabout sailor and physician who was discovering that the supposedly lost art of Polynesian navigation was not so lost after all. As Lewis related in December 1974's "Wind, Wave, Star, and Bird," the old ones still found their way from one widely scattered island to the next by detecting the direction of swells and prevailing winds, monitoring submarine luminescence, and following the *kaveinga*, or "star path."

So using the star path as his sole chart, Lewis sailed 2,400 miles from the Society Islands to New Zealand. When he sighted his first headland 35 days later, he was only a few miles away from his intended target.

His were only some of the antique sails billowing in *National Geographic*'s pages. Norwegian explorer Thor Heyerdahl, working from ancient Egyptian drawings, built two boats out of nothing more than papyrus reeds. In 1970 he managed to cross the Atlantic in one of them, *Ra II*, proving at least the possibility that the pyramid builders of Mesoamerica had been influenced by their pharaonic counterparts.

Cut from the same canvas was Tim Severin, whose passion was reenacting legendary sea sagas. In 1976–77 Severin crossed the stormy North Atlantic from Ireland to Newfoundland in an Irish curragh lashed together with leather thongs, just as sixth-century monk St. Brendan is said to have done. He then voyaged from Arabia to China in a lateen-rigged dhow that Sinbad would have recognized. Like Jason and the Argonauts, Severin embarked on a quest for the Golden Fleece, this time in a facsimile of a Bronze Age galley. And finally he morphed into Ulysses, retracing the wanderings of that forlorn Homeric hero thanks to a galley full of crewmen heaving on oars—who perhaps recalled with every stroke that only Ulysses survived the long journey home.

Meanwhile, David Lewis dusted off his compass and sextant, took to a 32-foot sloop named *Ice Bird*, and attempted the first solo circumnavigation of Antarctica. Crossing the Screaming Sixties of latitude, he was rolled over by a storm. He jury-rigged a stump of a mast, then limped into Palmer Station, Antarctica, pulling into a berth alongside—of all legendary vessels—the *Calypso*.

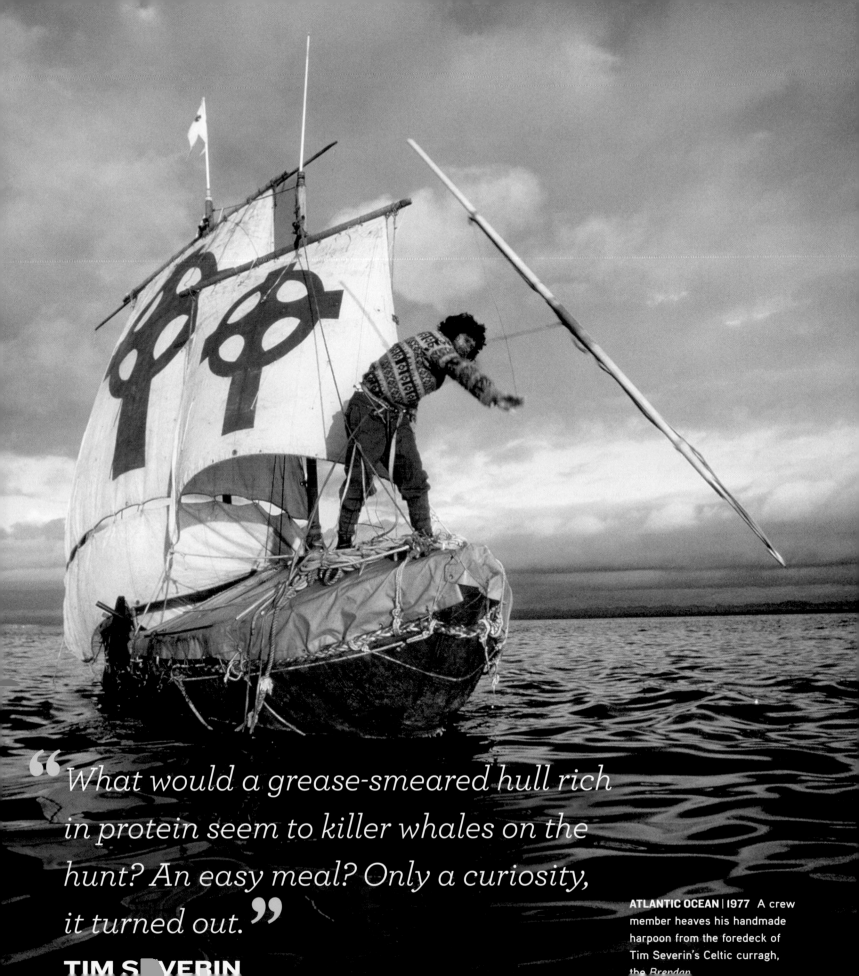

> *"What would a grease-smeared hull rich in protein seem to killer whales on the hunt? An easy meal? Only a curiosity, it turned out."*

TIM SEVERIN

ATLANTIC OCEAN | 1977 A crew member heaves his handmade harpoon from the foredeck of Tim Severin's Celtic curragh, the *Brendan*

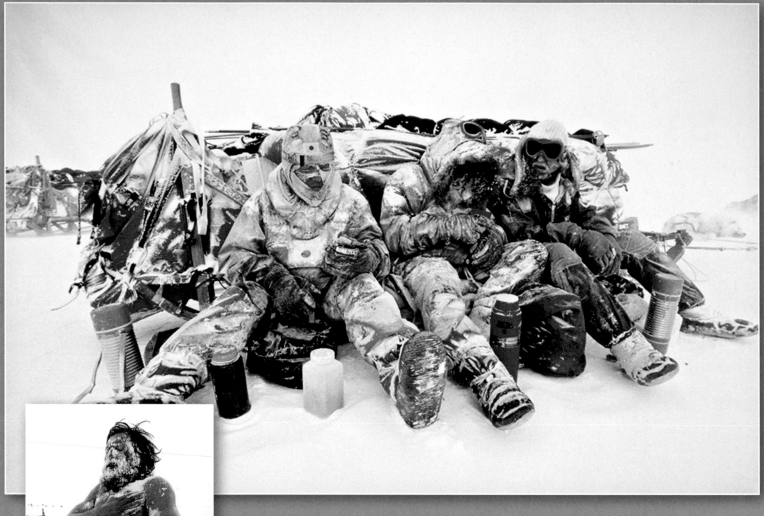

► **ANTARCTICA | 1989** Famished trekkers wolf a picnic, Antarctic style, during the epic 1989 dogsled crossing of the icebound continent.

◄ **ARCTIC OCEAN | 1995** Victor Boyarsky enjoys his morning ablutions during the 1995 attempt at a transarctic traverse.

✚ ICE IS NICE

"Our Russian snowman, Victor scrubbed himself clean every morning . . . 'Ice pushes us to East/Ice pushes us to West . . . ,' he penned in a poem. 'My God! Why have we chosen frozen?'"

On April 8, 1986, a funny thing happened on the way to the North Pole. It was day 32 of a 57-day adventure when the six-person Steger International Polar Expedition—the first to mush to 90° north by dogsled without aerial resupply since Robert E. Peary's day—glimpsed tracks on the ice. Only one other human was known to be on the frozen surface of the Arctic Ocean at the time: He was Dr. Jean-Louis Etienne, a French physician attempting to ski solo to the Pole. On that blinding, vast expanse of ice roughly the size of Russia the two parties collided. Perhaps they compared their respective National Geographic flags—Will Steger's was large; Etienne's pocket-size—before going their separate ways.

Three years later, Steger and Etienne found themselves driven to extremes once again. This time they were at the opposite end of the Earth but on the

same team, serving as co-leaders of an international party of six explorers—one each from the United States, France, Britain, China, Japan, and the Soviet Union—embarked upon a truly epic adventure. The International Trans-Antarctic Expedition was seeking to cross the ice-shrouded continent by dogsled alone—a historic first. After hitching the dogs into their harnesses at the northern tip of the Antarctic Peninsula in July 1989, the intrepid band slid into a Russian base on the shores of Wilkes Land seven months and 3,471 miles later.

A similar attempt by Steger just narrowly failed in 1995. Trying to cross the Arctic Ocean from Siberia to Canada by dogsled, his international team was forced to go partway by helicopter. That didn't stop the Geographic from asking Vice President Al Gore to award the Society's La Gorce Medal to the weather-beaten Steger. Appearing almost as an afterthought in a citation stuffed with commendations for advancing geographic science and international understanding were these three words: "arduous polar expeditions." ∎

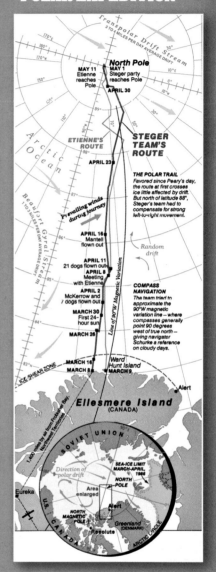

STEGER INTERNATIONAL POLAR EXPEDITION

▶ **PARALLEL TRACKS**
Starting within 24 hours of each other in March 1986, two Society-sponsored expeditions— one being Will Steger's six-person dogsled team, including Anne Bancroft, first woman to reach 90° north by that means; and the other being Jean-Louis Etienne, skiing alone toward the same destination—met en route but arrived at the North Pole ten days apart.

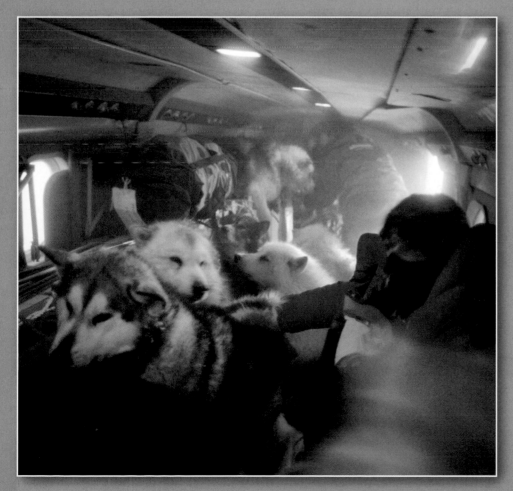

CANADA | 1986 Members of the Steger International Polar Expedition and their 49 sled dogs pile into a chartered aircraft to reach their mushing-off point.

AUSTRALIA | 1977 Robyn Davidson—with Zeleika, Dookie, Goliath, Bub (outside the frame), and Diggity the dog playing scout—treks into *National Geographic* legend.

ENDLESS ROADS

It was late in 1973 when a scruffy young man with a backpack and a dog arrived at Society headquarters. Merely by mentioning that he was in the middle of a cross-country hike, Peter Jenkins turned somebody's ear; for when he resumed his transnational trek, he had an assignment to write about it for *National Geographic*. This led to the phenomenally popular "A Walk Across America," appearing in two parts between 1977 and 1979. With color, candor, and unabashed patriotism, Jenkins detailed practically every step of his five-year peregrination from a village in upstate New York to the Oregon coast.

Meanwhile, on the other side of the world, Robyn Davidson had bounced from a Queensland cattle station to a knockabout bohemian life in Sydney before settling down—temporarily—in Alice Springs. But she too followed her own star, and in 1977 Davidson left town with a string of camels and a sheepdog in tow, heading for the Indian Ocean, some 1,700 soul-searing desert miles away. The *Geographic*'s May 1978 "Alone Across the Outback," the "camel lady's" pitch-perfect account of her adventures, remains one of the most poignant travel narratives the magazine has published. ■

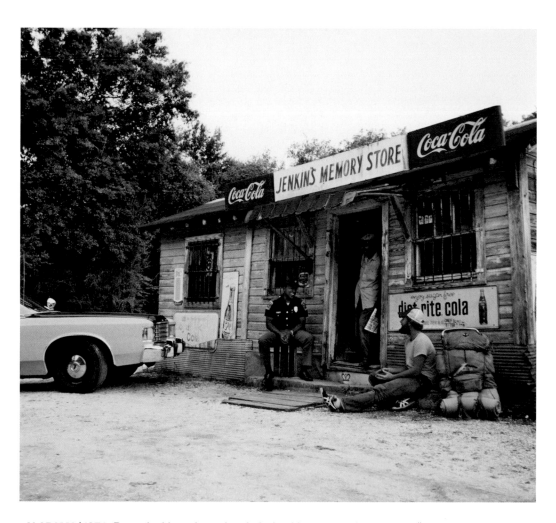

ALABAMA | 1974 Peter Jenkins takes a break during his transcontinental trek. "I guess wherever you go," he wrote, "you find some kind of reflection of yourself."

ADVENTURES IN EDUCATION

▶ **1985**
After polls reveal an alarming lack of geographic knowledge among American college students, President Gilbert M. Grosvenor—"angry, embarrassed, and determined"—founds a geography education program to address the problem.

▶ **1987**
Annual Summer Institutes are already bringing teachers from across the country to Society headquarters for training programs when Congress creates Geography Awareness Week (the third week in November).

▶ **1988**
The National Geographic Society Education Foundation is established to financially support nationwide instruction in geography.

▶ **1989**
The first National Geographic Bee, moderated by *Jeopardy!* host Alex Trebek, brings middle-school winners of local contests to Society headquarters for a competition that today is nationally televised.

▶ **1994**
The Society publishes National Geography Standards. Endorsed by the Department of Education, they define what students from kindergarten through grade 12 should learn from geography courses.

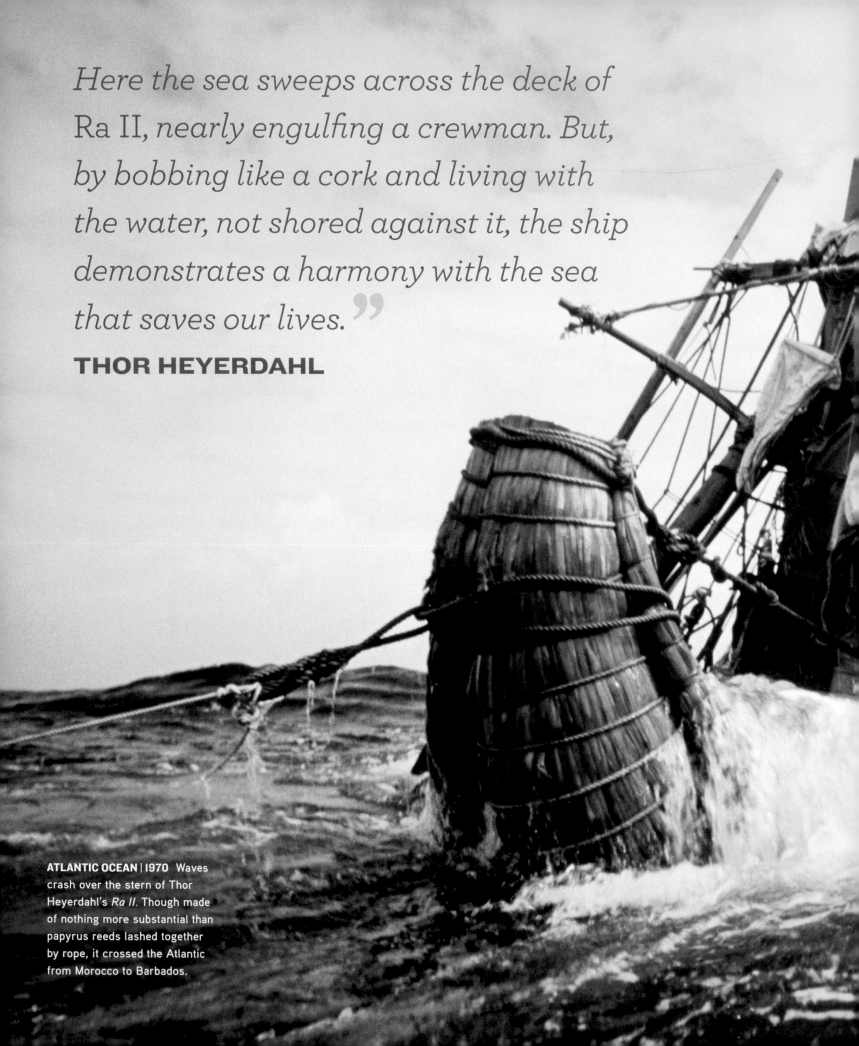

Here the sea sweeps across the deck of Ra II, nearly engulfing a crewman. But, by bobbing like a cork and living with the water, not shored against it, the ship demonstrates a harmony with the sea that saves our lives."

THOR HEYERDAHL

ATLANTIC OCEAN | 1970 Waves crash over the stern of Thor Heyerdahl's *Ra II.* Though made of nothing more substantial than papyrus reeds lashed together by rope, it crossed the Atlantic from Morocco to Barbados.

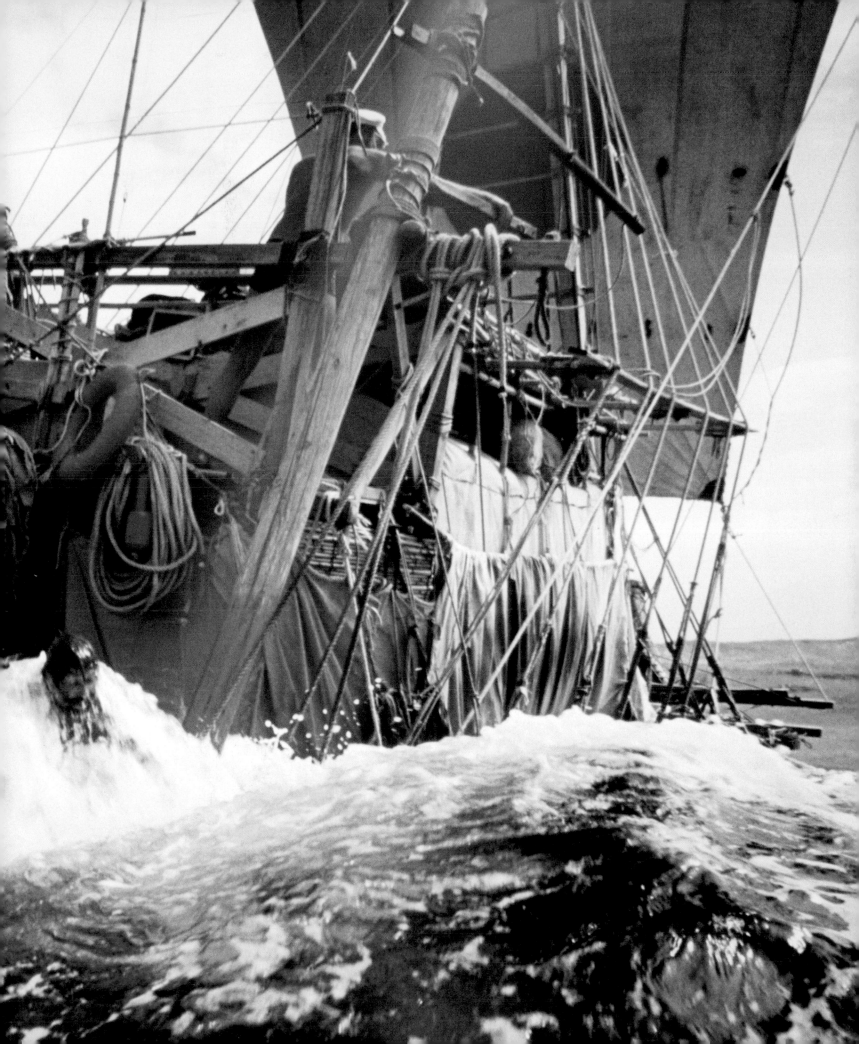

How do you stay perched on the cutting edge of tomorrow? *National Geographic* photographers and editors have wrestled with that question through all our yesterdays, whether they were covering Alexander Graham Bell's experiments with tetrahedral kites in the early 1900s, exploring the amazing computer chip in 1983, or explaining nanotechnology in 2010. The basic problem is that technology dates quickly: Certain photos from the early 20th century have a hopeful, futuristic feel that has since faded to sheer nostalgia. Magazine images of the wonders of celluloid or rocket-powered ejection seats, for example, projected a hopeful quality that gradually—and necessarily—ceded ground to a more realistic, journalistic approach. Viewed collectively, however, the Society's publishing record in the fields of science and technology represents the purest expression of its avowed mission to document the "world and all that is in it." For the next 125 years, it is hoped, *National Geographic* will continue to report on scientists' ceaseless quest to understand that world—and, perhaps, to reshape it for the better. ■

▾ **1911** *Dr. Edward Atkinson—staff surgeon, registered nurse, and parasitologist—works in his lab during Capt. Robert Falcon Scott's fateful expedition to reach the South Pole.*

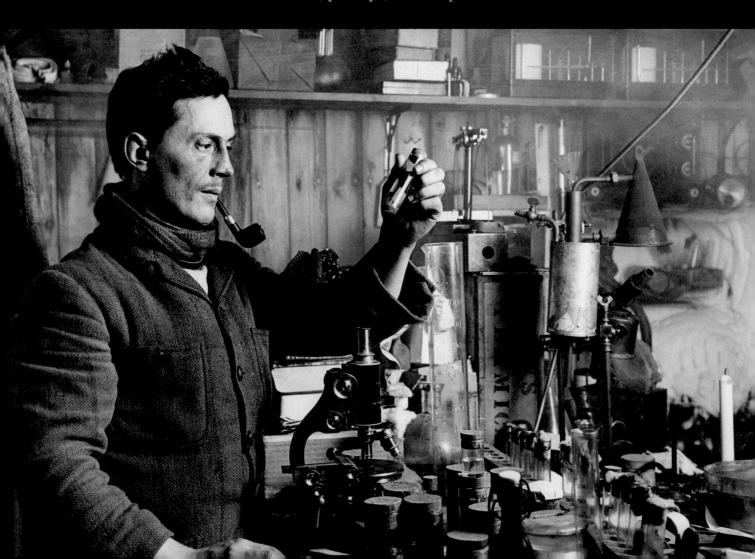

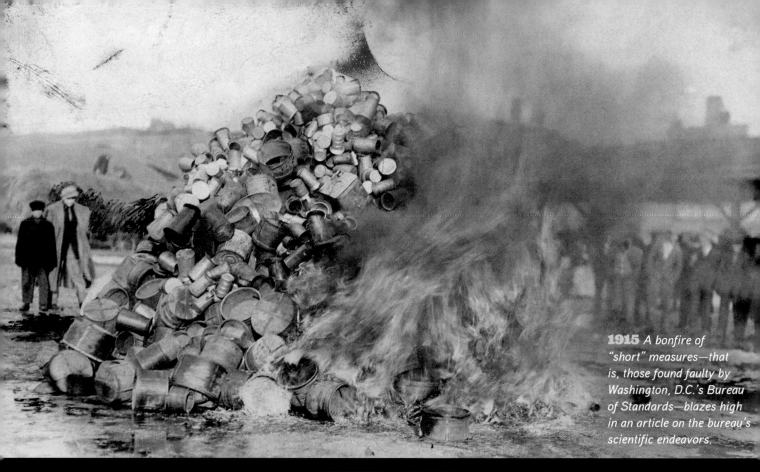

1915 *A bonfire of "short" measures—that is, those found faulty by Washington, D.C.'s Bureau of Standards—blazes high in an article on the bureau's scientific endeavors.*

▾**1939** *"Chemists Make a New World" touted the myriad novel toys that had come into being thanks to revolutionary celluloid and Lumarith.*

▸**1939** *Demonstrating the power of chemistry to solve a prosaic problem, scientists at the Mellon Institute use ultraviolet rays to tenderize beef.*

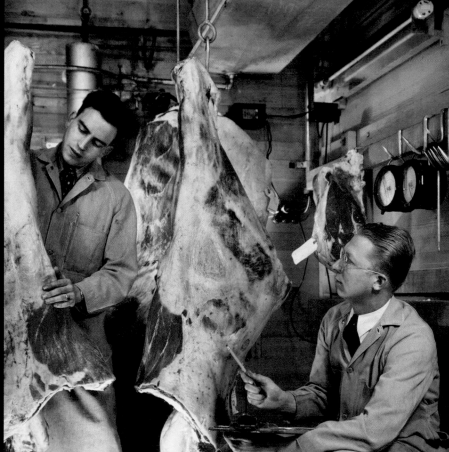

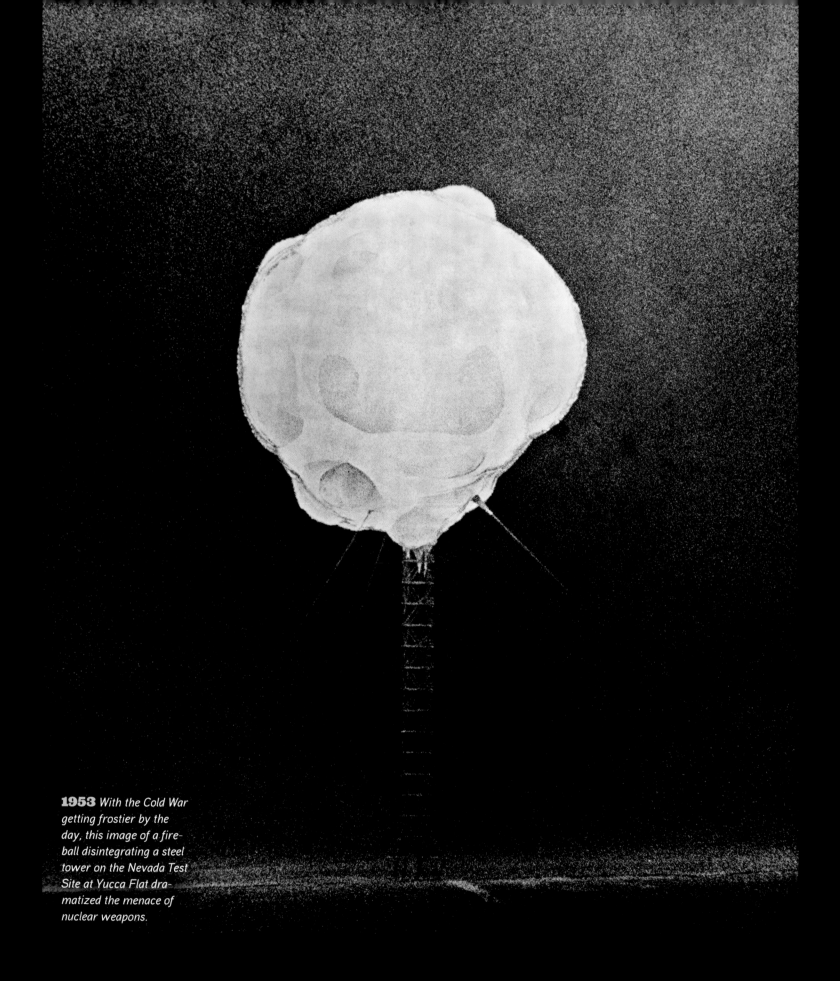

1953 *With the Cold War getting frostier by the day, this image of a fireball disintegrating a steel tower on the Nevada Test Site at Yucca Flat dramatized the menace of nuclear weapons.*

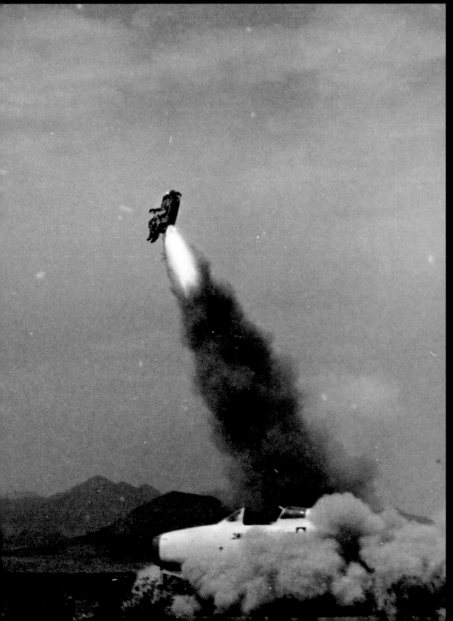

◀◀ 1940 *Persuaded by his friend Charles Lindbergh to grant the magazine access, Dr. Robert Goddard—father of the modern rocket—adjusts a steering vane in his Roswell, New Mexico, workshop.*

◀ 1963 *Boosted aloft by a 5,000-pound rocket thrust, a dummy pilot and seat soar 400 feet into the air in this test of an airplane's catapult escape system near Mesa, Arizona.*

▲ 1958 *Tentacles of tension, high-voltage wires converge in a nuclear fusion chamber used to study the effects of deuterium in Los Alamos, New Mexico.*

▼ 1963 *Employees thread fine wires to produce computer parts in Phoenix, Ar. General Electric computer required 3,500 man-hours for its manufacture at the time.*

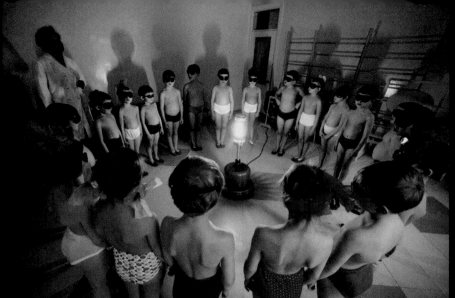

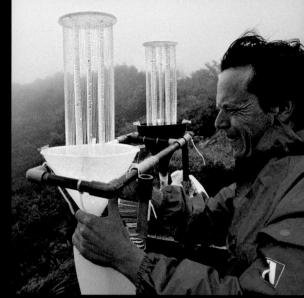

▲ **1997** *Wincing in the face of gale-force winds, an ecologist measures atmospheric nutrients being deposited in Costa Rica's Monteverde Cloud Forest Reserve.*

◀ **1996** *More than a million volts arc from a Tesla coil, shoot through a Christmas tree, course down a cage holding a physicist, and bolt into the floor of a San Francisco loft in a high-tech art installation.*

1994 *Lasers pierce the night sky over Starfire Optical Range in New Mexico, creating an artificial star that astronomers use to gauge the atmospheric distortion of real starlight.*

▲ **1996** *Created with new tools for studying the planet's structure and mechanics, this diagram illustrates the discoveries being made about Earth's mantle and core.*

⬆ **1977** *Children gather around an ultraviolet lamp to stave off vitamin D deficiency during a long winter in Murmansk, above Russia's Arctic Circle.*

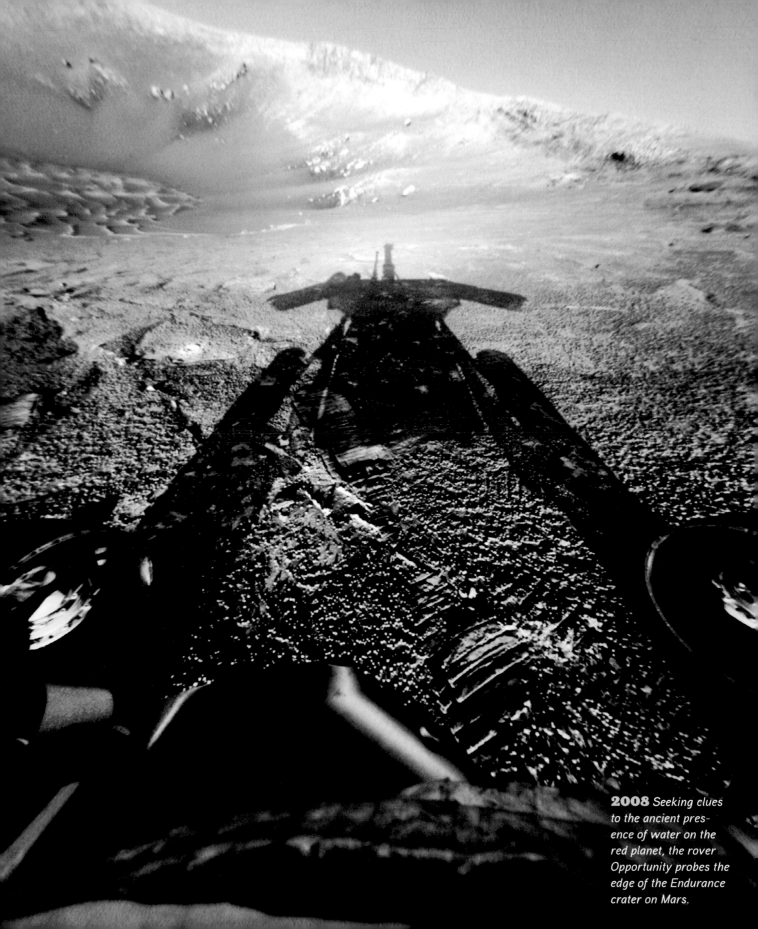

2008 *Seeking clues to the ancient presence of water on the red planet, the rover Opportunity probes the edge of the Endurance crater on Mars.*

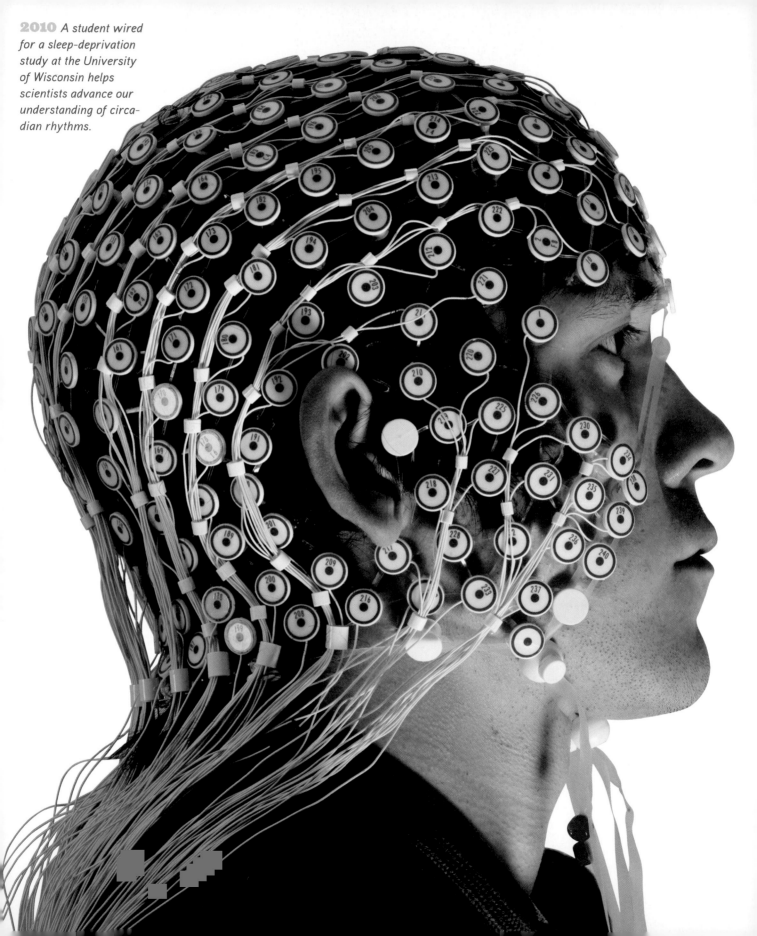

2010 *A student wired for a sleep-deprivation study at the University of Wisconsin helps scientists advance our understanding of circadian rhythms.*

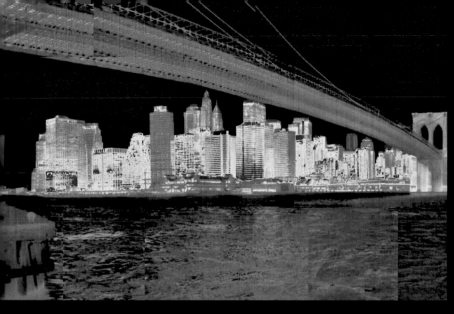

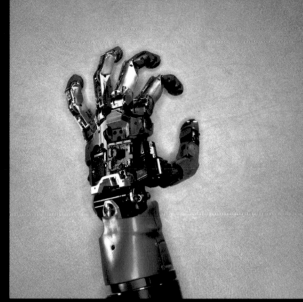

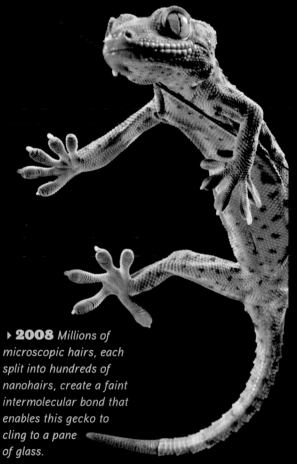

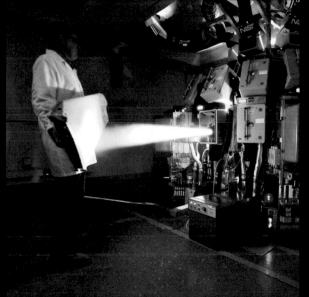

▲ **2010** *Mimicking a flesh-and-blood limb with unprecedented accuracy, this bionic hand is controlled by a user's nerve impulses; its sensors even register touch.*

◀ **2006** *At a government lab in Maryland, a device nicknamed the Death Star tests the strength of nanotechnology materials by bombarding them with intense ultraviolet light.*

▸ **2008** *Millions of microscopic hairs, each split into hundreds of nanohairs, create a faint intermolecular bond that enables this gecko to cling to a pane of glass.*

▲**2009** *Red and yellow zones indicate high-energy output in this thermal image of New York and the Brooklyn Bridge, photographed for a Geographic cover story on saving energy.*

▸**1967** *Frozen in time, this image of a bullet blasting through an apple was captured with stroboscopic photography, invented by longtime Society grantee Harold "Doc" Edgerton.*

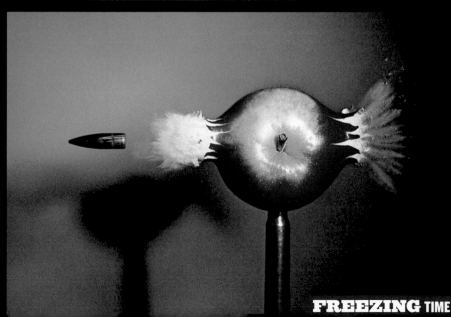

FREEZING TIME

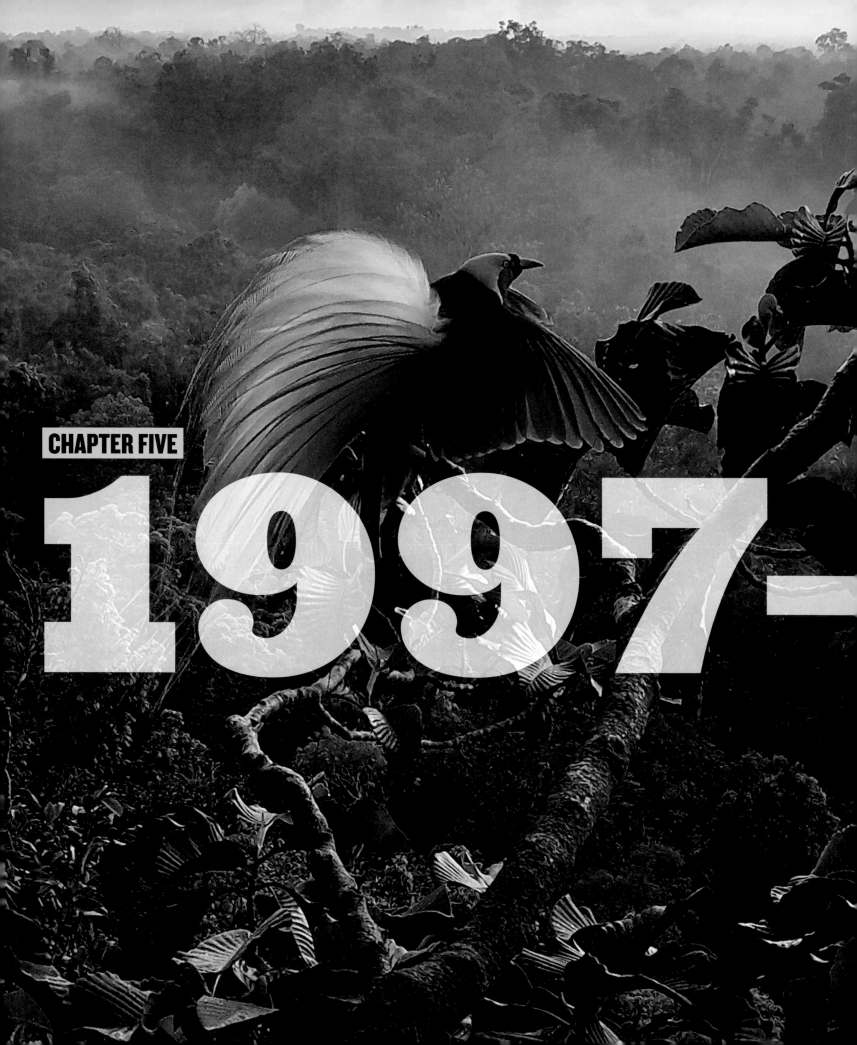

CHAPTER FIVE

1997

2013

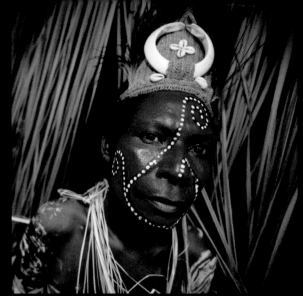

2007 *The Society's Enduring Voices Project is established so that Karim—the ancestral tongue of Christina Yimasinant, left—and other endangered languages might survive.*

1999 *Scientists are increasingly turning to the microcosmos, the very small—like these diatoms—seeking answers to fundamental questions about life.*

2006 *Brady Barr, hero of the popular Dangerous Encounters, is the only herpetologist to have captured all 23 extant species of crocodile.*

2010 *Archaeology is increasingly adopting noninvasive methods to preserve the inviolability of sites. Albert Lin is seeking the tomb of Genghis Khan in this way.*

2004 *Cesar Millan is indeed a dog's best friend, for in the popular TV show Dog Whisperer, he sets about reforming disobedient human owners.*

◀ **1999** Michael Fay's African "Megatransect," a slog through 1,200 miles of Central African rain forest, results in the establishment of a chain of national parks in Gabon.

▶ **2011** Society grantees have been instrumental in proving the likelihood that birds evolved from dinosaurs, but hardly a corner of paleontology has not been touched by the Geographic.

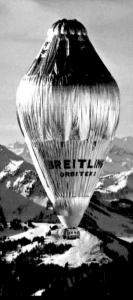

▼ **2012** The deep sea is the last unexplored region on the planet, as filmmaker and explorer James Cameron knows, having made the first solo dive to the deepest spot in the ocean.

▼ **2005** Society-sponsored studies of Homo floresiensis, dubbed the "hobbit" because adults stood only three feet tall, indicate it was probably a separate human species.

▼ **2009** Alarmed by plummeting numbers of lions and tigers, wildlife filmmakers Beverly and Dereck Joubert join the Society in establishing a Big Cats Initiative to help stem the decline.

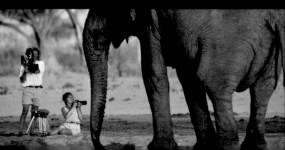

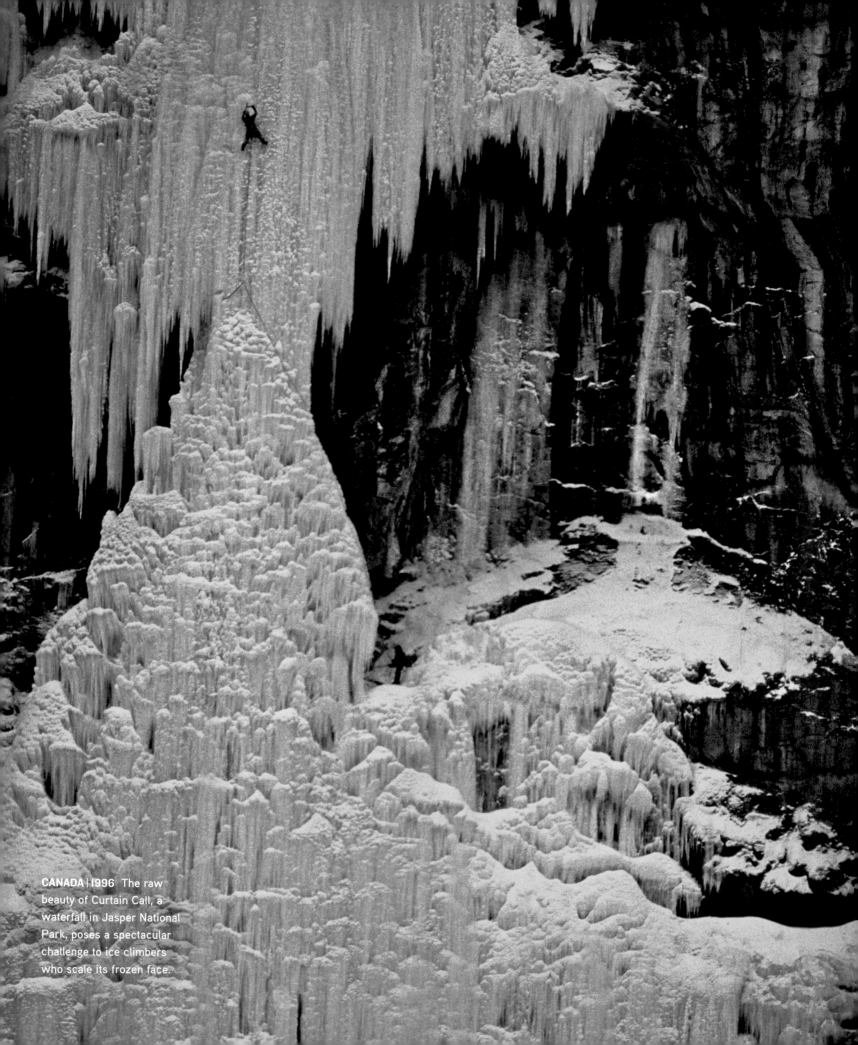

CANADA | 1996 The raw beauty of Curtain Call, a waterfall in Jasper National Park, poses a spectacular challenge to ice climbers who scale its frozen face.

GEO-DIVERSITY

"National Geographic is an incredible mix of science and education, of media and mission, of storytellers and explorers, all working to inspire people to care about the planet," said John Fahey in 2007, describing the Society that he had been guiding as President and CEO for the past nine years. A former head of Time Life Books, Fahey took the Geographic's helm at a time when the digital revolution was overturning old-line media everywhere.

To his credit, he kept the ship on course, though willing to tinker with its engines. The Society's publications continued to revolve around the consistently prize-winning *National Geographic* magazine, which was soon refracted through 36 local-language editions. But Fahey greatly increased the scope of its digital offerings, which pivoted around a flourishing website, and in common with universities and museums elsewhere initiated new licensing, retail, and travel programs, notably a successful partnership with Lindblad Expeditions. Under his leadership, National Geographic television and National Geographic Channel flourished. Ventures in feature filmmaking—*March of the Penguins* won an Academy Award for best documentary feature in 2005, while giant-screen films such as *U2 3D* and *Sea Monsters: A Prehistoric Adventure* were box office hits—were welcome successes. When in January 2011 Fahey stepped up to become the Society's Chairman, it was Tim Kelly, the architect behind the television and film triumphs, who was appointed the new President.

The Society produces magazines for all ages, dozens of new books annually, a website and television channels that never sleep, feature films, and a host of apps, games, catalogs, toys, clothing, and maps. Expeditionary ships cruise from the Galápagos to the edge of the polar ice and thanks to outreach activities, the Society at 125 has now awarded more than 10,000 scientific research grants, while its geography education initiatives continue to help primary and secondary school teachers all over the country. Though remaining loyal to its original mission—the "increase and diffusion of geographic knowledge"—the National Geographic now revolves, above all, around exploration and the conservation of natural and cultural resources. ◼

KEY MOMENTS

1997 National Geographic Channel launches internationally.

1998 Expeditions Council is founded.

1998 National Geographic produces its first large-format film, *Mysteries of Egypt*.

1999 *National Geographic Adventure* magazine premieres.

2001 National Geographic Channel launches in the United States.

2001 *National Geographic Explorer* magazine debuts in 50,000 U.S. classrooms.

2004 Society Chairman Gilbert M. Grosvenor celebrates his 50th anniversary and is awarded the Presidential Medal of Freedom.

2005 *National Geographic* publishes a special all-Africa issue.

2006 The Young Explorers Grants Program is launched to help budding scientists, conservationists, and explorers start their careers.

2009 "Terra Cotta Warriors: Guardians of the First Emperor" exhibition opens at National Geographic Museum, with 15 terra-cotta figures, the largest number ever to travel to the United States.

2010 *National Geographic* publishes its first interactive issue, a special single-topic issue on fresh water.

2010 National Geographic World Atlas app for iPhones launches with one million downloads.

2012 James Cameron successfully completes a solo dive in the Mariana Trench, deepest spot in the ocean.

MAKING A DIFFERENCE

By highlighting "hot spots"—areas where biodiversity is threatened—Society-supported scientists and photographers spur large-scale efforts to preserve them.

✳ THE SWITCH TO DIGITAL

Not only have digital cameras allowed photographers to see their pictures instantaneously but the new format has also freed them from the burden of lugging around cases of film. Today, photographers shoot thousands of digital images to obtain the two dozen or so that are published in a feature article.

ABOVE: The Canon EOS-1D X is one of several high-speed professional cameras used in the field.

W e're in one of the last great wild places, and we barely understand how it works," ecologist Mike Fay told the *National Geographic* team that had accompanied him into the sweltering forests of the Republic of the Congo in 1993. Though a long-necked beast was rumored to be prowling the swamp nearby, the ant-bitten, tick-ridden, parasite-infested, and utterly exhausted men were there for different quarry: to document the astonishing abundance of leopards, bongos, gorillas, and elephants that inhabit Nouabalé-Ndoki National Park, which Fay had just helped establish.

Within a decade, several more *Geographic* teams would string along behind Fay as the gorilla researcher turned explorer-in-residence plunged into a swath of pristine African rain forests. As a result, they would discover troops of chimpanzees that had never spied a human being. Michael K. "Nick" Nichols, a photographer specializing in the great apes, would compile an unmatched record of elephant pictures as well. And Fay would leave in his wake a string of national parks in unpopulated but highly biodiverse regions of Africa—parks, created just ahead of imminent timber exploitation, that might protect a portion of the continent's priceless natural inheritance.

OF MAHOGANY AND MACAWS

Photographer Joel Sartore, meanwhile, had exchanged the treeless prairies of his native Nebraska for a teeming lost world of leafy tropical profusion. In 1995 Bolivia had established its Madidi National Park, a chunk of greenery spilling off the Andes and into the Amazon Basin that was one of the most biologically diverse places on the planet. Jaguars, spectacled bears, sloths, vicuñas, giant otters, peccaries, and macaws—the latter one of an astounding 1,000 or more bird species—inhabited rain

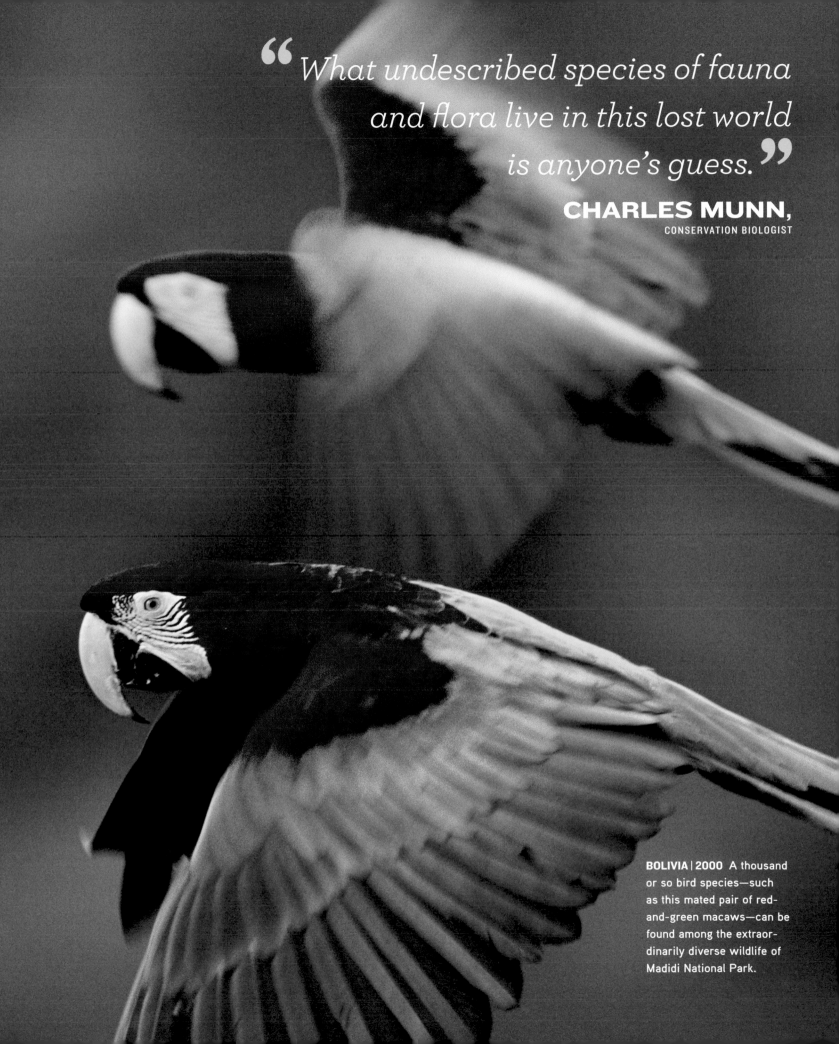

"*What undescribed species of fauna and flora live in this lost world is anyone's guess.*"

CHARLES MUNN,
CONSERVATION BIOLOGIST

BOLIVIA | 2000 A thousand or so bird species—such as this mated pair of red-and-green macaws—can be found among the extraordinarily diverse wildlife of Madidi National Park.

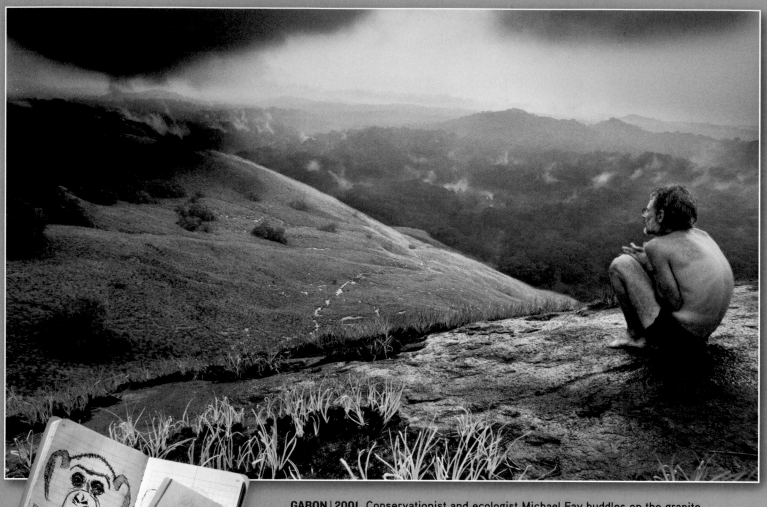

GABON | 2001 Conservationist and ecologist Michael Fay huddles on the granite of a mountaintop in Minkébé forest. In the Goualougo Triangle lived populations of chimpanzees (left) that had never seen human beings.

✚ **SHADOWED FOREST**

Though the expedition saw abundant leopard signs, they never saw one of the elusive cats. A more terrifying scourge lurked in the bush anyway. After crossing into Gabon, Fay noticed that the lowland gorillas had vanished. The culprit, he realized with a shudder, was the dreaded Ebola virus.

On September 20, 1999, wildlife biologist Michael Fay plunged into the bush of the Republic of Congo and—except for breaks during the rainy season—only emerged 455 days and 1,200 miles later on the Atlantic shores of Gabon. By that time the "Megatransect," as the old-fashioned inventory by foot of Africa's remaining pristine rain forests was called, was fast becoming a part of National Geographic legend.

Shirtless (and skinnier and more bearded by the day), Fay had driven the exhausted expedition onward by sheer force of will, pushing by compass and machete through thorny thickets, across Edenic glades frequented by elephants, and through swamps crawling with crocodiles.

Yet his trials paid off: Photographer Nick Nichols had slogged beside him, and after leafing through Nichols's photographs, Omar Bongo, President of Gabon, established 13 national parks—amounting altogether to some 10 percent of the country—along the route Fay had explored. ■

forests that had been only partially explored. Yet moves were afoot on the part of the Bolivian government to construct a giant dam that would have drowned more than 1,000 square miles of wilderness. Those plans ground to a halt around the same time the *Geographic*'s March 2000 issue reached its 40 million readers worldwide. With his article on Madidi having helped save an imperiled patch of wild, Sartore suddenly saw the insect torments he had undergone—and even the leishmaniasis he had contracted from a sandfly bite—as having been worthwhile.

THE FOREST FOR THE TREES

As *National Geographic* editors planned a major issue on the world's declining biodiversity in 1997, they turned to one man—Frans Lanting—to shoulder the bulk of the photographic load. Born in Holland, Lanting enjoyed a reputation as a superb wildlife photographer. In 1985 he had spent a year documenting the environmental degradation of Madagascar. His pictures from that assignment, published in the February 1987 issue, roused international interest in the island nation's plight and prompted the Malagasy government to boost its support for parks and reserves. Five years later, when Lanting's long-term coverage of Botswana's Okavango Delta was published in the December 1990 magazine, it too galvanized world concern—this time for "Africa's Last Eden."

Lanting spent eight months traveling the globe to make the pictures for February 1999's biodiversity issue. He has since undertaken many other assignments for a magazine justifiably known as perhaps *the* showcase of fine nature photography.

While primatologist Cheryl Knott was studying the orangutans of Indonesia's Gunung Palung National Park—and protecting them from the devastation being wrought upon their rain forest home by out-of-control wildfires and illegal logging—her husband, Tim Laman, was scaling the trees in order to get eye-level with the apes. Though he had earned a Ph.D. from Harvard for his work on Borneo's strangler figs, Laman was as superb a photographer as he was a biologist. He has since compiled a striking portfolio of animal portraits—flying geckos, flying frogs, flying lemurs, proboscis monkeys, and other denizens of the rain forest—taken mostly in the canopies and often at night. Laman has documented dozens of the world's declining hornbills and every species of New Guinea's birds of paradise.

Indeed, tropical forest canopies were being dubbed the "last biotic frontier" by one of their pioneering investigators, American ecologist Nalini Nadkarni. She discovered that certain tropical tree roots sometimes snake *up* the trunk to tap pockets of soil lodged high in its crown (the soil was deposited there by orchids and other epiphytic plants). Using a rig of her own devising called a "master caster," Nadkarni also dangled hundreds of feet above the forest floor in Costa Rica. This made her a natural lead for the Emmy Award–winning National Geographic Special *Rain Forest: Heroes of the High Frontier*.

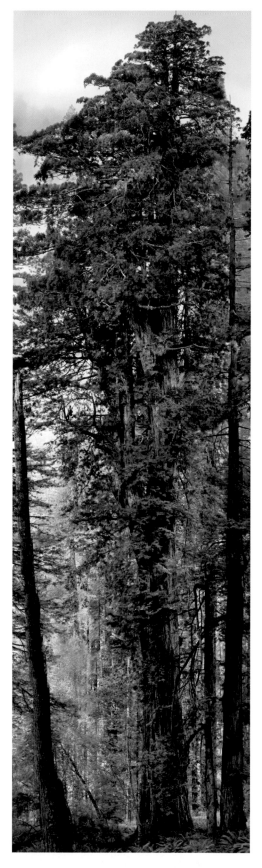

CALIFORNIA | 2009 A 310-foot redwood with the most complex crown ever mapped

⊛ EXTREME ICE

James Balog, founder of the Extreme Ice Survey, has placed 27 cameras on 18 glaciers across the Northern Hemisphere. Shooting one frame for every half-hour of daylight, these cameras generate close to 216,000 images a year. Edited into time-lapse videos, the pictures are an eye-opening testimony to the speed of glacial retreat.

ABOVE: Meltwater lakes and streams on the rapidly receding Greenland ice sheet made the cover of the June 2007 *National Geographic*.

Among his many *Geographic* assignments, Mattias Klum has photographed meerkats in Namibia, king cobras in Thailand, and lions in India's Gir Forest. But ask the Swede to name his favorite hangout and he doesn't hesitate: It's jungle canopies. Klum spent most of a year (1995–96) in the treetops of Malaysian Borneo, waiting for "interesting things to come slithering by," as he recounted in the August 1997 issue. The 100,000-acre conservation area in the Danum Valley had "changed little in more than a million years," he noted. In Central America, Klum spent numerous nights high in the branches of rain forest giants, capturing unprecedented images of the weasel-like nocturnal mammal called the kinkajou.

The planet's hot spots of biodiversity were showing up more and more in the magazine's pages. Vietnam's Tam Dao Mountains, for example, feature an ecosystem so diverse that a world-record 108 snake species have been counted there. In the Philippines, meanwhile, habitat loss threatens about 70 percent of the more than 500 species of endemic land vertebrates—many of which have never been described by science. The beautiful Brazilian monkey known as the golden lion tamarin is endangered to such a degree that it is found only in the few remaining fragments of Brazil's formerly extensive Atlantic coastal forests, where 450 species of trees were once counted on just two and a half acres.

THE HUMAN FOOTPRINT

Impressed by scientific findings suggesting that life on Earth was a single homeostatic system—that is, a sum greater than its interdependent parts—Geographic television producer Mark Shelly cast about for some way to dramatize such insights. The result was the four-part *Strange Days on Planet Earth*, broadcast on National Geographic Channels International and PBS in April 2005, which vividly demonstrated how seemingly disparate events—New Orleans houses undermined by termites from southern China, asthma outbreaks in the Caribbean linked to Saharan dust storms—have a hidden global connection. The series swept honors at many of the leading film festivals.

Mike Fay, too, had been seeking new ways to see things whole. In 2004, during his seven-month African Megaflyover, he and bush pilot Peter Ragg flew a Cessna some 60,000 miles from South Africa to Morocco, a mounted digital camera snapping landscape shots every 20 seconds. "The Megaflyover," *National Geographic* Editor Chris Johns announced when showcasing the September 2005 all-Africa special issue, "shows

THE SHORT STORY RARE: JOEL SARTORE DOCUMENTS EARTH'S MOST ENDANGERED SPECIES

Crocodylus acutus, Henry Doorly Zoo, Nebraska ▾ | *Mustela nigripes*, Cheyenne Mountain Zoo, Colorado ▾

< 2,000 REMAINING | APPROX. 800

AMERICAN CROCODILE

Heavily hunted for their hides in the mid-1900s, American crocodiles cling to existence from Florida to Peru. They have begun inching back into the United States.

BLACK-FOOTED FERRET

A government program to reduce prairie dogs in the 1920s nearly wiped out the black-footed ferret, which fed on the burrowing rodents. About 300 of the remaining population are in captivity.

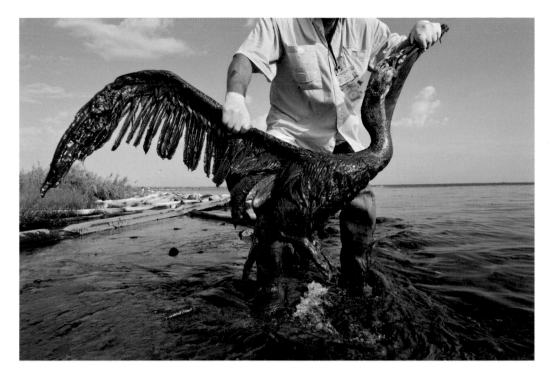

LOUISIANA | 2010 Parish official P. J. Hahn rescues an oily brown pelican on Queen Bess Island during the Gulf of Mexico oil-spill disaster. The bird survived.

that where Africans have learned to use their land in a sustainable way, they are doing well and the ecosystem is surviving. Where the human footprint has become too heavy and people have simply exhausted their resources, there we see suffering on an epic scale." The African example, Johns emphasized, was "a wake-up call for all of us."

Meanwhile, Iain Douglas-Hamilton was using GPS technology to map the movements of wandering African elephants, hoping to implement a range-wide conservation plan. It soon became clear that Chad's Zakouma National Park was the last sanctuary where more than 1,000 elephants still congregated in a single herd. Yet the park was ringed by ivory poachers, mowing the great beasts down whenever they migrated outside the boundaries. In the autumn of 2006, Fay and Nichols flew over the park and spotted 100 elephant carcasses dotting its rim. Their fierce "Ivory Wars: Last Stand in Zakouma," published in the March 2007 *Geographic*, mobilized public opinion worldwide. Within weeks of the magazine's appearance, a rapid-response team from the Wildlife Conservation Society had arrived in Chad to help protect the elephants. ■

✳ ONE CUBIC FOOT

Using a custom-designed metal cube, photographer David Liittschwager embarked on an ambitious photography project—ambitiously small, that is: to observe a single cubic foot of biosphere by documenting the life that moved through the metal frame. Spending three weeks in each of five environments from coral reef to temperate forest, Liittschwager photographed more than 1,000 organisms.

ABOVE: A spotted bass moves through the cube in Duck River, Tennessee, one of the nation's most biodiverse waterways.

Nicrophorus americanus, St. Louis Zoo, Missouri ▼ *Vireo atricapilla*, Fort Hood, Texas ▼

| < 25,000 REMAINING | APPROX. 12,500 |

AMERICAN BURYING BEETLE
Many biologists think this beetle, which likes dark, undisturbed areas rich in carrion, once feasted on the passenger pigeon.

BLACK-CAPPED VIREO
Returning each year from western Mexico to the same patches of land in Oklahoma and Texas, these small songbirds often find that livestock and deer have nibbled away the shrubs they need for nesting.

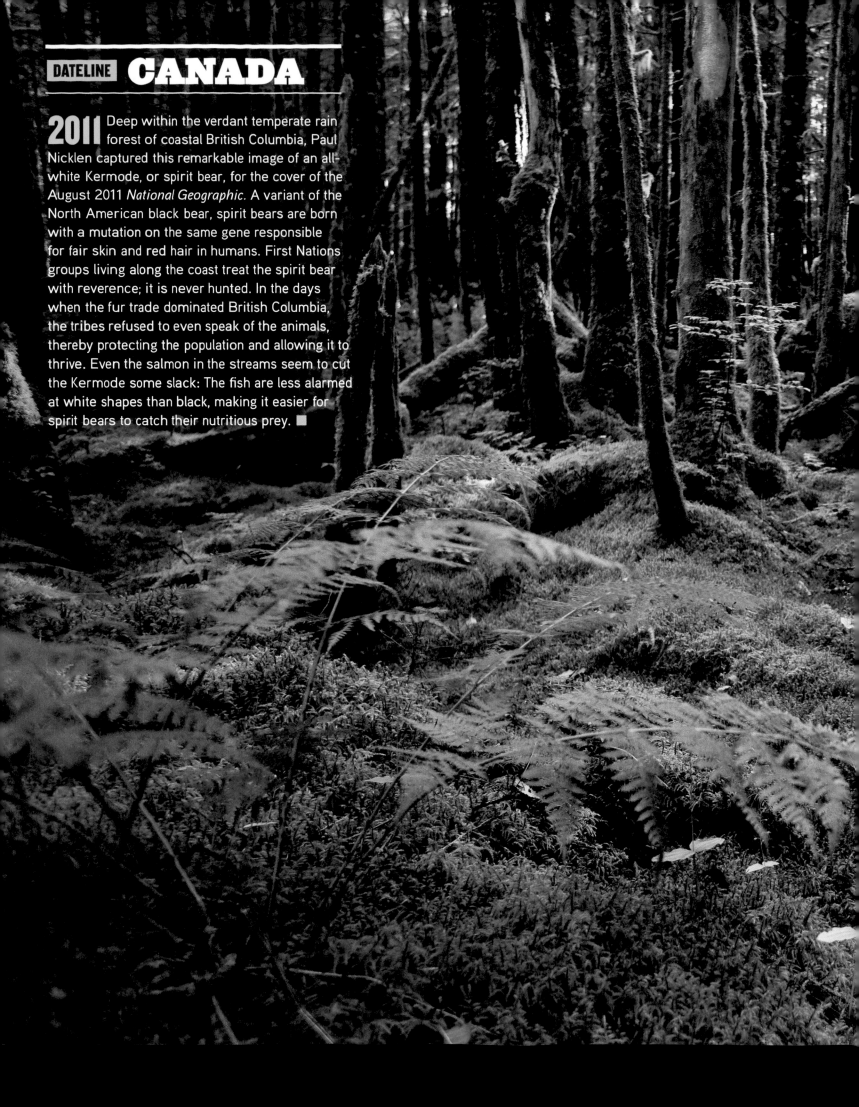

2011 Deep within the verdant temperate rain forest of coastal British Columbia, Paul Nicklen captured this remarkable image of an all-white Kermode, or spirit bear, for the cover of the August 2011 *National Geographic*. A variant of the North American black bear, spirit bears are born with a mutation on the same gene responsible for fair skin and red hair in humans. First Nations groups living along the coast treat the spirit bear with reverence; it is never hunted. In the days when the fur trade dominated British Columbia, the tribes refused to even speak of the animals, thereby protecting the population and allowing it to thrive. Even the salmon in the streams seem to cut the Kermode some slack: The fish are less alarmed at white shapes than black, making it easier for spirit bears to catch their nutritious prey. ■

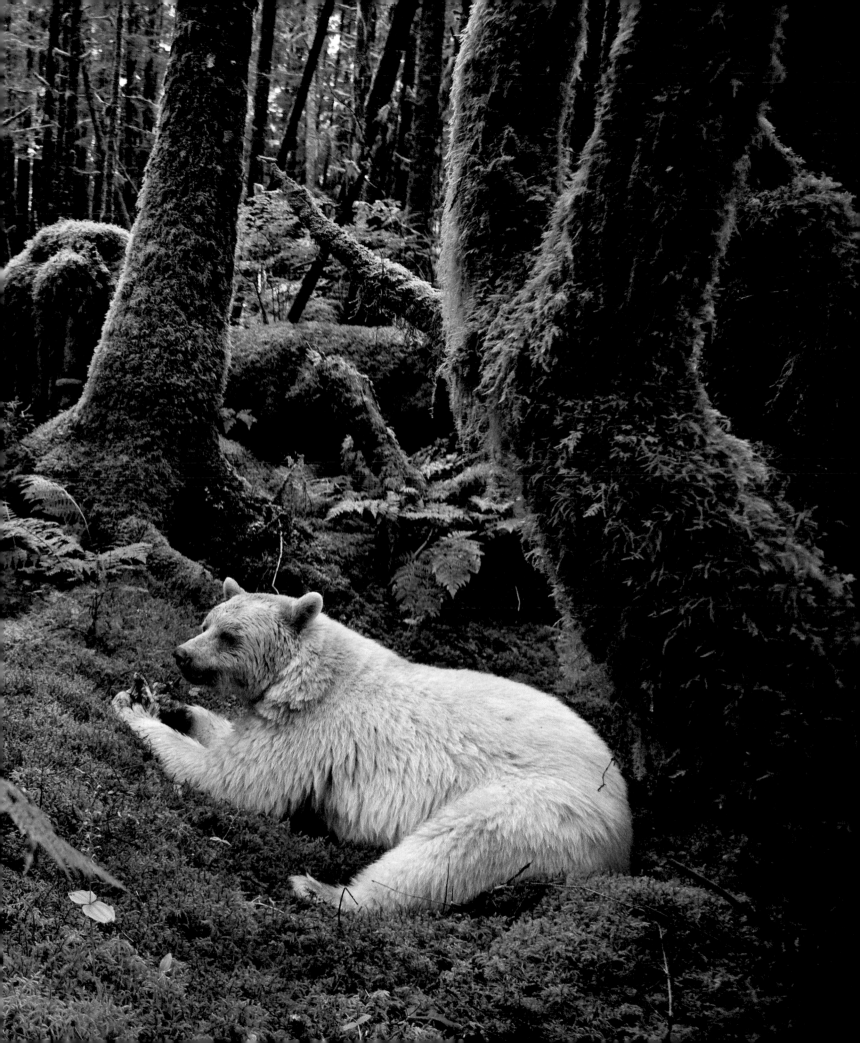

ALL CREATURES

Society scientists and photographers are racing to document, understand, and protect vanishing wildlife.

✳ "HONEY BADGER DON'T CARE"

Forty-seven million Web hits and counting: A National Geographic documentary featuring a honey badger attacking a venomous puff adder gained the diminutive carnivore a global following when a viewer known only as Randall added his own comic narration to a short segment of the film, then uploaded the spoof to YouTube.

ABOVE: Thick skin—twice as thick as humans'—protects the honey badger from teeth, claws, and venom.

Can elephant droppings help defend the pachyderms? Why else would biologists affiliated with the Elephant Ivory Project be collecting elephant dung in the war-torn forests of the Democratic Republic of the Congo? DNA analysis and GPS-based geo-referencing of scat samples yield better data about many aspects of a species' existence: its habitat use, home range, parasitic infections, population size, and sex ratios, for starters. But the Elephant Ivory Project also hopes to fill critical gaps in a genetic map of elephant distribution. With that map in hand, international law enforcement will have a tool for matching DNA recovered from seizures of illegally harvested ivory tusks. That will let the wildlife officers pinpoint where the animals were killed—which might help them disrupt poaching networks.

Many fronts have opened in the wildlife-conservation wars, and the Geographic's role in those battles has grown commensurately complex.

VANISHING ACTS

"To eat and not be eaten—that's the imperative of a caterpillar's existence," biologist Darlyne Murawski wrote in the March 1997 *Geographic*. If the creature managed to do the first and avoid the second, the caterpillar metamorphosed—in this case—not into a butterfly but a moth. Though moths play second fiddle to their showier cousins the butterflies in most people's imaginations, Murawski urged readers to look again: Moths, she wrote, are "wily insects" that have mastered the deceptive arts. They rank right up there with fungi, marine worms, diatoms, and other small fry that Murawski has made it her specialty to photograph.

For more than 20 years Mark Moffett—the "Indiana Jones of entomology"—has likewise been filling the magazine's pages with pictures of insects. To Moffett, who should know, there's no insect wilier than an ant. Moffett feels at home in both jungle canopy

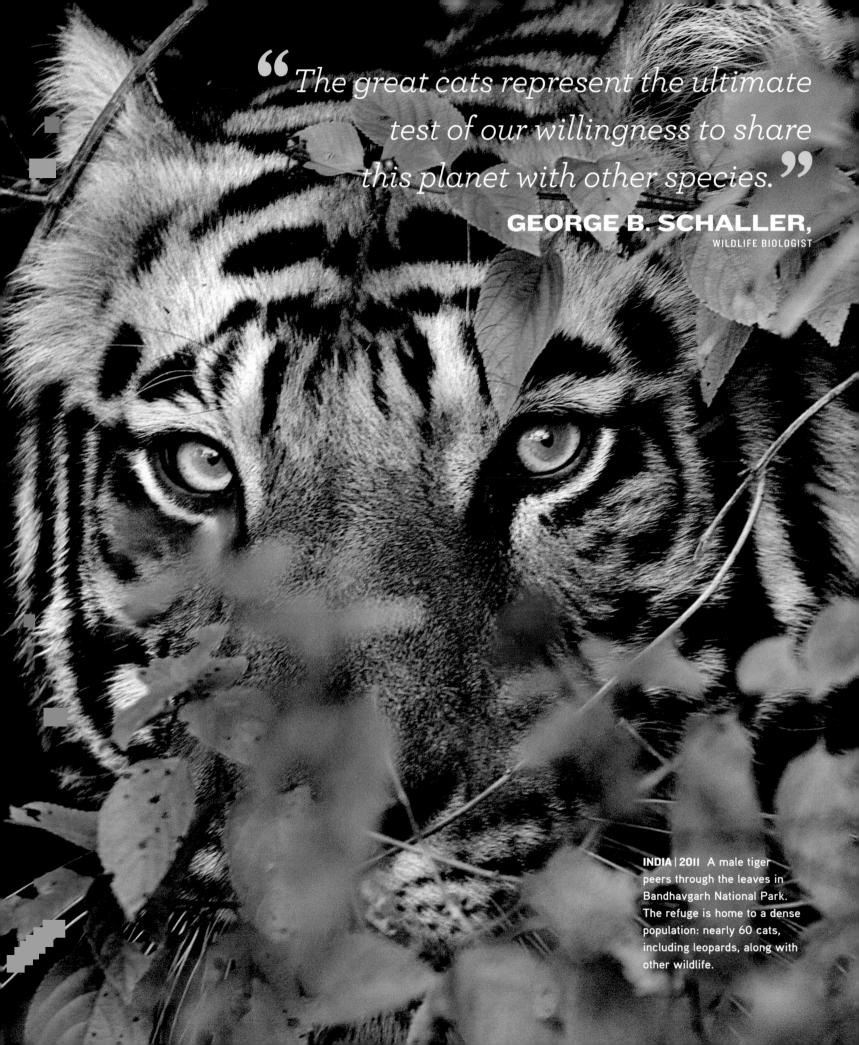

"*The great cats represent the ultimate test of our willingness to share this planet with other species.*"

GEORGE B. SCHALLER,
WILDLIFE BIOLOGIST

INDIA | 2011 A male tiger peers through the leaves in Bandhavgarh National Park. The refuge is home to a dense population: nearly 60 cats, including leopards, along with other wildlife.

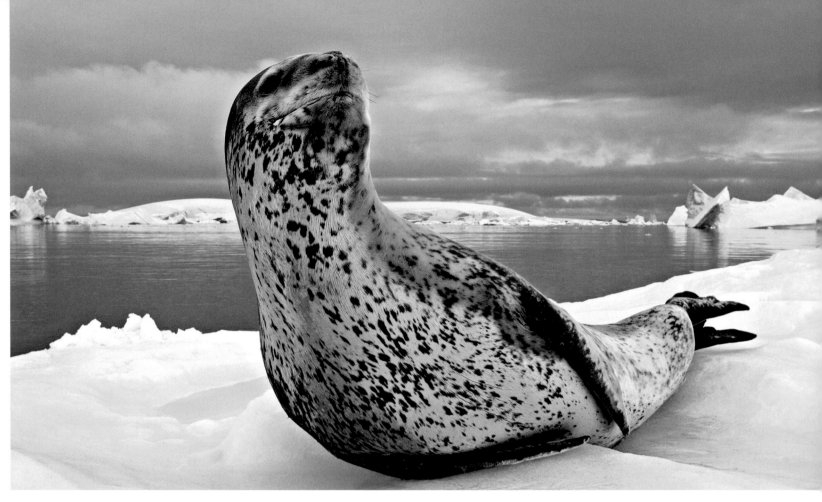

ANTARCTICA | 2006 On alert, an adult leopard seal scans her surroundings—the frozen world of the Antarctic Peninsula. Leopard seals are the only seals known to regularly hunt warm-blooded prey.

▶ **COLOMBIA, 1995**
The tiny golden poison dart frog, found only in the western Colombian rain forest, carries enough venom to kill ten adult humans. Destruction of its habitat has landed it on the endangered list.

and on forest floor, having photographed all sorts of ants all over the world: dinosaur ants, weaver ants, bulldog ants, scythe-jawed ants, army ants, slavery ants, dracula ants, and even Peruvian turtle ants that hang glide from branch to branch, surviving falls from the canopy by floating down via a membranous parachute.

Indeed, a parachute might come in handy these days for many of the animal species whose numbers are plummeting. The usual culprits are habitat loss, habitat fragmentation, or human encroachment. Klaus Nigge's photographs of vanishing Philippine eagles, to take one example, are set against a deforested background. Norbert Rosing's portraits of polar bears, arctic foxes, and walruses stand out against a falling curtain called global warming.

The ice is melting in the Antarctic, too. Though "The Seal Who Loved Me" might have made an apt subtitle for photographer Paul Nicklen's prizewinning 2006 *Geographic* feature on leopard seals, the Canadian wildlife biologist was all too aware how little was known about the life histories—or even the numbers—of the once greatly feared predators. Yet he let one of them fondle his head in her ferocious jaws, a moment simultaneously tender and terrifying.

Even today there are no reliable estimates of how many snow leopards remain in the Asian mountains, or how many jaguars roam the tropical American forests. When Steve Winter went to photograph jaguars for the May 2001 *Geographic*, he rarely saw

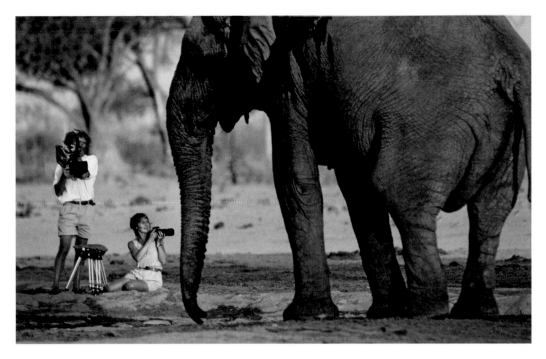

BOTSWANA | 1994 Renowned wildlife filmmakers Beverly and Dereck Joubert photograph an elephant at extremely close range. Botswana's Savuti region, home to lions, African buffalo, and antelope, as well as elephants, is one of the continent's last unspoiled wildernesses.

⊛ THE DOG WHISPERER

Cesar Millan is a dog's best friend. In his popular TV show *Dog Whisperer with Cesar Millan*, Millan tackles tricky cases of canine misdeeds, leaving good behavior—and a new calm—in his wake. Millan's aptitude stems from his ability to work with humans, addressing actions that negatively affect their dogs. Though he can be seen commanding dogs with a single gesture, or playing hide-and-go-seek, it pays to watch how humans react to him, too; many welcome the sage outsider's observations about their lives mirrored in their pets.

ABOVE: Cesar Millan plays with a pit bull.

one in his viewfinder. Then one day, from out of the jungle gloom, a jaguar materialized only 20 feet away—and Winter could hardly hold his camera steady.

That was one of many close encounters that set Winter's heart thumping as he photographed wildlife around the world. Inspired by leafing through *Geographics* as a boy, Winter had been an assistant to Nick Nichols before embarking on his life's work: a thoroughgoing documentation of the world's big cats, the scientists who study them, and the conservation issues surrounding them. His photographs, many of them published in the magazine, have had the kind of impact that helps secure funding for wildlife protection. As Nichols himself said about his protégé's pictures, "When they're that good you make a case for the whole environment the creature lives in."

No one knew that better than a South African couple making wildlife films in Botswana's Okavango Delta. Millions of viewers got their first glimpse of the work of Dereck and Beverly Joubert in 1990, when the pair produced a masterpiece of natural-history filmmaking: the Emmy-winning National Geographic Special *Eternal Enemies: Lions and Hyenas*. The Jouberts' success stemmed from their closeness to the land: The couple had chosen to spend most of their days under canvas in the wild, content to use an old giraffe pelvis as their washbasin. Becoming virtually one with the bush, they were able to follow and film wildlife day and night. The result: two dozen classic documentaries in 20 years featuring close-up looks at the lives of wild animals.

For three years the Jouberts had tracked a leopard cub's progress from birth to adulthood. They had closely monitored a pride of lions in the Okavango Delta, watching

them prey on elephants and African buffalo. So it was natural that the Jouberts should grow increasingly distraught as big-cat populations plummeted around the globe. In half a century lions alone had fallen from nearly half a million to perhaps 20,000. "If there was ever a time to take action," announced the leonine-looking Dereck in 2009, "it is now." He and Beverly had just joined forces with the Society in launching the Big Cats Initiative. This double-barreled effort to stem the decline is funding conservation projects and educational outreach programs worldwide. First, though, it aims to stabilize the lion and cheetah populations of Africa.

MOVE OR DIE

Besides human beings, the most populous animal in sub-Saharan Africa is probably *Eidolon helvum,* a large fruit-eating bat that congregates in immense roosts: Accra, Ghana, is home to more than a million of them. Yet the bats disappear for months at a time—and scientists can't say for certain where they all go.

Technology is finally enabling biologists like Martin Wikelski to track the migrations of creatures once considered unimaginably difficult to follow en masse. Wikelski has outfitted dragonflies with miniaturized radio transmitters. He has even measured a mass migration of bumblebees, and is currently working on those African bats as well. Wikelski's dream is to amass a global database of migratory data. Why? Because day and night, our planet is churning with movement as countless creatures embark on far-flung DNA-driven missions to feed or flee or reproduce—or perhaps just to wander. And much of their behavior remains poorly understood.

That was reason enough for National Geographic to tackle the largest project in its history. Fifty film crews, outfitted with HD cameras boasting superhigh frame rates (for better slow motion) or gyro-stabilized mounts (for better aerials), blanketed the globe. Three years of effort resulted in an epic seven-part documentary, *Great Migrations,* that premiered worldwide in November 2010. Collectively the film crews had traveled more than 400,000 miles—though as viewers of the series soon learned, a single sperm whale might travel one million nautical miles in its lifetime.

These migrations were moving stories indeed. It's hard to believe a crab could be made heroic, but the red crabs of Christmas Island, running a gantlet of ferocious yellow ants and flinging themselves off cliffs in order to spawn in the surf of the Indian Ocean, embodied knightly virtue. Viewers

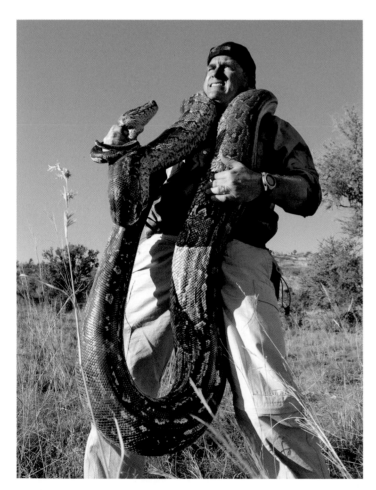

SOUTH AFRICA | 2006 Brady Barr, host of the National Geographic Channel series *Dangerous Encounters,* wrestles a python. Barr is the only herpetologist to have captured all 23 living species of crocodiles.

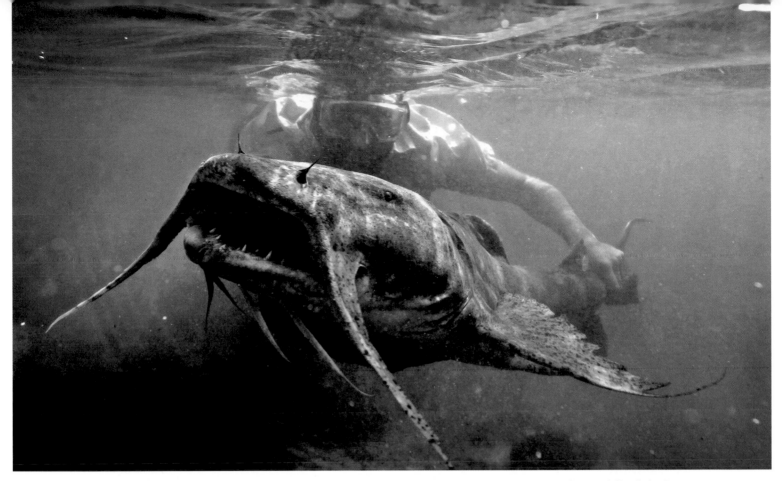

INDIA | 2011 Conservation biologist and host of *Monster Fish* on Nat Geo Wild, Zeb Hogan plunges fully clothed into the Ramganga River to help a goonch catfish swim away after being caught and tagged.

watched as Wikelski placed miniature transmitters on the wings of monarch butterflies to track the stages in an annual journey that took four insect generations to complete. Neither a biologist nor a cameraman had witnessed the white-eared kob migrate across southern Sudan in two decades, such had been the war and unrest in the region. A team risked land mines and armed gangs to film the 800,000 antelope on the move again.

Most Americans don't realize that an epic migration still occurs each year in the lower forty-eight. *Great Migrations* brought them the spectacle of pronghorn flowing across the 100 miles separating their calving grounds in Wyoming's Grand Teton from their wintering ranges in Colorado's Green River Valley—an ever narrowing corridor threatened by encroaching subdivisions and shopping malls. Viewers also watched the desert elephants of Mali ceaselessly tramp a 250-mile circle from one distant water hole to another, up hills, down dunes, across grasslands—threading their way, as they went, through a spreading network of permanent villages, complete with gardens and cropland, where once only scattered nomads had roamed.

Great Migrations garnered rave reviews, prompting its producer, David Hamlin, to write in a companion book: "Our task was to document the timeless journeys of wildlife—but some of these journeys may be running out of time." And because there is so little time, biologists like those with the Elephant Ivory Project are rushing with growing urgency to collect dung samples from the forests of the Congo. ■

MARCH OF THE PENGUINS, 2005

Thousands of penguins starred in this Academy Award–winning film about the birds' immemorial urge to find a mate and raise their young in Antarctica's forbidding climate. The film crew spent more than a year on the icebound continent to record the footage in this now classic documentary.

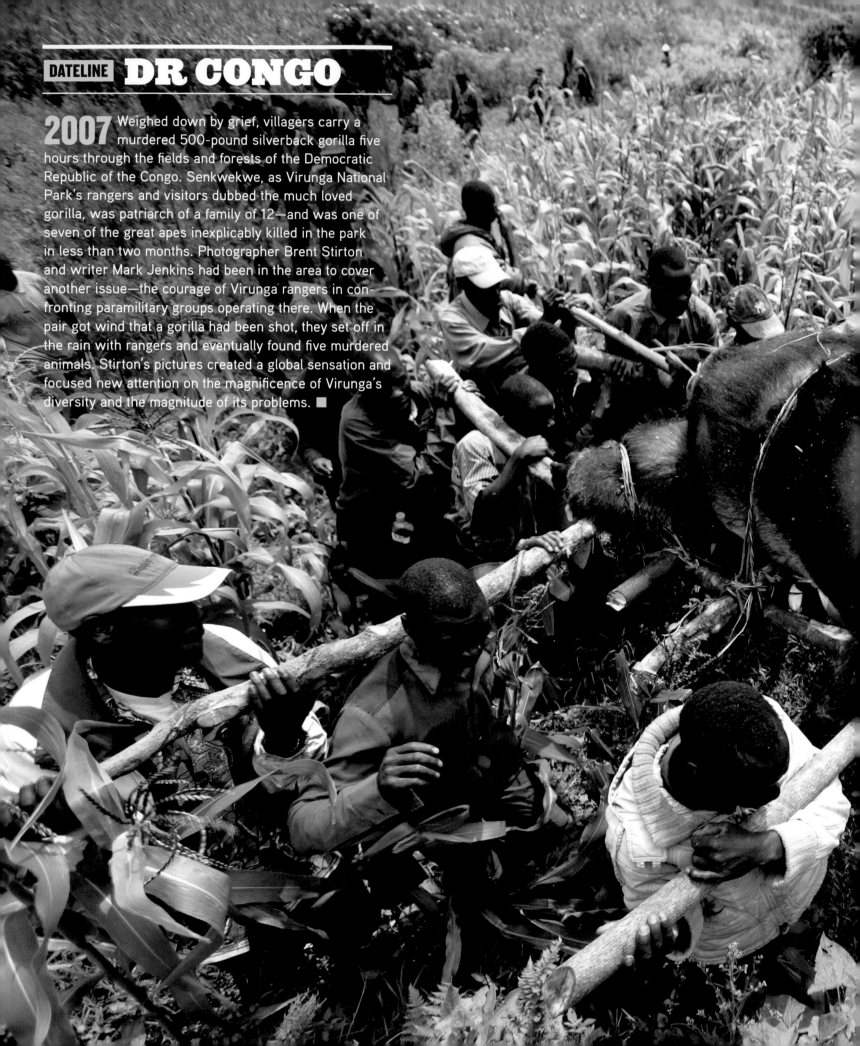

2007 Weighed down by grief, villagers carry a murdered 500-pound silverback gorilla five hours through the fields and forests of the Democratic Republic of the Congo. Senkwekwe, as Virunga National Park's rangers and visitors dubbed the much loved gorilla, was patriarch of a family of 12—and was one of seven of the great apes inexplicably killed in the park in less than two months. Photographer Brent Stirton and writer Mark Jenkins had been in the area to cover another issue—the courage of Virunga rangers in confronting paramilitary groups operating there. When the pair got wind that a gorilla had been shot, they set off in the rain with rangers and eventually found five murdered animals. Stirton's pictures created a global sensation and focused new attention on the magnificence of Virunga's diversity and the magnitude of its problems. ∎

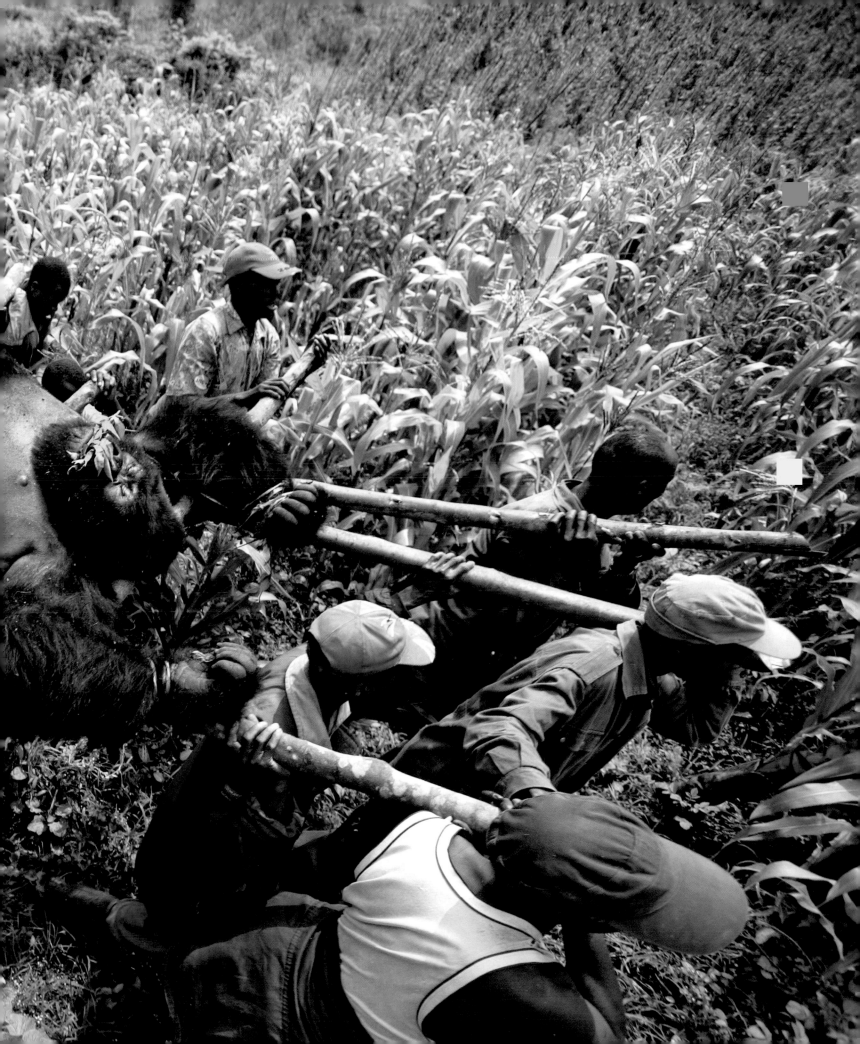

BOUND FOR ETERNITY

Mummies, mummies everywhere—and a few fossil skulls thrown in to upset the bone cart—are the hallmarks of recent Society-supported projects in archaeology and paleontology.

✳ ICE BABY

In 2007 a reindeer herder happened upon the startlingly well-preserved remains of a baby mammoth that had been buried in Siberian permafrost for over 40,000 years. Nicknamed Lyuba, the month-old calf still possessed eyes, trunk, and hair, while her internal organs and skin were in nearly perfect shape.

ABOVE: A baby mammoth, about the size of a large dog, surfaced in Siberia after spending 40 millennia entombed in mud.

I cy cold and clawed by furious winds, the 22,000-foot-high summit of Argentina's Llullaillaco Volcán presented the world's most daunting archaeological site in 1999. But that's where Johan Reinhard discovered the withered remains of two girls and a boy, sacrificed to Inca gods some 500 years earlier.

A casual inspection of the bodies never would have suggested that five centuries had passed since their demise. The high-altitude cold had preserved the corpses better than almost any others ever found. Their internal organs were still intact. Blood was found frozen in their veins.

Reinhard, a National Geographic explorer-in-residence and a pioneer of high-altitude archaeology, had become famous when he retrieved the frozen remains of another sacrificial victim from the slopes of Peru's Nevado Ampato in 1995. (The press had promptly dubbed that find the Ice Maiden.) Startling though the discoveries of Reinhard may be, they are hardly the only mummified (or fossilized) human remains a new crop of Society bone hunters and tomb seekers have been turning up.

A LAYERED FAMILY HISTORY

The stream of paleoanthropology ran strong through the pages of *National Geographic* in the early 1990s, a time when Society-supported fossil hunters kept the magazine's editors busy digesting new discoveries.

By 1994—five years after Richard Leakey became the full-time director of Kenya's wildlife service—the windswept camp at Koobi Fora had come under his wife's able management. Meave Leakey, as thoroughgoing a professional as any Kenyan fossil hunter, had joined paleontologist Alan Walker that year on the shores of Lake Turkana, where the fragments they excavated included a lower jawbone that resembled a chimpanzee's—but

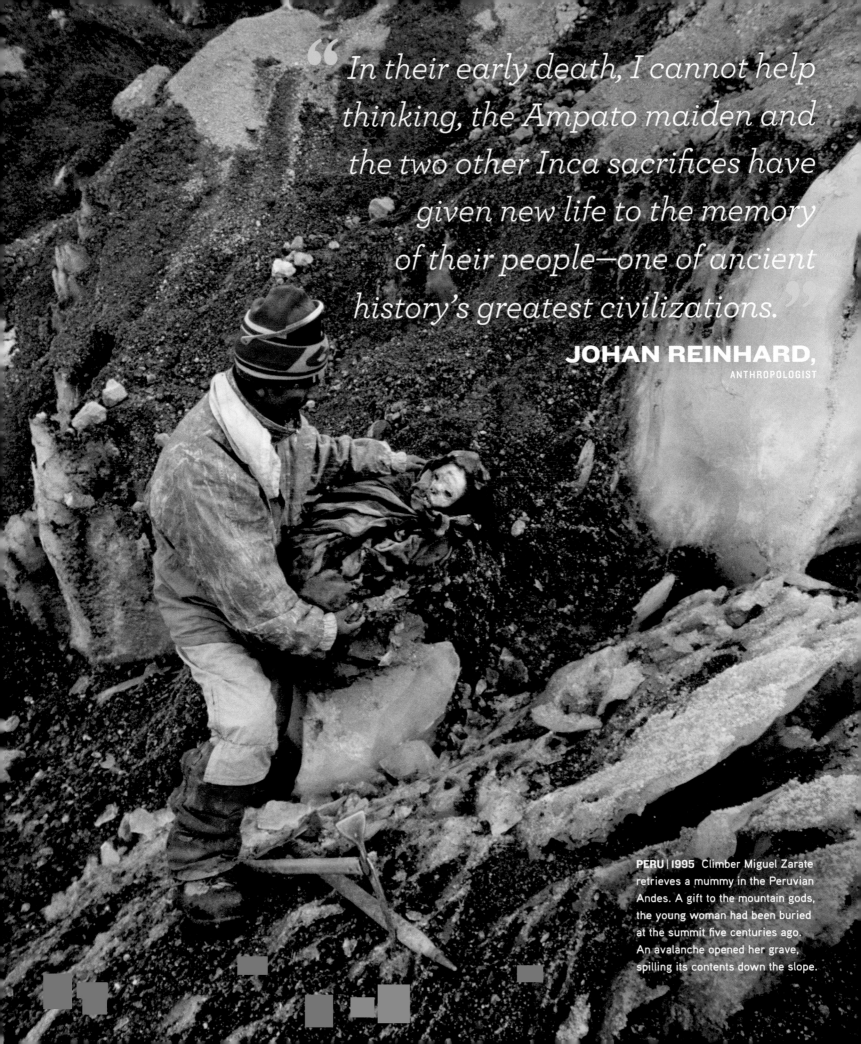

> " *In their early death, I cannot help thinking, the Ampato maiden and the two other Inca sacrifices have given new life to the memory of their people—one of ancient history's greatest civilizations.* "
>
> **JOHAN REINHARD,**
> ANTHROPOLOGIST

PERU | 1995 Climber Miguel Zarate retrieves a mummy in the Peruvian Andes. A gift to the mountain gods, the young woman had been buried at the summit five centuries ago. An avalanche opened her grave, spilling its contents down the slope.

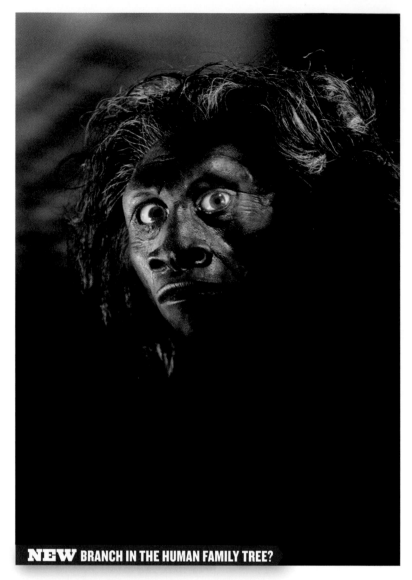

NEW BRANCH IN THE HUMAN FAMILY TREE?

INDONESIA | 2004 Synthetic skin and hair bring to life the 18,000-year-old skull of a three-foot-tall *Homo floresiensis* female found on the island of Flores.

▶ **PERU, 2006**
These gold figures were part of earrings found with the exquisitely preserved mummy of a powerful woman of the Moche culture, which occupied northern Peru from A.D. 100 to 800.

bore proto-human teeth. Dated at 4.1 million years old, it was dubbed *Australopithecus anamensis,* from the Turkana word *anam,* which means "lake."

Digging again along the lake shores in 1999, Meave's team unearthed not just another new species but a previously unknown genus: The 3.5-million-year-old skull and partial jaw that she named *Kenyanthropus platyops* was soon upsetting established notions that only *Australopithecus* had been around to give rise to true humans. "Flat-faced man of Kenya," it now appeared, had lived alongside *Australopithecus* all the while.

Meave, for her part, had acquired a new partner. Not only was Louise Leakey a fellow National Geographic explorer-in-residence but she was also Meave's daughter. That brought to three the number of generations of fossil-hunting Leakeys the Society had supported.

With newly discovered hominid species proliferating in this fashion, scientists had to face the fact that human ancestry might resemble a many-branched bush more than a lone-trunked tree. Yet which of those limbs had evolved into *Homo sapiens?* Lee Berger was one Society-sponsored anthropologist who dared challenge the "East Side Story"—the hold that East Africa exerted on the imaginings of paleontologists. While exploring a cave system in South Africa in 2008, Berger's nine-year-old son picked up a fossilized collarbone. That led to the recovery of two hominid skeletons several years later; both were just under two million years old. Because he saw these as representing yet another species, Berger named one of them *Australopithecus sediba;* here was the "missing link," he claimed, between *Australopithecus* and *Homo.*

Society members also learned of another intriguing find. In a lush valley of the Caucasus Mountains, archaeologist David Lordkipanidze had tunneled beneath the town of Dmanisi in 2001 and emerged with a fossil skull that one authority, seeing all the consternation it caused, jokingly said "ought to be put back into the ground." At 1.8 million years old, this hominid cranium seemed too old and too apelike to represent *Homo erectus,* our immediate ancestor—and the human species long believed to have been the first to leave Africa. This small-brained *Homo georgicus* (because it was found in the Republic of Georgia) suggested that Eurasia might have shared in cradling mankind.

The knotty story of human origins had one more kink: Working on the Indonesian island of Flores in 2003, Australian anthropologist Mike Morwood and his colleague

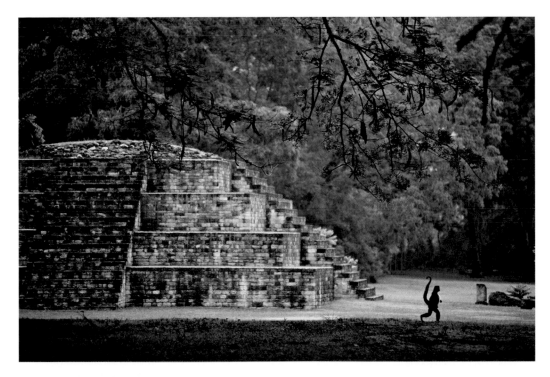

HONDURAS | 1992 Pancho the monkey, long a familiar presence at the ancient Maya city of Copán, strolls across the north plaza. Undiscovered tombs still lie beneath those grassy acres.

Richard Roberts collected the bones of an elfin hominid. This "hobbit," as the Flores find almost inevitably came to be known, stood no taller than a three-year-old child and possessed a skull the size of a grapefruit. Might it represent the survival of *Homo erectus,* or was it a dwarfish *Homo sapiens?* Or could it denote another human species altogether—one Morwood named *Homo floresiensis?*

As experts in early-human origins fell into another kerfuffle, Society-supported studies of that small skull came down on the side of those who favored a new species. The current of paleoanthropology may flow strong, but rarely does it run straight.

TURN LEFT FOR THE TOMB

The tunnel was stifling and so narrow as to be claustrophobic, but National Geographic's George Stuart crawled doggedly on, following archaeologist David Sedat as they wormed their way forward some 50 feet beneath the ancient Maya city of Copán in Honduras. A sharp left-hand turn, and what he saw next, Stuart wrote in the December 1997 *Geographic,* "remains one of the most exhilarating experiences in many years of trying to know the ancient Maya." Lying on a slab and surrounded by funerary offerings were quite likely the earthly remains of Sun-eyed Green Quetzal Macaw, god-king and founder of the Copán dynasty.

Eventually the body of his widow was found nearby, with 10,000 jade beads heaped about her legs. Archaeologists Robert Sharer and Bill Fash had been working in Copán for years, supported by Society grants. Now they found themselves unearthing the first royal tombs discovered in that famous city in a century.

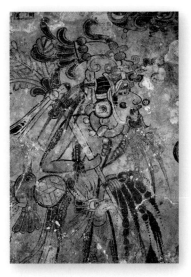

✳ MAYA MASTERPIECE

Scholars had always believed that Maya painting and writing dated only from the seventh century, the middle of that civilization's Classic period (A.D. 250-1000). Yet in 2001 archaeologist William Saturno, working at Guatemala's San Bartolo site, discovered an exquisite mural depicting key scenes in Maya mythology— a mural that predated the Classic period by hundreds of years. "In Western terms, it was like knowing only modern art and then stumbling on a Michelangelo or a Leonardo," says Saturno.

ABOVE: A pre-Columbian mural dated to around A.D. 100 has been dubbed the "Sistine Chapel of the Maya."

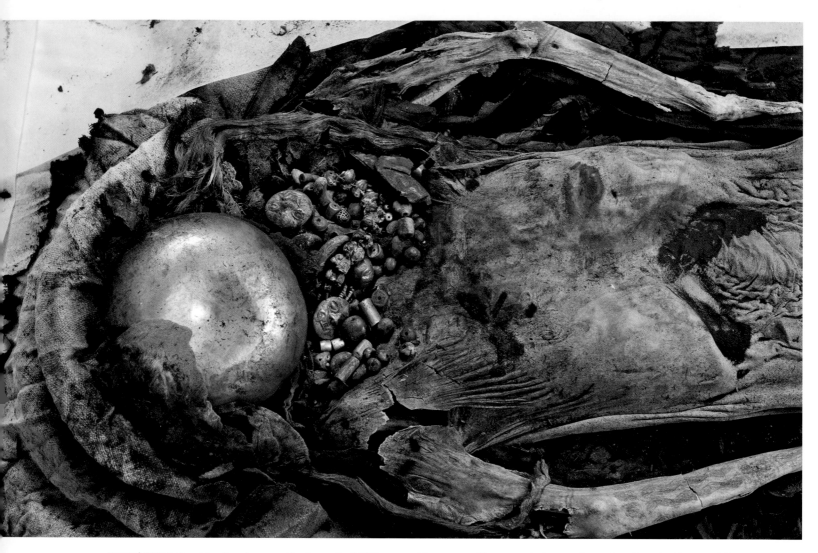

PERU | 2006 A golden bowl covers the face of a 1,500-year-old mummy. The ornately tattooed remains, found with war clubs and spear throwers, add to the puzzle of her authority and status.

▶ BACTRIAN GOLD,
2004

Gold earrings (above) were among 20,000 priceless artifacts from the 1978 "Bactrian hoard" discovered hidden in six safes in Kabul in April 2004. Archaeologist and National Geographic Fellow Fredrik Hiebert aided in cataloging the artifacts and curated the exhibit "Afghanistan: Hidden Treasures from the National Museum, Kabul."

Meanwhile, in the Guatemalan rain forest a few miles east of Copán, Arthur Demarest uncovered the vegetation-cloaked ruins of a major Maya temple at Cancuén. By 2005 his excavations revealed the remains of about four dozen men, women, and children. Many of them still wore jade jewelry and dazzling jaguar-fang necklaces. The group was probably massacred around A.D. 800, Demarest was able to establish. From this he surmised they may have belonged to a ruling family wiped out by conquerors.

In 2002 Peruvian archaeologist Guillermo Cock discovered, beneath the dirt streets of a Lima slum named Puruchuco, thousands of mummies representing a spectrum of ancient Inca society. And at nearby Cerro Cerrillos, an instance of ritual killing 1,300 years earlier was revealed when Dwight Wallace unwrapped a mummy bundle later called the "Feathered Fardo of Cerrillos": Beneath its beaked mask with a red crest and a pair of stylized wings made from 15,000 macaw feathers, Wallace beheld the skeleton of a woman—likely a shaman or healer, and certainly a human sacrifice.

Not long afterward, forensic anthropologist John Verano laid eyes on the mummy recently discovered in a mud-brick Moche-era pyramid in Peru's El Brujo complex. Once the elaborate wrappings—and golden mask covering her face—were removed, Verano gazed upon an exquisitely preserved (and elaborately tattooed) woman, her braided hair still dark a millennium and a half after she died. So amazed was Verano by the sumptuous offerings (including a sacrificed servant) found alongside the woman that he likened her burial chamber to a Peruvian King Tut's tomb.

"We never know what secrets lie hidden below the ancient sands of Egypt," one expert on the real tomb of King Tut told readers of the November 1998 *National Geographic*. The speaker was Zahi Hawass, longtime head of Egypt's Supreme Council of Antiquities and a National Geographic explorer-in-residence. More often than not those secrets were pried from tombs, and the fedora-topped Hawass rarely missed an opportunity to disclose them in print or on film.

A thousand years before Tut was born, a royal tomb was being sealed shut in Umm el-Marra, a caravan city in northern Syria. Some 4,300 years would pass before that seal was broken: In 2000 veteran archaeologist Glenn Schwartz got his first glimpse of the coffins occupied by skeletons of women and babies decked out in silver, gold, and lapis lazuli. From a mound beneath the site Schwartz also excavated a man wearing a silver diadem and another skeleton bearing a silver cup.

Indeed, as the 21st century dawned, even Stonehenge had ceased to be a mere sun temple or astronomical observatory. According to Mike Parker Pearson, digs in the surrounding fields suggested that the enigmatic circle of stone pillars and lintels had once served as an abode for the ancestral dead—and possibly as a place of healing, too. ■

✳ GOSPEL OF JUDAS

An ancient manuscript caused a sensation in 2006 when *National Geographic* published the first English translation of the Gospel of Judas. The early Christian document, lost for 1,700 years, relates how Judas was not Jesus' betrayer but rather his truest disciple—and that Jesus had asked Judas to betray him. The manuscript's champions see the "betrayal" as an act of mercy that restored Jesus to divine status. Others believe that Judas had a baser motive: money.

ABOVE: This papyrus page is one of more than 1,000 fragments making up the Gospel of Judas.

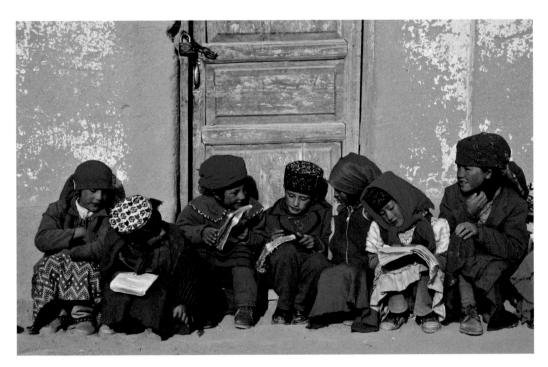

CHINA | 2001 Tajik children in western China prepare for school in a region rich with the archaeological remnants of past civilizations.

DATELINE YUCATÁN PENINSULA

2007 To us they remain a mysterious people, the Maya, whose brilliance must have illuminated Yucatán for 1,000 years. Even so, their crumbled pyramids and ruined cities have been photographed so often that they have become the humdrum fare of travel posters. So Simon Norfolk opted for a new approach—shooting ruins in the dark and lighting them almost like a movie set. That meant hauling equipment into remote sites and hoping that power would be available for the lights. The Maya gods must have smiled on Norfolk: Not only did he capture the rich detail of these masterpieces on film—not on a digital sensor—but a light fog at a few locations added depth and mood to the images. Norfolk says his brand of photography differs radically from that of wildlife photographers, who lie in wait and hope for action they cannot predict. He plans his shots so meticulously that, as with the Maya assignment, "I had a good sense of what the pictures looked like when I took them." ■

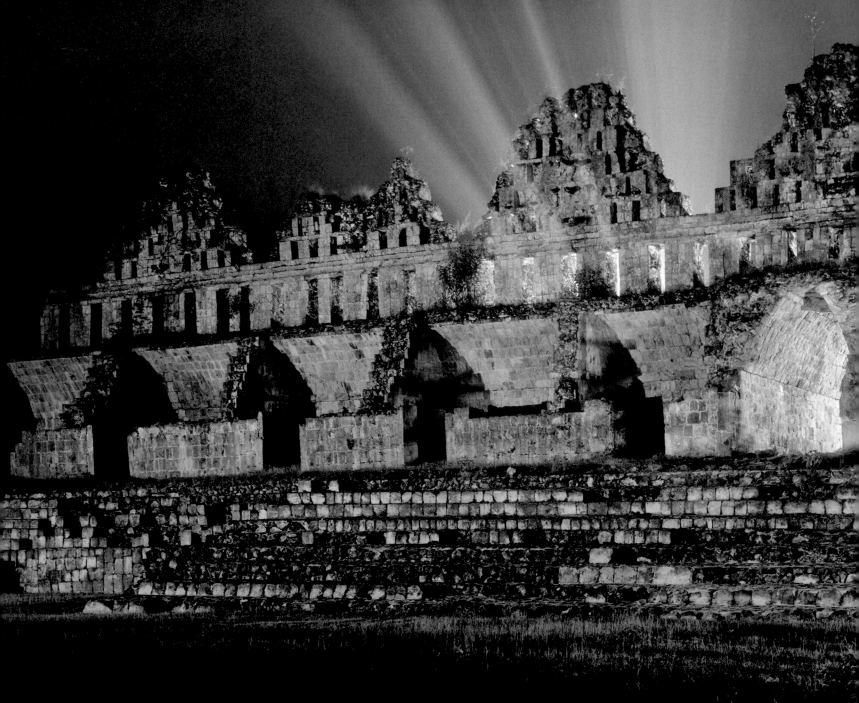

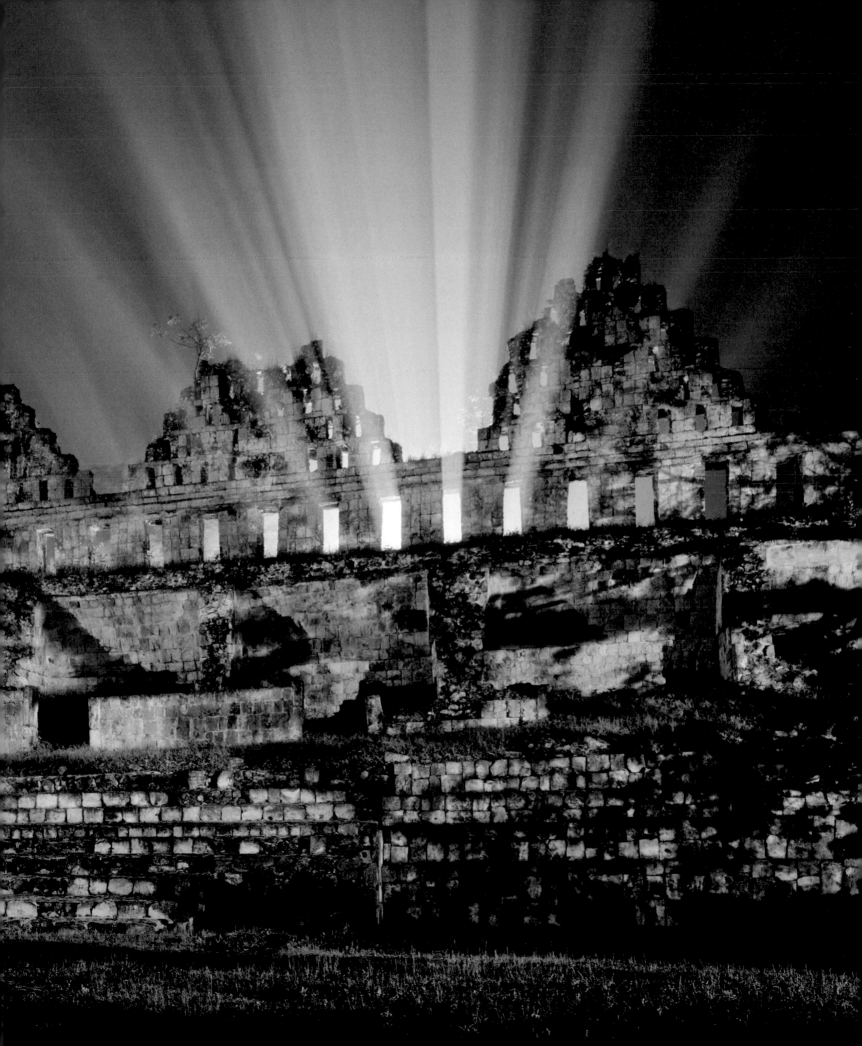

A NEW AGE OF REPTILES

Once the Society got a taste of paleontology, it began supporting dinosaur hunters wherever their digs might take them.

✳ LOCH LACKIN'

Locals blamed the no-show on bad weather, but *National Geographic* writer Virginia Morell found no Loch Ness monster when she investigated the legend in 2005. Neither did *Geographic* photographers Emory Kristof and David Doubilet when in 1976 they rigged automatic cameras in those murky waters—though they did glimpse a lake bed covered with discarded teakettles.

ABOVE: No beast of legend, the 13-foot *Nothosaurus giganteus* was brought to life by computer animation for the 2007 feature film *Sea Monsters*.

"I see paleontology as 'adventure with a purpose,' " says Paul Sereno, a University of Chicago paleontologist and National Geographic explorer-in-residence. Sereno belongs to a breed of upstart dinosaur hunters who in the past quarter century have turned the world of paleontology upside down—sometimes literally, as new finds in South America, Africa, India, and Australia have upended the hold that North American and Eurasian fossils once exerted on science and the popular imagination. But few bone hunters have enjoyed Sereno's string of remarkable successes.

RESURRECTING GARGANTUAN CREATURES

Sereno has been romping in remote corners of the globe since the 1980s. In his formative years he helped classify and name *Eoraptor*, or "dawn stealer," so called because at 230 million years old it lived at the dawn of the dinosaur age. By 1995, working Morocco's Kem Kem beds, Sereno had found most of a skull from *Carcharodontosaurus*, a larger and more fearsome version of *Tyrannosaurus rex*. After that he turned his attention to the regions around Niger's blisteringly hot Ténéré Desert, where rebels and bandits were known to roam.

In these bleak surroundings, Sereno found his mother lode. He was soon extracting from those sand-covered strata two long-necked herbivores—*Jobaria tiguidensis* and *Nigersaurus taqueti*—as well as the carnivore *Afrovenator abakensis*. He also recovered the fish-eating *Suchomimus tenerensis*—*Suchomimus* meaning "crocodile mimic," for this 100-million-year-old fossil with the long snout suggested to Sereno's imagination "a dinosaur trying hard to be a crocodile."

He then found just the opposite in the same formation: a crocodile trying hard to be a dinosaur. Although teeth and fragments of *Sarcosuchus imperator* had been picked up elsewhere in North Africa, no one had ever discovered this much of its skeleton.

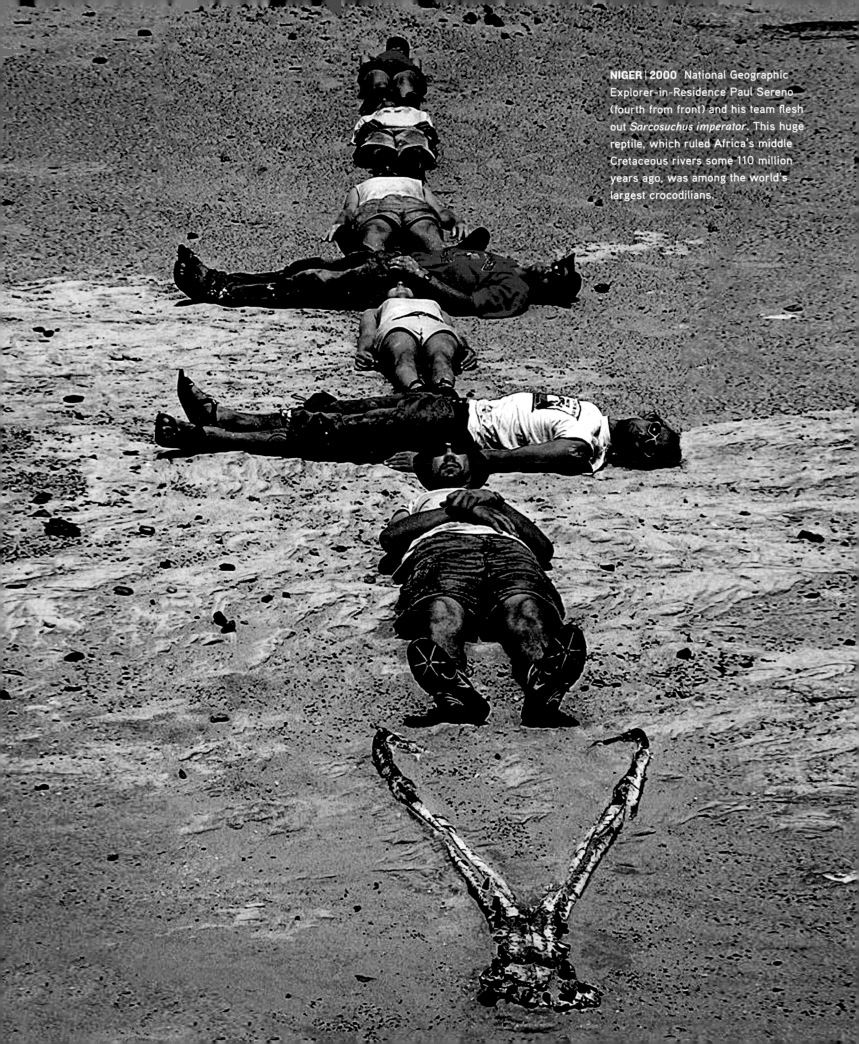

NIGER | 2000 National Geographic Explorer-in-Residence Paul Sereno (fourth from front) and his team flesh out *Sarcosuchus imperator*. This huge reptile, which ruled Africa's middle Cretaceous rivers some 110 million years ago, was among the world's largest crocodilians.

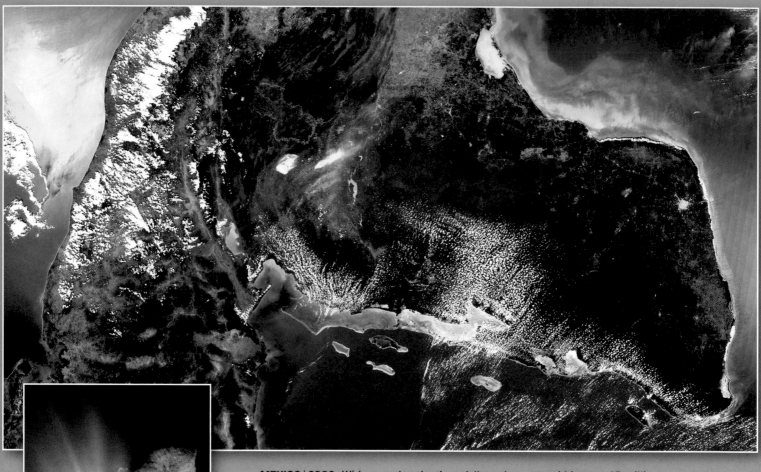

MEXICO | 2000 Widespread extinctions followed an asteroid impact 65 million years ago on the Yucatán coast, just visible in the upper left of this satellite view. To better understand such impacts, NASA studies the flash from its probe colliding with comet Tempel 1 in 2005 (inset).

✛ FIRE AND ICE

Whether it was an asteroid or a comet, whatever hit our planet and gouged out Mexico's Chicxulub crater was probably only six miles in diameter—roughly the size of Manhattan.

Shortly after the National Geographic Society awarded geologist Walter Alvarez a grant to further his investigations of the Italian Apennines in 1975, he noticed something interesting about the strata exposed by a road cut near Gubbio: Between the ancient Cretaceous-era limestone and the Tertiary-era limestone that capped it was a thin sandwich filling of clay infused with the element iridium. When Walter's father got wind of his son's discovery, he became attentive as well: Nobel Prize–winning physicist Luis Alvarez knew that iridium is exceedingly rare on Earth's surface but common on other celestial bodies, notably meteorites—and, presumably, the asteroids that spawn them.

The upshot? A few years later, after similar evidence was found imbedded in the same geologic boundary at various points around the world, father and son propounded an astonishing but now widely accepted theory: The iridium layer represented the fallout from an asteroid's collision with Earth about 65 million years ago—an impact that swathed the globe in iridium-rich dust, wiping out the dinosaurs. ◼

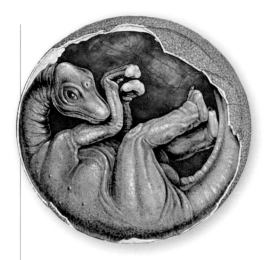

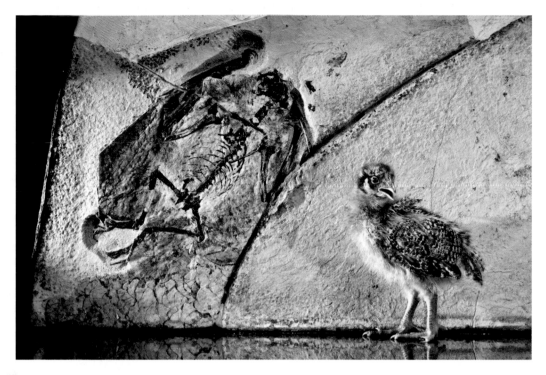

CHINA | 2011 The origin of feathers may reach back to the ancestor of dinosaurs and pterosaurs. These flying reptiles were covered with something like the down on this pheasant chick.

When reassembled, the so-called SuperCroc was all whiplike tail and stony maw—and measured nearly 40 feet long. The reconstituted reptile was exhibited at the Society's Washington headquarters, where it became the cynosure of every eye.

BIRDS OF A FEATHER

By the eve of the 21st century an average of ten new dinosaur species were being uncovered somewhere in the world every year. Because many were excavated on Society supported digs ranging from Argentina to China, a corresponding explosion of images thundered across the pages of *National Geographic*. It was a phantasmagoria of painted dinosauria: Mesozoic heads carapaced or crested or domed, festooned with horns, maned with spikes, and fringed with feathers.

Speculation about feathers, in fact, had been on the wing since the 1970s. After certain fossils found in China showed traces of primitive feathers covering small therapods, or two-legged carnivores, that conjecture reached warp speed. Although more recent discoveries suggest that feathers may actually *predate* dinosaurs, many people now agree with novelist John Updike, who wrote in the December 2007 *Geographic:* "The dinosaurs in their long reign filled every niche several times over, and the smallest of them—the little light-boned therapods scuttling for their lives underfoot—grew feathers and became birds, still singing and dipping all around us. It is an amazing end to an amazing evolutionary story—*Deinonychus* into dove." ∎

✳ DINO SKIN

In 1997 paleontologist Luis Chiappe unearthed exquisitely preserved dinosaur eggs in Patagonia, yielding the first ever fossils of embryonic dinosaur skin. His find allowed Mick Ellison to illustrate an embryo (above) with scaly skin like that of modern lizards. Ten years later, paleontologist Phil Manning discovered an exceptionally well-preserved dinosaur mummy in North Dakota. With soft tissue encased in an envelope of skin, the mummy helped unlock secrets about the evolution of dinosaurs.

ABOVE: Extensive research was required to create this illustration of a Patagonia embryo for the March 1998 *National Geographic*.

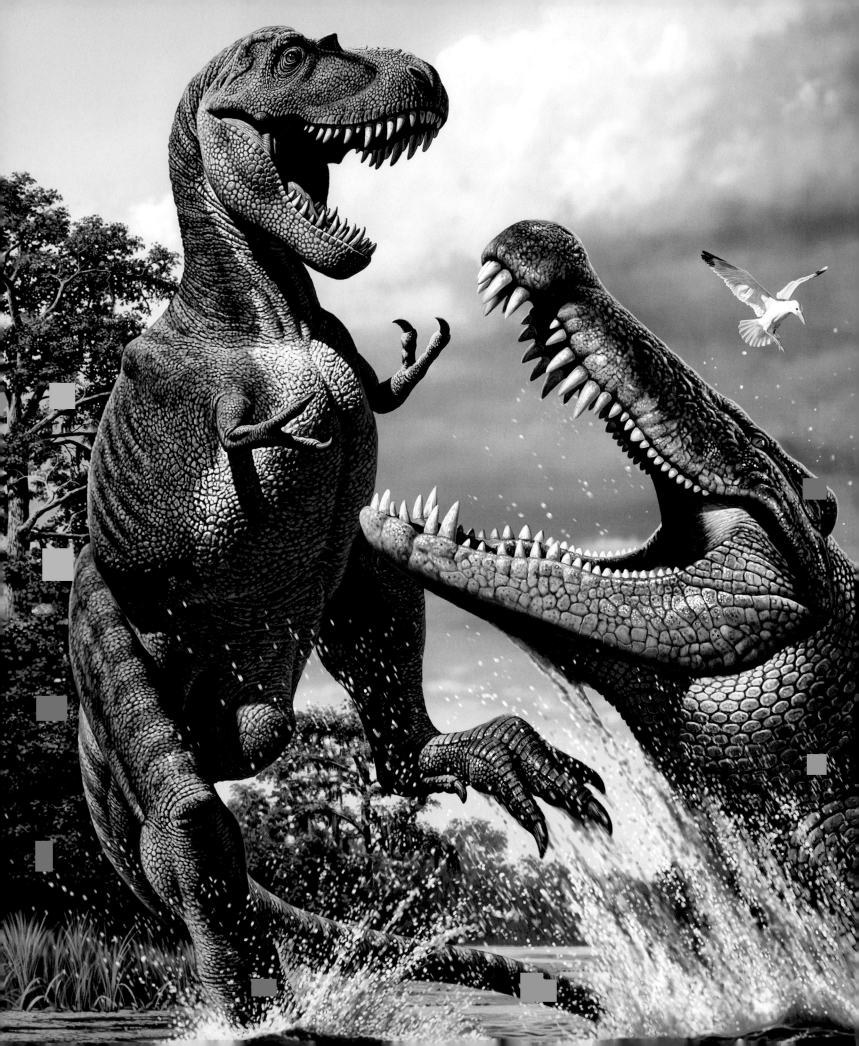

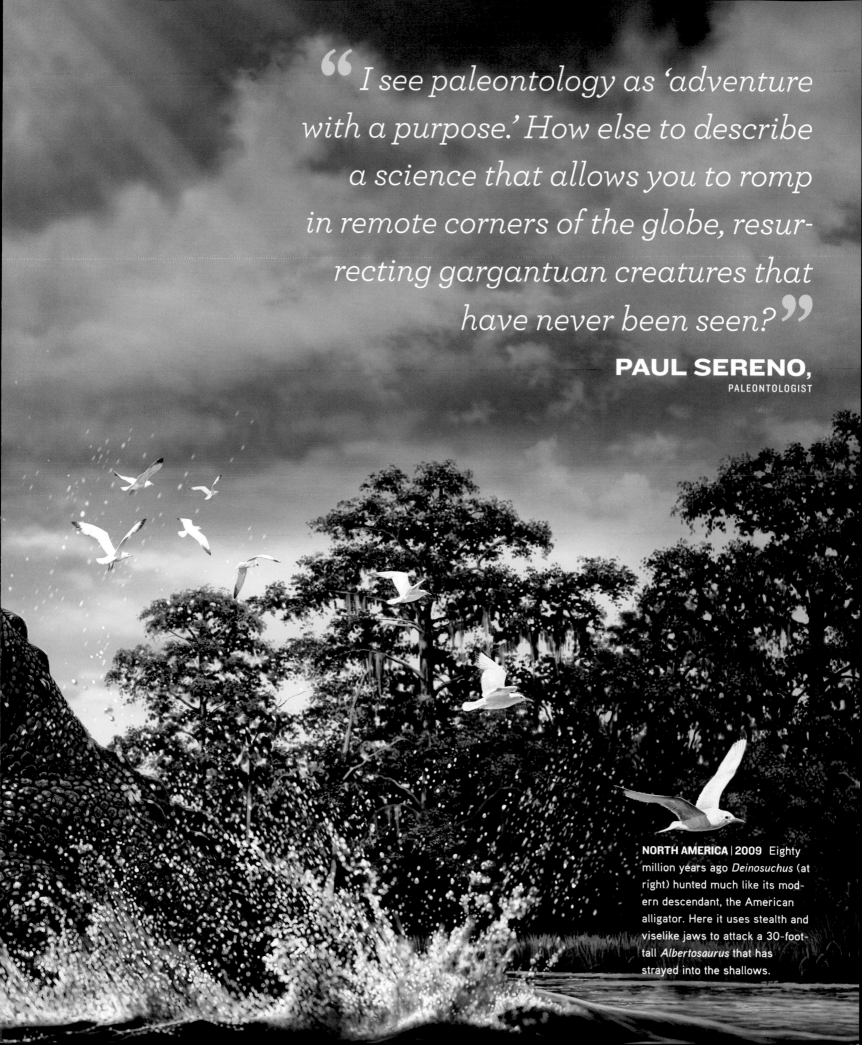

> " *I see paleontology as 'adventure with a purpose.' How else to describe a science that allows you to romp in remote corners of the globe, resurrecting gargantuan creatures that have never been seen?* "

PAUL SERENO,
PALEONTOLOGIST

NORTH AMERICA | 2009 Eighty million years ago *Deinosuchus* (at right) hunted much like its modern descendant, the American alligator. Here it uses stealth and viselike jaws to attack a 30-foot-tall *Albertosaurus* that has strayed into the shallows.

TO SEE THE SEA

New challenges—and new opportunities—are coming into view for the Geographic's latest generation of ocean explorers.

✳ CIVIL WAR SUB

The first submarine to sink an enemy ship, the Confederate Navy's *H. L. Hunley* saw the light of day again on the morning of August 8, 2000, 136 years after it slipped beneath the murky Atlantic. National Geographic co-funded the reclamation effort that dredged it from the depths.

ABOVE: Remains of the *H. L. Hunley*'s nine crewmen were found inside, still manning their posts.

D eeper, ever deeper—like a hero from one of his science-fiction films, Hollywood director turned aquanaut James Cameron piloted his submersible, the *DEEPSEA CHALLENGER*, down through the inky dark. Hunched in his capsule, Cameron sank below the limit where whales can sound. Deeper still he dove—past the two-mile-deep resting place of the *Titanic*, past a point as low as Mount Everest is high, until finally he reached—35,756 feet beneath the surface—the stark desertlike floor of the Challenger Deep, the deepest deep in the deep blue sea.

When the National Geographic explorer-in-residence surfaced several hours later, he had shot plenty of footage for a 3-D film. But the robotic arm on the *DEEPSEA CHALLENGER* had malfunctioned, keeping him from collecting many scientific samples. That lapse aside, March 26, 2012, had been a landmark day for ocean exploration: No one had ventured into the Challenger Deep since 1960. And no one but Cameron had ventured there alone.

Robert Ballard knew a thing or two about technical difficulties at depth. He had been making headlines ever since his 1985 discovery of the *Titanic*. Thanks to strong Society backing, Ballard had located famous wrecks of war—the *Bismarck*, the *Lusitania*, and numerous warships sunk during the 1942 battles for Guadalcanal and Midway. He had even pinpointed the wreckage of John F. Kennedy's *PT-109*, strewn across the seafloor in the Solomon Islands.

Because manned exploration of the deep was so dangerous, Ballard had relied on robotic submersibles to do the bulk of the work. And those vessels conferred benefits beyond mere safety: They could stream images from the abyss to surface ships, and thence via satellite to laptops and televisions the world over. As a result, a much larger population than the fraternity of shore-based scientists was able to monitor deep-sea expeditions: Millions of schoolchildren participating in the JASON Project—Ballard's Society-supported attempt to train a new generation of explorers—were observing

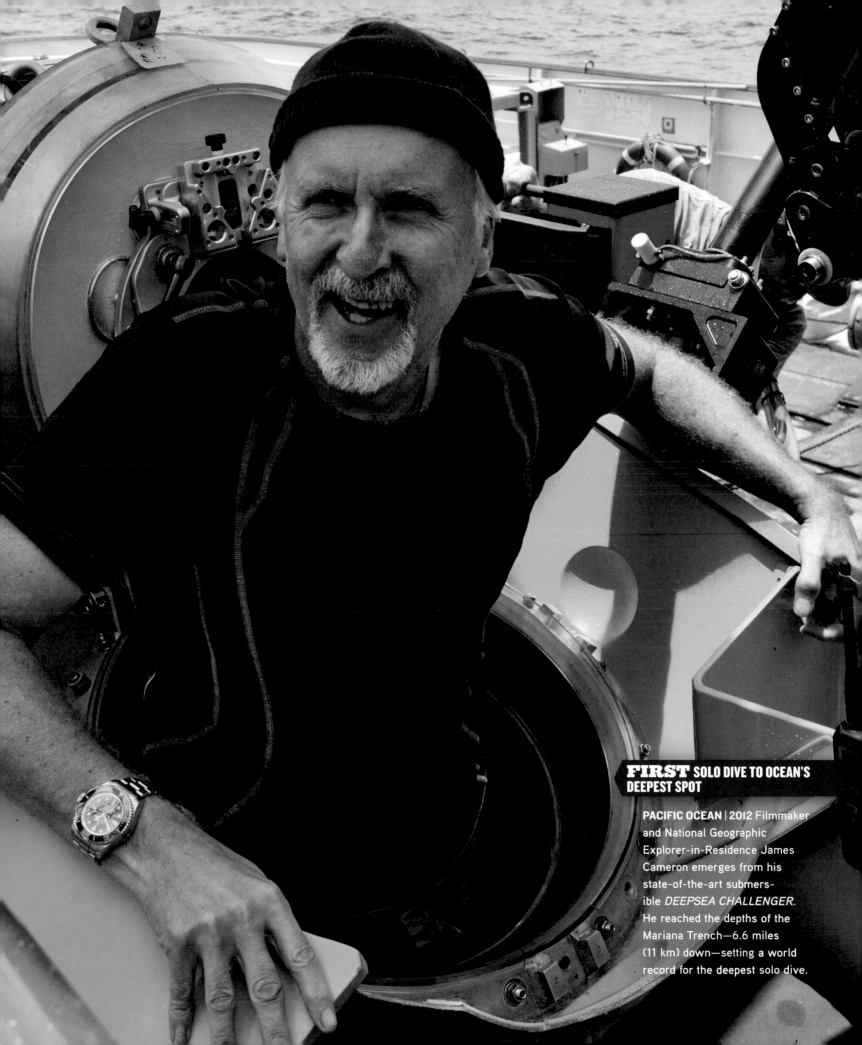

PACIFIC OCEAN | 2012 Filmmaker and National Geographic Explorer-in-Residence James Cameron emerges from his state-of-the-art submersible *DEEPSEA CHALLENGER*. He reached the depths of the Mariana Trench—6.6 miles (11 km) down—setting a world record for the deepest solo dive.

National Geographic
Fellow Barton Seaver
is a chef with a beef:
He writes eco-friendly
cookbooks that urge fish
lovers to expand their
seafood diet beyond the
ten species that con-
stitute 85 percent of
the fish we consume—
the overharvesting of
which is rapidly deplet-
ing the world's oceans.
Alongside explorers-in-
residence such as Sylvia
Earle and Enric Sala,
Seaver is part of the
Society's broad-based
Ocean Initiative, which
strives to replace "race
to the bottom" fishing
practices with sustain-
able alternatives.

ABOVE: The April 2007 *National
Geographic* carried a special three-
part report, "The Global Fish Crisis."

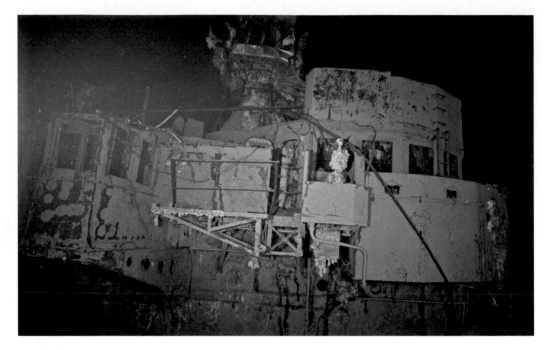

MIDWAY | 1999 World War II's Battle of Midway, fought in June 1942, turned the tide in the Pacific Theater. Fifty-six years later, deep-sea explorer Robert Ballard and a National Geographic team found the U.S.S. *Yorktown* where it had been sunk by Japanese torpedo bombers and the submarine *I-168*.

"more of the Earth's solid surface than all previous generations combined. They will then put at last our knowledge of this ocean planet on a par with that of Mars and of the far side of the moon."

DEEP BLUE TROUBLE

Bringing improved technology to marine science has revealed the ocean's complex impact on the global biosphere. It has also alerted us to an impending crisis. "The oceans are in deep blue trouble," the April 2007 *Geographic* announced. Thanks to mismanagement and overharvesting, global fish stocks had sunk to dangerous lows. Atlantic cod had been annihilated; bluefin tuna were fast disappearing. Such grim statistics were marshaled alongside spectacular images made by Brian Skerry, a Massachusetts native and the latest and most luminous of the *Geographic*'s underwater photographers.

Shark numbers have declined precipitously in the past quarter century. Even great white sharks were threatened, though they were finally showing themselves to be as curious as they were carnivorous, frequently surfacing off Gansbaai, South Africa, to gaze at gawking tourists. There David Doubilet and National Geographic Television's John Bredar deployed metal "seal-cams"—underwater cameras disguised as the sharks' favorite prey. When the pair retrieved the devices, their camouflaged housings were thoroughly raked by shark-tooth punctures.

Whales were likewise at risk. "These are some of the most extreme animals on the entire planet, probably among the most intelligent, and we hardly know a thing about them," researcher Hal Whitehead remarked of deep-diving bottlenose whales in the

HAWAII | 2002 Sand and sea oats meet pristine coral reef on Laysan Island in the 140,000-square-mile Papahānaumokuākea Marine National Monument, an area sacred to native Hawaiians.

August 1998 *Geographic*. Photographer Flip Nicklin plunged so deep into whale studies that he turned scientist himself, co-founding the Whale Trust in 2001. Part of his scientific commitment resulted in productive pairings with writers Doug Chadwick and Kenneth Brower to report for the *Geographic* on orcas, blue whales, and humpbacks. The complex harmonics of humpback songs may have continued to perplex researchers, but no one doubted the creatures' intelligence. One adult whale gently swept the snorkeling Nicklin toward its eye with a fin, Chadwick recounted in the January 2007 issue: "Who's to say this wasn't a case of a fellow big-brained mammal reaching out in wonder and curiosity, as in the electric moments when a chimpanzee or gorilla first touched a researcher's hand?"

UNSPOILED SEAS

Coral reefs—rain forests of the sea—are in serious decline too. The world's most spectacular reefs were once found in the southwestern Pacific, where they surrounded most of the 21,000 islands that lie scattered from Indonesia to New Guinea and the Philippines. These archipelagoes sheltered deep ocean basins such as the Celebes Sea; the heart of global marine biodiversity for eons, it was the site of a 2007 Society-sponsored expedition that discovered numerous previously unknown species. But the surrounding reefs, as David Doubilet and other underwater photographers were

✱ MOLA FISH

Some call it a gigantic swimming head. Others say it's a giant pancake of a fish. Marine biologist Tierney Thys is tagging the little known relative of the puffer to assess the impact of fisheries on the ocean sunfish.

ABOVE: At a weight of two tons and a length up to 13 feet, a mola dwarfs a diver.

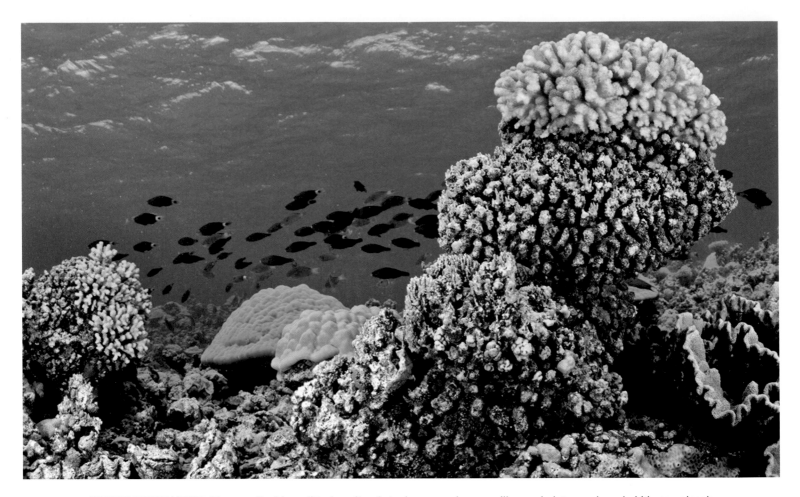

PACIFIC OCEAN | 2007 Kingman Reef is a glittering city of staghorn, mushroom, pillar, and plate corals, cohabiting so closely there's hardly a patch of bare ocean floor.

> " Sharks are everywhere, curiously following divers around, while fast-swimming jacks strike their prey like lightning coming out of the blue. As incredible as it may seem, top predators are so abundant that they account for more than half of the fish biomass; in other words, the Northwest Hawaiian Islands are like an African plain with one lion per wildebeest. "
>
> **ENRIC SALA**,
> EXPLORER-IN-RESIDENCE

discovering, were fast fading away: By the early 21st century, a paltry 10 percent of Indonesia's reefs remained pristine; in the Philippines it was even less than that.

Since scientists had little basis for comparing degraded coral ecosystems with healthy ones, there soon began a global quest to locate and inventory the world's few remaining pristine reefs. Marine biologist Gregory Stone and photographer Paul Nicklen found a few shining examples in the sparsely populated Phoenix Islands, which belonged to the Pacific nation of Kiribati. In these atolls marine life abounded. The sea must have looked this way thousands of years ago, thought Stone. "What we learned in the Phoenix Islands," he wrote in the February 2004 *Geographic*, "may be invaluable to help us understand and even diagnose degraded coral reef systems elsewhere."

Remarkably, in 2008, impoverished Kiribati established a 158,000-square-mile reserve around the Phoenix Islands. Two years earlier, in fact, National Geographic Explorer-in-Residence Sylvia Earle had helped persuade President George W. Bush to enact something similar: the establishment of the Northwestern Hawaiian Islands Marine National Monument (soon renamed the Papahānaumokuākea Marine National Monument). Embracing nearly 140,000 square miles of ocean, seamount, shoal, and island, it was larger than all the lower forty-eight's national parks combined. It provided rookeries for 14 million seabirds, as well as refuges for both the endangered Hawaiian

monk seal and the threatened green sea turtle. Papahānaumokuākea also contained, of course, the nation's most extensive coral reefs, home to some 7,000 marine species, half of which can be found nowhere else.

And numerous sharks, an observation not lost on marine ecologist Enric Sala. Inspired to his calling by watching Jacques Cousteau documentaries as a child in Spain, Sala accompanied a 2005–06 Scripps Institution of Oceanography expedition to the Line Islands—specks strewn across the Pacific 1,000 miles south of Hawaii—where he spent several weeks collecting data on creatures ranging from groupers to microbes. Kingman Reef in particular was so untouched that few if any divers had been there. Curious red snappers tugged at Sala's ponytail, cameras, and strobes.

And there were sharks all around—which happens to be a good thing, because sharks denote healthy reefs. That meant it was imperative to establish marine reserves large enough to include healthy populations of predators. Sala therefore set out to identify such places and protect them. His work helped engender the Society's Pristine Seas initiative—and got Sala appointed an explorer-in-residence. Not only has he returned to the Line Islands, documenting the healthiest reefs there with photographer Brian Skerry and a Geographic television crew, but he has also worked with the Chilean government to establish the 15,000-square-kilometer Motu Motiro Hiva Marine Park around the uninhabited island of Salas y Gómez. He has also negotiated with Costa Rican authorities to create a 10,000 square kilometer Seamounts Marine Management Area around Cocos Island.

Perhaps Sylvia Earle said it best. There will never be a better time than *right now,* she believes, "to explore and protect the natural ocean systems that provide the underpinnings needed for a sustainable future on this ocean planet." ■

✳ ENGAGED EXPLORATION

Getting up close and personal with marine life in the world's remote regions is all in a day's work for marine biologists. Aboard National Geographic/Lindblad Expeditions ships, travelers join forces with scientists for real-time scientific discovery. Passengers aboard the *Explorer* with NOAA's Robert Pitman and John Durban, for example, were on hand when the pair realized that a group of killer whales in Antarctic waters included two distinct types, and possibly even two distinct species. While one feeds mainly on seals, the other dives deep for fish.

ABOVE: More than a pleasure cruise, National Geographic/Lindblad Expeditions ships ply the seas bristling with high-tech research gear.

PACIFIC OCEAN | 2008 Wary of being eaten, a brightly colored combtooth blenny, just a few inches long, peers from the safety of its coral hideaway on Kingman Reef in the North Pacific.

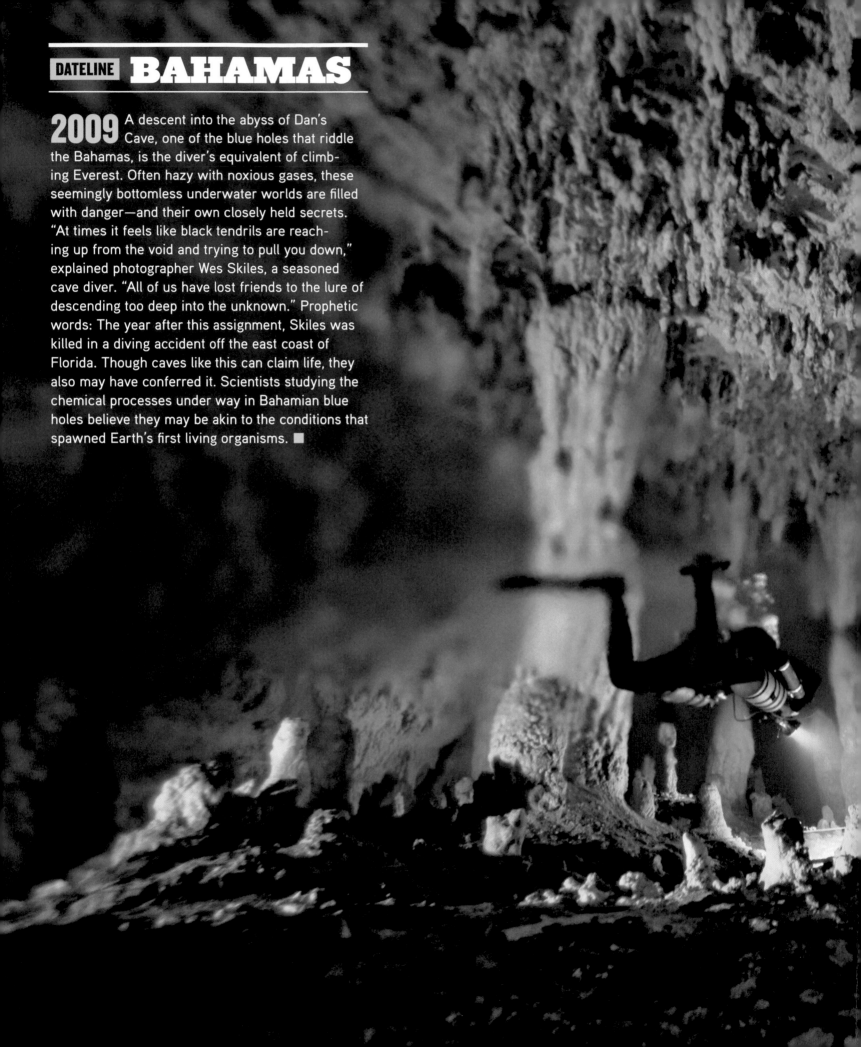

DATELINE **BAHAMAS**

2009 A descent into the abyss of Dan's Cave, one of the blue holes that riddle the Bahamas, is the diver's equivalent of climbing Everest. Often hazy with noxious gases, these seemingly bottomless underwater worlds are filled with danger—and their own closely held secrets. "At times it feels like black tendrils are reaching up from the void and trying to pull you down," explained photographer Wes Skiles, a seasoned cave diver. "All of us have lost friends to the lure of descending too deep into the unknown." Prophetic words: The year after this assignment, Skiles was killed in a diving accident off the east coast of Florida. Though caves like this can claim life, they also may have conferred it. Scientists studying the chemical processes under way in Bahamian blue holes believe they may be akin to the conditions that spawned Earth's first living organisms. ■

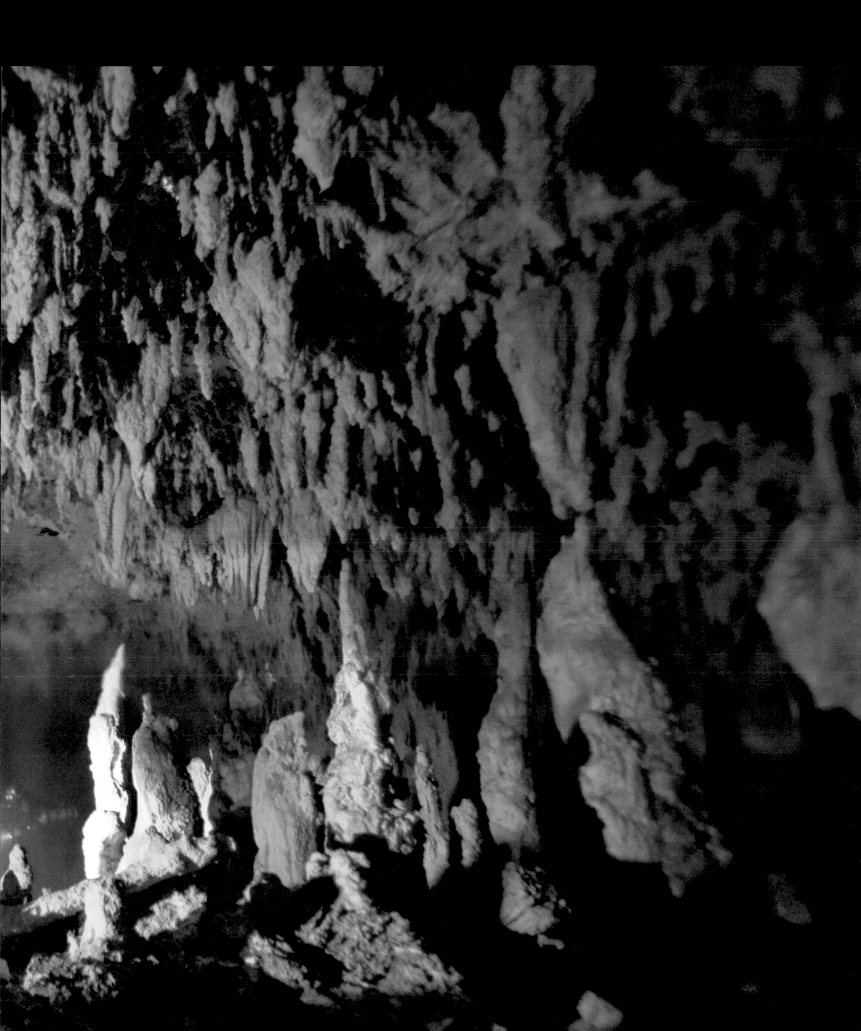

EXTENDING THE REACH

Above and beyond are still watchwords for the 21st-century National Geographic Society.

⊛ THE "POLISH OPRAH"

Author, economist, television personality, race-car driver: *National Geographic–Poland*'s **Editor in Chief Martyna Wojciechowska completed the famous Dakar Rally in 2002. Her driving passion, however, is mountains. She has climbed the highest peaks on each of the world's seven continents.**

ABOVE: *A Woman on the Edge of the World* is her hit TV show, but *National Geographic–Poland*'s Editor in Chief also is in the center of life, and everywhere.

Climbers now compete to set records as the youngest, the oldest, the fastest on Everest," cinematographer and veteran mountaineer David Breashears wrote in the September 1997 issue of *National Geographic*. It was no idle lament: Breashears had personally recovered several bodies from those unforgiving slopes. But there was no stopping those fixated on extending their reach, even if the goal might exceed their grasp.

Climbers have always been a part of the National Geographic story. Breashears and Ed Viesturs—the first American to summit all 14 of the world's 8,000-meter peaks, a feat first accomplished by *National Geographic Adventure* stalwart Reinhold Messner in 1986—were simply members of the newest generation to dangle from ropes somewhere in the Society's publications or films.

Readers of the February 1998 *Geographic,* for instance, marveled at the soaring ice-capped mountains of Antarctica's Queen Maud Land. Among the antlike figures scaling the sheer granite spike called Rakekniven—the Razor—was author Jon Krakauer, alpinist Alex Lowe (a godlike figure to most climbers), and team leader Gordon Wiltsie, whom Lowe described as the "most adventurous adventure photographer in the business." Eighteen months later, Lowe was killed by a Himalayan avalanche. In 2002 another pioneer of peak and piton, longtime *Geographic* contributor Galen Rowell, died in a plane crash in California.

Norwegian Børge Ousland was another who looked death squarely in its icy eye. He had been the first man to trek alone to both Poles, in 1997 and 2005, respectively. In 2006, alongside South African Mike Horn, Ousland also became one of the first two men to reach 90° north in the dark depths of a midwinter Arctic night. No dogs, no motors, no resupply—Horn and Ousland sledged, skied, and swam the 1,200 miles from Russia. (That's right, swam: Their buoyant dry suits gave them a polar bear's advantage no previous explorer had enjoyed.)

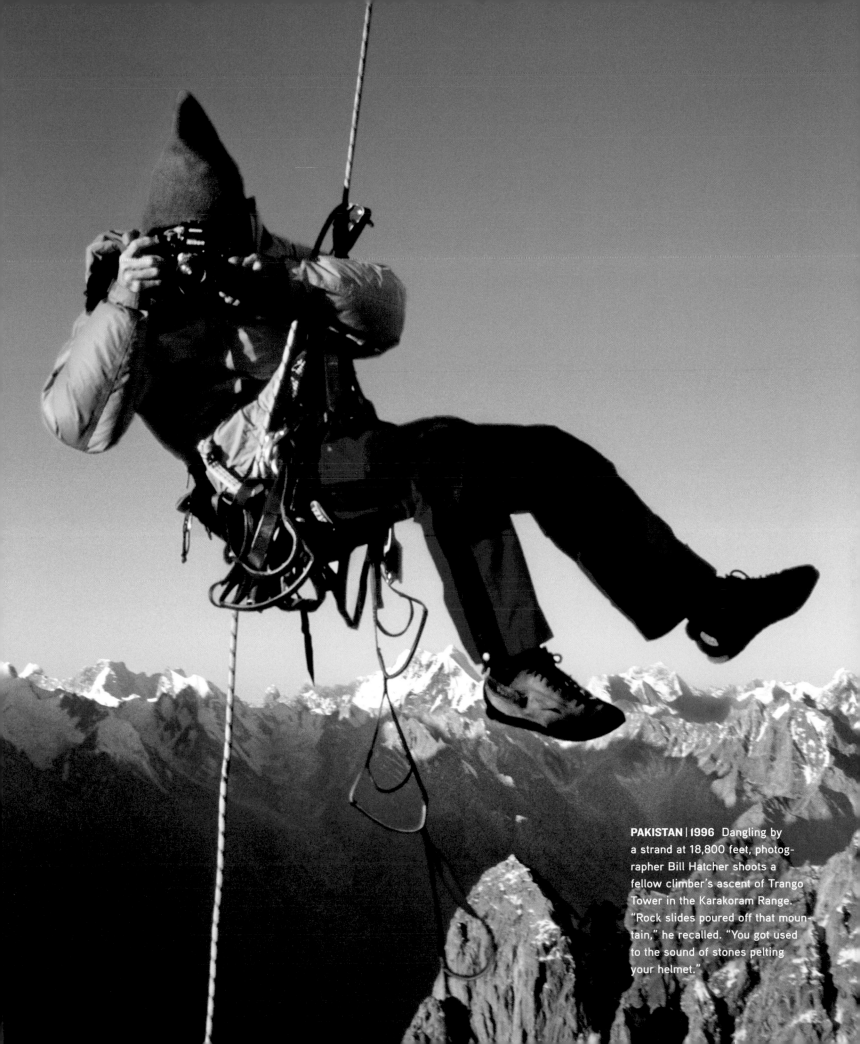

PAKISTAN | 1996 Dangling by a strand at 18,800 feet, photographer Bill Hatcher shoots a fellow climber's ascent of Trango Tower in the Karakoram Range. "Rock slides poured off that mountain," he recalled. "You got used to the sound of stones pelting your helmet."

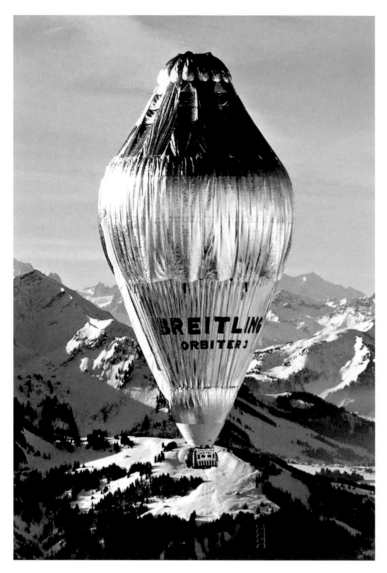

SWISS ALPS | 1999 The *Breitling Orbiter 3,* piloted by Bertrand Piccard and Brian Jones, completed the first nonstop round-the-world balloon flight.

JOURNEY TO THE CENTER OF THE EARTH

When risking death, one can always choose fire instead of ice. That's what German photographer Carsten Peter does whenever a volcano awakens somewhere in the world. Dressed in a heatproof suit, he has climbed over the rims of craters and edged down toward their fiery bubbling centers all over the globe. Peter was perched on the slopes of Sicily's Etna, for example, when it erupted in the summer of 2001. Six years later, he watched in awe as lava fountains from Tanzania's Ol Doinyo Lengai hardened to crystal in midair.

Photographer Stephen Alvarez winds up beneath the surface, where the world's labyrinth of underground caves is now being called the "eighth continent." To serious spelunkers, the journey toward the center of the Earth—tracing Krubera Cave's meandering passages, say, through the limestone bedrock buttressing the Caucasus Mountains—is mountain climbing upside down: Pursuing an ever lower "bottom of the world" record, you establish your base camp as deep as you can get it on an initial foray beneath the crust. Then you ease deeper, and still deeper, into the bowels of the unmapped interior.

EVERYWHERE AT ALL TIMES

Responding to this clamorous era of mass media, the National Geographic Society has also been extending its reach, taking steps to connect with its increasingly international audience. In 1995 a Japanese-language edition of *National Geographic* was unveiled. Shortly afterward, Spanish-language editions appeared in Europe and Latin America. Encouraged by reader response, the magazine

INTERNATIONAL EDITIONS

These covers show an issue devoted to water as it appeared on news-stands around the world.

U.S. Launched 1888

BRAZIL Launched 2000

CHINA Launched 2007

FINLAND Launched 2001

FRANCE Launched 1999

GREECE Launched 1998

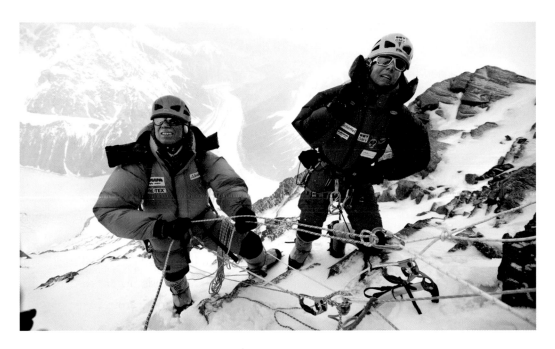

KARAKORAM RANGE | 2011 Gerlinde Kaltenbrunner (right) and a fellow expeditioner study the route up K2. She became the first woman to climb all 14 of the world's 8,000-meter peaks without oxygen.

began extending its yellow border beyond other borders in earnest. Today 36 local-language editions are published each month. A decade into the new millennium, one in four copies of the magazine was being printed in a language other than English.

Complementing the international shift in its print journal, in June 1996 a Society task force, subsisting for weeks on caffeine and pizza, launched *nationalgeographic.com*. Today it logs nearly 20 million visitors a month; there are nearly as many Facebook friends.

One year after that digital debut came the first stage in the realization of a long-held dream when the National Geographic Channel premiered in Europe, Asia, and Australia. In 2001 the channel began airing in the United States as well. Today it is beamed in 37 languages to some 435 million households in 173 countries worldwide. By its own reckoning, the Society reaches hundreds of millions of people a month, diffusing its brand of geographic knowledge around the clock as well as around the globe. ■

✳ NATIONAL GEO-GRAPHIC EXPLORER

National Geographic Explorer, which debuted in 1985, is currently the longest running documentary series on cable television. "Part of the adventure is being able to do it," reflects long-time host Boyd Matson, "and part is being able to do it with some of the best people in the field because I work for National Geographic."

ABOVE: Intrepid journalist Boyd Matson took viewers on *Explorer* adventures from 1993 to 2002.

▶ **ISRAEL** Launched 1998

▶ **JAPAN** Launched 1995

▶ **LITHUANIA** Launched 2009

▶ **SLOVENIA** Launched 2006

▶ **SPAIN** Launched 1997

▶ **THAILAND** Launched 2001

▶ **TURKEY** Launched 2000

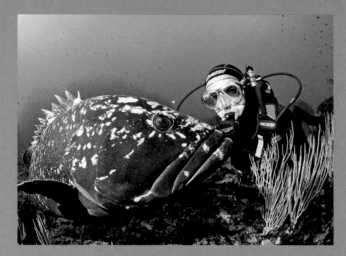

EXPLORERS *This is what it's all about: Every one of National Geographic's publications, products, and films generates funding for the Society's Mission programs, especially those devoted to furthering education, exploration, and scientific discovery.* ▲

GAME ON *Escape a witch hunt in Salem. Discover the secrets of Julius Caesar's assassination. National Geographic games are available as downloads, mobile apps, or online.* ▼

In the early 1980s, a young man with a vision walked into the Geographic's Washington, D.C., headquarters. The age of cable television was dawning, and Tim Kelly urged the Society to consider launching its own documentary channel. The Colorado native, who had grown up hiking and camping in the great outdoors, believed that such a platform could showcase the Geographic's unrivaled science and natural history programming.

His persistence paid off. Today Kelly is the Society's President, and the National Geographic Channels—which include Nat Geo Wild, Nat Geo Music, Nat Geo Adventure, the Spanish language network Nat Geo Mundo, as well as the flagship National Geographic Channel—are helping fuel the Society's international growth. They spearhead a dizzying array of magazines, Web pages, games, music, books, DVDs, maps, exhibitions, feature films, and live events that together reach over 400 million people worldwide every month—all generating support for the Society's programs in exploration, conservation, and education. ■

Lost Chronicles: Fall of Caesar
Discover the Conspiracy Behind Caesar's Murder

WILD AND WONDERFUL *The best-selling* Weird but True *series is among 100 titles that National Geographic Children's Books publishes each year.* ▼◀

THE BEE Jeopardy! *host Alex Trebek has moderated the National Geographic Bee since 1989.* ▶

FUN-FILLED KIDS
NG Kids *and* NG Little Kids *magazines open a world of adventure for children.* ▼

◀ **GEAR TO GO**
From boots to binoculars and from books to beaded jewelry, National Geographic's online store and catalog sell field-tested gear, educational products, and gifts.

◂ BOOKS

Atlases, travel guides, field guides, and photography and gift books offer a tome for every taste.

▾ NG.COM

Daily news, blogs, exclusive video, and photographs are on offer at nationalgeographic.com

NG TRAVELER ▸

National Geographic Traveler celebrates place, experience, culture, authenticity, and great photography.

◂ EXPEDITIONS

Led by National Geographic expert guides, National Geographic Expeditions offer unique travel experiences on every continent.

◂ EXHIBITIONS

National Geographic hosts exhibits at its Washington, D.C., headquarters, such as China's terra-cotta warriors as well as traveling exhibits.

▸ NG CHANNEL

Putting the wide world on a small screen has yielded popular series such as Dog Whisperer and Locked Up Abroad, as well as major international television events such as 2012's Untamed Americas.

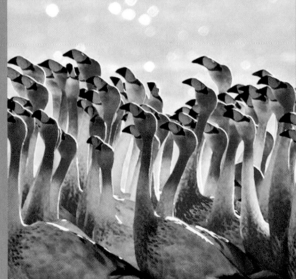

▴ FANTASTIC FILMS

From Academy Award nominees to multimedia extravaganzas such as U2 3D, large-format films bring the quest for adventure to the big screen.

▸ MAPS

National Geographic has a map for every need, from educational globes to write-on/wipe-off maps to high-tech map and atlas software, notably the TOPO! series.

◂ STORES

With lectures, performances, and exhibits and an array of products on offer from around the globe, National Geographic stores invite you to shop—and to learn.

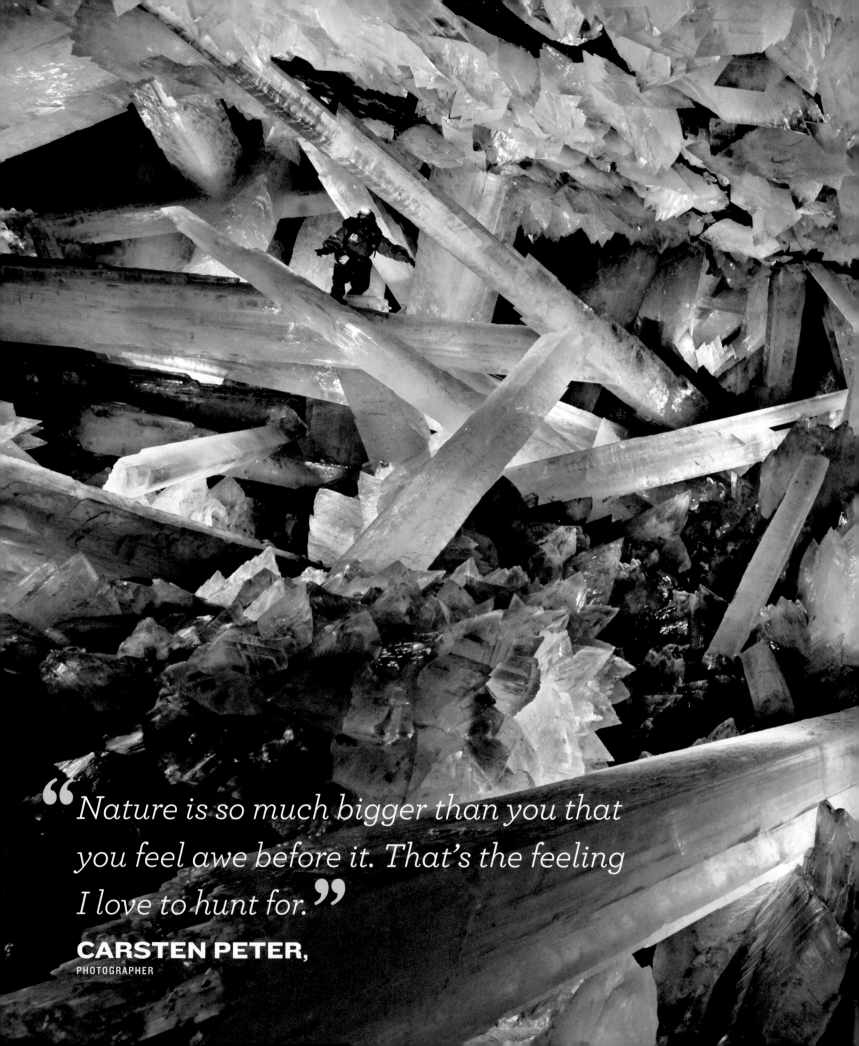

"Nature is so much bigger than you that you feel awe before it. That's the feeling I love to hunt for."

CARSTEN PETER,
PHOTOGRAPHER

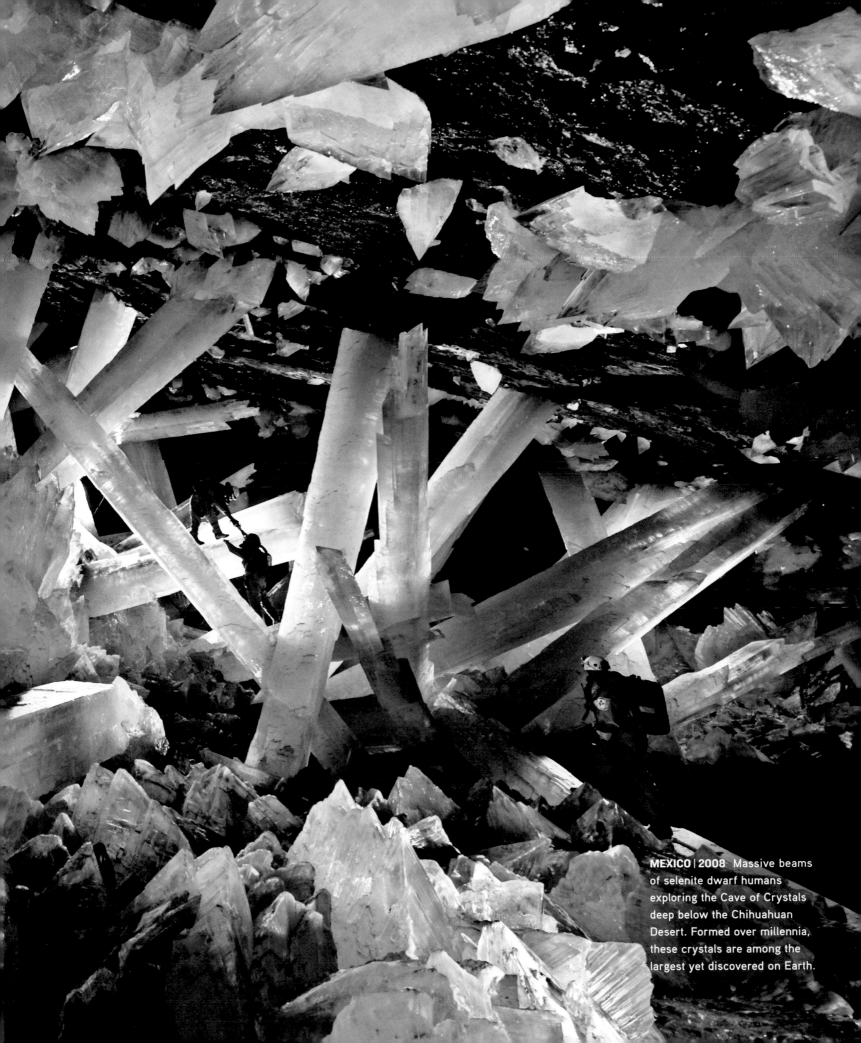

MEXICO | 2008 Massive beams
of selenite dwarf humans
exploring the Cave of Crystals
deep below the Chihuahuan
Desert. Formed over millennia,
these crystals are among the
largest yet discovered on Earth.

SUBJECTS THAT MATTER

At the Society's flagship magazine, a commitment to honest reporting
—through fresh perspectives—has never been stronger.

✳ TWO KIDS AND A CAMEL

Having worked in more than 100 countries, Annie Griffiths didn't let the births of her two children slow her down. She simply packed her camera gear in diapers and carried both kids and career on her far-flung assignments, remaining a hands-on mom despite her peripatetic lifestyle.

ABOVE: In 2008 Griffiths published *A Camera, Two Kids and a Camel,* a memoir about creating a meaningful life.

When on the night of May 9, 2011, *National Geographic*'s Editor in Chief, Chris Johns, stepped up to a Manhattan dais to accept the National Magazine Award for General Excellence, it marked the sixth time—and the third instance in the five years Johns had been in charge—that the Society's journal had won the industry's highest honor.

His predecessor in the post, William L. Allen, had also collected a shelf full of prizes during the ten years (1995–2005) that he took on complex and controversial topics. Announcing Allen's retirement and Johns's promotion in the pages of the March 2005 issue, the Society's President, John Fahey, had emphasized continuity, stating that a "fresh perspective and good stories about subjects that matter can truly change the world for the better."

The new Editor concurred. Johns had begun his own journalism career as a photographer, having shot 8 cover stories out of his 20 assignments. He knew that the magazine could be only as good as its contributors—contributors dedicated to changing the world for the better.

YEARS OF LIVING DANGEROUSLY

The imperative to get the story often places *Geographic* journalists in rapidly changing landscapes of civil unrest, toppled regimes—even war. As the *Geographic* tracked the unsettled post–Cold War world of Central and Eastern Europe, it relied on German-born Gerd Ludwig to document the scene. As it bore witness to events set in motion by 9/11, the magazine increasingly turned to journalists with entrée to the Islamic world. Steve McCurry's assignments inevitably circled back to Afghanistan. There, in 2002, his 17-year quest for the girl with the haunting eyes culminated when, with the assistance of a National Geographic television crew, he finally greeted

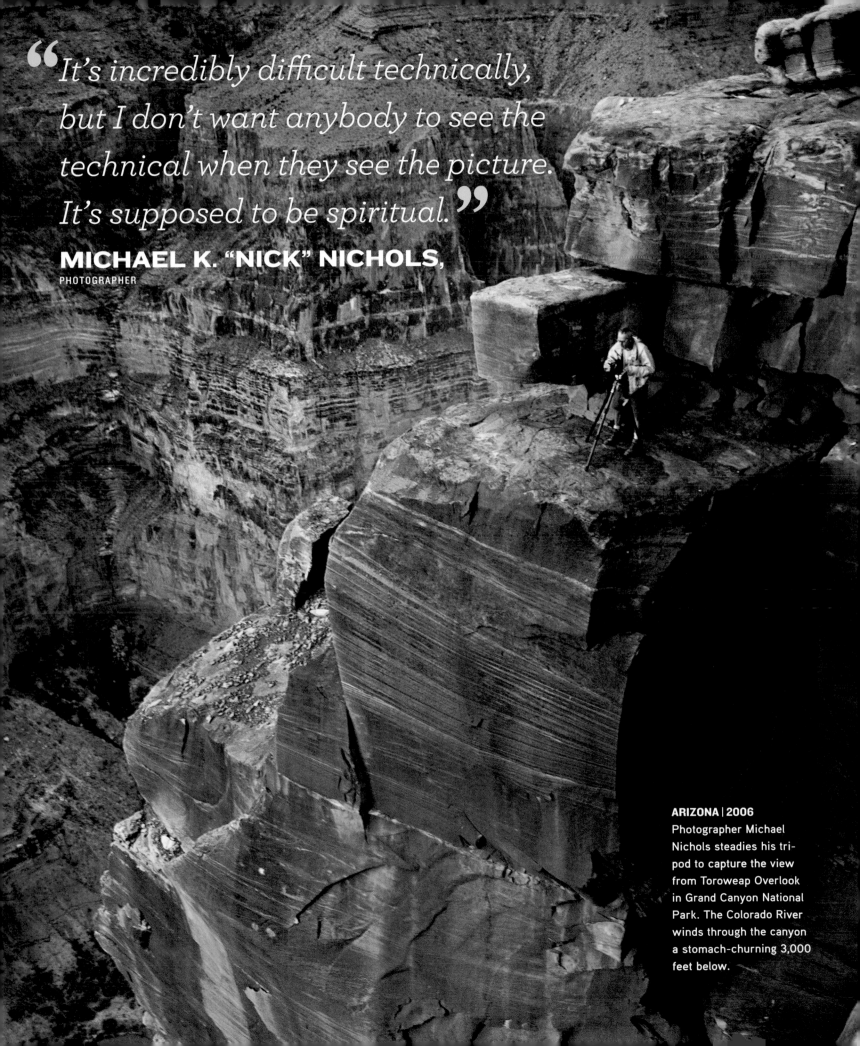

> "*It's incredibly difficult technically, but I don't want anybody to see the technical when they see the picture. It's supposed to be spiritual.*"
> **MICHAEL K. "NICK" NICHOLS,**
> PHOTOGRAPHER

ARIZONA | 2006
Photographer Michael Nichols steadies his tripod to capture the view from Toroweap Overlook in Grand Canyon National Park. The Colorado River winds through the canyon a stomach-churning 3,000 feet below.

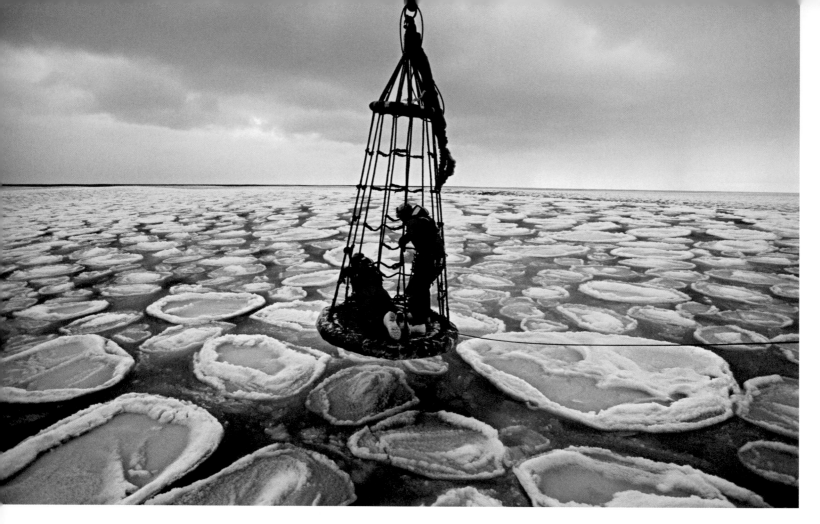

SOUTHERN OCEAN | 1996 Photographer Maria Stenzel captured this image of scientists fishing for secrets locked inside Antarctica's winter sea ice. Today on specially equipped ice-breaking vessels, researchers explore icescapes more complex—and flowing with life—than previously thought possible.

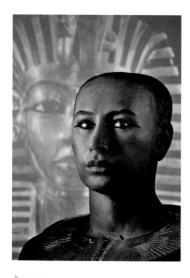

▶ **EGYPT, 2005**
A Geographic-financed forensic reconstruction of Tutankhamun put a face on King Tut.

Sharbat Gula by name. The story of her discovery made headlines around the globe.

Reza, a Paris-based, Iranian-born photographer whose connections have opened doors all over the Middle East, persuaded Colonel Qaddafi to grant the *Geographic* unprecedented access to Libya for a 2000 story. Alexandra Boulat posed as a refugee to obtain her searing depiction of the Kosovo war, also published in 2000. She died in 2007 of a brain aneurysm suffered while on assignment in Ramallah.

During the Iraq war, staff writer Neil Shea and freelance photographer James Nachtwey were embedded with U.S. forces. Their prizewinning December 2006 article on wounded American soldiers was shot in stark black-and-white. As Iraq tipped into chaos, photojournalist Ed Kashi revisited Iraqi Kurdistan, the subject of his first *Geographic* coverage in 1990.

While covering the African Sahel for the April 2008 issue, writer Paul Salopek was caught trespassing into Darfur and spent months in a Sudanese jail. He was ultimately released unharmed. Pascal Maitre, his colleague and the photographer on the Sahel assignment, went on to win a National Magazine Award for a subsequent article: "Shattered Somalia." Lynsey Addario, who has been kidnapped twice on assignment for other publications, fortunately covered "Veiled Rebellion: Afghan Women" without incident and went on to win an Overseas Press Club award for the story.

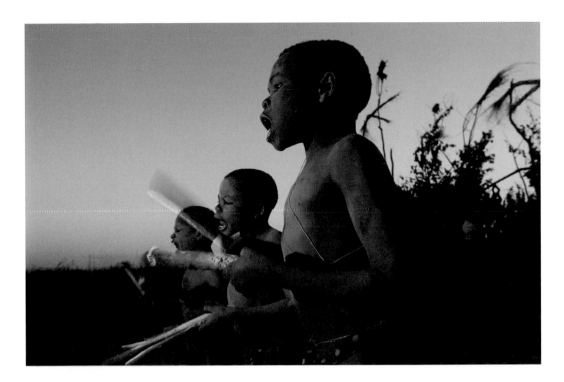

ZAMBIA | 1996 Boys of the Luvale tribe greet the dawn with traditional songs and drumming in the village of Lukulu on the upper Zambezi River. The photographer, Chris Johns, became Editor in Chief of the magazine in 2005.

PHOTOJOURNALISM UNBOUND

Meanwhile, Jodi Cobb found ways to depict subtle subjects like the enigma of beauty and the nature of love, and entered rougher territory in a September 2003 story on 21st-century slavery. In July 2004 Chilean photographer Carlos Villalon produced a prizewinning look at how the cocaine trade had permeated all corners of Colombian life, which was followed nine months later by Meredith Davenport's pictures of the murderous barrios of Medellín.

Lynn Johnson, who often turns her lens on the shadow lands of the human condition, photographed articles on the threat of worldwide pandemics, weapons of mass destruction, and land mines. John Stanmeyer's story on malaria won a 2008 National Magazine Award, and Peter Essick's photographs for a September 2004 article pointedly called "Global Warning" were discussed on the morning talk shows, while his work for a 2002 story on nuclear waste won first prize at the World Press Photos competition. The medical beat has been well represented by Karen Kasmauski's stories on aging, AIDS, obesity, and viruses.

Joe McNally brought a high-tech sensibility to stories on flight, the sense of sight, and the power of light, while the unexpected viewpoint is epitomized by George Steinmetz, who habitually photographs deserts from the vantage of his motorized paraglider.

In addition to its breadth of subject matter, the magazine has excelled at depth of coverage as well. Cary Wolinsky visited four continents to photograph an investigative piece on the illicit diamond trade. Other investigative forays include a piece on

✳ CHOMPER VS. CHOPPER

When this photo made the online rounds in 2001, the e-mail containing the image claimed it had been nominated as National Geographic's "Photo of the Year." People flocked to the Society's website, only to learn they'd been punked: The photo was a clever fake—a composite image of an Air Force helicopter and a breaching shark.

ABOVE: A digital prankster composed this impossibly compelling picture.

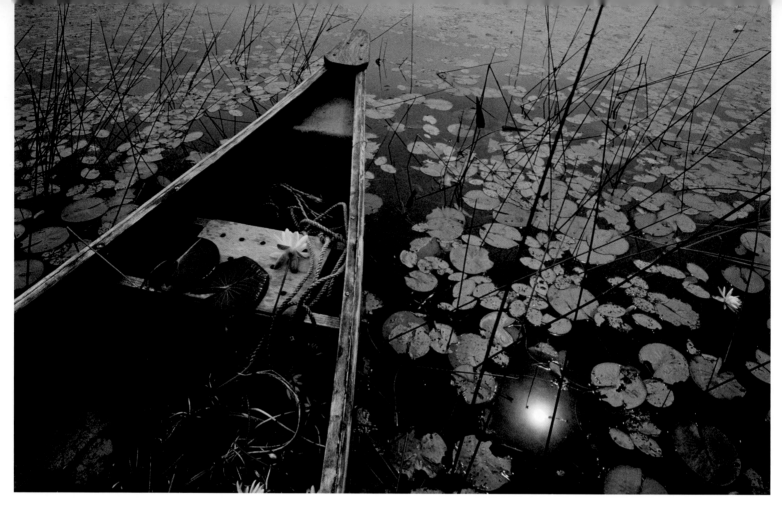

MAINE | 2000 Lynn Johnson captured a tranquil tangle of water lilies in a Maine pond for the article "Nature's Rx."

▶ **PAKISTAN, 2000**
Randy Olson shot this cover image of a hunter using an egret headdress to stalk birds along the Indus River near Moenjo Daro. Such hunting methods date to civilizations that flourished in the Indus Valley 5,000 years ago.

the Virunga gorillas by photographer Brent Stirton and writer Mark Jenkins, and the Asian wildlife trade by photographer Mark Leong and writer Bryan Christy. The latter stimulated a vigorous public dialogue on wildlife crime in Southeast Asia.

In the past few years, a younger generation has placed their imprimatur on the magazine—Carolyn Drake on the Uygurs of China's far west in December 2009; Jonas Bendiksen and his compassionate images of Bangladesh in May 2011; Aaron Huey and his moving portraits of the lives of Oglala Lakota on Pine Ridge Reservation in August 2012; Stephanie Sinclair and her "Polygamists" story published in 2010, and her 2011 story on child brides.

Even so, veterans like David Alan Harvey and William Albert Allard continue to give magazine readers the benefit of their experienced eye: Harvey with his 2012 story on Rio de Janeiro, Allard with his moving portrait of Hutterite life in Montana in 2006.

As spectacular as the photography is, sometimes the visuals call for a different approach. In recent years, the magazine has broadened its capacity to create maps and infographics with the help of Art Director Juan Velasco and staff artist Fernando Baptista, whose muscular portrait of an African lion stalked the December 2011 "Cats in Crisis" story. Baptista was also the driving force behind a *National Geographic* iPad special—an animated video of the Easter Island statues for July 2012. In November 2012 subscribers to the app were treated to a unique video—a slow-motion shot of the fastest sprinter on the planet—a cheetah, shot with a Phantom high-definition digital

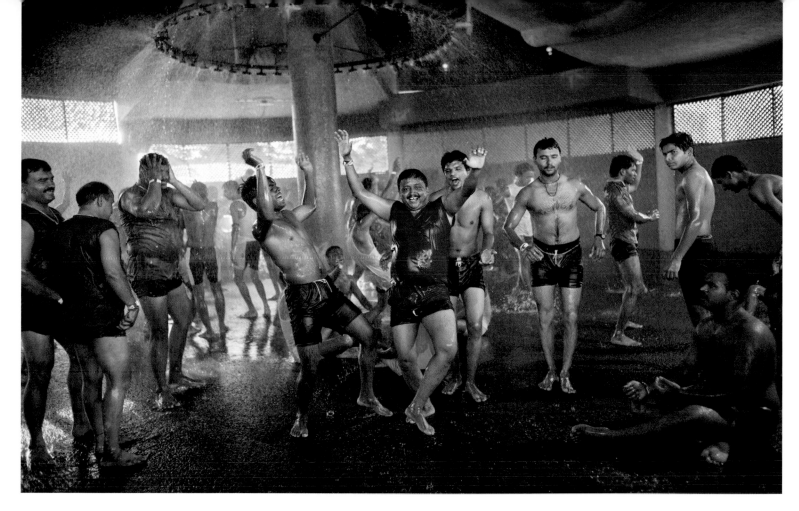

INDIA | 2009 Guests at the Wet 'N' Joy theme park near Shirdi revel in a good soaking, as caught by the lens of Lynsey Addario for an article on water.

camera. As the magazine transitions to the digital world, its reach has also been extended through its website and social media.

THE WRITE TOUCH

Whereas once a *National Geographic* author covered a "subject"—like pearls or India—the push is now to find a story narrative, as exemplified by Peter Hessler's prizewinning 2008 article on China's instant cities, or Alexandra Fuller's 2010 story on South Africa. The magazine has a mix of specialists and generalists. Douglas Chadwick, Virginia Morell, and the award-winning David Quammen often cover natural history. Timothy Ferris is the space expert, and Rob Kunzig and Elizabeth Kolbert tackle environment, as did the late John Mitchell. Robert Draper and Joshua Hammer have been reliable guides to the world's trouble spots, while notables like E. O. Wilson, Paul Theroux, and Garrison Keillor add their literary luster to the magazine's pages.

Additionally, the *Geographic*'s own staff brings its expertise and versatility to the text. Joel Bourne's October 2004 article on New Orleans, aided by Tyrone Power's photographs, predicted the catastrophic consequences of a hurricane's direct hit on the Big Easy. Peter Gwin, A. R. Williams, and Tom O'Neill, who wrote a story on Nigerian oil, are among the roster of distinguished staff bylines, while Cathy Newman's wry touch has graced stories on the Jersey Shore and Russian summer. ■

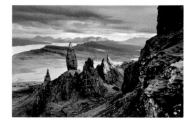

✳ ASK AN EXPERT

Jim Richardson got his start with the *Geographic* in 1984. Today he shares photography tips on *ngm.com* about producing images with a personal touch.

ABOVE: Jim Richardson was taken by these basalt pinnacles rising from an ancient landslide in Scotland's Hebrides.

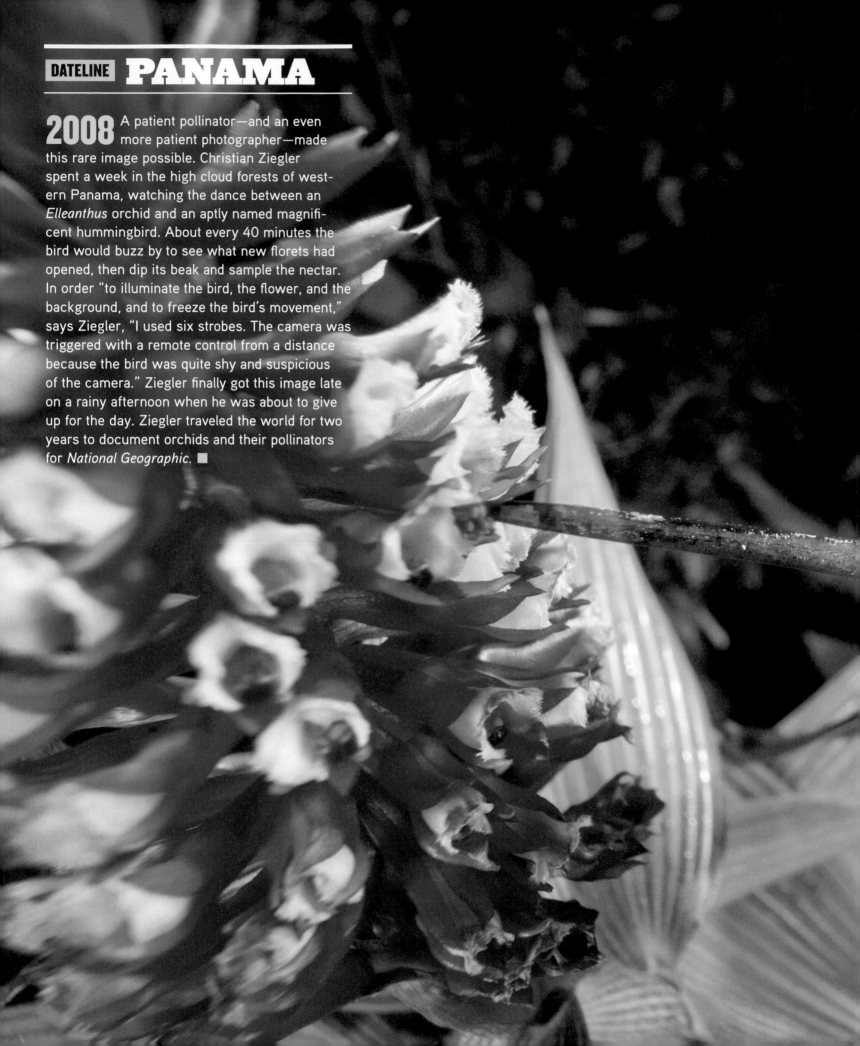

2008 A patient pollinator—and an even more patient photographer—made this rare image possible. Christian Ziegler spent a week in the high cloud forests of western Panama, watching the dance between an *Elleanthus* orchid and an aptly named magnificent hummingbird. About every 40 minutes the bird would buzz by to see what new florets had opened, then dip its beak and sample the nectar. In order "to illuminate the bird, the flower, and the background, and to freeze the bird's movement," says Ziegler, "I used six strobes. The camera was triggered with a remote control from a distance because the bird was quite shy and suspicious of the camera." Ziegler finally got this image late on a rainy afternoon when he was about to give up for the day. Ziegler traveled the world for two years to document orchids and their pollinators for *National Geographic*. ■

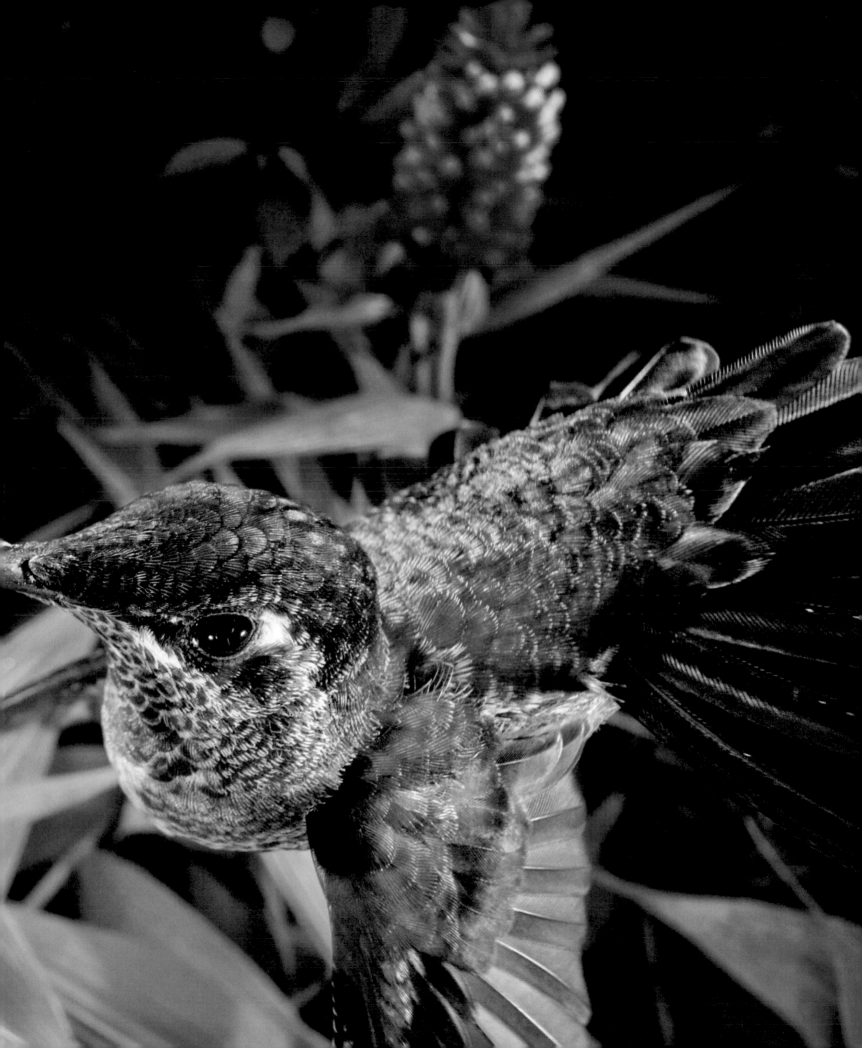

THE HUMAN JOURNEY

Whether you look backward or forward, it's a long and winding way down the star path.

✳ THE LION OF PANJSHIR

On assignment in late 2000, writer Sebastian Junger and photographer Reza were among the last Western journalists to interview legendary Afghan resistance leader Ahmad Shah Massoud. The interview aired on the newly launched National Geographic Channel shortly after September 11, 2001.

ABOVE: Ahmad Shah Massoud

Spencer Wells is a new kind of explorer. Call him a genetic paleontologist, for instead of digging into the dirt he delves into our cells, and using a genetic sampling kit seeks fossils in our chromosomes. An explorer-in-residence, Wells heads up National Geographic's Genographic Project, leading an international team of scientists and researchers that analyzes historical patterns in DNA being contributed by hundreds of thousands of people worldwide. Because the particular sequences of mutations preserved in each strand of our DNA occur at a known ratio, they can lead us back through time, down through the tree of humanity, from twig to limb to branch to our common genetic roots, for we are but one result of over a billion years of evolutionary transformations.

So Wells is also a mapmaker, charting the greatest journey in human history, one that started some 60,000 years ago when a small band of *Homo sapiens* began trekking out of Africa to populate the world.

Mapping ancient migrations helps us understand where we came from, and by what paths we arrived at the critical juncture we have reached today. Ever since the first hand planted the first seed, perhaps some 12,000 years ago, the human footprint has led inexorably toward civilization, and now one billion people live in slums surrounding sprawling megacities that unsustainably devour the Earth's natural resources. Globalization, by intermixing once isolated populations on an unprecedented scale, is also scrambling the genetic sequences Wells is collecting from once isolated indigenous peoples, obscuring the story of our origins. It is also eroding the thousands of culturally distinct expressions of our common humanity, washing away languages at an alarming rate, undermining what anthropologist Wade Davis, a fellow explorer-in-residence, calls the "ethnosphere." Lost languages, for instance, are as irreplaceable as lost species.

It's a fair guess that most of the explorers who will be associated with the Geographic will be concerned with ecological issues such as dwindling resources, overpopulation, and the looming extinction of cultural and biological diversity.

> *"It's the story of a journey, the journey of our species, and each of us is carrying a unique chapter."*

SPENCER WELLS,
GENETICIST

BOTSWANA | 1996 A better hunter than ranger, in his own view (he's able to track game for days on end), San tribesman Klaas Kruiper left his job with Kalahari Gemsbok National Park to resume a traditional way of life.

THE LAST SPEAKERS

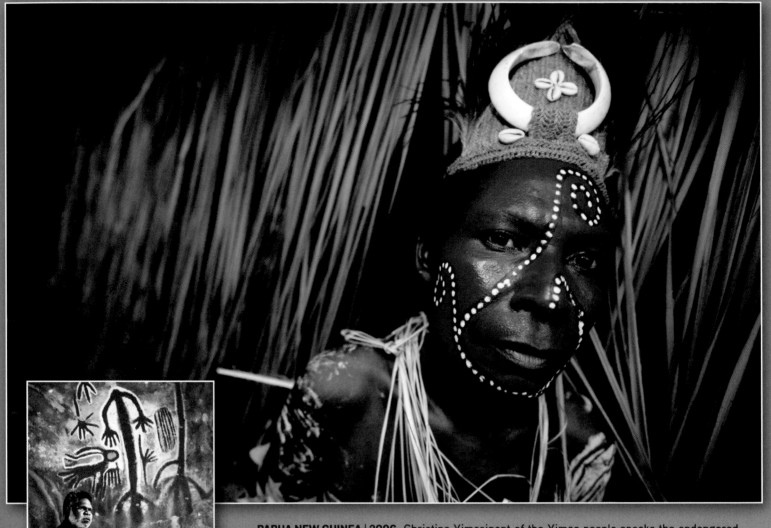

PAPUA NEW GUINEA | 2006 Christina Yimasinant of the Yimas people speaks the endangered Karim language of the Karawari region.

✚ **AUSTRALIA, 2006**

Cyril Ninnal, of the Yek Nangu clan, relates the Murrinh-Patha dreaming story of the headless man—depicted behind him in ancient rock art near Wadeye, Northern Territory, Australia.

anguage has much in common with living things. A species goes extinct when its last member dies; similarly, when the last speaker of a language goes silent, not only words but cultural knowledge fades away. K. David Harrison, author of *The Last Speakers* and co-director of Enduring Voices, a project he launched with the National Geographic Society in 2007, works tirelessly to protect the world's linguistic diversity. An expert in the Turkic languages of Asia, Harrison is concerned that 7,000 languages are rapidly disappearing. "I am keenly interested in how languages shape the structure of human knowledge," he says. As a professor of linguistics at Swarthmore College, Harrison emphasizes that traditional tongues pass down knowledge through the generations simply by being used. Such knowledge is lost when an outside language supplants a local or regional one. In ice or heat, monsoon or drought, how we live is expressed in the words we speak. ■

It's a race against time. On the biodiversity front alone, as of 2011 scientists were estimating that Earth holds 8.7 million species. But only 1.2 million of them have ever been described, and the others are disappearing faster than biologists can inventory them, much less peer into their genetic codes. Scientists have sequenced most of the extinct mammoth genome from carcasses found frozen in Siberia. But they might never be able to resurrect one. Nor will they clone a dinosaur from fossilized DNA, though Jack Horner, a former Society grantee, is trying to genetically "nudge" the DNA of a chicken back a few million generations.

The quest for the universal ancestor, the living cell that lies at the root of evolution's branching tree, might lead toward space. We may truly be wanderers, if life on Earth was seeded by meteorites, which have been found in Antarctica bearing traces of amino acids—the building blocks of proteins, and hence of DNA. Many astrobiologists, with an eye on our own once teeming biodiversity, suspect that life is abundant in the universe. An astonishing profusion of other worlds has been discovered orbiting stars in the nearer reaches of our Milky Way galaxy. If even one in a thousand such stars supported a terrestrial planet—why, that would add up to at least a billion potential Earths in our galaxy alone. And there are billions of galaxies.

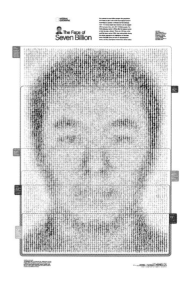

✳ THE FACE OF SEVEN BILLION

Global population topped seven billion in 2011. As part of a yearlong series on the topic, the magazine asked: Who is the world's most typical person? Research shows there are more men than women, the median age is 28, and the largest ethnic group is Han Chinese. So, the world's most typical person in 2011? A 28-year-old Han Chinese male—but not for long. By 2030 that commonality will shift to India. An app and online component to the series is available at *ngm.com/7-billion*.

ABOVE: The world's "most typical person" appears in a composite image made from 190,000 photographs of 28-year-old Han Chinese men.

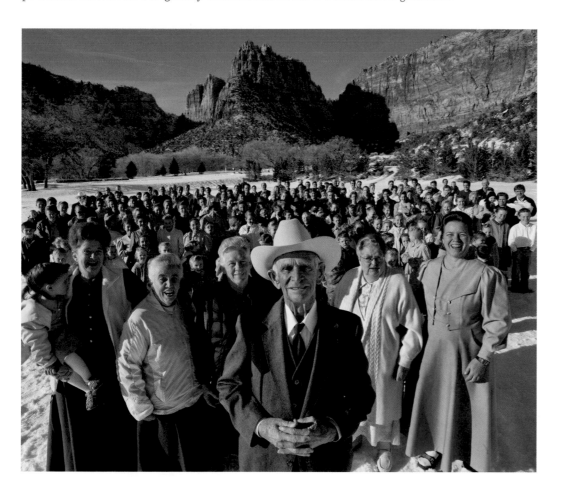

UTAH | 2010 Joe Jessop stands with his five wives and some of his progeny, who numbered 285 in 2010. He is an elder of the polygamist Fundamentalist Church of Jesus Christ of Latter-Day Saints.

✳ HIGH TECH AND HORSEBACK

National Geographic Emerging Explorer Albert Yu-Min Lin is searching for Genghis Khan's tomb in Mongolia's Valley of the Khans. To do this (and to survey the remote region while also remaining sensitive to local concerns about the tomb's sanctity), Lin invited people to join in a National Geographic expedition by tagging satellite images online. Using these images and noninvasive tools such as 3-D virtual reality and ground-penetrating radar, Lin targets promising archaeological sites without picking up a shovel.

ABOVE: Albert Yu-Min Lin gallops across northern Mongolia, where he is looking for Genghis Khan's tomb.

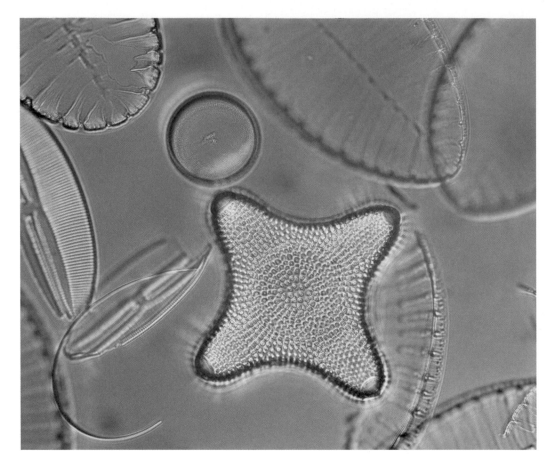

MICROCOSMOS | 1999 Magnified 1,600 times, diatoms—the silica shells of single-celled algae—shine forth in all their microscopic beauty. Diatoms generate one-fourth of the oxygen we breathe.

The human journey is already proceeding into the Milky Way, if the two Voyager spacecraft, launched in 1977 and now leaving the solar system, are "caravels bound for the stars," as Carl Sagan put it, the equivalent of Columbus's small ships, heralds of a new age of exploration. They have already served as our eyes, discovering that Jupiter's moon Europa was covered with an ocean that might harbor life in hydrothermal vents, and that Saturn's moon Titan possesses an atmosphere remarkably like our own. They may serve as our emissaries, too, should by some slim chance they be intercepted sometime during the 600 million years, barring the likelihood of collisions, it might take to arrive in the heart of the galaxy. Each carries an identical gold-plated record containing sounds and scenes of Earth intended for the amusement or edification of any passing alien. There are greetings in many tongues, snatches of Bach and Mozart and Louis Armstrong, the song of a humpback whale and the hoot of a chimpanzee. There are also 116 images, nearly two dozen of which—sequoias, snowflakes, autumn leaves, cresting dolphins, Red Sea reefs, a Balinese dancer, Jane Goodall, the Great Wall of China, and a spring woodland in Virginia among them—were provided by the National Geographic Society, increasing and diffusing geographic knowledge to the cosmos.

Had the government scientists who convened that long-ago night in January 1888 been granted even a glimpse of that, they might have poured another round. ■

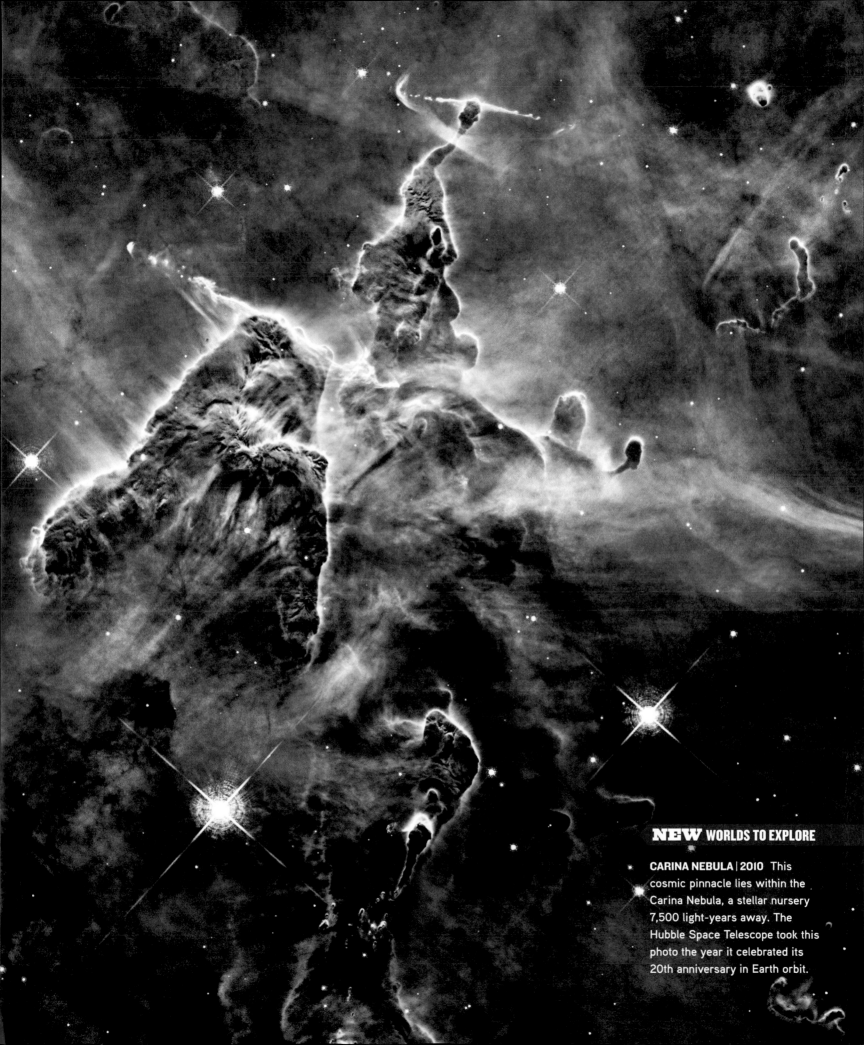

NEW WORLDS TO EXPLORE

CARINA NEBULA | 2010 This cosmic pinnacle lies within the Carina Nebula, a stellar nursery 7,500 light-years away. The Hubble Space Telescope took this photo the year it celebrated its 20th anniversary in Earth orbit.

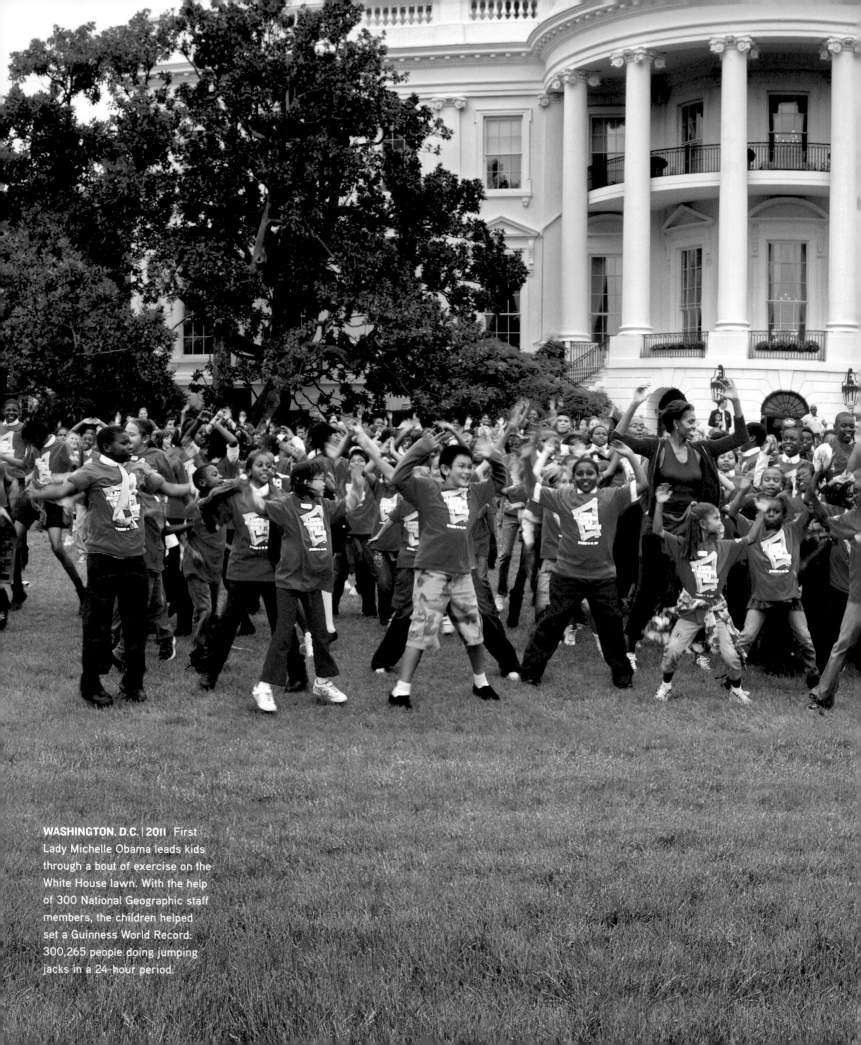

WASHINGTON, D.C. | 2011 First Lady Michelle Obama leads kids through a bout of exercise on the White House lawn. With the help of 300 National Geographic staff members, the children helped set a Guinness World Record: 300,265 people doing jumping jacks in a 24-hour period.

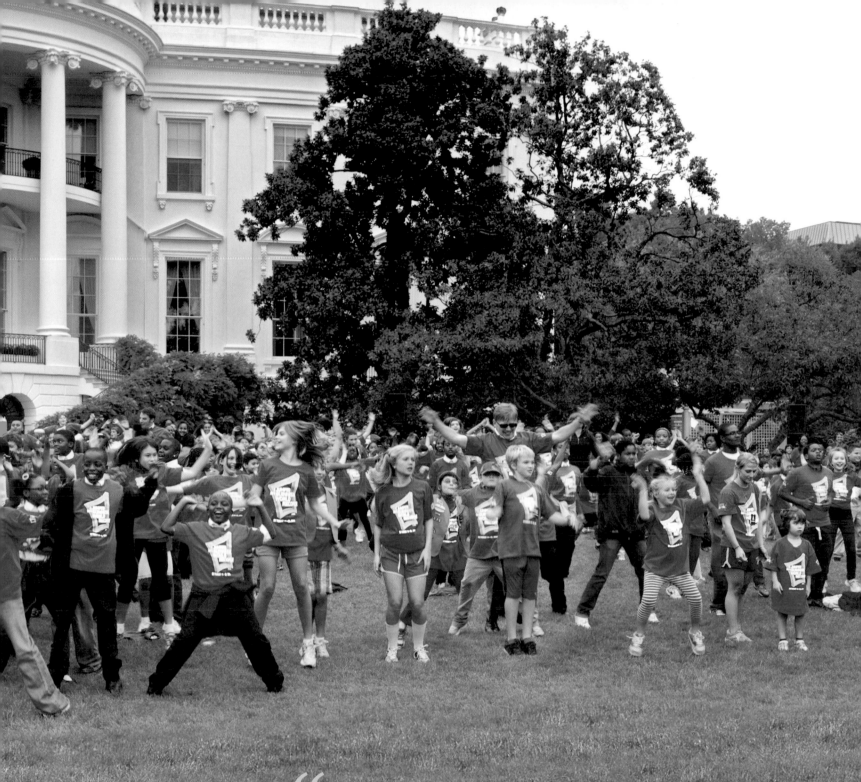

I believe that each of us—no matter what our age or background or walk of life—has something to contribute.

MICHELLE OBAMA,
FIRST LADY OF THE UNITED STATES

Flipping through the pages of a magazine that just arrived on our doorstep or in our browser, we gaze but for a moment on the photos it contains. Yet certain scenes—like the fishermen leading precarious existences on the opposite page, or the toddler and infant orangutan caught in startlingly similar stances on page 369—stay with us the rest of our lives. Why is that? Might it have something to do with the camera's uncanny ability to capture our common humanity? People the globe over share pretty much the same vital interests and experiences, the lens has disclosed for the past 125 years: We embrace our faith in fashions both quiet and loud, and we celebrate universal rites of passage as casual as connecting at a school dance or as momentous as graduating from high school. We think you'll have fun spotting the common threads that stitch together the slices of life that follow. ■

▼**1983** *A Wodaabe man in Niger rolls his right eye in and out—a talent highly prized during the* yaake, *or charm competition.*

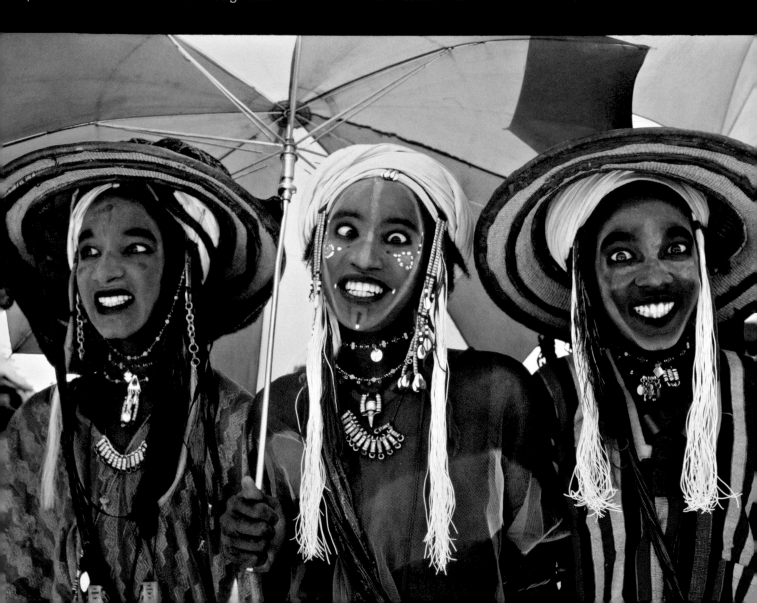

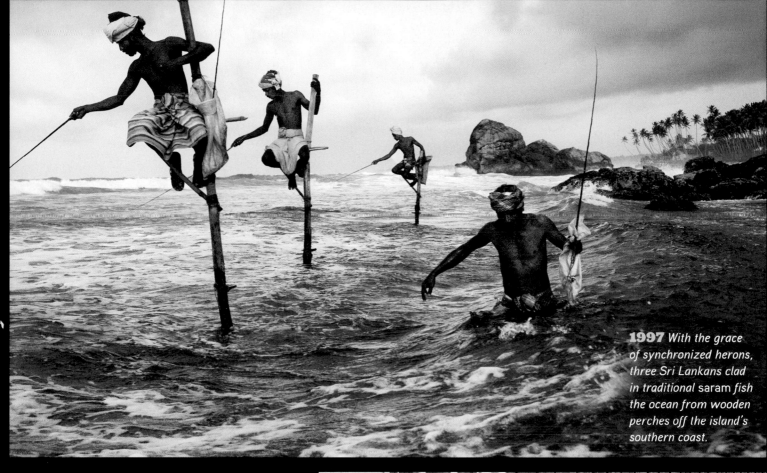

1997 *With the grace of synchronized herons, three Sri Lankans clad in traditional saram fish the ocean from wooden perches off the island's southern coast.*

▾**1942** *Eskimo boys show off the plane they made on remote Nunivak Island in the Bering Sea. Air service was a lifeline to their world at the time.*

▸**1931** *Two midwestern youngsters strike Norman Rockwell poses as they soak in the news that the circus is coming to town—in this case, Bristolville, Ohio.*

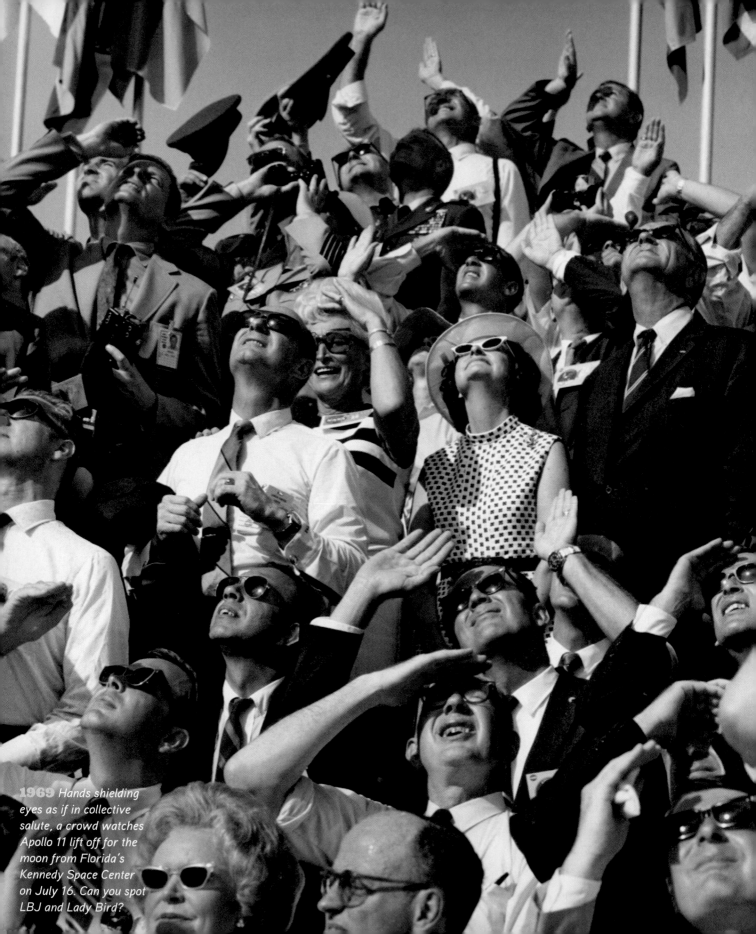

1969 *Hands shielding eyes as if in collective salute, a crowd watches Apollo 11 lift off for the moon from Florida's Kennedy Space Center on July 16. Can you spot LBJ and Lady Bird?*

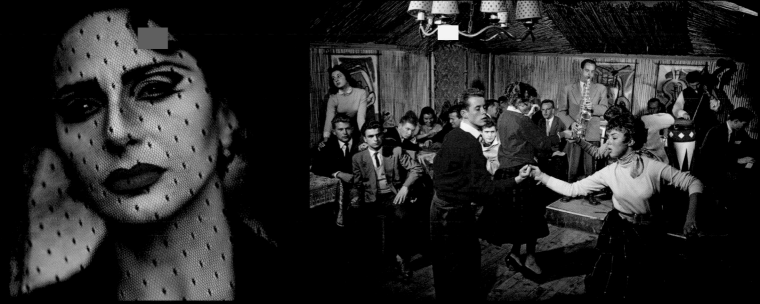

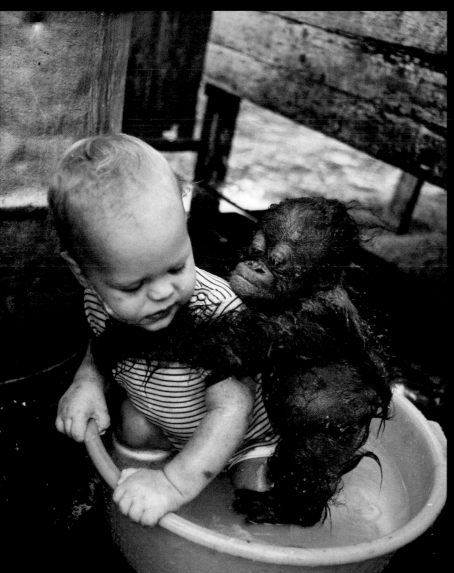

◀◀1995 *Benedetta Buccellato radiates tragic beauty before taking the stage in an updated* Prometheus Bound *at the Teatro Greco in Syracuse, Sicily.*

◀1980 *Anxious about the suds below, a young orangutan clings tight to Binti, the one-year-old son of primatologist Biruté Galdikas, at Borneo's Tanjung Puting Reserve.*

▲1959 *If the jazz band's playing "Besame Mucho," it must be . . . Vienna?! Yup—but these Austrian college students would have looked right at home swing dancing in California.*

▼1969 *Intent on telling an old story a new way, Bill Allard photographed a gondolier— only in shadow on a crumbling wall in Venice.*

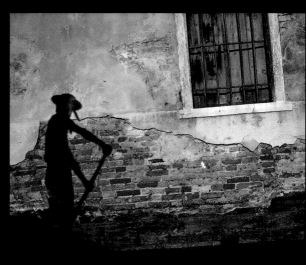

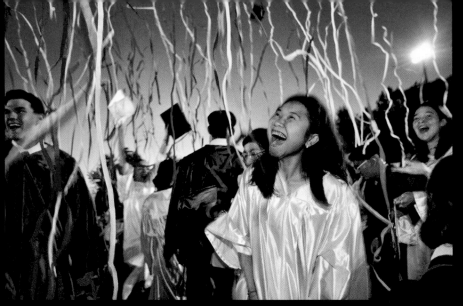

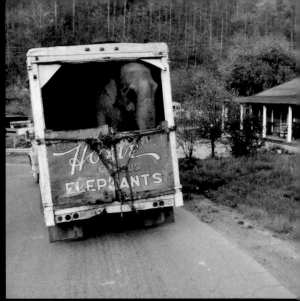

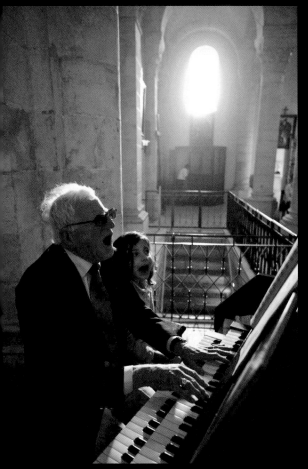

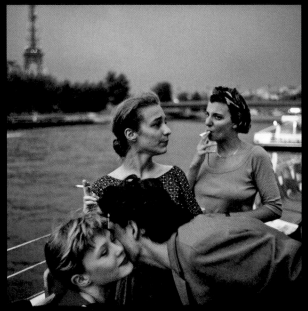

▲ **1972** *An elephant travels a back road in Kentucky as the Hoxie Bros. Gigantic 3-Ring Circus wanders through the heartland.*

◄ **1989** *Students Eric Geneste and Julie Bhaud exchange les bises on a Seine River cruise celebrating the end of school.*

▼ **1984** *A cowboy castrates a calf on the Ken Rosman Ranch in Utica, Montana. Don't ask what the red bucket is for.*

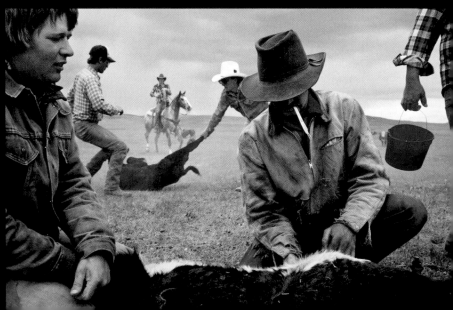

▲ **2008** *An intergenerational duet brings alive a piece of organ music played at Easter Mass in the Armenian Catholic Church of Jerusalem's Old City, Israel.*

▲ **2001** *Truc Nguyen and her fellow graduating seniors savor a cascade of streamers on their last day at J. E. B. Stuart High School in Falls Church, Virginia.*

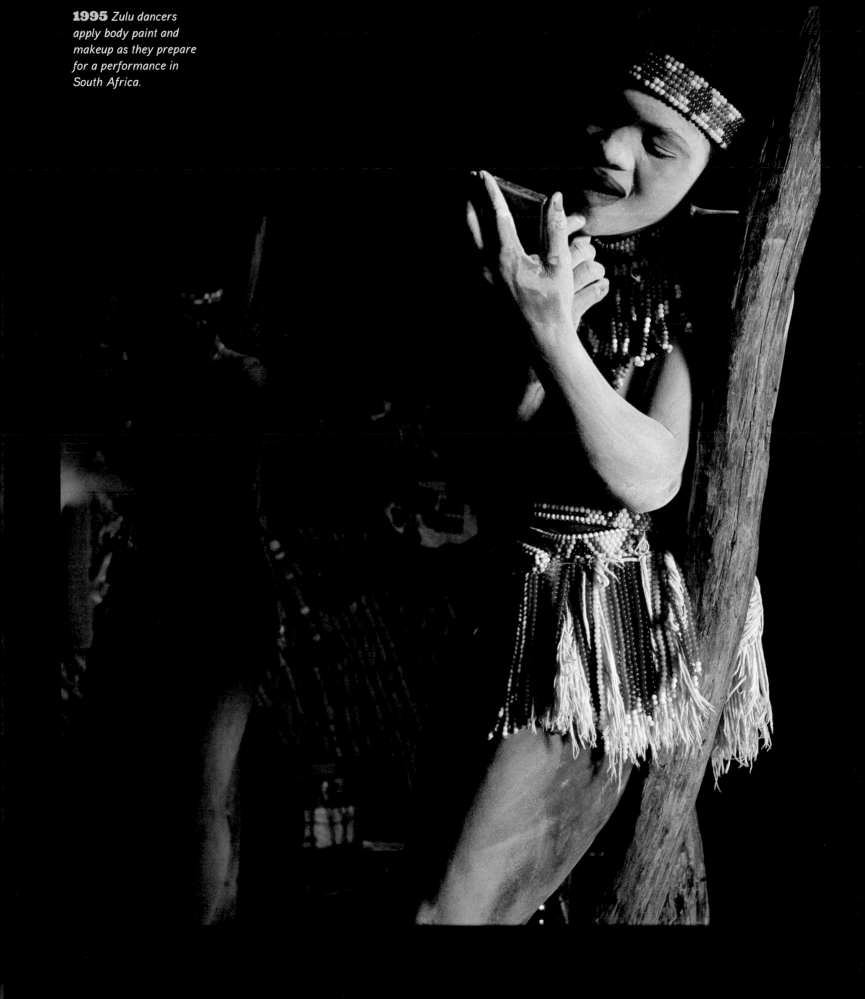

1995 *Zulu dancers apply body paint and makeup as they prepare for a performance in South Africa.*

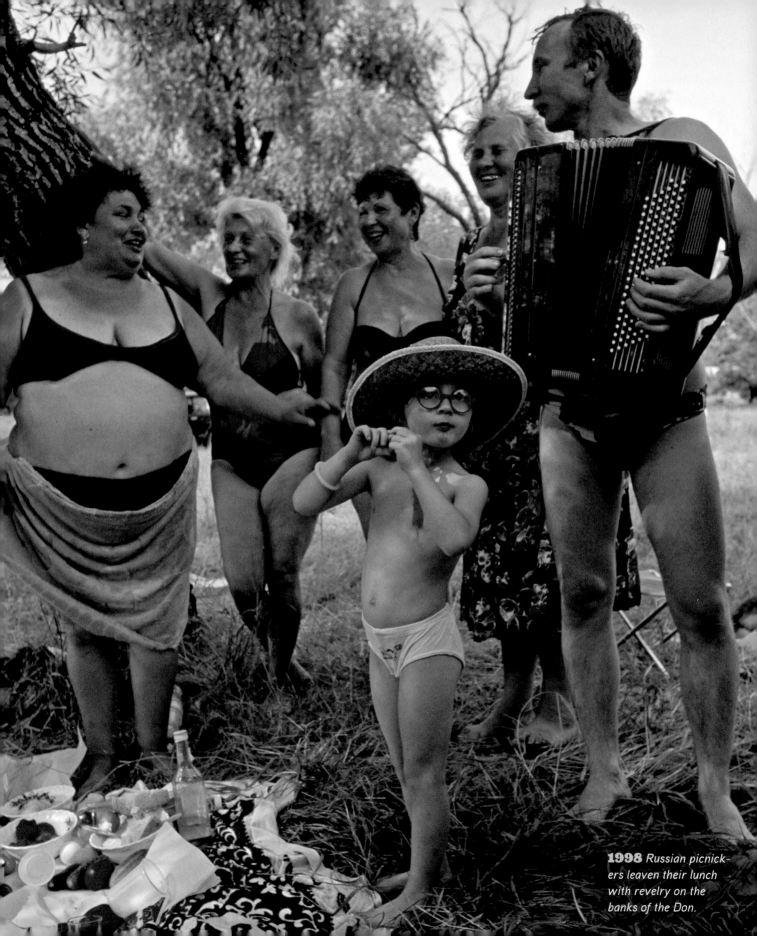

1998 *Russian picnickers leaven their lunch with revelry on the banks of the Don.*

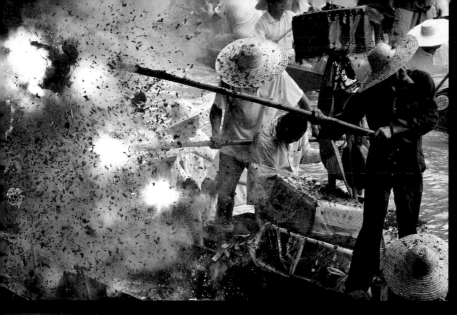

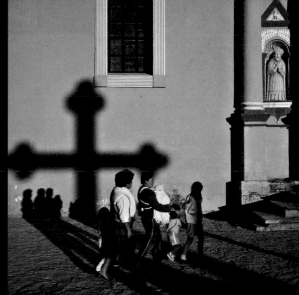

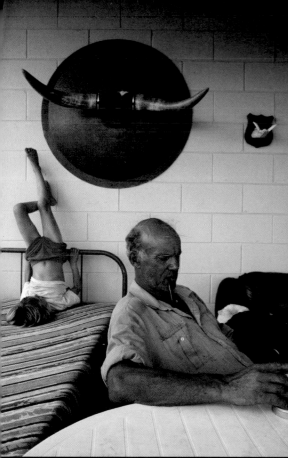

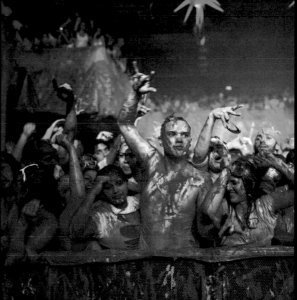

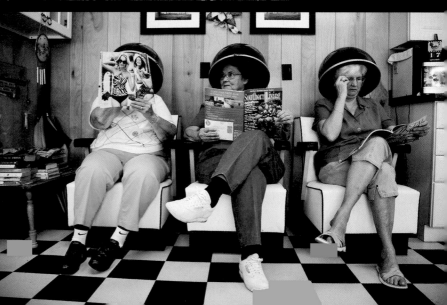

▲ **1996** Shadowed by a cross, a Mexican family makes its way to worship at a Catholic church in San Cristóbal de las Casas, Chiapas.

◄ **1996** Wall-to-wall hipsters doused in Day-Glo paint and bathed in black light color the magazine's coverage of adolescents for a story on the teen brain.

▼ **2007** Fantasy and reality collide in a hair salon in rural Georgia.

▲ **1996** Australian rancher John Fraser and his granddaughter, Amanda, contemplate life on his 600,000-acre cattle station in Queensland.

▲ **2010** Dang that's bright! Celebrants at a traditional Dragon Boat Festival in Guangzhou avert their eyes from the glare of bursting firecrackers.

ABOUT THE AUTHOR/ ACKNOWLEDGMENTS

AFGHANISTAN | 1968 A woman in red carries her caged goldfinches in the traditional manner.

ABOUT THE AUTHOR

Mark Collins Jenkins is the author of many books, including *On Assignment With National Geographic: The Inside Story of the National Geographic Society*, *Worlds to Explore: Classic Tales of Adventure From National Geographic*, *Vampire Forensics*, and *The War of 1812 and the Rise of the U.S. Navy*. He lives in Fredericksburg, Virginia.

ACKNOWLEDGMENTS

The staff of this book extends our deepest thanks and appreciation to the following people for their time and contribution to this project: Gil Grosvenor, Tim Kelly, Declan Moore, Chris Liedel, Melina Bellows, Maura Mulvihill, Claudia Malley, Victoria Pope, John Bredar, Rebecca Martin, Renee Braden, Cathy Hunter, Bill Bonner, Betty Clayman, Barbara Moffet, M. J. Jacobsen, Alex Moen, Chris Albert, Pat McGeehan, Karen Kostyal, John Francis, John Keshishian, Bill and Lucy Garrett, Peter White, Bob Poole, Lynn Abercrombie, Viola Wentzel, Jim Blair, Bruce Dale, George and Owen Williams, the late Luis and Ethel Marden, Jon Schneeberger, Emory Kristof, David Doubilet, Enric Sala, Klaus Liedtke, Amy Kolczak, Andrew Brown, Joan and Gene Smith, David Braun, Leah Bendavid-Val, and Jackie Hollister. Special thanks to copy editor Jane Sunderland, and to those sharp-eyed proofreaders, Larry Shea and Nancy Zanner Correll.

ILLUSTRATIONS CREDITS

2-3, Mark Thiessen, NGS; 4-5, Donald McLeish; 6-7, Carsten Peter; 8-9, George F. Mobley; 10-11, Brian Skerry, 14, James L. Stanfield; 16, Gilbert M. Grosvenor; 17, Gilbert M. Grosvenor; 18-19, Stanley Meltzoff; 20, Edward S. Curtis, Library of Congress, #3c30715; 22, Dario Sabljak/Shutterstock; 23, National Anthropological Archives, Smithsonian Institution [INV 02873800]; 24 (UP), Library of Congress, #3c36196; 24 (LO), Greely Expedition/Wentzel Collection; 25 (UP), from *Tent Life in Siberia* by George Kennan, G.P. Putnam's Sons, 1910; 25 (LO, ALL), NGS Archives/Mark Thiessen, NGS; 26 (UP), NGS Archives; 26 (LO), National Anthropological Archives, Smithsonian Institution [INV 02874400]; 27, I.C. Russell Collection, U.S. Geological Survey; 28 (LE), NGS Archives; 28 (RT), John Oliver La Gorce; 29, Alexander Graham Bell Collection, NGS; 30 (UP), John K. Hillers, National Anthropological Archives, Smithsonian Institution [NAA INV 06282600]; 30 (CTR LE), Library of Congress, #01344; 30 (CTR RT), C.D. Walcott/U.S. Geological Survey; 30 (LO LE), U.S. Geological Survey; 30 (LO CTR), C.D. Walcott/U.S. Geological Survey; 30 (LO RT), Library of Congress, #3c37690; 31 (UP LE), Gilbert Thompson/U.S. Geological Survey; 31 (UP CTR), Library of Congress, #14599; 31 (UP RT), Courtesy Naval Historical Foundation; 31 (CTR LE), Library of Congress, #03417; 31 (CTR RT), J.S. Diller/U.S. Geological Survey; 31 (LO LE), "Charles Valentine Riley Inspecting an Insect." Charles Valentine Riley Collection. Special Collections, National Agricultural Library, Beltsville, Maryland, http://specialcollections.nal.usda.gov/; 31 (LO CTR), Kets Kemethy Studio; 31 (LO RT), Alexander Graham Bell Collection, NGS; 31 (BOTTOM), Courtesy DC Public Library, Washingtoniana Division; 32, NGS Archives; 33, NGS Image Collection; 34, Asst. Paymaster J.Q. Lovell, USN; 35 (UP), William Henry Holmes; 35 (LO), Percival Lowell; 36-37, Edward S. Curtis, Library of Congress, #3g08289; 38, NG Maps; 39 (UP), NG Maps; 39 (LO LE), Paul Pryor; 39 (LO RT), Sisse Brimberg; 40, NG Maps; 41 (UP LE), Robert F. Sisson; 41 (UP RT), NG Maps/Ned Seidler; 41 (LO LE), NGS Archives; 41 (LO RT), NG Maps/Peter E. Spier; 42 (UP, BOTH), NG Maps; 42 (CTR LE), NG Maps; 42 (CTR RT), NG Maps/Allen Carroll; 42 (LO), NG Maps; 43, Joseph H. Bailey; 44, Pete Souza; 45 (UP), NG Maps/photos from NASA; 45 (LO), NG Maps/Sean McNaughton; 46-47, Eliza R. Scidmore; 50, Wallis W. Nutting; 52, NGS Archives; 53, Lehnert & Landrock; 54, John Alexander Douglas McCurdy; 55 (UP), Lehnert & Landrock; 55 (LO), NGS Archives; 55 (LO), Luther G. Jerstad; 56 (CTR), Rebecca Hale, NGS; 56 (LO LE), J. Baylor Roberts; 56 (LO RT), Thomas J. Abercrombie; 57 (UP), Paul R. Hagelbarger; 57 (LO LE), Al Giddings; 57 (LO RT), Emory Kristof; 58-59, John Claude White; 60, NGS Archives/Mark Thiessen, NGS; 61, Robert E. Peary Collection, NGS; 62 (UP), Matthews-Northrup Works of Buffalo/NGS Archives; 62 (LO), Anthony Fiala; 63 (UP), Robert E. Peary Collection, NGS; 63 (LO), NGS Archives/Robert S. Oakes; 64, Frank Hurley/Scott Polar Research Institute, University of Cambridge; 65 (UP), Photographer: unknown/National Library of Norway; 65 (LO), Leet Brothers; 66-67, O.D. Von Engeln; 68, Harrison W. Smith; 69, Harriet Chalmers Adams; 70-71, Hiram Bingham; 71, Robert Clark; 72 (UP), James M. Gurney; 72 (LO), NGS Archives; 73 (UP), Kermit Roosevelt; 73 (LO), Carl E. Akeley; 74-75, Maynard Owen Williams; 76, William Wisner Chapin; 77, Eliza R. Scidmore; 78 (UP), Herbert Corey; 78 (LO), Christina Krysto; 79 (UP), NGS Archives/Matt Propert; 79 (LO, BOTH), Dean C. Worcester; 80-81, American Colony Photographers; 82, NGS Archives; 83, Scottyboipdx Weber/National Geographic My Shot; 84, Henry Pittier; 85, Carl E. Akeley; 86 (UP), Michael Nichols, NGS; 86 (LO), George Shiras, III; 87, George Shiras, III; 88-89, George Shiras, III; 90 (UP), Alex Staroseltsev/Shutterstock; 90 (LO), Frank M. Chapman; 91 (BOTH), Louis Agassiz Fuertes; 92-93, Louis Agassiz Fuertes; 94, Courtesy Marian Albright Schenck; 95, Franklin Price Knott; 96, Gilbert H. Grosvenor Collection, NGS; 97 (UP), Franklin Price Knott; 97 (LO), NGS Archives; 98-99, Robert F. Griggs; 100, JIJI PRESS/AFP/Getty Images; 101 (UP), F.J. Youngblood; 101 (LO LE), Steve McCurry; 101 (LO RT), Mario Tama/Getty Images; 102, Carsten Peter/National Geographic Stock; 103 (UP LE), Carsten Peter/National Geographic Stock; 103 (UP RT), Ralph Perry/Black Star; 103 (CTR),

Carsten Peter; 103 (LO LE), Israel C. Russell; 103 (LO RT), Roger Ressmeyer; 104 (UP LE), Carsten Peter; 104 (UP RT), REZA; 104 (CTR LE), Mike Theiss/National Geographic Stock; 104 (CTR RT), James L. Stanfield; 104 (LO), Alison Wright/National Geographic Stock; 105, Carsten Peter; 106, Colin Monteath/Minden Pictures/National Geographic Stock; 107 (UP), Library of Congress; 107 (CTR), Steve McCurry; 107 (LO LE), NOAA-NASA GOES Project; 107 (LO RT), Mark Thiessen, NGS; 108-109, B. Anthony Stewart; 112, J.B. Shackelford/American Museum of Natural History; 114, N.C. Wyeth/National Geographic Collection; 115, Hans Hildenbrand; 116, Lehnert & Landrock; 117 (LE), Jules Gervais-Courtellemont; 117 (RT), J. Baylor Roberts; 118 (UP), Moviestore Collection Ltd/Alamy; 118 (LO), Maurice Savage/Alamy; 119 (UP), © Garrett Price/The New Yorker Collection/www.cartoonbank.com; 119 (LO), Willis T. Lee; 120 (UP), Tatiana Popova/Shutterstock; 120 (LO), B. Anthony Stewart; 121, J. Baylor Roberts; 122-123, B. Anthony Stewart; 124, Steve St. John; 125, Howell Walker; 126, Maynard Owen Williams; 127 (LE), Maynard Owen Williams; 127 (RT), Mark Collins Jenkins; 128 (UP), John D. Whiting; 128 (LO), Maynard Owen Williams; 129 (BOTH), Maynard Owen Williams; 130 (LE), Edward Westmacott/Shutterstock; 130 (RT), Volkmar Wentzel; 131, Volkmar Wentzel; 132, Luis Marden; 133 (UP), Mark Collins Jenkins; 133 (LO), Sarah Leen & Leo Barish; 134-135, W. Robert Moore; 136, Robert Scheindlenger; 137, Joseph F. Rock; 138 (BOTH), Joseph F. Rock; 139 (LE), Joseph F. Rock; 139 (RT), NG Maps; 140 (UP), Joseph F. Rock; 140 (LO, BOTH), NGS Archives/Robin Siegel; 141 (UP), Owen Lattimore; 141 (LO LE), NGS Archives/Robin Siegel; 141 (LO RT), NGS Archives/Mark Thiessen, NGS; 142-143, Joseph F. Rock; 144, W.H. Longley and Charles Martin; 145, Ernest G. Holt; 146, Walter A. Weber; 147 (UP), Luis Marden; 147 (LO), Volkmar Wentzel; 148 (UP), Bradford Washburn; 148 (LO), © Bradford Washburn, courtesy Decaneas Archive; 149, Bradford Washburn; 150-151, Bradford Washburn; 152, Kenneth Garrett/National Geographic Stock; 153, Richard H. Stewart; 154, Richard H. Stewart; 155 (UP), Neil M. Judd; 155 (LO), NGS Archives/Mark Thiessen, NGS; 156-157, Neil M. Judd; 158, Kenneth Garrett; 159, Keystone View Co./NGS Image Collection; 160 (LE), NG Maps; 160 (RT), Arthur Beaumont; 161, W. Robert Moore; 162-163, Fenno Jacobs/Black Star; 164, Underwood & Underwood/Corbis; 165, Topical Press Agency/Getty Images; 166 (UP), Else Bostelmann; 166 (LO), New York Daily News Archive via Getty Images; 167 (UP), Emory Kristof; 167 (LO), John Tee-Van/Wildlife Conservation Society; 168, Major H. Lee Wells, Jr.; 169, Richard H. Stewart; 170-171, Mount Wilson and Palomar Observatories; 172, Edwin L. Wisherd; 173 (UP), Jules Gervais-Courtellemont; 173 (LO LE), Edwin L. Wisherd; 173 (LO RT), Donald McLeish; 174, Andrew H. Brown; 175 (UP LE), James P. Blair; 175 (UP RT), Kenneth Garrett/National Geographic Stock; 175 (CTR), Bob Krist; 175 (LO LE), David S. Boyer; 175 (LO RT), Sam Abell; 176 (UP LE), Catherine Karnow; 176 (UP RT), Aaron Huey; 176 (CTR LE), James L. Stanfield; 176 (CTR RT), Susan Seubert; 176 (LO), Jodi Cobb; 177, Steve McCurry; 178, REZA; 179 (UP LE), Tino Soriano; 179 (UP RT), Michael Melford; 179 (CTR), Paul Chesley/National Geographic Stock; 179 (LO LE), Jackson & Melissa Brandts/National Geographic My Shot; 179 (LO RT), Frans Lanting; 180-181, Barry Bishop; 184, James P. Blair; 186, Paul Nicklen; 187, Robert B. Goodman; 188 (UP), World Ocean Floor Panorama, Bruce C. Heezen and Marie Tharp, 1977, Copyright by Marie Tharp 1977/2003. Reproduced by permission of Marie Tharp Maps, LLC, 8 Edward Street, Sparkill, New York 10976; 188 (LO), Heinrich C. Berann; 189 (UP), NGS Archives/Mark Thiessen, NGS; 189 (LO), Thomas J. Abercrombie; 190-191, Bates Littlehales; 192, NGS Archives; 193, Luis Marden; 194, Barry Bishop; 195 (UP), NGS Archives/Robin Siegel; 195 (LO), Barry Bishop; 196, Paul Zahl; 197 (LE), Thomas Nebbia; 197 (RT), NGS Archives; 198-199, Wilbur E. Garrett; 200, Robert F. Sisson; 201, Gordon Gahan; 202, Hugo van Lawick; 203 (UP), Jack Fletcher; 203 (LO), NGS Archives/Mark Thiessen, NGS; 204-205, Hugo van Lawick; 206, Mark D. Martin; 207, William Albert Allard; 208, David S. Boyer; 209 (LE), Wilbur E. Garrett; 209 (RT), Thomas J. Abercrombie; 210 (BOTH), NASA; 211 (LE), Dean Conger; 211 (RT), Time

SICILY | 2009 Head bowed as if in eternal prayer, a mummified corpse in a Palermo catacomb wears the telltale scarlet cape and black hat of a priest.

MEXICO | 1999 Resplendent in silver body paint, a man prepares to celebrate Carnival in San Nicolás de los Ranchos, a town in southeastern Mexico.

& Life Pictures/Getty Images; 212 (UP), Winfield I. Parks, Jr.; 212 (LO), NGS Archives; 213, Dean Conger; 214-215, Thomas J. Abercrombie; 216, NGS Archives; 217, William Albert Allard; 218 (UP), Thomas Nebbia; 218 (LO), NGS Archives; 219 (LE), William W. Campbell III; 219 (RT), B. Anthony Stewart; 220, Charles Nicklin; 221, Frederick Kent Truslow; 222, Paul Zahl; 223 (UP), Alan Root; 223 (LO), Hugo van Lawick; 224-225, Theresa Goell; 226, NGS Archives; 227, Charles Allmon; 228, Volkmar Wentzel; 229, NASA; 230-231, B. Anthony Stewart; 232, Mitsuaki Iwago; 233, Frans Lanting/www.lanting.com; 234, Melissa Farlow; 235 (UP LE), David Doubilet; 235 (UP RT), Bill Curtsinger/National Geographic Stock; 235 (CTR), Brian Skerry; 235 (LO LE), Bianca Lavies; 235 (LO RT), George Grall; 236 (UP LE), Norbert Rosing; 236 (UP RT), Mattias Klum; 236 (CTR LE), N.A. Cobb; 236 (CTR RT), Paul Nicklen; 236 (LO), Joel Sartore; 237, David Alan Harvey; 238, Tim Laman; 239 (UP LE), Michael Nichols/National Geographic Stock; 239 (UP RT), Mark W. Moffett; 239 (CTR), Des & Jen Bartlett; 239 (LO LE), Michael Nichols, NGS; 239 (LO RT), Chris Johns, NGS; 240-241, Bruce Dale; 244, Steve McCurry; 246, NASA Goddard Space Flight Center Image by Reto Stöckli (land surface, shallow water, clouds). Enhancements by Robert Simmon (ocean color, compositing, 3D globes, animation). Data and technical support: MODIS Land Group; MODIS Science Data Support Team; MODIS Atmosphere Group; MODIS Ocean Group Additional data: USGS EROS Data Center (topography); USGS Terrestrial Remote Sensing Flagstaff Field Center (Antarctica); Defense Meteorological Satellite Program (city lights).; 247, Dewitt Jones; 248 (UP), George F. Mobley; 248 (LO), James P. Blair; 249 (UP), NGS Archives; 249 (LO), Jodi Cobb; 250-251, David Alan Harvey; 252, Greg Marshall, NGS; 253, George B. Schaller; 254, Robbie George/National Geographic Stock; 255 (BOTH), Tim Laman; 256, Albert Moldvay; 257 (UP), Katharine B. Payne; 257 (LO), NGS Archives; 258-259, Jim Brandenburg; 260, Bob Campbell; 261, Rod Brindamour; 262, Gordon Gahan; 263, Jonathan Blair; 264 (UP), Gordon Gahan; 264 (LO), Philippe Plailly/Photo Researchers, Inc.; 265 (UP), AP Photo/Houston Chronicle, Kevin Fujii; 265 (LO), Bob Campbell; 266 (UP), George F. Mobley; 266 (LO LE), Jonathan Blair; 266 (LO RT), O. Louis Mazzatenta; 267 (UP), O. Louis Mazzatenta; 267 (LO LE), George F. Mobley; 267 (LO RT), Martha Cooper; 268-269, Emory Kristof; 270, Lennart Nilsson/SCANPIX; 271, Malcolm S. Kirk; 272, Eric Valli; 273 (UP), Sisse Brimberg; 273 (LO), O. Louis Mazzatenta; 274-275, James L. Stanfield; 276, NGS Archives/Rebecca Hale, NGS; 277, Flip Nicklin; 278 (UP), Kip Evans; 278 (LO), Charles Nicklin; 279 (UP), NGS Archives; 279 (LO), Emory Kristof; 280-281, David Doubilet; 282, NGS Archives/Mark Thiessen, NGS; 283, Cotton Coulson; 284 (UP), Will Steger; 284 (LO), Gordon Wiltsie; 285 (LE), Jim Brandenburg; 285 (RT), NG Maps; 286, Rick Smolan; 287 (UP), Elena Elisseeva/Shutterstock; 287 (LO), Peter Jenkins; 288-289, Carlo Mauri; 290, Herbert G. Ponting; 291 (UP), National Institute of Standards and Technology; 291 (LO, BOTH), Willard R. Culver; 292, Edgerton Germeshausen & Grier; 293 (UP, BOTH), B. Anthony Stewart; 293 (LO, BOTH), Robert F. Sisson; 294 (UP LE), Dean Conger; 294 (UP RT), Mark W. Moffett; 294 (CTR LE), Chuck Carter; 294 (CTR RT), George Steinmetz; 294 (LO), Roger Ressmeyer; 295, NASA; 296, Maggie Steber; 297 (UP LE), Tyrone Turner; 297 (UP RT), Mark Thiessen, NGS; 297 (CTR LE), Robert Clark; 297 (CTR RT), Mark Thiessen, NGS; 297 (LO), © Harold Edgerton, 2012, courtesy of Palm Press, Inc.; 298-299, Tim Laman; 302, Chris Noble; 304, Courtesy of Canon USA. The Canon logo is a trademark of Canon Inc. All rights reserved.; 305, Joel Sartore/National Geographic Stock; 306 (UP), Michael Nichols, NGS; 306 (LO), NGS Archives/Mark Thiessen, NGS; 307, Michael Nichols, NGS; 308 (UP), NGS Archives; 308-309 (LO, ALL), Joel Sartore/National Geographic Stock; 309 (UP LE), Joel Sartore; 309 (UP RT), David Liittschwager; 310-311, Paul Nicklen; 312, Meoita/Shutterstock; 313, Steve Winter; 314 (UP), Paul Nicklen; 314 (LO), Mark W. Moffett; 315 (LE), Beverly Joubert; 315 (RT), Mark Thiessen, NGS; 316, Simon Boyce/NGT; 317 (UP), Rob Taylor/www.robtaylor.tv; 317 (LO), Poster art, 2005, © Warner Bros./Courtesy: Everett Collection; 318-319, Brent Stirton/Getty Images; 320, International Mammoth Committee; 321, Johan Reinhard; 322 (UP), Art by John Gurche, Photo by Kenneth Garrett; 322 (LO), Ira Block; 323 (LE), Kenneth Garrett/National Geographic Stock; 323 (RT), Kenneth Garrett; 324 (UP), Ira Block; 324 (LO), Kenneth Garrett; 325 (UP), Kenneth Garrett; 325 (LO), Michael Yamashita; 326-327, Simon Norfolk, with permission of Conaculta-INAH, Mexico; 328, © 2007 NGHT, Inc.; 329, Mike Hettwer; 330 (UP), Jacques Descloitres, MODIS Land Science Team/Visible Earth, NASA (http://visibleearth.nasa.gov/view.php?id=54571); 330 (LO), NASA/JPL/Caltech; 331 (LE), Robert Clark; 331 (RT), Mick Ellison; 332-333, Raul Martin; 334, Don Foley; 335, Mark Thiessen, NGS; 336 (LE), NGS Archives; 336 (RT), David Doubilet; 337 (UP), James D. Watt/SeaPics

.com; 337 (LO), Mike Johnson/earthwindow.com; 338, Brian Skerry; 339 (UP), Ralph Lee Hopkins/National Geographic Stock; 339 (LO), Brian Skerry; 340-341, Wes Skiles; 342, NGS Archives; 343, Bobby Model/National Geographic Stock; 344 (UP), AP Photo/Keystone/Fabrice Coffrini; 344-345 (LO), NGS Archives; 345 (UP LE), Tommy Heinrich; 345 (UP RT), Beverly Joubert; 346 (UP), Josep Clotas; 346 (CTR LE), NG Games; 346 (CTR RT), Rebecca Hale, NGS; 346 (LO LE), NGS Archives; 346 (LO CTR), NGS Archives; 346 (LO RT), NG Catalog; 347 (UP LE), NGS Archives; 347 (UP CTR), www.nationalgeographic.com; 347 (UP RT), Traveler Magazine, Available for Kindle; 347 (CTR LE), Ryan Heffernan; 347 (CTR RT), Rebecca Hale, NGS; 347 (LO LE), Photos 12/Alamy; 347 (LO CTR), NG Maps, TOPO! software; 347 (LO RT), Courtesy National Geographic Channel; 347 (BOTTOM), Mark Thiessen, NGS; 348-349, Carsten Peter/Speleoresearch & Films/National Geographic Stock; 350, NGS Archives; 351, John Burcham; 352 (UP), Maria Stenzel; 352 (LO), Kenneth Garrett; 353 (LE), Chris Johns, NGS; 353 (RT), Composite image: Helicopter by Lance Cheung, U.S. Air Force/Shark by Charles Maxwell; 354 (UP), Lynn Johnson; 354 (LO), NGS Archives; 355 (UP), Lynsey Addario; 355 (LO), Jim Richardson; 356-357, Christian Ziegler; 358, REZA; 359, Chris Johns, NGS; 360 (BOTH), Chris Rainier, National Geographic Enduring Voices Project; 361 (UP), Bryan Christie; 361 (LO), Stephanie Sinclair; 362 (LE), Mike Hennig; 362 (RT), Darlyne A. Murawski/National Geographic Stock; 363, NASA, ESA, and M. Livio and the Hubble 20th Anniversary Team (STScI); 364-365, Dan Westergren, NGS; 366, Carol Beckwith; 367 (UP), Steve McCurry; 367 (LO LE), Amos Burg; 367 (LO RT), Jacob Gayer; 368, Otis Imboden; 369 (UP LE), William Albert Allard; 369 (UP RT), Volkmar Wentzel; 369 (LO LE), Rod Brindamour; 369 (LO RT), William Albert Allard/National Geographic Stock; 370 (UP LE), Karen Kasmauski; 370 (UP RT), Jonathan Blair; 370 (CTR LE), Ed Kashi; 370 (CTR RT), David Alan Harvey; 370 (LO), Sam Abell; 371, Chris Johns, NGS; 372, Gerd Ludwig; 373 (UP LE), Yu Andy/National Geographic My Shot; 373 (UP RT), Tomasz Tomaszewski; 373 (CTR LE), Sam Abell; 373 (CTR RT), Kitra Cahana; 373 (LO), Michael Hanson/National Geographic Stock; 374, Thomas J. Abercrombie; 375, Vincent J. Musi; 376, Sarah Leen/National Geographic Stock; 377 (UP), David Liittschwager/National Geographic Stock; 377 (LO), Susan Middleton; 378, Alison Wright/National Geographic Stock; 379, Merlin D. Tuttle, Bat Conservation International; 380, Michael Melford; 381, Raymond Gehman; 382, Beverly Joubert/National Geographic Stock; 383, Robb Kendrick.

GATEFOLD

1, Robert S. Oakes; 4, NGS Image Collection; 7, NGS Image Collection; 9, Robert E. Peary, courtesy Cmdr. Edward Peary Stafford; 11, William Wisner Chapin; 12, Hiram Bingham; 13, Paul G. Guillumette; 15, Bentley B. Fulton; 16, 12/Shutterstock; 17, Joseph F. Rock; 20, W.H. Longley & Charles Martin; 21, Bettmann/Corbis; 26, Else Bostelmann; 27, Richard H. Stewart; 28, Bradford Washburn; 30, Richard H. Stewart; 33, Howell Walker; 34, Volkmar Wentzel; 35, Michael S. Quinton/National Geographic Stock; 38, Bates Littlehales; 39, Luis Marden; 40, Luis Marden; 41, Frank & John Craighead; 42, NGS Archives; 46, Otis Imboden; 48, Jane Goodall; 51, Bates Littlehales; 54, Barry Bishop; 56, Hugo van Lawick; 57, NGS Archives; 60, Jonathan Blair; 62, Heinrich C. Berann; 63, George F. Mobley; 64, NASA; 67, David Doubilet; 68, Flip Nicklin/Minden Pictures/National Geographic Stock; 72, Craig Hartley/Bloomberg via Getty Images; 73, Bianca Lavies; 74, Emory Kristof; 78, NGS Archives; 80, Steve McCurry; 82, Pete Souza; 85, Emory Kristof; 86, NGS Archives; 88, Bill Ballenberg; 91, Stephen L. Alvarez; 93, NGS Archives; 94, Rick Ridgeway; 96, courtesy National Geographic Channels; 99, Kenneth Garrett; 100, Michael Nichols, NGS; 101, Joel Sartore; 104, REZA; 105, NGS Archives; 107, Mark Thiessen, NGS; 108, Michael Fay/National Geographic Stock; 111, Carsten Peter; 113, Randy Olson; 114, Frans Lanting/National Geographic Stock; 116, Florence Darbre; 117, James D. Balog; 119, Beverly Joubert/National Geographic Stock; 122, Gerlinde Kaltenbrunner; 125, Mark Thiessen, NGS.

INDEX

Boldface indicates illustrations.

A

Abbe, Cleveland 30, **30**
Abel, Sam 249
Abercrombie, Thomas J. 16,
 56, 182, 183, 206, **209,** 212,
 214
Adams, Clifton 128
Adams, Dick 243, 266, **266**
Adams, Harriet Chalmers
 68–70
Adapazari, Turkey **104**
Addario, Lynsey 352, 355
Afghanistan **110,** 117, **126,** 127,
 273, 350; *see also* Kabul
Akeley, Carl 84, 85
Alaska
 curlew's nesting grounds
 147–148
 glaciers **27, 148, 198–199,**
 248
 Tlingit seal hunters **36–37**
 see also Disenchantment
 Bay; Katmai Peninsula;
 St. Elias, Mount; St. Elias
 Mountains; Valley of Ten
 Thousand Smokes
Albatrosses **239, 377**
Aldrin, Buzz 229
Allard, William Albert 207, 209,
 212, 243, 249, 354, 369
Allen, Arthur 147–148
Allen, William L. 245, 350
Alvarez, Luis 330
Alvarez, Stephen 344
Alvarez, Walter 330
Amboseli National Park, Kenya:
 elephants **257,** 260
American Mount Everest
 Expedition 185, 193, **194, 195,**
 197
Amundsen, Roald 65, **65**
Anders, Bill **210,** 228–229
Anderson, Orvil 169, **169**
Andrews, E. Wyllys 219
Andrews, Roy Chapman **112,**
 113, 118, 120, 148
Andros Island, Bahamas
 90, 91

Antarctica
 dogsled expedition **284,**
 285
 first solo circumnavigation
 282
 icebound ship **64**
 leopard seal **314**
 see also South Pole
Aphrodisias (site), Turkey 68,
 242, **263,** 265, 266
Apollo 8
 capsule **210**
 image of Earth 228–229, **229**
Apollo 11 185, 211, 229, 368
Apps 303, 346, 354, 361
Arctic Ocean 62, 65, 284, 285
Armstrong, Neil 229
Arnhem Land, Australia 124,
 125, 130, 148
Asteroids 170, 331
Atkinson, Edward **290**
Atlases, world 16, **41,** 185, 196,
 245, 303, **347**
Australopithecus 242, 265, **265,**
 268, 322
Autochromes 51, 76, 114–116,
 115, 127, 128
 plates 76, **79,** 114, 119
 process 79, 114

B

Bahamas
 blue holes 340, **340–341**
 pink flamingos **90,** 91
Ballard, Robert D. **57,** 243, 245,
 266, 269, 279, 334, 336
Balloon flights **111,** 113, **168,**
 169, 228, **228, 344**
Balog, James 308
Banff National Park, Alta.,
 Canada: squirrel **179**
Baptista, Fernando 354
Barr, Brady 300, **300,** 316, **316**
Bartlett, John Russell 29
Barton, Otis 113, 166, 167, **167,**
 169
Bass, George 185, 219–221
Bathyspheres 113, **119,** 166, **167,**
 169
Beckwith, Carol 270, 272

Beebe, William 113, 119, 164,
 166, 167, **167,** 169
Beijing, China 127, 138
Bell, Alexander Graham **29,**
 51–55, **54, 65,** 83, 158, 185, 290
Benchley, Peter 246
Berann, Heinrich 188
Berger, Lee 322
Berlin airlift **111,** 162, **162–163**
Big Cats Initiative 301
Bingham, Hiram 68, 70–71, 118
Biodiversity 304, 307, 308, 337,
 361
Bionic hand **297**
Birds of paradise 255
Bisel, Sara 267
Bishop, Barry **56,** 195
Blair, James P. 209, 212, 243, 248
Bonner, John **43**
Borman, Frank **210,** 228
Bottlenose whales 336–337
Boulat, Alexandra 352
Bounty, H.M.V.S. 147, 185, 192
Bourne, Joel 355
Bowerbirds **242,** 250, **255**
Boyarsky, Victor **284**
Boyer, Dave 208, 212
Brandenburg, Jim 258
Breashears, David 342
Bredar, John 336
Breeden, Bob 16
Breitling Orbiter 3 (balloon) **344**
Brimberg, Sisse 249, 273
Bristle-thighed curlews 147–148
British Columbia, Canada:
 spirit bear **310–311**
Brooks, Alfred 87
Brooks Range, Alas. 87
Brower, Kenneth 337
Bush, George W. 338
Byrd, Richard E. 57, **111,** 113, 114,
 158, 164, **165, 166**

C

Calypso (ship) 186, 282
Cameron, James **301,** 303, 335,
 335
Canada
 Peary expedition (1909)
 61, 62

HAWAII | 2005 A Laysan albatross chick that starved to death because its stomach was full of indigestible plastic trash, including a cigarette lighter, a pump-top sprayer, and a shotgun shell

TIBET | 2009 A Tibetan girl dresses in traditional clothes for an upcoming horse festival.

KENYA | 1986 A Wahlberg's epauleted fruit bat licks its chops after enjoying a particularly delectable fig.

RUSSIA | 2009 A flowering bog-star graces a misty river meadow on the Kamchatka Peninsula.

CANADA | 1993 The aquamarine hue of Moraine Lake in Banff National Park results from silt-laden meltwater flowing in from surrounding glaciers.

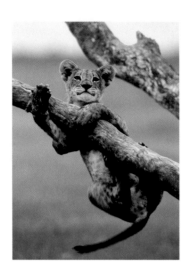

BOTSWANA | 1980s Swinging playfully from a tree branch, a lion cub gazes fearlessly at photographer Beverly Joubert.

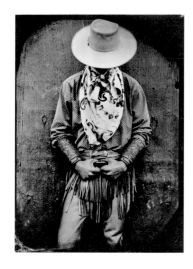

CANADA | 2007 Incarnating the spirit of the Old West for a modern tintype photographer, a young cowboy wears a flat-brimmed hat to ward off the sun and leather cuffs to prevent brush burn.

MARK COLLINS JENKINS

NATIONAL GEOGRAPHIC 125 YEARS

Published by the National Geographic Society

John M. Fahey, *Chairman of the Board and Chief Executive Officer*

Timothy T. Kelly, *President*

Declan Moore, *Executive Vice President; President,*
Publishing and Digital Media

Melina Gerosa Bellows, *Executive Vice President; Chief Creative Officer,*
Books, Kids, and Family

Prepared by the Book Division

Hector Sierra, *Senior Vice President and General Manager*

Jonathan Halling, *Design Director, Books and Children's Publishing*

Marianne R. Koszorus, *Design Director, Books*

Lisa Thomas, *Senior Editor*

R. Gary Colbert, *Production Director*

Jennifer A. Thornton, *Director of Managing Editorial*

Susan S. Blair, *Director of Photography*

Meredith C. Wilcox, *Director, Administration and Rights Clearance*

Staff for This Book

Lisa Thomas, *Editor*

Allan Fallow, *Text Editor*

Melissa Farris, *Art Director*

Meredith Wilcox, *Illustrations Editor*

Carl Mehler, *Director of Maps*

Clifton Wiens, Karen M. Kostyal, Margaret Krauss, Allan Fallow,
Barbara Seeber, *Contributing Writers*

Marshall Kiker, *Associate Managing Editor*

Judith Klein, *Production Editor*

Katie Olsen, *Production Design Assistant*

Manufacturing and Quality Management

Phillip L. Schlosser, *Senior Vice President*

Chris Brown, *Vice President, NG Book Manufacturing*

George Bounelis, *Vice President, Production Services*

Nicole Elliott, *Manager*

Rachel Faulise, *Manager*

Robert L. Barr, *Manager*

The National Geographic Society is one of the world's largest nonprofit scientific and educational organizations. Founded in 1888 to "increase and diffuse geographic knowledge," the Society works to inspire people to care about the planet. National Geographic reflects the world through its magazines, television programs, films, music and radio, books, DVDs, maps, exhibitions, live events, school publishing programs, interactive media and merchandise. *National Geographic* magazine, the Society's official journal, published in English and 33 local-language editions, is read by more than 60 million people each month. The National Geographic Channel reaches 435 million households in 37 languages in 173 countries. National Geographic Digital Media receives more than 19 million visitors a month. National Geographic has funded more than 10,000 scientific research, conservation and exploration projects and supports an education program promoting geography literacy. For more information, visit www.nationalgeographic.com.

For more information, please call 1-800-NGS LINE
(647-5463) or write to the following address:

National Geographic Society
1145 17th Street N.W.
Washington, D.C. 20036-4688 U.S.A.

For information about special discounts for bulk purchases, please contact National Geographic Books Special Sales: ngspecsales@ngs.org

For rights or permissions inquiries, please contact National Geographic Books Subsidiary Rights: ngbookrights@ngs.org

Many of the spectacular images in this book are available for purchase as high-quality, frameable prints. Please visit our site at www.NationalGeographicArt.com/125th for ordering instructions and pricing.

Most of the photographs in this book are also available for editorial and creative licensing. For details, please visit www.NationalGeographicStock.com.

Library of Congress Cataloging-in-Publication Data
Jenkins, Mark Collins.
 National Geographic 125 years : legendary photographs, adventures, and discoveries that changed the world / by Mark Collins Jenkins.
 p. cm.
 ISBN 978-1-4262-0957-4 (hardback) — ISBN 978-1-4262-1105-8 (deluxe)
 1. National Geographic Society (U.S.) I. Title.
 G3.N37J46 2012
 910--dc23
 2012024943

Printed in the United States of America

14/CK-CML/3